Baselitz

C. An

Terry
Winters

Richter
& Polke

Ruff
Struth Bechers

Cy Twombly Gursky

hards
ormat) Food F. Gonzalez
- Torres Hans
Haacke

politics

G. Matta
- Clark

Paul
Thek

irot Sue
Williams Terrorism

Cindy
Sherman

THIS IS MODERN ART

THIS IS MODERN ART

MATTHEW COLLINGS

Weidenfeld & Nicolson
London

First published in Great Britain in
1999 by Weidenfeld & Nicolson

© 1999 Matthew Collings

Design and layout © Herman Lelie
Artists' biographies © Melissa Larner

A CIP catalogue record for this
book is available from the British
Library.
ISBN 0 297 84292 7

Typeset by Stefania Bonelli
Set in Gill, Joanna and Garamond
Printed in Great Britain by
Butler & Tanner Ltd,
Frome and London

Weidenfeld & Nicolson
The Orion Publishing Group Ltd
Orion House
5 Upper Saint Martin's Lane
London, WC2H 9EA

Frontispiece: Tracey Emin on a boat
in Norway with Matthew Collings
1998

Contents

INTRODUCTION

KICKING ARSE

Gary Hume 1999

Start here

The sun was shining over Hoxton Square in London's East End. The sky was blue. The square was leafy. The buildings were picturesque. The air was buzzing with creativity and irony. Everybody was an artist. I walked past the Lux Cinema, the LEA gallery, and Rongwrong, the restaurant named after the title of a Dada pamphlet from 1928, published by Marcel Duchamp, on my way to the north-east corner where Gary Hume's studio is to look at some of his paintings. I was going to see if there was one that could go on the cover of this book – something that said Modern art but in a new way. But not so new that it didn't have any dignity or looked like it had just come out of nowhere and wasn't connected to anything, even though that's the main principle of Modern art, it's sometimes thought. It must be auto-genetic, born out of its own heavings and not come out of the frothy waves of the sea of joy that the art of the past swims around in, like schools of rainbow fish. This was the rambling course of my thoughts as I was smiling and saying Hello and Gary Hume was asking me how I wanted my coffee and telling me he'd given up smoking. 'What a problem it is', he was saying, 'to think up new ways to arrange the body and limbs when you're out with a lot of people and you suddenly realize there isn't a smoking ritual to unconsciously fall into.' 'White, please!' I was saying.

Magnolia

The abstract sublime – hospital doors; his paintings of the 80s joined them up into an expression of the age. They were big, stark, reflective surfaces of shop-bought

magnolia gloss, with a configuration of circles and lines showing faintly through the magnolia, the geometric shapes suggesting the rectangular finger-plates and circular windows of hospital swing-doors.

They suggested hospital cuts and Thatcherism and decadence and death and designer-handsome-ness. Minimalism is empty, death is emptiness, death occurs in hospitals. Minimalism is democratic. Death is too. Meaning bounced off the magnolia if you wanted it to, along with the high sheen. You didn't have to torture it out though.

I looked around the studio at his new paintings with their emphatic silhouette forms and bright colours. They had the attractiveness of wallpaper but the depth and mystery of art.

Burger King

In the early 90s he varied the hospital door style. He did this by introducing searing high colour combinations or having door-configuration paintings of unequal size and different colour schemes joined in a row, or by joining up door paintings that were all the same colour but the colour might be a strongly loaded one like flesh pink.

Then he wanted to drop doors and get on to something more flexible. But to get there he first had to try some things that were more awkward. It was to get his mind in a new shape. One of them was a film made in the studio yard. In it he wears a Burger King cardboard hat and talks aimlessly to the camera about art while sitting in a tin bath with all his clothes on. His young son hands him matches to light his fags. The film just comes on and he does all that for a while and then it ends.

Perhaps it was a Rimbaudian derangement of all the senses. Or a Jungian rite of passage. Or just an artist being an arse. You'd have to think you had a really worthwhile self in the first place to believe that deranging it for art might be a worthwhile experiment. But that's why I like his art, because he's imaginative, even though he has an alarming personality. Alarming alternating with charming. So you're often not sure if you've been insulted or not when he's just insulted you.

King Cnut

Hume's film was called *King Cnut*. It was grungy and grainy, with bad sound quality. The action was minimal, the atmosphere abject. It was an allegory of art. What can you do with art? How can you make it make sense and be real? King Canute has to perform an impossible task. He is mad and thinks he can do it, or else his people are mad for believing he can do it. Conveniently Cnut might really be an Anglo-Saxon spelling of Canute as well as an anagram. Burgers, burger hats, cunts and ordinariness are all outside the realm of art but here they all were in *King Cnut*, jostling forward impossibly.

Around the same time, he painted abstract shapes of brown and blue to represent the earth and sky in a cosmic union. He fringed the sides of the painting with pages from *Shaven Ravens*, *Asian Babes* and *Big Uns*, extending the painted surface out

Gary Hume
b Kent (England), 1962
A member of the phenomenal group of British artists who graduated from Goldsmiths College in 1988, Hume came to the attention of the art world with his extensive series of door paintings. These achieve an interesting balance between figuration and abstraction. Painted in household gloss on large-format sheets of metal or MDF to imitate the double swing-doors found in hospitals and other institutions, they are the ultimate in representational painting, but at the same time, they are two-dimensional studies reduced to circles and rectangles. More recently, Hume has been taking his subject matter from the imagery of popular culture to create large, shimmering works in enamel paint that explore the seductive possibilities of surface, colour and form. Again, these are not easily categorized as either figurative or abstract – images and shapes are immediately recognizable but are subjugated both to the emotional aura they convey and to the intellectual investigation of painting they undertake.

Gary Hume's studio.
Messiah is on the left.

into real space and making the union a porny one as well as a cosmic one. Another painting was a blue Madonna with a stuck-on plastic dummy instead of a nipple.

Out of these awkward stumblings came a steady flow of large, decorative, logo-like paintings. And that's basically his style now. Gloss paint and pop mass imagery. A Modern look combined with a high street look.

The Messiah

I was looking at one now, an image of a boy on a heroic scale painted on metal which had just been completed. The colour was mostly shades of blue with accents of red. He said the title was *Messiah,* and the image came from a photo in a news story about a deaf boy. The whites of Jesus's eyes were beige. His halo was unpainted metal reflecting the colours in the rest of the studio. The aggressively frontal, painted and unpainted areas of the painting – thick gloss slicks and shiny reflective steel – all jostled against each other in a visually satisfying way, like Modern painting is supposed to do, from Picasso to now, whether it's Monet or Patrick Caulfield.

Divertimento pentimenti

The classic model of Modern painting I had in mind was Picasso's *Les Demoiselles d'Avignon* of 1907, because of its fractured space. Like the fracturing that these metal areas and painted areas in *Messiah* seemed to be a reminder of. And the paintings by Monet I had in mind were his waterlilies of the 1920s, with their looming banks of mysterious *pentimenti*, because they were all on show at the moment at the Royal Academy. Monet is nothing like Gary Hume, except they're both supposed to be full of pleasure, or bringing back pleasure. The papers were full of articles about a new Monet for our age. Was he really a ridiculous snob and a sugary-minded moron? But that's his image now and we have to live with it – the Queen Mother of Impressionism.

Britain's image abroad

After looking at the *Messiah*, Hume and I looked at some *assemblages* or *bas-reliefs* or take-away-coffee-cups-used-to-mix-paint-in-and-then-stuck-to-aluminium paintings, which were a new decorative abstract departure. But before that, he showed me a model of the British pavilion in the little park in Venice where the Venice Biennale is held. This year, he would be representing Britain there. Colour photos on double-sided Sellotape of about twenty of his paintings lined the walls, with plastic model people standing around to show the scale. A flower-pattern painting from a couple of years ago hung upside down on a ceiling. And a hospital door painting from ten years ago lay out on the steps of the pavilion. Through the cardboard rooms there were more paintings showing plant forms, cell forms, single naked women, multiple naked women with their outlines all overlaid, faces, a teddy bear, a pair of abstract circles on their own, a pair of circles laid over a face.

Monet Exhibition at the
Royal Academy, London 1999

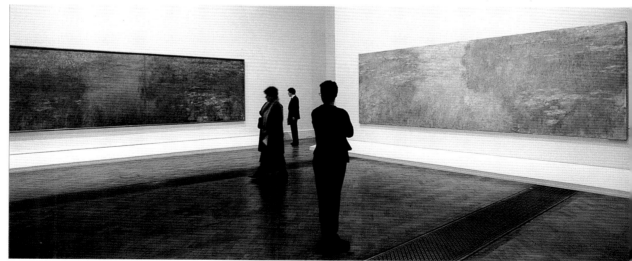

Tracey Emin
b London (England), 1963
Tracey Emin takes to an extreme
a strand in contemporary art
that utilizes intimate details from
the artist's own life as subject
matter. Haunted by an unhappy
adolescence, she treats her art
as a kind of therapy, creating
an overall, complex self-portrait.
Her best-known work is
*Everyone I Have Ever Slept With –
1963–1995* (1995), a tent
appliquéd with all the names
of her lovers and bedfellows,
including her aborted foetuses.
In other works, she has displayed
her contraceptive coil, or child-
hood dental brace. In the video
piece *Why I Never Became a Dancer*
(1995), she reconstructed painful
memories of her teenage experi-
ences in Margate. She has also
toured America, giving readings
from her book *Exploration of the
Soul* (1994), and opened a shop
with Sarah Lucas selling their
works. And in 1995, as the
ultimate gesture of self-
commemoration – or perhaps
self-invention – she inaugurated
The Tracey Emin Museum in
south London.

Tracey Emin advertising
Blue Sapphire Gin 1998

'It's good to get all this layering of possibilities all laid out and for it all to make sense,' I said. 'Yeah,' he said. 'But does it kick arse?' 'Ha ha!' I laughed. 'Well, you know, you don't have to kick arse all the time.'

Very Modern art

Today there is a lot of interest in very Modern art. When I was at art school in the 1970s Modern art seemed detached from everything else and nobody talked about it except artists and art students. You used to sometimes see it on TV with someone complaining about it. There would be a canvas with nothing on it except a line round the edges drawn with a biro. Or there would be a sculpture made of bricks on the floor. Nobody knew the names of the artists who made these works or what they looked like. Now that's all changed. Tracey Emin's colour-graded blue eyes look out from ads for Blue Sapphire Gin at all the airports. Gary Hume models Hugo Boss. Ads for Go Airlines imitate Damien Hirst's spot paintings – or imitate 60s graphics, which Hirst's spot paintings also imitate. And new Modern art is well known to a wide audience almost as soon as it's made.

Art fits with everything else now, all the other expressions of our time, and it's not out on a limb. Love tents, paintings of supermodels, Minimal sculptures, maps of the London tube system with all the names of the stations changed – they all fit with contemporary pop culture. (Well, one painting of a supermodel – Hume's

painting of Kate Moss – but a general feeling that Modern art and supermodels might be naturally aligned.) They all make sense. Myra Hindley paintings, cow sculptures, blood heads, a bullet hole in the head – Modern art's new sights are part of glamour, part of fashion and they fit with the spirit of now.

Earlier stirring

There used to be a similar relationship between the pop world and the art world in the 60s, people think. But in fact it was only a little spurting of the huge thing we now have. There was Pop art, dresses influenced by Op art, Pop art films, like Antonioni's *Blow-Up*, and there were album covers designed by artists, like Peter Blake's Pop art cover for *Sergeant Pepper* and Richard Hamilton's Minimal cover for The Beatles' *The Beatles*. *The Beatles* is the real name for what became known, because of Richard Hamilton, as *The White Album*. But how many other albums were designed by Modern artists? I can't think of any now. Except Andy Warhol's unzippable banana for *The Velvet Underground and Nico*. Does that count, though, since The Velvet Underground didn't really exist before him? His later unzippable jeans cover for The Rolling Stones' *Sticky Fingers* might be a better example. But still that's only four records, hardly a revolution, and it was all over pretty soon.

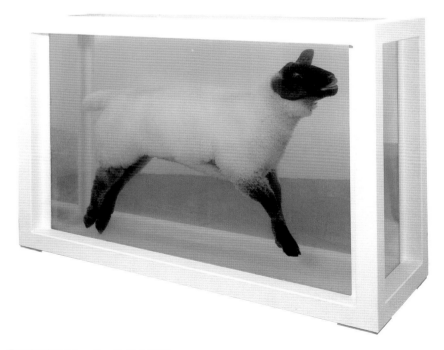

Damien Hirst *Away from the Flock* 1994

Minimal flats in the 80s

With Pop art in the 60s, popular culture just absorbed the part of Modern art that seemed to fit it and rejected the rest. Then the rest rejected Pop art and popular culture. The rest was Minimalism and Conceptualism, which was basically what art was in the 70s, as well as all the offshoots of Minimalism and Conceptualism – video art, performance art, body art, land art. This was the least popular art there has ever been. It was art drifting out to sea in a boat on its own and with nobody waving, either to it or from it.

Then unexpectedly in the 80s, Minimalism seemed to be influencing ordinary life. Minimalism was now a lifestyle choice instead of an obscure art movement because everyone wanted a Minimal flat with no furniture or they wanted to look at Minimal flats in magazines. It wasn't exactly Minimalism but a kind of sampling of an earlier notion of modern, pared-down living, which came to be known in the 80s as Minimalism. It was Modern art finding its way back into the wider culture.

Jake and Dinos Chapman in their studio
1999

Picasso and now

Picasso and the art of the Chapman brothers, their shocking sights that we're not really sure we're actually shocked by – is there a complete gulf between the two? Is our present Modern art something new, with no links at all, virtually, with anything in art further back than Conceptual art? Or is it all part of a seamless whole that goes back to Impressionism? We're sometimes supposed to believe the second idea and think well-known artists of today are like the geniuses of the past and it's great that we've suddenly got a lot in London when we used not to have so many and they were all in New York or Paris. The first idea is more realistic and likely and less confusing. The type of Modern art that goes back to Impressionism is over and the thing we have now is something new.

It's not just that it expresses the present and the present is different to the past. It's also that it doesn't express reverence for the art of the past, which older art used to do. A weird inversion of something that used to be a truth of art now

Pablo Picasso
self portrait taken
in Picasso's studio

operates – new Modern art often imitates the exact surfaces of old Modern art, precisely because it doesn't care about it. It does the same to pre-Modern art, whereas old Modern art used to strive not to imitate the exact surfaces of older art precisely because it believed in it. It believed in it enough to want to develop it and advance it, and developing and advancing meant not copying the surface but advancing the idea or principle that lay beneath the surface.

On the other hand, new Modern art is still art. It's art because it isn't anything else. It wants to be popular and to go on being popular and never go out of fashion but that doesn't mean it's only cynical – or only enjoyable because of its witty way of expressing cynicism. It expresses new meanings, it doesn't express only itself and it doesn't express only popularity or fashion or glamour.

Rise of now

At some point – perhaps it was the late 80s, early 90s – between the craze for Minimal flats and whatever the equivalent domestic architectural craze is now, Modern art became popular. The version of Modern art we now know was established and settled in. And this time it was glamorous, mysterious, sexy, soulful, macabre, gloomy, quirky, kinky and funny and it was going to last the course, it wasn't going to go away. It wasn't going to be only ritzy and funny, like Pop, and it wasn't going to be only uptight and white like mid-60s Minimalism.

Looks are everything

Modern art today often imitates the past, whether it's older Modern art or pre-Modern art. But popular culture is fascinated by the surfaces of the past too. It's a drive towards the retro which has been going on since the 1970s. We don't find it hard to imagine that ads and movies have a weightless relationship with the past and that when the past is sampled in these contexts, well, that's all it is. But when art does the same or seems to, it is more disturbing and we ask ourselves if it's really allowed and we feel a bit relieved when there's someone thundering against it in the papers, taking a stand against cynicism, even though there's something a bit reheated and un-urgent about the thundering position as well, as often as not.

Some things from the past are more likely to be sampled or recycled by the present. Matisse and Magritte, for example, are always coming up now but Cubist paintings of newspapers and pipes and mandolins hardly ever do because we are out of sympathy with this kind of subject matter and also this kind of space. Magritte and Matisse, previously so different, now align in their way of making a very compressed image – an image with a single, clear impact.

Magritte plays a game of ambivalent meanings. You could say ambivalence was two meanings. But Magritte's impact is in the idea of ambivalence itself, or contradiction. With Matisse the impact is in the colourful flat sign for an object – a plant or a face or a figure. And both the world of ads and the world of new art are full of these types of singular impact. Cubism is everywhere in the look and

Duane Hanson *Tourists II* 1988

Simon Patterson *The Great Bear* 1992

surfaces of modern life in diluted amounts but real high Cubist paintings from 1908 or whatever are too much Cubism for us.

How looks work is a mystery. It's clear now that looks are everything but why do we want some looks at some times and not others?

Less usable Modern art

Some parts of old Modern art go on being more and more popular but are not recycled or sampled by new art. They can't be re-used to express the age in a new way however expressive of the age they might already be. Crowds of couples stand around like Duane Hanson sculptures of ordinary people, updated to the 90s by having whirring CD exhibition guides hanging on their chests in transparent CD

players. They're at a big blockbuster show of Monet. So what if he stayed at the Savoy when he was painting the Thames? His paintings are beautiful, moving, and ravishing, the height of aestheticism and powerful, expressive art as well. Charing Cross Bridge, overcast weather, the bridge blue, the Thames banana yellow, the steam coming from a train on the bridge, purple: it's *Charing Cross Bridge, overcast weather*, a painting by Monet from 1900, the year Freud's *Interpretation of Dreams* was first published.

Landscapes

A typical new Modern art landscape scene — say, early 90s — is an urban landscape with a warehouse and an Underground station. The sky is an unnatural blue, as if the blue is bumped up artificially by some computer digital technique or other. The warehouse is a converted one, formerly part of industry but now part of culture and full of artists, with a private view going on downstairs and studios upstairs. The Underground station has had its name changed from Walthamstow to Walter Benjamin. The artists have had their T-Shirts changed from striped like a Marseilles fisherman's T-Shirt to ones with Mod targets on them or *My Drug Hell*.

The scene is one of a series of 90s urban landscapes, all the same but with variations, going on throughout the decade until now, maybe going on forever. In this landscape there is a blurred figure — it's your guide, myself. A blur with a pass for Zones One and Two — the old and the new. Shortly we'll be touring them both, going back and forth, taking six basic ideas about Modern art which are common and popular as the main stopping off points.

The first idea is that the notion of genius is still an important one. After that it will be Modern art's shocks — why are there so many, what are they for? Then beauty — is Modern art against it? Then nothingness — why are there so many blank canvases or all-white ones? Then jokes — why is Modern art full of jokes, are they funny? Then lastly hype, money, repetition, realism, all at once, and the anxiety that goes with them.

So let's go then, down the tunnel to the platform where mannequin children smile, supermodels glide, sharks loom, heads bleed, Myra Hindley stares and the trains are rushing in and the passengers are getting out and the next stop is St Thomas Aquinas, for the Comedians and Footballers Lines.

CHAPTER ONE

I AM A GENIUS

Gilbert and George

Gilbert Proesch: b Dolomites
(Italy), 1943;
George Pasmore: b Devon
(England), 1942
As students of St Martin's
School of Art in the late 1960s,
Gilbert and George designated
themselves 'Living Sculptures',
a decision that has not only
involved dedicating their entire
existence to art, but which also
broadens the definition of what
art can be. Their performances
and photographs may be
shocking, but their principal
aim is to make art that is as
accessible as possible. Early
works ranged from the 'Singing
Sculpture' performances, in
which they dueted 'Underneath
the Arches' for an eight-hour
period, to photographic collages
with titles like *George the Cunt
and Gilbert the Shit* (1970).
More recently, they have been
producing vast, brightly coloured
photographic works, in which
they present taboo imagery,
sometimes political or religious
in content but usually featuring
themselves, naked or surrounded
by giant turds (*Naked Shit Pictures*,
1994). As a result of their
provocative, dead-pan
double-act, Gilbert and George
are amongst Britain's most
famous contemporary artists,
pushing questions of taste and
conformity into the mainstream.

Three big myths

Three important myths of Modern art are the myths of Picasso, Jackson Pollock and Andy Warhol. All three myths are vivid and powerful and each myth, once it emerged, changed the codes of art history. These myths are all referred to unconsciously all the time by critics and art historians and by artists. And in the popular imagination they are also referred to because everyone knows them.

Old sausage

Sometimes mythologizing is part of what a Modern artist does – Gilbert and George and Joseph Beuys are well-known examples. These artists have their acts and acting is part of what their art is. They make objects as well, but their mythic rituals are just as much their art as their objects. Obviously an old sausage by Beuys is less of an object than a huge multi-part photo-work by Gilbert and George. So we could say Beuys relies more on myth. But both rely on myth in a way that Picasso, Pollock and Warhol don't.

Camp

Warhol of course had an act but he didn't present his act as art, or say he was a living artwork, which Gilbert and George do. But in doing this, Gilbert and George might be said to be only foregrounding or theatricalizing or making camp the whole idea of artists having acts within a mythical context where having an act is considered to be bad and art speaking for itself is good. Which was the same mythical context that Warhol elaborated his act within, even though he didn't call his act art and he didn't even call it an act. He just carried on like that. And even though it was a camp act.

Siberian camp

Beuys actually had a myth of his own self-realization as an artist, which he told to people and which has entered art history not as fact but as a myth. He said he crashed his plane in Siberia when he was a Luftwaffe pilot in the war. He was rescued by primitive Siberian tribesmen who took him back to their camp and bound his

Joseph Beuys
*Explaining Paintings
to a Dead Hare*
1965

Joseph Beuys
b Krefeld (Germany), 1921;
d Düsseldorf (Germany), 1986
In 1943, as a Luftwaffe pilot,
Beuys was shot down in the
Crimea. His life was saved, he
claimed, by a group of nomadic
Tartars, who kept him warm
with felt and fat. These materials
and his trademark fedora hat,
which he wore to hide the scars,
became central therapeutic
symbols in his personal
mythology, expounded in highly
influential performances and
installations. Beuys was a leading
figure of the European avant
garde in the 1970s and 80s. Like
other members of Fluxus, which
he joined in 1962, he was intent
on the demystification of art,
and on demonstrating that life
itself is a creative act. His
sculptures were made of junk
and rough wood. Eventually,
however, he rejected the art
object as 'a useless piece of
merchandise'. His performances
often involving living or dead
animals included *Explaining
Paintings to a Dead Hare* (1965),
in which he attempted just that.
When, in 1972, his policy of
unrestricted admission got him
sacked from his Professorship at
Düsseldorf University, he turned
his attention to public debate,
exchanging ideas with Andy
Warhol and the Dalai Lama. By
the end of his life, his spiritual,
democratic practice had accorded
him the status of internationally
celebrated art guru.

broken body in layers of felt and fat as part of his recovery treatment. This myth is the ur-myth of Beuysian Happenings and installations and objects, and it connects to all the fat and felt that he used as materials. There might be some truth in it or it might be entirely true but it isn't necessary for the Beuys myth to work that it should be true, whereas it is necessary for the Pollock myth for it to be true that he had drunken rages because it connects to the aspect of doom which is a major part of his myth.

Different self-mythologizing

Other examples of self-mythologizing artists are Sophie Calle and Cindy Sherman. Gilbert and George and Beuys's self-projections are always the same or variations on the same theme – twenty-four-hour living sculptures or wise guru of art and life. Whereas Calle's and Sherman's are deliberately always different. No one will ever know the real Cindy because she is always in disguise as someone else. Someone grotesque and glamorous at the same time. While the real Sophie is always present but only in whimsical fragments. Narrative fragments presented in an installation form. Cindy is a cypher and Sophie is a modern psychoanalytical, perpetually fragmented, self.

So these artists' mythologizing goes in the opposite direction to Gilbert and George's and Beuys's but mythologizing is still the basis of what they do.

Cindy Sherman
Untitled No 70 (Girl at Bar)
1980

Sophie Calle
Days Under the Sun B, C & W (detail)
1998

Usual myths

But usually, or classically, myths build up around the artist and it is a delicate question as to how much the artist is pushing the myth self-consciously and how much the myth is a product of fantasies imposed upon the figure of the artist from outside. This is certainly the case with Picasso and Pollock but even with Warhol too.

Sunny

Picasso's myth is of the protean genius who keeps coming up with new ideas and styles. Attached to this is the myth of painting like a child. And attached to this is the myth of revolution against false finesse. Picasso stripped away pomposity and falseness and painted in an incredibly direct way. He attacked convention. He risked ugliness instead of beauty.

Attached to these myths is the myth of the good life. He lived a life of sensual pleasure. He got up when he liked and it was always sunny, except at night when he painted while everyone else was asleep because they had to get up early. And attached to sunniness is the myth of darkness. Picasso was a man like any other and aggression and fierceness ran through his veins. Bad Picasso!

All these make up the glaring aspect of the myth of Picasso. One of the subtle aspects of the myth, that we might mention, is the sub-myth of Picasso's archaism. His avoidance of cars and aeroplanes and business suits or nylon cardigans or TV sets, as subject matter for his art. They were as much a part of his life as they were a part of everyone else's but he preferred to paint centaurs.

Nowhere

Jackson Pollock's myth is the myth of rugged inarticulacy and untamed genius. He came from nowhere and invented a style that came from nowhere. With it he defeated Europe and oldness and made American newness the new thing. But he didn't know what he had done or if he had really done it. So he could not feel satisfaction. Attached to this is the myth of his martyrdom. The false world was too much for Pollock and it made him die young in a tragic car crash.

Pollock's main sub-myth is the myth of tragic unevenness. After the moment of triumph he lost his way and remained in a failure-limbo for years. It was not a limbo-lounge but a limbo-inferno, full of suffering. Obviously limbo is not hell, but a stage just before it, I think. But for Pollock it was all the same because in America failure is considered to be even more hell than war.

Supporting this myth are numerous mythic incidents of depressed, violent, drunken behaviour in an art context. These actions, innovated by Pollock and described shakily by craggy oldsters who now make up a familiar cast on TV documentaries about Pollock, are now archetypal and part of Modern art martyrology and also the martyrology of film and rock and roll culture.

No cigarettes

Andy Warhol's myth is the myth of Pop celebrity and shallowness and packaging replacing tortured sincerity and inner depth – the myth of self-consciously making yourself into a myth to begin with instead of waiting for a myth to build up. Picasso is Gauloise, Pollock is Marlboro, but Warhol is the pure concept of the brand name without even the necessity for cigarettes.

With shallowness Warhol defeated the withering disease that had afflicted Modern art because of its turning away from the outer world. Artists were in conflict with the outer world because it was rubbish or plastic or phoney or too consumerist or capitalist. But Warhol let the outer world into his inner world so there wasn't any conflict. He remade himself in its image. His iconic, celebrity mass art was a pure expression of his new inner self.

Warhol sub-myths include being gay as well as coming from the wrong side of the tracks socially. And being a Catholic. And having an old mother who was Catholic and who he kept in the basement. And never having sex because he preferred voyeurism. And being an obsessive collector of bric-a-brac which he kept in boxes.

As with Pollock, Warhol's triumph was achieved by a great gesture of skill-dumping and finesse-ditching and etiquette-trashing. Shallow naïveté is part of the glaring aspect of the Warhol myth but equally present is his mythic, sharp business acumen. His skill lies in his charlatanism, it is thought – unrivalled while artists attempting to emulate it are numerous (the inevitable connecting thought).

Freud

Other Warholian sub-myths include the myth of killing the father. He was formed as an artist in a climate of Abstract Expressionism but he could only become an artist by killing Abstract Expressionism. This Freudian myth is a given in all Modern art myths. Pollock had to kill off Picasso. And Picasso had to kill off tradition.

Rank

The myth of stylishness that attaches to Warhol as it attaches to all the main mythic figures, includes a distinguishing myth of rankness – stylishness that is gone off because of archness and mannerism and camp.

Industry

Another Warhol sub-myth is the myth of industriousness – he worked very hard; he had nutty, shallow ideas about what new art could be, but unlike his circle of decadent friends, who all took even more drugs than he did, he had the energy and industry to make the ideas into objects. (And they turned out not to be all that shallow after all.) Yet another Warhol sub-myth also connects to industry. His output, because it is so vast, is uneven. He had no quality control. (In fact he did and it's only a myth that he didn't.)

Picasso at Villa la Californie, Cannes, France 1960 Andy Warhol in the Factory, New York 1966

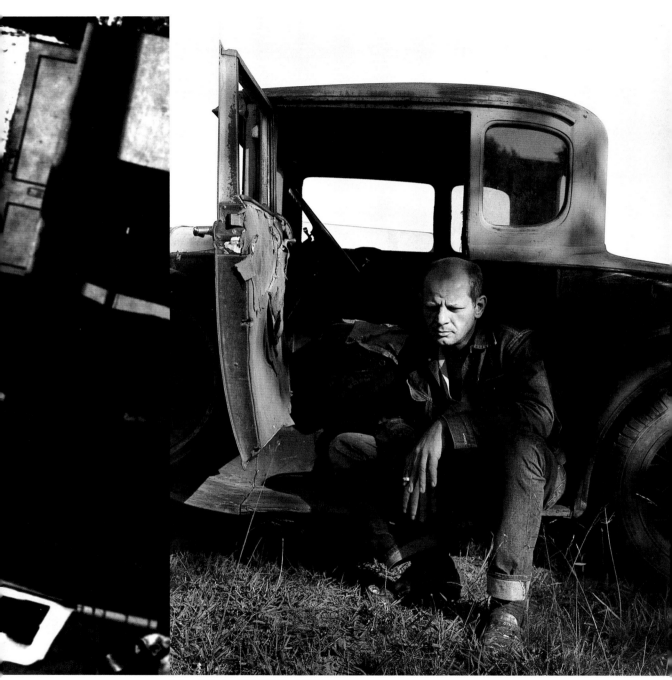

Jackson Pollock and Model A Ford 1948

What did they do?

All these artists changed the definition of what Modern art is. With Picasso it was ugliness instead of beauty. With Pollock it was American instead of European. With Warhol it was irony instead of tortured emotion. Each of them in their time stood for making art that seemed to be aggressively about the present and not about the past. But now they're all in the past too. Warhol entered culture in about 1961. A lot's happened since then.

Up-to-date myths

Who are the mythic artists of now? Damien Hirst is one. He stands for constant innovation and popularity. Obscurity is part of his myth but it is never all that obscure. For instance, death is a mystery and death is part of the Hirst myth but

it is not difficult to get why dead animals might symbolize death. So the idea of Hirst as an artist of death has entered the popular imagination. Plus, he stands for a new connection between art and the jazzy world outside art. So he has made art more jazzy. Fashion people and ad people and people in rock and TV all embrace him and he embraces them but there is no doubt who the band leader is. He also stands for clear ideas, which he got from going to Goldsmiths College in London in the 80s. His restaurant Pharmacy, in Notting Hill Gate, stands for the buzzing generality of art now, the way Modern art is part of glamour and show biz and the way the old deep ideas of art can be made into bar décor, which is a twist on the popular idea of the old deep artists hanging out in bars like The Four Cats in Barcelona or the Cedar Tavern or Max's in New York.

New image of Modern art

Many vivid impressions make up the new image of Modern art. These impressions also make up the legacy of the earlier geniuses. Installation bric a brac and films and videos is one – things lying around, staging meanings. They break up pleasure because they are literally broken up and the pleasure or meaning isn't all concentrated in a single object. A TV monitor is a single object but the video playing on it in a typical installation of nowadays rarely has a narrative so the fragmentation principle is still operating.

Another impression is people arguing for and against installations in a stagey way on TV. The arguments are straightforwardly unreal, with everyone happily talking in short-cut versions of formerly difficult ideas only roughly connected to the short-cuts everyone else is using. And the installations only roughly seem to stand for the ideas. New pleasure is the main idea and everyone more or less gets it (even if they are on stage to attack it).

Old clothing and personal effects in installations is another impression. They can be from Oxfam or from the artist's childhood but they are always emotionally charged, because old clothing now stands for that idea. 'Hmm, where did she get that old cardigan?' would be an inappropriate response at a Louise Bourgeois exhibition, for example.

Important artists from Germany or other European countries having retrospectives at big public galleries in London and nobody knowing why and the art all looking a bit like 'Sensation' but with Swiss titles is another.

Vivid realistic ordinariness is another impression – ordinary council blocks, dads, mums, kebabs, mattresses, cans of Guinness, the *Sunday Sport*, the police, the map of the London Underground system: all these now have a place in Modern art iconography.

The new sights of art are all seen in white sites, the pleasurable, grungy, realistic ordinariness of the art surrounded by a corporate-style whiteness. It's a pleasure just to find yourself in there, separated from the real reality outside, like being in

Damien Hirst
b Bristol (England), 1965
Hirst broke onto the art scene as a recent graduate of Goldsmiths College when he curated two historic exhibitions – 'Freeze', 1988 and 'Modern Medicine', 1990 – which launched the work of the Young British Artists. He deals with the big themes of Birth, Life, Death, Love in a series of controversial, visceral works often involving dead animals, such as a shark or a bisected cow, suspended in formaldehyde. These shocking qualities are balanced, however, by his use of the vitrine, which gives his work the formal cool-ness of Minimalism, and by his references to art history: the Vanitas, the Madonna and Child, the works of Francis Bacon, for example. Installations often include his medicine cabinets – simple structures supporting packets and bottles of drugs – and his *Spot Paintings*, glossy canvases covered in rows of coloured circles. Never afraid of self-publicity, and seeing little difference between his art and the products of popular culture, Hirst has also made commercial music videos and films and opened his own restaurant.

Sarah Lucas 1998

a cinema, only more brainy. The uniformly corporate style of art galleries makes it clear they really are galleries, not a new thing that hasn't got a name yet. The art must be unconventional but the galleries must be conventional so you can tell it's really art in them and not just something left over from a party or a murder.

The things artists say on TV or their statements in magazine articles make up another impression. With very few exceptions they tend to be full of reserve and dryness even though their art might be vivid. There will always be an interesting concern of some kind, about something the artist has personally noticed which no one ever thought was worth thinking about before, like the holes in cheese or the design of skirting boards or the patterns on socks.

There are many art bands, warehouse shows and private views, all adding their own textures to the other impressions. Art bands are full of irony. And artists stand

around at private views in neurotic ironic knots with their stomachs in knots, their faces twisted in ironic grimaces and with belly ache and their necks broken from twisting to see who's there or if their friends are being interviewed on TV.

Insider art jokes that would have become part of art scholarship and stayed there in a scholarship limbo, in the past, now make it straight into the Sunday supplements while the irony and sarcasm are still hot or icy.

Mass market magazines and little art magazines coming together is a part of art's new pleasure. 'Well done!' the members of the Bank artists' collective write in the margins of press releases which they send back to the galleries who sent them, stamped with the 'Bank Fax Back Service – Helping You to Help Yourself!' logo. They give marks out of ten for pompousness and general authoritarian feel. 'This last sentence is insufferably pompous,' one comment goes. 'Doesn't read as

Bank *Press Releases* 1999

deliberate, though. Try harder. 2/10.' Then it appears in the *Guardian* and everyone gets the joke.

The art magazines with their banal ideas and observations all twisted up and strangled in an impenetrable language contribute their own fun. Outsiders must never try to read them but artists must always be in them otherwise they cannot be serious, so they can't be nominated for the Turner Prize, which is about making Modern art more popular.

Place of art history

Art history has a place in the new system of art but it's hardly ever used. If the new art doesn't seem to be expressing urgent new meanings then art history can be called upon to explain why art exists at all. So in this sense art history is a kind of theology. It functions in relation to art as a kind of temporary back-up system. Because it's got nothing to do with new meanings, but only dates and influences, it cannot itself get the sparks of meaning going and it's art with vivid, immediate impact and meanings that society values now.

Anyone can relate to the new urgent meanings expressed by new art even if they don't want to. And to get meaning going, jokes will do. In fact they're good, even jokes about art history. Banal ideas, wrong ideas, popular ideas – anything will do as long as it's plugged directly into the present and there are sparks coming out the wire.

Jake and Dinos Chapman
Disasters of War 1999

Influence of Goya

For example, the Chapman brothers' art is influenced by appropriation, a style of the 80s. Their art appropriates Goya but Goya didn't influence the Chapmans in the way Cézanne influenced Cubism or Picasso influenced Jackson Pollock. Cubism makes a new kind of sense out of Cézanne and the sense Cubism makes is part of what Cézanne does, so there is a live connection between the two or a positive critical relationship. And it is the same with Pollock and Picasso but not with Goya and the Chapmans. Goya stands for goriness because his pictures are often gory and the Chapmans stand for goriness too because they copy his pictures. But that's it.

Meaning

Meaning itself is only a part of art. We object to there not being any but when there is some it's often not all that interesting.

Individualism

Individualism is not bad in itself but we don't want to be individual in a corny way like the Abstract Expressionists. They were not corny but to be like them now would be. Or, they were corny. Either thought works OK. In any case, we want to be individual but within a new climate, a climate where basically we have signed up to advertising. We simply don't challenge its assumptions. It expresses us. It has to sell things but this in itself isn't interesting or even particularly bad. In the old days it would say 'Go to the Regal, it is open at 7.30 in the evening' in a strained accent. But now it has all the accents we have ever heard and it does them all brilliantly and effortlessly. Advertising expresses a new world of oceanic oneness where no one is alone and that's good.

Do we believe in geniuses?

Mostly we do but we are wrong. Geniuses are out, along with crying clowns and Montparnasse and smoking pipes. Picasso is one of those artists where genius is a natural word because of the culture of Picasso but that's not our culture, like bullfights aren't part of our culture. Actually bullfights *are* part of our culture, because of Picasso. So we can't really say we reject him now because of his connection to bullfights. Actually we can't really say we reject him — it's the notion of Picasso as a magic being or a god that we feel it's important to reject because it makes him absurd somehow whereas in fact we know he is quite good.

Genius of Duchamp

Even with Duchamp, who we must agree has turned out to be the winner in the war with Picasso because now Conceptual art is known to be a powerful source for new ideas in art and Picasso's art isn't — but even with Duchamp the idea of genius isn't that interesting. Plain ideas about him, not ideas of magic, are more interesting.

For example, he was socially at ease and not wild. He might have modelled the realistic three-dimensional headless nude woman in his last work, *Etant Donnés*, on

the wife of the Brazilian ambassador in New York, whom he had an affair with. He made a living from advising collectors on what to buy. He acted as a dealer. He was an iconoclast but an aesthete. He never met Picasso. He met Matisse. He was kind to children. He was always profane but not angry. The charming American assemblage artist Joseph Cornell, who was interested in the poetic implications of Duchamp's Readymades, found his swearing appalling and it disturbed him. But Cornell was always dreaming about Duchamp and he had a fixation with him so he was probably more sensitive to bad language because he expected noble or poetic language. In fact Duchamp probably laid it on a bit heavy with Cornell just to keep his distance. When he was old there was a sudden widespread resurgence of interest in Readymades because of the vogue for Jasper Johns and Robert Rauschenberg in the 50s who both claimed Duchamp as an influence. So he started having them

Marcel Duchamp in 1963

remade in Italy and signing the remakes and selling them in editions, because, although he was against commercialism, he thought it wasn't an impossible contradiction to get some cash in at this late stage while he still could.

All these things send up echoes for us of Modern art today and they all seem more interesting than worrying about whether Duchamp was a genius or a charlatan to say a urinal could be art.

Genius of Whiteread

Is Rachel Whiteread a genius? It's only part of the world of hype that is part of her world, as it is part of everyone else's, to use the word. Of course hype is false and an illusion. On the other hand, the world of Minimalism that connects to her world is not false but only unclear because it's still being explored. But Minimalism is about not relying on a mysterious force called genius but about paring art down to essentials. Therefore it's always uncomfortable to hear about the genius of an artist at all involved with Minimal forms which is what Whiteread is, even if she does make Minimalism more poetic or human.

Picasso likely genius

With Picasso it might be an acceptably loose use of the word to say he is a genius at transforming things so economically. With just a few strokes of the brush he transforms a triangle into a face and then into a flower and it's a wonderful sight to see that happening, especially when it's in a film from the 1950s. But this idea

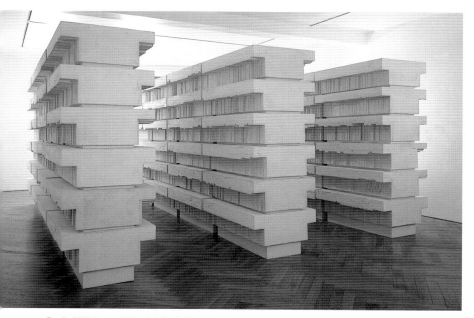

Rachel Whiteread *Untitled (Book Corridors)* 1998

Rachel Whiteread
b London (England), 1963
Whiteread became known for her plaster and resin casts of the interiors of domestic objects. The spaces beneath chairs were made visible as glowing chunks of amber-coloured resin, both familiar as Modernist forms, and revealing the unfamiliar nooks and crannies of everyday life. Baths cast in plaster were transformed into tomb-like manifestations of negative space; the subtly corroded innards of hot-water bottles turned inside-out. Whiteread has taken this metaphor for memory, the intimacy of private life, the spectres and traces of daily existence, to increasingly poetic realms. In *Ghost*, 1990, she cast a complete room, creating a haunting mausoleum, and in her most famous work, *House*, 1993, an entire derelict Victorian dwelling. Standing alone on a piece of wasteland in London's East End, this profound memorial to everyman documented door-knobs, fireplaces, windows in negative. Following great public controversy, it was quickly demolished. More recent projects continue to revolutionize the public monument – notably a concrete cast of a library in Vienna, presenting the concave spines of thousands of books, a poignant, permanent memorial to the 65,000 Austrian Jews who died in the Holocaust.

Jeff Koons
Signature Plate 1989

Picasso in a still from
Le Mystère Picasso 1955

of genius is always accompanied by a challenge to the notion of finesse so genius itself is challenged.

Koons possible genius

I might catch myself sometimes believing Jeff Koons is a genius because of the weird way he talks – confident but awkward, disjointed but streamlined, poetic but syntactically eccentric. It makes you want to shake him or tell him to snap out of it but it hypnotizes you at the same time. But this would be to use the word for its commonly acknowledged association of madness or being inspired to the point of madness, because he has that slightly mad feel about him when he's in full flow and this has been seen often on TV. Not the Romantic madness of the age of Shelley or Keats but some other new, unlabelled type, as if art school syntactic eccentricity had been given a poetic form and a load of mescaline.

Joie de vivre

Why do we have Warholian blankness now and not Picasso's joie de vivre? Compared to Koons and Hirst, Picasso seems sentimental. They have black joie de vivre, he has the full-blooded kind which has a lot of dancing and gamboling and pan-pipes and Mediterranean sunshine as one of its textures and this is a texture we don't approve of or want in art any more. We reject the *Zorba the Greek* notion of

Picasso, where darkness is never really all that dark because it is always ready to burst into song.

Two fried eggs and a kebab please

Sarah Lucas's symbols of female figures are morbid and obscene, made out of ordinary objects. A packet of kippers at one end of a table and two melons in a string bag at the other make up a sculpture called *Bitch*. A more famous one makes a female symbol out of two fried eggs and an open kebab. Another one is a couple – a fire bucket and two melons on a mattress, next to a cucumber and two oranges.

These sculptures are typically grim and deathly, like primitive totems but at the same time they seem deliberately beneath the level of art, too awful and silly to qualify as art or to make it onto the respectable

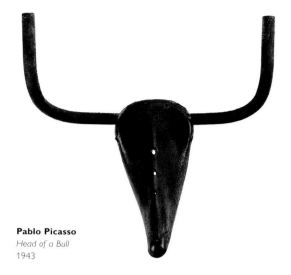

Pablo Picasso
Head of a Bull
1943

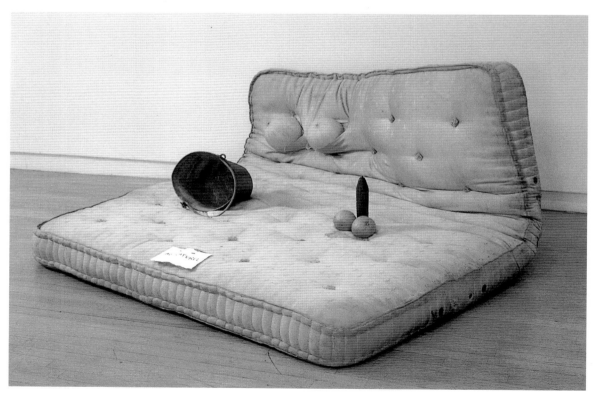

Sarah Lucas *Au naturel* 1994

Sarah Lucas
Two Fried Eggs and a Kebab 1992

Sarah Lucas
b London (England), 1962
Traditionally, female artists
interested in stereotyped gender
roles and the objectification
of women have focused on
an investigation of femininity,
eschewing the frameworks of
the male-dominated art world.
Lucas, however, adopts and
recontextualizes the tactics
of the laddish, innuendo-ridden
world of tabloid journalism and
sniggering schoolboy humour.
Two Fried Eggs and a Kebab (1992),
for example, is reminiscent of an
adolescent's smutty representation
of the female form. *One Armed
Bandits (Mae West)* (1995) – a
lavatory with a cigarette floating
in it, placed next to a chair
'dressed' in male underwear with
a candle sticking up from the
seat, is a gross depiction of
masculinity. This crude, 'bad girl'
approach is underlined by self
portraits in which she adopts
butch poses, suggestively eats
a banana, or aggressively smokes
a cigarette. *Bunny* (1997) extracted
the abject, unsettling qualities of
the earlier works in a poignant
evocation of contemporary
alienation. Most recently, Lucas
has been making smoking vaginas
and lavatories moulded from
urine-coloured resin or encased
in cigarettes.

intellectual plane where the idea of a primitive totem has some currency. But still there is an aura about them of objects that are intended for a tomb. They express life in an essential way – even if the essentials they express are the bleakest lowest denominators of existence – sex, life, death and relationships.

Lucas makes bits of discarded stuff stand for something, with a minimum of fuss, which is a sculptural technique that goes back to Picasso's welded metal sculptures of the 40s and 50s and back from there to his constructed objects of the 1910s. Her art might seem to laugh at the myth of Picasso but in this way at least it respects the myth too. That's why she's good. She keeps the ball rolling. It would be a parody of art history to say that *Bitch* therefore stands at the end of a timeline that begins with Picasso's earliest Cubist painting, *Les Demoiselles d'Avignon*, but it's true in a way.

I also like her ugly *Sunday Sport* blow-ups from the early 90s. They're really disgusting of course but quite impressive as a single visual blast. They too would be fine in a tomb, like hieroglyphs in a pyramid, to be pored over by future civilizations seeking the key to the meaning of the old mattresses and fossilized kebabs in the central chambers. *Sod you gits! Men go wild for my body!* That's what one of the headlines reads. A semi-naked dwarf woman grins out at the camera, all around

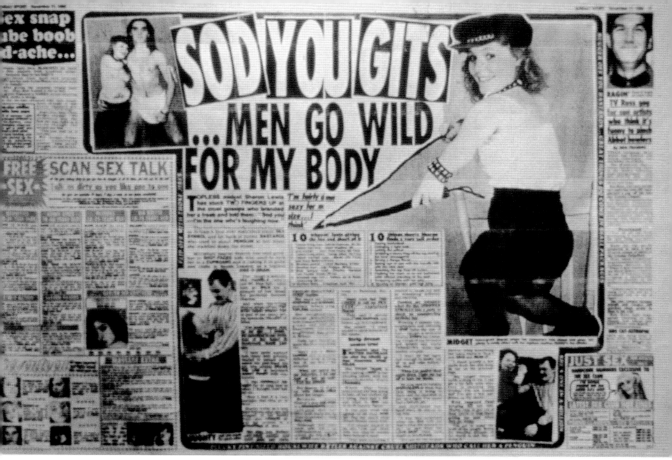

Sarah Lucas *Sod You Gits!* 1990

Pablo Picasso *Les Demoiselles d'Avignon* 1907

her are ads for phone sex-lines. Of course there's no point in looking at this work for long unless you want to read the ads. A lot of them are quite funny but it's not like looking at Picasso's welded metal assemblages from different angles or at the fractured space of *Les Demoiselles d'Avignon*. On the other hand, a lot of the same elements are present.

Myths again

Since the old myths seem to be rearing up on their own now, let's go back to them properly and see what's there. Picasso's blue and rose period paintings are well known, liked by people who don't normally like Modern art, disliked by people who like it. For Picasso, in the early 1900s, they were poetic symbolic paintings that expressed existence. At the same time he painted them he turned out hundreds of other pictures – engravings, watercolours, sketches – that expressed the texture of modern life as he experienced it. Night-life, bars, dancers, prostitutes, friends, lovers, other artists, all make an appearance, frequently in a context of mockery or outrageous obscenity, as well as a context of moody dreaminess or a poetic atmosphere. Another feature of this body of work, though not its most obvious one, is the different ways of making a figure read as a figure or simply of making representation work. Seen in this light, his blue and rose paintings might seem powerful and interesting and an odd quirk of Modern art and it is surprising that, since Modernism is over now, no one has thought of rehabilitating them or putting them in a big exhibition at the Royal Academy. From a Modernist perspective, though, these paintings are merely a lead up to *Les Demoiselles d'Avignon*; they haven't yet found a Modern form to express modernity so they're not that interesting.

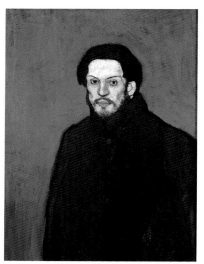

Pablo Picasso
Self portrait
1903

Pablo Picasso
b Malaga (Spain) 1881;
d Mougins (France), 1973
Picasso is probably the most influential twentieth-century artist. His vast output of paintings, sculptures, graphics and ceramics passed through many styles and disciplines. The melancholy symbolism of his early 'Blue Period' (1901–4) gave way to the Harlequins and saltimbanques of the 'Rose Period' (1904–6), leading to the savagely revolutionary *Les Demoiselles d'Avignon* (1907), which combined the influences of African art, El Greco and Cézanne. With this work, and the subsequent sombre paintings developed with his close collaborator, Georges Braque, he invented Cubism. Picasso and Braque also pioneered collage with their radical *papier collés* and reliefs of 1912. After visiting Italy in 1917, Picasso began to make Neo-Classicist works with the recurring motif of the minotaur, but in the mid-1920s his paintings came under the influence of Surrealism. His strong political and nationalist views reached an intense pitch during the Spanish Civil War, when he produced the great anti-war protest, *Guernica* (1937). Post-Second World War works include variations on images by other artists and many graphics and ceramics.

Les Demoiselles d'Avignon

Painted in 1907, *Les Demoiselles d'Avignon* is the picture at the beginning of Modern art books. It introduces Cubist fragmentation and a scary notion of the anti-aesthetic, like the anti-Christ. It is a six-feet high squarish painting of five women in a room with drapery and a still life of fruit. The figures are blunt and flattened and the space of the room is also flattened so there's nothing behind the figures. Everything is pushed up to the surface. The figures have the feel of cut-outs. The middle one shares a contour with a section of drapery that runs down the length of the painting and the length of the woman. So there is a visual confusion running through the middle of the painting as if one side of the scene has been folded over the other. Sometimes it looks like the right side is folded over the left, sometimes the other way around. The same effect occurs with all the contours of all of the objects. This one makes a more continuous division while the others stop and start. The overall effect is of spaces and shapes interlocking and reversing. The expressions on the faces are mild or blank or masks of mild blankness. Three of the faces are actually stylized like African masks, one of them in a way that doesn't particularly jar with the stylization elsewhere, but two of them in a way that is very jarring and grotesque. This particular distortion is the main symbol of a new aesthetic of ugliness in Modern art that Picasso ushered in. And that's why this painting exerts a fascination.

It was originally conceived as a symbolic scene in a brothel with prostitutes, a sailor and a student carrying a skull. So the themes are prostitution, death, philosophizing about sex and death, connected to the themes of Picasso's pre-Cubist art. But here they're expressed in a primitive or pseudo-primitive form, so primitivism is the theme as well.

Picasso's comments on his use of African art are distorted by Chinese whispers, the subtlety of the original thought long ago lost. But apparently he really thought there was a voodoo magic to African masks and his fascination with them at this time wasn't on the aesthetic level. He thought they really were powerful and they could be used to make art more powerful.

I am Nature

Jackson Pollock made art more powerful by blasting it with primitivism. The Jackson Pollock story is a melodrama into which anything can be read. But directness and authenticity and agonies connected to the dilemma of authenticity, are constant themes of the story. Connected to these themes is the theme of a pared-down, pure type of art, an art free of phoniness.

The few statements Pollock made about his art which have been recorded fit in with the accepted ideas of his circle and are designed to explain why his art was abstract not figurative. He said, 'I don't paint Nature, I am Nature.' He said he was concerned with the rhythms of Nature: 'I work from the inside out, like Nature.'

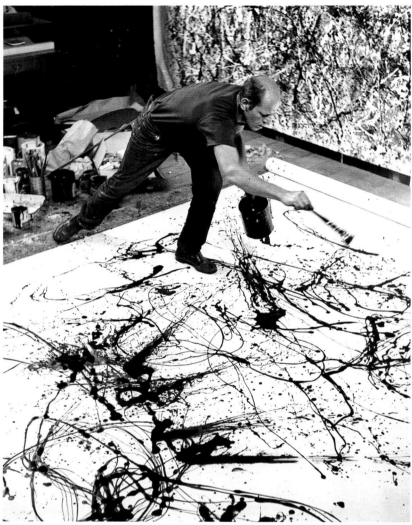

Another time he compared his method of working on the floor, working on all sides of the painting at once, to American Indian ritual sand paintings. Pollock's high point as an artist is considered to be the three-year period between 1947 and 1950 when he painted drip paintings. Before that he painted unremarkable, generalized abstract paintings. Influenced by Picasso, Surrealism, Mexican murals and psycho-analysis, they are not particularly bad but not particularly adventurous or distinctive either. His drip painting period is full of unevenness, but what makes these paintings

good when they are good is a kind of overwhelming light, airy, rhythmic, pulsating shimmeryness that appears to be present. And he achieves this simultaneously with an impression of overwhelming raw crudeness.

Close to, an airy high period classic Pollock of 1950, like *One* or *Autumn Rhythm,* can look ugly in the sense that the paint has a shiny curdled look, where the oil has contracted, like any dried oily drip. If your sense of beauty was mainly of smoothness then this could be offensive to the eye. But it would be odd nowadays and maybe even neurotic to have such a restricted sense of the beautiful. And also the shiny wrinkled surface of the dripped paint is off-set by the woven matt surface of the cream-coloured canvas. There's a lot going on.

Backing off and looking at the whole thing, you get an impression of absolute visual rightness but a rightness that can't be pinned down. There seems to be a high element of chance. But chance itself isn't the content because that would be banal, just as drips aren't the subject. The content is the expression, the intensity of the sensation, the authenticity of the feeling.

What is meant when it is said that the paintings of the last years of his life represent a falling-off of quality is that they tend to be elegant and light and rather beautiful but without the impacted surface of the classic drip paintings. Or else too much in the other direction, sludgy and heavy like slabs of lino. They are still primitive but not eloquent, just inert tokens or reminders of a former eloquence.

Jackson Pollock
One (Number 31) 1950

Are drips wrong?

Dripping in itself is not bad. Hans Namuth's 1951 film of Pollock in action has been seen by many people and is a cliché of Modern art. It shows him dripping, pouring and flicking paint in elegant loops onto a white canvas stretched out on a paint-spattered floor, as well as pouring it onto a surface of glass scattered about with bits and pieces of glass and pebbles and wire and stuff. Pollock is seen working intensely, with great concentration. The soundtrack includes a statement read by him in a stilted, distanced way. He starts a painting on glass and then after a minute wipes it off and starts again because it isn't right.

It's all quite artificial because it's a film. But one striking feature is Pollock's amazing control over the paint. Another striking feature is how un-macho the painting looks, how sensitive. The paint pots and rugged look of the studio environment are one thing, but the painting itself as it builds up is delicate and not particularly muscular and also not particularly tortured or anguished.

Pollock's ordinary life

Pollock was married to the artist Lee Krasner. They lived in a house in Fireplace Road in Springs, in the Hamptons, on Long Island, three hours' drive from Manhattan. Other artists lived in the area. His studio was a separate building at the back of the house. Krasner's was a small bedroom upstairs. She was dedicated to helping him even though in many ways it was damaging to her. They encouraged each other, she promoted his art and introduced him to artists, writers and dealers. One of the critics she introduced him to was Clement Greenberg, who became a close friend of the couple.

Greenberg was the writer most responsible for getting the Pollock style of painting over to other critics and to a gallery and museum audience and consequently to a wider public. Greenberg later said he had nothing against alcoholics but Pollock was the most radical alcoholic he ever met because his personality changed so dramatically when he was drunk. He also said Pollock got a lot from Lee Krasner in the way of understanding what art was about and he said he did too.

In 1955 Greenberg introduced Pollock to his own psychoanalyst, Ralph Klein. Before that, Pollock had seen a Jungian analyst. In a subsequent interview he said he thought everyone was influenced by psychoanalysis. Many of his symbolic paintings of the early 40s had Jungian titles.

In 1956, the last year of his life, he didn't paint but drank constantly and was depressed and often violent. He behaved outrageously and picked fights with anyone and smashed things up. He started an affair with a 25-year-old woman, Ruth Kligman, who worked in an art gallery in New York. He flaunted her in front of Krasner, who went on a trip to Europe in the hope it would blow over and when she came back things would be different. But as soon as she left, Pollock moved Kligman into the house. Then he became confused. It's like a soap opera.

Jackson Pollock
b Cody, WY (USA), 1912; d Long Island, NY (USA), 1956
Jackson Pollock, or 'Jack the Dripper', as he was affectionately known, was the most famous of the gestural American Abstract Expressionist painters. He earned his nickname as a result of his method of dripping and flicking paint onto a canvas laid on the floor, sometimes adding texture with sand or broken glass. This process may sound messy or random, but these works emanate a harmonious, rhythmic control. Pollock emphasized the importance of process, the actual act of painting, often physically standing on his canvases when working. In 1949, the American critic Harold Rosenberg coined the phrase 'Action Painting' for this type of work. Pollock's early paintings, which alternated between elegantly linear compositions and all-over impasto surfaces, were also championed by the highly influential critic Clement Greenberg. Throughout the 1950s, Pollock was extremely prolific, swapping from black-and-white figurative works to the colourful drip paintings. By the time of his death in a car crash at the age of forty-four, however, he had lost confidence in his own ideas and was struggling to produce works.

Comic

Another thing that's like a soap opera is the story of Abstract Expressionism that many people have in their heads. They imagine it was all rough, tough, garrulous men, painting and drinking and fighting and calling each other out at the famous Cedar Tavern in New York for punch-ups. Pollock used to go there after his sessions with Klein. He would have a few drinks and destroy someone's hat or stare horribly at someone he didn't know or hit them and if they hit him back he would cry.

The Cedar doesn't exist any more but a facsimile of it does. It was built after the original burned down in the 60s. People still go there hoping to get a whiff of the old Abstract Expressionist spirit – perhaps see it rising off the tables like steam or ectoplasm. It all seems comic in a way but for Pollock it was tragic because he was in the grip of illness and also in the grip of a new surge of art, publicity, money and hype – the awakening rumble of the Modern art system of now.

Life

In one famous comment from his last tortured days he said he had been in *Life*, referring to the famous article about him in 1949, but all he knew was death. He was in *Life* twice in fact. First as one of a number of new artists cited in a round table discussion about Modern art – why was it so ugly, so strange, so alienating? Then in 1949 *Life* gave him an article to himself (called *Jackson Pollock – is he the greatest living painter?*) with pictures of him painting and posing in front of his old Ford (he already owned a different car). And then his paintings were in *Vogue*, used by Cecil Beaton as backdrops for fashion models. As a result of this kind of thing, he became world famous and letters from people he'd never met started arriving at his house. Critics argued over what his work meant – whether it was heavy-breathing Existential art, where the end-product didn't matter but the act of making it did, or whether he was a sensitive, creative, intelligent, aesthetic artist of great feeling, attempting to re-do traditional art by modern means.

Two views on meaning

The two main apologists for Abstract Expressionism in the 40s and 50s were Greenberg and Harold Rosenberg. They stand for opposite views on meaning. Greenberg in fact has come to stand for not standing for any talk about meaning at all because such talk is pretentious, while Rosenberg stands for the idea that not talking about meaning is some kind of moral betrayal of art. Rosenberg is a caricature Existentialist, Greenberg is a caricature aesthete. But bits of their mental wrestlings are joined up nowadays in CD-exhibition-guide rhetoric.

With the Rosenberg line, key subjects naturally flow into one another. The Void, Existentialism, psychoanalysis, the unconscious, the Bomb, subjectivism, primitivism, the depths, the id, Nature, authenticity, sincerity. It was a rhetoric that came out of the experience of the Second World War and its horrors and tumultuous changes. But also it was a response to the Cold War and to the emerging consumer society

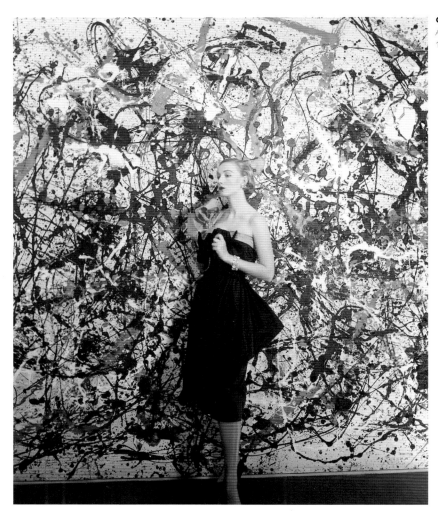

Cecil Beaton
Autumn Rhythm for *Vogue*
1951

and the fear of everything turning commercial and plastic and higher values going down the drain. This all runs through Abstract Expressionism's radical abstractness. It was abstract for a reason, not just to be aesthetic, because Rosenberg thought everything the artist did was a moral act.

But Greenberg thought Rosenberg was too windy. He noticed that artists behaved badly and were often actually quite immoral. He didn't want to be part of the artist-adoration cult growing up in America which he thought was a cult of regression, regression into childishness. He thought it was better if you were an art critic to try to think toughly about what you were actually looking at on the walls and this was a moral position in itself.

Willem de Kooning
b Rotterdam (Netherlands), 1904;
d New York (USA), 1997
In Rotterdam, de Kooning was a
commercial painter and decorator.
By the late 1940s, having travelled
as a stowaway to New York,
he had become a leading figure
of Abstract Expressionism. The
turning point came in 1927, when
he met Arshile Gorky, who
introduced him to the avant
garde. His works had previously
been influenced by Dutch Art
Nouveau, and the Barbizon
school; now they became
energetic, thickly painted
abstractions. Throughout the
1930s, however, he was still
making meticulous figurative
paintings alongside these, and
even when his style coalesced
in 1946 into black and white
abstracts executed in commercial
enamel paints, many of his
works still teetered on the brink
of figuration. The series *Women
Nos I-VI*, 1950 – sprawling,
frowsy grotesques painted in
frenzied brushstrokes – was
received with near-universal
disgust. However, *Woman I*
became one of America's most
reproduced paintings, and de
Kooning's influence on the young
painters of his day was immense.
He continued to work well into
his eighties, after being diagnosed
with Alzheimer's disease.

Action painting

Rosenberg published a famous essay about Abstract Expressionism in 1952 called
'The American Action Painters.' In it he proposed an Existential account of the
movement. He said the canvas wasn't a canvas any more. Instead it was an arena
in which to act. The painting wasn't a painting any more but an action and the act
was the thing not aesthetics.

Although nowadays the essay is thought to have a general significance, at the
time it was understood by the art audience to be a polemic in favour of one group
of Abstract Expressionists and against another. The leading figures of each group
were Pollock and Willem de Kooning. It was de Kooning's style of frenzied, gestural,
brushy painting that Rosenberg was for and it was Pollock's airy, atmospheric

abstraction that he was against, because it stood for a reduction of abstract painting to 'apocalyptic wallpaper.'

Death

On the last day of his life Pollock took Ruth Kligman and a friend of hers, Edith Metzger, out for a drive in a green Oldsmobile convertible he'd recently got in exchange for two small paintings. It was August and the top was down. He was drunk. They were supposed to be going to a concert. But when they got there he changed his mind and said he wanted to drive home. But first he thought he wanted a meal. Then when they got to the restaurant he said he wanted a nap in the car first. So he passed out and the women waited until he came round. Then he said he didn't want a meal after all and was going to drive everyone to his house right away. Metzger wanted to leave but Kligman persuaded her to stay on. Pollock started driving crazily at high speed.

Metzger was terrified and hanging onto the safety strap begging Pollock to stop as he drove the familiar winding roads back to the house at eighty miles an hour. But he just pulled ugly grinning faces at her and went on driving and then on a corner near the house, one he'd negotiated many times in the past, he lost control of the car and it sped off the road and ran up some thin saplings and flipped over. Pollock and Kligman were each thrown from the car but because Metzger was hanging on tightly she was caught and crushed to death in the back. If Pollock had lived he would have been charged with her manslaughter. Kligman was thrown into the brush and suffered major fractures including a broken pelvis. She was knocked unconscious. But Pollock was thrown fifty feet through the air. Ten feet above the ground he hit an oak tree head-first and was killed instantly. He was thrown so far from the car that when the police arrived it took them nearly an hour to find the body.

The crash was in all the papers. A story in one of the local ones featured a photo with the title: *A Still Life*. It showed a couple of Rheingold beer cans, a hubcap and Pollock's stylish right loafer, all in a group, with a caption claiming nothing in the picture had been arranged – it was all natural – and a warning against drunk driving.

Blankness

Andy Warhol's blank manner is sometimes interpreted as the manner of someone so emotionally traumatized they can only stand blankness because anything else would be unbearable. In fact for the last twenty years of his life Warhol really was in constant physical pain because of his shooting which occurred in 1968 when he was about forty (his real age wasn't known because he lied about it but it is usually assumed he was born in about 1928).

We don't have anything to go on with regard to his possible inner pain or tortured soul because agony and tortured feelings weren't part of his art and his statements about his art were parables or allegories or aphoristic insights that

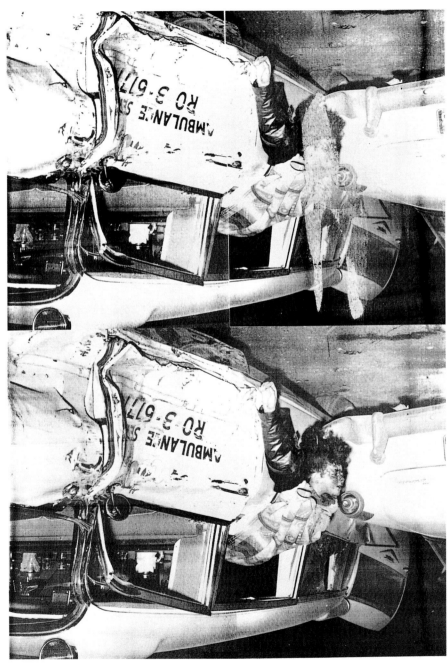

Andy Warhol
Ambulance Disaster 1963

could be unravelled in lots of different ways. Blankness was his forte as an artist and that's all we can say.

But blankness with Warhol is a new twist on Modern art's theme of directness. His paintings are like primitive totemic icons in the sense that they are compelling and we want to look at them but we don't know why. Some are of celebrities and some are of death or disaster scenes. Some are of piss, some are of Rorschach blot tests, some are of shoes. None seem particularly more important than any others and all are abstracted from any kind of context. They come from life but the life is cut out. Typically they come in rows or in a grid formation. The context is repetition because they repeat themselves. This is a simplification of Warhol because he produced thousands of paintings, all working in slightly different ways or failing to work – on the occasions where they do fail – for slightly different reasons, but basically this is how his paintings operate. They turn ordinary things into weird totems that you want to stare at.

Being camp

Warhol's films of the 60s divide into very abstract and less abstract. The less abstract ones have dialogue and actors and the scenes sometimes change from one room to another room, or the shots change from a wide shot to a close-up, although once they've changed they usually stay locked off for a long time before changing again.

His early films didn't have any dialogue and sometimes not even actors, or if there were actors they didn't have to act, just sleep or get a haircut or have sex. They had pared-down titles like *Sleep, Haircut* or *Blowjob*. These more abstract films, which are nevertheless very concrete and real because the subjects are concrete and real, are good from a formal point of view. They introduce radical new ideas about structure. Films can be formal or abstract, as well as paintings and sculptures. If they are purely formal that can be off-putting but it's worth making the effort. And his early films are full of interest even though they might only be shots of someone sleeping, or a single shot of a building. You don't have to watch them all the way through. Obviously you wouldn't come away from *Empire*, his 1963 film of the outside of the Empire State Building that lasts eight hours, saying, 'That was full of interest!' and mean that every minute was full of interest. It would be the idea of the duration of the film that might be interesting coupled with the impression made by the image and its slow change from dark to light as day follows night.

But this pared-down aesthetic runs through Warhol's other films too, the ones that have a soundtrack and actors speaking and moving around. These films are also highly formal, although they show scenes of people interacting with her people. Usually the location is a single room, sometimes the scene changes from one room to another. But until the films of the late 60s and early 70s there's no ending or beginning or sense of dramatic build-up in the middle, no narrative to speak of,

Andy Warhol
b Pittsburgh, PA (USA); d New York, NY (USA), 1987 Warhol invented himself as the enigmatic icon of Pop art and experimental film-making in the 1960s. His influence on contemporary culture is profound. Moving to New York in the 1950s, he worked as an advertizing illustrator. Early works included stencilled rows of dollar bills and Campbell's soup cans. Later, he took as subject matter newspaper images of fame – embodied by Marilyn Monroe, Elvis Presley, Elizabeth Taylor – or of death – the electric chair, road accidents. By the mid-60s, he was disrupting the notion of the unique artwork by mass-producing these as silkscreens, or creating large series of sculptures of household objects such as Brillo pads in his ultra-fashionable studio, 'The Factory'. Avant-garde films including *Sleep*, 1963 or *Empire State*, 1964 take place in real time, the camera fixed on the static subject. *The Chelsea Girls* (1966) is a seven-hour film shown on a split screen. Warhol was also the manager of cult rock band the Velvet Underground. In 1968 he was shot and severely wounded by Valerie Solanas.

Andy Warhol *Marilyn Diptych* 1962

and basically it's the same all the way through. Anything might happen – there might be crying or shouting or slapping or laughter or all sorts of nuances of conversational tone, but the overall tone is one of distance. Like the earlier films, these ones are very real but very abstract too. And like them, there is nothing to indicate where Warhol stands as an artist, what his take or view on the action or non-action is, nothing apart from his literal position behind the camera.

In typical films of the mid-60s, say *My hustler*, *Beauty No.2*, or *Chelsea Girls*, someone is usually trying to get something from someone else, love, attention, money, a place to stay, and there is usually a resistance from the other person, resulting in frustration, misunderstanding, maybe even violence. Usually only a light flurry of violence though. Or sometimes there is just a soliloquy, someone talking

Andy Warhol *Blow Job* 1964

on the phone for twenty minutes in a monumentally self-absorbed way, or cutting their fringe in monumentally narcissistic way and talking to the camera. So there is a sense of a possible Hollywood-type scenario but an absence of Hollywood effects — an absence of a Hollywood-type script but also all the techniques of framing and cutting that contribute to a sense of narrative pace or drama in Hollywood films. Instead of effects there are anti-effects, because everything is so minimal.

The actors might frequently deliver lines woodenly or artificially or in a way that is melodramatic or over the top or outrageously camp — obviously, because it's Warhol, camp is the most frequent mode. But then, these are not really actors but anti-actors, Warhol's superstars, exhibitionists on drugs. People whose natural mode of communication was exactly all those things — basically unnatural. And the overall effect is not at all wooden but the reverse, amazingly animated and weirdly like realism. In fact it's quite startling how much like documentaries these films seem to be, or how much like fly-on-the-wall observational film-making they seem to be.

This sense of a new type of realism comes from the pared-down perfect rightness of all the elements — the right non-moving shot, with the right non-acting actors expressing human emotion in the right cut-off, detached context. Right because it seems real. So the films are not about how glamorous the Warhol world is or how camp or funny or even about how phoney Hollywood is but they are representations of how the world works, images of existence.

Being less human

Warhol's famous quotes are all designed to deflate pomposity or a falsely elevated sense of self or of individualism, or the larger than life individual that artists are expected to be. Being a machine, being blank, not thinking, finding ideas tiring, not having feelings, revering celebrity, revering the ordinary, revering money and commercialism were all mock-wicked notions floated by Warhol in interviews between 'wows' and 'gees' and 'I don't knows' to be annoying.

In fact they were comments specifically against Abstract Expressionist values. Abstract Expressionists couldn't stand phoniness, or small talk. Warhol admired Abstract Expressionism and he was against phoniness too but he was for smalltalk because he was against the Abstract Expressionist ideal of over the top, loud individualism. It had become an ideal of sincerity that was a bit too much to take because it was a bit too aggressively human. He wanted something a bit less human. And that's why Warhol is closer to our present moment than Picasso and Pollock but not entirely divorced from them either, just as we are not entirely divorced from them.

Geniuses R Us

A good example of new subjectivity today is offered by the work of the twins Jane and Louise Wilson. They make dramatic, moody, menacing, atmospheric film installations, with the films set in various readymade locations. These include hotel and motel rooms, warehouses and the Stasi former headquarters in East Berlin. The twins are known to be a funny combination of daft and stylish in real life and this impression carries on into their art. So it's camp as well as menacing. It expresses a new paranoid world of fragmented selfhood and urban surveillance but in a light way, or in a way where lightness and heaviness can seem easily swappable.

When the twins themselves have appeared as the main focus of their films they are hypnotized or on drugs, so they are not themselves or only themselves in a trance. In other films they appear in fragments or glimpses and the location itself is the main focus. So they are probably not themselves then either, and there is always some kind of comment on subjectivity.

Women's camp

For example, *Gamma*, made in 1999, is a film installation by the twins based on the former nuclear weapons base at Greenham. The silo still exists and they filmed it without changing anything. Scenes of its grungy, dilapidated interiors go by as if shot by surveillance cameras – that is, in a disconnected way. But at the same time connected by suggestions and atmospheres. The main suggestion is of an exploration of alienated selfhood in the context of a science fiction horror film. So it's not really a surveillance film but it might express contemporary fears of surveillance and it's not fiction because the silo is real. So it's a fake masquerading as a fiction or vice versa. In any case, the comment doesn't seem to be that we should all breathe a sigh of relief that the cruise missiles have gone.

Jane and Louise Wilson
b Newcastle-upon-Tyne, 1967
The Wilsons' work frequently deals with popular culture, focusing on the role it accords to women, particularly in terms of sexual power. Adopting the tools of the media – video and large-format photographs, often presented in installations that include props from their scenarios – the Wilsons evoke its conventions in order to pinpoint its influence and allure. For the video *LSD* (1994), they submitted to hypnosis. Watching the twins in their trance, the viewer is also voyeuristically seduced by their passivity. Thus, the artists refer to the mass media's power of suggestion, but do not necessarily condemn it as more insidious than art's. *Normapaths* (1995) plays with the codes of horror and action films. Again, while they may be alluding to the contradiction between male fantasies of leather-clad, Avengers-type girls and the submissive way in which real women are expected to behave, the Wilsons – avid TV consumers in the 70s – demonstrate that performing aggressive stunts while dressed like Emma Peel can also be a female fantasy. *Stasi City* (1997), made in the disused Stasi headquarters in the former GDR, explores video as a means of control.

Jane and Louise Wilson
Gamma (Silo) 1999

Gamma offers a lot of textures all fragmented and broken up. Excitements are everywhere. It's so exciting it's hysterical. Or it could seem hysterical. Hysteria usually means over-excitement with an implication of displacement. The real fear is displaced and something that isn't really the fear becomes frightening and the result is hysteria. But there isn't any fear of that here because there isn't any real fear, just textures.

These textures include the look and atmosphere of old 60s and 70s conspiracy films with titles a bit like *Gamma* – like the *Parallax View* or *Capricorn One*. Plus Bomb scare films of the 80s like *The Day After*, or of the 60s like *The War Game*. Plus the pleasure of old décor, the excitement of almost anything from more than ten years ago, but not fear. Obviously not fear of the Bomb because that's over now, more or less. But also not fear exactly of psychological fragmentation or urban surveillance or sinister government agencies. That would be like being frightened of LSD or frightened that *1984* really happened, which no one is. Fragmentation, urban surveillance – they are new quirks of modern life, full of richness, but nothing to be frightened of. They're mock fears that contemporary art is interested in to make itself more spooky.

Old interior

In the film, mundane, old dilapidated interiors are made aesthetically exciting by vast enlargement, because the film screen is big, and by stylish editing. In fact there are four screens, in two opposite corners of a room. The room is relatively small, just a sectioned-off part of the gallery. Weird sounds from the film permeate the rest of the gallery. In some of the rooms there are large colour photos mounted on metal of silo scenes – corners of offices, plastic sheeting, graffiti on a wall, sinister, heavy steel hatchway doors left open. In another room, there is a mocked-up concrete bunker, or a mock-up of a stereotype idea of a concrete bunker – just a thick-walled box shape with two sets of metal security doors. Inside it's dark and claustrophobic, or it would be if the walls were concrete instead of plasterboard. The doors have NO ALONE ZONE and TWO MAN POLICY stencilled on them.

These stencilled signs read as ordinary signs and also as loaded signs, signifiers of challenged individualism or spookily modified subjectivity. For example, the twins' own psychological no alone zone and their two-man policy as collaborationist artists of the 90s. Also, the signs resonate with memories of women of the 80s. Women merging their subjectivity and becoming a collective of protesters and looking strange – living in 'benders' made of twigs, submerging individuality within a collective mass, resisting a monolith by becoming uniform, initiating a new model of protest and a new model of women. The literal meaning of the signs is loaded too – military personnel within the sinister silo barred from going unaccompanied into significant button-pressing zones in case their individuality has made them go mad and they might press the button and start a nuclear winter.

Clang

The film part of the installation is dark too. Gallery-goers walk into darkness, clangy sounds all around them. Or something like the roaring sound of amplified air-conditioning. Or ghostly sounds of sudden voices that can't quite be made out. Or clinking cutlery from a ghostly military canteen maybe. And then the viewer is suddenly surrounded by a filmic vastness of old corridors and stuff, with stylish panning and tracking shots all going by at a lively pace. The scenes are of abandoned atmospheric rooms, corridors, old clutter, sudden huge empty spaces, sudden close-ups of telephones, yards of flashing control systems. The same scenes are shown out of synch on different screens, or sometimes in synch, so they're doubled, or sometimes they're doubled and inverted, so they're mirror reflections. Sometimes they slide into each other, a scene disappearing into itself. It only takes a short time and then it starts up again, with no credits, just a burst of black.

Jane and Louise Wilson
Gamma (detail) 1999

Help!

The exterior of the silo on a hill at night or at dusk is the first shot, accompanied by the sound of panting as if someone's dragging themselves up there. Maybe the nuclear winter's already here and it's a post-apocalypse figure, because time is challenged. After that it's all interiors. Pipes, lights, buttons, tubes, control panels, conduits, security doors, signs saying EMERGENCY, lists of phone numbers with countries next to them – UKRAINE, RUSSIA – all go by. A shot of a real mirrored wall comes up, the mirrored surface divided into squares. A delirium of mirrors suddenly fills all the screens and then the images roll into each other in an ecstasy of kaleidoscopic mirroring. Sinister green arrows run along the floor of an old grim concrete corridor, with the camera tracking in the opposite direction. Plastic chairs, military brown, flashing red lights, diagonal yellow and black scare stripes, all contribute interesting texture-accents. A metal canister about a foot long drops with a clang – Help! It's plutonium! Or maybe it's just a thermos flask. A live twin appears, in a grey uniform, and does some walking in an emotionless way. Then there are some other shots of corridors and then a sudden close-up of a twin's ankles and calves and black military-style shoes, offering a *Carry On* texture of sauciness. Then it's the end. Then it's the beginning again.

CHAPTER TWO

SHOCK, HORROR

The grim stream

Modern art has a lot of shocks to offer. Increasingly, we find we want to be shocked by art. We know Damien Hirst's famous shocks aren't really that shocking – whether it's his shark at the Saatchi gallery, called *The Physical Impossibility of Death In The Mind of Someone Living*, or his bisected cow and calf at the Venice Biennale, called *Mother and Child Divided*, or his two eviscerated cows cut into lots of sections and all the sections intersected with each other, in 'Sensation', called *Some Comfort Gained from the Acceptance of the Inherent Lies in Everything*, or his flayed cows' heads in the upstairs bar at the Quo Vadis restaurant in Soho's Dean Street, one in a blue frame and one in a pink frame, called respectively *Kiss My Blue Arse* and *Suck My Big Pink Cock*. But nobody has yet written at all sympathetically about him without pretending to be a bit shocked by the sight of viscera in an art gallery.

It is felt that these sights must be shocking because they are real and not painted – reality is more shocking than paintings. But in fact they are presented as if they were painted. If they weren't they wouldn't be so good. Also, they are presented as if they were ads, even though they aren't advertising anything. They have the crispness and neatness of ads. Chaotic viscera in gleaming rectangles.

Damien Hirst
Some Comfort Gained from the Acceptance of the Inherent Lies in Everything 1996

Goya

Goya is at the black source of the grim stream. He's at one end and Jake and Dinos Chapman are at the other. At least, they might be connected but we don't know for sure. They were born in 1962 and 1966. Goya was born in 1746. To find Goya shocking you have to edit out a lot of what you're feeling. To find the sculptures of the Chapman brothers shocking you have to do that too. But the editing and the shocks are different in each case.

With Goya – not a Modern artist but a famous precursor of Modernism – an inevitable museumification interferes and makes even his most shocking sights less shocking. However gruesome and hair-raising Goya gets, he is an incredibly refined painterly aesthete, a master of the painterly shimmer – of a kind of form that seems to be making itself as you look. A form of dazzling complexity as well as gruesomeness.

That's what painterly painting is. Whether it's a painting of a water lily by Monet or demented women giving their babies to Satan by Goya. And the taste for it is a cultivated taste. Anyone can get something from it. But if they have a cultivated taste they will get a lot more from it, as with a taste for wine. Which is confusing because in some ways we might wish the values of art to be absolutely opposed

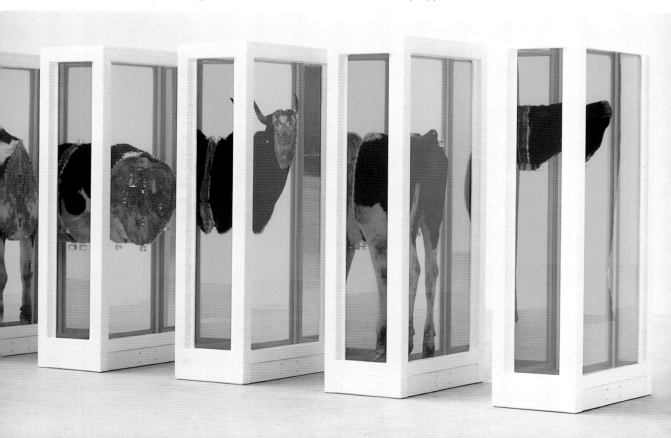

Francisco Goya
Saturn Devouring one of his Sons
c. 1820

to the values of the wine-tasters of this world, because we don't like their preciousness. But of course that might only be ignorance of the world of richness that wine-tasting offers. Or it might be inverted snobbery.

The Chapmans

But with the Chapmans, the aesthetic is a comparatively low one. It's not that it goes from wine to Tizer. It's more that complexity is suddenly somewhere else. Off the form. The forms themselves are too ordinary to be all that interesting. They are hardly forms at all in the formal sense.

Damien Hirst has an eye for a painterly sight. The Chapmans might have that too – it's not all that uncommon. But that isn't what they do in their art.

Francis Bacon

With Francis Bacon, gruesome writhing things appear neatly framed. Not just framed by the gold frames that were always part of the finished painting with him. But by the painted doorways and black screens with pull-strings and weird glass cases and arbitrary shadows and so on that made up his well-known repertoire of rectangle devices. This contrast of sights comes from European Surrealism of the 20s and 30s, which was the dominant international style when Bacon was first getting interested in painting. Something nasty inside something geometric.

Hirst and Minimalism

With Damien Hirst, a Francis Bacon-Surrealist type of sight is presented as if it were an abstract Minimal object from the 1960s, possessing all the mysterious radiating power of Minimalism – the way Minimalism made the placing of a geometric, emotionally blank object in the middle of the white cube gallery seem powerfully theatrical.

The effect with this appropriation of a Minimalist aesthetic and a grafting of it onto a startling spectacle is of a kind of Minimalism of advertising. It's advertising marrying Minimalism and having a gruesome baby that is only partly shocking.

The parts in themselves aren't that interesting. The viscera is the most interesting but it's not mind-bogglingly interesting. It's interesting because we don't see that stuff every day. So it's interesting to see what it actually looks like. A lot of writing about Hirst actually takes this line as if it were the main thing about him. This is certainly wrong. The main thing is making spectacular images of alienation. Is he a great artist? Phew, that's a hard one. Obviously we can't dispute Goya's greatness though. That would be insane.

Francisco Goya
b Fuentendos (Spain), 1746;
d Bordeaux (France), 1828
Goya began working in Madrid, influenced in his early tapestries (depicting scenes from everyday life) by the decorative realism of Tiepolo. In 1789 he was made portrait painter to the King. Left permanently deaf by a serious illness in 1792, he became increasingly occupied with imaginative invention, and with satirical observations of humanity. A bolder, freer style evolved, his portraits becoming penetrating character studies. In his religious frescoes he employed an earthy realism unprecedented in religious art. During the Napoleonic War, he served as court painter to the French, expressing his horror of armed conflict in his series of etchings *Disasters of War* (1810–23) and in the painting *3 May 1808* (1814). When the Spanish monarchy was restored, Goya was called before the Inquisition to justify the shocking *Naked Maja* (1797–1800). From 1819–1924, he lived in seclusion, adopting an increasingly intense style. In the *Black Paintings*, executed on the walls of his house, he expressed his darkest vision.

Murder

One strand of Hirst criticism is the vegetarian strand. Is the Great White shark a pro-tected species? That's an arm of the strand. Animals shouldn't be eaten. Even though he didn't slay those animals himself he shouldn't exploit the fact that they've been slain. Because meat is murder. That's another arm. Well, the same arm really.

With this criticism a lot has to be edited out and a lot has to be edited in. It's not exactly like saying physical deformity is nothing to laugh at, so Picasso is cruel. But it's close.

Arms

A pile of severed arms. That's a painting by Gericault. And an image in the memory of Marlon Brando in *Apocalypse Now*. It's good when Gericault does it but a bit pretentious when Marlon does it. Don't do that Marlon!

Arms in theory

Many artists and writers on art now read books of theory by French authors or by authors influenced by these authors. A powerful and recurring theme of this literature has to do with the body and how it is not all that centred any more but all over the place, psychologically speaking. For example, this might apply in Feminist theory. But Feminist theory now applies in contemporary art theory, because Feminism has been very influential on art.

However, the image of the body as not all reassuringly centred with the self at the centre but fragmented or divided or always in a weird state of flux – and the self itself in such a state of flux – has become a cliché of contemporary art and discourse about art. Its employment can often seem like an empty mannerism, signifying that something important or original is being expressed – like when Alanis Morrisette or Robbie Williams appear to be very angry or intense in their songs. Fragmented bodies in this sense are more late Brando than Gericault.

More arms

The Charnel House. That's one of the paintings Picasso did in his run-up to *Guernica*, his protest against fascism. It has a lot of human arms and other limbs lying around in a shallow Cubist space.

Dismemberment

Dismemberment is always a shock. A painting by Goya shows cannibals in a misty wood about to cook some limbs and a head on a fire. Goya's title, which is jour-nalistically matter of fact, makes it clear the subject of the painting is a historical event which actually happened – the Archbishop of Quebec and his secretary were murdered and eaten by Indians, and Goya painted the scene from imagination. However, the cannibals don't seem like typical savages but more like Europeans gone savage. They are naked and there is an atmosphere of unbridled sexuality within the general atmosphere of unbridledness.

Francis Bacon
b Dublin (Ireland), 1909;
d Madrid (Spain), 1992
Reviled in his early career, Bacon is now seen as perhaps the most important twentieth-century British painter. Existential horror, revulsion, loneliness, alienation are his overriding themes, treated with a hallucinatory, distorted realism that derives in part from the influence of film and photography, in part from an uncompromisingly bleak attitude to the modern human condition. Recurring images are carcasses, cages and empty rooms imprisoning deformed, grotesque figures. Originally an interior designer, Bacon received no formal art training, making his first drawings and watercolours in 1926. He has stated, however, that he 'began' as a painter at the age of 35 with *Three Studies for Figures at the Base of a Crucifixion* (1944), undertaken after he had given up painting for several years. This work subjects a conventional art-historical theme to a violent, contemporary treatment (the figures are reduced to lumps of meat). Similarly, his famous series of incarcerated, raging popes is based on reproductions of Velàzquez's *Pope Innocent X* (1650).

Francisco Goya
Cannibals Contemplating Human Remains
c. 1804

Bestiality, disgusting appetites, humans gone wrong – these are frequent themes in Goya's art. His suite of engravings, *Disasters of War*, which he began during the Peninsular War of 1808 – 14 and completed some years after the end of it – but which wasn't published until some years after his death – also includes terrifying scenes of dismemberment. Goya may have witnessed some of these scenes firsthand.

One of the *Disasters*, called *Great Deeds! Against the Dead!*, shows three naked male bodies hanging from a tree. The scene has been paraphrased by the Chapman brothers in their sculpture by the same name. Shop window mannequins with nylon wigs are used.

In the Chapmans' version, Goya's realism is contrasted with the nutty unrealism of high street shop window culture – the fashion dummy. Goya's engraving is about desecration but the Chapmans' version is a redesecration of one of the sights that sent Goya off the rails.

Francisco Goya
Great Deeds! Against the Dead!
from *Disasters of War* c. 1810

Grande hazaña! Con muertos!

Jake and Dinos Chapman
Great Deeds against the Dead 1994

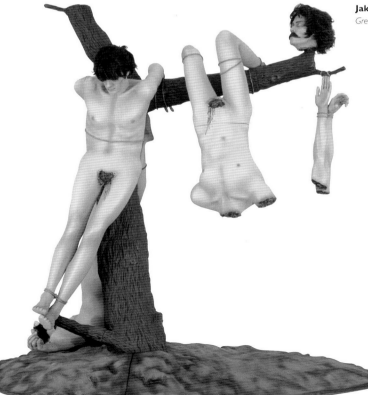

The details here – the airbrushed nipples and nylon wigs and exposed awkward seams of the mannequin limbs; the join of hand and arm, waist and torso; and the weirdly sexual look of the figures; their heroin-chic complexions – all suggest a perverse departure from Goya's theme of horror at atrocity: the subterranean desire-drives of the 1990s consumer world.

Mad flowing excitements

In Goya's original picture one of the corpses is castrated. One has been divided into three separate parts – four if you count the pair of arms tied together at the wrist as two. A third corpse is only half seen, hanging downwards from the tree, the head pushed into the chest – we have to imagine what horrible acts have been committed in this case. But it's pretty horrible just seeing the corpse upside-down and naked, hands tied behind the back.

The second corpse is headless. The armless torso with legs still intact hangs from one part of a branch. And the arms, tied at the wrists, hang further down. Next in line is the head, stuck upwards on a jutting fork of the main branch. So the head seems to be part of a body that is standing to attention. But the body is now a tree-body. The limbs of the tree and the three sets of separated human limbs are all a unity now, all making a single convincing satisfying dynamic rhythm.

Part of the shock of this image is the integration of body parts and tree – the sense of pleasure and satisfaction in making them fit together. Was it aesthetic for the dismemberers?

The solidity and rightness of Goya's drawing and his composition – the liveliness and energy and power of his arrangement of forms – shadow, grass, tree, leaves, body parts – is a powerful excitement in itself. We feel there ought to be a dividing line somewhere – between art and sadism. Someone should tell us what it is. Did Goya have a dividing line in his head? Were there any boundary lines in there at all?

Goya's titles are sardonic and ironic. In fact it's never completely clear to a non-Spanish speaker what they are because they're always different in different translations. They sometimes seem to be fragmentary – parts of a testimony or a report. They sometimes seem like gasps or ejaculations at the beginning of an idea, or at the end of one. Every title could suggest a lot of different things. And every image has an oddness and a rightness and cleverness about it – wit as well as horror.

Don't look

What more can one do? shows a group of soldiers castrating a naked prisoner with a sabre. Another one, called *This is worse*, shows an armless naked man impaled on a tree – the tree itself is only a black stump. *This I saw* is another title. And another one is *It is not possible to look.*

Disasters of War is a surprisingly complex document. Not just because some of the plates show fantasy images with mythical beasts and monsters and allegorical figures of Purity and Truth, while others are presented as realistic observation and

are believable as such. But because the direction of the thought is never clear and everything is open-ended. There is no particular sense of righteousness. Evil-doers might be French or Spanish, soldiers or monks, women or men. Corpses might be civilians or soldiers, monks might be evil or good, civilians might be tragic, courageous, heroic, or murderous, bestial or greedy.

Shocked by Airfix

The Chapman brothers' first big success in the art world was a remaking of all 82 of Goya's *Disaster* engravings in Airfix form, with all the scenes staged on a single smallish white table top, using plastic model soldiers as the raw material, and model-making techniques as the method. Little plastic one-inch high Eighth army soldiers, Romans, Koreans, German Storm Troopers – whatever – are mutated and melted with penknives and soldering irons and re-formed and painted by the two laughing dismemberers to make little eighteenth-century Peninsular War soldiers and civilians torturing each other.

With their *Disasters of War*, made using low model-making techniques – techniques which have a certain fascination but which we don't associate with the heroism or tragedy of art but on the contrary with banality or the rather circum-scribed creativity of male children – Goya's artistic vision suddenly becomes something else. The *Disasters of War* suddenly stop being art. Museumification evaporates. The figure of the artist evaporates. All his heroism and tragedy is taken away. New artists materialize in his place. But it might not be art they're making. Except it must be, because even though it's only model-making, which we know is mundane, the models are in a white cube art gallery. And we know these galleries are mysterious and important and places of transcendence.

Everything odd and inexplicable about Goya rushes to the foreground. And everything that was a timeless humane truth about the horror of atrocity seeps away.

Guernica

Picasso painted *Guernica* in 1937 as a protest against fascism. It is an allegory of war. A screaming horse at the centre is off-set by a burning building and dramatically posed figures, including a wailing mother and child. The composition is a stark, powerful pyramid. The colour is black, white and grey. The event referred to in the title was the bombing of a small town in Spain during the Spanish civil war – the conflict which had its origin in the civil war of Goya's time – by German aircraft collaborating with Franco's republican army. Picasso had already been invited to contribute a painting to the World Fair and he sent this one. It was intended to shock the world.

Unlike *Guernica*, *The Charnel House* was considered to be a successful painting by formalist critics and artists in New York after the Second World War. It was a marvel of greys and black and white. Whereas *Guernica*, although a dramatic image, with

Jake and Dinos Chapman
Dinos Chapman: b London (England), 1962
Jake Chapman: b Cheltenham (England), 1966
Ex-assistants to Gilbert & George, the Chapmans began to produce their own provocative works in 1993. Their first solo show, 'We are Artists', was an æsthetic manifesto presented on a wall smeared excrementally with brown paint. This was followed by a three-dimensional version of Goya's *Disasters of War* series (1810–23), in which detailed miniature models acted out the atrocities of conflict. In *Great Deeds Against the Dead*, 1994, they singled out a pair of Goya's mutilated soldiers, this time blowing them up into life-sized figures, amplifying the brutality of their ruptures. Recently, they have made their own versions of Goya's prints, loading them with contemporary allusions and anachronisms. For the 1996 exhibition 'Chapmanworld' (ICA), they unleashed their grotesque population of hermaphrodite pre-pubescents, with names like *Fuckface* (1994), or *Two-Faced Cunt* (1996), joined together Siamese twin-style, their features replaced by genitals and sphincters. These bewigged mutants in Nike trainers test our attitudes to beauty, humour, abnormality and taste.

Pablo Picasso *Guernica* 1937

the same colours, was considered too rhetorical and stagey. It couldn't support its own hugeness. It was a windy painting.

This was the prevailing thought about *Guernica* for a long time. Nowadays the thought that *Guernica* is nothing but a masterpiece has replaced that thought. But not because the masterpiece idea has been rigorously thought through. Formalism died away in the 1970s and the masterpiece idea just flopped back centre stage as if by default, with no one particularly pushing it.

Feelings change

But although we may not be able to back up a natural feeling of awe we might experience nowadays in front of *Guernica* with a convincing formal analysis we have read somewhere, that's not necessarily a reason to doubt the significance of that feeling. We are part of a different culture now. Feelings change.

One of the reasons formalism died away was that there was a prevailing feeling against thinking about art as purely a matter of form. Or, to put it differently, there was a gradual rejection of the idea that forms alone had an incredible, mysterious power. We've seen all the forms, it was felt. They're not that mysterious. Let's have the other stuff back. What about those screams for one thing?

The Unconscious

Obviously child abuse is nothing to laugh about. Nazis too. The Chapmans have made a Nazi death camp out of Airfix soldiers and they make sculptures, using mannequins, of children with adult sex organs on their heads. But they are not cruel because of that. Their unconscious fantasies are probably quite cruel. But so are

Jake and Dinos Chapman
The Un-Namable 1997

all our unconscious fantasies probably. We can never know for sure because they're unconscious. That's what the unconscious is. You can never know what's back there.

Screaming

Modern art is full of screams. For example, Munch's *The Scream*; Gilbert and George screaming; Francis Bacon's screaming popes; the screaming horse in Picasso's *Guernica*.

Other people

When Gilbert and George scream at each other in the film *The World of Gilbert and George*, which was made in 1981, their faces are in profile – one on each side of the TV screen, with a black void behind them – and they each take turns to scream. When Gilbert screams his tongue is out and George's is not. When George screams his tongue is out and Gilbert's is not. Their tongues are like pink, quivering sex worms. The screaming noise is quite harrowing, more so than you would imagine if you just read about it somewhere. In this book for example. 'Hell is George,' you imagine Gilbert thinking when he's screaming. 'Hell is Gilbert,' you think when it's George's turn. They take the Existentialist cliché and make it into Morecambe and Wise and then turn it back into Existentialism.

Morecambe and Wise

In the images Gilbert and George present – frequently, images of themselves – a number of things mill around which are recognizable from various levels of culture but which, in their art, are recast in different ways. Morecambe and Wise's claustrophobic bedroom act plus Magritte's deadpan and his atmosphere of dread. Andy Warhol's wise / imbecile interview style plus Beckett's alienated loneliness: hip meets *Watt*. Francis Bacon's horrors and screams and smears plus an attitude of not caring about Bacon's painterly world – or perversely looking for and finding concrete, realistic, unmistakable objective correlations for the hints of effluvia-excitement that painterly goo in Bacon always suggests.

Annoyance

In the 60s it was reckoned any material could be art so Gilbert and George chose annoyance as their main material.

Their affected voices rise from their early works: 'That's a lot of bloody bollocks!' Or: 'He's just a silly old queen!' That's them sputtering drunkenly in their video of themselves as young men in the pub drinking their drinks and smoking their Senior Service.

They had real lives before then but from now on they would always be artificial because it was more real. Their whole lives would be art even when they were drunk which was every day on gin.

Everything they did they called a sculpture. Sculpture included singing or falling over. But also taking photographs and writing, and making up slogans like: *Art we only wish to serve you!* Serving art meant not believing anything anyone else said or thought. Especially if it was a polite or normal thought. They were the Unnormal.

Gilbert and George stills from *The World of Gilbert and George* 1981

Ruin Art

In their house off Brick Lane in London's East End they pour champagne and George tells slightly offensive rumpy-pumpy jokes in an unreal Prince Charles accent. Earlier they were up on the roof talking about confrontation. They always want it, they say. And they want to shock their viewers because they want them to remember their pictures. Their new ones are full of spunk, shit and piss and extensive quotations from the Bible. As well as life-size images of themselves naked or in their underpants. The quotes are about the punishments that shall be meted out to men who lay with men, or with their sisters or their brother's wife, and so on.

'We want them to be disturbed for a minute,' Gilbert is saying. 'And we do believe they are shocked. They shouldn't be but they are.'

Gilbert and George and the Bible. They were bound to clash sooner or later. 'We want to be against it,' Gilbert goes on, in his Italian accent. 'We want to ridicule

Gilbert and George
Underneath the Arches 1971

Gilbert and George
Human Shits 1994

the Book! Ridicule the nonsense in front of us! Everybody for two thousand years, they tell us: You should do this! You should do that! And when you start reading it, it's nonsense. That's what we want to show the world. Confronting it with our nudity – our nakedness that should be totally acceptable. But the Bible says no. So we say yes!'

'Yes!' they say. To underpants whiter than white. But always either about to come off or already around the ankles. That's my inner voice as they're talking and pouring the drinks.

'The audience is shocked by the idea of the subject,' Gilbert goes on, 'the idea of spunk. Or – we don't want to look at piss! Or shit – Oh I hate that! But when they see – because we make them very powerful – they think: ooh! It's quite inter-esting! I didn't know that spunk would look like that! That's quite beautiful!'

'Normally,' George is saying now, 'we only drink this champagne called Ruinart.'

'Ruinart? I don't know it,' I say.

There is one called Ruinart.

'Cheers!'

Francisco Goya
The Sleep of Reason Produces Monsters
from *Caprices* 1799

'Cheers!'

I like being served champagne by the anti-Christs at their antique table in their oak-lined sitting room, feeling a bit like a living sculpture myself.

Goya's sitters

Goya's blurry portraits with their haunted eyes – his official portraits, even his portraits of royalty – are aesthetic marvels and marvels of timeless human feeling.

To feel deranged or unhinged or somehow in pieces, we feel, is a timeless human feeling. To be rampantly subjective would be to be mad. Goya actually painted mad people in insane asylums as well as mad people in nightmare fantasy scenes. These are just as marvellous, as paintings, as his formal portraits. But it's quite clear he didn't just think madness is the human condition and part of everything. Or that artists are mad so they must paint everyone looking a bit mad. Goya went temporarily mad himself so he would be in a good position to know the difference.

The Scream

Munch's *The Scream* is a painting of a homunculus-type figure on a bridge, under a red sky, screaming. The shock of Munch is the shock of the cold air as the protective outer layer is peeled away and the quivering inner being exposed. That's a cliché of what a typical personality is. Real inside, unreal outside. They must always be like that. The other way round is never considered.

Edvard Munch *The Scream* 1893

Edvard Munch

b Lote (Norway), 1863;
d Oslo (Norway), 1944
Munch's harrowing, angst-ridden
subject-matter, exaggerated use
of colour, and distortion of
contours and line gave rise
to Expressionism in Europe.
When he was a teenager, he was
exposed to death and misery,
both his mother and his sister
dying of consumption. His first
paintings were of domestic inte-
riors, but when he returned
from a trip to Paris in 1885,
where he met Seurat, Van Gogh
and Gauguin, he resolved to
make works that would express
various mental and psychological
states. Themes of illness, death
and depression followed, in
parallel with the concerns
of contemporary Scandinavian
writers such as Ibsen. From
1892–1908, he lived in Berlin,
devoting himself to the ambi-
tious series 'The Frieze of Life',
of which his famous *The Scream*
(1893) was a part. It also included
works betraying his fear of
women, whom he depicted
in terms of three life stages
– awakening sexuality, voracious
sexuality, and death. After he
recovered from a nervous
breakdown in 1908–9, Munch's
works became less psychologically
charged, shot through with
a new optimism.

Munch suffered a series of unlucky losses which certainly would have contributed to a feeling of inner instability. First his mother – who died of TB when he was only five – and then his sister who died from the same thing. And then when he was still young his other sister and his father and later his brother. Many people live a great part of their lives without experiencing death. And then it's just their parents dying when they're old which isn't too bad. So they're not all that mortified about death. But Munch was tortured by it.

Tragedy is part of the frieze of life. Munch's paintings are particularly morbid though. Death, illness, bitterness, loss are constant themes with him. He suffered a breakdown – complicated by alcoholism – in 1908 when he was in his forties and was treated at a sanatorium. He recovered and went on to live a long life. He died in 1944 when he was 80. But after his illness he painted more realistically. Or at least, he turned away from the Symbolist/Expressionist style he had been famous for since he was 22 and reverted to a version of the Impressionism he learned at art school before he really became Munch. And now his subjects were taken from life rather than made up out of his head.

This change in subject matter and style might imply that he became less morbid because his inner suffering had abated – he didn't need to keep on expressing it. But that would imply his morbid subjects were only therapy. And also that his objective subjects were less emotionally urgent. Or less emotionally realistic. Or even that his realistic subjects were only therapy, to get over being morbid. In fact, we can't assume any of this. He was an ironic humorist as well as being psychologically tortured. He joked in letters to friends after his style-change that he had given up alcohol and women too.

Expressionism

Expressionism is a style as much as a mind-set. It is not a driving necessity or inevitability. Whether it's tortured German Expressionism – influenced by Van Gogh and Soutine or Munch himself – or American Abstract Expressionism.

Goya and Munch and shock itself

Both Goya and Munch introduce new things into painting which push ahead a kind of realism of emotions. They are sympathetic artists because of the humanist vision they each express and because of their psychological realism. Goya is more universal. Munch is more extreme and personal or obsessive, more tortured.

These are the prevailing feelings about both of them. There isn't a prevailing feeling that shock itself might be their main subject. But with the Chapman brothers this is the prevailing feeling, even though in interviews they don't ever say that. Never-theless it is widely assumed they are out to shock. That would be shallow of them of course.

Maybe they are bad to do that. But maybe they don't do it. Or maybe they do and it's not bad, because shocks are good. Maybe for us, shock itself is an interesting

subject and one worth thinking about, because we're so alienated. And they are masters of an art of alienated spectacularism.

How many artists?

'How many artists are here from that show "Sensation?" I'm here. I'm drunk. I've had a good night out with my friends and I'm leaving now. I want to be with my friends. I want to be with my mum. There's no way I want this fucking mike on me.'

That was Tracey Emin in 1997 on a live TV programme about whether or not painting was dead. It was a shock to the TV system when she got up and left. But it was only random reality and it didn't have any meaning. It was a weird awkwardness.

Her life slops over into her art. But when it's there it's expertly edited. It's spread out on hand-appliqued blankets with decorative sperm motifs and diary thoughts wrongly spelled – *And I said fuck off back to your week world where you come from* – and cleverly summed up in artful drawings that not anyone could do, and in short stories and films.

Tracey Emin in live TV discussion on Channel Four 1997

She wrote her autobiography from 0 to 13, from conception to loss of virginity. It was called *Exploration of the Soul*. She toured the book across America, from New York to San Francisco. She took a chair with her and embroidered it on the way. She gave public readings in bed.

What makes her good or interesting or shocking? Is it the the way she edits her art and her awareness of Conceptual art strategies? Or the raw material of it – her abortions and teenage promiscuity and rape and broken-up tortured love affairs?

The things Emin confesses about herself are things we don't want to hear about. Or not in this way, at least. However artful the way is. It's too intimate, too personal. It's a shock to hear it.

Maybe it isn't the events or their presentation but the spectacle of her own confidence that makes an impact. We can't believe what we're seeing. Her life is the same as anybody's, more or less. And you could look those strategies up in Conceptual art books. But somehow you've got to hand it to her – some kind of award for confidence.

Also, her most famous work, her tent with the names embroidered on it of everyone she had ever slept with, was ingenious in the way it forced men, who wanted to go inside and see what names were in there, to crawl.

Shocking feelings

Munch's statements about art suggest that for him it is both the expression of a curse and a redemption at the same time. He would give it up in exchange for a relief from suffering. This is the idea we have about Expressionist painting generally: Why am I not as others are? Why was there a curse on my cradle? Why did I come into the world without a choice?

In her statements and interviews Tracey Emin says the same kind of thing: 'I would give up the art tomorrow – I would instantly give it up – if I could get rid of these feelings.' But she isn't a painter. She was one but she gave it up. The spectre of her former life as a painter keeps coming back though. Expressionist paintings and drawings appear in her art as elements within installations.

We don't question Munch's authenticity because we don't think of him as a stager of shocks. We think of him as a painter of images filled with feeling. We think of Tracey Emin's installations as stagings. Her suffering is real enough but on its own suffering is neither here nor there. And so her authenticity is questioned all the time because of her spectacularism and her exhibitionism and her willingness to

Tracey Emin
Monument Valley (Grand Scale) 1995

Edvard Munch
Painting on the Beach in Warnemünde
1907 (photo taken by Munch)

employ the forms of Conceptual art. And because of what we imagine to be an incredibly enjoyable life of constant champagne drinking. Authenticity can't go with those things, we think. We can't tell if we are right though. It would be absurd to re-do Munch as if nothing had happened in art since his time. But to re-do him in some other way might well be a good idea.

Male and female

I went on a boat up a fjord in Norway recently with Emin to see *The Scream* in the flesh at the Munch museum in Oslo. Was it male or female did she think? A foetus, she thought. And it wasn't the mouth screaming but the whole painting: the fjords, everything. It was a painting of a sound – maybe it was the first Conceptual art painting. After that she went out on the jetty near Munch's house and did some screaming herself. It was for art so it wasn't a raw scream. It was already half cooked. It was half embarrassing, half harrowing.

Shocks in 'Sensation'

When the exhibition 'Sensation' was at the Royal Academy there was a big media shock fest, like the one the media had in the 70s over the bricks sculpture at the Tate Gallery. Only now multiplied and amplified because the structure of the mock-shock news drama was well ingrained in the media nervous system and the drama only had to have more luridity added on. And also because there were a lot more shocks now. When it's bricks there's only the shock of there apparently not being much to look at. But with Myra Hindley and cows and sharks and mannequins with sex organs it's art-with-no-skill coming round again but this time being disgusting and immoral as well.

The artists were probably all a bit shocked that what had seemed old hat at art school and in the art world was considered to be absolutely outrageous in the world of the media. Alternatively they weren't shocked at all and neither were the media because both were lying or playing.

O-levels

Recently the Chapmans applied to do their O-levels and then showed the results of their examination as an exhibition. It seemed to be an exhibition about the ordinary world and what art and creativity are considered to be in that world. Their drawings looked adolescent, cramped, amateurish, obsessive, violent, funny. They all followed the brief of the examination paper and you could believe they were sincere and not contrived because there wasn't much at stake – they weren't being asked to be at the cutting edge of avant gardism but to be ordinary. So it was only natural that the drawings should include effortful but uninspired copies of shocking sights from 'Sensation.'

Their other exhibitions which are grander and more expensive to produce, with higher production values, appear to be about ordinary notions of what art might be too. Even when they've got Goya in them – who is an artist much less well-known to the ordinary world than, say, Salvador Dali or Andy Warhol or David Hockney or Leonardo da Vinci or Ralph Steadman. It's sometimes shocking what the prevailing idea about what art is actually is.

They got B-passes.

You can't be shocked

Shocking art shocks people who don't think much and who read the tabloids but not people who are always wrinkling their brows and thinking and buying paperbacks of Felix Guattari's *A Thousand Plateaux* and wondering what it means.

An in-between stage is symbolized by the Sunday supplements' arts sections. This is the zone of middle-brow thought. Including thought about what art is. Every weekend you get a geiger-counter reading of where thought on art is at now. It's always pretty banal compared to the *Thousand Plateaux* zone.

Vivienne Westwood's dresses and T-shirts with swastikas and 'Destroy' printed

Vivienne Westwood
Gay Cowboys T-shirt c. 1975

on them, or homo-erotic images of cowboys with huge erections printed on them, caused a jolt in the 70s. 'How much can you take?' they asked. But the question could only be put in this way because the culture was secretly ready for this imagery. It was already there in the collective nervous system, just waiting to be put on a T-shirt.

Galleries are like that now. 'You can't be shocked by us,' the Chapmans' mannequins say to an outraged public, as it peers at perfect chins joined together by vulvas, and at hyper-realistic erect penises replacing tiny innocent noses – 'you produced us!'

But the middle-brow-thought people probably are a bit startled by them. Just as their 70s counterparts were startled by straitjacket dresses and bondage trousers and shirts made of bin-liners and blackmail writing. I know I was when I first saw them.

Hell

A lot of Nazis in miniature scale are eating other Nazis in a miniature concentration camp and torturing them with electronic equipment. Little piles of Nazi skulls lie around, as well as gnawed torsos and piles of feet. Some of the Nazis have doctors' white coats on and some have ordinary Nazi uniforms.

It's a sculpture by Jake and Dinos Chapman. It's not finished yet. They will be sending it to Germany when it's done, for an exhibition there of new international contemporary art.

The camp is incredibly detailed, with little shelves on the walls and realistic light switches and windows and doors and bunks and drainage pipes. It is quite extended, with many huts and offices. There are horrible scenes everywhere, with plenty of gnawing and writhing going on.

At the centre of the camp is a wide, dark circular hole with a high puckered ridge all round the edge. And from this hole, with its unmistakable anatomical associations, genetic-experiment mutant humans issue forth. These super-human or sub-human creatures seem to be the leaders of the camp and the Nazis their victims. But it's not completely clear because beyond the hole where the experiment-creatures are coming out, it seems to be all Nazis, all experimenting on each other or sucking the eye sockets or gnawing the spines of each other.

A drawing shows how the whole thing will look eventually. A giant swastika, twelve feet wide, with the hole at the point where the four swastika legs intersect. When it's done it will be a model of Hell.

'What are you doing?' I asked them. They said they want to drag refined aesthetic natures towards something more base.

Orgasm

In Katherine Hamnett's shop in Knightsbridge, a brain sits on a table. It is connected up by some wires or tendons to a penis. Both organs are part of a mechanical contraption. A real hammer is part of the contraption too. The hammer hits the brain at regular intervals. Every time it strikes, the penis ejaculates. It's another sculpture by the Chapmans, from 1993, called *Little Death Machine*.

Paul McCarthy
b Salt Lake City, UT (USA), 1945
Since the late 1960s, 'Bad boy' Paul McCarthy has worked in many different media, including painting, video and performance. Most of these works are voyeuristic stagings of taboo processes – birth, death, sodomy, masturbation. In 1972, he used his body as a brush, laden with ketchup and other food stuffs. The influence of Kaprow and Klein led to clumsy, autistic, often smelly events in which the masked McCarthy takes on a series of roles. In *Bavarian Kick* (1987), he introduced the motorized figures for which he is best known, placed in *mise-en-scènes* evoking trash-utopias such as Disneyland or B-Movie fantasies. Both disturbing and funny, these life-like characters commit obscene acts such as copulating with a tree (*The Garden*, 1992). The cynical suggestion of these 'tasteless' works is that the mass media and controlling social structures mould the individual into a hopeless, alienated victim.

Paul McCarthy stills from *Santa Chocolate Shop* 1997

Santa Chocolate Shop

Somewhere else, some elves are walking around a wooden structure. The structure is more or less like a room, only there are openings where there wouldn't normally be openings. So it's a bit like a dream. A dream of a lopsided house. Through one of the openings the bare arse of one of Santa's reindeer hangs. Out of a metal funnel Santa holds between the reindeer's legs, a stream of chocolate sauce pours. An elf with a phallic rubber nose holds her mouth open to receive it. So much of it pours in – so fast – the poor thing can't possibly swallow it all. It spills up out of her open mouth, pouring down the sides of her helplessly upturned elfin face. She's an obsessive, gorging, compulsive glutton elf in a film by the artist Paul McCarthy.

Seedbed

Some people go into a room in New York, which appears to be empty. It's 1972. At the end of the room is a ramp. They walk up it and they walk around it. They hear muttering and groaning. A man underneath the ramp is masturbating. 'I'm touching your leg,' he says. 'My hands are on your hair.' They hear groaning. It's Vito Acconci under there. The New York performance/video artist.

Vito Acconci *Trappings* 1971

Edvard Munch
The Dance of Life c.1899

The Dance of Life

Now it's Norway, where the torture never stops. Some people are dancing by the sea under a red sun. It's the nineteenth century. A painting by Munch. The men wear black evening clothes. The women wear long dresses with symbolic colours. One woman is innocent. Some flowers grow in the grass near her white dress. One is haunted. Black dress. No flowers. One is being devoured by a man. Blood-red dress. It's the dance of life.

Somewhere else a sexy naked vamp with white skin and black hair and black eyes and a red mouth poses satanically in a lithograph, the image set off by a decorative frame with wriggling sperm motifs.

Munch said the camera could never compete with the brush and the palette so long as photos couldn't be taken in Heaven or Hell.

In fact Munch took photos himself in the 1920s, sometimes of himself. He photographed himself as a transparent shadow like a Victorian ghost. And he photographed himself painting naked in the garden outside his summer house, full of joy.

Santa's orders

Now it's modern times again. Santa and the elves mill around the chipboard and Formica space with their family-size, plastic food containers of chocolate and their metal funnels. The legs of the elves are bare except for Christmas socks with red and white stripes. There is runny brown liquid everywhere. The elves slide in it and stumble around the chipboard home, going about their work. They must do what Santa says. They are his helpers. One of them is calling out to another one: 'Bring that chocolate over here right now you God damned elf!'

Shadow Play

Now it's back in time again, only not very far – the 70s. The era of encounter groups and therapy cults. A man is boxing his own shadow. Vito Acconci again. It's his own self. His private self. But it's out in the open. It's a grainy video. A recording of a performance.

Now it's another one, called *Two Takes*: he stuffs grass in his mouth until he chokes and then he stuffs a woman's hair in there.

He faces a nude woman in *Manipulations* and directs the movements of her hands over her body through his own hand movements. His reflection in a mirror faces out to the camera, alongside the woman. Side by side they appear to synchronize awkwardly.

In *Theme Song* he puts some tapes on by Van Morrison and The Doors and Bob Dylan and from the lyrics of the songs he improvises sleazy come-on lines to a woman in a horrible, insinuating, pleading, leery voice.

'I'll be honest with you OK? I mean you'll have to believe me if I'm really honest!' he whines.

Darkness

'It's not just that darkness will come,' says Acconci, in the studio in Brooklyn where he now works, making furniture sculpture and architectural projects, which is what he does now instead of videos and performances. 'But that it's here all the time.'

'There's always been the dark side. The underside. There is death, yes. But there's also the uncontrolled and uncontrollable deep desires of the mind. Ha ha!' He laughs his now middle-aged stones-and-gravel laugh.

'People walk around in the city. Everybody has clothes on but there's a mass of seething desire there. It always seems like the wonder of the city is, with all these people so close together – why aren't they just fucking each other all the time? Ha ha! Or why aren't they eating each other up? So you make a convention of politeness. But the other side is always there.'

Acconci never thought his films and performances were about producing shocks. It wasn't a time when people could be shocked by art, he thought. It was the end of the 60s. And since there was such an atmosphere in the air of shocks that had already happened in life, he didn't think anything he was doing within art was really particularly shocking.

Artists warping

But also Modern art wasn't popular in the 70s like it is now. So it would very rarely be seen by anyone who wasn't already part of the culture that produced it. And who already knew the terms and language and issues. Nowadays there's still a gap between art culture and popular culture but there is an illusion – at least in Britain – that the gap has been closed because of the availability of the products of art culture within popular culture.

In reality, though, it's quite a leap. Artists look at the culture outside art culture and warp bits of it. They warp the movies or ads or daytime chat shows or sitcoms. They even warp art. Then they get invited to make movies themselves, or ads, or be on chat shows. And, er, be artists.

Vito Acconci
b New York, NY (USA), 1940 Acconci was one of the leading exponents of Body art in the late 1960s and early 1970s. His provocative performances reacted against the austerity of Minimalism and, since they were not saleable, against the art market. His early works were 'language pieces' similar to concrete poetry. In 1969, he began a series of photographs of himself bending, throwing, jumping in a landscape. By the 1970s, he was filming his live performances and making provocative installations. For *Rubbing Piece* (1970), Acconci sat in a restaurant and rubbed his arm until it came up in a welt; for *Trappings* (1971), he dressed his penis in doll's clothes and talked to it like a friend. His most famous work is *Seedbed* (1972), in which he used himself as the subject of the work, masturbating for hours under a gallery ramp, while visitors above listened to the amplified sounds of his activity. More recently he has been making large-scale public artworks such as *Floor Clock* (1989), a permanent time piece in a Chicago plaza.

Being compulsive

Paul McCarthy's Santa and his elves are on colour TV screens at the Whitney Museum in New York. It's early 1997. The TV monitors are arranged here and there throughout the wooden structure that the film was made in. Art lovers walk around the structure, seeing the film on different screens, picking up the action in fragments, from different points.

The impulse is to laugh. The horrible low brutality of *The Texas Chainsaw Massacre* comes to mind. And the baroque black humour of that film – punky, culty, extremely unpleasant.

But with *Santa Chocolate Shop* you're not trapped in a cinema with the smell of everyone's sweat of horrible expectation in the air. You're not trapped in a horrible narrative. Or trapped in a room with Leatherface or at the dinner table with Grandpa sucking your blood from your fingertips.

You're just picking things up in fragments. And because of the nature of art you can walk out at any minute – without it being the kind of walking out you might do when you're watching a film and you've just got to get out of there.

No one is being murdered or eaten alive. And everything is clearly what it is – a set, people dressed-up, chocolate sauce, a stumbling, improvised narrative that is barely a narrative at all. Although everything is also powerfully associative – of gorging, shitting, being compulsive, being insane, being trapped, being in a nightmare version of ordinary everyday life – you can easily shrug off the associations.

McCarthy devised the performance and directed the film of the performance, and played Santa. Making the film was part of the performance. Everything is transparent. The house has spaces, the narrative has spaces.

The acting is hardly acting at all. Just impulsive commands issued by Santa, with the film crew and actor-elves all following the commands and playing along with a crude dialogue that sputters up and dies away. The structure of the film/installation is very simple and minimal. The feeling is the same all the way through. Nothing develops. If you went out and came back you wouldn't miss something essential.

It's a work that comes from the context of art. It doesn't make sense to take it out of that context – take a clip and put it on a TV programme, say. And say: 'Bloody hell, that's shocking!' But you naturally want to anyway. It feels claustrophobic to always have to obey the commands of the art context.

What's happening?

'What's happening at this point?' I asked McCarthy in his house in Pasadena, in LA, a year after I first saw *Santa Chocolate Shop*, as we watched a tape of the film rolling by on a monitor. 'What are they doing now?'

'Well, there were two elves,' he said. 'A green elf and a blue elf. And the reindeer is sat down in the hole with his ass hanging down over them. The chocolate flows through a funnel. The Santa Claus stoops over and pours as if he's taking a dump.

Paul McCarthy
in his LA studio 1998

But it's really also just pouring chocolate into a funnel. And the chocolate being both chocolate as in Christmas and the chocolate association of shit and then this eating of it. You know – eating the chocolate? The gluttony of eating chocolate but also eating shit. It's obsessional. It's traumatic. I don't know if it's personal to me or something I've witnessed, through the media.'

Six million pages

I looked *Santa Chocolate Shop* up on the Internet the other day, just out of interest, and the screen said there were over six million pages of entries that applied to that combination of words and I should refine my request. It's amazing the allure those three concepts have for ordinary people.

Proverbs, caprices

Artists are always complaining when only the shocks are talked about. 'What about the ideas!' they complain, because on the whole (when it isn't Tracey Emin rehabilitating Munch's raw pain as a viable type of contemporary expression) the shocks contemporary art delivers aren't about child abuse, murder, cannibalism, war, or other terrible things artists have witnessed and need to express in a burning way. They tend instead to be ironic stagings of abstract ideas about the alienated self or the capacity of the mass media to mould or fashion reality.

Goya is considered to be different because he really was expressing what he saw. Also, he had an Enlightenment agenda – to paint evil and darkness from a sophisticated point of view, maybe to propagandize against regression and in favour of progress.

But in reality Goya's pictures are so perverse that such a propaganda reading never seems particularly the point (in fact the point might well be the opposite). He will always appear quite inexplicably weird and his open-ness means that he is open to being appropriated by anybody at any time, for any purposes, whether it's by Fuseli or Picasso or the Chapmans.

Goya stages scenes that seem psychologically realistic. People and things look believable. But his realism is non-naturalistic – dramatic poses, dramatic editing, dramatic spaces, dramatic expressions. But all this drama is set around ordinary people very believably observed. Their muscles, their looks, their clothes, their demure smiles or their demented ones.

His portraits of royalty are psychologically convincing not because royalty must always be grotesque, as his royal subjects famously are and as the British royal family is often thought to be, but because you believe, with him, that these people appeared in this way, even though they're staged phantoms. And the space they're standing or posing within is a shallow, dramatic stage set. Or phantom space.

As well as *Disasters of War*, Goya produced other groups of engravings, including the *Caprices*. The *Caprices* include a sub-set of engravings called the *Proverbs*. The *Proverbs* all illustrate follies – for example, *Feminine folly*, *Flying folly*, *Ridiculous folly*, *Poor folly*, *General folly*, *Folly of Confusion* and so on. But the imagery is more grotesque and excessive than the popular sayings it's supposed to be illustrating – however richly dark and fascinating and revealing of bestial appetites and desires and human darkness old Spanish folklore might have been in the nineteenth century. As if the hidden twistedness of those popular sayings provided an open door for an anarchy of art.

Flying, gigantism, monstrous deformity, hallucinations, all play a part in the *Proverbs*. The atmosphere is surreal without Surrealism – heavy, black, lunar, dreamlike. *Un Chien Andalou*-like.

In the *Caprices* as a whole the dramas shown are peculiar. The images have a clear didactic intention. Goya lived through war, invasion, famine, the end of the

69.

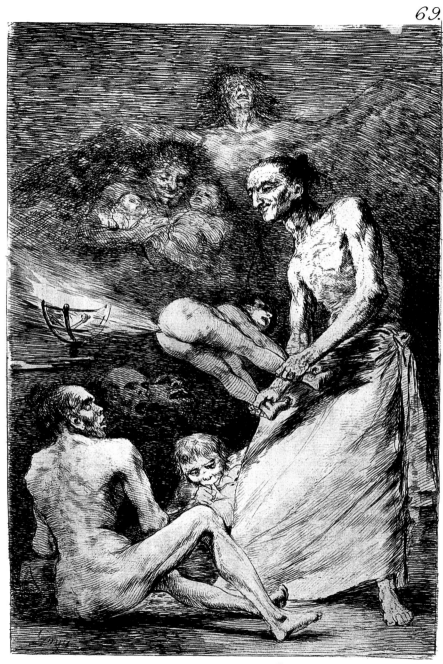

Sopla.

Francisco Goya
What Next?
from *Caprices* c. 1799

Inquisition, sudden reversals of political regimes. He was in and out of favour with these regimes. He was director of the Academy of Painting and the court artist and the favourite of aristocrats and ministers. He was charged at one time with conspiring with the French – he found the invaders cultivated and sophisticated like him – but then got off. He was a schemer and a strategist. At times he was on the run or in hiding. He suffered an extreme illness from which he nearly died and which left him profoundly deaf after the age of forty. He painted all the pictures he is remembered for after then. He had a dramatic adventurous life. He witnessed a lot of atrocity and horror. When he portrays darkness we can almost believe it's because he wants to cast a light there and get rid of it.

But the human darkness he brings forth in the art he produced after the end of the eighteenth century – the point at which he started to set his own themes – is so peculiarly weird and savage, the tone so assaultive, so insinuating, so nasty, you have to wonder what he thought was worth saving. Or if he hadn't at some point just grown out of wanting to save anything. *Don't scream, stupid!* is one title.

The tone of the *Caprices*' most famous image – *The Sleep of Reason Produces Monsters*, which is now a favourite symbol of dreamy or disturbing nineteenth-century Romanticism – is not the general tone of the suite. The general tone is more ghastly. In *What next?* (which coincidentally is *Caprice* No.69) a demon fellates a baby. In the same scene a weirdo giant man/woman fans the flames of a fire with air pumped from the backside of a naked child, the stiff legs manipulated like the handles of a machine. Nude men with bestial, lolling-jawed, corpse-faces look on.

In another engraving in the series, a naked matron suspended in the air is caressed by flying creatures, part human, part animal, all making a totem-pole structure. The title is *Where is Mummy going?* An owl looks out from the crotch of one of the creatures – human legs splayed – while a pussy cat masturbates Mummy with the handle of a parasol.

Allegories of everyday Spanish life are clearly present throughout the *Caprices* but always far more twisted and obsessive than the point of the thought demands – so there is a continual doubt about what the point really is. The mind is continually shuffling, processing, filtering, feeling exhausted by the effort.

Beauties with blank faces, prostitutes maybe, wear upside down chairs on their heads but only gossamer nighties on their bodies. Dissolution is always dissolution gone so ripe and strange that the ordinary rottenness portrayed by contemporary English caricaturists like Rowlandson – who we know is very savage and whose prints Goya would have seen – seems only mild or obvious by comparison.

Stupidity and vanity is always terminal, very far gone. Prostitutes' clients are plucked like chickens and then swept away with brooms. They actually are little plucked chickens with human heads. Some of them fly around a tree. Goya himself is one of them with his sideburns and top hat and peasant face. Monkeys paint asses, donkey doctors feel the pulses of sick men, donkeys teach donkeys to read the

Francisco Goya
Dog Drowning in Quicksand
1820

alphabet. There are many drooling cretins, beaten bottoms, sex-frenzied crones and moonlit human sacrifices.

Black paintings

Between 1819 and 1823 Goya painted a number of images directly onto the plaster walls of the house where he lived, which were later removed and lined and now hang in the Prado under the collective title, *Pintura Negra* or Black Paintings. They're not really all black but the mood is very black. Approaching 80, he ate his meals every day surrounded by them. He painted them in bursts, apparently between

stints of gardening. They never had any titles and nobody knows what they mean. The titles they have now were given after Goya's death.

They were acquired by a French aristocrat who exhibited them in Paris but then returned them to Spain because nobody liked them. It was only relatively recently that they were considered to be any good. And in fact Goya generally was not widely considered to be much good until well into the twentieth century. An English art critic, who fought with Whistler, reviewed the exhibition of Black Paintings at the Paris Fair in 1878 for a London magazine. He said they were incomprehensible vile abortions painted by a sinner.

In these paintings the light is grim, space is unreal, objects often appear transparent, intangible. There are arbitrary scale changes — figures appear like giants because scenes featuring smaller figures are in the same painting. But there is no rationalizing narrative. A city appears to be flying in the sky. Maybe the sky was just painted around it one day. Soldiers in the corner of the painting aim at the city with their rifles. They might have been shooting something else though.

A cannibal giant in one painting is possibly a reworking of a classical theme. Goya would have studied a painting by Rubens in the royal collection, of the same theme — *Saturn Devouring one of his Sons*. The Rubens is polished and glowing. In the Goya version, a naked, mad-eyed giant holds the headless corpse of a young man and sucks one of the arm stumps. The strokes of the painting are broad and urgent. The old thin white-haired giant looks out from the blackness with a horrible expression — hungry, furtive.

A dog drowns in quicksand. Or else looks out over a hill. Most of this picture is just a dim void. Gruesome old people leer and eat their gruel. Women sit in a row in a smoky dark place worshipping Satan. Men stand in swamps beating each other with cudgels. A procession of mad people comes round a hill. The eyes are either blank or staring. The light's gone out in there. It's like the news on TV. All our own weirdness and randomness and blackness. As one of the captions of the *Disasters* reads: 'This is bad.'

With all these pictures — the cannibals and witches' Sabbaths and Satan and Saturn and processions of mad people and vampire oldsters sucking babies and demented royalty and the braying of animals parodying human society — the life of the imagery is only ever flickering. It can suddenly appear very vivid but it can easily die down. Aesthetic distance intervenes. Time intervenes. Amnesia intervenes. When it flares up it's a shock.

CHAPTER THREE

LOVELY LOVELY

Henri Matisse
Capucines à la Danse II 1912

Don't smile

Beauty and loveliness — we don't expect them to be high on the Modern art agenda or even on it at all because nobody talks about them. Did they used to in the old days?

We know Matisse was a great artist of beautiful colour and patterns. But we are not sure what to do with him since (apart from his late cut-outs which look like logos or fabric patterns and which seem to be everywhere in high-street culture and in advertising and packaging) he fits so awkwardly with the art of now. Shouldn't he have been more angry? Why was he only calm, luxurious and voluptuous instead?

Picasso seems more suitably restless and agitated. That's more like it, we think, what with all the wars and torture, and so on, that our century has seen.

On the whole, though, we don't think about either of them very much, unless there's a big blockbuster show on somewhere of them. Which there often is because of the culture industry and its need to keep rolling on and expanding. But neither of them are really part of our *fin de siècle zeitgeist* — to join French with German in an unsonorous way. Which Picasso or Matisse would never have done because it would have felt wrong to them. Perhaps it feels wrong to us too. Obviously not everything has changed since their time as much as we might sometimes believe it has.

Matisse and Picasso don't have a place in our Modern art heads now because they are too aesthetic. Matisse is the worst because he is the most aesthetic. He didn't want to be annoying but only to be soaring and swelling and beautiful like lovely music. What was he on, that Matisse?

Luxe, Calme et Volupté

Luxe, Calme et Volupté. That's the title of a famous painting by Matisse which was completed in 1905, two years before Picasso painted *Les Demoiselles d'Avignon*. It is from Matisse's Fauve period. But although Fauve means wild beast and Matisse was the leader of the Fauves — the Post-Impressionist movement based on the colour theories of Seurat, which started up in about 1900 and lasted for many years — we don't see the wildness in Fauvism any more.

In this painting, we see an arrangement across a white canvas of small squarish patches of colour, each roughly the same size, like a mosaic, with small areas of white left uncovered, roughly an equal amount across the whole space, so every colour is matched by white. Therefore, the light in the painting is hot and brilliant. The scene is of women lounging voluptuously, like patchy cartoon Ingres nudes, beside a Fauve multicoloured sea.

The nudes don't stare out contemptuously like the jostling prostitutes in *Les Demoiselles d'Avignon*. They are a bit distorted but their distortions aren't disturbing or hilarious. It is a painting of a beautiful or purely pleasurable sensation, not a sensation of violent strangeness.

Henri Matisse
b Le Cateau-Cambrésis (France), 1869; d Nice (France), 1954
Matisse stands beside Picasso as a colossus of modern art. The joyous, curvaceous forms, decorative agility and emotional, vibrant colours in a work such as *The Dance*, 1910, may be a delight to the contemporary eye, reflecting Matisse's definition of art as 'mental soother', but in 1905 his work, along with that of Derain and Vlaminck, was called *fauve* (wild animal) by a scandalized critic. Matisse's use of colour was revolutionary, and his interest in Eastern and African art brought about a new, exotic style. In 1890 he abandoned law to study art in Paris. Early works were restrained interiors and still lifes, followed by a period of intensive experiment with Post-Impressionist techniques. Neo-Impressionism and the colours of Nice were major influences on his heightened palette, but Cézanne was his dominant inspiration. The great mature works — the *Odalisques* (1920–5), the Barnes mural (1930–2), the Chapel at Vence (1949–51) and cut-paper gouaches (*L'Escargot*, 1953) — reflect his ambition to create an enriching, decorative art.

Henri Matisse
Luxe, Calme et Volupté 1904

Picasso might not be the artist of the present moment either but we don't turn away from him with a quite such a shudder. Being lovely, being angry — we know which is right. We know no artists will ever be nominated for the Turner Prize for their contribution to loveliness.

What is it?

Beauty, loveliness. What on earth are they?

There is a strain of Modern art beauty which is quite respectable. The intellectualized hysterical beauty of Surrealism for example — the poetic beauty of some odd thing or other next to something else odd on an operating table. This is a terrible beauty or a strange or ecstatic or mad or new beauty.

But the loveliness we find in a lot of art — even in much Surrealist painting — is another story. We don't talk about it, or at best only talk contemptuously of it, but hardly any forms of painting don't have it. It seems to be a property or quality that can never be wholly got rid of. However much we may stop mentioning it and try and shame it into leaving, it just keeps on hanging around.

Welcome

Matisse's most famous saying is that he wanted his art to be like a comfortable armchair for a tired businessman to relax in at the end of a busy day. This seems

Henri Matisse
Large Red Interior 1948

Pablo Picasso
Nude in a Red Armchair 1929

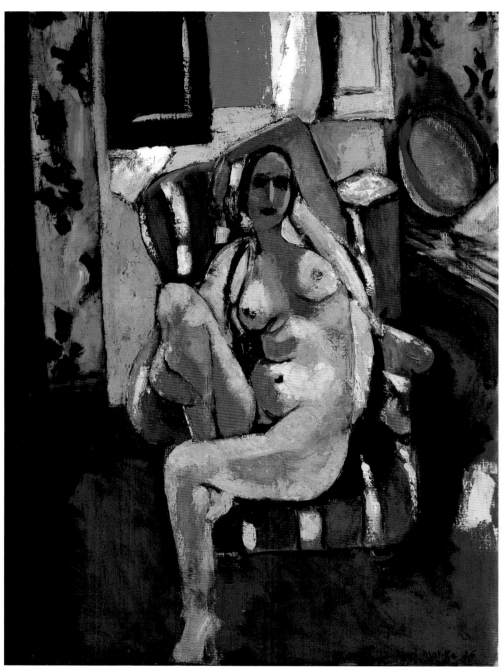

Henri Matisse
Odalisque with
Tambourine 1926

absolutely outrageous to us. Almost every element of the idea is offensive. Businessmen can bugger off, we say. And you can keep your armchairs.

But we probably don't really say this because the human nervous system is tuned to seek out loveliness and beauty and to crave them. Maybe what we really feel nowadays is a restlessness with the present rhetoric of anti-loveliness in art and a sense of alienation from it. As if it were a foreign invader who we must obey because otherwise we would be shot. But inside we know it's just an act. Or maybe it's a foreign invader we quite like even though they're foreign. Inside we know obedience is only an act but it's not like we're being driven mad by the split between inner feelings and outer behaviour. This is probably more like it. It's that Turner Prize coming round again, we say. Welcome to our land, disturbing sights that express a profound unease! Come drink with us! Share our women!

Beauty and abstraction

Is beauty in art simply a matter of art not being so abstract all the time? This is a common assumption. Pre-Modern art, like the Pre-Raphaelites, or Raphael, was not abstract and it did not value ugliness. Also, all the various isms of Modern art seem to be departures from a norm of beauty. Therefore it is natural to imagine each one might be a variation on an idea of ugliness. But in fact this is not true. For example, many forms of abstraction in Modern art are variations on a theme of beauty. A norm of representation might be departed from but not a norm of beauty.

Can there be a norm of beauty without representation though? How would we know if any beauty is there if it is not radiating off of something recognizable? And that's a good point. From the bluntest thoughts quite complicated issues arise.

Not going too far

Matisse was born in 1869, Picasso in 1881. They are the two great painters of our century. Nothing in painting that happened since 1900 can't be traced back in some way to them. We feel distanced from them now but for a long time they were the personifications of Modern art and avant gardism.

Picasso was thoroughly avant garde at least until the 1950s when his avant gardism was challenged by American art. Matisse was in and out of the avant garde but still mostly in it. In the 1920s he painted too many languid nudes in armchairs in a relatively undistorted style. So he was out for a few years and Picasso was the leader until the early 30s when they were neck and neck again. But in the 20s Picasso was charging ahead painting wild distortions and even occasionally parodying or caricaturing Matisse with a cruel sneer.

Picasso's *Nude in a Red Armchair* of 1929 is probably a conscious parody of one of Matisse's 1920s nudes. Matisse's nudes of that period look tame by comparison. For example, *Odalisque with Tambourine*, from 1926, has the same colours as the Picasso. This painting looks conventional at first instead of contemptuously idiotic

and horrible like Picasso's painting. Picasso's horror might be a horror at women or a horror at Matisse or a horror at painting.

But even to get the horror at all of Picasso's painting you'd have to be thinking quite hard about it because at first, both paintings look like generic Modern art. Nudes, interiors, oil paint, patterns.

Although, looking now at the Matisse, we do see it more for what it is – the rightness of the colour, the build-up of the textured surface, the beauty and love-liness of the painting. The posed model seems less of a type and there is less of an impulse merely to categorize her. The red and green in the Picasso and the red and green in the Matisse are also suddenly very different. And this difference is more engaging and striking suddenly than the difference between the surrealized, de-boned, nutty, cartoon woman-creature of Picasso – with its furniture-leg limbs and pin head – and the ordinary, passive, dauby, corny model in the Matisse.

But that's just the difference between the two artists. Matisse is about achieving a meditative, rare, sublime beauty with everything he does. Picasso is about being savage and masculine and psychological and peering mercilessly inside his own head and looking at what it is to be sexual or to be old or to be dying or to be still feeling OK and full of beans. How could you portray that? What hoops would you have to jump through as a painter? But he still has to hang on to quite a lot of beauty, though, because of the nature of painting.

Beauty and avant gardism

Beauty is part of painting. There always has to be some. For both Picasso and Matisse, avant gardism was not just moving forward, or being in the lead, as the military term suggests. They saw themselves as profoundly connected to the past as well. As if they had given themselves the job – or accepted the job when it was divinely thrust upon them – of carrying on the great tradition of Western painting but looking forward to the future at the same time.

Each had the same idea as the other of their role as a guardian of something important – the tradition of painting. They had to move it on and change it but in order to preserve it, not destroy it.

There would be no point for them in systematically getting rid of loveliness. The point was to re-make it, or make it new, mixing ugliness with it to freshen it up. If beauty and loveliness were things that had to be held on to, it was because there was a line that couldn't be crossed without painting ceasing to be painting at all and becoming just art. And then art could easily just seep out into everything else and there'd be no difference between it and the rest of the world. And that would be awful because it would be like Duchamp's idea of art and they never thought about him.

For Picasso and Matisse the stopping point before seeping started was not so far out as it was for some other artists – for example, Mondrian, who painted

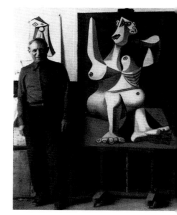

Picasso in his studio in Royan with *Woman Dressing Her Hair* 1940

Piet Mondrian
Composition with Large Blue Plane
1921

Piet Mondrian
b Amersfoort (Netherlands), 1872;
d New York, NY (USA), 1944
A key figure in the evolution
of abstract art, Mondrian is
celebrated for his geometric grid
paintings, in which strong black
lines accommodate asymmetric,
floating rectangles of primary
colours (*Composition with Blue
and Yellow*, 1929, for example).
Priestly and ascetic (he originally
considered becoming a minister
and converted to Theosophy in
1909), he believed these pure,
restrained works reflected the
laws of the universe. His early
paintings were naturalistic, taking
on a Symbolist character between
1907 and 1910. In 1912–14 he
lived in Paris, where he became
strongly influenced by Cubism.
During this period, he made a
series of a tree paintings, which
became progressively more
abstract until curves were
completely eliminated. Back
in the Netherlands in 1915, he
founded De Stijl with Theo van
Doesburg, promoting this new,
radically geometric abstraction,
which he described in *Neo-
Plasticism*, his book of 1920.
Moving to New York in 1940,
Mondrian developed a more
colourful, rhythmic style,
influenced by jazz and typified
by *Broadway Boogie-Woogie*
(1942–3).

abstract squares. For Picasso and Matisse the stopping point was well before pure abstraction. On the other side of that was just a blank, for them. For other artists, blankness was still a long way off and loveliness could be stretched a lot further.

Racy or normal

Picasso and Matisse had quite definite ideas about the types of beauty they wanted to be known for. Picasso wanted to be known as an artist for whom anarchy and raciness and swearing and sneering were as natural as palettes and cadmium red and a beret and a T-Shirt. Whereas Matisse wanted to be known as a bourgeois not a bohemian, with bourgeois tastes. When he was having a retrospective of his paintings in America in 1948, he was desperate for the publicity for the show to present him to the American audience as a family man who loved beautiful music. Not as a wild beast.

Nature

Matisse thought instinct had a role in the creation of art. But it had to be thwarted, he said – just as the branches of a tree are pruned so the tree will grow better.

For Matisse, not being wholly abstract – even at his most simplified, which he was in the 1950s with his paper cut-outs – meant not losing touch with nature. Nature was primal. Early on he had the idea that the patterns and colours of

primitive and oriental art were powerful and expressive and offered a path out of academicism on the one hand, or a languid – as opposed to expressive and urgent – decoration on the other. He thought painting was an art of sensation and he saw all the possibilities of his sensations offered up to him in, for example, Persian miniatures. But it was in nature that he thought these sensations had to be re-found.

Slow Matisse

Matisse is considered to be slower than Picasso and more methodical. And so it is easy to assume he was less adventurous or inspired. And he taught younger artists whereas Picasso never did. He was notoriously secretive and ungenerous.

Both of them surrounded themselves with the kinds of objects that appeared in their paintings. Lovely doves and musical instruments and pots and vases and patterned fabrics and old furniture and couches and examples of their own art and the art of other artists they admired, which included each other's art.

But Matisse drew and painted these things with a concentrated gaze. Just as we see him in old documentary films of the 40s – filling in the colour of the hair and dashing off the eyes, nose and mouth with a flourish, and with the costumed model in her make-up posed right there before him. Whereas Picasso just soaked up the forms of nature by osmosis and they came out transformed on the canvas, while his back was turned to them.

Everything

Matisse is often criticized for being outrageously chauvinist and sexist. The thought goes that he makes women into objects by reducing them to the level of patterns or wallpaper. We cannot criticize an artist for wrong views when they weren't wrong in his time though. Well, maybe we can. But in any case, another view might be that Matisse seems more and more cosmic as time goes on. As if he wanted to make an art where everything seemed to be in an explosion of utter feeling. And from that perspective, we can see the women in his paintings not so much reduced but elevated along with everything else to the same point of transcendental unity. The real human beings in his studio, receiving their modelling fees, taking their tea breaks, or absinthe breaks, whatever. And the trailing plants and patterned cushions and the view through the window and the sea and sailing boats and Riviera palm trees beyond. All now just a cosmic hallucination in oil paint.

We might say, well that's an objectionable subjugation of those models' real selves. It is an objectionable objectifying of their bodies. But that's to project Matisse into the values of a later age.

For example, in a lot of art of the 80s there was a big exploration of what pleasure was, what painting was and what the self was. It was part of identity politics and race and gender politics. It's good that there was that because a lot of the artists we now like – for example, the Turner Prize winner, Chris Ofili – who were art students when all that stuff was going on, and thus were formed as artists in

that climate, wouldn't now feel so relaxed with those notions and able to push them around and advance them by playing games with them. And we wouldn't be now applauding their brilliance or their Right On attitudes.

Another criticism sometimes levelled at Matisse is that he wasn't very active in the Resistance during the Second World War even though his wife and daughter apparently were and were even arrested and questioned by the Gestapo.

During this period Matisse was painting nudes in oriental costumes posing on cushions in lovely patterned interiors. Again, there probably isn't much that can be said in his defence. He knew what he was and what his mission was and there was no going off the course. He lived in a house near Vence called La Rêve, or The Dream. He named it himself. He was detached from the modern world. He lived in his own symbolic world of beauty. He thought that was enough for the war effort.

Expression theory

Matisse said it wasn't the expression on the face of a figure in a painting that was the key to the beauty of the painting but the expression of the whole painting. The face might be a set of curves that wasn't much different to the curves in the wall-paper pattern behind the face. Therefore, the wallpaper was just as expressive. We fear the wallpaper idea now because we fear Matisse is only wallpaper. We have already seen, though, that this might be wrong.

Colour, beauty, painting

With Matisse, colour is the key to beauty. He said colour wasn't descriptive but it was a value in itself and it possessed its own beauty. He said a square centimetre of blue is never the same as a square metre of the same blue.

The mystery of the exact quantity of a certain colour and its expressive quality – this kind of thought had a forehead-creasing urgency for art students at least up to the 1970s. After that it was less urgent because there was a general feeling that even if Matisse was right it didn't matter because colour in itself wasn't all that interesting. What had seemed like a radical idea now didn't seem so any more.

This is the thought we still have now about colour. Other things are more interesting. We think a talent for manipulating quantities of colour, or a feel for colour, is nothing special. It was special in the past but there's only so much we really want from the past, at present.

Quality

Colour was very important in Post-Painterly Abstraction. This was the name given by Clement Greenberg to the stream of abstract painting in America that attempted to follow the example of Jackson Pollock. It was an important movement of the 1960s with its roots in the abstract art of the 1950s. It was Post-Painterly because it was painterly but not gestural. Gestures were out. Colour was in. You had to get the colour on the canvas without using gestures. That was the task.

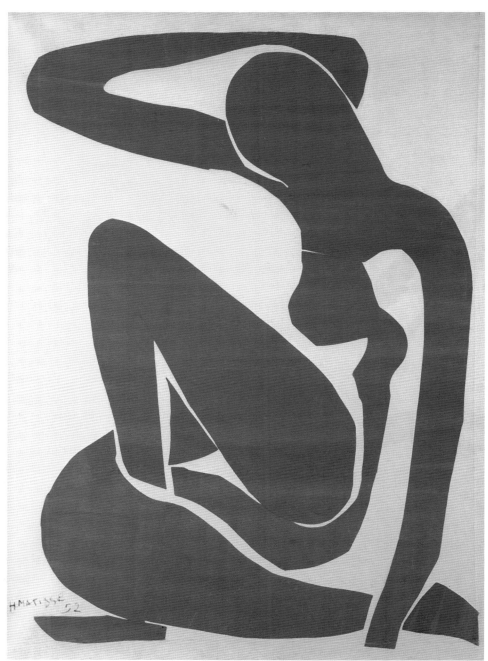

Henri Matisse
Blue Nude I 1952

Morris Louis
Aleph 1960

There were many followers but the leading figures were Morris Louis, Kenneth Noland, Helen Frankenthaler and Jules Olitski. They were all impressed by Pollock and encouraged by Greenberg. They thought Pollock's art was expressive and full of feeling. It was not absolutely amazing as far as colour was concerned though. But the other formal and technical things about it, they thought were good. And these could be used to advance the cause of colour.

It might seem a bit twisted put this way. But this was pretty much the idea. They didn't want the angst of Pollock but they did want the sensitivity and feeling and formal drama of his art. They thought that was a reasonable separation.

Pollock painted directly onto unprimed canvas – or canvas that was only sized, rather than coated with white paint. Unprimed or only-sized canvas was very absorbent. When the paint was very liquid it bled into the surface. The colour was therefore within the surface of the canvas rather than on top of it. These new painters really got hold of this notion and started to paint in a way that was more staining than painting. The results were often strikingly beautiful. It was a new type of beauty.

Their colour was high and strong and bright and spread out. Their canvases were big, sometimes vast. It seemed to work better that way. It was like Matisse's idea of the expressive quality of a colour being perhaps connected to quantity – fine judgements of quantity.

And indeed Matisse was a great figure for Greenberg and for these artists, even though they were abstract and not figurative. They liked him being Apollonian and not Dionysian. Apollonian means plenty of reason and dignity. Dionysian means all-out hairy savagery. It was a symbolic opposition that had a resonance at the time. We don't care about it now but for Post-Painterly Abstractionists it was a helpful idea.

Maybe it seemed appealing because there was an anxiety at this time about the way a vulgar idea of Modern art was creeping into the high idea because this was also the time of the arrival of Pop art. Not that Pop was savage. In fact, with hindsight, it seems a lot like Post-Painterly Abstraction – cool, large, flat, unemotional. But at the time it seemed like barbarism. Whereas Post-Painterly Abstraction seemed the height of refinement.

Pop art was only novelty art, Greenberg thought. It didn't have enough quality because it didn't have aesthetic power and consequently it didn't have any feeling – it did not express feeling. Feeling was the thing. If art had no feeling it wasn't worth bothering with.

This seems reasonable enough. But as soon as anyone looked a bit harder, or in a different way than the Greenberg way, at all these qualities – quality itself, feeling, aesthetic power – there were problems, it was thought. They could mean too many different things. One person's quality might not be another person's. In fact, quality could be a bad fascistic thing. Feelings might not even be an interesting thing to have in art.

Jules Olitski *High A Yellow*
1967

For Greenberg and the artists he supported there wasn't any problem so long as you stood your ground and saluted the notion of quality because, they thought, quality – or its absence – really was there in art for all to see. The good, the bad: you could see it. And it was just a philosophical game, or an intellectual perversity, or it was barbarism, to try and say that quality was incredibly fugitive and couldn't possibly be pinned down.

It was a bit fugitive, Greenberg thought. But not all that fugitive.

Greenberg himself became a hate figure quite soon into the 60s – at least for those outside his circle. He had seemed very authoritative when he was the critic who discovered Jackson Pollock before anyone else. But gradually he was thought to be only authoritarian. And then it was considered quite unbelievable that such a narrow view of art had been taken so seriously at such a high level for so long. The artists he supported went on painting in the Post-Painterly Abstraction way, experimenting with new formats, or going on and on with the old ones. But now they were just a little world unto themselves and their new works stopped appearing in Modern art museums and art magazines. Louis died tragically early from cancer. The others all continue today in the old vein.

One exception is Jules Olitski who changed his style recently and now paints landscapes and sunsets and sailing boats and nude women. In real life he is a

Jules Olitski
Envisioned Sail 1998

Jules Olitski
b Gomel (Russia), 1922
Olitski was born in Russia but went to art school in New York and Paris. He is associated with Post-Painterly abstraction and Colour Field painting, which rejects textural brushstrokes, linear boundaries and compositional devices in favour of the primacy and visual sensation of colour. His early works were densely textured, smeared surfaces in sombre hues. But in the 1960s, he began to stain the canvas using sprayed acrylics, to create smooth, biomorphic forms in the manner of Morris Louis and Helen Frankenthaler. By 1963 he aimed to dissolve the contours of these shapes altogether, through the sheer force of rich saturated colour, and by spraying tiny particles of paint onto the unprimed canvas. In his recent landscapes, he has returned to the impasto texture of the earlier paintings, manipulating the pigment with sponges, blasting the surface with a leaf-blower, or allowing paint to drip down the vertical canvas. Olitski still lives in New York, where he has taught for many years.

sympathetic figure: in his 80s; still painting; still frowning and smiling and philoso- phizing. But because he is associated with a movement that is hated and feared — a wrong myth of beauty — there is not much interest in whether he paints sunsets or not. At the moment they are not being allowed into culture so it will be up to posterity to decide if they have any quality or not.

Alex Katz and beauty

What about beauty now in painting? The American painter Alex Katz, now in his 70s, has painted beautiful people in sunny landscapes since the 1950s, in a way that has seemed quite stylish or else impossibly bland to various sets of audiences since then — or illustrational or even inept. He has been in and out of critical fashion and when he's out it's usually because of a suspicion of blandness.

But it might be that beauty itself is considered too bland a purpose for painting at the times when he is out. Beauty definitely seems to be the point with him — the beauty of Japanese wood-prints or of any art that is about dynamic arrangements of flat areas of colour. And objective things in the world rendered in a stylized way. And an execution that is not extremely functional or inexpressive, nor extremely the other way — extremely dramatic or wild. But hovering oddly just above functional — just at the level where functional might be about to take off into something more self-conscious.

With Katz, the self is hardly conscious at all. His style is a self-effacing style not a self-dramatizing style.

Now he's in fashion again. Not because there is a sudden new heightened dramatic relationship of a psychological kind between the suntanned figures he paints, standing around in their swimming trunks or with their well-pressed, pastel-coloured casual-wear and in their well-combed hair-dos. But because painting scenes in an ordinary way has come back into fashion.

It's more interesting than painting them in an exaggeratedly emotional way. Both ways require a lot of devices and tricks, so neither of them are all that ordinary. With all the technical devices and skills and concentrated discipline that painting requires, that's enough artificiality. A normality of subject matter seems a better balance of ordinary and extraordinary than an extreme subject matter.

Matisse, too, was self-effacing. He wanted to hide anguish and hide the heroic effort that went into making beauty look effortless. But he wasn't without anguish. In fact he suffered anguish when he thought the effort behind his art wasn't acknowledged. He wanted it both ways.

In Matisse's case he needed a lot of peace and quiet and a long run-in before starting painting. He could never paint when travelling for example. And he lived in Nice not just because he liked the light but because there were fewer distractions there than in Paris.

Once Matisse started a painting he was always erasing and restarting it. His paintings look effortless but they invariably show signs of change and movement.

In fact, when you follow all the joins and parts of his paintings, as if remaking them by looking at them this way, they almost always show signs of ugliness and awkwardness. And the final effect of effortless harmony, looked at again, is usually seen to be an odd harmony – one made of individually awkward or unharmonious or discordant things. Things leaning over, or oddly matched or unsymmetrical. It's odd that a slight discordant quality often seems to accompany beauty.

In Katz's case, his paintings are very large and it is part of their effect of both extreme stillness and dynamism that they seem to have been done all in one go. In fact they were. The colours are mixed and the brushes loaded and the image is painted in a few hours. There's no turning back or erasing allowed in the process. The lead-up to this process is a matter of making sequences of little oil paintings which each represent a different visual idea – variations on the original oil paintings or watercolours which were done from life.

His recent paintings are of piers and reflections in the water around his home in Maine. There are reflections, depths, motion, light. 'Water is like flowers,' he says. 'Very few people can paint them well.'

He says he's trying to paint a twenty-second sensation. The reflections are painted at sunset. Where he lives the sunset lasts from about 7.30 to 7.45 or so. He's got twenty minutes to soak up enough visual data to make an equivalent in

Alex Katz
b New York, NY (USA), 1928
On leaving art school, Katz supported himself by painting murals, and a billboard scale still dominates his work. The movie close-up also contributes to his larger-than-life, simplified images of beautiful sophisticates (often modelled on his wife Ada). His group scenes sometimes crystallize an enigmatic moment of social drama. In other works, a single subject gazes blankly from the canvas, both intense and detached. Due to their stylized light effects and the speed and facility with which they are painted, Katz's glowing, empty landscapes often recall Oriental art. But overall, the works have a quintessentially American feel that stems in part from his subjects – drawn from the New York art world and leisurely affluent life in Maine – in part from the influence of Pop art and jazz music, which gives the works their restrained cool. Katz became known in the late 1950s for his immediate, all-over, Abstract Expressionist canvases. Only now, however, has he achieved true art-world acclaim.

Alex Katz *Lawn Party* 1965

paint for a twenty-second sensation. Then the eventual big painting will have the same high-speed sensation.

'Beauty in modern art is usually associated with something soft, something wrong,' he says, 'like enjoying academic salon painting in the nineteenth century instead of Monet.' When Katz started out, though, he thought beauty could be something 'first class, like the image of Nefertiti.' And he thought he could paint beautiful people and the effects of light in a way that would stand up to the most ambitious achievements of muscular Abstract Expressionism.

Elizabeth Peyton
Jarvis at Press Conference
1996

Stars

With art there's lots of problems with beauty. But with people it's not such a problem. Everyone knows when they find a person beautiful. Some people have the job of being beautiful. They're stars. They're polished and perfect and unreal. These are the subjects of Liz Peyton, the American painter, now in her early thirties and a recent star of the New York art world.

Her paintings seem even less like Modern art than Alex Katz's. They're beautiful in the way we might say a fashion drawing is beautiful. The subjects are sometimes her friends but mostly they're the famous, or the mega-famous. Jarvis Cocker. Leonardo DiCaprio. David Hockney. The Brazilian footballer, Ronaldo. Done in a frankly illustrational style. But she turns prettiness and illustration into a virtue. She answers a recent appetite for roots art. Not brainy or ironic. But straightforward.

She does straightforward, attractive, glamorous beauty that no one could dislike: transparent oil colour portraits from photographs, with the paint brushed freely onto grounds of brilliant white gesso, and the skin and hair and features and shirts of the figures appearing to have been formed by the colour simply melting into contours and highlights and shadows and forms.

Oasis keep appearing in her pictures. One picture shows the famous Gallagher brothers as infants. But even when they're not children any more, the stars of her paintings have had all the realism taken out and exaggerated elegance put in instead.

'There's loads of glamorous stars out there,' she says. 'But that's not the beauty I'm interested in.' She is outside her studio in Long Island, wearing reflecting sunglasses. A river runs by the back of the house. A yellow boat in the yard with a smiley face painted on it is reflected in her lenses.

'I like people who are glamorous because they're wilful and talented and they can make beautiful things. I think that's what gives them a very special beauty.'

She thinks the reason something from the Matisse world might be considered by many to be more important than something from the pop culture world is that pop is so new it isn't wholly known yet.

She paints stars as they're shown by the media — they're at the centre of historical events, personal events, glamour events. Events which are moving for everybody. 'And that's how Gros painted Napoleon in the early nineteenth century,' she says. 'He saw him as history personified. He was obsessed by him. It's the same with Ronaldo arriving at the airport after his panic attack, or Liam arriving at the airport when it was rumoured Oasis were splitting up. We find those moments riveting. We find those icons irresistible. Gros was in love with Napoleon. He romanticized him. When Napoleon lost his power he committed suicide.'

She makes Ronaldo much more faun-like than he actually is in the press photo she's painting his portrait from. His head is more perfect and sculptured and narrow and prettier than it looks in the photo, a transforming process that seems to happen just by the action of her brush. 'Well, the colour of the skin isn't right yet,' she says. 'It's looking a little plastic. But I love his Brazil jacket — their outfits are so great!'

Symbolic Basquiat

Jean-Michel Basquiat was a star of the New York art world of the 80s. Although he died in the late 80s his star still shines high in contemporary pop culture, where he is considered an absolute model of stylish hipness — in fact he really did model clothes on a fashion catwalk with real models and was always appearing in magazines looking amazing. He was famous for his suits. Famous for modelling them on the catwalk and for painting in them and for them being smeared with paint even though they were expensive.

Many older art critics take it for granted that Basquiat is just a symbol of 80s excess. They probably hate the 80s because it was the decade when critics were laughably weak and galleries and collectors were shockingly strong. So Basquiat appears in at least one mythology as a symbolic victim of the inevitable hangover after unearned gallons of free champagne because that's how the New York art world of the 80s is often seen. But in fact there were a lot of exciting things happening in art then. Not beauty or loveliness so much, maybe.

Elizabeth Peyton
b Danbury, CT (USA)
Peyton refers to her works as 'History Paintings'. When one compares the large, heroic canvases conjured by this term with Peyton's tiny, thinly painted portraits of pop-stars and footballers, this may seem inappropriate, but she is encapsulating the preoccupations of her celebrity-obsessed age in exactly the same way. Her earlier works were indeed of historical figures such as Ludwig II, Napoleon and Marie Antoinette, but since then she has turned her attention to the heroes of 90s popular culture, using magazines and videos as source material. Each of her idols, whether Jarvis Cocker, Renaldo, David Hockney, or Sid Vicious, is etherealized into a pretty, pouting pin-up with a romantic, faraway expression. The way in which she feminizes her subjects into a single type, not dissimilar to her own elfin looks, may even hint at an element of self-portraiture, or may betray the identification of the fan with the star. The translucent, artificial colours and glazes and the small scale of these works transforms them into the religious icons of latter-day saints.

Within pop culture and youth culture Basquiat is considered to be incredibly soulful and the champagne isn't a problem. Even if it's the most expensive champagne money can buy. Which it was with him, along with the most expensive caviar, because he made so many hundreds of thousands of dollars from his enormous output of paintings. He used to carry huge fortunes in cash around with him, apparently, dropping hundred dollar bills in the laps of tramps.

But neither of these mythical Basquiats – shallow surfer of a brief wave of soulless fake art, or soulful model of artistic hipness – is talked about as a painter of supremely beautiful paintings, in the Matisse vein. But his paintings really are quite beautiful.

Colour with Basquiat is often just a matter of bits of rubbish stuck to a surface. Or welts or runs or splashes of paint – paint that might be iridescent or metallic or gold or silver acrylic. Or scrawled coloured lines – or black or white – done with a wax crayon or an oil-stick. Or simple crude gestural patches of colour laid on with a big brush roughly, like the painterly gestures of the 1950s Abstract Expressionist, Franz Kline.

But Basquiat is fizzy and elegant in every part of the painting and there is a dynamic relationship of every little part of the surface to every other little part. Everywhere there is an interest in painterly effects and in the bruised, tenderized colour-textures that are typical of Matisse.

Sampling

But aren't these just disaffected shallow quotings of already known effects? Post Modern samplings – samplings from Cy Twombly, Franz Kline, Robert Rauschenberg – not to mention Picasso and Matisse and all the other European painters that these American painters derived their styles from?

It's true Basquiat does sample. This is his mode because he is a product of the painting world of his time – a world that starts more with Jasper Johns or Andy Warhol than it does with Picasso or even with Jackson Pollock.

Jackson Pollock is somewhere toward the end of Modernism, Jasper Johns is somewhere at the beginning of Post-Modernism. Picasso and Matisse are the heart of Modernism. Post-Modernism doesn't have a heart, we think.

Jasper Johns enigma

Jasper Johns painted some beautiful, intense, melancholic surfaces in the 1950s, surfaces where everything was detached from everything else and there was no centre and no self and no meaning and only alienation. Only an enigma.

A flag. The alphabet. The numbers 0 through 9. A coat hanger. A target. A map. They were powerfully iconic compared to the vague, fuzzy abstract look of the Abstract Expressionist style that still dominated the art world when Johns first emerged. But they were iconic of nothingness, not going anywhere or saying anything. And that was what was excliting about them. Whether the colour was only grey or only red, yellow and blue. Or red, yellow and blue but with the names of wrong colours ironically stencilled over them: like GREEN stencilled over red. Or even sometimes the right one stencilled over: RED on red.

For about five years everything Johns painted seemed to have this cerebral, enigmatic, emotionless, cul-de-sac quality – an enigmatic, melancholic, deadpan, dead-end quality that was humorous in a supremely twisted way.

Johns was influential on the development of both Pop art and Conceptual art in the 1960s and even, partly, on Minimal art – the three big movements of the 60s from which all subsequent movements stem and which stand at the junction of Modernism and Post-Modernism. He was sensitive to the beauty and loveliness of Modern art but emotionally detached from it. Instead of faking a feeling of identification with it, he created a form that expressed his detachment. And it was a form that seemed to sum up and crystallize a whole state of mind. An exquisitely aesthetic surface like a system of communicating points – like electrical points – only with all the points short-circuited.

Jasper Johns
Flag on Orange Field 1957

Jasper Johns
b Allende, SC (USA), 1930
In 1955, not long after he had
moved to New York and begun
his collaboration with Robert
Rauschenberg, Johns dreamt that
he had made a painting of the
American flag. The resulting,
heavily textured canvas became
the first of many such works
focusing on mundane, emblematic
subjects such as targets, letters
and numbers, which avoided
representational concerns in order
to concentrate on the possibilities
of painting. In his interest in
forcing the viewer to look at
familiar objects in a different
way, which led to metal casts
of everyday items such as beer
cans and light-bulbs, Johns
created a bridge between Abstract
Expressionism and Pop art. One
of his major works, *False Start*
(1959), set up fake connections
between colours and the stencilled
labels incorrectly identifying
them. In 1961, he began a series
– similar to Rauschenberg's
'combine paintings' – in which
he attached collaged fragments
and found objects to the painted
surface. He now makes numerous
prints and is one of the most
collected living artists.

Live wires of Picasso and Matisse

Of course Picasso could never do that because he couldn't be Post-Modern. He couldn't be Post-himself. He could only express himself. That's why Picasso and Matisse are considered part of the past and not part of the present. They express themselves and their sensations. They express the world through their sensation of it. But we can't take that kind of thing for granted any more.

Even with them, we can't totally take it for granted that that's what they were doing because it's us thinking about them and we think in a different way to them. But we can certainly believe it a lot more with them than we can with us. In fact we have to believe it because it's one of the beliefs that defines us – that they were self-expressive and we are not. Or not in the same way. We are ironic. They were not.

Except when they were. Picasso was often ironic in a black-humorous or even sadistic way. And in his old age he was ironic in an amazing, mad, flowing, spattering, last gasp way, with the surfaces and forms of his last great paintings all looming and swimming almost in a Matisse-like way. But not in a torturous Conceptual art way, with wrong colour labels.

Because whatever age they were at, or whatever period they were in, or however much irony might occasionally play a role in their art, Picasso and Matisse could

only express themselves. They couldn't express a fear that there wasn't any self. Or that expressing anything at all might be an impossibility.

Virtually unalienated

On the other hand, Basquiat, who stands for a peculiarly Post-Modern type of beauty, wasn't alienated like Johns. In fact he doesn't seem to have been alienated at all. At least, not in that way. He might have felt alienated from some parts of society but who doesn't? And we don't know if he really felt this all that much more intensely than anyone else. We just assume it because he was black and he died young in tragic circumstances.

Samo

Basquiat was born in 1960, six years after Matisse's death and thirteen years before Picasso's. His father came from Haiti and his mother was born in Brooklyn of Puerto Rican parents. He was brought up in Brooklyn, speaking Spanish but watching American TV and reading English-language comics and being taken to art museums occasionally by his mother. His parents split up when he was seven. He spent two years in Puerto Rico in his early teens and then returned to Brooklyn and went to high school there. Then when he was sixteen he went to a progressive school in Manhattan. He didn't go to art school afterwards, but entered the New York

Jean-Michel Basquiat
New Nile 1985

art world via the clubs and music scene, which in the late 70s was integrated with the art world.

While still a student, living on his own with no money, he was a graffiti artist and he was in a band. The band was called Gray, after *Gray's Anatomy* which he studied as a child while recovering from a road accident. The musicians were all untrained. The music was improvised over pre-recorded tapes and influenced by the club music of the time -- No Wave, White Noise, hip-hop, funk and post-punk rock. Which already sounds quite nice just as a list.

Basquiat's graffiti art was done mostly on the walls of the art districts in New York and not so much in the subways – as is often erroneously assumed because that's where graffiti artists are expected to operate. He was consciously trying to get into the art system from the position of an outsider, but with the outsider-persona exaggerated or theatricalized. He famously signed his graffiti Samo, meaning 'Same Old Shit.' But then he killed himself off as a graffiti artist and sprayed 'Samo Is Dead' on the walls instead.

Black star

He was taken up by various galleries one after the other. He became successful very quickly. He was the first black art star. His post-graffiti paintings were usually dense with marks and words and sign-like images. They had a deliberately rough look and were done on various surfaces, including canvas. But often with the cloth roughly stretched, or stretched on eccentric supports that he had specially made for him. But they might also be on doors or other old bits of wood. His method was improvisatory, letting imagery build up in a stream of consciousness flow.

The results emphasized touch, surface, texture as much as signs or imagery. In fact an image with him might be only a sign. A single word, like MILK, drawn in black. Or a copyright symbol and the sign for a crown. Or it might be a crowded image full of different things. A diagram of the chemical composition of light fuel perhaps. Or negro bone structure. Or schematized figures from a Leonardo da Vinci book. Or lists of names – for example, jazz musicians or black sports stars. Or the faces of black men done in a primitive stylized way, grinning or grimacing, with rows of square teeth.

The pictures were frequently dense with wide-ranging references and learning. The references were as much to white culture as to black, to high culture as much as street culture. Because he wasn't working class he probably didn't particularly identify with the black sports stars whose pictures he painted or whose names he listed. They were just part of anyone's culture. He painted pictures of famous black stars like Jimi Hendrix or Charlie Parker but in interviews he said he it was more because he was interested in being famous than in being part of black culture.

But the wonky, irregular, off-square rectangles he tended to paint on and the flowing, rhythmic, visual structures he came up with meant that nothing on its own

Jean-Michel Basquiat
b New York (USA), 1960;
d New York (USA), 1988
Catapulting from New York graffiti artist to fabulously successful art-world star almost overnight, only to die tragically from a drug overdose at the age of 28, Jean-Michel Basquiat has taken on mythical status. Never losing the raw, playful immediacy of graffiti, his work explored notions of the 'primitive', challenging stereotypical views of the black artist. Negroes wearing crowns, athletes, musicians and revolutionaries populate his works, along with animals, consumer goods, cryptograms and texts. Using a wide variety of media including crayons, ink, paintstick and oils, he dripped, daubed, scribbled, doodled and sketched over furniture walls and canvases. But despite their naive, informal appearance, these quintessentially Post-Modernist works are complex, finely balanced compositions, full of witty references and puns – a kind of visual hip-hop. Whether one sees him as glamorous artist-hero, or tragic victim of the white art world who presented him as an 'urban noble savage', Basquiat's unique explorations of identity and spirituality continue to inspire new generations of artists.

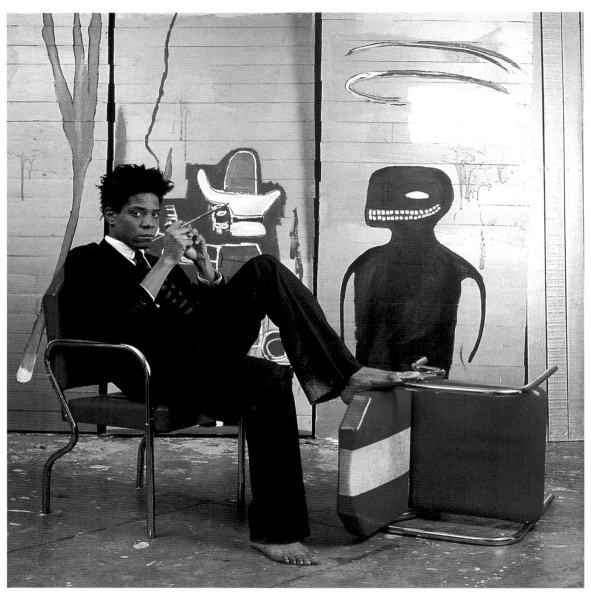

Jean-Michel Basquiat in his studio
in New York 1985

seemed to be the picture. The focus was everywhere. The surface of the canvas or
paper or piece of wood or fridge door was as sensitized as anything done on top
of it, and as much a part of the impression. It was a stylish look, full of hip references

and wittily jangled-up sign systems. But it was also unmistakably a *belle peinture* look, with painterly *cuisine* written all over it.

Basquiat started making a lot of money straight away with his first one-man show in 1981 and he lived an expensive, restaurant-infested, notoriously sybaritic lifestyle, before dying tragically from an overdose of heroin in 1988 at the age of 28.

Untortured

Basquiat was at the centre of New York art culture in the 80s. But he clearly wasn't alienated from his own creativity and self-expression. He just had an expanded sense of what a self might be and he naturally expressed it.

So, although an American like Johns, he seems to belong just as much to the heroic painting world of Picasso and Matisse as he does to our own Post-Johns, or Post-Warhol, ironic or alienated world. But because his touch is so nuanced he is more like Matisse than Picasso (who was the one he admired).

On the other hand, in formal terms, his art is almost purely an art of touch. The touch is so eloquent that it is easy to forget that painterly touch could be put to a grander formal purpose, which it was with Matisse. So it would be an exaggeration to say he really is like Matisse. But it would be an odd idea anyway to insist that he should be because Matisse's type of grandness was only possible at a time when painting was important.

The good life

But in the end Basquiat belongs in a museum of sensuous, beautiful, painterly High Modernist art and not merely to a myth of doomed youth. In fact he probably doesn't even really belong to a myth of the tortured artist. Since although it was short his life seems to have been a pleasure-filled one.

Outside in

Some of Basquiat's paintings have symbols of globes. Some have references to African art. It would be nice and circular to think of the story of Modern painting starting with a movement around the globe westwards from Africa to Europe; from primitive outsider art to sophisticated insider art. With African masks first shown to Picasso by Matisse in 1906, in Matisse's studio in Paris. And then African art used by both of them in different ways to revivify traditional Western forms which had grown tired. And then Modern painting gearing up in a tremendous wave of new totem-like green-striped faces and symphonically blasting red studios and transcendental patterned nudes and open windows with trailing pot plants, all made possible initially by the injection of primitivism. And then Modern painting running its course and winding down and coming to an end. But then being revivified again in the 80s by Basquiat, coming in the opposite direction, from the outside in.

But that wouldn't work because however beautiful Basquiat's painting is, it's still only painting and painting isn't the centre of art any more. Also, Basquiat wasn't a primitive outsider but part of the modern, multicultural melting-pot.

Jean-Michel Basquiat
Untitled 1984

Chris Ofili
in his studio 1998

Captain Shit

In a studio in London King's Cross at the end of the century Chris Ofili glues small circular cut-out photocopies of Op art patterns from the 60s onto a big canvas, using a can of Spray-Mount. Music plays. The room is crowded with pictures in various states. Lots of little watercolours are stuck on the wall. There are shelves and boxes of junk. Take-away food containers sit around with their tin-foil covers stacked up beside them. One covered container is labelled *Dick Pink* in felt pen. Another one has cut-out body parts from porn magazines in it. Lumps of elephant dung from the Zoo stand on the floor nearby. Soon they will stand under the painting he is doing right now and support it because that's how he shows his paintings, standing on dung instead of hanging on the wall. A blow-up black sex doll

Chris Ofili *Afrodizzia (2nd version)* 1996

with blond hair lies squashed on a shelf. Perhaps it was the model for one of his paintings – *Foxy Roxy*, where the figure is black but partly pink, with yellow hair. That would make him like Oskar Kokoshka, then, the Austrian Expressionist, who used a specially-made life-size doll as the model for one of his frenzied paintings, called *Murder Hope of Women*.

'Beauty will be convulsive,' André Breton, the Surrealist leader, wrote in the 1920s, 'or it will not be at all.' With Ofili, apparently, the idea is that beauty will not be at all if it's going to be all high and mighty and up its own arse. But it will be, if it's going to be amazingly intricate and decorative and partly out of the arse of an elephant.

Dung. Why does he use it?

'I made a decision to make these paintings that were really ornate and full-on about attractiveness,' he says. 'I wanted to include something in the paintings that would criticize that – to challenge that.'

He works fast on lots of different things at once, so that although his paintings are built up slowly, with many different layers, they never clog up. He glues stuff on one painting and then paints in dots on another one and then does some water-colours and then some drawings and then some two-inch high oil paintings of tiny black faces. They might have six eyes or the normal amount.

In all his paintings he combines a lot of different looks. Low high-street looks combined with high-art looks from all different periods. The look of *Shaft* combined with the look of Aubrey Beardsley. The look of Japanese gods on ancient chinaware or in woodcuts, with their bulgy eyes and flowing robes and fatness. The general look of free, painterly abstract gestures and blobs and lovely patterns. The look of doilies and wallpaper and spangly stuff and glitter and the look of Smarties. And the look of ancient cave paintings in Africa and body-scarring.

Is it identity politics that drives him? It would be exhausting now to remember what they are and write it all down. You must not accept the stereotype selves that are offered to you but, er, expose them as stereotypes. Plus the same with gender. But we are all driven by this stuff now and we don't have to look at a lot of art to get it any more. Now there's a new agenda – all the multiple possible selves that are now available, all gearing up to make as yet unimaginable new hybrids. Selves which are imagined or allegorized or prophesized in Ofili's painting, *The Adoration of Captain Shit and the Legend of the Black Stars*, perhaps.

He was born in 1968 in Manchester. His parents came from Nigeria. He went to church and was an altar-boy. He went to the Royal College of Art at the end of the 80s and studied painting there. His teachers were abstract painters who'd been successful in the 70s with a type of painting that imitated New York abstract art of the 50s and 60s. In 1992 he went to Zimbabwe on a scholarship and saw ancient Matopos dot paintings on cave walls and the body scarring of the Nuba tribe. When he came back he brought some elephant dung in his suitcase. He laid it out on a

Chris Ofili
b Manchester (England), 1968
Ofili's elaborate, decorative canvases layer up materials, imagery and meanings to build a complex picture of race and related issues. Born in Manchester of Nigerian parents, Ofili injects the subject of black identity with freshness and humour. Negro stereotypes, such as the pimp-like superhero in his series featuring 'Captain Shit', or an African goddess (*The Holy Virgin Mary*, 1996) are ironically presented under a palimpsest of transparent resins, sequins, tiny faces cut from magazines, and blobs of bright lacquer. Many of these works incorporate roundels of elephant dung, varnished and decorated with map pins, either supporting his large canvases like feet, or decorating its surface. In 1993, he adorned a lump of it with dreadlocks in a wry self portrait (*Shithead*). The use of elephant dung not only creates an earthy foil for the *cloisonné* beauty of his paintings, but also deftly questions the exoticizing of African culture in Western art.

cloth in street markets, first in Berlin and then in London. It wasn't to see if it would sell but to see what it would be like. It was the beginning of his career. Next he placed an ad in an art magazine that just read *Elephant Shit*. Then he was away.

The look of Ofili's paintings is always beautiful. Beauty with him is a matter of shimmering watery transparency, layered imagery, and an illusion of luminous depths. But also the beauty of some of the phrases and words of his titles, which have the ring of Victorian bible-reading about them. Even if it's a ring of blasphemy. Not just *Captain Shit* but *The Adoration of Captain Shit* or *Seven Bitches Tossing their Pussies before the Divine Dung* or *The Chosen One*.

Every interview he gives is different, and a bit like the way he moves around from painting to painting. He goes off on sound-association trips. *Captain Shit* might be explained as 'a king or King Kong or King Dong.'

When I ask him if he thinks the tension of ugliness and beauty in his art is like the same tension in Picasso and Matisse, he says he never thought about ugliness in Matisse. He always found Matisse to be about luxury. And lounging. Paintings in lounges and people lounging.

Chris Ofili
The Holy Virgin Mary 1996

Heron and Matisse

Until his death in 1999, the abstract painter Patrick Heron was a last surviving link with the world of Matisse. He once tried to wish Matisse a happy birthday in 1947, at La Rêve, but was turned away at the door by Matisse's assistant, Lydia Delectorskya, because Matisse was too tired to see anyone.

In the 80s and 90s Heron spent his days painting and thinking about Matisse. He looked at pictures by him all the time in art books and always found the master's organizational powers unpredictably marvellous. He thought, 'God I've never seen that before! The unfailing novelty! Totally twentieth century!'

'Matisse just goes on spurting inventiveness,' Heron was saying to me a few months before he died as we sat in his front room. 'He launches into crudities and achieves incredible harmony.' He said he would go half way round the world to see a Matisse that hadn't been exhibited before, even though he couldn't travel much because of bad lungs.

Spiritual beauty

At the time Patrick Heron tried to visit him, Matisse had duodenal cancer which was first diagnosed during the War. It was now ravaging his body and his intestines were so far gone he had to be drained each day by a nurse. Until he died in 1954 he was confined to a wheelchair. His last cut-outs — large paintings of dancing bodies, plants, flowers and waves, made from torn and cut pieces of paper painted over with gouache — were all made from this chair.

One of his nurses during the War became a nun later and in 1948 she came back to him to convince him to decorate a new chapel that had just been built near Vence. This is now known as the Matisse chapel.

Matisse said he wanted to make the chapel, which is quite small, seem to have the dimensions of infinity, purely through relationships of colour. If you don't believe in infinity, though, or in Jesus, or even in Matisse, that's a lot of work for colour to do. But it would be sad if you didn't believe in any of those things.

The light floods in through stained glass windows with desert flower motifs — symbolizing hope — onto linear paintings done in black oil paint on white tiles.

The black and white is striking against the luminous greens and blues of the windows. And as the sun moves during the course of each day, the pattern of light changes over the white tiles.

The paintings are of a Dominican monk, a nativity and the Thirteen Stations of the Cross. In themselves the paintings are not particularly visually pleasing, although the handling is very exciting. It is direct, primal, coarse — as if you could imagine holding one of these tiles in your hand and painting it yourself with a scrawling fast daub.

Picasso said it was absurd and hypocritical of Matisse, who was not religious, to decorate a chapel. The usual view, though, is that Matisse's art is quite spiritual and so it makes sense to have some of it in a chapel.

Patrick Heron
b Leeds (England), 1920;
d St Ives (England), 1999
Heron's principal concern was a passion for colour. Heavily influenced by Matisse, Bonnard and Rothko, he experimented extensively in his paintings with juxtapositions of colour and the resulting spatial effects. During the Second World War, as a conscientious objector, he went to St Ives in Cornwall, where he became assistant to the potter Bernard Leach. Later, he was an associate of Barbara Hepworth and Ben Nicholson, and in keeping with the aesthetic of St Ives, his forms were initially inspired by nature. Later, however, he totally rejected any notion of representation or anthropomorphism, seeking a pure abstraction in which large, simple shapes or stripes of strong colour hover on plain, contrasting backgrounds. The resulting relationship between image and ground creates a shifting, ambiguous sense of space. Heron also worked as an art critic, writing many texts based on his colour theories, designed textiles and taught at the Central School of Art in London.

The Chapel of the Rosary at Vence
1949–50

Henry Matisse at work on a preliminary
drawing for the Nativity in the chapel 1949

Patrick Heron in studio 1997

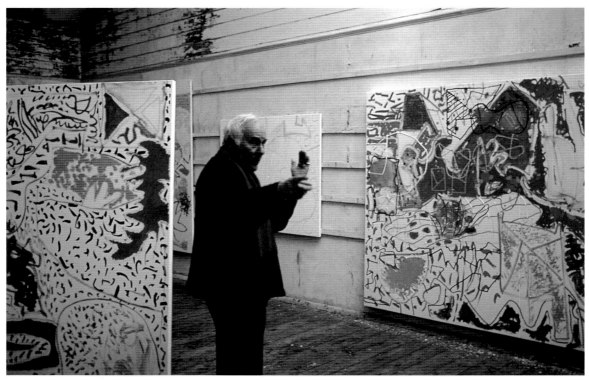

Patrick Heron in his studio

The centre of the universe

Chris Ofili's urban style. Patrick Heron's rural style. Heron was 79 in 1998, the year Chris Ofili turned 30 and won the Turner Prize. At that time both were sensitive consumers of the visual world. They were both painting beautiful paintings that could easily be thought of as being about pure visual pleasure. But pure visual pleasure isn't like lovely cakes. Nothing is purely beautiful or purely visual or purely pleasurable, probably.

Heron played the violin at school. Ofili plays all sorts of chopped-up rhythmic hip-hop sounds in his studio. His paintings are filled with the same thing in a visual version. Heron's are filled with the shapes and rhythms of the place where he lived, which was Cornwall, in a house on a cliff near Penzance, with a view onto the sea, 600 feet below. The fields between the house and the sea are laid out in patterns that go back 40,000 years to the bronze age. The grey granite boulders around his house were pushed up by volcanoes a million years ago. The shapes of the rocks are echoed in the shapes of the trees in his garden, which he had been personally clipping for 25 years. Everything echoes everything else and it all goes back a long time.

Patrick Heron *Red Garden*
Painting: June 3 – June 5 1985

'What is it that grabs one and gets one's juices flowing?' Heron asked me.

He answered his own question: 'It must be beauty. So beauty,' he went on, 'although a meaningless word, is nevertheless perhaps a word that evokes all kinds of intensely felt and experienced relationships.'

Heron's paintings of the last twenty years have all been open and free with a lot of white showing through nervous calligraphic scribbles of colour. The landscape he lived in is the subject but the form is abstract. The landscape is a submerged influence, a matter of rhythmic flows. Wherever he looked every day, there were typical, irregular, essentially organic shapes. The shapes of the fields, the hills, of small stones. He found them very powerful.

'I find it enjoyable and pleasurable to talk about colour/shape interactions and the idea that the pleasure and enjoyment of art might be entirely a matter of those interactions.'

But I know a lot of people don't like that kind of talk and I can't really blame them. 'This whole discussion of form and shape,' I said to him as we went into his studio, 'people don't like it.'

The studio used to belong to Ben Nicholson. All around us on the day I was visiting were Heron's paintings. Some were finished in half an hour. Some he kept

going back to and they took nine years. They were all nervousness and no tailoring or flair. They seemed to want to be crude rather than handsome. So it would be odd to talk about them as elegant or composed-seeming. And yet they were as solidly rhythmic and composed as a Byzantine mosaic.

'People don't like it,' I was saying. 'They think you're bossing them around and telling them to pull their socks up and think about form and colour and they don't want it.' 'Really?' he responded, as if someone had said they liked mixing sugar with caviar.

'The subject matter of a painting is the least important thing,' he said. 'You apprehend it immediately but it's the last thing you want to dwell on. And you can't look at anything without moving your eye. Try it! The eye goes from this point to that point to that point. And the stuff of that is rhythm. A robin springs from branch to branch but each move has a perfect starting point and a perfect ending point. It's exactly the same with painting.'

I congratulated him on a good and appropriate metaphor for the visual mechanics of his paintings and he agreed that it was indeed a good one. 'How about some champagne?' he said. 'I think it's worth it – don't you?'

But it wasn't Ruinart, because the last thing he wanted to do was ruin that stuff. He found it the centre of consciousness, the centre of the universe. Especially the art of Matisse, who he considered to be his master and guide. But not Alex Katz who he found baffling: 'God Almighty! I mean, anyone who wanted to earn a living doing illustrations for *Vogue* or something could do better than that!'

But that's loveliness for you. It's pretty subjective.

CHAPTER FOUR

NOTHING MATTERS

Martin Creed
Work Number 200,
Half the Air in a Given Space 1998

Lights out

Standing on the pavement in Old Street, London, the other evening, I looked up at the first floor of a building across the road and watched the lights in there going on and off. It was a new artwork by the artist Martin Creed, who is in his early 30s. The artwork was in a new space that had just opened. This was its first event. It was only on for one evening. And you only had to look at it for a few seconds. All Creed's works have plain descriptive titles preceded by a number. A work in the early 1994 is a piece of paper screwed up into a ball, called *A Sheet of A4 paper crumpled into a ball.* A more recent work is the sound of a doorbell amplified through a guitar amp in a gallery. The sound can be heard inside every

time someone rings the bell outside. The event lasts as long as the sound lasts. When it's not heard there's no event.

Maybe the screwed-up ball of paper is always a sculpture, or always art. Or it goes back to being only paper again when no one is looking at it or if they're looking at it but not realizing it's art. If all this wasn't happening within an art context it would be happening in a vacuum, which might mean it wasn't happening at all. It would still be the lights turning on and off but not *The lights turning on and off*.

That was the title of the work I was looking at. They didn't turn on and off slowly because if they did it might be missed that they were going on and off. But it wasn't fast either because then it might just be a flickery strobe effect and that would be *The lights strobing* not *The lights turning on and off*.

After a few seconds I went to the private view of the event, which was in a nearby pub. It was full of people from the London art world, drinking and standing around, occasionally mentioning the event. And that was all that was needed to make art happen – virtually nothing. In fact Creed never uses the words art or artist, so even that wasn't needed. It was a crescendo of nothing.

Pale

It seems outrageous to many people that there are so many blanks in Modern art. So many blank canvases, so many white squares, so many black ones, so many paintings of nothing. One artist in the history of art making a white square is not so annoying for many people. They draw the line, though, at more than one doing it. Repetition in art is bad enough, they think. Artists should be original and always think up new things. But repeating nothingness is considered beyond the pale.

Martin Creed
b Wakefield, Yorkshire (England), 1968
Using the language of Minimalism, Fluxus and Conceptualism, Creed creates subtle interventions into social or art situations. These range from a screwed-up ball of paper, mailed to members of the art world, to a musical composition in which a single note is played once. Pieces like *Work No. 102 (a protrusion from a wall)*, 1994, or *Work No, 127 (the lights going on an off)*, 1995, speak for themselves. 'Nothing' – the CD released by Creed's art band, Owada – hammers home the reductive message. Apparently more affirmative was *Work No. 203*, 1999, in which the statement *Everything is Going to be Alright* was emblazoned in neon across the colonnaded façade of a classical Greek-style building in East London; a CD with equally cheerful-sounding titles such as 'I Like Things' and 'Nothing is Something' completed the work. But there was something sinister about these pale letters, hovering on the surface of the unoccupied, incongruously elegant building, like a message from the alien administration of a sedated, gullible society.

Martin Creed
Work no 88, A sheet of A4 paper crumpled up into a ball 1994

Martin Creed *Work no 127,*
The lights going on and off 1995

Nothingness as a principle first emerged in Modern art at the time when pure abstraction emerged, which was in the years immediately after 1910, in particular in the work of the Russian artist, Kasimir Malevich. Since then, absence has been a constant presence in Modern art and we have seen a steady stream of radical blanks, nothings and voids. They won't go away and they used to be one of the main reasons for Modern art being unpopular.

Of course, there is no reason why Modern art should be popular. Enough other things are. Why not give popularity a rest now and then?

Fear of nothing

But certainly in ordinary life popularity and nothingness are old enemies. We even have a term for our horror of nothingness: *horror vacui* – horror of the void. Many Modern artists demonstrate their *horror vacui*. These tend to be the more popular ones – Picasso, for example. He is always obsessively filling up the canvas with stuff.

But recently it has become evident that Modern art generally is not that unpopular any more because it is more connected to ordinary life now. And even its most radically blank manifestations are probably not all that unpopular either.

Minimalism in the 60s

One art movement known to be extremely tolerant of empty spaces and blankness is Minimalism. Within the Minimalist mind-set these emptinesses were probably not all that empty or blank. But when Minimalism came out in New York in the 60s it was extremely unpopular because of its apparent blankness. It was popular with artists but not with everyone else.

In fact Minimalism is not an art of nothingness. It was an art of very little made into a radical something. But at the time, people saw Carl Andre's metal plates on the floor, or Donald Judd's boxes, or Robert Ryman's all-white paintings, or Dan Flavin's single neon tubes, and they felt there wasn't really anything there.

To see something there instead of nothing much required a massive effort. And nobody wants that because they've got better things to do.

60s Minimalism now

Nowadays we don't feel all that horrified by Minimalism. It's not that a hidden friendliness within Minimalism suddenly emerged, like aliens shedding their frightening metallic or green skins and coming out as handsome Prince Charmings. When Minimalism became more popular in the 80s it wasn't Minimalist principles so much as the general Minimalist look that was popular. The popularity of Minimalist art today is largely a product of that 80s type of popularity. It isn't because the education departments of the big museums all heroically got the difficult meanings of 1960s Minimalism over to a wider public and made them understandable. Minimalism's difficulties were just suddenly ignored by this public and a new stylishness that Minimalism was thought to possess was enjoyed instead. And Minimalism was now about an essential pared-down simplicity with a *World of Interiors* spin.

And the museums weren't complaining. The old terms of the Minimalist discourse are still used in museum culture – the 'thing in itself'; the 'object'; the 'space' around 'the object'; the use of non-traditional materials; the relationship between the viewer and the object; the presence of the object; the theatricality of the object. But no one cares what the terms mean or once meant and they are just an empty litany. They can be employed any way round and no one will notice.

Christmas crackers

Art is still quite difficult. Artists are still artists and the culture outside art is still outside it; it hasn't moved in with abstractions and difficulty. It has just given art a different job – not to be so serious all the time. 'You're fired!' the ordinary world says to abstractions and difficulties in art. 'But you're on double overtime with big Christmas bonuses!' it says to all blandness in art.

Still odd

So Martin Creed's minimalistic processes and events and balls of paper, and so on, capitalize on the way Minimalism as a philosophy or a style or an art movement has become part of ordinary consciousness but is still quite an odd thing – taken for granted but not easily explainable. He is an example of the culture changing.

People at art school

In the 70s the newspapers said Minimalism was only rubbish and they deplored it. And it was natural they should do that because art had no business being beyond normal understanding. But people at art school in the 70s often thought Minimalism was fantastic. Carl Andre was absolutely fantastic, they thought. 'It's so simple!'

But it was a bit pretentious, too, of course, the students thought. And you had to do a bit of pseudo-spiritual wiffling to get it. You had to get from an absolutely glaring sense of outrageous nothingness to a sense of something. And it was a fine

Carl Andre
b Quincy, MA (USA), 1935
Andre's background as a worker on the Pennsylvania railway may have informed his preference for strong, industrial materials laid out in rows and grids. The influence of Russian Constructivism is also evident. In his Minimalist arrangements of identical elements such as bricks, planks, metal tiles, he never uses adhesives or joints, relying instead on the gravity of his materials to give the works their coherence and balance. Most often, they are displayed on the floor and can sometimes be walked on. His most controversial piece is *Equivalent VIII* (1966), a composition of builder's bricks, whose reductiveness and simplicity provoked accusations of squandered public money when it was bought by the Tate Gallery in 1976. In 1985 he was accused and acquitted of the murder of his wife, the artist Ana Mendieta, when she fell from a window.

Daily Mirror headline 1976

line between the Minimalist artists that made it and the ones that didn't.

But it may not have been only the main historical figures of Minimalism they were thinking of; they might have been mixing up Carl Andre or Donald Judd or someone, with just a kind of generalized Minimalism, because by now there were thousands of Minimalists and Minimalism was everywhere in art. And conversely it was probably this generality of Minimalism that was being deplored when Minimalism was being deplored.

But now all that has changed and today there is a broad acceptance of Minimalism by everyone so long as it isn't too hard. This is our broad idea of Minimalism now. We don't care that much if it's Donald Judd or someone else.

Alarm

Today there is a new thought about Minimalism shared by art students and by people who are broadly cultivated but not necessarily all that up on art.

'Maybe Minimalism wasn't all that difficult in the first place; the meanings of Minimalism were probably not all that complicated. We were intimidated when we needn't have been. Silly us!' It is a common error to believe this. In fact the meanings of Minimalism were really complicated and contradictory and there were lots of them, all swirling around, all alarming.

For one thing, the typical Minimalist look – an apparently absurdly simple, elementary form on the floor or on the wall in a big white square art gallery – had

Carl Andre *Equivalent VIII* 1966

Flavin, Dan
b New York (USA), 1933;
d New York (USA), 1996
Flavin had little formal training
as an artist, but became one
of the key exponents of
Minimalism in the 1960s with
his works using light-fittings.
In 1961, he received his first
one-man show of watercolours
and constructions, held in
New York. He described the
series of 'icons' that he began to
make in the same year as 'blank,
almost featureless square-fronted
constructions with obvious
electric lights'. *Diagonal of Personal
Ecstasy* (1963) consisted of a
single fluorescent light-tube,
which entirely dispensed with any
form of support or structure.
These simultaneously take light
as the ready-made medium and
the subject of the work. Simple
and elegant, they make subtle
interventions into the gallery,
dissolving and redefining walls,
corners and ceilings, and shifting
the entire focus of the space.
Flavin has also received many
public commissions, including
the lighting of several tracks at
New York's Grand Central

quite different implications depending on who had made it. A stainless steel open-topped box by Donald Judd, in 1966, meant something quite different to a plywood box painted grey, in 1963, by Robert Morris. And both of them were different to a row of bricks on the floor by Carl Andre, put there in 1967; or a neon light on the wall by Dan Flavin, with the switch turned on in 1963.

One shared idea was that the Minimalist object was about a mysterious interaction between the object and the space around it. This applied generally: the thing – the nothingness around it. This is already a bit different to just thinking everything was in the object itself. But there were variations even on this idea. And each variation had a lot of different ideas attached to it, or springing out of it. Here are some of the ideas, coming up now.

Possibly chi-chi
A neon tube by Dan Flavin was nothing in itself – or nothing more than a neon tube that anyone could buy in a shop. And it might easily be sent back to the shop at the end of the exhibition because at first he didn't sell much. No one took his tubes seriously enough to buy them. Later they were bought by museums and collectors and they cost a lot.

But when the tube was in the shop again it would sink back into the world of ordinary objects. When it was in a gallery and someone was looking at it, there would be a magical rising of its status as an object.

Flavin himself was quite humorous about this and he saw the funny side of Minimalism. He liked its effrontery in the way it dared to be close to interior decorating, when obviously interior decorating was a bit chi-chi and nothing – certainly nothing like Abstract Expressionism. Abstract Expressionism had to be moved on from, it was widely agreed. It was the Freudian father who had to be killed. But all

Dan Flavin
*The Diagonal of May 25, 1963
(to Constantin Brancusi)* 1963

its sons and daughters had something of the father within them. Actually there weren't any daughters.

But at the same time, like all the other Minimalists, Flavin was serious as well and his art was complex. It was complex because of everything that was involved – art's past, its present, everything that wasn't art, everything that might be art. Plus it had to look absolutely excellent.

So here there was an important issue about what art essentially was, whereas, with some other Minimalist art, the issue of whether the object was really art or not wasn't there. It might be assumed to be there as the conceptual gag or identity tag of the artist, but it wasn't really. Or at least, that issue wasn't the issue the artist was most thinking of.

No doubt

With this other type of Minimalist art, where there isn't a doubt about what art essentially is – for example, when it's Donald Judd making the art – the Minimalist object is a right and true art object, really well made; like a Brancusi sculpture might be thought to be well made. Or even one by Michelangelo or Bernini or an African tribesman.

Judd rejected the term Minimalism and the term 'sculpture' as well. But nevertheless, a fantastically concentrated effort went into thinking up what the exact proportions of his boxes should be and how the surfaces should be finished and what the scale should be. With him, the box was not an unaesthetic but a super-aesthetic object. And even when the gallery lights were out it was still art.

Or if it wasn't, that would be because of some philosophical or perceptual problem he wasn't all that concerned with – 'It's art if an artist says it is,' he would shrug – not wryly or shrewdly or provocatively, like Marcel Duchamp, with Old-Worldly world-weariness, but straightforwardly, with New-Worldly matter-of-factness. Even though, paradoxically, Judd's type of Minimalist object was made by a factory and not by the artist.

He sent the plans to the factory and the factory made the object. But he personally checked the steel was polished correctly and it was three-eighths of an inch thick and not three-quarters, and soldered and not riveted, and so on. And if the object was painted, or industrially sprayed, by the factory, it wasn't just any old colour but one carefully chosen by Judd.

So industrial mass-production techniques were part of the process of art-making for him but his box wasn't a mass-produced object. It was a unique art object. Unless there were three of them, or ten, or whatever. But even then, that was just a number greater than one. Not an infinite number.

Judd very rarely exhibited single boxes but usually two or several together. To see one was to see it in relation to another one that was the same but different. Each one had something slightly different about it – a top plane or a side one

Donald Judd
b Excelsior Springs, MO (USA), 1928;
d Excelsior Springs (USA), 1994
A leading theorist and exponent of Minimalism, Judd began as an art critic and painter. In the 1960s, abandoning what he later called his 'half-baked abstractions', he began to make monochrome reliefs and large, wooden, box-like constructions, which he called 'specific objects'. Placed on the gallery floor or hanging from the walls like paintings, they made no emotive appeal, never aiming to be representational. Their only subject was the object itself. Although they were exquisitely crafted, Judd wished to eliminate all evidence of the artist's hand, forcing the viewer into an intense acknowledgement of the relationships between onlooker, object and space. In 1963, he had the sculptures industrially fabricated from stainless steel and Plexiglas. A decade later, when he was producing site-specific pieces and outdoor works, he escaped the New York art scene by moving to Texas, converting an old army base into studios and eventually taking over the town. In the 1980s, he designed furniture in a similar style to the sculptures.

Donald Judd *Untitled* 1972

might be sloping inward, for example; or it might be running flat a few inches below the top edge of the side planes, so there was an effect of a shallow tray.

All this certainly looked different to the old idea of sculpture but it only looked different because Judd wanted to advance sculpture, or advance art, and make it better. Not because he wanted to kill art and have something else instead.

There was no sense with Judd of a magic wand of Conceptualism, or a Duchampian poetic gesture, making an ordinary object of the everyday world turn suddenly into something unique or extraordinary, or into art or anti-art.

Judd's boxes were never anything but art. With him there was still a mysterious interaction between the object and the empty nothingness around it but the mystery wasn't so mysterious or outlandish and there wasn't such a leap as there was with Flavin's neon tube. With Flavin there was the extra mystery of what happened when the lights went out.

Maximum negative

Judd's mystery was just the mystery of any sculpture – the negative and positive space of the sculptural experience. Except with him negative space was massively foregrounded. It was almost positive negative space. All sculptures by Michelangelo and Bernini articulate the space around them because that is the nature of any three-dimensional object. But with them we don't care about all that. It would be boring or perverse or tediously academic or pedantic to discuss them in that way.

But with Minimalist boxes negative space was unavoidable. It was bouncing off the Minimalist box's metal planes like crazy – totally there at maximum energy and not just shyly hovering like a wallflower at a perceptual psychology party, knowing no one cared about it. Which is what negative space used to do in the past before Minimalism was thought of. Nothingness was never so maximalized as it was with Minimalism.

Flavin shining

Dan Flavin's tubes had the mystery of the maximally activated negative space too but a bit more mystery as well. They were tubes that stood somewhere between Judd's boxes and Marcel Duchamp's urinal because they had the extra mystery of industrial, mass-produced objects having been made into art merely by an act of placement.

But they were also unlike Duchamp in that a poetic gesture wasn't part of the process. What kind of gesture was it then? I don't know. It wasn't really a gesture at all. It was more sculptural art than poetic gestural art. It wasn't Conceptual art. It didn't lie on a shelf challenging you to think of it as art, with the artist standing around smiling wryly at you. It stood on the wall shining its neon light and perceptually changing the space around it and charging it with meaning. But it still wasn't quite sculpture. It doesn't sound like much, I know.

top: **Donald Judd** *Untitled* 1972

middle: **Giovanni Lorenzo Bernini** *The Abduction of Proserpina* 1622

bottom: Stool in form of a kneeling woman from Zaire. Late 19th century

No Wow

But the normal sculptural mystery of Judd wasn't entirely normal either: the sculpture was only a box, or several boxes, made of polished steel or brass or aluminium or wood; or sometimes a kind of metal with a really crazy sparkly finish to it, like the finish on a 50s car. But however interesting these surfaces might be, there was a radical reduction of form to simply a rectangle. A rectangle in three dimensions. You wouldn't be likely to say: 'Wow, I'm really getting a good sculptural experience, here.' It was some other kind of experience. A bit like architecture, maybe. But still definitely art.

No to OK

But the Judd interaction between object and space was not as mysterious as the interaction that was supposed to be going on with a different type of Minimal box art – one where the box was made of plywood painted grey. This was the Minimalism of Robert Morris, another of the main, first-wave New York Minimalists. With Morris's box art, the idea was that the box really was nothing in itself. Even though, in this case, it had been laboriously hand-made by Morris in a real studio, using saws and hammers and nails and sandpaper, and not by a factory.

The mysterious interaction in this case was between the box, the space and the mind of the viewer. With the mind maximally foregrounded. Obviously, the mind of the viewer is engaged in any art experience. Except when the art is sent back to the neon supplier and has sunk back into the world of ordinary objects – because then it's not art any more.

But with Morris the intellect was more engaged because the aesthetic of his type of Minimalism was an anti-aesthetic. The aesthetic heart of art had been surgically removed. Or there was an attempt to do that. Some other weird stuff was put there in its place. It was new anti-art, within the old Duchampian anti-art stream. An art of negativity and dissent. Anti-art but still art. In fact, more truly art than art-art, Morris thought, because art must always be a radical No and not a wimpy OK.

Art good

With the other type of Minimalism – the right and true, well-made Judd art – no one is saying the aesthetic experience is bad or wrong or old hat. They are just saying it can be in metal boxes as much as lovely paintings. Judd maintained in the 60s that the great tradition of European painting and sculpture had run its course and now it was time for something new; something that was neither painting nor sculpture but still art – in fact, great art. The best that can be done. On the same plane as art by Dürer, or Impressionism, or the pyramids.

Robert Morris
b Kansas City, MO (USA), 1931
Sculptor, painter, performance artist and writer, Morris was a leading exponent of Minimalism. He began his career in San Francisco as an Abstract Expressionist painter, also creating improvisatory performances such as a work of 1961 in which he rocked back and forth inside a plywood column until it fell over. In 1962, when he moved to New York, he took up sculpture, experimenting with site-specific pieces and earth-works that disrupted the idea of the autonomous Modernist object, removing art from the gallery. The sculptures of this period were hard-edged, geometric, non-illusionistic forms in the tradition of Constructivist sculpture. Later, he made a series of 'anti-form' works involving softly folded, hanging fabrics. These were more concerned with the process of manipulation of materials than with their constitution into an object, linking back to Action Painting's emphasis on process and leading to further experimental performances concerned with temporal duration. In 1983 he reverted to paintings – this time figurative and often political. More recently, he has produced fossil-like reliefs containing body and machine parts.

Robert Morris *Two Columns* 1961

Very specific

But both these opposite types of Minimalist box forms – Judd and Morris types – align or come together or share common ground over certain issues. And the same ground is shared with shop-bought – or temporarily borrowed – neon tube-type art. The main shared ground is that they all agree the reason to have boxes or tubes at all is that these are very specific forms with all the matter-of-fact object-ness of non-art things. And somehow specific forms are better than complex forms because they are more modern.

Not that complexity is bad. Complexity is good. In fact it is an inevitable fact of life. But in New York in 1965 simple forms were felt to have more potential for radical artistic complexity than complex ones.

No to the extraneous

The objects of Carl Andre are just bricks or metal plates laid on the floor. The basic idea about space in Andre's case is that the space musn't be complicated but it is physical matter and the properties of matter that his sculptures are primarily about, not so much the mystery of the negative space being electrified. In fact he is one of the few Minimalists who doesn't object to the label of Minimalism because he likes its association of a radical purge. Everything extraneous purged, everything pertinent still there. 'Art is a very high form of pleasure,' he says. And he believes that for an audience to have to make an effort to get it is only right, as it is not entertainment.

Carl Andre *Equivalent I-VII* 1966

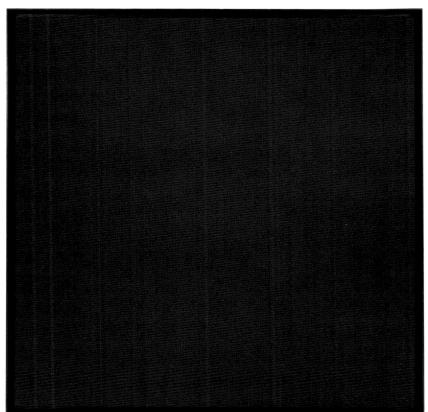

Ad Reinhardt
Abstract Painting 1960

Ad Reinhardt

Ad Reinhardt painted all-black squares which were always five feet across. They had a faint cross formation within the black; so that, when viewed very close to, the painting could be seen to be composed of nine faint black squares. The cross was not religious but was merely a formation. Reinhardt was part of the Abstract Expressionist generation rather than the Minimalist generation which succeeded Abstract Expressionism but he was against all the tenets of Abstract Expressionism. He wrote long lists of everything that art was not. For example, he said it wasn't about surface or gesture or shape or colour and it wasn't about self-expression. He published a long list of elaborations on Nos, many of them satirical. Among them he included 'No illusions, no representations, no associations, no distortions, no paint-caricaturing, no dream pictures or drippings.' Nobody can understand his paintings and they are not popular yet.

An exhibition of Ad Reinhardt's black paintings in New York 1966

Ad Reinhardt
b Buffalo, NY (USA), 1913;
d New York, NY (USA), 1967
Reinhardt strove for an art 'without illusion, allusion, delusion', believing that 'Art is art. Everything else is everything else' – that it is impossible to represent an object on canvas. Neither satisfied by geometric abstraction, nor by notions of beauty, he eventually made his final statement in the 'Black Paintings', a series of monochromes executed in minutely nuanced shades of black. In the 1930s he had produced solid, geometric abstracts influenced by Cubism and the work of Mondrian, moving in the 1940s from all-over paintings to Abstract Expressionist works similar to those of Robert Motherwell, with whom he edited the book *Modern Artists in America* (1950). The monochromes emerged in the 1950s, initially executed in blue or red. In the black works of the late 1950s, ghostly rectangles and squares were just visible through the pigment. His uncompromising views on the trends of modern art were expressed in his polemical writings and lectures, and in his series of satirical cartoons for the avant-garde newspaper *PM*. His work created an important link from the Abstract Expressionist works of Rothko and Newman to American Minimalism.

Everyone else's meanings and identities

After Minimalism had been around for a short while, it started to become clear that there was a problem with it which the Minimal artists hadn't thought of. Which was that it was a movement of male power. Male power was bad and so was High Modernism because they were fantastically exclusive. Exclusiveness was wrong and bad. Minimalism was the high point of High Modernism.

The thing that was excluded from both, it was felt, towards the end of the 60s and into the 70s, was everyone who wasn't a male Minimalist. Suddenly Minimalism became a thing for everyone else to identify themselves in opposition to.

For this reason Minimalism was incredibly important once again, but for a negative reason. So that's another important negativity that Minimalism stands for. It triggered a massive rise of forms expressing alterity. This was Post-Minimalism. Floppy forms or forms that were on film rather than on the floor or the wall; or performed forms; or forms that were not forms at all but only ideas, or written-down words; or just gases or condensation or steam. These new forms were only possible because of the reductionism that Minimalism ushered in, but they were forms that were against reductionism.

They were connected to a new consciousness of the possibility of art after Modernism – an art that was inclusive rather than exclusive. An art that could be an expression of everybody, not just white males, although white males could be expressed too.

At first it was right to talk of black art or women's art or gay art. Then there was a gradual socialization of art and the idea emerged that, however reduced or abstract or strange art was, it had a social aspect and a social meaning, or meanings; not just an art meaning. So with this new idea or attitude, art became more an expression of the swirling mass of different identities that the world is actually made up of. So it didn't make sense to hold onto these reductive labels indicating social groups or types.

Update on Judd, Andre, Flavin, Morris

Judd died in 1994, after establishing a fabulous empire of Minimalism out in the desert in Texas. He bought up a small town near the Mexican border and filled all the largest buildings with his own Minimalist art and the art of the other Minimalists he admired. Many pilgrims go there to see Minimalism at its most amazing.

Dan Flavin died two years after Judd. Carl Andre is still alive. And so is Robert Morris. Andre's work is like it always was. Morris's is too, but that's because it was always changing. So it is quite different now to how it was in 1966. It was only Minimalist for a short while. At first it seemed the same as Judd's – partly because it was mostly seen in reproduction in magazines, and one square in a small grainy black and white photo looks much the same as another. But also, it was only after a while that Morris and Judd found they were radically different artists. Judd liked Andre and Flavin but not Morris. He thought he just changed his style all the time to fit what was happening in the art world. Judd was a stern artist who did not tolerate much bending of what he felt were the rules.

White square

Robert Ryman really does paint all-white paintings that are always square. This is a mythical hate object for middle-brow cultured people. But with Ryman, who first started painting all-white squares in the late 50s and is still going today, the white square is not about mere repetition of whiteness or mere sameness. In fact it is about difference. The paintings are all about light and surface and making a million different types of white by refracting light off of different types of white. The white is different because it is put on in different ways. Squareness stays the same in order to draw attention to where the important differences are – which is the whiteness. Ruffled whiteness, flat whiteness, thin whiteness, transparent whiteness, encrusted whiteness – warm, cool, flowing, stumbling, agitated, and so on.

This might seem like there is no meaning but it is really just a different idea of meaning to one where there is a something happening somewhere else and the painting is referring to it. In Ryman's case it is all happening on the painting. Everything that a normal painting might have – a date, a signature, a shape, a surface, some paint, some white – these things are the only things Ryman's paintings have. So they all have a lot to do. Rather than just doing nothing. Which is the wrong idea that people often have about him. If they are thinking about him at all rather than an imaginary annoying artist who paints white canvases.

Back to Ad

Ad Reinhardt's black squares have a certain mysticism about them because Eastern philosophies were in the air when Reinhardt was alive and it was part of 50s and 60s art culture to feel at home with Zen. Reinhardt in fact taught Eastern art at art schools and he knew a lot about it. But this mysticism is only a vague idea that people have about his black paintings. It wasn't Reinhardt's idea – his idea was that

Robert Ryman
b Nashville, TN (USA), 1930
It is not what to paint that interests Ryman, but how to go about it. He began his career as a jazz musician in New York, but took up painting while working as an invigilator at MOMA. Soon, he was making the predominantly white paintings, often with brightly coloured underpainting, or elements of black, that would define his style. He used a variety of different paints, supports and scales, but stuck to the square format to avoid the idea of a window or door, and for symmetry and balance, though sometimes surfaces are curved, or the work displayed like a shelf. By 1966, with the emergence of Minimalism, Ryman had found a context in which to show his work, although his concern with the intuitive working of paint set him apart from these artists. Believing that 'representation is illusion' and that his works were 'real' things in themselves, he felt that they needed no frame, but should interact with the gallery space as objects. Works on paper are glued, stapled or bolted directly to walls, the bolt heads activating the surface.

Robert Ryman *Term 2* 1996

art was art and there wasn't any reason to read anything else into it. This particular reading – an optional one, we might say – is not like the amazing certainties of Minimalism, which started up just at the point when Reinhardt died.

In charge

Who is in charge of meaning? It is a consensus. The artists, the writers, the audience – they all play a part. In the 60s there was a consensus that Minimalist art had certain meanings. Therefore it really did have those meanings. To think about the art in a different way would be to get it wrong. However, it is not against the rules of art for someone to do this. If they are not artists it will just mean they have missed the point. But if they are artists they might get the art wrong in a creative way, which might mean they would make some new art based on a misunderstanding, but the misunderstanding would give rise to a new idea that worked.

This isn't what happened with Post-Minimalism though. The Post-Minimalists got Minimalism right and they positively wanted to develop it in a different way.

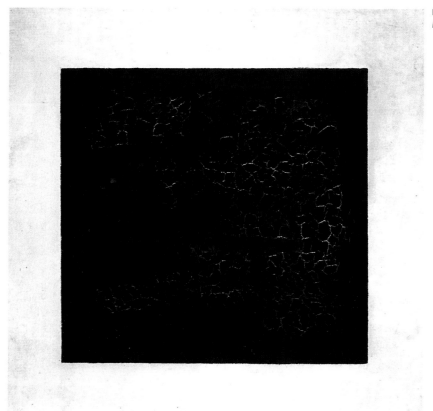

Kasimir Malevich
Black Square 1913

Black square

The other Modern artist known for painting a black square is Kasimir Malevich. Malevich, who died in 1935, is not particularly popular now but in Russia both before and after the Revolution he was well known and widely revered. He stood for the principle of Non-Objectivity.

Non-Objectivity means not painting pictures of the objects of the world but painting abstractions that symbolize dynamic energy and cosmic order. His painting *Black Square* was first exhibited in Moscow in 1915. It is not known when it was actually painted. Probably some time in 1913. It was during this year that Malevich began painting purely abstract shapes using only primary colours and black and white.

It is just an oddity for many people now, even for lovers of Minimalism. A plain black square within a white border, not particularly large. There are several versions. The first one still exists and is kept in a museum in Moscow. The black is a riot of

Kasimir Malevich
b Kiev (Ukraine), 1878;
d St Petersburg (Russia), 1935
'The painting of pure form' and
the 'supremacy of pure feeling'
was how Malevich described
Suprematism, the movement he
founded in 1915. This tendency
was characterized by its total
non-objectivity and the reduction
of subject matter to pure,
simplified, geometric elements.
The idea achieved its ultimate
expression in *Black Square* (1915),
and *Suprematist Composition: White
on White* (1918), in which the
monochrome image was painted
on a background of the same
colour, becoming the emblem of
Suprematism. Malevich reached
this position through early Post-
Impressionistic works followed
by paintings on 'peasant' themes
executed in Léger's tubular style.
These led to Cubo-Futurist
paintings and mechanical figures.
In 1927, he visited Europe,
meeting Arp, Schwitters and
Richter, and his treatise, *The
Non-Objective World*, was published
as a book by the Berlin-based
Bauhaus. His connections with
Germany, however, led to his
arrest in 1930, when he was
banned from publishing his
writings. During this period,
he returned to representational
works.

white cracks. Versions from the 1920s are blacker, but still they seem very under-stated, plain paintings, without much painterly energy. The energy is all in the idea, we feel. The idea to project nothing but black squareness.

This wasn't exactly the idea with Malevich but we are not in a good position any more to understand exactly what his idea was, even though all his main writings on art are available in translation. We are too distanced from the age he lived in and his cultural horizons are not our horizons. It's pretty hard now even to imagine that one of the most basic structures of cultural life then was for writers, poets and artists to all think the same thing, let alone that the main same thing might have been to have a revolution and storm the Winter Palace.

But also, the look of Malevich's art is relatively plain. We feel we can understand the ideas of Abstract Expressionism because it is easy to believe the ideas might all be more or less there in the churned surface of Abstract Expressionist paintings. With Malevich's *Black Square*, though, there isn't much going on with the surface. That's why Malevich is relatively unpopular now compared with Jackson Pollock.

Non-Objectivity and objects

Is Malevich Minimalism? No. Just don't even try to work out all the objects in Non-Objectivity and the Minimalist 'object.' There aren't any objects in Non-Objectivity but only geometric shapes. Minimalism is all geometric shapes but it is not Non-Objectivity. Minimalism is against the subjective realm and for the objective realm. Non-Objectivity is for a radical subjectivity and against Futurism.

The impersonality and understated painterliness of Malevich's Non-Objectivity look might make it seem a very sympathetic or influential look as far as Minimalist artists of the 60s were concerned. But although Judd admired Malevich's paintings and wrote eloquently about them and Flavin titled one of his neon tubes after Tatlin, the famous colleague of Malevich, neither Malevich nor Tatlin particularly figure in the story of Minimalism. They stand for a stage in the history of Modern art that probably didn't have much more resonance in the 60s than it does for us today. Maybe it had less, because since the 60s there has been a designer revolution and post-80s typography and magazine layout owes a lot to Malevich's graphic art.

A Malevich black square is quite small but Minimalist art is usually very big. With Minimalism in the 60s less was famously more. But it came in big sizes nevertheless. Less being more was a credo connected to a critique of 1950s Abstract Expressionism. Abstract Expressionism was allusive, atmospheric, gestural, illusionistic, sometimes violent and hysterical. Minimalism was against that but Malevich couldn't be against it because it hadn't happened yet. Malevich died ten years before Abstract Expressionism started and thirty years before Minimalism.

Remember – everything in art comes out of something and what it is against is part of what it is.

Kasimir Malevich
Suprematism (with eight red rec-
tangles) 1915

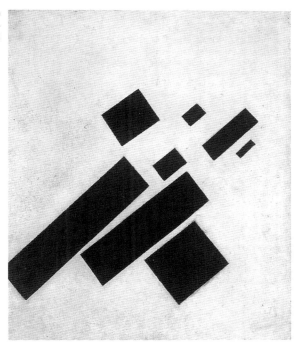

The world

Non-Objective art after Malevich is a strand of art that was considered a bit boring by the time of Abstract Expressionism. Within the general category of Non-Objective, was included Neo-Plastic and Constructivist. They all featured geometric abstract forms. By the 40s they didn't seem radically modern any more. In fact they seemed a bit dry. Surrealism was much better, it was thought. It was more exciting than just squares. Abstract Expressionism swallowed them both up: squares and Surrealism — objectivity and subjectivity.

Surrealism came back later in various mutant forms but although Non-Objectivity might be said to have lingered on in some areas of avant gardism after Abstract Expressionism, these were not the glamour hotspots of Modern art.

Did Abstract Expressionism share any ground with Non-Objectivity, since they were both abstract? Pollock said painting for him was 'nothing less than the expression of the age.' Malevich thought painting was linked to the totality of a particular culture and it expressed the world-view of that culture.

But with Pollock we think there is a lot of self-expression going on as well as age-expression and probably age-expression with him was just an unwitting by-product. Malevich's paintings are impersonal by contrast and we don't feel he is a great self-expresser. He must be expressing the age more, we think.

The cosmos

When *Black Square* was first exhibited in 1915 it was very exciting. It was the first icon of Suprematism, the movement Malevich invented, which was based on the principle of Non-Objectivity. Malevich thought of it not as a matter of mere geometric design but as a form of cosmic realism. There were other Russian artists involved, but Malevich was the leader and the main polemicist, pamphleteer and theorist.

His theories haven't particularly lasted. They are fascinating but they have a comic aspect for us. The comedy is partly witting, partly unwitting. Avant gardism had a brief to be menacing at this time, and Malevich is one of the great avant garde declaimers: The President of Universal Space was one of the names he called himself; Kasimir the Great was another. But he only did this because the Czar was a figure of everyone's dreams then and because Malevich's culture was different to ours and he thought the painterly world was connected to a great spiritual vastness and to cosmic depths or heights.

The *Black Square* was exhibited in a show called 'Last Futurist Exhibition 0.10 (Zero-Ten).' As well as Malevich, there were nine other artists participating, all advocating the new principle of Non-Objectivity. Photos of Malevich's section of the exhibition show a room crowded with smallish abstract paintings. They are

spread all over the walls in an irregular formation, three or four deep. Nearly all of them are of configurations of squares with other elementary geometric shapes – diagonal bars, circles, semicircles, triangles, all floating in a white space. The exceptions include a painting featuring a single wide rectangle and one of a cross.

But the most radically reduced formation is *Black Square*, which is just the square within a white border. It hangs higher than the rest, its top edge touching the ornate molding of the ceiling. It is the only painting to be hung across a corner of the room rather than flatly on a wall, in the normal way. From this position it looks down on the rest of the space as if it holds the key to meaning, which it does. Or did. It was a new Russian icon, replacing the old ones with Jesus on them.

The numerical flourish at the end of the exhibition title – '0.10' – was related to the radical nothingness of the *Black Square* – the idea of Malevich advancing from nothing to infinity. 'I have transformed myself in the zero of forms and gone beyond zero,' he wrote in his manifesto of Suprematism, which he handed out to visitors at the exhibition.

Victory

The event immediately preceding the 'Last Futurist Exhibition' was an avant-garde opera, with the libretto written by Mayakovsky, for which Malevich designed the costumes and sets. It was called *Victory Over The Sun*. The victory was the victory over illusion.

Before the moment of Suprematist consciousness, Malevich painted in various Modern art styles, including Impressionism, Pointillism, Symbolism, Cubism and Futurism. He gave them new style-names like Cubo-Futurism or Transrational Cubism or Alogism, as in a-logic. A lot of this art looks pretty hideous now. Malevich was a supreme aesthete but not a delicate flower. He thought of all this work as research. The already given styles were pushed in order to discover new theoretical contents and the styles just had to take the strain. His versions of these styles seem so clumsy and wooden compared to the real thing, it almost looks as though he was torturing them.

He painted some Cubo-Primitive pictures of peasants toiling. But even these paintings – which are moving because the idea of Modern art and peasants somehow coming together just is moving for us – are visually hideous in their bucklings and strainings and weird luridness. But Suprematism when it came was amazingly simple and elegant. And it remains a marvel, however removed we might feel from its historical moment.

For some, the new movement was a vile desecration and the *Black Square* meant the destruction of everything. But for others it actually was everything. It summed up everything. It had all meanings covered. It was the height of art. The best it could do. It was an art revolution. 'My new paintings no longer pertain to the earth,' wrote the President of Universal Space.

Kasimir Malevich
Red Square: Painterly Realism of a Peasant in Two Dimensions 1917

Red Square

Malevich's art of pure feeling was considered to be right for the Revolution at first but then it was considered to be wrong. For a few years he was a hero. He painted red squares and he produced suprematist teapot designs, book covers, textiles and film posters; and he helped found and run new museums and art schools dedicated to radical Modern art. Then splits began occuring within the radical groups he was associated with, and he began to appear too mystical and not hard-headed enough. And to those outside these groups he began to appear to be mad. As the political climate hardened he fell into wide disrepute. He was attacked by *Pravda* for being a crackpot. In 1927 he was briefly imprisoned for taking a trip to Berlin to promote his work. He was incarcerated for two months and interrogated on the nature of abstraction – What was its ideology? But then he was released. By now, with the rise of a new official realist propaganda style in the Soviet Union and the official dissolution of all independent artistic groups or movements, Malevich was officially tolerated but made to feel severely pressurized. He was no longer allowed to hold

any of the important academic or curatorial posts that had been created for him in the early post-Revolutionary years.

When Malevich died in 1935 his body lay in state for five days. A photo shows the long-haired, bearded, white-robed corpse, Rasputin-like, lying in a coffin that looks like a Suprematist sculpture, against a wall lined with Suprematist paintings. The body was transported from Leningrad to Moscow by train – paid for by the City of Leningrad – and the funeral procession through the streets of Moscow included mourners carrying banners bearing the icon of the black square. After Malevich's cremation his ashes were interred in a grave marked by a white marble square and a photo of the *Black Square*. The State Russian museum bought several of his works and awarded a pension to his family.

Strange bug within

Malevich's paintings from the mid-20s to his death in 1935 show him apparently torturing Suprematism in the way he had tortured Impressionism and Cubism in his pre-Suprematism period. He went back to all the old styles with weird results. He painted a lot of ugly Impressionist pictures and backdated them, apparently to make money, because the official Soviet museums were willing to buy them. And then he went back to Cubo-Futurist peasant paintings of the old days but now making them seem as if they were Suprematist-style compositions. Some of these have a rough brightness and strength about them, like bright signs or notices to 'Hire Your Beach-Hut Here.' But a lot of his later paintings are indistinguishable from a vapid brown academic realism.

Malevich really was oppressed creatively in his last years but also there is a feeling from his last works, and the weird twists he put his own ideas through, of something genuinely different about his version of pure feeling to the version that, say, Chagall or Kandinsky – his Russian contemporaries – demonstrate. They are sweet, he is harsh. They keep an even keel, he is full of uncomfortable contrasts. But to him it was all part of the same thing. Dreadful, insipid self-portraits and portraits of family and friends from his last years are still signed with the emblem of the black square. He seems to wind down from a cosmic vision of art to more or less outright rubbish. And as a result less of pressure from without as from a strange bug within.

Kasimir Malevich in Suprematist coffin 1935

Optimism and pessimism

Historically Non-Objective art is an optimistic, forward-looking art. The forms are geometric because they are more democratic. Anecdote is out because it is trivial and symbolic subject matter is out because it is connected to the old order. Art was now freed to convey new cosmic meanings directly, without having to go round the houses. Also, houses could be geometric too, and everyone would live in the same kind of one and it would be more democratic in a good way. This was Constructivism, the movement that was developed by Rodchenko and El Lisitsky, partly inspired by Malevich but partly in opposition to his religious mysticism. But geometric art in general has these associations, at least up until the Second World War. It is connected with an idea of utopia, of society progressing and getting better, leaving the gloomy past behind.

Abstract Expressionism, when it came, was not just a stylistic twist on Non-Objectivity – abstract forms turning more organic, brushwork turning more frenzied, the scale getting bigger. It was a change in attitude. Rather than optimism about the future, it expressed a deep tragic feeling about man. Gloom, awe, the sublime – this was one strand of Abstract Expressionism. Turmoil, frenzy, the flesh – this was another strand. But pessimism was there in both strands, you could say, because there was no longer a feeling that abstract forms were necessarily democratic or even that art necessarily had to be democratic.

Feeling depressed

Mark Rothko was always incredibly depressed. He was an Abstract Expressionist but his paintings were not gestural and frenzied but atmospheric and virtually formless. What forms they had were feathery and soft and looming. Rather than form his paintings emphasized colour.

These colours could often be amazing to the eye – really odd and striking and in great expanses: plum, magenta, purple, brown, silvery-white, heavy yellow, strong blue. White that billowed or misted or frosted or flashed, or lay dense like snow. All sorts of blue tones, inky to milky. Nameless tones. Greys. Blacks of all different kinds – harsh, charcoaly, stormy, crisp, hard, terrible, subtle. Really odd combinations of colours shining through each other – like magenta shining through brown. And sudden steady expanses of strong mid colours all banked up solidly almost like Pop art – red, orange, blue, white.

But rather than colour, Rothko said, his paintings emphasized the Void. The Void with all its dread. It would be a mistake to see only colour relationships there, he said.

The spirit

Rothko was a deeply spiritual man. Malevich seems marvellous now, when we notice him, because he was spiritual too. But the Spiritual eighty or ninety years ago is different to the Spiritual now. It was a time when seances were still a craze and there was a belief in ectoplasm. And spiritualists used early phonograph

Mark Rothko
b Dvinsk (Russia), 1903;
d New York, NY (USA) 1970
Rothko is bracketed as a leading exponent of Abstract Expressionism. His calm, meditative works, however, show less concern with the gestural qualities of Abstract Expressionism than with the retinal effects of colour-field painting; less interest in exploring abstract notions of colour and form than in generating emotion in the viewer. Largely self-taught, he co-founded the Expressionist group The Ten in 1935. In the 1940s, his paintings showed strong affinities with Surrealism and the biomorphic compositions of Arshile Gorky. By 1947, he was moving towards Abstract Expressionism with the works for which he is now well known – seductive rectangular forms, their edges softly blurred, which appear to float hazily above pulsating coloured backgrounds. He regarded these as 'things', or portraits, expressing basic human sentiments such as tragedy, ecstasy or doom, and described the experience of painting them as 'religious'. Plagued by depression for much of his life, Rothko committed suicide in 1970.

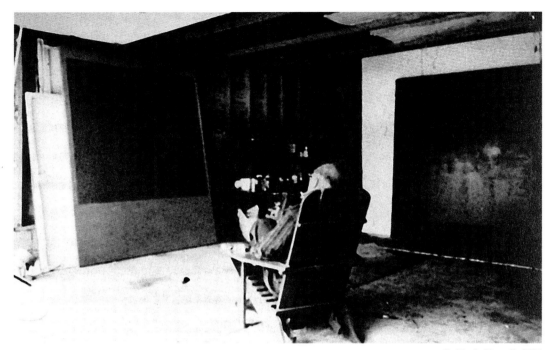

Rothko in his studio 1964

recordings to fake the voices and moans and groans and mutterings of departed spirits. It was the age of the locomotive and the aeroplane and the early telephone probably, too. So the spiritual had all that to be the opposite of. What was it the opposite of thirty or forty years ago?

For Rothko, spiritually wretched in the 1960s, drinking heavily and taking medication for his depression, the Spiritual was different as well. It was the age of Andy Warhol. Rothko was appalled by a lot of modern art. The way it was going. When he passed Warhol on the street one day in the early part of the decade, he had to turn away. The sight was too horrible for him. He couldn't bare the Pop glare. He wanted the murky Void with all its doom.

The blank orange of Warhol's big disaster diptych in the Museum of Modern Art in New York: one canvas has the repeated car crash silk-screened in black over orange but one canvas is just the orange. Warhol's mass media Void. It's probably not all that different to Rothko's solemn Greek tragedy or Old Testament Void.

The blank redness of the Rothko nearby. There's not much to say about it. It's not the red of Matisse's *Red Studio* downstairs. But it's not that different either. Except there's no studio in it. Just red. And the idea of Rothko's studio. Gloomy. Filled with Rothko's depression, his sense of timeless tragedy. And his own tragedy, which he experienced in real time, of no one seeming to feel all that tragic any more.

Mark Rothko *Number 22* 1949

And we've given him the job of being our tragic artist of nothingness. We will never say, well this Rothko's maybe not much good. That one before was better. Weighing them up like that would be churlish or pedantic or presumptuous. It would be a sacrilege anyway, because that's the way we believe in Rothko. It's our generosity toward him. Which we don't quite have for Warhol because we feel Warhol can take his knocks even in death.

The end

Rothko's strong colour period lasted about fifteen years, from the end of the 40s to the mid 60s. His paintings from the last part of the 60s are generally dark with less contrasts of colour. His most famous dark paintings are fourteen virtually all-black paintings completed in 1967 as a commission for a chapel in Houston. He did some other really murky maroon ones for a restaurant in 1959 but then changed his

mind and they went to the Tate Gallery in London instead. But his chapel paintings included his first true monochromes. Some have faint frame shapes three inches or so wide showing through the black – or seen the other way around, the shape of a huge rectangle of black floating in a void of a slightly different black. But the others are only black with no differentiations of form, however slight. In 1970 he committed suicide. His absolute last paintings were just flat sections of grey and black, artless and plain.

No to nothing

The Rothko Chapel is still there. Over the years it has become a centre of vague New Age religion, or religion *Lite*. It is a real chapel where people go to meditate or get married or just flop around outside on the benches – the flotsam and jetsam of modern society seeking a place to flop. Inside, there are Bibles and Korans instead of art catalogues. The paintings are hung as Rothko arranged them using a scale model in his studio, surrounded by his mixtures of tempera and size and his six-inch brushes and his packets of powdered pigment. He never saw the finished paintings installed because they didn't go up until a year after his death.

'There is no such thing as a painting about nothing,' Rothko said. And these ones are arranged around the octagonal central space of the chapel in giant looming threes and singles, suggesting holy trinities and Supreme Beings, maybe even symbolic crucifixions.

Rothko was outrageously over-fruity and grandiose in his statements about art and religion and the solemn importance of his own art. But actually the feeling here is not all that oppressive or laughable but sympathetic – black paintings, high ceiling, stone walls, prayer mats, unpretentious people with rucksacks standing around quietly in the dark calm.

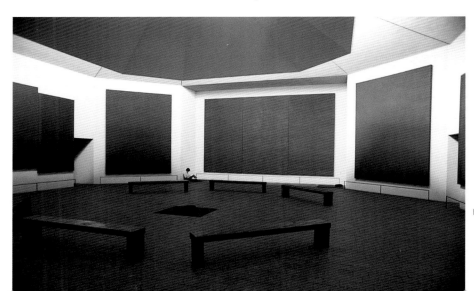

Rothko Chapel, Houston, Texas

Yves Klein
Leap into the Void 1960

Judo mats

The French artist Yves Klein is famous for paintings that were all blue. He painted blue monochromes in the mid-1950s and early 60s. He used a blue which he patented himself under the name IKB, or International Klein Blue. The blue was symbolic of the Void. Klein advocated a theme of immateriality. His void was far from Rothko but it wasn't far from Malevich. It too was arrived at by passing through a zero zone: 'Having rejected nothingness,' Klein wrote, 'I discovered the Void.'

When we find ourselves in an art gallery today, frowning into one of Klein's strange, erotic, round-cornered, textured, densely blue monochromes, we see our own contemporary selves. Partly because we see our own reflection clearly frowning back at us in the Plexiglas glazing that typically encases them. But also because Klein was an extremely theatrical and literary artist and an inspired performer, as well as a visual sensualist. And he seems a lot like Andy Warhol or Gilbert and George who we also feel quite comfortable with. We feel in tune with them and their fake selves more than we do with Rothko, with his flayed self and his bleeding moaning all the time.

Yves Klein *IKB* 79 1960

Klein's blue is almost always textured, but the texture isn't tortured Modern art texture but rollered-on texture, obvious and light. It is at its craziest when the texture is exaggerated by the addition onto the already textured surface of real sponges soaked in IKB. Klein lived his whole life as an artist as a play. He called himself Yves Le Monochrome. And he tried to teach himself to levitate. He had an approach to art which can seem childish. But he was an intellectual with an elegant and forceful prose style. So he wasn't just an irritating Peter Pan figure who you could feel like punching — or shouting at them to join the army.

As a child he could believe in Modern art but it didn't have to be on Modern art's terms. It could be on his own monomaniac terms. All systems of knowledge went into his system of belief — the system of Modern art but also the system of alchemy and the system of Judo. He really was a Judo expert, earning his Black Belt at the Kudokan Institute in Tokyo in 1953 and teaching Judo in Paris for five years. And he was a member of the secret society of Rosicrucians and an initiate into the Holy Order of the Knights of Saint Sebastian. He believed he had made the sky into a blue painting and that he would fly behind it and sign it.

In one of his manifestos he announced that 'birds must be eliminated' for the crime of flying into his greatest painting — the blue void of the sky — and 'boring holes into it.'

He had himself photographed apparently leaping from a tall building into the street, as if into the Void. It was called *Leap Into The Void*. He lectured at the Sorbonne on 'The evolution of art toward the immaterial.' He sold Zones of Immaterial Pictorial Sensibility but he would only accept pure gold as payment. Offered ingots, or gold leaf, by collectors, he threw the gold into the Seine in a special ceremony, and burned the receipts from a receipt book he had specially printed — they read: *Received XX grams of pure gold against one zone of immaterial pictorial sensibility.*

He put on a show called 'The Void,' which was an empty gallery with white curtains and an empty vitrine. He composed a monotonal symphony called *Monotone — Silence — Symphony*. A lot of instruments playing a single chord followed by a silence. And he made paintings with a flame-thrower, with a fireman standing by. Plus he made a wall of blue flames using gas burners, with the collaboration of the gas company.

Climate of flesh

As well as densely textured IKB monochromes painted with rollers, or covered with sponges, he produced a series of *Anthropometries*, which were paintings of flying blue bodies — sometimes gold — in a white space, made by imprinting the IKB-smeared bodies of nude models onto canvas. Klein said it wasn't at all the shape of the body that he was interested in, because that would be mere illusionism. But only 'the essential, pure, affective climate of the flesh.'

Yves Klein
b Nice (France), 1928;
d Paris (France), 1962
Klein was closely associated with Nouveau Réalisme, but his anti-traditionalism was filtered through a spiritual vision. After extensive travelling in his twenties, including a year spent mastering judo in Japan, he returned permanently to Paris in the mid-1950s. The textured, monochrome canvases made at this time virtually denied their own existence by blending with the wall. In 1958, he developed this idea by exhibiting an empty gallery – the 'Void' that was to preoccupy him throughout his short life. His Rosicrucian theories on the cosmic energy of colour eventually led to the exclusive use of his trademark 'International Klein Blue' in monochromes and works using natural sponges. In the *Anthropometries* (1958–60), he made imprints on canvas from the bodies of naked women covered in blue paint. This live work exemplifies not only Klein's provocative showmanship, but also his interest in ritual, activity and process. Similarly, the *Cosmogonies* of 1960 reached completion only by exposure to air and water; the *Fire Paintings* were made with a blow-torch.

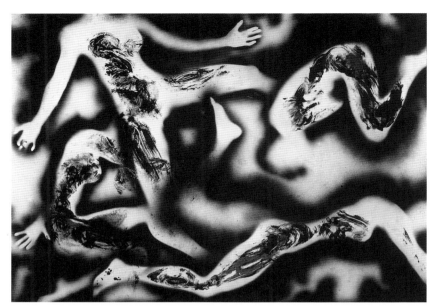

Yves Klein
Untitled Anthropometry 1961

When he began them in 1957 they were made in his flat in Paris. It was a small one, in rue de Campagne-Prèmiere, a street now famous for its cultural associations: Modigliani had lived at one end and Trotsky had briefly stayed at the other. Marcel Duchamp lived in the Hotel Istria, there, for three years. And Jean-Luc Godard filmed Jean-Paul Belmondo's death scene in *Breathless* there. In fact during the filming, Belmondo and Godard visited Klein and had a look at his work.

Klein would roll up the carpet and get out the painting materials and the female models would work with him in a process that was, at least in part, a genuinely collaborative one. They had to do a kind of method-imprinting, rather than just a deadpan imprinting – they really had to believe in their imprinting.

When the *Anthropometries* first started to be shown, they were the subject of rumours and scandal. Klein's response was to ritualize the process. He tried out a semi-public performance first and then a fully theatricalized event in a gallery.

This time the event was filmed, with some of the footage later turning up at the Cannes film festival in the movie *Mondo Cane*. Which unfortunately was a rubbish film about saucy goings-on in a plastic version of Bohemia. And not at all the dignified poetic drama Klein had imagined when he agreed to collaborate with the film-maker.

Don't do it women!

When this old footage is shown as it sometimes is on TV in art programmes, most viewers now are appalled at the sight. The audience of Parisian toffs is all lined up in rows on chairs, wearing formal outfits; a posh orchestra plays the monotonal symphony; and Klein in his tuxedo looks like Alain Delon at an outrageously offensive

Yves Klein painting models in
Anthropometry performance in Paris
1960

1960s art event. The nudity of the models is shocking compared to the stiff overdone evening-wear of everyone else.

'Don't do it models!' we cry out – 'Liberation is just around the corner!'

But they go on smearing their strikingly voluptuous forms with the blue mud – which in the black and white film, of course, is black mud. And Klein, up a ladder, directs them with imperious arm gestures where to roll and squirm on the virgin canvas. Lengths of which are spread out on the wall and on the floor.

'Oh OK then. If you must!' we sigh – 'But we're turning away!'

Ascent into the Void

But really this sequence is a comic-tragic example of the way you can never really control the discourse of art. Klein was an artist of the Void and all his activities were directed toward expressing the poetic meanings of the Void. Anthropometric art was art about a poetic principal of Voidish celestialism meeting a poetic principal of flesh. When he saw this footage – which he felt would be a vindication of his seriousness – used as farce in *Mondo Cane*, he suffered the first of the three heart attacks that led to his early death at age 34, in June 1962.

Klein's *Anthropometries* were meant to be ritualistic, technical, aesthetic paintings. Bodies dissolving in a celestial blue. The year he started making them was the year Yuri Gagarin first circled the earth. 'It's blue,' the Russian cosmonaut reported back to earth, on his crackly radio. 'An intense blue.'

Extremely foreign

When some of Klein's works were shown in New York after his death, Donald Judd, who was earning a living as a reviewer, was the only one there to give him a good one. In New York, Klein was thought to be merely an artist of shenanigans. But Judd, himself a fierce opponent of shenanigans, nevertheless was impressed by Klein's textured monochromes. He said they were simple and broadly scaled and thus related to the best new American art, as he saw it.

But what he found 'extremely foreign' was the 'unmitigated, pure but very sensuous beauty' of the blue monochrome. He suggested a parallel in Ingres' painting, *Turkish Bath*. 'There is nothing which objectifies or mitigates the pungent beauty,' he wrote, 'but its difficult strength.'

This was a striking type of language because the new American art that was rising up at this time was nothing to do with beauty and nobody much used that word; if they did it was to disparage not to praise.

But Klein's theatricality and old-style avant gardist manner was difficult to take in New York in the 60s. It was intellectual in a completely alien way – seriousness just wasn't signified in this way. You just didn't behave like that.

When he exhibited there in 1961 he had a manifesto distributed to explain his paintings, which he'd written in the Chelsea Hotel. In it he listed all his exploits of the last fifteen years in quite literary language and then distanced himself from all associations of American Action Painting. He said he kept as far away as possible from all messiness. He preferred to wear his tuxedo and white gloves instead. Then, warming to a theme of outrage, he said morbidity, graves and tombs now interested him and the next phase of his art would be cannibalism.

Avocado El Dorado

Jonathan Richman and the Modern Lovers was a proto-Punk album that came out in 1976. I bought it when I was at art school because of the name – The Modern Lovers. It was already making a good statement. Track Four was called *Pablo Picasso*. It just droned on in E minor without any complicated chord changes or any changes at all. The words were intoned rather than sung. The verses were about Picasso's effect on women. *He was only five foot three*, the words went. *But girls could not resist his stare. They turned the colour of an avocado when he drove down the street in his El Dorado.* The chorus went something like, *No one ever called Picasso an asshole – not in New York!* With a variation that went, *No one ever called Picasso an asshole – not like you!*

I didn't know it at the time but this was the sound of Post-Modernism. Picasso doesn't really rhyme with asshole. And of course he never went to America, he was much too arrogantly European. And he couldn't drive. And was he really only five feet three? In fact the song is all lies and the words are deliberately empty, deliberately meaningless. Meaning was somewhere other than in the meaning.

Peter Halley
*Glowing and Burnt-Out Cells
with Conduit 1982*

The problem-maker in your head

Post-Modern art of the 70s and 80s was an art where all the old meanings were drained out. It was art of radical draining leaving a lot of baffling blanks. It was nothing like Picasso but very much like *Pablo Picasso*. Lots of new art forms came out which just seemed to recycle older art forms. Even Non-Objective abstract art made a reappearance. But the meaning was always somewhere other than what seemed to be right there in front of your eyes. Just as it was with recycled Rothkos. Abstract red squares in the paintings of Peter Halley, for example, were not the Void any more, or a peasant in two dimensions, but only cynical blanks or psychological prison cells. Recycled Op Art swirls in Philip Taaffe's paintings were not seductive visual explosions like a Modern version of Impressionism, as they had been in 1962, but signifiers of the death of meaning and the end of history. (In the 90s they would be recycled again by Chris Ofili and then they would be recycled Philip Taaffes as well as Bridget Rileys.) And Seduction itself was a menacing abstract force that now ruled the world, controlling and manipulating highbrows and barbarians alike, in a unified environment of rising psychic poison. Apparent meanings were wrong and real meanings were baffling, because the real meanings

were anti-canonical and most people weren't even sure what the canon meant yet, let alone the anti-canon. Meaning meant nothing and nothing mattered. But now Nothing mattered in a traumatized Post-Punk way, not in a spiritual or celestial or tragic or even Minimalist negative space way.

And not even in a revolutionary way, since there was nothing to revolt against – not even yourself, in a 60s or 70s self-awareness way – because the problem was not you but the problem-maker in your head.

'Phew!' everyone thought at last – 'What about having our meanings back?' But they couldn't have them back, because they didn't mean the same any more. The old meanings were dead meanings. To bring them back would be to bring back zombies.

Depressing joy division

In a bright white studio in East London, Glenn Brown, an artist in his 30s, who sucked in 80s blankness like mother's milk when he was at art school in that decade, paints a stunningly detailed copy of the nineteenth-century German Romantic painter Arnold Boecklin's *Island of the Dead*. There seem to be even more details than in

Glenn Brown
*Searched Hard For You And
Your Special Ways* 1995

Peter Halley
b New York, NY(USA) 1953
Peter Halley has been called the 'chief theorist' of Neo Geo, a cool, impersonal tendency that emerged in New York in the mid-1980s as a reaction against the emotionalism of Neo-Expressionism. He cites his inspiration as a combination of growing up in Manhattan as it developed into a grid of office towers, to the influence of Albers at the Phillips Academy in Andover, to the New York School of the 1950s, and the works of Guston and Baldessari. Characterised by Day-Glo colours and synthetic Roll-a-Tex surfaces, his large geometrical compositions are parodic, Post-Modern critiques of transcendental artists like Ryman, Newman and Rothko, whose evocative forms he translates into mechanistic conduits ('I've taken Newman's zip and made it into plumbing,' he has said). But these schematic diagrams aim to put the content back into formalism. Not simply abstract images, they are representations of spatial experience, showing that abstraction can also function on figurative, political and symbolic levels. And while the recurrent presence of cells in his work equates ideal geometry with prison, the Day-Glo conduits and arteries suggest communication and energy, piped into these systems of isolation and control.

Glenn Brown in his studio 1998

the original. Now all the wriggling sheens, arbitrary lights and darks, and new colours of the reproduction from which the new image is being painted, are details too.

He has painted copies of Frank Auerbach and Salvador Dali as well, and de Kooning and the works of a 70s cult science fiction illustrator. He gives the re-done versions new titles which are often grimly comic, or camp, like the titles of 70s cult horror films. For example, *The Living Dead* is the new title for a re-done painting by Auerbach, which had originally been titled just with the initials of Auerbach's sitter. But now Auerbach's gouged expressionist surface has a new meaning, of creeping mutant flesh. Another painting is Brown's upside down copy of a beautiful face painted by Fragonard. Its new title is a line from a depressing Joy Division song – *Searched Hard For You And Your Special Ways*. Perhaps it is appropriate that this song was recorded in 1980 – the dawn of the dead.

'I'm just using the contemporary landscape,' Brown says, about his use of art that was made originally by someone else.

His studio is a conventional one, with lots of tiny brushes and tubes of paint and little jars of turps and medium. And his work as an artist is not mechanical or without feeling. Or it may be a bit mechanical but there's a definite feeling. It is the feeling of being alone in a studio, taking a very long time to paint something, living an unhealthy inward-turned, isolated life with long stretches of boredom. The feeling is expressed right there in the exaggerated hyper-detail of the brought-back-to-life paintings.

'The exaggeration comes from the colour. It's hyped-up colour, so it appears drug-induced, acidic. In my best paintings the colour is almost as if the painting's gone off. It's decaying. It was fresh once.'

It's an odd new nothingness. His paintings are so full you'd think this would be the last place to find it. But they're full of something that already exists perfectly OK somewhere else. It's the opposite of Robert Ryman, for example, who makes much out of little – the opposite turned inside out as well and with all the oxygen taken out. On he works, a figure at the end of a white space, painting a painting that doesn't need to exist again.

Very new monochromes

In another studio, Jason Martin paints a monochrome. The canvas is huge. There are many hundreds of pounds worth of oil paint on it. The paint was scooped out of big tins of different colours and then mixed up in a big plastic bucket to make a mass of strong deep blue. Then the mass was knifed onto the white canvas in gloops and the gloops were smeared out. They had to be plastered over the white so it would be covered more or less evenly with no bald patches. Then a long length of metal, like a metal comb, was dragged across the surface of the paint, scoring deep grooves in it. It was dragged back and forth again and again. For hours. It was exhausting to see it. After that, the painting was finished. And now there it stands. The formerly gloopy matter is now a single balletic movement of matter, extremely satisfyingly grooved, in a wave movement, across a wide deep surface.

'What you see is what you see' was a maxim of Minimalism in the 60s. There wasn't anything other than what you saw, was the idea. So what you saw had to be very particular and you had to be particularly careful to see it in the right way and not be looking for something else, because Minimalism wasn't anarchic and free but rigid and with lots of rules. At least, that's what was thought after a while, when a reaction against it set in. But now some of the rules are fine again. And they can be mixed up with other rules too.

The surface of this new monochrome is a record as well as an expanse of inert matter – the movement of the metal comb records and documents the movement

Glenn Brown
b Hexham (England), 1966
Glenn Brown studied for his
MA at Goldsmiths, London in
1990–2, and his witty theoretical
work reflects the intellectual
aesthetic emerging from this
influential institution at the time.
Appropriating and ironically
renaming iconic paintings from
the canon of Modern art –
Auerbach, de Kooning, Karel
Appel – he presents exact copies
using a tiny brush, which reduces
their textures to a completely flat
surface, like a colour photograph.
This playful enquiry into authen-
ticity, authorship, and celebrity
hit the nail directly on the head
when in 1994, in the exhibition
'Here and Now' at the
Serpentine Gallery, his works
were excluded from the show
when the Dalí Foundation
threatened to take legal action
over the unauthorized use of
their images. Brown began by
making *trompe l'oeil* representations
of the moon's surface, but found
the results 'too rich in romantic
meaning'. In recent works such
as *Jesus; The Living Dead (after
Adolf Schaller)*, 1997–8, he avoids
this problem by reproducing
on a billboard scale a scientific
rendering of a planetary surface
by the American commercial
artist Adolf Schaller.

Jason Martin
Untitled (jet loop paint #6) 1997

James Turrell
b Los Angeles, CA (USA) 1943
Turrell sculpts with light, making
it seem almost tangible. An
experienced pilot, his vision is
influenced by the big Californian
sky and by Eastern traditions
such as meditation. After studying
for his degree in perceptual
psychology at Pomona College
in 1965, he began to make light
sculptures using flames. The
current works can be separated
into four categories: the *Projection
Pieces* in which precise rectangles
of light are created through
high-intensity projection; the
Space-Division pieces, where pulsing
architectural chambers hold hazy,
atmospheric light; the *Dark Pieces*,
so dim that artificial light can
barely be distinguished from
the natural light generated in the
retina; and the *Skyspaces* – knife-
edged apertures into open sky
that make light seem like a film
of intense and ever-changing
colour, seemingly stretched across
the opening. Turrell's ambitious
work-in-progress, the *Roden Crater*
project in the Arizona desert,
incorporates all four types.

of the artist's body through space. 'So what?' we might say if we weren't artists. But to artists, it's an important idea from the 60s. Something to do with some rule or other from then.

The thoughts stopping

Jason Martin, a London artist still not yet thirty, does matter without spirituality. It might be thought of as having spirituality. But at the same time it wouldn't matter if it didn't. James Turrell, a minor American Minimalist from the 60s, who has become the undisputed leader of radical insubstantiality in the 90s, does spirituality without matter. His art is just planes of coloured light. Every installation is a different experience of light. If it's in a gallery it might be a wall of red light, with the light shone by projectors. Or a blue light. Or it might be a tiny spot of light in a black space that you have to wait in for a long time before anything happens. Feeling a bit claustrophobic. Or if it's not in a gallery and it's natural light, then it might be the vast natural light of the night sky in the open desert in Arizona seen from a crater and you have to make a heroic pilgrimage to get out there.

Meeting is a new work by Turrell at a big public art space in New York. It is a square minimal section of bright white space. A square of natural light from the sky. You go into a room and the atmospheric Minimalist square is above you. Maybe

Meeting is a meeting of atmosphere and mind, or the rational and the irrational, or some other spooky dichotomy. Maybe to section off a misty atmosphere in a geometric square is Caspar David Friedrich *Lite*.

The room itself is square-shaped and smallish. A wooden bench goes right round all four walls, stopping only at the door. You come in, look up, sit down. Time passes. You find yourself now lying back and looking up. It's the natural elements. You feel like a child. The sky gets darker and the white becomes blue and then bluer and the ceiling around the square gets correspondingly yellower.

What happens when it does that? Some spacing out. The sound of your own breathing. It's like transcendental meditation. We're probably going to fly in a minute. The minutes are very long. What else? Well, we're just lying here. We don't reject the spectacularization of all experience. We love it. We can see it happening – a square going from blue to black. The mind blowing. The chapter coming to an end. The thoughts stopping.

CHAPTER FIVE

HOLLOW LAUGHTER

Piero Manzoni
Artist's shit No 068 1961

Modern art jokes

There are many jokes in Modern art. They are never all that funny. They often put people off. They often express self-hatred or sarcasm. If Modern art was a big communications company and there was a big shake up of it, to make it perform better, the jokes would all be called in to do a consciousness-adjusting course. On it, they'd be asked to think of Modern art as a person: 'There's no room for nasty people in Modern art,' they'd be told. Or they might be told to think of Modern art as a washing machine: 'It has many settings. You're only used to using two or three. Try some of the others.'

Top of the Pops

If a Top Ten of Modern art joke types were compiled, number one would certainly be jokes that are either outrageously obvious or outrageously obscure. Or both. The illustration for this type would be Marcel Duchamp's urinal. Marcel Marceau, as opposed to Duchamp, could stand on a French stage and easily mime the other nine types. They would include: No.2 (ha ha!): jokes about shit. No.3: jokes about sex. No.4: jokes about bottoms. No.5: jokes about ivory towers. No.6: jokes about any old rubbish. No.7: posh jokes in French, often based on asinine puns or word plays. No.8: jokes about the mystery of language (related to the last type but more mysterious). And No.9: Zen jokes. The tenth category might be the repetition of No.9 in a droning, annoying way, like the repetition of the words 'number nine' on *Revolution Number Nine* by The Beatles, which was influenced by Yoko Ono, who was a member of the Fluxus movement.

Two jokes

I went to see a psychiatrist. He said tell me everything. I did and now he's doing my act. This was a line written on a piece of paper by the artist Richard Prince, in 1985. It was just a joke copied from a joke magazine. He wrote it out, dated and signed the paper and then sold it as art for a small sum. Ten dollars. It was called *Untitled*. Then he wrote down another one and sold that one too, but this time for twice as much. Then he did it again and again.

Yoko Ono
Fluxfilm 1966

Richard Prince *Untitled* 1985

I WENT TO SEE A PSYCHIATRIST. HE SAID "TELL ME EVERY THING" I DID AND NOW HE'S DOING MY ACT.

An index finger points upwards from a sculptural plinth, painted white. The finger is a cast of a real finger, done in wax. It is an artwork in a gallery. The title is *Receptacle of Lurid Things*. The artist is Sarah Lucas. It's the early 90s – that's when it was shown at the Saatchi gallery in London. Maybe it's a finger giving the finger to the world. What would the lurid things be?

Not even funny

Is the world the receptacle? Maybe it's the gallery. Wherever the finger goes on show, maybe that's the new receptacle. If Saatchi sells it in one of his sales, maybe whoever buys it and puts it in their living room will be sitting in a receptacle now. Maybe that's the joke. It's definitely different to the psychiatrist joke. Maybe it isn't even funny. Or not even a joke.

Not funny either

The psychiatrist joke might not strike everyone as funny either. In itself it might not be all that funny and many people might find it even less funny in a gallery. 'An art gallery is no place for jokes!' they might exclaim. Maybe they are psychiatrists themselves. Or they were having some psychiatry that morning, before going to the gallery. And this joke might have touched a raw nerve. Even more so, if they were stand-up comedians. But then, of course, they'd just make a joke about their pain.

Bad bourgeois

We assume all Modern art jokes target bourgeois people. But we are never all that sure of our ground. Who are the bourgeois? They change all the time. We praise them for having a French revolution but we despise them for being uptight and a drag.

Sarah Lucas *Receptacle of Lurid Things* 1991

Obviously Modern art jokes target the second type more than the first one, we assume. If we use the word at all to describe something, we will always be meaning something bad. But at the same time we will know we are bourgeois ourselves because today there is little resistance to a basic bourgeois outlook on everything.

A basic bourgeois value is that everybody has something mysterious and ineffable deep inside themselves that they could express if they were artists and if they weren't artists they could feel it being expressed by art. This is Romanticism. All Modern art comes from Romanticism but particularly Surrealism. Surrealism is vehemently against bourgeois consciousness because it is merely a tissue of lies. That's the idea today too. If you don't get it, the thought goes – in connection with some joke or other in Modern art – you are bourgeois. Even though you are bourgeois anyway.

Oppression

It is not true that the bourgeois class is now the only class. We all aspire to bourgeois values but we are still divided up into classes. Slaves and masters. Workers and bosses. The bourgeois are still basically the bosses. It is right to give them the finger. Therefore, Sarah Lucas's *Receptacle of Lurid Things* could contribute to a sudden awareness of class consciousness on the part of arty people within the bourgeoisie. Someone could argue that. They might find it harder to argue the same for the sculptor Anish Kapoor, though, because he seems so posh on the telly.

The media

Media people who comment and bray about art are, of course, dreadful foes of the proletariat because they are so weak and slippy-slidey. But they are not the ultimate foe. The ultimate foe is the oppressors. The media people work for them. But they could just as easily work for the workers and help overthrow the oppressors. They have bad faith though. And they don't have class consciousness. They laugh about all that stuff and they don't think anything bad will ever happen to them.

The Surrealists and the Situationists

Today, Surrealism seems the safest of all the dangerous art movements, the one least likely to cause offense. It is more or less laughable to think of the Surrealists ever bringing down world capitalism. We may as well admit that it is laughable too to imagine the Situationists ever doing it either. 'What? Have you forgotten the *evenements* of 1968!' Er, yeah, on the whole, we have. We have to remember them all the time, of course, because they are on TV all the time in documentaries about art or about ancient influences upon Punk music and graphics and fashion.

But we don't think of the paving stones coming up and the police batons coming down and the Renault workers and the black polo-necked students standing side by side and making capitalism tremble briefly, as much more than a photo-opportunity any more. So in a sense we have forgotten them because they are not inspiring.

Psychogeographic map c. 1960

THE NAKED CITY
ILLUSTRATION DE L'HYPOTHÉSE DES PLAQUES
TOURNANTES EN PSYCHOGEOGRAPHIQUE

For this is the terrible prophecy of Situationism coming true in our time – illusionism and cynicism and slavery and photo-opportunism going on and on and never ending. We don't care though. In fact we enjoy it. And that's the thing it didn't prophesy.

Situationist slogans really were on the walls during the Paris uprisings. *Beneath the paving stones – the beach! Live in free time!* Then in no time the workers were back in the factories and the slogans were on the walls of the Museum of Modern Art in New York.

Alienation

Situationism came out of Surrealism. But it didn't want any more Surrealist art. It advocated a revolution of everyday life. It wanted to get back to something more like Marxism in its early development. Marxism could not literally be got back to because of Leninism and then Stalinism and totalitarianism. And also because Marxism was a nineteenth-century idea of working-class emancipation and it was no use trying to make a nineteenth-century idea fit 1950s conditions.

What Situationism wanted to get back to, or to redo, was Marx's view of alienation, and Marx's famous line: 'All the time and space of his world becomes foreign to him with the accumulation of his alienated products.'

Bad fake world

The Situationists believed in an evil called The Society of the Spectacle. They believed it had to be got rid of. The Spectacle was what the new consumer society offered. From a Situationist point of view, consumerism offers lots of consumer

Détourned comic strip c. 1960

products as a substitute for real experience. Thus it offers lies instead of life and it is a bad fake world constructed upon the real world. It offers nothing but desires that can never be satisfied.

The reason for the existence of the Spectacle is to give the slave class an illusion of freedom. 'Take this illusion,' the boss class says, 'and don't worry about all that freedom stuff.' But really it is only freedom to buy more rubbish and to feel dead instead of alive. The Spectacle's lies infiltrate consciousness, making all consciousness into lie-consciousness.

To combat the Spectacle, the Situationists advocated setting up temporary situations as a new form of art, or as a substitute for art, or as something not quite art but definitely replacing art. The *dérive* and the *détournement*, Psycho-geography and Unitary Urbanism – these were the special names the Situationists gave to the things they did; which included walking pointlessly, reversing or upsetting meanings, making maps that were nonsense and having a revolutionary attitude toward architecture and public spaces.

The Situationists combated *arrondissements* by dividing the city up into emotional *quartiers* instead. Instead of conforming to the laws of the Post Office or the traffic police, the new made-up city sections would now have their own emotional laws, their laws of *ambience*, which existed only in the heads of Situationists.

The Situationists went on long walks throughout the city and they produced psychological maps that documented their moody travels. And they scrambled and turned around the meanings of the Spectacle by doctoring its language and imagery. They did this mostly with Situationist films and Situationist comic strips. They put reality-invoking Situationist slogans in them instead of the lies of the Spectacle – lies that only mollified or nullified. For the raw material they used bits of existing films and existing comic strips. This was the origin of Punk slogans in the 70s, composed in blackmail writing.

Spontaneity

With Situationism, jokes and jokiness were important because they were connected to spontaneity. Spontaneity was important because feeling and emotions were important. They had to be systematically monitored though. And there was something grim and mad about this aspect of Situationism. It is good to scandalize or slightly terrorize the bourgeoisie with *dériving* but it is bad for your documents recording your own self-monitorings to have to be handed in on time to a rigidly controlling leader.

Reasons to be expelled

Objects were out. So it was impossible to have a Situationist painting, say, or sculpture. It wasn't completely impossible because there are such things and they still survive today but their creators were expelled by the leader of Situationism. Expelled Situationists might form their own splinter groups but then they were just considered to be advocating second-class theory by the main group — they were unrevolutionary and merely artistic and they were unintelligent.

Life lived graffiti, Paris 1968

George Maciunas
b Kaunus (Lithuania), 1931;
d Boston, Mass (USA), 1978
Maciunas founded the radical
movement, Fluxus, in 1963,
coining the term from the Latin
word for 'flowing'. Its ethos was
that anything can be art and
anyone can make it, and its
activities embraced photography,
street art, poetry and Happenings.
Maciunas is often described
as a clown, or jester, though
his revolutionary ambitions were
deadly serious. Plagued
throughout his life by illness,
he nevertheless energetically
provoked controversy, losing
an eye in 1975 when a group
of 'Mafia thugs' attacked him
for alleged non-payment of debts
on his Fluxhouse Co-operative
Building project, which instituted
artists' lofts in Soho. He also
embarked on a lengthy
'Fluxcombat' with the State
of New York, incurring many
arrests and subpoenas, to which
he responded with insulting
letters and photographs of
himself in a gorilla mask. He
had emigrated to New York
in 1948, studying design and
musicology, both of which
would remain central to his
Fluxus Festivals – literary and
musical events with John Cage,
Yoko Ono, and Joseph Beuys,
amongst others. From 1965
he shifted emphasis onto
publications, 'Fluxfilms',
multiples and installations.

The leader of Surrealism, on the other hand, would only expel you if you betrayed Surrealist principles by, for example, making some art which expressed a lack of amazement at the marvellous, or which expressed a belief that the conscious mind is better than the subconscious mind. But you couldn't be expelled just for making art at all.

Nevertheless, Situationism was like Surrealism in that with both movements there was a paranoid climate and a terror of weakness or badness breaking out within the movement and thus delaying the revolutionary process that the movement was a catalyst for. So there had to be purges.

Three leaders

André Breton was the leader of the Surrealists. Guy Debord was the leader of the Situationists. An off-shoot of both Surrealism and Situationism was the Fluxus movement, led by George Maciunas – another charismatic leader who also was notorious for having mad purging fits.

Fluxus was anti-art. All its manifestos were against it. Like Situationism, it was for some other kind of thing that was still creativity, but which would go on in the streets and in people's houses instead of in galleries and museums. It was full of light-heartedness. Maciunas was full of good humour and jokes and he frequently displayed a Zen attitude toward existence. In his last interview, conducted on his deathbed, when he was asked if Fluxus really was art after all, he said, 'No, I think it's good inventive gags.'

'I make jokes!' he said. But he was known to be an outrageous tyrant and control freak, as well as a Zen-fan, who had to control every detail of Fluxus events and personally design all the Fluxus posters and cards and statements. Or at least see that all such stuff was designed along lines he initiated. And if anyone went off the strict lines they were excommunicated.

Is it odd or inevitable or banal that these Modern art movements, which valued jokiness, should have such angry leaders? Or are all leaders angry?

Typical

A typical Fluxus object is a games box or a puzzle box produced inexpensively as a multiple. It has no appearance of being art at all. But it might contain dust or eggshells or dried up tea bags. Or it might contain a lot of cards with printed pictures of a hand pointing a finger on each one. Or there might be some yo-yos in there, or plastic balls. So its useful function is extremely limited too. There will be a title and a process, some instructions, something to do, something to think about, even if it's just a silly thing. Which it always would be.

The Fluxus movement had members from all over the world, including Joseph Beuys and Yoko Ono. Yoko Ono made films of an eye blinking and bottoms wobbling. She showed a piece of wood with a nail in it and a hammer hanging from the wood, called *Painting to hammer a nail*. And she produced works that were merely

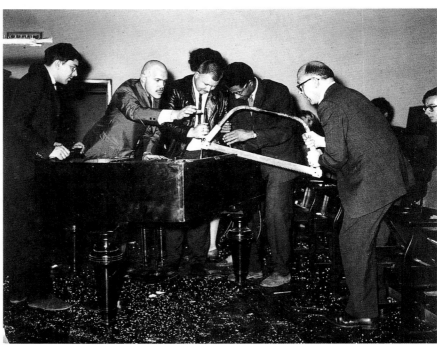

George Maciunas, Dick Higgins, Wolf Vostell, Benjamin Patterson, Emmet Williams performing Philip Corner's *Piano Activities* 1962

André Breton 1924

A Fluxus Travel Aid with a prototype
made by George Maciunas using
a *Games and Puzzles* label c. 1970

requests to imagine something, printed on postcards. Did she really break up The
Beatles? Maybe we'll never know. But that's the kind of empty random thought-
stream that Fluxus films seem to inspire – the mind zoning out on images of a toilet
flushing or an idiotic sign reading *Genius at work* or a TV screen going fuzzy.

Fluxus was about life not art, Maciunas insisted. The artists took bits of life and
made them into events. A Fluxus event or happening might be a pouring water
event, or making music on a piano with a saw or a hammer event, or a lot of people
roped together in the street and walking event, until they fell over as an event.

The lightness of the movement makes it seem odd that there was such an element
of rigour running through it and that expulsions and excommunications for the sin

Poster for Fluxus
retrospective exhibition 1995

of rule-breaking were so commonplace. But in fact it's not so odd. Fluxus art or anti-art, or whatever it was, was very precise. It was rubbish structured precisely.

Zen v Mafia

Although the Fluxus look and the Fluxus attitude are trendy today, and they run through a lot of the art of well-known art stars of today – and the word 'Fluxus' has some of the same impressive mystery power within a dinner table context as the word 'Situationism' – Maciunas is little known. He died from cancer but his departure was hastened by some Mafia guys who beat him up badly and put his eye out, following an altercation over some building work which he considered to

have been badly done and refused to pay for, which occurred shortly before cancer was diagnosed. A Fluxus principle was that artists should live in communal situations and one of Maciunas's great contributions to the present-day lifestyle of artists was his conversion in the 60s and 70s of many loft spaces in New York's SoHo area into artist's living spaces. So this assault was a rare case of both Zen and avant gardism being defeated by the Mafia.

Guy Debord

Guy Debord is a cult figure and since his suicide in 1994 he has become almost a media star. From 1957 he began to operate Situationism as if it was a sect or secret society and to conduct purges. And in 1972 he dissolved the movement and went underground and was hardly seen or heard of again until twenty years later. In 1992 he wrote a new preface for the third edition of his famous book, *The Society of the Spectacle*, which was first published in 1966. In it he stated that everything the book had claimed and prophesied was true. The only difference was that with the fall of the Berlin Wall in 1989 the Spectacle was now an 'integrated' Spectacle and it seemed even more unlikely that it would ever be defeated.

André Breton

André Breton is a well-known art historical figure but for many people there is something boring about the mention of his name and they find themselves glazing over when they hear it, or see it written on the page. There is hardly anything he was famous for doing which seems all that interesting now.

He was a writer and a poet. He was a doctor in the First World War and he was interested in madness. He met Freud. He wrote a book called *Nadja*. He wrote the first Surrealist manifesto in 1924.

Only two interesting things

Interestingly, like Marcel Duchamp, Breton made a living from dealing in art for a while and in fact it was him who brokered the sale of Picasso's *Les Demoiselles d'Avignon* to the Museum of Modern Art, New York. Why this is interesting is because it seems the opposite of revolutionary idealism. But it might just seem like only common sense to choose to make money out of something you know about.

But it is also interesting from another perspective, which is that art dealers today are hardly ever intellectuals in reality, as opposed to in their fantasies, or even particularly sophisticated or interesting usually, or much more than quite amazingly thick considering all the Conceptual art they sell. So it's pretty interesting to think of the inventor of Surrealism being one.

Also, Breton conducted some Surrealist discussions about the nature of sexuality, which have come down to us in the form of pseudo-scientific verbatim reports, with earnest inquiries into things like whether Hans Arp had ever ejaculated into a woman's ear.

Guy Debord
b Paris (France), 1931
Debord was the intransigent, self-appointed leader of the subversive movement, Situationist International. SI was born in 1957 when the anti-art, neo-Dada group Lettrist International, of whom Debord was a rising star, merged with the Movement for an Imaginist Bauhaus. It reached its high point with a series of occupations (the National Pedagogic Institute, the School of Decorative arts), pamphlets, songs and graffiti during the May events of 1968, disbanding in 1972. Debord's first essay in subversion, *Memoires* (1958), was bound in sandpaper so that it could not be comfortably accommodated on the bourgeois bookshelf. Central to Debord's theories was the concept of the spectacle, outlined in his book, *La Société du Spectacle* (1966), which indicted Capitalism for turning people into passive consumers of the depoliticized media spectacle that had replaced active participation in public life. To Debord, active public participation meant disrupting Charlie Chaplin's press conference at the Paris Ritz and 'hijacking' a priest of Notre Dame so that a member of the group could take his place during Easter Mass to declare that 'God is dead'.

But so far there has not been a way of really getting Breton's story off the ground as far as many people are concerned. They would much rather hear the story of Marcel Duchamp or Picasso, or Jackson Pollock or Tracey Emin, for example.

Of the movement of Young British Art, there is no charismatic leader in charge of purity. A list of principles of this movement could easily be drawn up and offenders against the principles could be isolated and expelled. But it's just not that kind of movement.

Flow of movements

Surrealism, Situationism and Fluxus all flow into Young British Art. Sarah Lucas's *Receptacle of Lurid Things* is a product of this flow. Although if it was taken back in a time machine to the peak moments of the three movements – say, the late 1920s for Surrealism; the late 1960s for Situationism; and the late 60s and early 70s for Fluxus – it would seem out of place. Surrealism would be the least awkward fit, maybe.

It wouldn't fit with Situationism because it is a well-made art object on a museum-like plinth. There would be something a bit too well-turned about it for Fluxus too. The gesture would be right but not the form, because it is realized so roundly and sculpturally.

The title of Lucas's work would fit with all the movements, although it would be quite flowery for Fluxus. It could certainly be part of a Situationist slogan. But the plinth would be the most wrong thing about it as far as Surrealism is concerned. The plinth is from a different flow – the flow of hyper-objects, mock-museum objects, mock-Minimalist objects, that began with the Neo Geo movement of the 1980s. If it was Surrealism, the finger would more likely be on a piece of black velvet, or only viewable through a keyhole.

Wry, dry, etc

Marcel Duchamp was revered by the Surrrealists but he never wanted to join them. He was a one-man art movement. He had various personae, and that was enough of a group for him. One of his personae was Rrose Sélavy, a pun on *eros c'est la vie*. He signed some of his works with that name and he had himself photographed as Rrose, in drag, by Man Ray. Another persona was R. Mutt, the name he signed on his most famous work, which was a urinal. It was a play on Mott, the company that made the urinal, and Mutt, of *Mutt and Jeff*, the strip cartoon characters. R stood for the French slang term *richard*, which means 'moneybags.'

Marcel Duchamp – ironic, laconic, sardonic, wry, dry, a bit austere and a bit erotic. A cool French guy. Never disturbed, always amused, always ready with a sardonic joke. Famous turn-er on-er of the stream of black, off-humour which runs through Modern art and which drives people nuts. It streams from his frightening urinal. The receptacle of lurid urine.

André Breton
b Tinchebray Orne, (France), 1896; d Paris (France), 1896 Breton has been called the 'Pope of Surrealism'. With the publication of his 'Surrealist Manifesto' in 1924, he invented the movement, becoming its chief theorist and promoter, hirer and firer. A poet and essayist, Breton originally concentrated on literature in his writings on Surrealism. However, he had a variety of passions, ranging from Gothic novels to butterflies, and was interested in naive and 'primitive' art, free association, automatism, psychotic painting – perhaps deriving from his work with the insane as a medical student – and the work of the Dadaists, whom he supported through his magazine, *Littérature* in Paris. In 1925, he organized the first Surrealist exhibition, famously attended by Dalí in a diver's suit. His most important statement on art was 'Surrealism and Painting', 1928, which saw painting as a way of releasing one's true nature. In 1927 he joined the French Communist party, and in 1938 wrote the manifesto 'Towards a Free Revolutionary Art' with Trotsky. During World War II he emigrated to the USA, where he belonged to a group of expatriot Surrealists who influenced Abstract Expressionism.

Fountain

Modern art jokes. They're not all that funny. But they are big. And *Fountain* is the first one, the biggest one of all, the unofficial icon of the Turner Prize. Bought from a shop, signed R. Mutt, sent to a big exhibition in New York in 1917, rejected, thrown away, then the next day raised from the dead and preserved forever in the minds of conservatives as the arch icon of the great Satan of Modern art.

'I was really trying to kill the artist as a god by himself,' the Great Satan told Joan Bakewell in a TV interview in the 1960s. It would be outrageous to remind ourselves now of the offensive nickname Joan Bakewell used to have — the thinking man's crumpet — but she certainly was an appropriate choice of interviewer. *Una cosa mentale*, was what Leonardo da Vinci thought art should be – 'a thing of the mind.' And Duchamp thought so too.

Today, *Fountain* lies in storage, in Paris, in the hidden vaults of the Pompidou Centre, the strong walls protecting an unsuspecting public from its full ironic blast. It wasn't actually Duchamp's first Readymade, because he had been producing them since 1913. But the others are not nearly so powerful as icons and they don't have the unique mixture of opposite tones – the cool and brassy – that *Fountain* has.

Do art in

Duchamp shrouded everything in irony, so you couldn't get the meaning straight away, or ever. You could only get intimations of meaning, or meanings. His main meaning was eroticism, it is often thought, based on things he said sometimes. He was always going on about erotic things. He made endless sex puns and saw the erotic symbolism that permeated the world but which no one else noticed, except Freud, who Duchamp didn't want to be psychoanalysed by, because there wasn't anything wrong with him. He didn't believe in psychoanalysis or in God either. And he said he was anti-art too. It was time to do it in, he said, because it had become a cult. So it was the time of the Readymade. Onto the stage it came.

At first it was a joke, then a whole line of works, then a world-shattering paradigm shift. The snow shovel, the bottle rack, the bicycle wheel, the typewriter, the metal comb, the urinal. They weren't from the art world but from the opposite world, the industrial one, the world of mass production – the desert wasteland which art had feared before but which from now on it would feel OK about.

Blankness, indifference, contempt. That's the message of Duchamp's look as he poses for a screen test for Andy Warhol in 1966. Warhol – the artist who said he wanted to be a machine, to have no feelings, to have a factory instead of a studio, to be a kind of robot of art – filming Duchamp – the artist who said anything could be art so long as an artist said it was.

Duchamp said to Joan Bakewell that the idea of Readymades generally was that only a thing he had no feelings towards – or only a feeling of indifference – could be chosen to be one.

Marcel Duchamp
b Blainville (France), 1887;
d Neuilly (France), 1968
Duchamp's influence on contemporary art – particularly Conceptual art – is profound. A member of the anarchic Dadaist movement, he disrupted conventional attitudes with such gestures as appending a moustache and an obscene caption to a copy of Leonardo's *Mona Lisa*. More ground-breakingly, however, he entirely redefined the status of the original, unique artwork when in 1913 he began his series of 'readymades' – everyday items such as a urinal or a bicycle wheel, which he displayed almost unaltered in the gallery, claiming that any object is art as long as the artist defines it as such. In 1912 he produced *Nude Descending a Staircase*, one of his most famous canvases, which became the precursor to Futurist works depicting movement in two dimensions. Between 1915 and 1923 he created his monumental glass-and-wire construction *The Bride Stripped Bare by her Bachelors, Even*, (also known as *Large Glass*). Eventually, he gave up art in order to devote himself to chess.

Marcel Duchamp as Rose Sélavy 1921

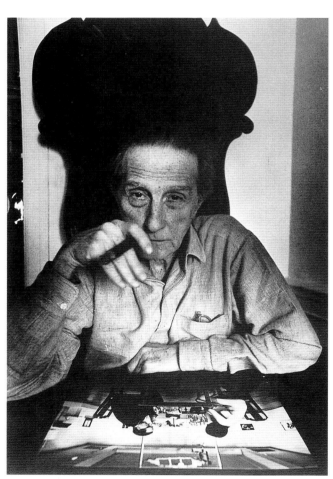

Marcel Duchamp 1965

So it wasn't him who first said his urinal was a beautiful white Modern sculptural object, sleek, shiny, smooth, gleaming, curvy, elegant. But this is how *Fountain* is often talked about now and how it has come to be viewed within art culture. And, yes, you could have all this without any skill, just by plagiarizing – using somebody else's skill.

Art kryptonite

Irony, eroticism, the mind. No need for manual skill of a special kind. Basic manual skill will do and, if need be, no skill too. These are the main themes running through Duchamp's works, a lot of which are housed in the Philadelphia Museum of Art. This is a huge building standing on a steep hill, rather like a tomb from the outside, at least from certain aspects – dark, gothic, Victorian, Edgar Allen Poe-like. Inside, it's like Pharoah's treasures. Except it's not all dark and musty but filled with light and dazzling advanced abstract and figurative Modern art hits. In the furthest chamber, like a nugget of art kryptonite radiating negativity vibes, is the Duchamp oeuvre.

An old American news film from the 40s shows Duchamp in the museum, in his shirt sleeves, smiling, kindly going along with the ideas of the film director. A voice announces: 'In the Philadelphia Museum of Art is a collection of paintings by a man whose unique view of life has greatly influenced Modern art.' Then the shot moves closer onto the figure of Duchamp and the voice says, 'Ah here you are Marcel, looking at your big glass.'

'Yes,' says Duchamp, as if he's in an ad for something. 'The more I look at it, the more I like it!'

Duchamp was already planning this work – the *Large Glass*, or *The Bride Stripped Bare By Her Bachelors, Even* – when he created *Fountain*. The *Glass* is thought to be an allegory of love. A lot of notes were produced by Duchamp to accompany it and to be a kind of guide to the various things going on. The notes are full of word plays, puns and word-associations. The Milky Way, a chocolate grinder, semen, wasps, malic moulds, dust, a polygon of sexual organs, a butter churn – they're all in there. The first three letters of *mariée*, which means 'bride,' is MAR; the first three letters of *celibaire*, which means 'bachelor,' is CEL; and that spells Marcel. That kind of thing is in there too.

Fountain is a Readymade but the *Glass* was very laboriously hand-made by Duchamp over a period of many years. He had already been making or producing or choosing Readymades for four years when he produced *Fountain*, and the *Glass* was a new departure. It was the most ambitious art work he made. Or it came to be seen in this way because it seemed to contain all his themes in an incredibly dense and layered form.

Other works could have the themes read into them. But this one has such a complicated and elegant appearance, it seems to map out the whole Duchamp

Marcel Duchamp
The *Large Glass* or
*The Bride Stripped
Bare by Her Bachelors, Even*
1915–23

vision in detail, rather than just symbolize it – or an aspect of it. But in fact there is no ultimate truth or treasure that the *Glass* is leading to. Because Duchamp was always being so erotic, the ultimate truth of Duchampianism is said by Duchamp scholars to be exactly that – eroticism, but of some special intellectual kind. But Duchamp himself said, 'There is no solution because there is no problem.'

Duchamp said the main thing he wanted from art was that it should amuse him. To do that, he didn't think it necessarily had to have a lot of manual skill. No skill being needed – or not much – to make art, is an unnerving idea for many people. Either it wasn't unnerving for him or else he wanted to be unnerving.

He claimed to have given up art for many years. He said he was working on chess problems instead. But it turned out he was secretly making the *Large Glass*. Then during the last twenty years of his life he was secretly making *Etant Donné*.

Which consists of a view through a peephole onto a life-size, hyper-realistic, headless naked woman. So he was always making something. But he wasn't making new things for the joy of seeing them in a gallery. He said that kind of thing just made him ill.

Duchamp's Readymades look good now. They look sculpturally elegant. He said he chose them out of indifference but we know there's no such thing. It would be like saying you didn't think there was any meaning behind jokes. When he was asked in the 1960s at a museum conference, why – when he had said he wanted to destroy art – his Readymades now appeared so aesthetic, so much like art, he replied with the quip: 'Well, no one's perfect.'

Western civilization

'Hey Western civilization, artists deserve the fame of rock stars, let's begin with me.' That's a quote from one of the word paintings of the New York artist Sean Landers, who is now in his mid-30s. I am remembering it now, as I stand in Landers' studio in New York, looking round at some of his new works. It is in fact almost possible to be like a rock star if you are a successful artist in New York. Egotistical, arrogant, expecting to be worshipped. Landers, who became well known and successful in the early 90s, tempers the ego's urgings by playing the artist a different way – as abject and gormless and unformidable and as generally teenage as he possibly can be, without actually falling over.

He paints stream-of-consciousness thoughts in tiny words painted with tiny brushes. The thoughts rise in great banks. Each one is a perfect gag, perfect for the painting, which only requires the gags to have a mild comedic value but to have a definite beginning and ending so you can tell visually where one stops and another begins. The canvases end up as vast fields of tiny marks with rhythmic patterns running through them. Thus, early 90s Slacker atoms mingle with mid-60s Conceptualism atoms and make a new genetically modified Slacker-Minimal hybrid.

'Not only does he mock modernism but he also writes his mindless drivel all over each of his abominations,' another quote reads. The art reflects on its own making, like a classic work of 60s Conceptualism.

Many of his gags are about paranoia. The twist to these ones is that Landers actually is quite paranoid. I ask him if thinks he's more paranoid than everyone else or if it's only paranoia that makes him think that. 'That I can't answer,' he says, reasonably enough.

Let's look in his head anyway. Part of him is a grown man, part is arrested at a floppy, gormless stage. This part is well summed up in the 30-minute minimalistic video he exhibited at the Venice Biennale in 1993. In it he poses languidly in front of a wall of his own writings on sheets of yellow legal paper. They are neatly pinned in rows, in a parody of the favoured grid form that runs through 60s Minimalism and Conceptualism. The poses must be exaggeratedly moody, because the title is *Italian High Renaissance and Baroque Sculptures*.

Sean Landers
b Palmer (MA), USA, 1962
'My original idea was to make Conceptual art entertaining, sloppy, emotional, human and funny,' New York-based Sean Landers has said, adding that this ironic stance eventually turned into sincerity. The result is a kind of slacker art, in which naively painted images and banal subjects are set against a backdrop of scrawled texts – a ramble along his stream of consciousness. Painting, however, is only one of the many media he employs, eschewing 'masterly genius' in a single art form. The dichotomy of genius versus dumbness is one with which he often plays, presenting in a number of works a nerdy, self-deprecating image of himself: as a bronze monkey in *Singerie: Le Sculpteur* (1995); as an 'idiot', in his autobiographical book *[sic]* (1993); as a vain model in the video *Italian High Renaissance and Baroque Sculpture* (1993), or as a seventeenth-century Irish drunk in the series *A Midnight Modern Conversion (An Altercation)*, 1996.

Sean Landers in his studio 1998

Even though it's wrongly spelled he's got it to look as much like a sculpture as he can. Which is probably why his jeans are gradually coming down, inch by inch, revealing, first, jockey shorts, then as these inch down as well, alarming full hairy nudity. His long hair flops down, too – conditioned with Pantene, apparently, as we learn from his rambling autobiographical book entitled *Sic*, as a joke on wrong spelling and a play on sickness.

In another video, mental floppiness is expressed by a Sean surrogate, a live chimp, who paints a random painting with paint brushes that Sean hands him. 'At least I didn't saw him in half and put him in formaldehyde!' he joshes to me, with the direction of the josh once again back toward art itself – reflection piling upon reflection.

Sean Landers *Bubble Boy* 1998

Sean Landers *Self-Something* 1994

But anyway, back to this dialectic of the floppy and fully formed. One part looks at the other, draws from it, makes a form from it. The floppy part flops out spontaneity. The grown part hones and perfects the material. It's a dialectic but you can't tell which is which.

'See I wanted to paint pictures,' another quote goes, 'but I wasn't that great at it so I decided to write on them to make them better. And check it out, it worked.'

Why Magritte is popular

There are visual gags and word gags. Artists who make art gags use both. The idea, the image — they must never fit. They must just grate together making art sparks. This was the system of René Magritte, the most popular Surrealist ever, next to Salvador Dali. Magritte's joke is the joke of the wrong label. The wrong word for the image. The wrong thought for the word. The wrong feeling for the thought. *Ceci n'est pas une pipe* it reads under his painting of a pipe. 'The valise,' it says, under a church. 'The horse,' under a clock. *The Palace of Curtains* is the title of a painting which doesn't show any curtains, but has the word 'sky' painted on it instead.

Magritte made a lot of little films with his friends in the late 1950s and early 60s which are kept in an archive in Brussels. They record nothing but whimsical non-sense — middle-aged people in mid-century bourgeois sitting rooms pulling faces, dressing up, doing miming acts. Then here and there, something flashes — memories of Surrealism. A couple with sheets over their heads, or Magritte walking down the road in his Gilbert and George outfit — putting on his bowler hat, taking it off again, smiling, frowning. He looks like he's miming the meanings of his famous paintings, paintings that turned meaning upside down.

Like an old Kingsley Amis he appears, with his pals in the Belgium suburb where they all lived. The film running fast. His wife eating a suggestive Freudian banana like there was no tomorrow. And like there was no reason, because the film is running backwards too. The old devils.

Magritte is popular because his jokes don't stay up an ivory tower. But also because everyone knows his painting style is old style and he seems like a real artist. Although actually nothing like it exists in traditional art. It is a sign style, flat like posters or ads — ads in the 1930s. The point of it is to make a point, not to draw attention to itself as a style. But it is beautiful in a way. The economy of the style makes you stare — the ingenious picking out of outlines, making silhouettes expressive.

For example, the multitudinous silhouettes of the famous raining bourgeois men in *Golconda*, from 1953 — a time when Abstract Expressionism, not Surrealism, was the reigning international painting style. These strange little iconic uptight business guys that no one under thirty has ever seen in real life, only in Magritte — are they raining down or levitating up?

René Magritte
b Lessines (Belgium), 1898;
d Brussels (Belgium), 1967
Magritte's characteristic dead-pan style may reflect his roots as a commercial artist, but it is also the perfect vehicle for his games with visual truth and illusion. The matter-of-fact look of his works gives them a documentary authority that makes the Surreal subject matter all the more disorientating, and emphasizes the ambiguity of visual truth. The series *Ceci n'est pas une Pipe*, for example, informs us that the pipe in the painting is not one, a reference to the difference between reality and representation. This is constantly blurred in works such as *The Human Condition* (1933), a painted view of a painting of the painted view outside the window. Magritte experimented early in his career with Futurism, Cubism and automatism. It was after seeing a Giorgio de Chirico painting that he adopted the dream-like imagery of Surrealism, becoming a leading member of the movement and only occasionally diverging from this style — most notably in the cartoon-like *vache* works of the late 1940s.

René Magritte
Golconda 1953

Nightmare

Magritte's style is like the illustrations in Ladybird books. The Ladybird book of phenomenology perhaps. What would it say? We have pictures in our heads for everything we see, conceptual signs that guide us round the visual world. But what happens when you paint only the signs and not the things they refer to? And make the signs tell lies? Ugh! That would be horrible!

Magritte tried mixing the deadpan style with a sunny Impressionist style briefly during the War. The results look quite gruesome and they seem to prove that the Magritte delivery must only ever be dead straight for it to work – everything must be absolutely straight in a world of logical wonkiness.

But then later he tried an Expressionist style, even more briefly, in fact only for one exhibition, for which he dashed off all the paintings quickly. And these all look

René Magritte in his studio 1950s

Piero Manzoni

b Soncino (Italy), 1933;
d Milan (Italy), 1963
Manzoni first exhibited his
'Achromes' in 1957. Showing
the influence of Fontana, these
were white paintings made from
folded or stitched canvases,
dipped in kaolin and often
covered in white objects such
as eggshells or polystyrene balls.
Neither paintings nor sculptures,
these reductive works were
characteristic of an artist who
constantly sought out new
artistic definitions. He was
particularly interested in testing
the boundaries between aesthetics
and life. In one work, for
example, he signed the bodies
of naked women, designating
them works of art. Many of
his sculptures, including *Artist's
Shit* (1961), in which he canned
his own faeces, attacked the pre-
tensions of the art world as well
as the wider bourgeois sensibili-
ty. In similar works, he signed ·
balloons of his breath and blood
as if they were religious relics. In
1959 Manzoni became a founder
member of Galerie Azimuth
in Milan, a showcase for the
growing anti-conventionalist
tendency in Italy. He died
of cirrhosis at the age of 30.

quite funny. One is called *Famine* and it shows heads eating each other. Throughout
these paintings, the contours are all unsteady and the colour is all ghastly – tasteless
tartans and lurid stripes instead of Magritte's characteristic tasteful greys and
browns and infinite nuances of dingy flesh colour. Another one shows a nutty man
with too many noses and too many arms, smoking too many pipes, like a nightmare
of Modern art.

Cans of shit in the 90s

Piero Manzoni was an Italian artist who died at the age of 29 in 1963. But before
he went he got some excrement – his own – and put it in a tin can. 'Excellent!' he
said, in Italian, 'I think I'll call it *Merda d'artista*!'

Manzoni's canned shit is well known now, or the idea of it is. It's an idea as
powerful in the popular imagination as the idea of blank canvases. In fact the actual
cans are not all that well known. There are many of them. Each one contains an
amount of the artist's own shit. On the label it says 30 grams but of course no one
can really tell. The labels are quite detailed and well designed, with the name of the
work in three languages, plus the date, the artist's signature and the name of the
collector who owns the individual can – all this is part of the look. PIERO MANZONI
is printed on the label in light grey letters on a grey ground, with the name repeating,
so it makes a mantra of the artist's name, as well as a grey and yellow pattern.

When they were first sold they cost their weight in gold. Now they're worth
much more. If one came on the market today it would cost about £30,000. So
when a pile of them was shown in a vitrine in London's Serpentine gallery recently,
it was a pile of shit but it was nearly a million pounds' worth.

Holy shit

Money, shit, art: the holy trinity. Manzoni took jokes to a higher plane than Duchamp, in that he elevated them to the spiritual plane which was somewhere Duchamp never wanted to go. Manzoni transubstantiated the things of the earth into mystery things. His signature was his magic medium. With it he could turn balloons filled with his breath into saintly relics or make women into art works. He signed them and issued them with a certificate so they knew what class of living art work they were – temporary, permanent, intermittent and so on. Each state was symbolized by a stamp of a different colour on the certificate – for example, a state of permanent art was symbolized by a red stamp. The women had no special duties as works of art but they did become prisoners of Manzoni, prisoners of his idea.

He wanted to make the whole world into a prisoner too, with a metal cube inscribed with the words 'Base of the world', which he exhibited upside down on the floor, making the earth into a sculpture, one that floated in infinite space.

The cult of the signature

The young British artist, Gavin Turk, has copied Manzoni's signature a few times, not to forge Manzonis, and perhaps make Manzoni his prisoner, but just to see what would happen if he wrote the word on a piece of paper – would it be art? What kind of art? What if he tried writing his own name – 'Gavin Turk'? Or 'Gav'? He did all these things and it was art, because of the cult of the signature, which

Piero Manzoni
signing woman 1961

Gavin Turk
b Surrey (England), 1967
Turk's works circulate around the theme of the cult of the artist. His piece for his MA degree show at the Royal College of Art – a blue plaque reading 'Borough of Kensington/Gavin Turk Sculptor/Worked here 1989–1991' (*Relic*, 1991–3) placed in an empty gallery – was failed by examiners, but this has not prevented him from joining the group of successful YBAs who emerged at that time. In subsequent pieces he has elevated masticated lumps of his chewing gum to museum status by displaying them under glass (*Floater*, 1993), or presented his signature as the work. By ironically setting up a self-aggrandising connection between his own work and that of famous historical artists, he examines ideas of authenticity and celebrity. He has made self portraits in the guise of David's dead Marat (*The Death of Marat*, 1989), as Sid Vicious in the pose of Andy Warhol's *Elvis* (*Pop*, 1993), or based on Warhol's paintings of himself (*A Man Like Kurtz*, 1994). In 1996, he placed a gleaming black industrial skip (*Pimp*) in the gallery à la Duchamp's readymades.

Manzoni was already commenting on in the early 60s, like Duchamp in the early teens. But he didn't write on any women because today we draw the line at that kind of thing.

Old boot in the 80s

The year: 1987. The place: Germany. The mood: defiant. The place a bit more specific than Germany: a gallery. Inside: an object on a plinth. The object is a zip-up wedge-heeled square-toed 1970s Glam Rock boot. The item is solid and real and was obviously actually worn by someone and now is genuinely worn out. It is black with a gold pattern. Perhaps because it is black it is not even 70s but early 80s. Which would be even more absurd. Maybe it was worn by Lemmy from Motorhead. The plinth is a cube made of machine-cut thick sections of yellow foam rubber separated by thin sections of chipboard, also neatly cut. On top is a Turkish carpet. Between the carpet and the foam is a metal plate. The old boot stands solidly upon the carpet.

Bergwerk II is the title, which means something like '*Coalmine II or Mine II*.' Because it is the 80s we know plinths are never just plinths. They are loaded with all sorts of meanings. Meaning runs through them like strata. Or emanates off them like ectoplasm or radio waves. This one actually is stratified, so we don't even have to be clever to get it.

But what is it excavating or mining, this sculpture or anti-sculpture? And what was excavated before, in *Mine I*? Was there a *I*? Is mining or excavating really the theme? Is it people's minds that are being mined – the confusions and wrong thoughts in there? Is it everyone's minds or just its creator's, Martin Kippenberger?

Martin Kippenberger
Coalmine II 1987

How long can we keep this up?

8 pictures to see how long we can keep this up is the title of a group of paintings by Kippenberger, from 1983. Kippenberger was a very successful artist of the 80s who became even more successful in the 90s. By the time he died in 1997 from liver failure brought on by alcoholism, he had produced an enormous volume of work, in a lot of different styles and media. His most usual painting style, though, was a fast, light, robust, cartoony, mock-Neo-Expressionist style.

The joke of the title might be against Kippenberger himself and his circle of friends at this time – writers, artists, dealers – who were often criticized for being only a gang of opportunists. Or it might be against other Neo-Expressionists who took the Neo-Expressionist style too seriously, or who believed in it as a style, when it could easily be thought to be only an anachronism.

In any case, a jokey approach to all styles was characteristic of Kippenberger's use of them. *Bergwerk II* was in a Neo-Duchampian style and it was made at a time when the trend for Neo-Expressionism in Germany had died away and been replaced by a trend for a kind of designer-object style with clever Conceptual art ideas attached.

Jokes aren't the whole thing, though, with Kippenberger – it's not just joking for the sake of joking. But probably by now we have got this point about all jokes in Modern art.

Kippenberger churned out many paintings. They were abstract and figurative and they had all sorts of different types of space scrambled up together. They had titles like *Five little Italians made of chewing gum* or *War bad*. One of these was a little green monochrome, the other was a painting of a little Father Christmas making a 'halt' gesture to an army tank. Both paintings have the same scruffy but sensitive painterly aesthetic. You could believe Kippenberger really could paint but also that for him really being able to paint wasn't the main point. What was the main point? It was to be ironic and jokey and creative and individual.

Correct

Was it correct to be an individual? Was it individual to be correct? An untitled painting by Kippenberger has the not-quite-right words *Political corect* painted in red in the middle of a white space. Because the rest of the painting around the white is mostly green and grey, the red and white look good. Under the red letters are some smaller black ones. They spell out *bistro pub*. The jazzy green and white patterning is actually the pattern on a schematically rendered jazzy shirt. The rest of the painting is wood-grain pattern, like wood-grain wallpaper.

This painting from 1994 is typical of Kippenberger's output as a whole, whatever the medium, in that there seems to be some kind of comment about the modern world. The modern world is definitely there in all his art – the look of it, its surfaces, the feel of it, what people think, changing liberal values, changing lumpen values,

Martin Kippenberger
b Dortmund (Germany) 1953; d Vienna (Austria), 1997 Kippenberger seems to have spent his career rebelling against his strict evangelical upbringing in the Black Forest. Amongst other unconventional acts, he bought a gas station in Brazil as a joke and founded a punk band. His playful work embraces drawing, painting, sculpture, installation, artist's books, graphics and performance. In the mid-1970s he opened a space in Berlin showing work by his collaborators Georg Herold, Albert Oehlen and Werner Büttner. He initially became known as a painter, influenced by Polke, his outrageous imagery taken from cartoons, German tradition, and the conventions of Modernism. Deliberately offensive, he followed an elaborate aesthetic of bad taste and deliberate obfuscation of meaning. In 1987, he incorporated a painting by Gerhard Richter into a banal coffee table, a sardonic gesture that commented on art in the service of bourgeois ornament. The same sense of bitter pain can be seen in his 1985 series of self portraits depicting his deteriorating body. However, he claimed he wanted to disseminate a 'good mood'. This ambition was wittily achieved in his last major project *Metro-Net. Subway Around the World* (1993–97), for which he installed entrances, emitting convincing sound effects, to an imaginary global underground railway in various sites throughout the world.

Martin Kippenberger
Untitled (Political corect) 1994

newspapers, the transport system, racism, sexism, museums, Neo-Nazism, cartoons.

When you try to be clear what the comment is, though, the mind starts sliding. The comment doesn't work in paraphrase. Is the painting a paraphrase of a comment? But paintings have their own autonomy. At least they do if you are an aesthete. Is aesthetics important? Obviously being politically correct is important. But is it important to spell it right? If you are German will you be forgiven if it's wrong? Could painting ever be correct? Is it wrong to be decorative? Should we read lots of books by Wittgenstein?

Wittgenstein

Wittgenstein is the title of a sculpture by Kippenberger, made at the same time as *Bergwerk II*. It is a plain shelving unit probably bought from Ikea. The only work he did on it was to paint it grey, not even with much finesse. So it's a Readymade made into a sculpture by an act of painting rather than naming; although naming is a factor because Wittgenstein was a favourite author among Minimal and Conceptual artists of the 1960s. That's quite a superficial way of referring to the important influence of Wittgenstein on those movements. But it seems appropriate because grey was the favourite colour of both those movements and that's quite a superficial thing to say too.

If the grey was put on more smoothly the whole mood might be different. So lack of finesse is wrong – absolutely the right amount of finesse was used because otherwise this work would have a completely different aesthetic. The distinctive aesthetic draws you in, as does the jokiness. They draw you in up to a point but once you're there you could feel you're not quite sure where you are. Which was the feeling we were beginning to have about *Mine II*.

Martin Kippenberger
Wittgenstein 1987

Heil Hitler you fetishists!

The wrongly spelled but politically correct bistro pub – it goes with Kippenberger's exhibition called 'The No Problems Disco' and his endless stream of slogans and jokes and baby-talk and alarming acronyms on scruffy abstractions. (For example, the letters *H.H.I.F* all on top of each other down the right-hand edge of a painting from 1984 of what might be an abstracted German letter-box – *Heil Hitler Ihr Fetischisten!*) If we were at the bistro now, we might be hearing one of his records with lyrics that just go 'ja ja ja' or 'yuppi do' in a mournful idiotic Bavarian beer-hall drone, with an Easy Listening keyboards backing track.

We might be flicking through *No Problem*, his book of thoughts, including his thoughts on identity crisis, alcoholism and chocolate mousse. 'We don't have problems with the Rolling Stones,' one of the thoughts goes, 'because we buy their guitars.'

'We don't have problems with people who look just like us because they feel our pain. We don't have problems with the Guggenheim because we can't say no if we're not invited. We don't have problems with disco door waiters because if they don't let us in we don't let them out. We don't have any problems with women because they know why. We don't have problems with tomato and mozzarella salad because we pay back with *mousse au chocolat*! We drink, we fall down, no problem.'

Maybe he'd be sitting there talking to us, in a non-stop wisecracking way, which could be quite intimidating, or so I thought when I used to have to sit through it sometimes, in Cologne, in the Chelsea Hotel. He owned a part share in the hotel and it was his idea to name it after the one in New York, as a kind of Appropriation art gesture. All of the rooms had art works in them by him or by his friends. He'd be in the restaurant firing off wisecracks. 'Every artist is a human being!' he'd exclaim.

He had a scarred nose, the single legacy of a savage attack by a group of Punk girls outside a bar in Berlin one night, in 1981. 'Dialogue with youth' was the announcement on the invitation card for his exhibition in Stuttgart shortly afterwards, next to a photo of his heavily bandaged and wired-up face in hospital.

Martin Kippenberger
Self portrait 1982

Kippenberger and Joseph Beuys

When Kippenberger said every artist is a human being it was a twist on Joseph Beuys's famous quote that 'Everybody is an artist.' Beuys – who died in 1987, a year after Warhol and ten years before Kippenberger – was a messianic hero of art who wanted to change the world and make it better. Art should not be an exclusive, hermetic system of inward-looking ideas, he thought, but it should be an integration of all systems of understanding or processing or expressing the world. Whether it was Jung or Zen, or green politics or Marxism, or even a bit of capitalism, or the Maharishi or Duchamp or Andy Warhol, or drawing.

Kippenberger said the Beuys approach was successful when Beuys stated that from an aesthetic point of view the Berlin Wall was bad because it was 8cm too low. But when Beuys attempted to create the impression that the natural end of the Beuys system was for Beuys to take his place in the German parliament – with his famous felt hat and his shamanism – this was the failed side of the approach.

Dictates from above

Meine Fusse von unten gegen das Diktat von oben means 'My feet from below against dictates from above.' It might be a well-known German saying. Maybe children at *kindergarten* learn it and it helps them be more organized. In fact it is the title of another Kippenberger painting from the 80s, showing an abstract shape made of glowing red and blue paint, throbbing in the centre of some gestural squiggles.

To be trapped in contradictions is a well-known idea about modern life. And well-known ideas were Kippenberger's forte. It was odd to make them into art because they already seemed to work OK as ideas. They were banal. They were beneath art. But then once they were made into art they seemed odd as ideas and a bit more up to the level of art.

The images and jokes flow by. A ghastly cartoon kitsch porn prostitute staring aghast at a giant rippling drooping penis of Amazonian Anaconda dimensions. A painting of a naked beauty queen with a face full of goofy, pained disappointment and hands full of shopping, called *Self-inflicted justice by bad shopping*. A painting of Lemmy from Motorhead called *Motorhead II (Lemmy)*. Henry Moore sculptures with holes in the middle, called *Family Hunger* – a photograph on the invitation card shows a woman breast-feeding one of the smaller ones. And hundreds of drawings on hotel stationery from around the world – multi-style but with a lot of recurring jarring, unaesthetic, Woolworths style, or the romantic girly style of *Petticoat* or *Jackie*. A real lamppost from Venice, but adapted for drunks, with the post bent into a graceful S curve. And a wall-size photo of a gas station in Brazil, which Kippenberger owned. He bought it on a trip there once, just to have the answering machine message announce: 'Hello, Martin Bormann gas station here!'

Ugly lumpy

Eggs and egg symbols keep coming up in Kippenberger's art. An egg as big as a head made of plaster with a zip running up the side stands on a plinth. A fried egg table was another sculpture, along with a chair upholstered with fabric bearing a fried egg pattern. A Humpty Dumpty man in a Bavarian hat and *lederhosen* looks angry in an ugly lumpy blue painting called *German Egg Banger*. A painting from 1991 shows Jesus on the cross being menaced by a fried egg. Another one from the same year shows a semi-naked Kippenberger rendered in a queasy ugly-realism style, posing absurdly, like a Renaissance sculpture, with a Van Gogh-style beard and cropped hair, sharing a layered Post-Modern space with multi-style symbols of a hangman's noose, a rubber life belt and a hatching egg.

Traditionally eggs symbolize birth and rebirth and new beginnings. And jokes, because jokes are hatched. Or if you're German they sound like yolks. Which rhymes with folks. And Kippenberger was an artist of the German *volk*. 'One of you, among you, with you,' he announced on a poster from 1979.

Martin Kippenberger *German Egg-banger* 1996

At the Chelsea Hotel he was often to be found in the restaurant, drinking if it was the evening, or recovering if it was the morning. The artist of the perpetual hangover, staring at his breakfast and making up new egg symbols out of his head.

What would they be hatching? New Kippenbergers, hundreds of them, rolling through his art in oil-paintings, drawings and photos. Each one more ravaged and sagging than the last, as alcohol took its toll. In an art calender called *Elite 88*, he made himself into the pin-up for every month. On the July page, he poses nobly before a mirror in nothing but underpants pulled up over a big belly, Picasso-style – but looking a lot less healthy at 35 than Picasso did at seventy.

Noodles yummy
Eggs for breakfast, noodles for dinner. Pasta and noodles make up another Kippenberger *leitmotif*. They are the stuff of life, of course, but also the stuff of nonsense. In *Daddy do love Mummy, noodles all find yummy* – a woozy, smeary abstract-figurative painting from 1982 – noodles, baby-gurgling and a silhouette boy penetrating a silhouette girl from behind all somehow equate.

Spaghetti and the Pentagon intermingle in another image, this time a photo on a poster, from 1985, showing the artist in sunglasses forking a trail of the stuff up to his mouth – 'Selling America and Buying El Salvador: Problem – No Problem' is the announcement.

A sculpture from 1991 is a life-size golden gondola hanging on chains in an empty space, with two packing crates stacked where the passengers should be. One has the word *Social* printed on the side. The other says *Pasta*. Social pasta – is it that we can't feed the world but we can come up with tomato and mozzarella salad and anachronistic theme park tourist spots? And Venice is the city of art and art is an anachronistic theme park?

The Society of Spaghetti
If only Guy Debord would excommunicate Kippenberger and put us all out of our misery, we are probably thinking by now. The association is right because Kippenberger is a bit Situationist, but it's Situationism adapted to be more modern and alive, less ossified and rigid.

That's enough jokes
Challenge all bourgeois assumptions – this is what art must do. But don't challenge too much because then you lose touch with reality. Reality basically is quite bourgeois. We can't escape it. We are it. We certainly go to all the same restaurants they go to and eat the same noodles. What else? Art must be stylish and good. So it's just as well Kippenberger had a sympathetic aesthetic running through his multi-aesthetic. His painterly style is sympathetic and his jokes draw you in too. You look again at what had seemed gruesome and see that it could be beautiful after all.

A man comes home and finds his best friend in bed with his wife. The man throws up his hands in disbelief and says, "Hey Rick, I have to, but you too?"

Richard Prince *Untitled* 1994

Somebody else's act

When Richard Prince first copied out his psychiatrist's joke in 1986, he was known as one of the main originators in New York of Appropriation. Appropriation artists of the late 70s and early 80s borrowed pre-existing imagery and gave the imagery a new twist. Often, the imagery was from the mass media. And often it was part of the shock of the art that the artist didn't seem to have done any work. For example, Prince rephotographed ads from magazines, framed them and sold them as his own art. So, in this climate, an appropriated joke about somebody's act being appropriated by somebody else and used by them, would have been funny.

Suburbia

Prince is in his studio, now, silk-screening some jokes onto white T-shirts. One reads: *I went down to Miami, they told me I'd get a lovely room for seven dollars a week. The room was in Savannah Georgia.* The studio is a new, purpose-built building next to his house, which is just outside Albany, a pretty, leafy, peaceful small town, four hours' drive from Manhattan. Prince prints the writing – which is his own hand-writing, photographically processed onto a silkscreen – and then paints it out and prints it again further down, with the joke now emerging from a washy atmospheric smear.

Other paintings of jokes from the 80s until now lean against the walls. The more recent ones are bigger. The style is loose and improvised. Some of them look like lyrical 1950s abstracts, with free swirls of thick paint over most of the surface and

Richard Prince

b Panama City, FL (USA), 1949 Prince became an art star in the 1980s with his 'Jokes' – monochromatic canvases presenting visual and verbal gags, sometimes corny, sometimes enigmatic. These gently mock the intellectually rigorous works of Minimalism and Conceptualism, which made use of the monochrome and the text. Appropriating material from popular culture, they also provide a critique of authorship and artistic value. Often taking psychiatry, race and sex as subject matter, they retain the anxious undertow of the original joke. Prince began as a figure painter, but by the mid-1970s was creating collages of photo and text. In 1977 he became the first artist to re-photograph magazine advertisements. These images of luxury items, and later, male and female models, exposed the mechanisms of seduction and alienation. Manipulated travel and leisure ads followed, casting doubt on the authority of the photographic image. Themes of identity and gender recur in his 1984 group 'Cowboys', taken from Marlboro ads, and in 'Girlfriends', appropriated from biker magazines. In 1987, Prince began a series of repainted car-hoods, and by the 1990s, he had conflated these with the jokes in what he calls his 'White Paintings'.

Richard Prince
The Literate Rack 1994

Man walking out of a house of questionable repute, muttered to himself, "Man, that's what I call a business...you got it, you sell it, and you still got it."

the jokes scrawled across the bottom edges. The ones from the late 80s are more minimal: flat bright monochromes with jokes silk-screened across them in type-written lines, the type set in a uniform Helvetica bold.

The type on a red monochrome reads: *Two psychiatrists, one says to the other I was having lunch with my mother the other day and I made a Freudian slip. I meant to say pass the butter and it came out you fuckin bitch you ruined my life.*

Prince is now in his mid-40s. He has been painting jokes since his 30s. They are not particularly loaded for him now. He thinks of the jokes as subject matter and he thinks of his paintings as quite straightforward. Not Conceptual art gags but paintings. It is quite easy to think of them as scenes from suburbia. The subjects are almost always petty cruelty of some kind. If you took almost any of them literally they would be quite painful. You wouldn't want it to happen to you. But because they're just common jokes, they're the kind of thing that happens to everybody.

Once a painting is finished it seems 'extremely abstract' to him and he forgets about the subject matter. He just thinks about the construction and the form, like normal painters. In fact when he started painting jokes it was because he wanted to be normal. He was fed up being thought of as conceptual.

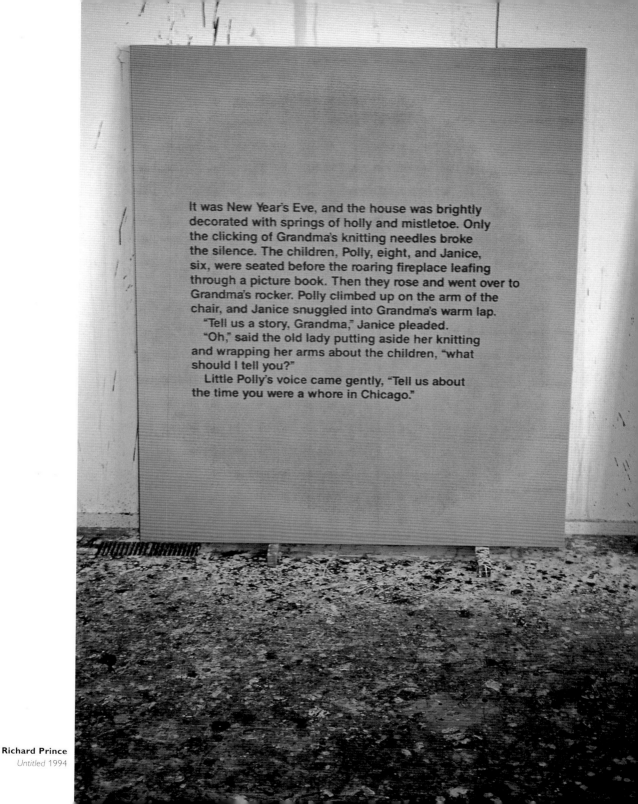

It was New Year's Eve, and the house was brightly decorated with springs of holly and mistletoe. Only the clicking of Grandma's knitting needles broke the silence. The children, Polly, eight, and Janice, six, were seated before the roaring fireplace leafing through a picture book. Then they rose and went over to Grandma's rocker. Polly climbed up on the arm of the chair, and Janice snuggled into Grandma's warm lap.

"Tell us a story, Grandma," Janice pleaded.

"Oh," said the old lady putting aside her knitting and wrapping her arms about the children, "what should I tell you?"

Little Polly's voice came gently, "Tell us about the time you were a whore in Chicago."

Richard Prince
Untitled 1994

I ask him if he always thought of himself as funny.

'No. I never thought I had a sense of humour. I'm very bad at telling jokes. And I've only made one joke up in my entire life – Why did the Nazi cross the road?'

'That's the joke?'

'Yeah.'

Maybe it's a joke on jokes.

Coming second

Prince's painted jokes have different punctuation styles, ranging from no punctuation at all to standard punctuation, depending on the house-style of the source joke book or magazine. But the differences are immediately noticeable and are part of a range of differences that now animate Prince's joke world, making it seem very complicated and baroque and dramatic compared to its original simple beginnings in biro on A4 paper.

Another painting leaning on the wall is a big black and white one with a silk-screened cartoon image of a stock desert island situation. A sexy blonde and a marooned man, a palm tree, the endless sea. The caption for this one is completely dislocated from the joke, which has the effect of emphasizing an ideal joke world – a world of stock situations, which might not be all that ideal in fact because of the pain never stopping.

A wife tells her husband he's the world's biggest schmuck. 'In fact,' she says, 'if they had a contest for schmucks, you'd come in second.' 'Why second?' he asks. Says the wife, 'Because you're a schmuck!'

Tragic joke

Prince says when he likes some of the famous jokers of American pop culture it's because of their seriousness. He likes Mohammed Ali's quick-fire limericks and his self image as a politician and not just a boxer. He likes the fact that Lenny Bruce never thought of himself as a comedian. He likes Charlie Chaplin and Rodney Dangerfield always making themselves the subject of ridicule. He used to work in a night club and he saw first-hand that the cliché of stand-ups being quite depressed was quite true. He likes some of Woody Allen's early comedy routines and he quotes a line from a Woody Allen cassette:

I married my first wife on Long Island and we got married by a rabbi, a very reformed rabbi, a Nazi.

Fearing there might be a misunderstanding about repetition, or Nazi obsession, he says it's the idea of jokes as a survival mechanism that makes him remember this one.

For some reason, he has his first psychiatrist joke in the studio. He pulls it out of a drawer. 'It looks pretty beat. It doesn't really look like art right now. And I suppose that would have been more interesting at the time. But right now I just want to make something that looks like art.'

CHAPTER SIX

THE SHOCK OF THE NOW

Gillian Wearing
Dancing in Peckham, 1994

Tick tock

Hi! You're here. And it's now. And soon it will be the end. Let's sort out all the anxieties of now in ten thousand words. That's already 25. Twenty-eight now. Phew, it's hard to conceptualize time! Why do we have to conceptualize anything, is one of the main anxieties that society has about the art of now. Within art there are many anxieties too because art expresses the anxieties of the society among other things. But it rarely expresses the main one directly, the anxiety that art is vacuous now.

This anxiety exists just as strongly nowadays as the impression that art has suddenly become incredibly popular and full of significance and meanings, whereas before it was unpopular and only had introverted meanings. One is superimposed over another, an anxiety over an impression. Or there is a sequential relationship: the more popular art gets the more vacuous it is. Or one is inside the other.

Jack in the box

Art now has meanings by the bucketful and anyone can get them, at least after an initial puzzlement, because meanings that can't be got straight away have been banished by artists. And the adventure now is for artists ceaselessly to seek out any obvious or inane meanings that might have been overlooked since obviousness became the new thing, whenever it was, the 80s maybe.

Before, in the golden age, with Chagall or Matisse, say, it was quite a leap to accept a musical kind of meaning that art might now have instead of a literary type of meaning. But then with Conceptual art or Minimalism, the meanings were all obscure or too dry or studious and it wasn't worth the effort of leaping at all. And now – the third phase – there is a jack-in-the-box effect, where the lid of meaning is in the closed position but you know when it opens, which it always will do now – on well-oiled hinges because of art's new popularity – something stupid will be popping out and whistling.

Hell

Relatively recently the assumption was that there was no point in thinking about contemporary art because it didn't mean anything to anyone except artists and you could easily live your life without it. Now there is a growing anxiety that there might not be any point to it because its meanings are too available and also too available elsewhere, in ads, rock videos, crappy moronic blockbuster films, on the Internet and so forth. As art draws ever closer to maximum immediate impact it becomes less valued. Films and ads are better because at least you know where you are with them. In hell, probably, or in a Salvador Dalí painting.

Think about it art

When art is about ideas and not about aesthetics or loveliness or inner spiritual depths – well, OK, when it's about ideas, let's keep it simple – how do you tell a

Gillian Wearing

b Birmingham (England), 1963
Wearing's photographs and videos play with the limitations and possibilities of documentary truth. *Sixty Minute Silence* (1996), for example, seems at first to be a still photograph of a group of police officers, but after a few seconds, their twitching and shuffling reveals the work to be an unedited video in which they pose for the duration of an hour. Similarly, while the experience of *10-16* (1997), in which the voices of children emanate from the mouths of lip-synching adults, is bizarrely 'unreal', an interpretation of their words emerges that is not so much false, as insightful. Wearing's enquiry walks the tightrope between perceptive observation and painful voyeurism. For *Confess all on video…* (1994), she persuaded a group of complete strangers wearing masks to divulge their innermost secrets. And in the series of photographs *Signs that say what you want them to say not signs that say what someone else wants you to say* (1992–3) she invited her subjects to write personal messages on cards. In these and other works, she presents a touching, if disturbing, form of portraiture in which the subject is given a voice.

Cornelia Parker
Exhaled Cocaine 1996

good idea from a bad one? The audience for art now feels suspicious because it suspects there isn't a hierarchy – it's just an anything goes ethos, and that makes the audience feel it is being fooled. It isn't necessarily furious about being fooled. It just takes it for granted that fooling is occurring. Therefore the Turner Prize, for example, is an amusing talking-point, a laugh on the cultural calendar, but not an outrage. It is important because culture is part of amusement and part of what makes dinner parties tick. But also not important because it is felt that the art is unimportant.

Anxieties of now

The main anxiety of now is that art is vacuous. Consequently there is an exaggerated and perhaps unrealistic respect for old Modern artists like Chagall, where you can judge for yourself if it's good. Today art is popular and there are lots of new Modern art museums opening up all the time. But the audience feels they could easily think up a lot of this stuff themselves and it would fit the bill providing it was empty, shocking, sexual and a bit pretentious. And that makes them despise it even if they enjoy it as a kind of circus.

Three samples of audience ambiguity

When art is a little pile of burned cocaine by Cornelia Parker, you can't tell if it is successful or not. You want to be able to say you've praised something that seems to be fairly rich. And when something seems vacuous you want to dislike it on the grounds of it being vacuous. But the system won't allow this.

Chris Ofili might well be doing something profound. He's putting the hours in and you can tell he means it. It's art with a lot of ideas but a lot else as well and you can judge when one painting is more successful than another. But you might not care to hear that he is introducing humour into the context of art or into the context of political correctness, because you ought to be allowed to be the judge of that yourself. Yes, he is funny, you think. So what? So are you. On the other hand, there is a discursive aspect to this art and it's quite acceptable therefore to think about the forms being under pressure from some interesting idea or other from outside painting, or to think about the way references and samplings might be operating.

Gillian Wearing's film *Dancing in Peckham* seems interesting straight away so some information about her thoughts might be welcomed. Or it could be a history of the rise of video art since 1967. But, unlike with Ofili's paintings and their multiple layerings, whatever the information was it wouldn't make the film any better.

What made it good in the first place was the silence, the passers-by not looking, the slightly autistic nature of the dancing, the locked-off camera, the fascination of wondering if anything really was going to happen next, the artist's confidence, the feeling it was a brave thing to do, the whole idea, even if it was only an idea about making slightness work.

So there's already a lot going on here just with these examples and it's beginning to be clear that the language and look of art now is important. And it's not all the same, it's not all just trying to get attention in a shallow way.

Anxieties expressed by contemporary art

These are easily listed. Repetition, the media, illness, mutation, the body, surveillance and fragmentation. Repetition is part of art but since the 80s it has become speeded up. Styles are now repeated immediately and not decades after they first appeared, because style itself doesn't mean anything and it is untied from its moorings. In fact style is not style but a new thing you can hop on or off, like hip-hop. The media is bad. Death is important. Illness is AIDS. Mutation is genetic engineering. The body is frightening because it's always changing, there is a mind-body split, and super-models are eerie. Surveillance is automatic video cameras in car parks and banks never closing down. It is an all-seeing eye a bit like Big Brother but not telling you to do anything because power is invisible. Fragmentation is the self fragmented and without a centre, not like *The Second Coming* which is the centre being a good thing that cannot hold any more, but like paranoia, where you don't know who you are because an outside force is controlling your mind and telling you what your values are. Sub-issues of fragmentation are race and gender which both connect to identity. Identity is good but we don't have a single sense of it. We have a multiple sense of it. Art that doesn't acknowledge this is bad.

Cornelia Parker
b Cheshire (England), 1956
Parker tests the physical and spiritual properties of objects by crushing, suspending, exploding, juxtaposing. For *Thirty Pieces of Silver* (1988–9), she subjected the eponymous objects to 'cartoon death' by squashing them with a steam-roller, suspending their mangled, one-dimensional remains in the gallery. *Cold Dark Matter: An Exploded View* (1991), a dramatically lit, sculptural reconstruction of the moment when she exploded a garden shed and its contents, achieved a similar effect – the shards frozen in time like a frame from a comic book. In her collaboration with actress *Tilda Swinton, The Maybe* (1995), she juxtaposed poignant historical objects such as Queen Victoria's stocking or Churchill's cigar with the living form of Swinton, sleeping in a vitrine. This enquiry into the resonance that ordinary things can acquire through association was, paradoxically, further intensified in *Avoided Object* when she displayed what was not present in familiar objects, such as the swarf from the grooves made in a master record, or 'the negative of words' – the crumbs of silver left over after engraving silver.

Mannerisms of anxiety

The 'body' rose in the late 80s starting in New York and soon spread everywhere. Now it has the same buzz about it as acrylics had in the 60s. That is, everyone previously excited by it now probably feels slightly jaded about it.

Perhaps its rise in the first place was due to the obsession in the early 80s with the idea that nothing was real and everything was an illusion. Then at the end of the decade there was a sudden combination of really bad realities that shook artists up – AIDS still going on, the Gulf War arriving and the art market collapsing and all the money going down.

And so then it was the return of reality and nothing could be more real than the body because it's the opposite to the mind. But because unreality was still a strong part of the contemporary mood, the absolutely dominating type of returned body in art was the realistic but clearly totally unfeeling and dead mannequin.

At first mannequins in art in the early 90s were a sign of importance – the body is important because it's alien even when it's your own because its got all its somatic drives driving you nuts.

Then because mannequins became so ubiquitous they became a sign of dreariness unless you could think of something really outrageously unreal to do with them. Have seven life-size replicas of your own body in an art gallery having an orgy, for example, as Charles Ray did with his sculpture *Oh Charley! Charley! Charley!*

But on the whole the mannequins are slipping back in their boxes now and joining other former signs of importance in art, like the colour grey in the 70s, or silk-screened photos and stripes in the 60s, or drips in the 50s.

Importance itself

Today art can be a green pea in the middle of a gallery but somehow some artists still think it should be something like the highest mountain, the widest ocean, the biggest sky. For example, Bill Viola and Anselm Kiefer. These artists stand for dignity. They give their respective forms – video and painting – a good name as far as museums are concerned. But they are both windy and there is a preposterous side to their art that can obscure what is genuinely to be congratulated.

What makes Kiefer seem important is that he has a grand, romantic view of history and art, and he wrenches pre-Modern art meanings out of Modern art paint surfaces. So he is good for an audience which has been starved of schmaltz. He simulates Old Master effects and his works are full of German history and wrought surfaces and visual dynamism. He paints old faces of Goethe and Heidegger or old German heroes who fought the Romans and he constructs vast, wide, perspectival, illusionistic painterly vistas of important architectural structures, like Ziggurats from ancient civilizations, or Valhalla, or monuments to dead soldiers that were designed by Hitler's architect, Albert Speer, but never built. And he is witty and makes artists' palettes with wings made out of lead and sticks them on his paintings.

Anselm Kiefer
b Donaueschingen (Germany), 1945
German History and myth are the central themes in Kiefer's work – which has not always made him popular in his own country. In 1969, striving to come to terms with Germany's recent past, he embarked on a journey through Europe to make the photographic series 'Occupations' in which he depicted himself giving the Nazi salute. Also in that year, he assembled lead books on steel library shelves, symbols of the heavy burden of historical knowledge. However, it was for his densely worked Expressionistic paintings, sometimes incorporating straw, blood, sand and sewn material, that he became known. Kiefer made the first of these large-scale paintings, *Heath of Brandenburg March*, in 1971, going on to explore the Niebelung legends and their adoption by Hitler for nationalistic purposes, subsequently broadening his subject matter to the Old Testament and Alexander the Great. He also made three-dimensional works, beginning his series of monumental painted wooden interiors in 1973 with *Parsifal III*, and later making aircraft sculptures. The theme of flying recurs in his work, particularly the flying palette, symbolizing the transcendence of art.

Chris Ofili *Through the Grapevine* 1998

Bill Viola

b New York, NY (USA), 1951
Viola is a pioneering video artist,
recognizing its potential as a
student in the early 1970s and
fulfilling it in highly imaginative
ways. In the mid-1970s he
worked for video studios,
gaining access to state-of-the
art equipment and travelling
extensively to document non-
western cultures. This experience
contributed to the deep seam
of spirituality in his work, which
finds poetic intimations of the
sublime in everyday life, taking
birth, life, death as its central
themes. The works are presented
in increasingly sophisticated
ways: with altered-aspect ratios
or in triptych form (*City of Man*,
1989), twenty-four-hour window
projection (*To Pray Without Ceasing*,
for the seventeenth-century
chapel in Nantes); projected
as ghostly figures onto a veil
(*The Veiling*, 1995); or offering
up the viewer's image in a
teardrop (*He Weeps for you*).
Perhaps his most dramatic work
was *The Sleep of Reason* (1988)
in which a slumbering man
was shown on a monitor in
a sparsely furnished room, which
suddenly became pitch black
while the walls were bombarded
with images of burning buildings,
attacking dogs, a swooping owl.

For years Kiefer's work was shown endlessly in museums and galleries all over the world, to the extent that it became annoying and oppressive and you just wanted to forget about it. Then gradually it wasn't seen so much. And nowadays you can come across one of his paintings in a museum somewhere, having not been oppressed by one for a while, and it will look surprisingly good.

All his works have the same initial impression of a broad, expansive, impacted, seductive powerful surface, very painterly and vigorous, but also like some vast, windy-looking backdrop or piece of scenery for a new staging of a Wagner opera.

And this blowy aspect is what allows a small section of the hyper-informed art audience to find Kiefer pretentious. He is but that doesn't mean he isn't also quite good on an aesthetic level. Maybe there is something a bit tedious about the writing on his paintings but the dynamism of the marks generally is good.

With Bill Viola the pretentious grasping after importance can be really powerfully off-putting and the turgid, bad, unobservant, terrible writing about this artist which is always appearing everywhere can be quite amazing, like an inadvertent parody of art culture. There it will be in the *New York Review of Books*, say, in an article about why Modern art museums are like places of religious contemplation, and how Bill Viola is like St Thomas Aquinas, right next to articles by intelligent writers about interesting subjects.

But behind the grandiosity of Viola's enormous, straining video installations there is something there, some trick he does with the after-image or a dramatization of absences – making absences dramatic in a context of important subjects like death, life, birth, God, what death means, what a numinous experience might be, what a spiritual awakening might be, what art is.

What is it that makes some people contemptuous of Viola? Typically, his video installations show disjointed scenes of significant things: someone giving birth, someone dying, some flames, some water, some darkness, some people disappearing and seeming to be ghosts, some other people meeting each other and looking a bit like they're in a Renaissance painting. Obviousness, banality, sentimentalism – these are all negative absolutes, they can't be turned around. Much art since Warhol has all three but in a mix of other elements so the overall effect isn't these things. There is an element of the pared-down with Viola but it clashes with the element of the overdone.

It's complicated to be irreverent about this kind of thing because anyone should be moved by the idea of someone recording their own wife's labour or their own mother's actual moment of death. But there is a problem when it seems to be all wrapped up in a neat or crass metaphor for the cyclic nature of existence. And astoundingly the bait is taken by museums and the work is sanctified and it becomes a video version of Giotto and a new standard that all contemporary art must now look up to.

So both Viola and Kiefer are contemporary romantic artists who capitalize on

Bruce Nauman
Clown Torture 1987

the general public's too-easy belief in certain signs of greatness or significance. If an artist is romantic and sentimental and works on a vast scale, then they will be considered to be important and profound. Caspar David Friedrich invented a certain cliché of vastnesses equalling the spiritual and these artists keep it going in spades. Friedrich has the benefit of the doubt because he was there first but the others can't complain if there is a bit of resistance to their hocus pocus.

Stripped-down clown

Can sentimentalism ever be good? No, it's a pejorative and it can never be turned round. It is always ill-making and clowns in art are always bad. Except when it's a Bruce Nauman video clown crying 'NO!' at the Hayward Gallery. But his is a stripped-down video clown because Nauman is a Post-Minimalist and he strips things down and looks for the most pared-down form to express the important subjects in life. Clown-ness is only one element of this particular work though, going with video itself as an element and the script as another element, and the throwing around of his body the clown has to do while acting the script. So it's a pretty interesting twist on the unacceptability of clowns.

Are artists clever?

Artists frequently turn out to be alienated from intellectual culture. They take what they need from it but only that. So a significant proportion of the audience for art finds itself asking for an expression of themselves from a section of society which

Gillian Wearing
Sixty Minute Silence 1996

is quite different to them and which doesn't feel comfortable with the same things as them and hasn't had the same experiences. Ideas in art are not like ideas in Nabokov.

The ideas in Gillian Wearing's film about the police, for example, might be said to be about repression, restraint, a sudden relief from restraint. It's a good idea that the police should be restrained and then suddenly released. And that it should all happen in real time and on a human scale, with the police filmed life-size. Because there's so many of them it becomes a monumental scale. And that connects to order and rigidity too. In fact the only bad idea about the film is that it isn't really the police, it turns out, but only actors. This is a disappointment that slightly spoils the idea. But in any case there's virtually nothing here that even begins to parallel literary ideas.

Intellectual culture and mysticism

Anxiety about cleverness connects to anxiety about the spiritual. Today the spiritual often equates with mysticism. Popular culture loves mysticism but it is intellectually

despised. Aliens, psychic readings, Celtic tattoos, stone circles, the tarot, cults, pop medievalism are all part of the mysticism of today. But art isn't.

When intellectuals are not mistaking artists for intellectuals they sometimes mistake them for pop mystic cultists. But this isn't right either. There is a difference of tone, the tone of art culture is less predictable. You can't predict exactly what will happen in an art context as surely as you can in a pop mystical one.

For example, when a discussion starts up about the Macchu Picchu remains in Peru and Tutankhamen and the god Seth and total eclipses of the sun, you know with a heart-sinking certainty they will all turn out to be connected by a very long number. This is an order of things, or a world view, that must never change or be challenged, and people who talk like this get pleasure from the fact that it really does never change. A razor blade will always be sharpened if it's put under a certain type of pyramid and spacemen really did invent runes. But it's wrong to think art is like that. Art changes all the time and it is fundamental to its nature for it to do that.

Cocaine

So this cocaine then, charred and grey and in a little group of crumbs in a vitrine in the Tate Gallery, having initially been confiscated and burned by Customs officers – is it any good? A bit thin maybe. Grey crumbs in a glass case, off-centered, not that interesting to the eye. And the fluff from Freud's couch, also by Cornelia Parker? The same, thinner maybe, because Freud's couch and fluff and Modern art as a set is a cosier notion or joke than burned cocaine and Customs officers and vitrines and museums. But still there's not a lot happening with either of them. Or with both there are too many possibilities or lines of thought that are possible.

For example, with one work Freud might be part of what's happening. And the history of psychoanalysis and the whole of the twentieth century. And imagining the whole process of how she got the cocaine might be a line of thought with the other work. And also wondering who was arrested for it and then wondering about the history of cocaine. And then you'd have to consider Freud being addicted briefly to cocaine because that would be part of the story of Freud and the story of cocaine. So almost any point of departure seems like banality and it seems an effort even to begin to follow any of it up.

But effort is part of art. What did that fluff look like? Like a shadowy feathery form, white on black, very simple as a drawing, delicate, nice; although in fact it was a photo rather than a drawing and and not fluff but some feathers from the stuffing of the couch that were carefully swept up and bagged by the artist and then photographed. So yes it was quite good, very contained and clear.

Sacred cows, publicity, hype

Damien Hirst is not a sacred cow of contemporary art like Viola or Kiefer because he is constantly attacked for crassness and they never are. He is a sacred cow of

Julian Schnabel
b New York, NY (USA), 1951
The huge prices commanded by this hero of the New York art scene led the media to treat him more like a pop star than an artist and by the time he was thirty-one he had already received a retrospective at the Stedelijk Museum in Amsterdam. With the dominance of other art forms in the 1980s, Schnabel brought about a resurgence in painting. Early works were abstract, but by the late 70s, figuration had crept in and Schnabel was presenting a Post-Modernist image of a fragmented world through collage, pastiche, the collision of high and low cultures, and by attaching shards of broken crockery to the surface of his works. Along with recurrent imagery of crumbling classical statues and columns, these introduce an archaeological theme reinforced by the layering of references to history, psychology, literature, art, cinema and the mass media. Perhaps informed by his Eastern European roots and a childhood spent in Brooklyn, Texas and Mexico, a blend of Pagan, Jewish and Catholic imagery creates a kaleidoscopic view of humanity. In 1985, Schnabel began an extensive series of paintings on tarpaulins, Japanese cloths and Spanish linen, and in 1996 he directed the film *Basquiat*.

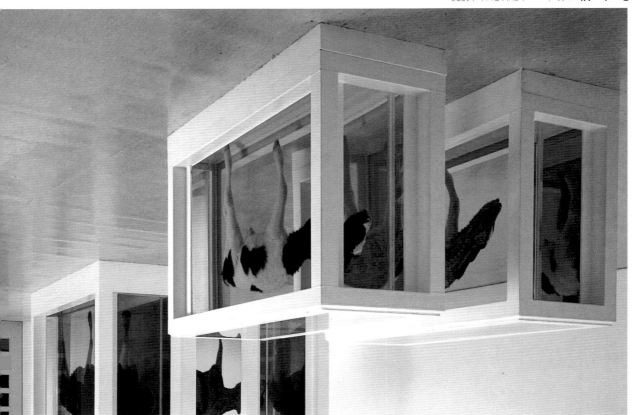

Julian Schnabel
Prehistory: Glory, Honor, Privilege
and Poverty 1981

Andy Warhol
Cow Wallpaper 1966

cow art following Julian Schnabel's antlers on paintings and paintings on pony hide done in the early 80s and Andy Warhol's *Cow Wallpaper* done in the mid-60s.

Death is his subject but it is not expressed in a profound way but in a designer way because his death objects are supreme designer objects. But they really are good as designer objects and that's where the good idea lies. It's a good idea to make something look good if it's art. You don't have to but it's good if you do.

To say 'designer object' is to say that the aesthetic is a designer one. 'Designer' means nothing deep or profound is to be expected and all there is is that which can be grasped straight away. The appearance, the image, the atmosphere of the image, the visual intelligence.

Also, it's a good idea to bring medicine and art together. He makes packets of drugs on shelves look good.

All hype about Damien Hirst on a deep level is to be ignored but there isn't all that much anyway or what there is is not all that oppressive because the constant

Damien Hirst
Carbon Monoxide 1996

attacks on him and the values he stands for, by all sections of the art audience, balance it out.

Utter hype and contemporary art's utter connectedness to it is just a fact of life but it's still obvious when it is hype and it doesn't become the Bible or Nietzsche or Shakespeare or Iris Murdoch just because it's in an art context.

Interestingly, the second and fourth figures on this list, which frankly is an arbitrary one, both wrote about art and both died after losing their minds.

Arbitrariness

Arbitrariness is the bad or unsuccessful idea with Hirst's spin paintings. The colours, shapes and textures are arbitrary and hideous. But with his dot paintings a different kind of arbitrariness must be operating because these paintings look good. The spin paintings make any exhibition they're included in look like a carnival and a bad mess but the dot paintings make a sophisticated decorative statement and they dignify their surroundings.

They were painted with the aid of assistants, or entirely by assistants in many cases, apparently. Maybe they're all done by assistants now. But the assistants must have really entered into the original sensibility because the colours are always interesting and surprising.

Because of John Cage and chance and Jackson Pollock and drips, we have learned to value the arbitrary but we still care how things look because we don't want to be going round all the time being in pain.

Polke and Picasso

We must always be judging. It's part of looking. So Picasso is better than Polke. Really? Well OK, I don't know. It's hard to tell what's better or worse about the art of your own age compared to the art of a previous one.

Les Demoiselles d'Avignon is iconic. When you see it, it's got a lot of overlaid drawing that looks profoundly modern and the pleasure in the colour of the painting is always a surprise too. There are many different types of grey and a strong dark green, as well as the main pink, brown, earthy colours and mid-blue and white that are usually associated with the painting.

And there is relatively little black compared to Picasso generally. The outlines are mainly red, blue or white rather than black and the overall effect is very light and fresh. Some of the faces have a lovely sweetness and that's something else you forget about it.

But it's full of reminders of other stages of Picasso – the massive legs, the black, witty lines where there is black, the arbitrary distorted faces, the bodily forms made out of flared shapes and triangles, the many different ways of making space: the odd twists and warps and perceptual strangenesses in all parts of the painting

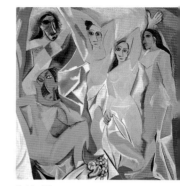

Pablo Picasso
Les Demoiselles d'Avignon 1907

Sigmar Polke *Nicolo Paganini* 1982

and the resulting impression of an overall magnificent painterly intensity.

That's a catalogue of everything Picasso did throughout the century and all the Modern art that everyone else did in that broad vein up to whenever it was they stopped. So you can't say, 'Compare this historical icon with something in your own period', because an icon is always layered with everything you know about it and you can't go up to a Polke you've never seen before with that level of pre-knowledge.

However, Polke, a German artist born in the 40s who has recently become a sacred cow of American museum culture but who has enjoyed cult celebrity for a much longer period, will probably never quite, if at all, really describe us, because basically the world of representations or sign systems that he references is too thin for that. Even though, of course, he's giddyingly brilliant and a spaced-out pixie former commune-dwelling, top German acid tripper who deserves at least 51.5 per cent of his present worldwide reputation.

Higher beings

A Polke painting from the 60s with nothing in it except a black triangle has some writing in the bottom section of the canvas – painted in by a professional sign-writer – which reads: *Higher beings command – paint the upper right hand corner black!* This is a good joke on materialism and Post-War Germany and the idealism of abstract art, from Malevich's ideal of Suprematism as an art of pure feeling onwards, and the spiritual vacuum of commercial art. But it is not exactly an intense type of human content. It is human but not all that intense.

Sigmar Polke
b Oels, Lower Silesia (Germany), 1941
Throughout his career, Polke has positioned his innovative work as a humorous parody of the conventions of Modern art. In 1963, he launched what he called Capitalist Realism, a reaction to (and German form of) Pop art, making works such as *Biscuits* (1964), which elevated foodstuffs to the status of aesthetic signs in an exaggeration of Pop's concerns. *Higher Beings Command: Paint the Top Right Corner Black* (1969) attacked conventional ideas about innate creativity. In works such as *Crowd*, 1969, he introduced the pattern of 'Polke' dots, almost obscuring the image, that became his signature. Polke was one of the first artists to present incongruous subject matter, superimposing images, creating witty juxtapositions of high and low culture, appropriated imagery and found materials. *Dürer Hare* of 1968, for example, features a hare drawn in the manner of Albrecht Dürer nestling in a gaudy fabric. These works address questions of reproduction and authorship. In the 1980s he concentrated on process, making a series of large, gestural paintings that mixed traditional materials with dangerous toxins, which continued to react after the painting was 'finished'.

Moderne Kunst

Sigmar Polke *Modern Art* 1968

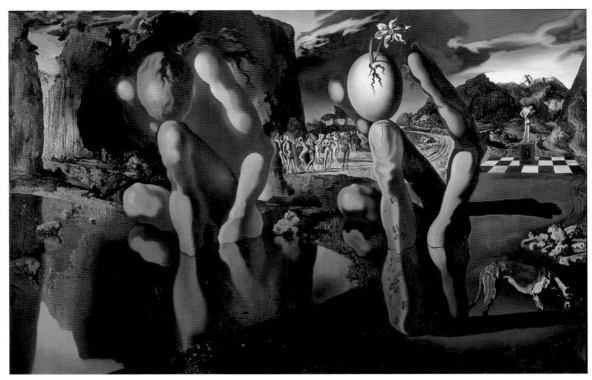

Salvador Dalí
Metamorphosis of Narcissus 1937

Hell coming up

Art is getting more and more relaxed into everything else because everything else is changing and there is no centre of certainty or centre of official ideas that everyone must obey. New ideas are everyone's domain now, not just art's. We go around with a troubled look though because hell is near.

Low Dung

Salvador Dalí is the lowest of the low, just dung that Chris Ofili should fix to a painting with resin. That's the basic idea of Dalí's status within Modern art. Teenagers and the uneducated revere him because of his sensationalism and love of detail. But he was a fake genius and only tried to get money. All the money in the world flowed to him. His burning giraffes with grasshopper legs and his hands with ants coming out the palms were only fake Modern and fake Freudianism.

'How do you like my new paranoic-critical method?' he said to Freud when he met him, showing him his painting *Metamorphosis of Narcissus* which he'd brought with him to Freud's house. 'Get outta here!' Freud is reputed to have said. Or something more Freudian but along those lines.

Dalí was fascinated by ocular trickery. He loved gadgets. He said, 'Painting will be

Dalí painting Laurence
Olivier during the
filming of *Richard III*
1955

Salvador Dalí

b Figueras (Spain) 1904;

d Figueras (Spain), 1989

Dalí is one of the best-known twentieth-century painters, partly due to his talent for self-advertisement, partly because of his bizarre vision. His work has encompassed most of the key styles of the century, including Impressionism and Cubism, but his admiration for nineteenth-century realism, combined with the influence of Giorgio de Chirico (whom he met at the Academy of Fine Arts in Madrid before being expelled for indiscipline), and later of Miró, in Paris, led to his famous dreamlike, hyper-realist paintings. Developing a method that he called 'paranoia critical' and making paintings based on Freud's theories, he was soon embraced by the Surrealists, but was eventually dispelled over his support for Franco. Dalí was obsessed with what was forbidden by conventional society. His grotesque paintings of chimeric monsters, burning giraffes and melting watches – often set within a dusty Spanish landscape – eccentric sculptures and outrageous performances, and his collaborations with the filmmaker Luis Buñuel, throb with references to sex, death, defecation, and cannibalistic violence.

stereoscopic or it will not be at all.' André Breton called him Elvira Dollars and expelled him from the Surrealist movement for becoming a fake Surrealist who only exploited the irrational for money. He went to America and was welcomed with open arms and given a lot of Hollywood backdrops to design.

He grew old and his wife Gala grew old too. How weird they both went in their old age! They got the hippies and playboys and playgirls all rounded up off the beaches at Cadaqués and round to Dalí's house to pose. Dalí masturbated over them, especially if they were transsexuals, his favourite, and Gala took the cleanest, pertest, most 70s daytime TV soap opera-looking young men as toyboy lovers.

Dementia set in. They were both as mad and frazzled and decadent as each other.

Gala, a former raging beauty, lover of poets, had her own castle. Dalí could only come round if he wrote first requesting an audience. 'Bring money for toyboys,' she would reply.

He couldn't stay away from the cameras, doing his mad act, appearing in ads for chocolate. 'Salvador Dalí,' he would say. 'Myself,' he would go on, 'is very rich!' The reporters and cameras would all gather round. 'And I love tremendously money and gold!'

He tells the camera in one film from the 70s that he's about to paint a butterfly. Or 'butterflyeeeee' as he suddenly screams, genius-style. He looks down from a wooden scaffolding leading up to a mural on the ceiling, showing his own giant self towering upwards, soaring toward a Renaissance vanishing point, the soles of his bare feet enormous in their fore-shortening, his moustache far away, near Heaven, and he announces: 'Dalí sleep best after one day of work receive one tremendous quantity of cheques!'

Now it's another film. Moustaches whirring, genius eyes rolling, mouth open wide, chocolate going in, outrageously amplified masticating sounds crashing forth, and suddenly Dalí's voice-over in French as broken as his English: 'Je suis FOU le chocolat LANVIN!' And then in another film he's fighting giant white sperm bubbles with a walking stick. Unless it's an ad for milk.

He appears like a burning genius in all his publicity appearances except possibly the last few, and particularly the very last one where he's practically dead, with tubes hanging out of his nose, and sight-seers and tourists and reporters are gawping at him, and the Christian concept of Hell now suddenly seems very real. But still he weakly gasps out cheers for Spain, Catalonia, the King and himself before being whisked away on a tube-strewn hospital trolley by sinister minders.

Before this point he got more and more mad and ill and Gala had him on a steady diet of pills. Tranquillisers to shut him up and stimulants to give him the energy to sign blank sheets of paper for fake Dalí's to be printed on, for more money to be made, to line the pockets of who knows who.

Then Gala died and Dalí went down to the fiery pit next, in 1987, after first catching his leg on fire by accident one night in his lonely bedroom. And now he lies in his tomb under the floor at the Dalí museum in Figueras, tourists walking on top of him, not even knowing he's down there. They look out to the courtyard where dozens of tall mock Neo-Classical sculptures are set within the high walls, each one an identical waving Hollywood Oscar.

Dalí posing in front of a photograph of José Antonio Primo de Rivera, founder of the Spanish Fascist Party 1974

I'd like to say a few words

'I'd like to thank my dentist,' Damien Hirst is saying on TV in a close-up shot, live from the Tate Gallery on the Turner Prize platform. 'The winner is' – 'Joan Bakewell starts her announcement, and then so does Agnès B and then Brian Eno – 'Rachel Whiteread!' 'Douglas Gordon!' 'Gillian Wearing!' They all come up and get their cheques and say a few words. 'Such is the culture we live in,' Rachel Whiteread is saying. 'Thank God!' says Chris Ofili. 'Where's that cheque?' he laughs. 'Yes! Yes! Yes!' cries Dalí standing in the French windows in his little house in Spain, his mad act of then joining in with ours of now.

Dalí standing next to *Soft Self portrait*
c. 1940

Laurence Olivier

The fishing boats lie on the beach at the little town of Cadaqués in Spain where Dalí lived. The waves lap on the beach. The house is white. The town is full of hippies and tourists. In Gala's former dressing-room the white walls are lined with pictures. Not Dalí's Surrealist ones but framed black and white 10 × 8 photos, the pictures that express Dalí's cult of celebrity – showing scenes of Dalí with Picasso and Jacqueline, Dalí with Laurence Olivier, Dalí with Gregory Peck, Dalí with Ingrid Bergman, Dalí with the Mayor of Figueras, Dalí with General Franco, and Dalí with someone who appears, unbelievably, to be Gandhi.

Peter Davies and the horrible sight

In a spiritual mood, it would be horrible to see Peter Davies' *The Hip One Hundred*, a very wide painting at the Saatchi Gallery showing nothing but a list of artists' names with numbers beside them and a one-liner description of what the artists do.

For example, 'Bruce Nauman' at Number 9 and the description 'double no.' And at Number 8, 'John Currin – big tits and beardy blokes.' At Number 56, 'Jeff Koons – giant flower power puppy.' Rodchenko is above Warhol and Beuys, Bridget Riley is after Gary Hume, Michael Craig Martin is after Bridget Riley.

What kind of order is this? Who are half these artists anyway? Where are Georges de la Tour and Tiepelo and Chardin? Help, it's contemporaneity! The raw now. Not even a deconstruction of now or a post-structuralist now. At least you wouldn't be able to understand that and you could be angry with it and want to hit it. But this is all too understandable. The gossip of insiders made into art. In fact, not made into art because gossip can't be art. It's short-circuited as art. It doesn't make it as art. It falls short. It doesn't even aim in the first place. It's aimless. It's the hip one hundred but it could be any one hundred because the hip is always changing. That's why the hip is shallow and low. In fact before this painting was finished it had already changed. It was only a fleeting impression of the hip, not a Neo-Classical monumentalizing of the hip, the hip fixed for all eternity, or the hip

THE HOT ONE HUNDRED

#	Artist	Description
1	BRUCE NAUMAN	ALMOST all of it (90-95%)
2	SIGMAR POLKE	Paganini
3	MIKE KELLEY	[unclear]
4	RICHARD PRINCE	Biker Girls/Jokes/Hoods
5	ANDY WARHOL	Brillo boxes, Jackie O
6	DONALD JUDD	Perspex/Metal Wall Pieces
7	J.M.W. TURNER	little boat in storm at sea
8	BRIDGET RILEY	B+w OP art lines
9	KASIMIR MALEVICH	Monochromes
10	MARCEL DUCHAMP	Fountain
11	JOSEPH ALBERS	Homage to square - colours
12	AGNES MARTIN	Small rectangles - subtle colours
13	PIET MONDRIAN	severest Hard edge stuff
14	JASPER JOHNS	Flags + Alphabets
15	SOL LE WITT	Wall drawings
16	ELLSWORTH KELLY	V. big squares of colour together
17	THOS. GAINSBOROUGH	Bad early Portraits
18	MARK ROTHKO	Seagram Murals
19	ROBERT RYMAN	white on white !!
20	FRANK STELLA	Grey line paintings
21	GILBERT + GEORGE	As themselves - shitt cunt
22	SEAN LANDERS	Text
23	WILLIAM HOGARTH	Paintings not etchings
24	JACKSON POLLOCK	Long brown 'skilful' ones
25	BARNETT NEWMAN	v. Big e.g. Voice of Fire
26	GERHARD RICHTER	Baader Meinhof
27	JEAN-MICHEL BASQUIAT	Miles Davis Play List
28	DAMIEN HIRST	shark + Dots
29	EL GRECO	Light on Face of Monkey
30	JULIAN SCHNABEL	Plates + Sail cloths
31	[unclear]	Frames
32	NIELE TORONI	Dabs on wall installations
33	CY TWOMBLY	scribbles (Lot of it the same)
34	WILLEM DE KOONING	More abstracted less fig and rude stuff
35	JONATHAN LASKER	When doodle's big on plain background
36	LEON KOSSOFF	Swimming Pools
37	CHRISTOPHER WOOL	Text with swearing, single words
38	JOHN BALDESSARI	Hand Pointing + Instructions
39	GEORG BASELITZ	Upside down - white + yellow cheeks
40	PHILIP TAAFFE	More B+W/B+Colours OP Art ones
41	JOSEPH BEUYS	Talking to Hare/Rabbit?
42	BRICE MARDEN	Earlier Hard Edge strips of colour
43	PETER HALLEY	More the conduits than cells
44	CLAES OLDENBURG	Soft Sculpture + bedroom
45	JEFF WALL	Steves Farm + Nosebleed
46	ROY LICHTENSTEIN	Brush strokes
47	MORRIS LOUIS	Corner Drips
48	JULIAN OPIE	Sculpture + wall drawing together
49	JOHN MCCRACKEN	Planks
50	CHUCK CLOSE	Recent Big Portraits (Not realist)
51	TITIAN	Army featuring monsters/dragons
52	JEAN DUBUFFET	Grungier ones
53	DAVID SALLE	Porno ones
54	FIONA RAE	Whatever she's just done
55	KAREN KILIMNICK	TV Film Bad portraits
56	RICHARD ARTSCHWAGER	Formica Furniture
57	JEFF KOONS	V. Big Sculpture, New paintings
58	ANDREAS GURSKY	MONTPARNASSE
59	LARRY CLARK	Tulsa
60	ROSS BLECKNER	concentric circle white dots on black
61	MICHAEL CRAIG-MARTIN	Biggest, brightest wall drawing
62	DANIEL BUREN	stripe constructions
63	RACHEL WHITEREAD	House
64	B+H BECHER	Water Towers
65	LAWRENCE WEINER	Letters carved into wall
66	GARY HUME	Both Figurative + Doors
67	ROBERT SMITHSON	Hotel Tape/slide
68	NAN GOLDIN	Transvestite photos
69	DUANE HANSON	Jogger + tourist
70	CINDY SHERMAN	Pigs snout
71	FELIX GONZALEZ-TORRES	Dancing queen + light bulbs
72	ED RUSCHA	Funky word paintings
73	FISCHLI + WEISS	Carved studio junk
74	ANDRES SERRANO	Ku Klux Klan Pics
75	DAN FLAVIN	Circular Striplight arrangement
76	CHARLES RAY	Mannequins + Firetruck
77	RICHARD DEACON	Varnished cardboard with triangle
78	KIKI SMITH	Waxone from Somewent Mad....
79	JOHN CHAMBERLAIN	Car Crash Sculptures
80	THOMAS RUFF	Single Portraits Head + shoulders
81	ANISH KAPOOR	Shiny Metal + Disney Mountains
82	RICHARD SERRA	heavy Metal
83	VICTOR VASARELY	Circle + Square coloured OP
84	LOUISE BOURGEOIS	Shiny bronze phallic stuff
85	ED KEINHOLZ	That bar you could walk into
86	RENE MAGRITTE	
87	RICHARD PATTERSON	Thomson skipping + Moto crossed
88	NAM JUN PAIK	T.V. Pyramid with J. Beuys
89	ALLAN MCCOLLUM	Plaster Surrogates
90	ALEX KATZ	V. big womens heads
91	PAUL MCARTHY	Bossie Burger
92	MARTIN KIPPENBERGER	As a whole
93	EVA HESSE	Translucent Wall hang/lean th
94	FRANCIS PICABIA	Realist nude women
95	[unclear]	Tall Figures with carved plin
96	JESSICA STOCKHOLDER	when wall is ripped out
97	MILTON AVERY	Coastal scenes
98	SARAH LUCAS	Sod You Gits, eggs, kebabs et
99	IAN DAVENPORT	Fine Line bright colour ones
100	IVAN HITCHENS	Biggy bolder brush marks

Peter Davies *The Hot One Hundred* 1997

after Poussin. And it was only the hip for one person anyway. It was a subjective view of the hip. Of hipness. And he hardly believed it anyway. Or only believed it for ten minutes. Not even fifteen minutes. The legal time limit on fame. It followed another painting like it called *The Hot One Hundred*, where Bruce Nauman was Number One instead of Number 9.

'I thought he was a really influential artist,' 27-year-old ex-Goldsmiths student Davies says, up in his studio, surrounded by new half-finished paintings of imitated colour abstractions, vaguely Frank Stella/Bridget Riley/Ken Noland, from a vague past world when colour abstractions had a different meaning.

On a desk a postcard advertising a Davies show in a gallery in a pub in Bethnal Green shows a lot of coloured shapes that look like they've been drawn on a canvas with a felt pen and then filled in, which they were. Above it, on the wall, another postcard shows a work by the New York painter Christopher Wool – stark capital black letters arranged on a vertical white ground: IF YOU CAN'T TAKE A JOKE GET THE FUCK OUT OF MY HOUSE.

'In terms of the last ten years and this current generation of British artists that was well known at the time I made *The Hot One Hundred* – in 1997 – I thought Nauman was the most important artist. But also, I wanted the feeling of saying: This is the most important artist in the world. Period. So that's like now and forever. But by the next week I might have been thinking: Well, no actually. Maybe he's not. And by the time I'd finished the painting a month after I started it, I was already thinking: Well, this person should be higher, this one should be lower – I can't believe that one's in there at all!'

This is an anxiety about what the now really is, or where it really is, its precise point before it slips away. It would be frightening if it wasn't funny. The blue sky and infinity, life and death, Zen calm, Goethe and Heidegger – these are all important, but not celebrity and hype and the artistic pecking order.

In fact on a list of a hundred important things about existence, celebrity and hype would be where Piero Manzoni is on Davies' *The Hip One Hundred*. That is, about half way through, somewhere under Gillian Wearing. But nowhere near as high as even Number 9, Bruce Nauman, because as issues they are not burning enough as far as existence is concerned, although, on the whole, they are probably more burning than we might care to admit. And actually any bit of urgency will do probably when it comes to looking for inspiration. Even the urgency of Sean Landers' paintings of words and his videos of chimps painting. When Davies first emerged he seemed to be celebrating Sean Landers or copying him. Then suddenly in Lot 61, the new media hang-out in New York, there was a huge new Sean Landers on the wall with a tiny patch of characteristically mis-spelled text in the middle somewhere, reading: 'Hey English guy whose copying my work and nameing me as the greatest artist. Thanks and youre right but youre eating into my profits.'

Peter Davies
b Edinburgh (Scotland), 1970
Davies became known for his trainspotter-like, large-format paintings, which present hierarchical lists of artists' names. *Text-Painting*, 1996, is a horizontal league-table of his favourite artists, and why he likes them, executed in childlike, multi-coloured letters. Tellingly, it begins with Sean Landers, his nerdy American hero. *The Hot One Hundred* (1997) and *The Hip One Hundred* (1998) continued this theme by cataloguing his all-time greats and living heroes respectively, this time presented in the form of charts. These works comment on the human desire for 'genius', and the urge to catalogue and analyse. They also address the fickle nature of celebrity – even Davies may have changed his mind about the relative importance of his mentors by the time he has finished the work – and play with the formal qualities of colour. Both of these concerns are pursued in more recent works, which revisit Bridget Riley's Op art of the 1970s or the works of Frank Stella, in the form of bright, geometric, optically disorienting mosaics of colour.

Sean Landers
Singerie: Le Peintre 1995

'You could ask who's the most important artist of the twentieth century, Picasso or Duchamp?' Davies is musing now. 'And no historian or academic or anyone will ever agree on who it is. And yet there's a sense in a kind of faddy way that there really is an artist of now. You might get an artist who emerges really quickly like Sean Landers, say, a fantastic artist who makes all kinds of different work that really sums up the world now. But you know these artists come and go. So in a way there might have been a point when Sean Landers really was the most important artist in the world. But when was that point exactly?'

Profits, hype, competitiveness, noticeability – it's a long way from Iris Murdoch.

The Iris within

What did she want anyway? She wanted art to be pictures of who we are, mirrors of our being, like the European art in the museums, a chronicle of ourselves – 'We too are like that.' But instead it was all just 'Minimalism, happenings, abstract paintings, designs designed to invite completion by provoked clients, natural objects or arti-facts offered as works of art, ambiguous entities posing the question: "Is this art?"'

Art was based on language now, Iris Murdoch thought, and the meanings within language. And it was all scepticism. It was sceptical of the past and anything that could be intuited as transcendent and anything that might exist separately in its own right outside of language. It was just expressions of the ephemeral or of the deliberately incomplete. And it was all a loss like the loss of grammar and good prose.

When did the now start?

In the 80s it started to become quite widely accepted that everybody expected to live an ideology-free lifestyle. And artists did too. And coinciding with this general mood was the rise of a new official super-preciousness that the leaders of the international art world had as their way of thinking and talking and being. Perhaps in the past the leaders were fanatically politically ideological or fanatically aesthetic, for example, depending on the era. But now they were fanatically delicate and that was the new ideology. Also the 80s saw the rise of corporatism, and preciousness seemed to fit with this.

So nowadays Modern art museum curators who rose in the 80s write the catalogue introductions to their corporate display exhibitions in a super-precious way. How moved they were by some drips they hadn't noticed before in a Jackson Pollock and how moved they were by a blurry scene in a video and how it reminded them of something else blurry they saw once in *Hiroshima Mon Amour*, or maybe they read about it in a novel by Alain Robbe-Grillet.

Smile

Jeff Koons is a well-known artist of the 80s who is often condemned for being a symbol of everything bad about that time – its artificiality, commercialism, corporatism, shallowness. And from this perspective there's not much that could be said to save him from the guillotine. I personally feel he is good though. His style of talking has a gliding feel about it, with a lot of inaccuracy in the use of prepositions, and the meanings and references and concepts just come up however they like and that's refreshing.

The bourgeoisie, the aristocratic, the objective realm, banality, sexuality, advertising, the media, God, love, society, a position of weakness, a position of strength, right now, puppy, embrace, humiliate – these are his often-used words and phrases. He only picks the ones that already have a good feel about them.

In the 80s he saw banality everywhere and he thought it should be embraced like a cuddly kitten. He saw art as equilibrium, as everything levelled. It was something people should love like they loved anything – like babies and sunshine and smiling. And it turned out to be quite a strange and unpredictable idea, after all, to think about what people actually want and then try to give it to them. Not from a Hollywood position but from a position of extreme avant gardism. So when they get it they're horrified.

Our dreams

Koons has not been talked about much for a few years but now he's back. He's been given the job of being our society's Michelangelo – given millions of dollars by a consortium of dealers in Germany, America and London to take years to produce the paintings and sculptures that will make up his 'Celebration' exhibition, as yet still to be completed.

Jeff Koons
b York, PA (USA) 1955
Before becoming a super-successful Neo Geo artist in the 1980s, Koons was a super-successful stockbroker who used his earnings to produce his first works: a series of pristine vacuum-cleaners, each encapsulated in a clinical, neon-lit vitrine (*The New*, 1980). *The Equilibrium Tanks*, basketballs suspended in water, followed in 1985. Koons went on to produce kitsch, large-format sculptures that were exact, scaled-up replicas of trashy ornaments, made in wood or porcelain by craftsmen. In the gallery context, they represent an elevation of the everyday object to the status of icon. This recognizes the dominance of consumer culture in the twentieth century, and raises questions about the value, authorship and originality of the artwork. Koons continued this blurring of art and life, high and low, by recording his union with the Italian porn-star La Cicciolina in a group of massive, explicit photographs and glass sculptures, prettified by butterflies and flowers. He is now working on *Celebration*, a large-scale, multi-media project for New York's Guggenheim Museum.

Jeff Koons *Amore* 1988

It will be art that expresses society or expresses the collective unconscious, our dreams, even if we don't know we're dreaming them and in fact never dreamed of dreaming anything like this. Normally we dream about buried bodies that someone's going to be finding soon – if only we'd buried them better! Or teeth falling out, or the roof leaking, or not being able to pay the therapist.

Not so much giant mild kittens and flower puppies, cakes and flowers, bows tied in heart shapes, brightly coloured Play-Do, children's games of tying the tail on the donkey. Or colossal, sexy, metal balloon dogs.

Good dog

Whatever Koons' *Balloon Dog* allegorizes or dreamily expresses I don't mind because it's a good dog, very big, the size of a room, an impressive monumental sculptural arrangement of big, nice, steel, shiny bulbous tubes. Cast in an edition of three, there is one standing in a room now, in a collector's private gallery space in LA. It has a pert shiny tail at one end and at the other the beautiful – it now appears – complicated roseate thingummy that happens when you tie up a balloon. All the surfaces are mirror-reflective, showing not so much society's unconscious as lots of distorted reflections of some of Koons' new wall-size Neo-Pop paintings of cakes and ribbons and stuff, hanging in the same room.

His new paintings are his Sistine Chapel ceiling. They appear slowly from year to year in bits, a painting here, another there, one or two seen in a magazine maybe, but the promised show of all of them all together keeps having its deadline extended because they can never be quite perfect enough.

It's like *The Agony and the Ecstasy*, with the Pope played by Rex Harrison always calling up to Michelangelo, 'When will it be ready? When will it be ready?' And Michelangelo, played by Charlton Heston, calling down 'Soon! Soon!'

Flower power puppy

Another Koons doggy can be seen in Spain at the new Guggenheim Museum in Bilbao, a puppy made of flowers, standing taller than a five-storey house.

'*Puppy* has 60,000 live growing flowers,' he says. 'And it has a hundred and fourteen separate irrigation and fertilization systems. So the technology of it is very sophisticated. But with this work I wanted to make a piece that people could really just feel a sense of warmth which has to do with the relationship with God. One of the important parts about *Puppy* is the sense of exercizing one's control where one can: choosing the heights of the plants and the richness. But after that, it's out of everyone's hands. It's in the hands of Nature then. Some plants are going to shoot off this way, others are going to start to dominate and so on. And the public has really taken the piece to heart. I'm told by many people it's like their Statue of Liberty.'

Bruce Nauman
One Hundred Live and Die 1994

Bruce Nauman
b Fort Wayne, IN (USA), 1941
Without the example of Bruce
Nauman, it is difficult to imagine
the current landscape of
contemporary art, especially in
the areas of Body art, video and
performance. As a student of
painting in California (1964–6),
Nauman was impressed by Man
Ray's focus on ideas, not media,
which now characterizes his own,
wide-ranging work. He became
a prominent member of the
West Coast art movement,
passing through a brief phase
of subversive Funk art before
embarking on his Conceptual
sculptures, wax body casts
and holographic self portraits.
His Beckettian films recorded
repetitive performances in which
he stamped in the studio or
played one note on the violin.
During the 1980s he produced a
number of animal sculptures and
a long series of puns, linguistic
experiments and neon text works
inspired by Wittgenstein. Amongst
his most powerful films are
the 'Clown' videos, in which
he performs ritualistic, repetitive
actions and emotions, exploiting
the ability of the clown to
be simultaneously funny and
discomfiting. These are often
included in Nauman's ambitious
installations, which corral all the
elements of his work – spoken
and written language, film, video,
and performance – into a hard-
hitting, superbly choreographed
experience.

The nice, the mild, the monumental

What Koons' art says is: 'Here's the ephemeral, the temporal, the fragile, the kitsch
– and here it is carved in stone.' And in fact it's a surprise to see it like that. It's not
the colours and surfaces, nice as they are, but the scale which is the striking thing
about his art – the monumentalizing of the utterly inconsequential.

Come in Number 9

Bruce Nauman. What an excellent surname for this chapter. Words sentient with
loaded meaning are his medium. His art is aphoristic and striking and funny and he
uses blunt, everyday, American-type short-hand language as if it were Latin phrases
in important literature. It's an art connected to some kind of idea about the human
condition. But what is the idea? Perhaps that the human condition is very dark.

In fact, it never seems all that convincing as an idea and there is something else
about his genuinely striking art that makes it striking, some distance he puts
between himself and the idea of what it is to be human and have feelings. He
comes up with words and phrases that seem to describe life or existence. Then
he sometimes puts them in lists, so it's like the human condition spelled out as a list.

But there are lots of other forms as well that he uses. Words are spoken or droned or shouted across a gallery or whispered in a room or set in neon, or printed in ink or drawn in charcoal. Or simple images are dramatically animated – TV monitors on the floor with some cages and lights show real rats in a cage. Other TV sets in stacks or hanging in the air or standing singularly on plinths show people fighting or falling over or spinning and groaning or calling out stark propositions about sucking and dying. Psychological traps or loops or hells are shown on little monitors or giant screens or combinations of both.

Whatever the point is it isn't the ineffable, the deep, the inexpressible, but the sayable and the believable. And matching them up in a dramatic but minimalistically pared down way that leaves them still a bit disconnected.

Sucking and dying

In Nauman's film installation *Anthro/Socio (Rinde facing camera)*, 1991, shown in 1998 at London's Hayward Gallery as part of a retrospective of his work, a giant bald-headed face, twenty-feet high maybe, repeated on different screens, calls out phrases in an operatic drone. The drones are overlaid so the phrases can only be made out in bits and it is only after the viewer has been standing around for a while within this installation that the whole set of words that makes up the repeated phrases can really be heard.

The same droning head on different screens seems to flicker into action because the film is edited in jump-cuts. One of the heads is upside down, another one isn't, then they're both the right way up. Close to, the head is all multi-coloured dots on a film screen, quite nice in themselves.

The mouth opens, four-feet wide, out comes the drone but from a speaker somewhere else. 'Feed Me,' another head drones, 'Feed me.' The same head upside down drones 'Feed me.' And on small TV monitors it's droning 'Feed me' too. But by now you can hear 'Eat me' in there as well. It's a big droning Modern art opera, seductive, beautiful, the apotheosis of video art and definitely giving video art a good name and a bit of museum dignity. 'Feed me Eat me Anthropology, Help me Hurt me Sociology.'

This droner is an opera singer, the 'Rinde' of the title. The clown in *Clown Torture*, 1987, another video, is an actor. 'Oh!' he says in a dismayed childish way, as if something didn't add up. Then he tries out a little saying: 'Pete and Repeat were sitting on a fence, Pete fell off, who was left?' 'Oh!' Then he tries saying it quicker in case the answer might come out differently and then it goes on and on, the repeats and the groans of despair. And you can hear the cries of 'NO NO' all through the rest of the gallery, merging with all the other groanings and shoutings.

SUCK AND DIE, STAND AND DIE, KILL AND DIE, COME AND DIE. There is a wall of many variations on these three-word sentences set in coloured neon lights in four vertical rows near the entrance to the exhibition – variations on two verbs

and an AND. When he was young he played guitar in a jazz band and studied engineering and he was impressed by the notion of the elegant solution in mathematics. And his art works always have a rough and ready look but a wittily tailored look too. And they have a coded look and they look as if they might be solving some kind of problem. With this one, one sentence flickers on in white, then another one in blue, then more in other colours, then they're all on, blazing away, with the sound of the wires buzzing and hissing. Leaving art school, he paced about his studio in Pasadena, not knowing what to do next to make art, seeing the messes on the floor, watching the neon beer sign across the road flickering on and off.

'This must be life then,' he probably thought. 'Make art from it!'

Corny heads in void

Nauman certainly can be quite corny with his waxy heads all spinning in a void and stuck upside down on each other, like it's an Existential hell. But like Samuel Beckett, he is dryly humorous. Only not all that like him because he is not loquacious and slippery and poetic as well as dryly humorous. He repeats and repeats and makes meanings go blank and then animates the emptiness in a witty way. And he uses colour in a witty way too, so it seems like colour-coding rather than colourism, although of course you never know what the code is or if it's really a code.

All over the world his works fill out celebrated private collections. In the basement at the Eli Broad Foundation in LA, one of his circles of wax heads hangs in

Bruce Nauman
Ten Heads Circle/Up and Down
1990

space at this moment, surrounded by large-scale colour photos by Cindy Sherman. Staged Shermans surrounding spinning Naumans. The heads are in sets of twos, one upside down, one the right way up, the two skulls meeting. Each one is a waxy, transparent 'off' colour. A waxy, ivory-yellow bald head on a liverish-grey one. Orange on brown. Pink on pink. Grey on pink. Pink on pink-orange or flesh.

The eyes are closed, there is still stuff up the nose and in the mouths and ears to keep the plaster out during casting, the finish is rough. The pulled-down expressions are like the expression on William Blake's death mask, all doomy. Frozen, waxy, lollipop Existentialism, creepy and camp, a bit voodoo and silly. The Cindy Shermans surrounding them show dirt-covered, waxy dead faces with wispy, peroxide wig hair, or fragments of plastic bodies in science fiction goo, and the contents of horror film prop baskets.

More time

Time. There's nothing we can do about it. There's no use complaining. A film screen as big as a room shows an image of the actual room that it's as big as – a real prison cell, filmed in real time for ninety minutes. A bunk, two beds, chairs on the beds. A locker. Some heating pipes. A barred window. And a timecode on the screen. It ticks off the seconds, with the fractions of the seconds whirring by very fast.

The film is a live feed running into an art gallery. The sounds heard are doors opening and closing and many overlapping echoing voices, not violent particularly but keeping up a continuous medium-level racket. The time runs out when the cell is needed for a new prisoner. It's some art by Darren Almond, an artist in his late twenties. He makes live relays of situations. Empty rooms with the clock ticking. You can't get any more now than that.

So it's not a modern version of Van Gogh's prisoners going round a courtyard then?

'No,' he says. 'It's very specific. I wanted the cell to be empty in a working prison. I didn't necessarily want to focus on somebody's personal tragedy.'

Another film shows the artist's studio – a drawing table, an electric fan unplugged, a swivel chair, a radiator, and a clock.

'It was set up by the BBC from my studio. And it was broadcast via a very complicated set of satellite dishes all around London to a disused shop in Exmouth Market in the East Side of London to my studio in the West. It was a still shot of my studio. In the middle of the frame, on the back wall, was an industrial flip clock. The microphone was inside the flip clock. So every minute, you saw this life-sized image of my studio and then crash! – over came the time! You'd wait and wait and wait and then smash!'

So it's all pretty interesting. He says he could do it anywhere, in an operating theatre, for example, 'where you could watch someone die!' Crikey! Or on the moon.

'The next satelite link is going to be the moon. It's probably going to be in California but the moon will be the clock, because time begins with the moon.'

Darren Almond
b Wigan (England), 1971
The relationship between space and time is central to Almond's work, often represented through trains and clocks, the machines that attempt to negotiate these concepts. In *Schwebebahn*, 1995, Almond filmed Wuppertal's 20-km, inverted monorail. By slowing down and reversing the footage so that the train appears the right way up but everything else is upside down, he created an eerie distortion of temporal and spatial perception. *A Real Time Piece*, a live, 24-hour video relay of film of Almond's studio, led to *Tuesday (1440 minutes) (with clock)* (1996). For this work he took a photograph every time the clock in his studio flipped over to the next minute, laying out the 1,440 images representing a whole day in a sequential grid. In *HMP Pentonville* (1997), time and space converged again in footage of a claustrophobic, alarmingly noisy cell, satellite-beamed from Pentonville Prison to the ICA, giving an immediate, disturbing taste of the experience of 'doing time'.

Darren Almond
H.M.P Pentonville 1997

Real reality

Real-time art about doing time, until reality sets in and a new prisoner arrives or the patient dies and the art has to stop. Reality is what new art has to adjust to. It's adjusting all the time. It's working overtime to keep up.

Jaunty and Maine and Courbet

One thing that still exists, though, is painting. Thank goodness! Painting with palette knives and brushes and linseed oil and turpentine. John Currin is a good example of painting never dying. Or a devil sent to torment the *Moral Maze* panelists on Radio Four. He paints like Courbet but in a way that seems 100 per cent kitsch. But being unreal, the paintings are quite funny about what society often seems to want from

John Currin *Jaunty and Mame* 1997

John Currin *Ms Omni* 1993

the art of museums, even though society might not admit that something so low as big breasts might be so high on the agenda.

Jaunty and Maine, 1997, features a spectacular meeting of busts. The heads of the two figures are vigorously modelled with a lot of skilful palette knifing, like the modelling of rocks in a Courbet landscape only not grey and green but livid flesh-coloured, while the flat, red background is post-60s American abstract style. The bottoms are as exaggeratedly rounded and solid as the busts. And there are even some symbolic gestures for the imagined art lover not to bother interpreting: Jaunty or Maine holds out a dangling bra to Maine or Jaunty, while Maine or Jaunty holds out a fluttering dollar bill to Jaunty or Maine.

Other paintings show a recurring male figure that looks like a jazzy swinger or an intellectual arty type. *Entertaining Mr Acker Bilk* is the title of one of these weirdy beardies. Sometimes the figure is accompanied by blondes who stand for art or loveliness or sensuality or Nature or who are just painterly, cartoon, kitschy bunnies.

The paintings are like amplified caricatures or cartoons of stereotyped experience. You don't have to do any work when looking at them. It's quite unusual to have that in a contemporary art context. Usually you have to do a lot of work yourself because that's the contract between the art work and the viewer. Here it's all done for you and you can relax with a cigar.

John Currin
b Remscheidt (Germany), 1965
The early paintings of New York-based John Currin include a series of portraits of teenage girls based on photos taken from a high-school yearbook, reduced to a set of uniform, characterless images with empty, black eyes. He has continued to investigate stereotypical representations of different social groups in subsequent series, including a group of paintings of older women, caught between icy glamour and touching vulnerability. His more recent works feature bearded, middle-aged men, sportily dressed in country casuals, the implausible idols of wide-eyed, busty young blondes. Initially, these conjure a male fantasy of compliant, pneumatic femininity, but Currin is taking an ironic look at the relationship between the sexes, and the clichés of gender. This irony is underlined by the way in which he caricatures his subjects, rendering their skin-tones in heightened colours that would be at home in a Rococo painting but are quaintly anachronistic in a work of contemporary art.

'Yes,' says Currin. 'It's like having narrative in the movies – instead of making a Godard movie, making a Hollywood movie. It's going to appeal to more people. And therefore it's going to be considered low brow and obvious, not as smart, more right wing – it's going to have all those kind of associations.'

What are the associations of *Ms Omni,* painted in 1993?

'A menopausal kind of woman, cultivated, a member of an elite. In other words, the kind of person that would look down on my work at the time I was making it.'

What kind of painting would he say the more recent *Jaunty and Maine* was?

'Partly, this painting was meant to be less subtle, obviously, than my other work. In a way to kind of ruin the premise – to consciously start out with a failed irony, or to take the stance of a failed bad boy. It would be so much of a lame joke. You tell the big joke, nobody laughs and there's this awful silence for the rest of the painting.'

Another painting shows a bra dangling from a screen and a doctor with a stethoscope leaning into the space behind the screen. The screen takes up the centre of the picture – the brush work is sensitive, or parody-sensitive, abstract, flat, self-conscious, with an unmistakable suggestion, for anyone who's been to art school or read any recent art books, of a parody art history lecture, a lecture on painterly Modernism from Manet to Brice Marden.

Well, that's enough kitsch, however nuanced or quirky or studied or enjoyable, we might be thinking, except Courbet is very kitsch too – for example, his paintings of naked women in forest glades which are weekend crowd-pleasers in the nineteenth-century wing of the Metropolitan Museum in New York.

'It's never been my intention to be ironically low brow,' Currin says.

'In thirty or forty years it'll look pretty clearly like something from the decade in which it was made,' he says about *Jaunty and Maine.* 'And that's either a good or bad thing but you certainly can't escape that. No matter what. No matter how consciously you try to expand out of your own time I think you're always pretty dated. And great art is dated as much as terrible art.'

New Modern art museums

New museums of Modern art are opening all the time. Léger-like scenes of heroic construction workers operating cranes swinging horizontal girder shapes across complicated, interesting, angular abstract structures, are a familiar sight throughout the art capitals of the world, as the new museums spring up. Once finished, everything that is glossy and current will shine inside them and vast crowds will stream through them, like Nuremberg rallies of the now, saluting the new.

Museums are important because they go beyond society's preoccupation with material things. Just as the art of Europe from the last several centuries collected in the old museums offers transcendent meanings and a chronicle of ourselves and our history, so new Modern art museums are places of higher values, dedicated

Jeff Koons' Puppy in front of Guggenheim Museum, Bilbao 1998

not only to collecting and preserving but also, like the old museums, to searching – searching for meaning. They stand for civilization's highest achievements.

And of course new Modern art museums are works of architectural genius in their own right, as well as centres of high artistic excellence. For example, Frank Gehry's new Guggenheim spin-off in Bilbao. This strange, funny, shiny building with its strikingly non-Western curvilinear shapes, like a flowing silver outfit on a fashion model, looks like a quintessential work of Post-Modern architecture. Playful, enjoyable, silver and curvy, it houses a big display of the achievements of Post-War American art.

These include a circular labyrinth by Robert Morris, rectangular Minimal sculptures by Morris and Judd, big curved paintings by Frank Stella, a big black one by Warhol, and an endless, architectural, curve-echoing, high-walled, rippling abstract sculpture by Richard Serra that you can walk through, like you can walk through the labyrinth. Throughout, there is an unmistakable curatorial theme, a theme of curves.

Was that a joke by Lawrence Weiner, the 60s Conceptual artist? His one work here is a single word on the gallery wall, the word REDUCED in silver letters twenty-feet high. It certainly looks good and expansive from an aerial position, looking down from one of the curved white balconies, across Morris's circular labyrinth. Close to, you stand with your head near the top of the curve at the bottom of the U. From both positions it looks good and means little or nothing or just something ironic, an ironic flourish on the end of a blandness, the blandness being the whole, bland, idiotic, curatorial mindlessness of the rest of the exhibition.

But this is the most popular spot in the city, always crowded, so a big corporate global display not meaning anything is obviously the right idea for a museum now. Outside, near the main road, with the cars going by and the people passing, *Puppy*, inhabiting its own space, having its own charm, gets a loving pruning every week from skilled gardeners up a yellow crane.

Get in your own head

So if there's no meanings at all going on in the new museums we'll have to stay up here in our own chaotic heads for this last lap, the final stage of our enquiry into now. Dalí, our leader, will be watching over us, with his love of the past, and his love of money, and his virile moustaches and familiar burning eyes. And with Time now devouring the last minutes, and the industrial flip clocks booming, I look down and see the word-count on my laptop Toshiba mounting reassuringly.

'Will this do?' the twentieth century asks, all its great achievements in the arts laid out, waiting for rosettes from posterity. 'Well, that's something you'll never know,' the future replies. So 'will it last?' is not a question worth asking even now when frankly we're letting anything pass and anything goes.

Richard Serra
Snake 1997

Bruce Nauman

Self portrait as a fountain
1966

Mae West

Oh look, Dalí lying in state, but at the same time not dead yet, because time is going backwards and space is folded like the space in Cubism, and oracular truths about the power of genius issue from the lips of his pink Mae West sofa in his front garden at Cadaqués. Not the original sofa, I noticed when I was out there earlier this year, but a simulacrum for tourists, as enjoyably tacky as the rest of the chintz in his garden, including the spurting fountains there that go on and off like thoughts surging.

In the pellucid blue of his garden rock pool, with the fountains spraying, reflections reflect reflections, like the meanings in reviews of Conceptual art exhibitions. And I think I see Bruce Nauman's youthful photo of himself as a fountain, blowing a stream of water from his lips, called *Fountain*, after Marcel Duchamp's *Fountain*, which Nauman saw as a student in Duchamp's first museum retrospective held in Pasadena, a suburb of LA, in 1963.

And from the rock formations around Cadaqués a paranoic-critical vision of the great, wide field of Modern art arises, looking for all the world like a composition with boiled beans and burning giraffes one minute, and then with a subtle shift of stereoscopic vision, turning into all the new sons and dead dads of art, from Picasso to now, portrayed with a tiny sable brush. Not that it's all men of course.

Photo realism

And now it's Ron Mueck's *Dead Dad* dead once again in 'Sensation' as this exhibition goes on repeating forever on its world tour, restaged from city to city, exactly mirrored but looking slightly worse at each stop because that must be how they like it in the museums in Berlin and Brooklyn and elsewhere.

Mueck's popular sculptural photo-realism is a marvel to see. Or at any rate a kind of freakish thing, not quite art. A movement from the 60s repeated in the 90s to the same kind of applause. Kind of dying out quite quickly after the initial rise, because as a movement it hasn't changed all that much from how it was then – possessing a high degree of stare-ability, maybe seeming much better than art in a way, but not particularly having anywhere to go after the shock of the incredibly realistic nose hair, or the realistic frown, or in this case, realistic death at three-quarter scale.

Le deluge

Someone's own real dad, dead. Death, the big meaning of art now. However much Saatchi buys our stuff we will die. And then there will be nothing. *Après le deluge* the *Dead Dad* gets it plus all the other art. Well that's a bit depressing. But no! Here's an angel called *Angel*, also by Ron Meuck, in the same eternal 'Sensation' show, with realistic white wings like the wings of the Albatross.

Neo ego

Excitement still swelling after the music's faded – fibreglass *Angel* frowns on its wooden stool, regarding the landscape of art back to Picasso. And his copies of Poussin. *Et in Arcadia ego* – 'Even in paradise I am.' That was Death in seventeenth-century paintings of paradise. But now it's all inverted. However suspicious and blank and empty and ironic and repetitious contemporary art might be, hope is always here. Or some nice greys or something. Hope, marvels, beauty, a route to transcendent meanings, a few laughs.

First show of American art at Guggenheim Museum, Bilbao 1998

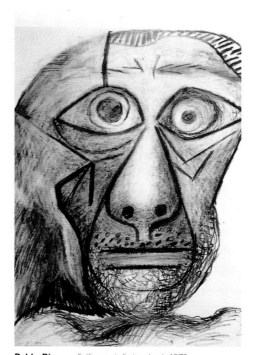

Pablo Picasso *Self portrait facing death* 1972

PICTURE CREDITS

Pictures on pages 2, 7, 21, 32, 63, 92, 95, 101, 130, 141, 178, 183, 204, 223, 262 are taken from *This is Modern Art*, an Oxford Television Company Production for Channel Four.

Introduction

Gary Hume in his studio, 1999
© Jill Furmanovsky

Gary Hume, *Messiah*, 1998
Courtesy Gary Hume Studio
© Jill Furmanovsky

Monet Exhibition at the Royal Academy, 1998
Photo courtesy PA NewsCentre, London
© Fiona Hanson

Tracey Emin, Blue Sapphire Gin advertisement, 1998
Courtesy Banks, Hoggins, O'Shea, FCB

Damien Hirst, *Away from the Flock*, 1994
Courtesy Jay Joplin, London

Jake and Dinos Chapman in their studio, 1999
Photo © Antonio Olmos

Pablo Picasso, Self portrait taken in Picasso's studio
© Succession Picasso/DACS 1999
© Photo RMN – B. Hatala
Musée Picasso, Paris

Duane Hanson, *Tourists II*, 1998
Courtesy Saatchi Gallery, London
© Jochen Littkemann, Berlin

Simon Patterson, *The Great Bear*, 1992
Courtesy Lisson Gallery, London
Photo © John Riddy, London

Chapter One

Gilbert and George, *The Singing Sculpture*, 1970
Courtesy Anthony d'Offay Gallery, London

Joseph Beuys, *Explaining Paintings to a Dead Hare*, 1965
© DACS 1999

Joseph Beuys, *Vitrine for: Two Fräuleins with Shining Bread*, 1963–82
Courtesy Anthony d'Offay Gallery, London
© DACS 1999

Cindy Sherman, *Untitled No 70 (Girl at Bar)*, 1980
Courtesy Saatchi Gallery, London/Cindy Sherman and Metro Pictures

Sophie Calle, *Days under The Sun B, C & W* (detail), 1998
© Violette Editions

Picasso at Villa la Californie, Cannes, 1960
© David Douglas Duncan

Billy Name, Andy Warhol in the Factory, New York, 1960
© Bruce Coleman, New York

Jackson Pollock on Model A Ford, 1948
Courtesy Peter Namuth
© Hans Namuth, 1990

Damien Hirst and Maia Norman at the Turner Prize, 1995
Courtesy Rex Features, London
Photo © Richard Young

Bank, *Press Releases*, 1999
Courtesy Bank Collective, London

Jake and Dinos Chapman, *Disasters of War*, 1999
Courtesy Victoria Miro Gallery
Photo © Stephen White

Marcel Duchamp, 1963
Photo © Julian Wasser

Rachel Whiteread, *Untitled (Book Corridors)*, 1998
Courtesy Anthony d'Offay Gallery, London

Jeff Koons, *Signature Plate (Parkett Edition)*, 1989
Portfolio Edition of 50, artist's proof

Pablo Picasso, *The Head of a Bull*, 1943
© Succession Picasso/DACS 1999
© Photo RMN – B. Hatala
Musée Picasso, Paris

Sarah Lucas, *Au Naturel*, 1994
Courtesy Sadie Coles HQ, London

Sarah Lucas, *Two Fried Eggs and a Kebab*, 1992
Courtesy Sadie Coles HQ, London

Sarah Lucas, *Sod You Gits!*, 1990
Courtesy Sadie Coles HQ, London

Pablo Picasso, *Les Demoiselles d'Avignon*, 1907
© Succession Picasso/DACS 1999
The Museum of Modern Art, New York. Acquired through the Lillie P. Bliss Bequest.
Photo © 1999 The Museum of Modern Art, New York.

Pablo Picasso, *Self Portrait*, 1903
© Succession Picasso/DACS 1999
© Photo RMN – B. Hatala
Musée Picasso, Paris

Hans Namuth, *Pollock painting*, 1950
Courtesy Peter Namuth
© Hans Namuth, 1991

Jackson Pollock, *One* (Number 31), 1950
© ARS, New York and DACS 1999
The Museum of Modern Art, New York. Sidney and Harriet Janis Collection Fund (by exchange).
Photo © 1999 The Museum of Modern Art, New York

Cecil Beaton, *Autumn Rhythm* for *Vogue*, 1951
Courtesy Sotheby's, London

Willem de Kooning, *Merritt Parkway*, 1959
© Willem de Kooning, ARS, NY and DACS, London 1999
The Detroit Institute of Arts, USA.
Courtesy Bridgeman Art Library, London

Andy Warhol, *Ambulance Disaster*, 1963
© ARS, NY and DACS, London 1999
© The Andy Warhol Foundation for the Visual Arts, Inc.

Andy Warhol, *Marilyn Diptych*, 1962
© The Andy Warhol Foundation for the Visual Arts, Inc/ARS, New York and DACS, London 1999
Photo © Tate Gallery, London 1998

Andy Warhol, *Blow Job*, 1964
© 1990 The Andy Warhol Museum, Pittsburgh, PA, a museum of Carnegie Institute
Film still courtesy the Andy Warhol Museum

Andy Warhol, *The Chelsea Girls*, 1966
© 1994 The Andy Warhol Museum, Pittsburgh, PA, a museum of Carnegie Institute
Film still courtesy the Andy Warhol Museum

Jane and Louise Wilson, *Gamma (Silo)*, 1999
Courtesy Lisson Gallery, London

Jane and Louise Wilson, *Gamma (detail)*, 1999
Courtesy Lisson Gallery, London

Chapter Two

Damien Hirst, *Some Comfort Gained from the Acceptance of the Inherent Lies in Everything*, 1996
Courtesy Jay Jopling, London

Francisco Goya, *Saturn Devouring One of His Sons*, c. 1820
© Museo del Prado, Madrid

Francis Bacon, *Seated Figure*, 1961
© Estate of Francis Bacon/ARS, NY and DACS, London, 1999
Photo © Tate Gallery, London

Francisco Goya, *Cannibals Contemplating Human Remains*, c. 1804
Musée de Beaux-Arts et d'Archéologie/Cliché Charles Choffet, Besançon, France

Francisco Goya, *Great Deeds! Against the Dead!*, c. 1810 (etching from *Disasters of War*)
© British Museum

Jake and Dinos Chapman, *Great Deeds against the Dead*, 1994
Courtesy Victoria Miro Gallery

Pablo Picasso, *Guernica*, 1937
© Succession Picasso/DACS 1999
Museo Nacional Centro de Arte Reino Sofia, Madrid
Courtesy Bridgeman Art Library, London/New York

Jake and Dinos Chapman, *The Un-Namable*, 1997
Courtesy Jake and Dinos Chapman

Gilbert and George (stills with tongues)
from *The World of Gilbert and George*, 1981
Courtesy Gilbert and George

Gilbert and George, *Underneath the Arches*, 1971
from *The World of Gilbert and George*, 1981
Courtesy Gilbert and George

Gilbert and George, *Human Shits*, 1994
Courtesy Prudence Cuming Associates Ltd, London

Francisco Goya, *The Sleep of Reason Produces Monsters*,
 plate 43 of 'Los Caprichos', 1799
Private Collection/Index/Bridgeman Art Library, London/New York

Edvard Munch, *The Scream*, 1893
© Munch Museum/Munch-Ellingsen Group/DACS, London 1999
Photo J Lathion, © Nasjonalgalleriet, Oslo

Tracey Emin on Channel Four, 1997
Courtesy Illuminations, London

Tracey Emin, *Monument Valley (Grand Scale)*, 1995
Courtesy Jay Joplin, London

Edvard Munch, *Painting on the Beach in Warnemünde*, 1907
© Munch Museum/Munch-Ellingsen Group/DACS, London 1999
Courtesy Munch-museet, Oslo

Vivienne Westwood, Gay Cowboys T-shirt, c. 1975
Courtesy *Mojo* magazine

Jake and Dinos Chapman, *Hell*, 1999
Courtesy Jake and Dinos Chapman

Paul McCarthy, *Santa Chocolate Shop*, 1997
 (videotape, mixed media, still from performance)
Courtesy Luhring Augustine Gallery, New York

Vito Acconci, *Trappings*, 1971
Courtesy Barbara Gladstone Gallery, New York

Edvard Munch, *The Dance of Life*, 1899–90
Nasjonalgalleriet, Oslo/DACS, London 1999
Photo J. Lathion © Nasjonalgalleriet, 1997

Francisco Goya, *What Next?*, plate 69 of 'Los Caprichos', 1799
© British Museum

Francisco Goya, *Dog Drowning in Quicksand*, 1820
© Museo del Prado, Madrid

Chapter Three

Henri Matisse, *Capucines à la Danse II*, 1912
© Succession H. Matisse/DACS 1999
Sammlung S.I. Schtschukin, Moscow, Pushkin Museum
Courtesy AKG Photo

Henri Matisse, *Luxe, Calme et Volupté*, 1904
© Succession H. Matisse/DACS 1999
Musée d'Orsay, Paris
Courtesy AKG/Erich Lessing

Henri Matisse, *Large Red Interior*, 1948
© Succession H. Matisse/DACS 1999
Musée National d'Art Moderne, Paris/Peter Willi/Bridgeman Art Library, London/New York

Pablo Picasso, *Nude in Red Armchair*, 1929
© Succession Picasso/DACS 1999
Musée Picasso, Paris
Photo RMN – J.G. Berizzi

Henri Matisse, *Odalisque with Tambourine*, 1926
© Succession Matisse/DACS 1999
The Museum of Modern Art, New York. The William S Paley Collection.
Photo © 1999 Museum of Modern Art, New York

Piet Mondrian, *Composition with Large Blue Plane*, 1921
© Mondrian/Holtzman Trust, c/o Beeldrecht, Amsterdam, Holland/DACS 1999
Museum of Art, Dallas, Texas
Courtesy AKG, London

Henri Matisse, *Blue Nude 1*, 1952
© Succession H. Matisse/DACS 1999
Fondation Beyeler, Riehen/Basel

Morris Louis, *Aleph Series I, DU#262*, 1960
© 1960 Morris Louis
Courtesy Bridgeman Art Library, London

Jules Olitski, *High A Yellow*, 1967
Courtesy Lauren Olitski Poster

Jules Olitski, *Envisioned Sail*, 1998
Courtesy Lauren Olitski Poster

Alex Katz, *Lawn Party*, 1965
Courtesy Marlborough Gallery, New York

Elizabeth Peyton, *Jarvis at Press Conference*, 1996
Courtesy Gavin Brown's Enterprise, New York

Jean-Michel Basquiat, *Untitled (Yellow Tar and Feather)*, 1982
© ADAGP, Paris and DACS, London 1999
Courtesy Gerard Basquiat

Jasper Johns, *Flag on Orange Field*, 1957
© Jasper Johns/VAGA, New York/DACS, London 1999
Lüdwig Musuem, Cologne
Courtesy AKG, London

Jean-Michel Basquiat, *New Nile*, 1985
© ADAGP, Paris and DACS, London 1999
Courtesy Gerard Basquiat

Jean-Michel Basquiat in his studio in New York, 1985
© ADAGP, Paris and DACS, London 1999
Courtesy Gerard Basquiat

Tony Shafrazi/Bruno Bischberger present Warhol and Basquiat, joint show, 1985
© Michael Halsband 1999, New York

Jean-Michel Basquiat, *Untitled*, 1984
© ADAGP, Paris and DACS, London 1999
Courtesy Gerard Basquiat

Chris Ofili, *Afrodizzia (2nd version)*, 1996
Courtesy Victoria Miro Gallery, London

Chris Ofili, *The Holy Virgin Mary*, 1996
Courtesy Victoria Miro Gallery, London

Hélène Adant, *Henri Matisse at work on the Chapel at Vence*, 1949–50
Succession Matisse/DACS, 1999
Musée National d'art Moderne, Centre Georges Pompidou

Henri Matisse, *The Rosary Chapel at Vence: l'Autel*, 1949–50
Succession Matisse/DACS, 1999
© Photo RMN – H del Olmo

Patrick Heron in his studio, 1997
© Susanna Heron

Patrick Heron, *Red Garden Painting: June 3-June 5*, 1985
© Patrick Heron. 1999 All Rights Reserved, DACS

Chapter Four

Martin Creed, *Work Number 200, Half the Air in a Given Space*, 1998
Installation at Analix Gallery, Geneva
Courtesy Cabinet Gallery, London

Martin Creed, *Work no 88, A sheet of A4 paper crumpled up into a ball*, 1994
Courtesy Cabinet Gallery, London

Martin Creed, *Work no 127, The lights going on and off*, 1995
Courtesy Cabinet Gallery, London

Carl Andre, *Equivalent VIII*, 1966
© Carl Andre / VAGA, New York/DACS, London 1999
Installation at Tibor de Nagy Gallery, New York
Photo © Tate Gallery

Dan Flavin, *The Diagonal of May 25, 1963 (to Constantin Brancusi)*, 1963
© ARS, NY and DACS, London 1999
Photo: Cathy Carver, Courtesy Dia Center for the Arts, New York

Donald Judd, *Untitled*, 1972
© Estate of Donald Judd/VAGA, New York/DACS, London 1999
Photo © Tate Gallery, London

Giovanni Lorenzo Bernini, *The Abduction of Proserpina*, 1622
Rome, Galleria Borghese
Courtesy AKG, London

Stool in form of a kneeling woman, 19ᵗʰ century
British Museum, London
Courtesy AKG, London

Robert Morris, *Two Columns*, 1961
© ARS, NY and DACS, London 1999
Courtesy Solomon R. Guggenheim Museum, New York

Carl Andre, *Equivalent I-VIII*, 1966
© Carl Andre/VAGA, New York/DACS, London 1999
Installation at Tibor de Nagy Gallery, New York
Courtesy Paula Cooper Gallery, New York

Ad Reinhardt, *Abstract Painting*, 1960
© DACS 1999
Courtesy Solomon R. Guggenheim Museum, New York
Photo by David Heald © the Solomon R. Guggenheim Museum, New York

The Black Square Room, Ad Reinhard Exhibition, Jewish Museum, New York, 1966–7
© The Jewish Musum, New York, Visual Resources Archive
ARS, New York and DACS, London

Robert Ryman, *Term 2*, 1996
Courtesy Pace Wildenstein
Photo © Ellen Page Wilson

Kasimir Malevich, *Black Suprematist Square*, 1914–15
Tretiakov Gallery, Moscow

Kasimir Malevich, *Suprematism (with eight red rectangles)*, 1915
State Russian Museum, St Petersburg

Last Futurist Exhibition 0, 10, 1915
Stedelijk Museum, Amsterdam

Kasimir Malevich, *Red Square: Painterly Realism of a Peasant in Two Dimensions*, 1917
State Russian Museum, St Petersburg

Mark Rothko in his studio, 1964
© Hans Namuth Estate, Collection Centre of Creative Photography,
University of Arizona

Mark Rothko, *Number 22*, 1949
© Kate Rothko Prizel and Christopher Rothko/DACS 1999
The Museum of Modern Art, New York. Gift of the artist.
© 1999 The Museum of Modern Art, New York/Kate Rotch

Interior, Rothko Chapel, Houston, TX, USA
© Kate Rothko Prizel and Christopher Rothko/DACS 1999
Nicolas Sapieha/Art Resource, NY

Yves Klein, *Leap into the Void*, 1960
©Yves Klein ADAGP. Paris/Harry Skunk, DACS, London 1999
Photo © Shunk-Kender

Yves Klein, *IKB 79*, 1960
© ADAGP, Paris and DACS, London 1999
Photo © Tate Gallery, London 1998

Yves Klein, *Ant 63 Anthropometry*, 1961
© ADAGP, Paris and DACS, London 1999
Private Collection/Bridgeman Art Library, London/New York

Yves Klein, Anthropometry performance in Paris, 1960
© ADAGP, Paris and DACS, London 1999
Galerie internationale d'art contemporain, Paris

Peter Halley, *Glowing and Burnt-Out Cells with Conduit*, 1982
Courtesy Peter Halley

Glenn Brown, *Searched Hard for You and Your Special Ways*, 1995
Collection Byron Meyer, San Francisco, CA
© Glenn Brown

Jason Martin, *Untitled (jet loop paint #6)*, 1997
Courtesy Lisson Gallery, London

James Turrell, *Meeting*, 1996
Courtesy PS1 Gallery, New York
Photo © Michael Moran

Chapter Five

Piero Manzoni, *Artist's shit No 068*, 1961
© DACS, 1999
Archivio Opera Piero Manzoni, Milan

Yoko Ono, *Film No.4 (Fluxfilm ≠ 16)*, 1966
© Yoko Ono

Richard Prince, *Untitled*, 1985
Courtesy Barbara Gladstone Gallery, New York

Sarah Lucas, *Receptacle of Lurid Things*, 1991
Courtesy Sadie Coles HQ, London

George Maciunas, Dick Higgins, Wolf Vostell, Benjamin Patterson, Emmett Williams
performing Philip Corner's Piano Activities, 1962
Photo © Harmut Rekord

May Ray, *Marcel Duchamp as Rose Sélavy*, 1921
Philadelphia Museum of Art

Marcel Duchamp, 1965
© Ugo Mulas

Marcel Duchamp, *Large Glass or Bride Stripped Bare by Her Bachelors, Even*, 1915–23
© Succession Marcel Duchamp, DACS 1999
Courtesy Philadelphia Museum of Art: Bequest of Katherine S. Dreier

Marcel Duchamp, *Etant Donné*, 1946–66
© Succession Marcel Duchamp/DACS 1999
Philadelphia Museum of Art: gift of the Cassandra Foundation

Sean Landers, *Bubble Boy*, 1998
Courtesy Andrea Rosen Gallery, New York
Orcutt & Van Der Putten

ACKNOWLEDGEMENTS

I had a lot of help with this book from Emma Biggs, so thanks a lot Emma. Also thanks to Rebecca Wilson at Weidenfeld for being so kind as to commission this and then edit it very patiently, and laugh at one or two of the jokes. Plus thank you Catherine Hill, also at Weidenfeld. Thanks to Ian Macmillan, Chris Rodley and Phil Smith for many good ideas. Thanks to Melissa Larner for the very well-written artists' biographies. Thanks finally to Herman Lelie and Stefania Bonelli for their patience and their design and type-setting.

INDEX

- Dave Hammons
- Stella
- A. Martin
- Ellen Gallagher
- Oldenburg
- Sc
- A. Caro
- D
- formalism!
- womanising
- Hardedge
- Kelly
- Race
- Olitski
- Noland
- Morris
- Jeff Wall
- B. Newman
- Lichtenstein
- Basquiat
- Sc
- Richard Patterson
- B. Riley
- Op
- Pop
- coolness
- a m
- R. Serra
- friends
- Chris Ofili
- Warhol
- rocky
- Peter Doig
- Documentation
- Machin
- Rosenquist
- J. opie
- Johns
- Sport
- Religion
- S. LeWitt
- P. Taaffe
- Bikes
- Mondrian
- Overbearing presence
- C. Wool
- M. Barney
- C. Weiner
- Wall
- preacher
- Bacon

THE ZHIVAGO AFFAIR

1956. Boris Pasternak knew his novel, *Doctor Zhivago*, would never be published in the Soviet Union as the authorities regarded it as seditious, so, instead, he pressed the manuscript into the hands of an Italian publishing scout and allowed it to be published in translation all over the world — a highly dangerous act.

1958. The CIA, recognising that the Cold War was primarily an ideological battle, published *Doctor Zhivago* in Russian and smuggled it into the Soviet Union. It was immediately snapped up on the black market. Pasternak was later forced to renounce the Nobel Prize in Literature, igniting worldwide political scandal.

With first access to previously classified CIA files, *The Zhivago Affair* gives an irresistible portrait of Pasternak, and takes us deep into the Cold War, back to a time when literature had the power to shake the world.

THE ZHIVAGO AFFAIR

THE KREMLIN, THE CIA, AND THE BATTLE OVER A FORBIDDEN BOOK

PETER FINN AND PETRA COUVÉE

ISIS

LARGE PRINT

Oxford

First published in Great Britain 2014
by
Harvill Secker
The Random House Group Ltd.

First Isis Edition
published 2015
by arrangement with
Harvill Secker
The Random House Group Ltd.

A catalogue record for this book is available
from the British Library.

ISBN 978–1–78541–044–4 (hb)
ISBN 978–1–78541–045–1 (pb)

Published by
ISIS Publishing Ltd.
7 Centremead, Osney Mead, Oxford

Set by Words & Graphics Ltd.
Anstey, Leicestershire
Printed and bound in Great Britain by
T. J. International Ltd., Padstow, Cornwall

This book is printed on acid-free paper

For Nora FitzGerald, and our children,
Rachel, Liam, David,
and Ria and
For Koos Couvée and Paula van Rossen

For Nora FitzGerald, and our children,
Rachel, Liam, David,
and Ria and
For Roos, Gunter, and Paula van Kessel

Contents

Prologue

"This is *Doctor Zhivago*. May it make its
way around the world."

On May 20, 1956, two men took the suburban electric
train from Moscow's Kiev station to the village of
Peredelkino, a thirty-minute ride southwest of the city.
It was a blue-sky Sunday morning. Spring had pushed
the last of the snow away just the previous month, and
the air was sweet with the scent of blooming lilac.
Vladlen Vladimirsky, easily the bigger of the two, had
bright blond hair and wore the billowing pants and
double-breasted jacket favored by most Soviet officials.
His slender companion was clearly a foreigner —
Russians teased the man that he was a *stilyaga*, or "style
maven," because of his Western clothing. Sergio
D'Angelo also had the kind of quick smile that was
uncommon in a country where circumspection was
ingrained. The Italian was in Peredelkino to charm a
poet.

The previous month D'Angelo, an Italian Communist
working at Radio Moscow, read a brief cultural news
item noting the imminent publication of a first novel by
the Russian poet Boris Pasternak. The two-sentence
bulletin told him little except that Pasternak's book

1

promised to be another Russian epic. The novel was called *Doctor Zhivago*.

Before leaving Italy, D'Angelo had agreed to scout out new Soviet literature for a young publishing house in Milan that had been established by a party loyalist, Giangiacomo Feltrinelli. Getting the rights to a first novel by one of Russia's best-known poets would be a major coup both for himself and the new publishing concern. He wrote a letter to an editor in Milan in late April, and before receiving a reply asked Vladimirsky, a colleague at Radio Moscow, to set up a meeting with Pasternak.

Peredelkino was a writers' colony built on the former estate of a Russian nobleman. Set down amid virgin pine, lime trees, cedars, and larches, it was created in 1934 to reward the Soviet Union's most prominent authors with a retreat that provided escape from their apartments in the city. About fifty country homes, or dachas, were built on large lots on 250 acres. Writers shared the village with peasants who lived in wooden huts — the women wore kerchiefs and men rode on horse-drawn sleds.

Some of the biggest names in Soviet letters lived in Peredelkino — the novelists Konstantin Fedin and Vsevolod Ivanov lived on either side of Pasternak. Kornei Chukovsky, the Soviet Union's most beloved children's-book writer, lived a couple of streets away as did the literary critic Viktor Shklovsky. As idyllic as it looked, the village was haunted by its dead, those executed by the state during the Great Terror of the late 1930s — the writers Isaak Babel and Boris Pilnyak

were both arrested at their dachas in Peredelkino. Their homes were handed off to other writers.

According to village lore, Soviet leader Joseph Stalin had asked Maxim Gorky, the father of Soviet literature and one of the founders of the socialist-realist school of writing, how his counterparts in the West lived. When Gorky said they lived in villas, Peredelkino was ordered up by Stalin. Legend or not, writers were a privileged caste. They were organized into the nearly four-thousand-strong Union of Soviet Writers, and lavished with perks unimaginable for ordinary Soviet citizens, who often lived in tiny spaces and suffered through long lines for basic goods. "Entrapping writers within a cocoon of comforts, surrounding them with a network of spies" was how Chukovsky described the system.

Novels, plays, and poems were seen as critical instruments of mass propaganda that would help lead the masses to socialism. Stalin expected his authors to produce fictional or poetic celebrations of the Communist state, the story lines full of muscular progress in the factories and the fields. In 1932, during a meeting with writers at Gorky's home, Stalin launched the new literature with a toast: "The production of souls is more important than the production of tanks . . . Here someone correctly said that a writer must not sit still, that a writer must know the life of a country. And that is correct. Man is remade by life itself. But you, too, will assist in remaking his soul. This is important, the production of souls. And that is why I raise my glass to you, writers, the engineers of the human soul."

<center>★ ★ ★</center>

After leaving the train station, D'Angelo and Vladimirsky passed the walled summer residence of the patriarch of the Russian Orthodox Church. They crossed a stream by a graveyard and walked along roads that were still a little muddy before turning onto Pavlenko Street, the narrow lane at the edge of the village where Pasternak lived. D'Angelo was unsure what to expect. He knew from his research that Pasternak was esteemed as a supremely gifted poet and was praised by scholars in the West as someone who stood out brightly in the stolid world of Soviet letters. But D'Angelo had never actually read anything by him. Within the Soviet establishment, recognition of Pasternak's talent was tempered by doubts about his political commitment, and for long periods original work by the poet was not published. He earned a living as a translator of foreign literature, becoming one of the premier Russian interpreters of Shakespeare's plays and Goethe's *Faust*.

Pasternak's dacha, emerging from stands of fir and birch, was a chocolate-brown, two-story building with bay windows and a veranda; it reminded some visitors of an American timber-frame house. As D'Angelo arrived at the wooden gate, the sixty-six-year-old writer, in Wellington boots and homespun pants and jacket, was working in his front garden, where the family had a vegetable patch among the fruit trees, bushes, and flowers. Pasternak was a physically arresting man, remarkably youthful, with an elongated face that seemed sculpted from stone, full sensuous lips, and lively chestnut eyes. The poet Marina Tsvetaeva said he

4

looked like an Arab *and* his horse. A visitor to Peredelkino noted that he could pause at certain moments as if recognizing the impact "of his own extraordinary face . . . half closing his slanted brown eyes, turning his head away, reminiscent of a horse balking."

Pasternak greeted his visitors with firm handshakes. His smile was exuberant, almost childlike. Pasternak enjoyed the company of foreigners, a distinct pleasure in the Soviet Union, which only began to open up to outsiders after the death of Stalin in 1953. Another Western visitor to Peredelkino that summer, the Oxford don Isaiah Berlin, said the experience of conversing with writers there was "like speaking to the victims of shipwreck on a desert island, cut off for decades from civilization — all they heard they received as new, exciting and delightful."

The three men sat outside on two wooden benches set at right angles in the garden, and Pasternak took some delight in Sergio's last name, stretching it out in his low droning voice with its slightly nasal timbre. He asked about the name's origin. Byzantine, said D'Angelo, but very common in Italy. The poet talked at length about his one trip to Italy when he was a twenty-two-year-old philosophy student at the University of Marburg in Germany in the summer of 1912. Traveling in a fourth-class train carriage, he had visited Venice and Florence but had run out of money before he could get to Rome. He had written memorably of Italy in an autobiographical sketch, including a sleepy half-day in Milan just after he arrived. He remembered

5

approaching the city's cathedral, seeing it from various angles as he came closer, and "like a melting glacier it grew up again and again on the deep blue perpendicular of the August heat and seemed to nourish the innumerable Milan cafes with ice and water. When at last a narrow platform placed me at its foot and I craned my head, it slid into me with the whole choral murmur of its pillars and turrets, like a plug of snow down the jointed column of a drainpipe."

Forty-five years later, Pasternak would become bound to Milan. Just a short distance away from the cathedral, through the glass-vaulted Galleria Vittorio Emanuele II and past La Scala, was Via Andegari. At number 6 was the office of Feltrinelli, the man who would defy the Soviet Union and first publish *Doctor Zhivago*.

Conversations with Pasternak could become soliloquies. Once engaged, he talked in long, seemingly chaotic paragraphs, full of coltish enthusiasm, words and ideas hurtling ahead before he alighted on some original point. Isaiah Berlin said, "He always spoke with his peculiar brand of vitality, and flights of imaginative genius." D'Angelo was enthralled, happy to be an audience, when Pasternak apologized for talking on and asked his visitor why he wanted to see him.

D'Angelo explained that his posting in Moscow was sponsored by the Italian Communist Party, which encouraged its leading activists to experience life in the Soviet Union. D'Angelo worked as an Italian-language producer and reporter for Radio Moscow, the Soviet

Union's official international broadcaster, which was housed in two buildings behind Pushkin Square in central Moscow. Before coming to the Soviet Union, he had been the manager of the Libreria Rinascita, the Italian Communist Party bookstore in Rome. D'Angelo was a committed activist from an anti-Fascist family who joined the party in 1944, but some of his Italian comrades felt he was a little too bookish and lacked sufficient zeal. They hoped a spell in Moscow would stoke some fire. The party leadership arranged a two-year assignment in the Soviet capital. He had been in the Soviet Union since March.

D'Angelo, who spoke Russian well and only occasionally had to ask Vladimirsky to help him with a word, told Pasternak that he also acted as a part-time agent for the publisher Feltrinelli. Not only was Feltrinelli a committed party member, D'Angelo said, he was a very rich man, the young multimillionaire scion of an Italian business dynasty, who had been radicalized during the war. Feltrinelli had recently started a publishing venture, and he especially wanted contemporary literature from the Soviet Union. D'Angelo said he had recently heard about *Doctor Zhivago*, and it seemed an ideal book for Feltrinelli's new house.

Pasternak interrupted the Italian's pitch with a wave of his hand. "In the USSR," he said, "the novel will not come out. It doesn't conform to official cultural guidelines."

D'Angelo protested that the book's publication had already been announced and since the death of Stalin

7

there had been a marked relaxation within Soviet society, a development that got its name — "the thaw" — from the title of a novel by Ilya Ehrenburg. The horizons of literature seemed to broaden as old dogmas were challenged. Fiction that was somewhat critical of the system, reflected on the recent Soviet past, and contained complex, flawed characters had begun to be published.

The Italian said he had a proposal. Pasternak should give him a copy of *Doctor Zhivago* so that Feltrinelli could have it translated, although he would of course wait until publication in the Soviet Union before bringing it out in Italy. And Pasternak could trust Feltrinelli because he was a Communist Party loyalist. This all sounded reasonable to the eager D'Angelo, anxious as he was to secure the manuscript and justify the stipend he was receiving from Feltrinelli.

D'Angelo had no sense of the risk Pasternak would be taking by placing his manuscript in foreign hands. Pasternak was all too aware that the unsanctioned publication in the West of a work that had not first appeared in the Soviet Union could lead to charges of disloyalty and endanger the author and his family. In a letter to his sisters in England in December 1948, he warned them against any printing of some early chapters he had sent them: "Publication abroad would expose me to the most catastrophic, not to mention fatal, dangers."

Pilnyak, Pasternak's former next-door neighbor in Peredelkino (the side gate between their gardens was never closed), was executed with a single bullet to the

back of the head in April 1938. Pilnyak was skeptical of the Soviet project, tackled themes such as incest in his fiction, and described Stalin's and Gorky's literary commands as the castration of art. Pilnyak's fate may well have been foreordained as early as 1929 when he was accused, falsely, of orchestrating publication abroad of his short novel *Mahogany* by anti-Soviet elements. Set in a postrevolutionary provincial town, the novel includes a sympathetically drawn character who is a supporter of Leon Trotsky — Stalin's bitter rival. Pilnyak was subjected to a public campaign of abuse in the press. "To me a finished literary work is like a weapon," wrote Vladimir Mayakovsky, the brash and militant Bolshevik poet, in a review of Pilnyak's work that noted, without blushes, he had not actually read *Mahogany*. "Even if that weapon were above the class struggle — such a thing does not exist (though, perhaps, Pilnyak thinks of it like that) — handing it over to the White press strengthens the arsenals of our enemies. At the present time of darkening storm clouds this is the same as treachery at the front."

Pilnyak tried to win his way back into the party's good graces with some kowtowing pronouncements about Stalin's greatness, but he couldn't save himself. The charge of disloyalty was memorialized in a file. With the Great Terror at its height, he was tormented by the fear of imminent arrest. The country was in the grip of a mad, murderous purging of the ranks of the party, the bureaucracy, and the military as well as the intelligentsia and whole ethnic groups. Hundreds of thousands were killed or died in detention between

1936 and 1939; hundreds of writers were among the victims. Pasternak remembered Pilnyak constantly looking out the window. Acquaintances he ran into expressed amazement that he hadn't already been picked up. "Is it really you?" they asked. And on October 28, 1937, the secret police came. Pasternak and his wife were at their neighbor's house; it was the birthday of Pilnyak's three-year-old son, also named Boris. That evening, a car pulled up and several men in uniform got out. It was all very polite. Pilnyak was needed on urgent business, said one officer.

He was charged with belonging to "anti-Soviet, Trotskyist, subversive and terrorist organizations," preparing to assassinate Stalin, and spying for Japan; he had traveled to Japan and China in 1927 and written about his journey. He had also spent six months in the United States in 1931 with Stalin's permission, traveling cross-country in a Ford and working briefly in Hollywood as a screenwriter for MGM. His travelogue novel *Okay* offered a harsh view of American life.

Pilnyak "confessed" to everything, but in a final word to a military tribunal he said he would like "to have paper" in front of him on which he "could write something of use to the Soviet people." After a fifteen-minute trial, from 5:45 to 6:00 p.m. on April 20, 1938, Pilnyak was found guilty and sentenced to the "ultimate penalty," which was carried out the next day — in the sinister language of the bureaucracy — by the "head of 1st special section's 12th department." Pilnyak's wife spent nineteen years in the Gulag, and his child was raised in the Soviet republic of Georgia by

a grandmother. All of Pilnyak's works were withdrawn from libraries and bookstores, and destroyed. In 1938–39, according to a report by the state censor, 24,138,799 copies of "politically damaging" works or titles of "absolutely no value to the Soviet reader" were pulped.

In the wake of the arrest of Pilnyak and others, the Pasternaks, like many in the village, lived with fear. "It was awful," said Pasternak's wife, Zinaida, pregnant at the time with their first son. "Every minute we expected that Borya would be arrested."

Even after the death of Stalin, no Soviet writer could entertain the idea of publication abroad without considering Pilnyak's fate. And since 1929 no one had broken the unwritten but iron rule that unapproved foreign publication was forbidden.

As he continued his patter, D'Angelo suddenly realized that Pasternak was lost in thought. Chukovsky, Pasternak's neighbor, thought he had a "somnambulistic quality" — "he listens but does not hear" while away in the world of his own thoughts and calculations. Pasternak had an uncompromising certainty about his writing, its genius, and his need to have it read by as wide an audience as possible. The writer was convinced that *Doctor Zhivago* was the culmination of his life's work, a deeply authentic expression of his vision, and superior to all of the celebrated poetry he had produced over many decades. "My final happiness and madness," he called it.

Both epic and autobiographical, the novel revolves around the doctor-poet Yuri Zhivago, his art, loves, and

losses in the decades surrounding the 1917 Russian Revolution. After the death of his parents, Zhivago is adopted into a family of the bourgeois Moscow intelligentsia. In this genteel and enlightened setting, he discovers his talents for poetry and healing. He finishes medical school and marries Tonya, the daughter of his foster parents. During World War I, while serving in a field hospital in southern Russia, he meets the nurse Lara Antipova and falls in love with her.

Upon his return to his family in 1917, Zhivago finds a changed city. Controlled by the Reds, Moscow is wracked by the chaos of revolution and its citizens are starving. The old world of art, leisure, and intellectual contemplation has been erased. Zhivago's initial enthusiasm for the Bolsheviks soon fades. Fleeing typhus, Zhivago and his family travel to Varykino, their estate in the Urals. Nearby, in the town of Yuryatin, Zhivago and Lara meet again. Lara's husband is away with the Red Army. Zhivago's desire for her is rekindled, but he is troubled by his infidelity.

Captured by a band of peasant soldiers who press-gang him into serving as a field doctor, Zhivago witnesses the atrocities of the Russian Civil War, committed by both the Red Army and its enemy, a coalition of anti-Bolshevik forces known as the Whites. Zhivago eventually "deserts" the revolutionary fight and returns home to find that his family, believing him dead, has fled the country. He moves in with Lara. As the war draws near, they take refuge in the country house in Varykino. For a brief moment, the world is shut out, and Zhivago's muse returns to inspire a burst

12

of poetry writing. The howling of the wolves outside is a portent of the relationship's doom. With the end of the war, and the consolidation of Bolshevik power, fate forces the couple apart forever. Lara leaves for the Russian Far East. Zhivago returns to Moscow and dies there in 1929. He leaves behind a collection of poetry, which forms the novel's last chapter and serves as Zhivago's artistic legacy and life credo.

Zhivago is Pasternak's sometime alter ego. Both character and writer are from a lost past, the cultured milieu of the Moscow intelligentsia. In Soviet letters, this was a world to be disdained, if summoned at all. Pasternak knew that the Soviet publishing world would recoil from *Doctor Zhivago*'s alien tone, its overt religiosity, its sprawling indifference to the demands of socialist realism and the obligation to genuflect before the October Revolution. The novel's heresies were manifold and undisguised, and for the Soviet faithful, particular sentences and thoughts carried the shock of an unexpected slap. A "zoological apostasy" was the reaction in an early official critique of the novel. The revolution was not shown as "the cake with cream on top," Pasternak acknowledged, as the writing neared completion. The manuscript "should be given to anyone who asks for it," he said, "because I do not believe it will ever appear in print."

Pasternak had not considered Western publication, but by the time D'Angelo arrived at his gate, he had endured five months of complete silence from Goslitizdat, the state literary publisher, to which he had submitted the novel. Two leading journals, *Znamya*

(The Banner) and *Novy Mir* (New World), which he hoped might excerpt parts of *Doctor Zhivago*, had also not responded. For D'Angelo, the timing of his pitch was the height of good fortune; Pasternak, when presented with this unexpected offer, was ready to act. In a totalitarian society he had long displayed an unusual fearlessness — visiting and giving money to the relatives of people who had been sent to the Gulag when the fear of taint scared so many others away; intervening with the authorities to ask for mercy for those accused of political crimes; and refusing to sign drummed-up petitions demanding execution for named enemies of the state. He recoiled from the group-think of many of his fellow writers. "Don't yell at me," he said to his peers at one public meeting, where he was heckled for asserting that writers should not be given orders. "But if you must yell, at least don't do it in unison." Pasternak felt no need to tailor his art to the political demands of the state; to sacrifice his novel, he believed, would be a sin against his own genius.

"Let's not worry about whether or not the Soviet edition will eventually come out," he said to D'Angelo. "I am willing to give you the novel so long as Feltrinelli promises to send a copy of it, shall we say in the next few months, to other publishers from important countries, first and foremost France and England. What do you think? Can you ask Milan?" D'Angelo replied that it was not only possible but inevitable because Feltrinelli would surely want to sell the foreign rights to the book.

14

Pasternak paused again for a moment before excusing himself and going into his house, where he worked in a Spartan study on the second floor. In winter it looked out over "a vast white expanse dominated by a little cemetery on a hill, like a bit of background out of a Chagall painting." Pasternak emerged from the dacha a short time later with a large package wrapped in a covering of newspaper. The manuscript was 433 closely typed pages divided into five parts. Each part, bound in soft paper or cardboard, was held together by twine that was threaded through rough holes in the pages and then knotted. The first section was dated 1948, and the work was still littered with Pasternak's handwritten corrections.

"This is *Doctor Zhivago*," Pasternak said. "May it make its way around the world."

With all that was to come, Pasternak never wavered from that wish.

D'Angelo explained that he would be able to get the manuscript to Feltrinelli within a matter of days because he was planning a trip to the West. It was just before noon, and the men chatted for a few more minutes.

As they stood at the garden gate saying their good-byes, the novel under D'Angelo's arm, Pasternak had an odd expression — wry, ironic — playing on his face. He said to the Italian: "You are hereby invited to my execution."

The publication of *Doctor Zhivago* in the West in 1957 and the award of the Nobel Prize in Literature to Boris

Pasternak the following year triggered one of the great cultural storms of the Cold War. Because of the enduring appeal of the novel, and the 1965 David Lean film based on it, *Doctor Zhivago* remains a landmark piece of fiction. Yet few readers know the trials of its birth and how the novel galvanized a world largely divided between the competing ideologies of two superpowers.

Doctor Zhivago was banned in the Soviet Union, and the Kremlin attempted to use the Italian Communist Party to suppress the first publication of the novel in translation in Italy. Officials in Moscow and leading Italian Communists threatened both Pasternak and his Milan publisher, Giangiacomo Feltrinelli. The two men, who never met, resisted the pressure and forged one of the greatest partnerships in the history of publishing. Their secret correspondence, carried in and out of the Soviet Union by trusted couriers, is its own manifesto on artistic freedom.

The Soviet Union's widely reported hostility to *Doctor Zhivago* ensured that a novel that might otherwise have had a small elite readership became an international best seller. *Doctor Zhivago*'s astonishing sales increased even more when Pasternak was honored by the Swedish Academy with the 1958 Nobel Prize in Literature. The writer had been nominated several times before in acknowledgment of his poetry, but the appearance of the novel made Pasternak an almost inevitable choice. The Kremlin dismissed Pasternak's Nobel Prize as an anti-Soviet provocation and orchestrated a relentless internal campaign to vilify the

writer as a traitor. Pasternak was driven to the point of suicide. The scale and viciousness of the assault on the elderly writer shocked people around the world, including many writers sympathetic to the Soviet Union. Figures as diverse as Ernest Hemingway and the Indian prime minister, Jawaharlal Nehru, rose to Pasternak's defense.

Pasternak lived in a society where novels, poems, and plays were hugely significant forms of communication and entertainment. The themes, aesthetics, and political role of literature were the subjects of fierce ideological disputes, and sometimes the losers in these debates paid with their lives. After 1917, nearly 1,500 writers in the Soviet Union were executed or died in labor camps for various alleged infractions. Writers were to be either marshaled in the creation of a new "Soviet man" or isolated, and in some cases crushed; literature could either serve the revolution or the enemies of the state.

The Soviet leadership wrote extensively about revolutionary art; gave hours-long speeches about the purpose of fiction and poetry; and summoned writers to the Kremlin to lecture them about their responsibilities. The men in the Kremlin cared about writing all the more because they had experienced its capacity to transform. The revolutionary Vladimir Lenin was radicalized by a novel, Nikolai Chernyshevsky's *What Is to Be Done?* "Art belongs to the people," Lenin said. "It should be understood and loved by the masses. It must unite and elevate their feelings, thoughts and will. It must stir them to activity and develop the artistic instincts within them. Should we serve exquisite sweet

cake to a small minority while the worker and peasant masses are in need of black bread?"

As Stalin consolidated power in the early 1930s, he brought the country's literary life under strict control. Literature was no longer the party's ally, but its servant. The artistic vitality of the 1920s withered. Stalin, a poet in his youth, was a voracious reader of fiction, sometimes devouring hundreds of pages in a day. He red-lined passages that displeased him. He weighed in on what plays should be staged. He once telephoned Pasternak to discuss whether a particular poet, Osip Mandelstam, was a master of his art — a conversation that was really about Mandelstam's fate. He decided which writers should receive the country's premier literary award, inevitably named the Stalin Prize.

The Soviet public longed for great writing with a desire that was rarely sated. The country's shelves groaned under the dry, formulaic dreck produced to order. Isaiah Berlin found it all "irretrievably second-rate." Those writers who held on to their individual voices — Pasternak and the poet Anna Akhmatova, among a few others — were rewarded with near adulation. Their readings could fill concert halls and their words, even when banned, found a way to their public's lips. In the Obozerka forced-labor camp near the White Sea, some inmates amused and bolstered each other by trying to see who could recite the most Pasternak. The Russian émigré critic Victor Frank, explaining Pasternak's appeal, said that in his poetry "the skies were deeper, the stars more radiant, the rains louder and the sun more savage . . . No other

poet in Russian literature — and, perhaps, in the world at large — is capable of charging with the same magic the humdrum objects of our humdrum lives as he. Nothing is too small, too insignificant for his piercing eye, the eye of a child, the eye of the first man on a new planet: rain puddles, window-sills, mirror stands, aprons, doors of railway carriages, the little hairlets standing off a wet overcoat — all this flotsam and jetsam of daily life is transformed by him into a joy for ever."

The poet had a deeply ambivalent relationship with the Communist Party, its leaders, and the Soviet Union's literary establishment. Before the Great Terror of the late 1930s, Pasternak had written poetry in praise of Lenin and Stalin, and he was for a time transfixed by Stalin's guile and authority. But as the bloodletting of the purges swept the country, he became profoundly disillusioned with the Soviet state. That he survived the Terror when so many others were swallowed by its relentless, blind maw has no single explanation. The Terror could be bizarrely random — mowing down the loyal and leaving some of the suspect alive. Pasternak was protected by luck, by his international status, and, perhaps most critically, by Stalin's interested observation of the poet's unique and sometimes eccentric talent.

Pasternak did not seek to confront the authorities but lived in the purposeful isolation of his creativity and his country life. He began to write *Doctor Zhivago* in 1945 and it took him ten years to complete. The writing was slowed by periods of illness; by the need to

set it aside to make money from commissioned translations of foreign works; and by Pasternak's growing ambition and wonder at what was flowing from his pen.

It was, effectively, a first novel, and Pasternak was sixty-five when he finished it. He channeled much of his own experience and opinions into its pages. *Doctor Zhivago* was not a polemic, or an attack on the Soviet Union, or a defense of any other political system. Its power lay in its individual spirit, Pasternak's wish to find some communion with the earth, some truth in life, some love. Like Dostoevsky, he wanted to settle with the past and express this period of Russia's history through "fidelity to poetic truth."

As the story evolved, Pasternak realized that *Doctor Zhivago* stood as a rebuke to the short history of the Soviet state. The plot, the characters, the atmosphere embodied much that was alien to Soviet literature. There was in its pages a disdain for the "deadening and merciless" ideology that animated so many of his contemporaries. *Doctor Zhivago* was Pasternak's final testament, a salute to an age and a sensibility he cherished but that had been destroyed. He was obsessively determined to get it published — unlike some of his generation who wrote in secret for the "drawer."

Doctor Zhivago appeared in succession in Italian, French, German, and English, among numerous languages — but not, at first, in Russian.

In September 1958, at the World's Fair in Brussels, a Russian-language edition of *Doctor Zhivago*, handsomely bound in a blue linen hardcover, was handed

out from the Vatican Pavilion to Soviet visitors. Rumors about the genesis of this mysterious edition began almost immediately; the CIA was first mentioned by name as its secret publisher in November 1958. Until now, the CIA has never acknowledged its role.

Over the years, a series of apocryphal stories have appeared about how the CIA obtained an original manuscript of *Doctor Zhivago* and its motivation in printing the novel in Russian. It was said that British intelligence had forced down a plane in Malta that was carrying Feltrinelli from Moscow and secretly photographed the novel, which they removed from his suitcase in the plane's hold. It never happened. Some of Pasternak's French friends believed, incorrectly, that an original-language printing of *Doctor Zhivago* was necessary to qualify for the Nobel Prize — a theory that has periodically resurfaced. The Nobel Prize was not a CIA goal, and an internal accounting of the agency's distribution of the book shows that no copies were sent to Stockholm; the CIA simply wanted to get copies of *Doctor Zhivago* into the Soviet Union and into the hands of Soviet citizens.

It has also been argued that the printing was the work of Russian émigrés in Europe and the agency's involvement was marginal — no more than that of the financier of émigré front organizations. The CIA was in fact deeply involved. The operation to print and distribute *Doctor Zhivago* was run by the CIA's Soviet Russia Division, monitored by CIA director Allen Dulles, and sanctioned by President Eisenhower's Operations Coordinating Board, which reported to the

National Security Council at the White House. The agency arranged the printing of a hardcover edition in 1958 in the Netherlands and printed a miniature paperback edition of the novel at its headquarters in Washington, D.C., in 1959.

A weapon in the ideological battles between East and West — this, too, is part of *Doctor Zhivago*'s extraordinary life.

CHAPTER
ONE

"The roof over the whole of Russia has been torn off."

Bullets cracked against the facade of the Pasternak family's apartment building on Volkhonka Street in central Moscow, pierced the windows, and whistled into the plaster ceilings. The gunfire, which began with a few isolated skirmishes, escalated into all-out street fighting in the surrounding neighborhood, and drove the family into the back rooms of the spacious second-floor flat. That, too, seemed perilous when shrapnel from an artillery barrage struck the back of the building. Those few civilians who ventured out on Volkhonka crab-ran from hiding spot to hiding spot. One of the Pasternaks' neighbors was shot and killed when he crossed in front of one of his windows.

On October 25, 1917, in a largely bloodless coup, the Bolsheviks seized power in Petrograd, the Russian capital, which had been called Saint Petersburg until World War I broke out and a Germanic name became intolerable. Other major centers did not fall so easily as militants loyal to the revolutionary leader Vladimir Lenin battled the Provisional Government that had been in power since March. There was more than a week of fighting in Moscow, the country's commercial center and second city, and the Pasternaks found

themselves in the middle of it. The family's apartment building was on a street that crested a hill. The flat's nine street-side windows offered a panoramic view of the Moscow River and the monumental golden dome of Christ the Savior Cathedral. The Kremlin was just a few hundred meters to the northeast along the bend of the river. Pasternak, who rented a room in the Arbat neighborhood, had happened over to his parents' place on the day the fighting began and found himself stuck there, eventually huddling with his parents and younger, twenty-four-year-old brother, Alexander, in the downstairs apartment of a neighbor. The telephone and lights were out, and water only occasionally, and then briefly, trickled out of the taps. Boris's two sisters — Josephine and Lydia — were caught in similarly miserable conditions at the nearby home of their cousin. They had gone out for a stroll on an unseasonably mild evening when, suddenly, armored cars began to career through streets that quickly emptied. The sisters had just made it to the shelter of their cousin's home when a man across the street was felled by a shot. For days, the constant crackle of machine-gun fire and the thud of exploding shells were punctuated by "the scream of wheeling swifts and swallows." And then as quickly as it started "the air drained clear, and a terrifying silence fell." Moscow had fallen to the Soviets.

Russia's year of revolution had begun the previous February when women protesting bread shortages in Petrograd were joined by tens of thousands of striking workers and the national war weariness swelled into a

sea of demonstrators against the exhausted autocracy. Two million Russians would die in the carnage at the Eastern Front and another 1.5 million civilians died from disease and military action. The economy of the vast, backward Russian empire was collapsing. When troops loyal to the czar fired on the crowds, killing hundreds, the capital was in open revolt. On March 3, having been abandoned by the army, Nicholas II abdicated, and the three-hundred-year-old Romanov dynasty was at an end.

Pasternak, who had been assigned to a chemical factory in the Urals to support the war effort, hurried back to Moscow. He traveled part of the journey on a *kibitka*, a covered wagon on runners, and warded off the cold with sheepskin coats and hay. Pasternak and his siblings welcomed the fall of the monarchy, the emergence a new Provisional Government, and, above all, the prospect of a constitutional political order. Subjects became citizens, and they reveled in the transformation. "Just imagine when an ocean of blood and filth begins to give out light," Pasternak told one friend. His sister Josephine described him as "overwhelmed" and "intoxicated" by the charisma of Alexander Kerensky, a leading political figure, and his effect on a crowd outside the Bolshoi Theatre that spring. The Provisional Government abolished censorship and introduced freedom of assembly.

Pasternak would later channel the sense of euphoria into his novel. The hero of *Doctor Zhivago* was spellbound by the public discourse, which was brilliantly alive, almost magical. "I watched a meeting

last night. An astounding spectacle," said Yuri Zhivago, in a passage where the character describes the first months after the fall of the czar. "Mother Russia has begun to move, she won't stay put, she walks and never tires of walking, she talks and can't talk enough. And it's not as if only people are talking. Stars and trees come together and converse, night flowers philosophize, and stone buildings hold meetings. Something gospel-like, isn't it? As in the time of the apostles. Remember, in Paul? 'Speak in tongues and prophesy. Pray for the gift of interpretation.'"

It seemed to Zhivago that "the roof over the whole of Russia has been torn off." The political ferment also enfeebled the Provisional Government, which was unable to establish its writ. It was overwhelmed above all by the widely hated decision to keep fighting in the world war. The Bolsheviks, earning popular support with the promise of "Bread, Peace and Land," and driven by Lenin's calculation that power was for the taking, launched their insurrection and a second revolution in October. "What magnificent surgery," Pasternak wrote in *Doctor Zhivago*. "To take and at one stroke artistically cut out the old, stinking sores!"

The Bolsheviks, in their constitution, promised Utopia — "the abolition of all exploitation of man by man, the complete elimination of the division of society into classes, the ruthless suppression of the exploiters, the establishment of a socialist organization of society, and the victory of socialism in all countries."

Yuri Zhivago quickly is disillusioned by the convulsions of the new order: "First, the ideas of

general improvement, as they've been understood since October, don't set me on fire. Second, it's all still so far from realization, while the mere talk about it has been paid for with such seas of blood that I don't think the ends justify the means. Third, and this is the main thing, when I hear about the remaking of life, I lose control of myself and fall into despair."

The word *remaking* was the same one Stalin used when toasting his writers and demanding engineers of the soul. Zhivago tells his interlocutor, a guerrilla commander: "I grant you're all bright lights and liberators of Russia, that without you she would perish, drowned in poverty and ignorance, and nevertheless I can't be bothered with you, and I spit on you, I don't like you, and you can all go to the devil."

These are the judgments of a much older Pasternak, writing more than three decades after the revolution and looking back in sorrow and disgust. At the time, when Pasternak was twenty-seven, he was a man in love, writing poetry, and swept along in the "greatness of the moment."

The Pasternaks were a prominent family within Moscow's artistic intelligentsia, who looked to the West, and were disposed to support the political reform of an autocratic, sclerotic system. Boris's father, Leonid, was a well-known impressionist painter and a professor at the Moscow School of Painting, Sculpture and Architecture. He was born to a Jewish innkeeper in the Black Sea city of Odessa, a multi-ethnic and dynamic center within the Pale of Settlement where most of Russia's Jews were forced to reside. Odessa had a rich

cultural life and Alexander Pushkin, who lived there in the early part of the nineteenth century, wrote "the air is filled with all Europe." Leonid first moved to Moscow in 1881, to study medicine at Moscow University. By the fall of 1882, queasy about working with cadavers, he abandoned medicine and enrolled at the Bavarian Royal Academy of Art in Munich. His daughter Lydia described him as "a man of a dreamy, gentle disposition . . . slow and uncertain in anything but his work."

After obligatory military service, Leonid returned to Moscow in 1888, and his first sale — a painting entitled *Letter from Home* — was to Pavel Tretyakov, a collector whose purchases denoted a kind of arrival for favored artists. Leonid also established a reputation as a skilled illustrator, and he contributed to an edition of Leo Tolstoy's *War and Peace* in 1892. The following year, Leonid and Tolstoy met and became friends. Over the years, Leonid sketched the Russian writer numerous times, including in death at the Astapovo train station in 1910. Leonid brought Boris on the overnight train to pay respects to Tolstoy, and Boris recalled that the grand old man seemed tiny and wizened, no longer a mountain, just "one of those he had described and scattered over his pages by the dozen."

Tolstoy visited the Pasternak apartment in Moscow, as did the composers Sergei Rachmaninov and Alexander Scriabin, among other cultural figures of the day, many of whom were painted by Leonid. The children viewed the visiting dignitaries as a fact of

home life. "I have observed art and important people from my earliest days, and I have become accustomed to treating the sublime and exclusive as something natural, as a norm of life," wrote Pasternak, recalling the luminaries who graced his parents' parlor and his father's studio.

Pasternak's childhood was also filled with music. His mother, née Rozalia Kaufman, was an extraordinarily precocious child who, as a five-year-old coming to the piano for the first time, perfectly reproduced pieces played by her cousin simply from having watched him. Roza, as she was called, was the daughter of a wealthy soda-water manufacturer in Odessa. She gave her first recital at age eight, by eleven was drawing glowing reviews in the local press, and two years later toured southern Russia. She performed in Saint Petersburg, studied in Vienna, and was appointed a professor of music at the Odessa conservatory before she was twenty. "Mother was music," her daughter Lydia wrote. "There may be a greater virtuoso, a more brilliant performer but no-one with greater penetration, something indefinable, which makes you burst out in tears at the first chord, at each movement in sheer joy and ecstasy." Roza's potential as a major pianist of her age was curtailed, however, by anxiety, heart problems, and marriage. She met Leonid Pasternak in 1886 in Odessa, and they were married in February 1889 in Moscow. Boris was born the following year. His brother, Alexander, was born in 1893, Josephine in 1900, and Lydia in 1902.

By twelve, Boris was imagining a career as a pianist and composer. The "craving for improvisation and composition flared up in me and grew into a passion." He quit when he realized that his skills at the piano lacked the brilliance and natural flair of some of the composers he idolized, such as Scriabin. Pasternak could not tolerate the possibility that he would not achieve greatness. As a boy, he was used to being the best and the first, and he had an inner arrogance about his own skills. He had equal measures of physical and intellectual confidence. After watching local peasant girls ride horses one summer in the countryside, Boris convinced himself that he, too, could ride bareback. It became an obsession to test himself. When he finally persuaded a girl to let him ride her mount, the twelve-year-old boy was thrown by a panicking filly while jumping a stream, and broke his right thighbone. When it healed, his right leg was slightly shorter, and the resulting lameness, although disguised for much of his life, kept him out of military service in the First World War. Pasternak's brother said that his natural talents "confirmed in him a strong faith in his own powers, in his abilities and in his destiny." Second-best was something to be cast aside in a fit of pique, and forgotten. "I despised everything uncreative, any kind of hack work, being conceited enough to imagine I was a judge in these matters," Pasternak wrote many years later. "In *real* life, I thought, everything must be a miracle, everything must be predestined from above, nothing must be deliberately designed or planned,

nothing must be done to follow one's own fancies." The piano abandoned, he turned toward poetry.

While he was a student at Moscow University, where he studied law and then philosophy and graduated with a first-class honors degree, Pasternak attended a salon of young authors, musicians, and poets — a "tipsy society" that mixed artistic experimentation and discovery with rum-laced tea. Moscow was full of overlapping and feuding salons built around competing philosophies of art, and Pasternak was an ardent if little-known participant. "They did not suspect that there before them was a great poet, and meanwhile treated him as an intriguing curiosity without ascribing any serious importance to him," said his friend Konstantin Loks. One observer at a reading said he "spoke in a toneless voice and forgot nearly all the lines . . . There was an impression of painful concentration, one wanted to give him a push, like a carriage that won't go — 'Get a move on!' — and as not a single word came across (just mutterings like some bear waking up), one kept thinking impatiently: 'Lord, why does he torment himself and us like this.'" His cousin Olga Freidenberg thought Pasternak was "not of this world," that he was absent-minded and self-absorbed: "Borya did all the talking as usual," Olga exclaimed to her diary after a long walk.

Pasternak was prone to unrequited infatuations, a spur for his poetry but dispiriting for the young man. While at the University of Marburg, where he studied philosophy in the summer of 1912, he was rebuffed by a woman, Ida Vysotskaya, the daughter of a rich

Moscow tea merchant, to whom he professed his love. "Just try to live normally," Ida told him. "You've been led astray by your way of life. Anyone who hasn't lunched and is short of sleep discovers lots of wild and incredible ideas in himself." Ida's rejection led to a burst of poetry writing on the day he was supposed to be turning in a paper for his philosophy class. He ultimately decided against staying at the German university to pursue a doctorate in philosophy. "God, how successful my trip to Marburg is. But I am giving up everything — art it is, and nothing else." Pasternak tended to talk at his wished-for lovers, interspersing rhapsodies of affection with philosophical treatises. Another woman, who balked at something more intimate than friendship, complained their "meetings were rather monologues on his part." These amorous failings left Pasternak emotionally shattered, and they prompted some intense periods of writing.

His first stand-alone publication appeared in December 1913 after a productive summer where he "wrote poetry not as a rare exception but often and continuously, as one paints or composes music." The resulting collection, called *Twin in the Storm Clouds*, drew little attention or enthusiasm and an older Pasternak later dismissed these efforts as painfully pretentious. A second volume, *Over the Barriers*, appeared in early 1917. Some of the poems were cut — grievously — by the czarist censor, the book was littered with misprints, and it, too, received little attention from the critics. Still, for *Over the Barriers*, Pasternak got paid for the first time — 150 rubles, a

memorable moment for any writer. The Russian writer Andrei Sinyavsky described Pasternak's first two volumes as "a tuning-up," and said it was "part of the search for a voice of his own, for his own view of life, for his own place amid the diversity of literary currents."

In the summer of 1917 Pasternak was in love with Yelena Vinograd, a young war widow, student, and enthusiastic supporter of the revolution. She took the poet to demonstrations and political meetings, enjoyed his company, but was not sexually attracted to him. "The relationship remained platonic, unphysical and unconsummated emotionally, and it was thus an intensely tormenting one for Pasternak," wrote one scholar. The fuel of passion and frustration, all playing out against the backdrop of a society that was being utterly transformed, led to a cycle of poems that would vault Pasternak into the front ranks of Russian literature. The collection was called *My Sister Life* and came with the subtitle *Summer 1917*. At first, only handwritten copies of the poems circulated and the work gained a popularity "no poet since Pushkin achieved on the basis of manuscript copies."

Because of the upheaval of revolution, and the subsequent privation of the civil war, when much literary publishing ground to a halt because of a lack of paper, the book did not appear until 1922 — long after Vinograd had departed and Pasternak had finally found love with Yevgenia Lurye, an artist.

They first met at a birthday party where Yevgenia, striking in a green dress, drew the attention of a number of young men. Pasternak recited his poetry, but the young woman was distracted and didn't pay attention. "Right you are, why listen to such nonsense?" said Pasternak.

She wanted to see him again and was responsive to his expressions of ardor. "Ah, it were better I never lose this feeling," he wrote her, describing how much he missed her when she visited her parents before their marriage. "It is like a conversation with you, murmuring profoundly, dripping mutely, secretly — and true . . . What am I to do, what am I to call this magnetism and saturation with the melody of you other than the distraction you compel, and which I would dispel — like one lost in the woods."

They married in 1922. Pasternak had the gold medal he won as his high school's best student melted in order to make wedding rings, which he engraved roughly himself: "Zhenya and Borya." Their son Yevgeni — named after his mother — was born in 1923. They lived in a small section of the Pasternak family's old apartment now divided among six families. "Hemmed in on all sides by noise, can only concentrate for periods at a time by dint of extreme sublimated desperation, akin to self-oblivion," he complained to the All-Russian Union of Writers. Often he could only work at night when silence fell over the house, staying awake with cigarettes and hot tea.

Both Pasternak and Yevgenia had their own artistic ambitions, and the marriage was marked by their

competing struggle to assert themselves creatively and an inability to make concessions. There was also the unavoidable and looming fact that Pasternak was "a man with inarguably more talent," their son later wrote.

Pasternak's relations with women continued to be fraught. The marriage was buffeted by the heat of some of his correspondence with the poet Marina Tsvetaeva, which greatly irritated his wife. In the summer of 1930, he found himself increasingly attracted to Zinaida Neigauz, the wife of his best friend, the pianist Genrikh Neigauz, with whom the Pasternaks vacationed in Ukraine. Zinaida was born in Saint Petersburg in 1897, the daughter of a Russian factory owner and a mother who was half Italian. When she was fifteen, she became involved with a cousin, a man in his forties and married with two children, an affair that informed some of the early experience of the young Lara in *Doctor Zhivago*. In 1917, Zinaida moved to Yelisavetgrad where she met and married her piano teacher, Neigauz.

Before he was even sure of Zinaida's feeling, Pasternak told his wife he was in love. He then immediately proceeded to announce his passion to Genrikh. Pasternak and Genrikh wept, but Zinaida, for the moment, remained with her husband. By early the next year, the two were sleeping together, and Zinaida confessed the affair in a letter to her husband, who was on a concert tour in Siberia. He left a recital in tears and returned to Moscow.

Pasternak, with more than a measure of narcissism, argued that he could maintain his marriage, continue his affair, and sustain his friendship, all the while

remaining above reproach. "I've shown myself unworthy of [Genrikh], whom I still love and always will," said Pasternak in a letter to his parents. "I've caused prolonged, terrible, and as yet undiminished suffering to [Yevgenia] — and yet I'm purer and more innocent than before I entered this life."

The complicated menage continued for some time. Yevgenia went to Germany with her young son, leaving Boris and Zinaida free to consort together. In a poem, he encouraged Yevgenia to make a fresh start without him:

Do not fret, do not cry, do not tax
Your last strength, and your heart do not torture.
You're alive, you're inside me, intact,
As a buttress, a friend, an adventure.

I've no fear of standing exposed
As a fraud in my faith in the future.
It's not life, not a union of souls
We are breaking off, but a hoax mutual.

Many years later, he remembered the marriage as unhappy and lacking passion. He said that "beauty is the mark of true feelings, the sign of its strength and sincerity." And he thought it unfair that his son bore the trace of his failure to love in his "ugly face" with its reddish complexion and freckles.

Yevgenia's eventual return to Moscow in early 1932 left Boris and Zinaida without a place to live in a city where flats were a very precious commodity. Zinaida,

feeling "painfully awkward," returned to Genrikh and asked him to take her back as "a nanny for the children" and "to help him do the housekeeping." Pasternak returned to Yevgenia — for three days. "I begged her to understand — that I worship [Zinaida] — that it would be despicable to fight against this feeling." When he met friends, he gave long, tearful accounts of his complicated family affairs.

Effectively homeless and in love, Pasternak began to despair. "It was around midnight — and freezing. A terrible, accelerating conviction of hopelessness tightened like a spring inside me. I suddenly saw the bankruptcy of my whole life." He ran through the streets to the Neigauzes' apartment. "Der spat kommende Gast? [The late-arriving guest?]," said Genrikh laconically as he opened the door and promptly left. Inside, Pasternak pulled a bottle of iodine from a shelf and drank it in one gulp. "What are you chewing? Why does it smell so strong of iodine?" asked Zinaida, who began to scream. A doctor living in the building was summoned, and Pasternak was induced to vomit repeatedly and then put to bed, still very weak. "In this state of bliss, my pulse almost gone, I felt a wave of pure, virginal, totally untrammeled freedom. I actively, almost languidly, desired death — as you might want a cake. If there had been a revolver by my side, I would have reached out my hand like reaching for a sweet."

Genrikh, who at this point seemed quite happy to rid himself of Zinaida, said, "Well, are you satisfied? Has he proved his love for you?"

For Pasternak, Zinaida, to whom he was now married, was a homemaker who allowed him the physical and emotional space to work — something Yevgenia was less disposed to do.

Yevgenia "is much cleverer and more mature than [Zinaida] is, and perhaps better educated too," Pasternak told his parents. Yevgenia "is purer and weaker, and more childlike, but better armed with the noisy weapons of her quick temper, demanding stubbornness and insubstantial theorizing." Zinaida had "the hardworking, industrious core of her strong (but quiet and wordless) temperament."

Yevgenia, said her son, "continued loving my father for the rest of her life."

Pasternak's complicated relations with more than one woman were far from over. Nor was his impulse to surrender to providence. And fate may have repaid his trust with the poet's unlikely survival of Stalin's purges in the years to follow.

CHAPTER
TWO

"Pasternak, without realizing it, entered the personal life of Stalin."

The revolution was followed by a devastating and prolonged civil war between the Red Army and the anti-Bolshevik forces, the Whites. The winters were unusually severe. Food was scarce, and the Pasternak family was routinely undernourished. Boris sold books for bread, and traveled to the countryside to scrounge for apples, dry biscuits, honey, and fat from relatives and friends. He and his brother sawed wood from joints in the attic to keep fires burning at the Volkhonka apartment, where their living space was reduced by the authorities to two rooms; at night the brothers sometimes went out to steal fencing and other items that could be burned. Almost everyone's health declined, and in 1920 Leonid sought and obtained permission to take Roza to Germany for treatment after she suffered a heart attack. Their two daughters also moved to Germany, and the family was permanently divided. Pasternak's parents and sisters eventually settled in England before the outbreak of the Second World War.

Boris saw his parents only once more, during a visit to Berlin after he married his first wife, Yevgenia. That

extended ten-month stay in Berlin, which had become the capital of émigré Russia, convinced Pasternak that his artistic future lay in his homeland, not amid the nostalgia and squabbling that marked the exile community. "Pasternak is uneasy in Berlin," wrote the literary theorist and critic Viktor Shklovsky, who also later returned to Moscow. "It seems to me that he feels among us an absence of propulsion . . . We are refugees. No, not refugees but fugitives — and now squatters . . . Russian Berlin is going nowhere. It has no destiny." Pasternak was deeply wedded to Moscow and Russia. "Amidst Moscow streets, by-ways and courtyards he felt like a fish in water; here he was in his element and his tongue was purely Muscovite . . . I recall how his colloquial speech shocked me and how it was organically linked to his whole Muscovite manner," observed Chukovsky.

Isaiah Berlin said Pasternak had "a passionate, almost obsessive desire to be thought a Russian writer with roots deep in Russian soil" and that this was "particularly evident in his negative feelings towards his Jewish origins . . . he wished the Jews to assimilate, to disappear as a people." In *Doctor Zhivago*, the character Misha Gordon articulates this point of view, demanding of the Jews: "Come to your senses. Enough. There's no need for more. Don't call yourselves by the old name. Don't cling together, disperse. Be with everyone. You are the first and best Christians in the world." When he was a child, Pasternak's nanny brought him to Orthodox churches in Moscow — services redolent with incense and watched over by

40

walls of Byzantine iconography. But his sisters said he was untouched by Russian Orthodox theology before 1936, and Isaiah Berlin saw no sign of it in 1945, concluding that Pasternak's interest in Christianity was a "late accretion." As an older man, Pasternak was attached to his own version of Christianity, a faith influenced by the Orthodox Church but not formally part of it. "I was born a Jew," he told a journalist late in life. "My family was interested in music and art and paid little attention to religious practice. Because I felt an urgent need to find a channel of communication with the Creator, I was converted to Russian Orthodox Christianity. But try as I might I could not achieve a complete spiritual experience. Thus I am still a seeker."

By early 1921, the White forces who opposed the Bolsheviks were defeated, and literary life slowly rekindled in the ruined country. The first print run of *My Sister Life*, which also was published in Berlin, ran to about one thousand. It appeared in somewhat impecunious-looking khaki dustcovers — "the last gamble of some croaking publisher." *My Sister Life* drew euphoric, head-turning reviews that announced the entry of a giant.

"To read Pasternak's verse is to clear your throat, to fortify your breathing, to fill your lungs; surely such poetry could provide a cure for tuberculosis. No poetry is more healthful at the present moment! It is koumiss [fermented mare's milk] after evaporated milk," said the poet Osip Mandelstam.

"I was caught in it as in a downpour . . . A downpour of light," swooned Tsvetaeva in a 1922 review.

"Pasternak is all wide-open — eyes, nostrils, ears, lips, arms."

The collection barely seemed to touch on the actual events of 1917 beyond what Tsvetaeva called "the faintest hints." The only time the word *revolution* was employed was to describe a haystack. In "About these Poems," which appears at the beginning of the collection, the airy indifference to the political moment engendered some carping that Pasternak seemed a little too precious for the times:

> The window-halves I'll throw apart,
> In muffler from the cold to hide,
> And call to children in the yard,
> "What century is it outside?"

A "hothouse aristocrat of our society's private residences," sneered the Marxist critic Valerian Pravdukhin. Such criticism would eventually grow louder, but in 1922 whatever ideological shortcomings might be surmised were muted by the widely acknowledged poetic genius of his lines.

Pasternak had arrived, and it did not take the Soviet leadership long to notice. In June 1922, Pasternak was summoned to the Revolutionary Military Council for a meeting with Leon Trotsky, the head of the Red Army, a leading theoretician of the new Marxist state, and the best-known, behind Lenin, of the new leadership. Trotsky was the member of the Politburo most interested in culture, and he believed artists, and agitprop, had a critical role in the elevation of the

42

working class, with the ultimate goal of creating what he called a "classless culture, the first that will be truly universal." In 1922, Trotsky began to familiarize himself with prominent and emerging writers, and the following year he would publish *Literature and Revolution*. "It is silly, absurd, stupid to the highest degree," he wrote in the introduction, "to pretend that art will remain indifferent to the convulsions of our epoch . . . If nature, love or friendship had no connection with the social spirit of an epoch, lyric poetry would long ago have ceased to exist. A profound break in history, that is, a rearrangement of classes in society, shakes up individuality, establishes the perception of the fundamental problems of lyric poetry from a new angle, and so saves art from eternal repetition."

"Trotsky was no liberal in affairs of culture," wrote one of his biographers. "He felt that no one in Russia who challenged the Soviet order, even if only in novels or paintings, deserved official toleration. But he wanted a policy of flexible management within this stern framework. He aimed to win the sympathy of those intellectuals who were not the party's foes and might yet become its friends."

Trotsky wanted to find out if Pasternak was willing to commit his lyrical talent and subsume his individuality to a greater cause: the revolution. Pasternak was recovering from a night of drinking when the summons by telephone came. He and Yevgenia were about to embark on their trip to Germany to introduce her to his parents, and a farewell party at the Volkhonka apartment had left a number of people the worse for

wear. Pasternak was sleeping late when the phone rang at noon. He was summoned to the Revolutionary Military Council for an audience with Trotsky in one hour. Pasternak quickly shaved, poured water over his throbbing head, and washed his mouth out with cold coffee before throwing on a starched white shirt and a freshly pressed blue jacket. An official motorbike with a sidecar picked him up.

The two men greeted each other formally with first name and patronymic.

Pasternak apologized: "Sorry, I have come to you after a farewell party with some heavy drinking."

"You're right," said Trotsky, "you really look haggard."

The two men chatted for more than half an hour, and Trotsky asked Pasternak why he "refrained" from reacting to social themes. Pasternak said his "answers and explanations amounted to a defense of true individualism, as a new social cell in a new social organism." Pasternak said Trotsky had "enraptured and quite captivated" him before confessing to a friend that he had monopolized the talk and prevented Trotsky from fully expressing his opinions. Indeed, the conversation seemed to achieve the remarkable feat of leaving Trotsky a little flabbergasted.

"Yesterday I began struggling through the dense shrubbery of your book," said Trotsky, referring to *My Sister Life*. "What were you trying to express in it?"

"That is something to ask the reader," replied Pasternak. "You decide for yourself."

"Oh well, in that case I'll carry on struggling. It's been nice to meet you, Boris Leonidovich."

Pasternak did not get a mention in *Literature and Revolution* — a fortunate snub given the emerging power struggle between Trotsky and Stalin, and Trotsky's ultimate fall. After Lenin's death in 1924, Stalin gradually outmaneuvered and crushed his rivals within the party.

There was a beguiling obliviousness to Pasternak's encounters with the powerful, which would continue to mark his relations with the Soviet state. He had a preternatural willingness to express his opinions in a society where people filtrated their words for ideological or other offenses. Pasternak was never openly hostile to Soviet power, and his attitude to the men in the Kremlin swung between fascination and loathing. No one engendered more of that strange ambivalence — allure and disgust — than Stalin, who also seemed a little transfixed by Pasternak's reputation as a poet-seer. Nadezhda Mandelstam, Osip's wife, wrote there was "one remarkable feature of our leaders: their boundless, almost superstitious respect for poetry." This was especially true of the relationship between Stalin and Pasternak. They never met, spoke only once on the phone, yet a mysterious, unknowable bond existed between the two. Pasternak, for a time, idealized the dictator. Stalin indulged the poet with his life.

On November 11, 1932, Pasternak stood at the window of his apartment on Volkhonka Street and watched the black funeral carriage, decorated with onion domes, which carried Stalin's dead wife to

45

Novodevichy Cemetery. Pasternak was agitated, according to his son. And his public response to the death — published six days later — would forever stir speculation that he had earned an unlikely benediction from Stalin, a former seminarian.

Early in the morning of November 9, 1932, Nadya Alliluyeva, Stalin's thirty-one-year-old wife, killed herself. No one heard the shot. By the time a maid found her body, lying in a pool of blood on the floor of her bedroom in a Kremlin apartment, she was already cold; down a corridor, in another bedroom, her husband was sleeping off a boozy night. The previous evening, the ruling party's moguls had celebrated the fifteenth anniversary of the revolution at the home of the defense chief, Kliment Voroshilov; the leadership all lived in claustrophobic proximity inside the Kremlin's thick, redbrick walls. Their parties tended to be boisterous, alcohol-soaked affairs, and Stalin, whose lupine malice was never far from the surface, was particularly obnoxious that evening. His wife, stern and aloof, even with their two children, eleven-year-old Vasili and six-year-old Svetlana, was an austere Bolshevik who favored the dull look of the dutiful servant. She had married a forty-one-year-old Stalin when she was a girl, just eighteen. He was neglectful, and she was increasingly prone to severe migraines, bouts of hysteria, and exhaustion. One of Stalin's biographers said Alliluyeva "suffered from a serious mental illness, perhaps hereditary manic depression or borderline personality disorder."

46

For the evening at Voroshilov's, Alliluyeva stepped out a little. She wore a stylish black dress with embroidered red roses, which had been purchased in Berlin. Her husband, who arrived at the party separately, didn't notice, although he sat opposite her, at the middle of the dinner table. Instead, he flirted with a film actress, the wife of a Red Army commander, playfully tossing little pieces of bread at her. The meal was washed down with Georgian wine and punctuated with frequent vodka toasts. Stalin at one point raised his drink to call for the destruction of the enemies of the state; Alliluyeva pointedly ignored the raising of the glasses. "Hey, you!" shouted Stalin. "Have a drink." She screamed back, "Don't you dare 'hey me'!" According to some accounts, Stalin flicked a lit cigarette at her, and it went down her dress. Alliluyeva stormed off, followed by Polina Molotova, the wife of Vyacheslav Molotov, chairman of the Council of People's Commissars. She complained to Molotova about her husband's behavior and talked about her suspicion that Stalin was sleeping with other women, including a Kremlin hairdresser. When the two women separated, Alliluyeva appeared to have calmed down. Nikita Khrushchev in his memoirs said that Alliluyeva tried to reach her husband later that night and learned from a doltish guard that Stalin was at a nearby dacha with a woman. Nadya is said to have written Stalin a last letter — lost to history — that burned with personal and political condemnations. She shot herself in the heart.

The death certificate, signed by compliant doctors, said the cause of death was appendicitis. Suicide could

not be acknowledged. Soviet ritual required collective expressions of grief from different professions. In a letter to the newspaper *Literaturnaya Gazeta* (Literary Gazette), a group of writers said Alliluyeva "gave all her strength to the cause of liberating millions of oppressed humanity, the cause that you yourself lead and for which we are ready to surrender our own lives as confirmation of the uncrushable vitality of this cause." There were thirty-three signatures, including Pilnyak, Shklovsky, and Ivanov, but Pasternak's was not among his colleagues'. Instead he somehow managed to append a separate, individual message. "I share in the feelings of my comrades," he wrote. "On the evening before I had for the first time thought about Stalin deeply and intensively as an artist. In the morning I read the news. I was shaken as if I had actually been there, living by his side, and seen everything."

Stalin's reaction to this bizarre message and its hint of clairvoyance is unrecorded. In the wake of the suicide, Stalin was deeply emotional, openly wept, and "said he didn't want to go on living either." Pasternak's words, amid all the chest-thumping and sterile pronouncements, may have been read by Stalin as the pronouncement of a *yurodivy*, or "holy fool" — an otherworldly man with a gift for prophecy. In the New York Russian-language newspaper *Novy Zhurnal*, the émigré scholar Mikhail Koryakov wrote, "From that moment onwards, 17 November 1932, it seems to me, Pasternak, without realizing it, entered the personal life of Stalin and became some part of his inner world." If the dictator, in response to the message, did extend a

protective cloak to the poet when others were being slain, it was not something Pasternak could know; he, too, could feel the cold fear that Stalin engendered.

One evening in April 1934, Pasternak ran into Osip Mandelstam on Tverskoi Boulevard. The poet — passionate, opinionated, and a brilliant conversationalist — was someone Pasternak acknowledged as an equal, another master of his art. But he was also a dyspeptic and incautious critic of the regime. Right on the street, because "the walls have ears," he recited some new verse about Stalin. It read:

We live, deaf to the land beneath us,
Ten steps away no one hears our speeches.

But where there's so much as half a conversation
The Kremlin's mountaineer will get his mention.

His fingers are fat as grubs
And the words, final as lead weights, fall from his
 lips,

His cockroach whiskers leer
And his boot tops gleam.

Around him a rabble of thin-necked leaders —
Fawning half-men for him to play with.

They whinny, purr or whine
As he prates or points a finger,

One by one forging his laws, to be flung
Like horseshoes at the head, the eye or the groin.

And every killing is a treat
For the broad-chested Ossete.

In the version that came to the attention of the secret police, the poem included the phrase "the murderer and peasant slayer."

"I didn't hear this; you didn't recite it to me," said Pasternak, "because, you know, very dangerous things are happening now. They've begun to pick people up." He described the poem as an act of suicide, and implored Mandelstam not to recite it to anyone else. Mandelstam didn't listen, and inevitably he was betrayed. The secret police appeared at Mandelstam's apartment in the early morning of May 17. The poet Anna Akhmatova had arrived the previous evening and was staying with the Mandelstams. As the search commenced, the three sat in silent fear; it was so quiet they could hear a neighbor playing the ukulele. The spines of books were cut open to see if they hid a copy of the poem, but the agents failed to find one. Mandelstam had not committed it to paper. It was already light when the poet was taken to the cells at the Lubyanka, the massive security complex in central Moscow that housed the Joint State Political Directorate, or OGPU, a forerunner of what became known as the KGB. His interrogator presented him with a copy of the poem, one that must have been

memorized by the informer. Mandelstam thought he was doomed.

Pasternak interceded with Nikolai Bukharin, the recently appointed editor of the daily newspaper *Izvestiya* and a man Lenin called the "darling of the Party" — one of the old Bolsheviks from the revolutionary leadership in 1917. Bukharin knew and admired the country's artistic elite, even those outside the reigning dogma, and he was a "persistent opponent of cultural regimentation," according to his biographer. "We serve up an astonishingly monotonous ideological food," Bukharin complained. As editor of *Izvestiya*, he had brightened up its pages with new subjects and writers. Pasternak had just contributed some translations of the Georgian poets Paolo Yashvili and Titsian Tabidze.

Bukharin was out when Pasternak came to see him, and the poet left a note asking him to intervene in the case. In a message he sent to Stalin in June 1934, Bukharin added a postscript: "Pasternak is completely bewildered by Mandelstam's arrest."

The entreaties worked, and Mandelstam, who could have been accused of terrorism and sent to almost certain death at a forced-labor camp on the White Sea canal, was allowed to admit to the relatively mild offense of "composing and distributing counter-revolutionary works." Stalin issued a decisive and chilling command that was passed down the chain: "Isolate but preserve." On May 26, Mandelstam was sentenced to three years in internal exile in the town of Cherdyn, far to the northeast in the Urals. He was

dispatched almost immediately, and his wife traveled with him.

In Cherdyn, Mandelstam threw himself out the second-floor window of a hospital. Fortunately he landed in a heap of earth that was intended for a flower bed, and only dislocated his shoulder. His wife sent a flurry of telegrams to Moscow to insist that he needed to be moved to a larger city to get psychiatric care. The OGPU was inclined to listen; Stalin had ordered him preserved. Moreover, the first Congress of Soviet Writers was soon to take place in Moscow, and the leadership did not want the death of a prominent writer to mar it. The writer's case again came to Stalin's attention, and he decided to speak to Pasternak directly.

By 1934, the building on Volkhonka had been turned into communal apartment housing where families each had a room to sleep, and shared a bathroom and kitchen. The phone was in the hallway. A call from Stalin was highly unusual, if not extraordinary, but Pasternak — as he did at first with everyone he spoke to on the phone — launched into a ritual complaint about the din around him because of noisy children.

Stalin addressed Pasternak with the familiar *you*, and told him that Mandelstam's case had been reviewed and "everything will be alright." He asked Pasternak why he hadn't petitioned the writers' organization on Mandelstam's behalf.

"If I were a poet and a poet friend of mine were in trouble, I would do anything to help him," said Stalin.

Pasternak told him that the writers' organization hadn't tried to help arrested members since 1927.

"If I hadn't tried to do something, you probably would never have heard about it," said Pasternak.

"But after all he is your friend," said Stalin.

Pasternak rambled on about the nature of his relationship with Mandelstam and how poets, like women, are always jealous of one another.

Stalin interrupted him: "But he's a master, he's a master, isn't he?"

"But that's not the point," said Pasternak.

"What is, then?"

Pasternak sensed that Stalin actually wanted to find out if he knew about Mandelstam's poem. "Why do you keep on about Mandelstam?" asked Pasternak. "I have long wanted to meet you for a serious discussion."

"What about?" Stalin asked.

"About life and death."

Stalin hung up.

Pasternak redialed the number, but Stalin's secretary told him he was busy. (Perhaps, or just as likely exasperated.) The OGPU allowed Mandelstam to move to Voronezh, about three hundred miles south of the capital, but decreed that he was barred from living in Moscow, Leningrad, as Petrograd had been renamed, and ten other major cities. Word of Pasternak's conversation with Stalin raced through Moscow, and some thought Pasternak lost his nerve and didn't defend his fellow poet with sufficient zeal. But the Mandelstams, when they learned of the call, said they were happy with Pasternak. "He was quite right to say

that whether I'm a master or not is beside the point," said Osip. "Why is Stalin so afraid of a master? It's like a superstition with him. He thinks we might put a spell on him like shamans." Pasternak continued to regret that he didn't get a meeting with Stalin.

"Like many other people in our country, Pasternak was morbidly curious about the recluse in the Kremlin," according to Nadezhda Mandelstam. "Pasternak still regarded Stalin as the embodiment of the age, of history and the future, and that he simply longed to see this living wonder at close quarters." And Pasternak felt that he, uniquely, had "something to say to the rulers of Russia, something of immense importance." Isaiah Berlin, to whom he confessed this sentiment, found it "dark and incoherent."

The First Congress of the Union of Soviet Writers opened on August 17, 1934, and ran through the end of the month with speeches, workshops, and pageantry. The gathering was broadly divided between those who favored strict party control of literary efforts, and liberals who argued for some artistic autonomy. The Soviet Union's artistic establishment was in almost constant debate over the form of literature, its relationship to the audience, and its duty to the state. These disputes often assumed the bitter character of religious schism — the conservative and heterodox in a running battle for supremacy. In a three-hour address, Bukharin spoke about "Poetry, Poetics, and the Tasks of Poetry Creativity in the USSR." Among those he singled out for praise was Pasternak. He acknowledged that Pasternak "is a poet remote from current affairs

. . . from the din of battle, from the passions of the struggle." But he said he had not "only gemmed his work with a whole string of lyrical pearls, but . . . also given us a number of profoundly sincere revolutionary pieces." For the champions of populist, committed poetry, this was heresy. Alexei Surkov, a poet, song lyricist, and budding functionary, who would grow to hate Pasternak with all the bitterness of envy, responded in a speech that Pasternak's art was no model for emerging Soviet poets.

"The immense talent of B. L. Pasternak," Surkov said, "will never fully reveal itself until he has attached himself fully to the gigantic, rich, and radiant subject matter [offered by] the Revolution; and he will become a great poet only when he has organically absorbed the Revolution into himself."

Stalin eventually weighed in, declaring in December 1935 that Vladimir Mayakovsky, dead by his own hand since 1930, "was and remains the best and most talented poet of our epoch." The pronouncement led Pasternak to write to thank Stalin: "Your lines about him had a saving effect on me. Of late, under the influence of the West, [people] have been inflating [my significance] terribly and according [me] exaggerated significance (it even made me ill): they began suspecting serious artistic power in me. Now, since you have put Mayakovsky in first place, this suspicion has been lifted from me, and with a light heart I can live and work as before, in modest silence, with the surprises and mysteries without which I would not love life.

"In the name of this mysteriousness, fervently loving and devoted to you. B. Pasternak."

The Leader scribbled on it: "My archive. I Stalin."

As the literary scholar Grigori Vinokur, who knew Pasternak, said: "I am never sure where modesty ends and supreme self-esteem begins."

Pasternak would, in the New Year's Day 1936 edition of *Izvestiya*, publish two poems that lauded Stalin as the "Genius of Action," and he expressed a vague desire for some "mutual awareness." Pasternak later characterized these adulatory lines as "a sincere and one of the most intense of my endeavors — and the last in that period — to think the thoughts of the era, and to live in tune with it."

In 1936, Stalin began a series of show trials, macabre pieces of theater that would over the next two years mow down the old revolutionary leadership — among them Kamenev, Zinoviev, Rykov, and, in 1938, Bukharin. "Koba, why is my death necessary for you?" Bukharin asked Stalin in a last note. He was shot in a prison in Oryol on March 15, 1938. Across the Soviet Union, there were waves upon waves of arrests and executions in the ranks of the party, the military, the bureaucracy, and the intelligentsia. Close to a quarter of a million people were killed because they were members of national minorities deemed a threat to state security. The country was in the grip of a deranged, pitiless slaughter. With each torture session, the enemies of the state grew exponentially. In 1937 and 1938, Stalin personally signed lists of names for

56

execution comprising 40,000 people, according to Robert Conquest, a historian of the Great Terror. He notes that on one day, on December 12, 1937, Stalin approved 3,167 death sentences. And Stalin only dealt with middle- and higher-ranking officials, and well-known individuals. Across the country, the system's lower tiers — the regional bosses — were engaged in their own paroxysms of execution to please Moscow. Feverish denunciation became an integral part of the political culture at all levels of society. Citizens felt compelled to name enemies, or be named.

In *Pravda*, on August 21, 1936, a letter appeared from sixteen writers under the headline "Wipe Them from the Face of the Earth." It called for the execution of sixteen defendants in the first major show trial, including Grigori Zinoviev, the former head of the Communist International, and Lev Kamenev, who was the acting chairman of the Politburo during Lenin's last days. Pasternak had refused to sign, but the writers' union added his name without informing him. He learned of the addition only at the last minute and came under heavy pressure to let it stand, which he did. His wife, Zinaida, backed his decision, regarding any other choice as suicidal. But Pasternak was ashamed of his failure to strike his name. All sixteen defendants were found guilty of being part of a Trotskyist conspiracy to assassinate Stalin, and they were shot in the bowels of the Lubyanka. Anatoli Tarasenkov, an editor of the journal *Znamya*, wrote Pasternak a letter about the incident, to which he didn't respond. When Tarasenkov confronted Pasternak, the poet was evasive,

and relations between the two ruptured. In the future, Pasternak decided, he would not allow himself to be compromised.

The sense of choking fear was all-powerful. Ordinary things struck strange notes. Pasternak's cousin Olga Freidenberg recalled how "every evening radio broadcasts telling about the bloody and basely conceived trial would be followed by the playing of gay folk dances — the *kamarinskaya* or the *hopak.*"

"My soul has never recovered from the trauma of the prison-like knell of the Kremlin chimes striking the midnight hour," she wrote in her diary. "We had no radio, but from the neighbor's room it came booming forth, cudgeling my brains and bones. The midnight chimes sounded particularly sinister when they followed on the terrible words 'The sentence has been carried out.'"

Even though Pasternak's signature ended up on the letter to *Pravda*, his reluctance to append his name marked him as suspect, and he came under increasing ideological attack from the purveyors of a literary credo. Vladimir Stavsky, a writers' union official and enthusiastic denouncer, accused Pasternak of "slandering the Soviet people" in some poems about Georgia. Pasternak later wrote of his own disillusionment: "Everything snapped inside me, and my attempt to be at one with the age turned into opposition, which I did not conceal. I took refuge in translation. My own creative work came to an end."

In a series of defiant gestures, Pasternak put himself at great risk. When Bukharin was placed under house

arrest in early 1937, Pasternak sent a note — sure to be read by others — to his Kremlin apartment to say, "No forces will convince me of your treachery." Bukharin, a dead man walking, wept at the expression of support, and said, "He has written this against himself." In the 1937 file of the poet Benedikt Livshits, who was summarily executed as an enemy of the people, Pasternak's name is on a list of writers who were possibly being considered as targets for arrest.

In June 1937, Pasternak was asked to sign a petition supporting the death penalty for a group of military defendants, including Marshal Mikhail Tukhachevsky. When an official arrived at his dacha in Peredelkino, he ran him off, shouting, "I know nothing about them, I don't give them life and I have no right to take it away!" The refusal was followed by further pressure from a delegation from the writers' union led by the odious Stavsky, who screamed at and threatened Pasternak. Zinaida, who was pregnant, beseeched him to sign. "She threw herself at my feet begging me not to destroy her and the child," Pasternak said. "But there was no arguing with me." He said he wrote to Stalin to say that he was brought up with "Tolstoyan convictions," adding, "I did not consider I was entitled to sit in judgment over the life and death of others." He then said he went to bed and fell into a blissful sleep: "This always happens after I have taken some irrevocable step." Stavsky was probably more concerned about his own failure to bring Pasternak to heel than about the poet's actual stance. When the letter of condemnation

appeared the next day, Pasternak's signature had been affixed. He was furious but safe.

Pasternak could not explain his own survival. "In those awful bloody years, anyone could have been arrested," he recalled. "We were shuffled like a deck of cards." That he lived left him with a fear that some might believe he had somehow colluded to save himself. "He seemed afraid that his mere survival might be attributed to some unworthy effort to placate the authorities, some squalid compromise of his integrity to escape persecution. He kept returning to this point, and went to absurd lengths to deny that he was capable of conduct of which no one who knew him could begin to conceive him to be guilty," wrote Isaiah Berlin. There was no apparent logic to the killing. Ilya Ehrenburg asked, "Why, for example, did Stalin spare Pasternak who took his own independent line, but destroy [the journalist Mikhail] Koltsov who honorably carried out every task entrusted to him?"

Around Pasternak people disappeared, their fates suspected but unconfirmed — Pilnyak, Babel, and Titsian Tabidze, a Georgian friend whose poetry Pasternak had translated. At a meeting of the Georgian Union of Soviet Writers, another Georgian friend, Paolo Yashvili, shot himself before the inquisitors closed in.

The only happiness was the birth of Pasternak's son, Leonid. The birth was noted in *Vechernyaya Moskva* (Evening Moscow) "The first baby born in 1938 is the son of Mrs. Z.N. Pasternak. He was born 00:00 hour January 1st."

60

Osip Mandelstam was arrested later that year to be "consumed in their flames," as Pasternak put it. He starved to death in a camp in the Far East in December 1938. "My health is very poor. I am emaciated in the extreme, I've become very thin, almost unrecognizable," he told his brother in a last letter. He asked him to send food and clothes because "I get terribly cold without any [warm] things." In 1939, his wife learned of his fate when a money order she had sent Mandelstam was returned because of the "death of the addressee."

"The only person who . . . visited me was Pasternak — he came to see me immediately on hearing of M's death," said Nadezhda Mandelstam. "Apart from him no one had dared to come and see me."

CHAPTER
THREE

"I have arranged to meet you in a novel."

Pasternak began to write *Doctor Zhivago* on a block of watermarked paper from the desk of a dead man. The paper was a gift from the widow of Titsian Tabidze, the Georgian poet who was arrested, tortured, and executed in 1937. Pasternak felt the weight of those empty pages, writing to Tabidze's widow, Nina, that he hoped his prose would be worthy of putting down on her husband's paper. Pasternak visited Georgia in October 1945 to mark the centenary of the death of the Georgian poet Nikoloz Baratashvili, whose work he had recently translated. He stipulated that 25 percent of the advance for translating Baratashvili should be paid to Nina Tabidze.

Through much of his life Pasternak assisted people imprisoned or impoverished by the regime, and his surviving papers included large numbers of receipts for money orders sent all over the Soviet Union, including to prison camps. Nina Tabidze had not appeared in public in eight years, quarantined from the artistic circles in the capital, Tbilisi, where her husband was once feted. Nina had no word of the fate of Titsian, who was arrested on manufactured treason charges, and she would not learn definitively that he had been

executed until after Stalin's death in 1953. While Nina Tabidze held on to some small flicker of hope that her husband survived in some distant camp, Pasternak later said he had not believed in the possibility that the Georgian poet was alive: "He was too great, too exceptional a man, who shed light all around him, to be hidden — for the signs of existence not to have filtered through any bars." When Pasternak arrived in Tbilisi, he said he would only participate in the festivities if Nina Tabidze also attended. At public events he sat her next to him. When he was asked to recite some of his translations of the poems of Baratashvili at the Rustaveli Theatre he turned to look at Nina Tabidze and asked if she wanted him to read. It was a defiant signal to the audience that he was embracing this outcast. Nina Tabidze returned the politically risky demonstration of respect with the gift of writing paper for the novel Pasternak planned.

Although Pasternak's reputation rested almost exclusively on his poems, he had written prose, including some well-received short stories, a long autobiographical essay, and drafts of a novel. Ideas and characters from these writings, but more fully developed, would eventually find their way into *Doctor Zhivago*, as if Pasternak were on a lifelong journey toward his novel. He was burdened over many decades by the sense that he had yet to create something big and bold, and came to believe that such an achievement could only be earned through prose — "what it can be, real prose, what a magic art — bordering on alchemy!" Pasternak also believed that "major works of literature

exist only in association with a large readership." As early as 1917, Pasternak wrote in one poem, "I shall bid goodbye to verse; my mania. I have arranged to meet you in a novel." He told Tsvetaeva that he wanted to write a novel "with a love intrigue and a heroine in it — like Balzac." The reader of an early draft dismissed the effort as "dreamy, boring and tendentiously virtuous." It was abandoned. Pasternak projected some of this failed ambition onto his ultimate hero, Yuri Zhivago: "Still in his high school years, he dreamed of prose, of a book of biographies, in which he could place, in the form of hidden explosive clusters, the most astonishing things of all he had managed to see and ponder. But he was too young for such a book, and so he made up for it by writing verses, as a painter might draw sketches all his life for a great painting he had in mind."

World War II heightened Pasternak's preoccupation with the need for some singular piece of work. His friend the playwright Alexander Gladkov said that "his usual sense of acute dissatisfaction with himself now found an outlet in an exaggerated feeling that he was doing too little when set by the side of the enormous exertions of the country as a whole." In October 1941, as Nazi forces approached Moscow, Pasternak along with other writers was evacuated to Chistopol, a small town of 25,000 people nearly six hundred miles east of Moscow. He subsisted there for nearly two years on thin cabbage soup, black bread, and readings in the dining room of the Literary Fund. It was a drab, cold existence.

Pasternak visited the front near Oryol in 1943 and read his poems to the wounded. General Alexander Gorbatov invited a group of writers to "a sober dinner" of potatoes, a little ham, one shot of vodka per person, and tea. The meal was marked by speeches. Unlike some of his colleagues who were dull and soporific, Pasternak gave a clear, patriotic address leavened with humor and poetic dashes. The officers listened in complete silence, pale and moved. The visit to the front inspired some war poems and two pieces of short prose, and some of the destruction he witnessed would appear in the epilogue to *Doctor Zhivago*.

Pasternak, however, was never among those writers, such as Konstantin Simonov, whose poems and dispatches, circulated by the millions, were woven into the country's bloody resilience. "I am reading Simonov. I want to understand the nature of his success," he said. He considered a novel in verse, and he contracted with theaters to write a play, but nothing ever came of these aspirations. Pasternak complained that he lived "with the constant, nagging sense of being an imposter" because he felt he was "esteemed for more than I have actually done." His poems were published in the newspapers, and small volumes of poetry appeared in 1943 and 1945. He continued to earn a living through his translations. "Shakespeare, the old man of Chistopol, is feeding me as before."

In 1944, Pasternak received some wrenching encouragement to continue to reach for a greater artistic achievement. Anna Akhmatova, who had been evacuated to Tashkent in the Soviet Republic of

Uzbekistan, arrived in Moscow in 1944 carrying an old letter for Pasternak from Osip Mandelstam, written two years before he perished. Mandelstam's widow had found it. Mandelstam, who had once warned Pasternak that his translation work would overwhelm his original creations, said in the letter, "I want your poetry, by which we have all been spoiled and undeservedly gifted, to leap further out into the world, to the people, to children. Let me say to you at least once in life: thank you for everything, and for the fact that this 'everything' is still 'not everything.'" For Pasternak, the letter, even if it referred to poetry, was a bitter prompt that there was more to strive for. The following year, in May 1945, Pasternak's father, Leonid, died in Oxford. Pasternak felt he should "burn with shame" when his "own role is so monstrously inflated" and his father's talent hadn't gained "a hundredth of the recognition it deserves."

Guilt, grief, dissatisfaction with himself, the need for that "great painting," the desire finally to write a classic were all combining to produce what one friend called a "profound inner change" that would propel Pasternak toward *Doctor Zhivago*. The first recorded mention of the novel appears in a letter to Nadezhda Mandelstam in November 1945, when Pasternak told her that he had been doing some new writing, a novel that would span the whole of their lives. On New Year's Eve 1945, Pasternak bumped into Gladkov on Mokhovaya Street near the Kremlin. The two were jostled by revelers, but they managed to exchange a few words as they stood in

light snow, which dusted Pasternak's collar and cap. Pasternak said he was working on a novel "about people who could be representative of my school — if I had one." He smiled sheepishly before moving off.

In an end-of-year letter to his sisters in England, he said that he was compelled to portray the great events of his country in clear, simple prose. "I have started on this, but it's all so remote from what's wanted from us here, and what people are used to seeing from us, that it's difficult to write regularly and assiduously."

Pasternak's mood became more buoyant as the writing accelerated. "I am in the same high spirits I enjoyed more than 30 years ago; it's almost embarrassing." It seemed to him that the days and weeks were whistling past his ears. "I wrote it with great ease. The circumstances were so definite, so fabulously terrible. All that I had to do was listen to their prompting with my whole soul and follow obediently their suggestions." Pasternak was also cheered that spring of 1946 by the enthusiastic reception he received from Muscovites at a series of literary evenings. At Moscow University, in April 1946, the audience called for him to continue to recite as he made to leave the stage. The following month, there was another series of encores at a solo recital at the Polytechnic Museum. Pasternak told his sisters that he was experiencing a kind of unexpected fairy tale in this romance with his audience. "You see it in the concert halls which sell out as soon as my name appears on a poster — and if I ever hesitate while reciting any of my poems, I'm prompted from three or four different directions." (One

67

acquaintance suggested Pasternak, who prepared for recitals, faked some memory lapses to test his audience, and bind it to him.)

On April 3, 1946, at a reading by Moscow and Leningrad poets, Pasternak arrived late and the audience burst into applause as he tried to sneak onto the stage. The poet who was speaking was forced to halt his recital until Pasternak sat down. The man who was interrupted and no doubt irritated was Alexei Surkov, his old and future foe, the poet who said Pasternak needed to imbibe the revolution to achieve greatness. The disruption seemed more than coincidental when much the same thing happened nearly two years later when Surkov was speaking at "An Evening of Poetry on the Theme: Down with the Warmongers! For a Lasting Peace and People's Democracy" at the Polytechnic Museum. The venue was one of the largest in Moscow, and it was so packed that people were sitting in the aisles while the street outside was crowded with those who couldn't get in. Surkov was nearing the end of a versified condemnation of NATO, Winston Churchill, and sundry Western belligerents when the audience erupted in applause, which seemed out of key with that moment in his recital. Over his shoulder, it was Pasternak again, stealing a little thunder from his rival, and supposedly slipping onto the stage. He stretched out his arms to hush the crowd, and allow Surkov to continue. When he was eventually called to the microphone Pasternak remarked coyly, "Unfortunately, I have no poem on the theme of the evening, but will read you some things I wrote before the war." Each

poem drew bursts of delighted enthusiasm from the crowds. Someone shouted, "Shestdeesiat shestoi davai!" (Give us the Sixty-Sixth!), a call for Shakespeare's sonnet, which Pasternak had translated in 1940, in which the Bard declaims:

> And art made tongue-tied by authority,
> And folly, doctor-like, controlling skill,
> And simple truth miscall'd simplicity
> And captive good attending captain ill:
> > Tir'd with all these, from these would I be gone,
> > Save that, to die, I leave my love alone.

Pasternak was smart enough not to recite the politically charged lines. But the sustained applause had become a clapping, stomping public demonstration — a potentially dangerous display of affection for its recipient. (When Akhmatova was similarly received at a reading during the war, Stalin is reported to have said: "Who organized that standing ovation?") The chairman of the meeting tried to restore order by ringing his bell, and Pasternak sported a smile of satisfied triumph. A large group from the audience followed him on his walk home.

Surkov could only fume. He had made his reputation during the war with unsubtle, patriotic verse that proclaimed:

> Death to Fascism! The Soviet
> Calls the brave to battle

The bullet fears the brave,
The bayonet the courageous.

One Western reporter in Moscow described Surkov as "emphatically masculine." Rudely pink-faced and muscular, he spoke in a loud voice — sometimes at such a decibel that he appeared to be addressing a crowd, not conversing — and he walked in exaggerated strides, fast and long. Nine years younger than Pasternak, Surkov grew up the son of a peasant in a district northeast of Moscow and on reaching the capital was consumed with his status there; the Hungarian writer György Dalos, who attended college in Moscow and knew Surkov, described him as a special Soviet case of Molière's *bourgeois gentilhomme*. Dalos concluded that "in order to understand a figure like Surkov, good and evil must be regarded not as opposites but as parts of one inseparable whole." A Soviet defector to the West later testified before the U.S. Congress that Surkov was "a KGB man," meaning he was one of a number of trusted prominent figures who would do the bidding of the secret police when called upon.

Nadezhda Mandelstam noted that in conversation, Surkov always referred to a mysterious entity called "they." He often wished to extend a kindness, but was unable to act until he had sounded out some superior entity.

" 'They,' as I noticed, were always thinking this, that or the other, or giving it as their view. Once I asked him outright: 'Who are they?' As far as I am concerned you

are 'they.' He was quite bowled over by such a question . . . Later I realized that in a world horizontally divided, as it were, into floors, 'they' were always those on the next floor." Mandelstam concluded that "like all his kind he stultifies language, stifles thought and life. In so doing, he also destroys himself."

Surkov nursed a particular hostility toward Pasternak, yet he showed genuine kindness to Akhmatova, mitigating the worst of her persecutions and bringing her flowers. However, "he worked heart and soul for a system that had a pathological fear of every unfettered word, and so especially of poetry." And no poet focused his animus more than Pasternak. One Pasternak intimate concluded simply that Surkov "hated him." Pasternak, on the other hand, was never angered by Surkov's hostility or criticism. After the war, he praised Surkov's verse as exemplary of a new realism and said he was among his favorite poets because of his rough-hewn, boisterous style. "Yes, really, don't be surprised. He writes what he thinks: he thinks 'Hurray!' and he writes 'Hurray!' "

The novel, which Pasternak initially entitled *Boys and Girls*, began to come into focus as he worked on it intensely in the winter months of 1945 and 1946, and his ambitions for it grew. "This is a very serious work. I am already old, I may soon die, and I must not perpetually put off giving free expression to my true thoughts." He called it an epic, and said it was "a sad, dismal story, worked out in fine detail, ideally, as in a Dickens or Dostoevsky novel." He became absorbed

with the writing. "I could not go on living another year unless this novel, my alter ego, in which with almost physical concreteness certain of my spiritual qualities and part of my nervous structure have been implanted, went on living and growing, too." He promised to give his views on art, the Gospels, on the life of man in history. He said it would "square accounts with Judaism" and with all forms of nationalism. And he felt that his subjects and their varying colors were "arranging themselves so perfectly on the canvas."

Like many of his contemporaries, Pasternak believed, or at least strongly hoped, that the sacrifice of the people in war, the millions dead and the awful struggle to defeat Nazism, would preclude a return to repression. But Pasternak was also alert enough to observe that the seemingly relaxed postwar atmosphere was eroding as tensions with the Western powers grew into the Cold War. In June 1946, Pasternak told his sisters that he moved around "on a knife-edge . . . It's interesting, exciting and probably dangerous."

The crackdown on the intelligentsia came in August 1946. The targets, initially, were the satirical writer Mikhail Zoshchenko and Akhmatova. Stalin opened the campaign when the editors of two Leningrad journals were summoned to Moscow and harangued for publishing "silly" material. Zoshchenko, Stalin railed, "writes all kind of cock and bull stories, nonsense that offers nothing for the mind or the heart . . . That's not why we built the Soviet order, to teach people drivel." The party's Central Committee followed with a resolution that said Zoshchenko had specialized in

writing "vapid, content-less and vulgar things, in the advocacy of rotten unprincipledness . . . calculated to disorient our young people and poison their minds." The resolution singled out a story, "The Adventures of a Monkey," which depicted an escaped monkey who returned to his cage in the zoo rather than deal with everyday life in Leningrad. The resolution described the story as a "hooliganish depiction of our reality." Akhmatova was also charged with causing damage to young people with her "bourgeois-aristocratic aestheticism and decadence — 'art for art's sake.'"

That a new unforgiving period of cultural repression had begun was driven home in a shrill, vulgar speech by Andrei Zhdanov, a member of Stalin's inner circle since the 1930s, a colossal boozer, and the piano player when the Leader sang on drunken evenings. Zhdanov spoke in the Great Hall of the Smolny Institute in Leningrad before an invited audience of writers, journalists, publishers, and bureaucrats. The location was well chosen; Lenin announced the Soviet takeover of power in the same hall in 1917. One attendee later wrote that the meeting, which began at five p.m. and lasted almost until midnight, was marked by "sycophantic contributions from the floor and hysterical self-criticism from writers taking part."

"Anna Akhmatova's subject-matter is thoroughly individualistic," said Zhdanov. "The range of her poetry is pitifully limited — this is the poetry of a feral lady from the salons, moving between the boudoir and the prayer stool. It is based on erotic motifs linked with motifs of mourning, melancholy, death, mysticism and

isolation . . . she is half nun, half whore, or rather both whore and nun, fornication and prayer being intermingled in her world."

Zhdanov's campaign for conformity, which was infused with a chauvinistic hostility to all things Western, spread to the theater, cinema, music, the university, and eventually the sciences. Pasternak's cousin Olga, who taught at Leningrad University, wrote in her diary that the new academic year began with the rector appearing before the faculty in a peasant shirt to symbolize a shift in ideology towards the "great Russian people." She rued that "anyone who in any way shows respect for European culture is dubbed a toady." New grounds for arrest included "Praising American Democracy" or "Abasement before the West."

It was inevitable that Pasternak would become a target, and the new head of the writers' union, Alexander Fadeyev, accused him of being out of touch with the people — "not one of us." When it was suggested that Pasternak should condemn Akhmatova in print, he refused and said he loved her too much; to help Akhmatova, who had been expelled from the Union of Soviet Writers and left with no way to earn a living, Pasternak would slip a thousand rubles under her pillow when she came to Moscow and stayed with mutual friends. Pasternak was removed from the board of the Union of Soviet Writers in August 1946 when he failed to attend a meeting called to denounce Akhmatova and Zoshchenko. Pasternak was warned that he was no less suspect as an aesthete than

Akhmatova, but he replied with characteristic insouciance: "Yes, yes, [out of touch with] the people, modern times . . . you know, your Trotsky once told me the same thing."

On September 9, 1946, *Pravda* reported that the Union of Soviet Writers had passed a resolution stating that Pasternak was "an author lacking in ideology and remote from Soviet reality." On the same evening, Pasternak had scheduled one of his first readings of the early part of the novel at his home in Peredelkino. He didn't read the newspapers and his wife didn't tell him about the attack, so the reading went ahead. It was attended by his neighbor Chukovsky and his son Nikolai; the literary scholar Korneli Zelinsky, who would, in time, launch a vicious attack on Pasternak and *Doctor Zhivago*; and about ten or eleven other listeners.

Chukovsky found himself perplexed by *Doctor Zhivago*. "For all the charm of certain passages," he wrote in his diary, "it struck me as alien, confusing and removed from my life, and much of it failed to involve me." The novel bewildered others who were close to Pasternak and steeped in the lyrical beauty of his poetry. When Akhmatova first heard an excerpt at a reading in a flat in Moscow, she "was acutely unhappy with the novel." She told the physicist Mikhail Polivanov, a friend of Pasternak's, that "it is a failure of genius." When Polivanov protested that the novel captures "the spirit and people of that age," Akhmatova replied, "It is my time, my society, but I don't recognize it." His neighbor Vsevolod Ivanov complained after a

reading that he had heard none of the exquisite craft he would expect from Pasternak and that the writing seemed hurried and rough.

Pasternak was unmoved by those who complained of the admixture of styles, the reliance on coincidence, slackened writing, and a torrent of characters even compared with the bounteous peopling of the standard Russian novel. Pasternak responded that every aspect of the novel, including its "failings," was, to him, conscious. Writing much later, in his idiosyncratic English to the poet Stephen Spender, he explained that there is "an effort in the novel to represent the whole sequence of facts and beings and happenings like some moving entireness, like a developing, passing by, rolling and rushing inspiration, as if reality itself had freedom and choice and was composing itself out of numberless variants and versions." He said he didn't so much delineate characters as efface them, and coincidence showed "the liberty of being, its verisimilitude touching, adjoining improbability." Pasternak was no longer interested in stylistic experiment but "understand-ability." He said he wanted the novel "gobbled down" by everyone, "even a seamstress or a dishwasher."

Other listeners were enthusiastic, and moved by the passages they heard. Emma Gerstein, who heard Pasternak read the first three chapters of the novel to a small audience in April 1947, came away feeling that she had "heard Russia," adding, "With my eyes, my ears and my nose I sensed the era." Pasternak's friend the Leningrad poet Sergei Spassky said, "A spring of

pristine, creative energy has gushed forth from inside you."

Pasternak continued to read drafts to small gatherings at apartments in Moscow, and those evenings formed a kind of dialogue with his audience and led him to make some adjustments to the text. At a reading in May 1947, the audience included Genrikh Neigauz, the first husband of his wife and long since reconciled to Pasternak, and Leo Tolstoy's granddaughter, among others. Pasternak arrived with the pages rolled in his hand. He kissed the hand of his hostess and embraced and firmly kissed Neigauz before sitting behind a table and saying, without any ceremony, "Let's start." He told the audience he hadn't yet decided on a title and for now was simply subtitling the novel *Scenes of Half a Century of Daily Life*. The following year, with four chapters completed, he would settle on the title *Doctor Zhivago*. While sounding like a Siberian name, Zhivago was derived from an Orthodox prayer. Pasternak told the Gulag survivor and writer Varlam Shalamov, who was the son of a priest, that as a child while saying the prayer lines "Ty est' voistinu Khristos, Syn Boga zhivago" (You truly are the Christ, the living God), he used to pause after *Boga* (God) before saying *zhivago* (the living).

"I did not think of the living God, but of a new one, who was only accessible to me through the name Zhivago," Pasternak said. "It took me a whole life to make this childish sensation real by granting the hero of my novel this name."

For Pasternakians, invitations to these literary evenings were cherished. On February 6, 1947, the home of the pianist Maria Yudina was packed despite the raging blizzard outside. Yudina told Pasternak that she and her friends were looking forward to the reading "as to a feast."

"They will all squeeze into my luxurious single-celled palazzo," she told the poet in a note. Pasternak almost didn't make it because he was uncertain of the address and snow drifts were making it increasingly difficult to maneuver the car carrying him and his companions to the event. Finally, a candle in a window drew the group to the right location. Yudina's house was stiflingly hot because of the number of people inside, and it reeked of kerosene from a vain attempt to kill bugs earlier in the day; they still visibly scuttled across the wall. Yudina was dressed in her best black velvet dress and moved among the guests passing out sandwiches and wine. She played Chopin for a long time. Pasternak seemed nervous, or perhaps he was just uncomfortable from the heat, wiping sweat off his face. He read about the young student Zhivago dancing with his fiancée, Tonya, and the Christmas tree lights at the Sventitskys' house. When he stopped reading he was bombarded with questions about how the story would unfold. As Pasternak left at first light, he told his mistress that the evening, almost lost because of the snow, had inspired a poem, which would become Yuri Zhivago's "A Winter Night":

It snowed, it snowed over all the world
From end to end.
A candle burned on the table,
A candle burned.

The gatherings were also attracting some unwelcome attention. The deputy editor of *Novy Mir* described them as the "underground readings of a counter-revolutionary novel." The secret police were also monitoring the soirees and noting the book's contents for the moment when they would strike.

The attacks on Pasternak continued into 1947. Among those who singled him out for criticism was Fadeyev, the head of the writers' union. But Fadeyev also embodied the establishment's duality toward Pasternak. Ilya Ehrenburg recalled meeting Fadeyev after he had publicly inveighed against the "aloofness from life" of writers like Pasternak. Fadeyev took Ehrenburg to a café where, after ordering brandy, he asked Ehrenburg if he would like to hear some real poetry. "And he began to recite from memory verses by Pasternak, going on and on, and only interrupting himself from time to time to say: 'Wonderful stuff, isn't it?'" Pasternak had once remarked that Fadeyev was "well-disposed to me personally but if he received orders to have me hung, drawn and quartered he would carry them out conscientiously and make his report without batting an eyelid — though the next time he got drunk he would say how sorry he was for me and what a splendid fellow I had been." Fadeyev shot

himself in 1956. As Pasternak bowed before his open coffin in the Hall of Columns in the House of the Unions, he said in a loud voice, "Alexander Alexandrovich has rehabilitated himself."

Official criticism of Pasternak in 1947 reached a pitch in a virulent signed piece by Surkov in the newspaper *Kultura i Zhizn* (Culture and Life), a principal mouthpiece for enforcing Zhdanov's line and labeled the "Mass Grave" by some of the intelligentsia. Surkov charged that Pasternak had a "reactionary backward-looking ideology," that he "speaks with obvious hostility and even hatred about the Soviet Revolution," and that his poetry was a "direct slander" of Soviet reality. He also said that Pasternak had "meager spiritual resources," which were incapable of "giving birth to major poetry."

On the totem of denunciation, which had its own semiotics in the Soviet Union, this was a couple of notches below a call for Pasternak's isolation and ruin — because if the article was signed, it was less menacing. Gladkov, who had anticipated the official censure and feared for his friend, said he could breathe easily again after reading it. "With all its dishonesty and deliberate obtuseness it did not amount to a definite 'excommunication.'" An anonymous piece in a major newspaper would have signaled ruin. "At least they are not going to let me starve," quipped Pasternak after getting a commission to translate *Faust*.

The times, however, demanded some punishment. The journal *Novy Mir* rejected some of his poems. The publication of his translated Shakespeare compendium

was put on hold. And 25,000 printed copies of his selected lyric poetry were destroyed "on orders from above," on the eve of distribution in the spring of 1948. The readings stopped and he noted that "public appearances by me are regarded as undesirable."

Pasternak was able to exact some sly revenge. In a revision of his translation of *Hamlet*, he introduced lines that bear little if any fidelity to the original. Even allowing for Pasternak's belief that a translation should never be an attempt at "literal exactitude," the lines from *Hamlet*, when translated back into English again, were a biting commentary on the politics of the hour. Where Shakespeare wrote of the "whips and scorns of time," Pasternak had Hamlet say: "Who would bear the phony greatness of the rulers, the ignorance of the bigwigs, the common hypocrisy, the impossibility to express oneself, the unrequited love and illusoriness of merits in the eyes of mediocrities."

The renewed sterility of cultural life after a flush of postwar optimism was both dismaying to Pasternak and a prompt to burrow further into his new project. "I started to work again on my novel when I saw that all our rosy expectations of the changes the end of the war was supposed to bring to Russia were not being fulfilled. The war itself was like a cleansing storm, like a breeze blowing through an unventilated room. Its sorrows and hardships were not as bad as the inhuman lie — they shook to its core the power of everything specious and unorganic to the nature of man and society, which has gained such a hold over us. But the dead weight of the past was too strong. The novel is

absolutely essential for me as a way of expressing my feelings." His attitude to the state, which had fluctuated between ambivalence and cautious embrace, was now consistently if quietly hostile. He told his cousin that he was as cheerful as ever despite the changed atmosphere in Moscow. "I write no protests and say nothing when addressed. It's no use. I never try to justify myself or get involved in explanations." He had other reasons for ignoring the deadening hand of the authorities.

Pasternak had fallen in love.

CHAPTER
FOUR

"You are aware of the anti-Soviet nature of the novel?"

When World War II ended, Pasternak's marriage to his second wife, Zinaida, had long since settled into an arid routine. Zinaida ran the household with stern efficiency, and he appreciated her for it. "My wife's passionate love of work, her skill in everything — in washing, cooking, cleaning, bringing up the children — has created domestic comfort, a garden, a way of life and daily routine, the calm and quiet needed for work." He told a friend he loved her for her "big hands." But there was an air of deep regret in the home — "a divided family, lacerated by suffering and constantly looking over our shoulders at that other family, the first ones." When Zinaida got pregnant in 1937, Pasternak wrote his parents that "her present condition is entirely unexpected, and if abortion weren't illegal, we'd have been dismayed by our insufficiently joyful response to the event, and she'd have had the pregnancy terminated." Zinaida later wrote that she very much wanted "Borya's child," but her raw fear that her husband could be arrested at any moment — this was the height of the Terror and he was refusing to sign petitions — made it hard to carry the pregnancy.

Zinaida had little interest in Pasternak's writing, confessing that she didn't understand his poetry. Her principal diversion was sitting at the kitchen table chain-smoking and playing cards or mah-jongg with her female friends. Hard-edged and frequently ill-humored, Zinaida was described by Akhmatova as "a dragon on eight feet." But she had earned her unhappiness. In 1937, Adrian, the older of her two sons with her first husband, Genrikh Neigauz, was diagnosed with tuberculosis of the bone, a discovery that began a long and agonizing decline in his health. In 1942, in an effort to arrest the spread of the disease, one of the boy's legs was amputated, above the knee, and the previously active seventeen-year-old was inconsolable. Adrian died in April 1945 from tubercular meningitis after being infected by the boy next to him in a sanatorium; his mother was by his side there. After his death, his body was held in the morgue for four days for research. When Zinaida saw him again he had been embalmed. She cradled Adrian's head and was horrified that it was light "as a matchbox." His brain had been removed. Zinaida remained haunted by the sensation of holding him. She was suicidal for days after the death, and Pasternak remained close, doing chores with her, to distract and comfort her. Adrian's ashes were buried in the garden in Peredelkino. Zinaida said she neglected her husband and felt old. Intimacy seemed a "curse" to her and she said she could not always "fulfill my duty as a wife."

★ ★ ★

On an October 1946 day, just as winter announced itself with a driving snow, Pasternak walked into *Novy Mir*'s cavernous reception area, a converted former ballroom where Pushkin had once danced, now painted the dark red of Soviet gaud. After he had crossed the long carpet to the back of the room where the junior editors sat, Pasternak encountered two women about to go to lunch. The older of the pair held out her hand to be kissed and said to Pasternak. "Boris Leonidovich, let me introduce one of your most ardent admirers." The devotee was Olga Ivinskaya, a blond, in an old squirrel-fur coat and an editor at *Novy Mir*. She was more than twenty years Pasternak's junior, and later was a source of inspiration for the character Lara in *Doctor Zhivago*. Pretty, voluptuous, and sexually self-confident despite the prudish mores of Soviet society, the thirty-four-year-old Ivinskaya immediately felt his lingering stare — "so much a man's appraising gaze that there could be no doubt about it." As he bowed and took Ivinskaya's hand, Pasternak inquired as to which of his books she possessed. Just the one, she confessed. Pasternak promised to return with some volumes. "How interesting that I still have admirers." The next day, five books appeared on Ivinskaya's desk.

Ivinskaya had recently attended a Pasternak recital at the Historical Museum. It was the first time she had seen him at such close range, and she described him as "tall and trim, extraordinarily youthful, with the strong neck of a young man, and he spoke in a deep low voice, conversing with the audience as one talks with an intimate friend." When she returned to her flat after

midnight, her mother complained about having to get up to let her in. "Leave me alone," said Ivinskaya, "I've just been talking to God."

Pasternak was typically self-deprecating about his own charms and described the "few women who have had an affair with me" as "magnanimous martyrs so unbearable and uninteresting am I 'as a man.'" He adored and idealized women and described himself as forever stunned and stupefied by their beauty. Among his fellow writers, Pasternak was known for his flings; women were drawn to him. Zinaida said that after the war Pasternak was showered by notes and unexpected visits from young women she chased out of the yard. Pasternak called them "the ballerinas." One of them sent him a note that she wanted to give birth to a Christ fathered by Pasternak.

Ivinskaya was twice married and had, by her own account, many passing relationships. Her first husband hanged himself in 1940 when he was thirty-two, after she had an affair with the man who would become her second husband. "Poor Mama mourned," remarked Olga's daughter, Irina, but her sorrow did not last very long; the forty-day mourning period had scarcely passed when "a guy in a leather coat turned up at the doorstep." Ivinskaya's second husband died of an illness during the war but not before informing on his mother-in-law (possibly to get her out of the crowded apartment), who then spent three years in the Gulag for making a slanderous remark about Stalin.

In 1946, Ivinskaya lived with her mother and stepfather; her two children, eight-year-old Irina and

five-year-old Dmitri, one by each husband; and her many beloved cats. The fifty-six-year-old Pasternak offered a release from a cramped world and an entrée into Moscow's salons. "I longed for recognition and wanted people to envy me," said Ivinskaya. She was seductive and devoted, clingy and calculating. Pasternak was a very big catch.

Ivinskaya had read Pasternak's poems since she was a girl; she described herself as a fan meeting her idol. "The magician, who had first entered my life so long ago, when I was 16, had now come to me in person, living and real." Ivinskaya's daughter would later nickname Pasternak "Classoosha," an affectionate diminutive of the word *classic*, and one mother and daughter came to share when referring to the writer.

The romance began as an old-fashioned courtship. Because both Pasternak and Ivinskaya had family at home, the couple had no private retreat. Pasternak would show up at *Novy Mir* at the end of the workday, and he and Ivinskaya would meander through the streets, talking at great length, before he would bid her farewell at her apartment building.

"I'm in love," Pasternak told a friend, who asked how this would affect his life. "But what is life?" Pasternak responded. "What is life if not love? And she is so enchanting, such a radiant, golden person. And now this golden sun has come into my life, it is so wonderful, so wonderful. I never thought I would still know such joy." He hated growing old and treated his birthdays as days of mourning, disdaining any attempt

to celebrate. This unexpected romance was a time-stopping elixir.

The ritual of walking and talking continued until April when Ivinskaya's family went out of the city for the day. "As newly-weds spend their first night together [Boris] and I now had our first day together. He was borne up and jubilant over this victory." That day, Pasternak inscribed a collection of his verse: "My life, my angel. I love you truly. April 4, 1947."

The early affair, punctuated by unkept promises to end the romance because of the obvious domestic complications, found its way into some of Zhivago's poetry:

Don't cry, don't purse your swollen lips.
Don't draw them together like that.

Moscow was soon chattering about the deliciously scandalous liaison, and Pasternak's female friends — some of whom had their own strong feelings for the poet — were less than enamored with Ivinskaya. Some would never trust her. The writer Lydia Chukovskaya, who worked with Ivinskaya at *Novy Mir*, remarked of one evening that the couple's "faces could be seen side by side. Her make-up was a dreadful sight next to his natural face. A "pretty but slightly fading blonde," commented the literary scholar Emma Gerstein, remarking on how, during one reading, she "hurriedly powdered her nose, hiding behind a cupboard." However, the young poet Yevgeni Yevtushenko who saw her at a Pasternak reading called her "a beauty."

Zinaida found out about the affair in the winter of 1948 when she found a note sent by Ivinskaya to Pasternak while cleaning his study. Initially she said she felt guilty and that it was all her fault. It also seemed to her that after the war, "in our village community, [the men] started to leave the old wives and replace them with younger ones." Zinaida confronted Ivinskaya in Moscow, telling her that she didn't give a damn about their love and she wasn't going to allow her family to be broken up. She gave Ivinskaya a letter from Pasternak announcing the end of the affair. Ivinskaya's children overheard conversations that "Mom had tried to poison herself," her daughter recalled.

Pasternak's sense of loyalty to Zinaida and their son became a strain as he vacillated between family and flame. The prospect of a second divorce, a third marriage, and all the potential excruciating chaos may have been more than Pasternak wished to endure. The couple huddled in doorways to argue. Ivinskaya returned home furious from these rows and took down Pasternak's picture. "Where's your pride, Mama?" asked her daughter after the picture had been put back up yet another time. Ivinskaya's mother harangued both her daughter and Pasternak about Olga's status as a mistress, not a wife. "I love your daughter more than my life," Pasternak told her, "but don't expect our life to change outwardly all at once." The affair, at one point, appeared to be over. In a letter to his cousin in August 1949, Pasternak confessed that he had "formed a deep new attachment," but, he wrote, "since my relationship with [Zinaida] is a genuine one, sooner or

later I had to sacrifice the other. Strangely enough, so long as my life was filled with agony, ambivalence, pangs of conscience, even horror, I easily bore it and even took pleasure in things that now, when I have made peace with my conscience and my family, reduce me to a state of unmitigated dreariness: my aloneness, my precarious place in literature, the ultimate pointlessness of my literary efforts, the strange duality of my life 'here' and 'there.'" He imagined at one point that he could get Zinaida, Olga, and his first wife, Yevgenia, to sit together happily on the veranda of the dacha with him. "He never wanted to cause anyone grief, but he did," said a friend.

By 1949, Pasternak was already a figure of some international renown, even if he was banished to the edges of literary life in Moscow. Cecil Maurice Bowra, who held the Oxford Chair of Poetry, had nominated Pasternak for the Nobel Prize in Literature in 1946, an honor that was repeated in 1947 and 1949. Bowra had also included seventeen poems by Pasternak in *A Second Book of Russian Verse*, which he had edited and was published in London in 1948. An American edition of Pasternak's *Selected Writings* appeared in New York in 1949. One of the leading academics in the West called Pasternak "the greatest of Russian poets." And in July 1950, the International Conference of Professors of English wrote to the Soviet ambassador to Britain to invite Pasternak to Oxford and said, "It appears to us beyond all doubt that the most eminent man of letters . . . in the Soviet Union today is Boris Pasternak."

The Kremlin leadership, locked in a global ideological struggle with the West, was exquisitely sensitive to any foreign depiction of Soviet culture and expended great national energy on projecting the country's intellectual achievements. Simultaneously, the government was pressing an increasingly sinister campaign against "rootless cosmopolitans," a policy that had an ugly anti-Semitic complexion. There were persistent rumors that Pasternak would be picked up by the secret police; Akhmatova at one point phoned from Leningrad to check that he was safe. A senior investigator in the prosecutor's office in 1949 said there were plans to arrest Pasternak. When Stalin was informed, he started to recite "Heavenly color, color blue," one of the Baratashvili poems that Pasternak had translated and read in Tbilisi in 1945. And then Stalin said, "Leave him, he's a cloud dweller."

Ivinskaya enjoyed no such protection; she was a surrogate who could be used to strike directly at her lover. The same pitiless logic was applied to Akhmatova, whose husband and son were both arrested separately in the second half of 1949 while she was physically untouched. On October 9, 1949, the secret police burst into Ivinskaya's apartment. Nearly a dozen uniformed agents, working through the blue haze of their cigarette smoke, searched the apartment, setting aside for seizure any book, letter, document, or scrap of paper that mentioned Pasternak. Ivinskaya was taken almost immediately to secret-police headquarters — the fearsome Lubyanka building, where she was strip-searched, had her jewelry and bra taken from her,

and was placed in a dark, stultifying isolation unit. She was left to stew in her own anxiety for three days before she was moved in with fourteen other female prisoners. The crowded cell was illuminated with harshly bright lamps to ensure that the women were sleep-deprived and disoriented in advance of nighttime interrogations. Ivinskaya recalled that "the prisoners began to feel that time had come to a halt and their world had collapsed about them. They ceased to be sure of their innocence, of what they had confessed to, and which other prisoners they had compromised apart from themselves. In consequence, they signed any raving nonsense put before them."

Among Ivinskaya's cellmates was Trotsky's twenty-six-year-old granddaughter, Alexandra, who had just finished her studies at the Institute of Geology and was accused of copying an illicit poem. Long after Alexandra had left, Ivinskaya continued to remember her desperate wailing as she was taken away to be sent to a camp in Kazakhstan. Another woman who befriended Ivinskaya was a doctor at the Kremlin hospital who had attended a party where incautious remarks were made about Stalin's mortality.

Two weeks after her arrest, the guards called Ivinskaya out of her cell and led her down several long corridors past closed doors from behind which muffled cries of distress escaped. She was finally placed inside a cupboardlike compartment that rotated and opened into an anteroom. A group of agents fell silent as she appeared, and stood aside as she was ushered into a large office. Behind a desk covered in green baize was

Stalin's minister of state security, Viktor Abakumov, another of the Leader's violent henchmen. Abakumov led SMERSH, an acronym for "Death to Spies," during the war. The military counterintelligence unit, which set up blocking positions immediately behind the front lines, killed Soviet soldiers who attempted to retreat. The unit also hunted down deserters and brutally interrogated German prisoners of war. Before torturing his victims, Abakumov was known to unroll a bloodstained carpet to save the sheen on his office floor.

"Tell me now, is Boris anti-Soviet or not, do you think?" began Abakumov, dressed in a military tunic buttoned to the bulging neck.

Before Ivinskaya could reply, Abakumov continued, "Why are you so bitter? You've been worrying about him for some reason! Admit it now — we know everything."

At that moment, Ivinskaya still didn't realize who was questioning her, and she pushed back with none of the caution an encounter with a monster like Abakumov would demand.

"You always worry about a person you love. As regards whether Boris Leonidovich is anti-Soviet or not — there are too few colors on your palette, only black and white. There is a tragic lack of half-tones."

The books and materials seized from Ivinskaya's apartment were piled on the desk in front of Abakumov. The KGB's accounting of its haul from Ivinskaya's apartment included: poems by Pasternak, Akhmatova, and Lydia Chukovskaya (to my dear O.V.

Ivinskaya); a diary (30 pages); various poems, (460 pages); a "pornographic" poem; various letters (157 pieces); photos of Ivinskaya; and some of her own poems. Among these items was the small red volume of poetry that Pasternak had inscribed after the couple first made love in 1947.

"I would suggest you think very carefully about this novel Pasternak is passing around to people at the moment — at a time when we have quite enough malcontents and enemies as it is," said Abakumov. "You are aware of the anti-Soviet nature of the novel?"

Ivinskaya protested and began to describe the completed part of the novel before she was interrupted.

"You will have plenty of time to think about these questions and how to answer them. But personally I would like you to appreciate that we know everything, and that your own as well as Pasternak's fate will depend on how truthful you are. I hope that next time we meet you will have nothing to conceal about Pasternak's anti-Soviet views."

Abakumov then looked to the guard. "Take her away."

The subsequent questioning was led by a much more junior official, Anatoli Semyonov, who, like his boss, did not employ physical violence with Ivinskaya. He charged that Ivinskaya was planning to escape abroad together with her lover. He said Pasternak was a British spy, had Anglophile attitudes, and repeatedly used the analogy that Pasternak had sat at the table with the British and Americans "but ate Russian bacon." For his

inquisitors, the fact that Pasternak had family in England and had held several meetings with the British diplomat Isaiah Berlin in 1946 was evidence enough of his disloyalty. Interrogation now became a nightly ordeal, until it went on so many weeks, it became routine, "quite humdrum."

"How would you characterize Pasternak's political sentiments? What do you know about his hostile work, his pro-English sentiments, his intention to commit treason?"

"He does not belong to the category of people with anti-Soviet sentiments. He did not have any intention to commit treason. He always loved his country."

"But in your home we confiscated a book of Pasternak's works in English. How did it get there?"

"That book I got from Pasternak, that's true. It is a monograph on his father, the painter, that was published in London."

"How did Pasternak get it?"

"Simonov [the acclaimed war poet and editor of *Novy Mir*] brought it to him from a trip abroad."

"What more do you know about Pasternak's ties with England?"

"I think he once got a parcel from his sisters, who are living there."

"What sparked your relationship with Pasternak? He is, after all, a lot older than you."

"Love."

"No, you were joined together by your shared political views and treasonous intentions."

"We never had such intentions. I loved and love him as a man."

Ivinskaya was also accused of speaking ill of Surkov, although the transcript — which no doubt bowdlerized some of the language and threats of the KGB official — misspelled the loyal poet's name.

"Facts testified to by witnesses show that you systematically praised the works of Pasternak and contrasted it with the work of patriotic writers such as Surikov and Simonov, whereas the artistic methods of Pasternak in depicting Soviet reality are wrong."

"It is true that I speak highly of him, and hold him up as an example to all Soviet writers. His work is a great asset to Soviet literature, and his artistic methods are not wrong but just subjective."

"You suggested that Surikov does not have any literary skills and that his poetry is merely printed because it is in praise of the party."

"Yes, I think those mediocre poems compromise the idea. But Simonov I always considered a talented man."

Ivinskaya was told to write a summary of *Doctor Zhivago*, and when she began to describe it as the life of a physician and intellectual in the years between the revolutions of 1905 and 1917, her interrogator scoffed. "You must simply say that you have actually read this work and that it constitutes a slander on Soviet life." At one point, Semyonov expressed bewilderment at the poem "Mary Magdalene" and the possibility that it might refer to Ivinskaya. "What era does it refer to? And why have you never told Pasternak that you're a Soviet woman, not a Mary Magdalene, and that it's

simply not right to give such a title to a poem about a woman he loves?" On another night, he questioned the romance itself. "What have you got in common? I can't believe that a Russian woman like you could ever really be in love with this old Jew." When one session was interrupted by some loud clanging in the distance, Semyonov smiled: "Hear that? It's Pasternak trying to get in here! Don't worry, he'll make it before long."

When Pasternak learned of Ivinskaya's arrest, he called a mutual friend, who found him sitting on a bench near the Palace of Soviets Metro station. He was crying. "Everything is finished now. They've taken her away from me and I'll never see her again. It's like death, even worse."

Several weeks into her detention, Ivinskaya said, it became obvious to her jailors that she was pregnant. Her treatment improved marginally. She was allowed to sleep longer, and salad and bread were added to her diet of porridge. The exhausting interrogations continued but to little avail for Semyonov — Ivinskaya did not break and refused to sign anything that would condemn Pasternak.

She probably became pregnant in late summer, when the couple reconciled after a long break. Pasternak wrote about the moment in the poem "Autumn":

You fling off your dress
As a coppice sheds its leaves.
In a dressing gown with a silk tassel
You fall into my arms.

(Akhmatova railed at these love poems: "About the gown with the tassels, how she falls in his arms, that's about Olga, I can't stand it. At 60, one should not write about these things.")

Ivinskaya was eventually told to prepare to meet her lover. She was torn between the fear that he was being abused in some nearby cell and joy that she might be able to exchange a few words with him, perhaps even embrace him. Ivinskaya was signed out of the Lubyanka, placed in a wagon with blacked-out windows, and driven to another secret-police facility just outside the city. She was led down into a basement, where she was abruptly pushed through a metal door that shut loudly behind her. It was hard to see. The smell was odd. Beneath her feet water pooled on the whitewashed floors. As Ivinskaya's eyes adjusted to the semidarkness she saw bodies on a series of tables, each covered with gray tarpaulin. "There was the unmistakable sweetish smell of a morgue. Could it be that one of these corpses was the man I loved?"

Ivinskaya was left locked inside the prison morgue for some time, but the effort to terrorize, or reduce her to some state of despair, failed. "I suddenly felt completely calm. For some reason, as though God had put it in my mind, it dawned on me that the whole thing was a monstrous hoax, and that Borya could not possibly be here."

Trembling from the cold damp of the morgue, she was led back to her interrogator. "Please forgive us," said Semyonov. "We made a mistake and took you to

the wrong place altogether. It was the fault of the escort guards. But now prepare yourself: We are waiting for you."

Ivinskaya was next subjected to a ritual of Soviet interrogation: a staged confrontation with a witness who had been primed, almost certainly after torture, to offer evidence of her treachery. The man brought into the room was Sergei Nikiforov, her daughter Irina's elderly English teacher. Nikiforov had been arrested shortly before Ivinskaya. He looked vacant and unkempt.

"Do you confirm the evidence you gave yesterday that you were present at anti-Soviet conversations between Pasternak and Ivinskaya?"

"Yes, I do. I was present," Nikiforov said.

Ivinskaya started to object but was told to shut up.

"Now you told us that Ivinskaya informed you of her plan to escape abroad together with Pasternak, and that they tried to persuade an airman to take them out of the country in a plane. Do you confirm this?"

"Yes, that is so."

"Aren't you ashamed, Sergei Nikolayevich?" shouted Ivinskaya.

"But you've confirmed it all yourself, Olga Vsevolodovna," he replied.

It was clear then to Ivinskaya that Nikiforov had been induced to provide false evidence after he was told that she had already confessed. Years later, Nikiforov wrote to Ivinskaya: "I have pondered for a long time whether to write to you. In the end, the conscience of an honest man . . . prompts me to account for the

situation in which I put you — believe me, against my will, given the conditions then existing. I know that these conditions were familiar to you, and that to some extent they were experienced by you as well. But they were of course applied to us men more forcefully and severely than to women. Before our meeting at that time, I had repudiated two documents, even though I had signed them. But how many people are able to go boldly, and uprightly, to the scaffold. Unfortunately, I do not belong to their number, because I am not alone. I had to think of my wife and shield her."

Ivinskaya was driven back to the Lubyanka in what she described as a state of nervous shock after the gruesome theater of the morgue and the draining confrontation with Nikiforov. She said she was suddenly racked with pain and taken to the prison hospital. She was in her fifth month. "Here Borya's and my child perished before it even had a chance to be born."

Ivinskaya said that her family had learned of her pregnancy from a cellmate who was released, and they, in turn, had told Pasternak. Word of the miscarriage, however, did not immediately reach them. In the spring of 1950, Pasternak was told to report to the prison by the secret police and he expected to be handed the baby.

"I have told [Zinaida] that we must take it in and care for it until Olya comes back," he told a friend, adding that his wife made "a terrible scene."

At the Lubyanka, Pasternak was given a bundle of books and letters. He at first refused to accept them

and wrote a letter of protest to Abakumov. It did no good. On July 5, 1950, Ivinskaya was sentenced to five years in a hard-labor camp "for close contact with persons suspected of espionage."

CHAPTER
FIVE

"Until it is finished, I am a fantastically, manically unfree man."

In October 1952, Pasternak suffered a serious heart attack and was rushed to Moscow's Botkin Hospital, where he spent his first night "with a miscellany of mortals at death's door." As he drifted in and out of consciousness, lying on a gurney in a corridor because the hospital was so crowded, he said, he whispered: "Lord, I thank you for having laid on the paints so thickly and for having made life and death the same as your language — majestic and musical, for having made me a creative artist, for having made creative work your school, and for having prepared me all my life for this night."

Death had brushed very close, and Pasternak, who was treated by some of the city's best cardiologists, spent a week in the emergency department and another two and a half months in a general ward. Before the hospitalization, Pasternak suffered constantly from toothache and boils on his gums. His heart condition was discovered when he fainted while coming home from the dentist. He also had dental surgery while in the hospital, and his uneven equine teeth were replaced

with a gleaming set of American dentures, which, Akhmatova said, gave him a new "distinguished" look.

His doctors warned him to be careful. His heart problems had begun two years earlier, after Ivinskaya's arrest and his visit to the Lubyanka. As with so much else, he explored his condition through Yuri Zhivago, who was bestowed with similar cardiac problems: "It's the disease of our time. I think its causes are of a moral order. A constant, systematic dissembling is required of the vast majority of us. It's impossible, without its affecting your health, to show yourself day after day contrary to what you feel, to lay yourself out for what you don't love, to rejoice over what brings you misfortune . . . Our soul takes up room in space and sits inside us like the teeth in our mouth. It cannot be endlessly violated with impunity."

Ivinskaya had been sent by train to Mordovia, about three hundred miles southeast of Moscow, sleeping on a luggage rack above the crush of prisoners. The rural camp was reached after a forced march from the train station. Prison life alternated between long, buggy summer days digging fields with a pick and the bitter cold of winter in bare barracks. Only immediate family were allowed to write to prisoners, so Pasternak, in his distinctive flowing script, sent postcards under the name of Ivinskaya's mother: "May 31, 1951. My dear Olya, my joy! You are quite right to be cross at us. Our letters to you should pour straight from the heart in floods of tenderness and sorrow. But it is not always possible to give way to this most natural impulse.

103

Everything must be tempered with caution and concern. B. saw you in a dream the other day dressed in something long and white. He kept getting into all kinds of awkward situations but every time you appeared at his right side, light-hearted and encouraging . . . God be with you, my darling. It is all like a dream. I kiss you endless times. Your Mama."

With Ivinskaya away, Pasternak continued to support her family, making arrangements for her mother to get direct payments from one publisher for his work. "Without him my children would not have survived," said Ivinskaya.

Pasternak alternated between paid translation commissions and *Doctor Zhivago*. "I am burying myself in work," he told his cousin. He had little expectation that his novel would be published. "When they print it, in ten months or fifty years, is unknown to me and just as immaterial."

Friends continued to encourage him. Lydia Chukovskaya wrote to him in August 1952 after reading Part 3: "Already for a day I don't eat, sleep, exist, I am reading the novel. From beginning to end, and again from the end, and in parts . . . I read your novel like a letter addressed to me. I feel like carrying it in my bag all the time so that at any moment I can take it out, convince myself it is still there, and reread my favorite passages."

Pasternak continued to read *Doctor Zhivago* to small groups, but his life was now largely confined to Peredelkino in summer, his apartment in Moscow in winter, and a small circle of trusted friends and young

writers. At the dacha he read in his upstairs study to groups of up to twenty guests for a couple of hours on Sundays, and the gatherings formed an alternative to the events at the Union of Soviet Writers. Often attending were Boris Livanov, the great actor from the Moscow Art Theatre Company, and the young poet Andrei Voznesensky, slouching in his chair. The pianist Svyatoslav Richter, his eyes half-closed in contemplation, and his life partner, the soprano Nina Dorliak, were also regulars.

On some weekends, Yuri Krotkov was present. Krotkov, a playwright, had a room in the nearby House of Creative Artists in Peredelkino. He was a familiar face among some diplomats and journalists in the city. A card player, he had endeared himself to Zinaida, earning a seat at her table. He was also a KGB informer who had been involved in a number of stings, including setting up the French ambassador in a "honey-trap" operation with a Russian actress.

When the reading was over, everyone carried their chairs and stools back downstairs and crowded around the feast Zinaida had prepared: often wine and vodka and kvass, a homemade fermented drink, with caviar, marinated herring, and pickles, sometimes followed by a stew made of game. Pasternak sat at the head of the table, Livanov at the other end, a hint of rivalry in their exchanges, both players to the boisterous crowd.

"I have a question for Slava!" said Pasternak, looking at Richter. "Slava! Tell me, does art exist?"

"Let's drink to poetry!" shouted Livanov.

Some reactions to the novel continued to be mixed, but Pasternak was unshaken. "Of those who have read my novel the majority are dissatisfied. They say it is a failure, and they expected more from me, that it is colorless, that it is not worthy of me, but I, acknowledging all this, just grin as though this abuse and condemnation were praise."

The anti-Semitic character of the long campaign against "cosmopolitans" became hysterical and brutal in 1952 and 1953. All of the Soviet Union's leading Yiddish writers were shot in August 1952 after a secret trial on treason charges. In January 1953, *Pravda* announced a "Doctors' Plot" in which Jewish physicians were accused of the medical murder of prominent figures, including Zhdanov. The persecutor of Akhmatova and Zoshchenko had died in August 1948 from a heart attack brought on by his prodigious drinking. But his death was characterized as part of an American-Zionist conspiracy. Among those caught up in the purge and savagely tortured was Dr. Miron Vovsi, the former surgeon general of the Red Army and one of the cardiologists who had recently helped to save Pasternak. Vovsi confessed to being the inspiration for a terrorist group of Kremlin doctors. Prominent Jewish cultural figures, including the journalist Vasili Grossman and the violinist David Oistrakh, were forced to sign an appeal to Stalin asking him to resettle all Jews in the East to protect them from the "wrath of the people."

Pasternak was probably saved from the danger of refusing to sign this petition by his heart attack. After

his release from the hospital he went to a sanatorium in Bolshevo, just northeast of the city, to continue his recovery and write. "I am now happy and free, in good health and cheerful spirits, and it is with a light heart that I sit down to work on Zhivago, that although of no use to anyone is an integral part of me." Pasternak was in Bolshevo on March 5, 1953, when Stalin's death was announced. Zinaida, who once said her sons loved Stalin before their mother, reacted like many Soviet citizens and mourned his death. She suggested Pasternak write a memorial poem. He refused, telling her that Stalin was the killer of the intelligentsia and drenched in blood.

On March 27, in the wake of Stalin's death, the new leadership announced a broad amnesty for prisoners, including women with children and those sentenced to five years or less. Ivinskaya, thinner and ruddily tanned from long days in the fields, returned to Moscow. Pasternak initially had qualms about rekindling the affair. Zinaida had nursed him back to health and he felt he owed her his life. He also was unable to tell Ivinskaya the relationship was over, and he blundered about like a child. He arranged to meet Ivinskaya's daughter Irina before her mother reached the capital. He asked the fifteen-year-old to tell her mother that while he still loved Olga, the relationship could not continue. Thinking it ridiculous that she should be his messenger, Irina said nothing to her mother. For Ivinskaya, informed of the conversation only years later, it revealed a "mixture of candor, guileless charm, and

undeniable heartlessness." Her lover could be gauche and cruel.

The dacha in Peredelkino was winterized in 1953 and "turned into a palace" with a gas supply, running water, a bath, and three new rooms. Pasternak said he was ashamed of the grandeur of his large study and its parquet floor. His father's drawings were hung on the pink-washed walls, including some original illustrations for Tolstoy's *Resurrection*. He started to live year-round in the village, the wish of his doctors, who wanted him in more restful surroundings than Moscow. Pasternak kept some emotional distance from Ivinskaya for several months after her return to Moscow. But the affair had resumed by 1954, and that summer she was a frequent visitor to the village, especially when Zinaida and Leonid went on vacation to Yalta on the Black Sea. Ivinskaya became pregnant again, but in August, after a very bumpy ride in a small truck, she was taken ill. The child was stillborn in the ambulance on the way to the hospital. The following summer, in 1955, Ivinskaya rented part of a dacha on Izmalkovo Pond, across a wooden footbridge from Peredelkino. She put a large bed in a glassed-in veranda and some dark-blue chintz curtains to create some privacy. When summer ended Ivinskaya rented an insulated room in a nearby house so she could be near Pasternak year-round. He commuted between his wife in what he called the "Big House" and his lover's pad — a ritual of lunch and lazy afternoons with Ivinskaya before returning home for dinner. Mornings were reserved for writing.

Ivinskaya now began to act as Pasternak's agent, managing his affairs in Moscow so he rarely had to go into the city. The role brought renewed questions about Ivinskaya's trustworthiness, allegations that, in various forms, would continue to shadow her. Lydia Chukovskaya said she ended her friendship with Olga in 1949 because of "her debauchery, irresponsibility, her inability to do any sort of work, her greed that generates lies." After Ivinskaya's release, Chukovskaya nonetheless said she entrusted her with cash to buy and mail a monthly package of food, clothes, and books to Nadezhda Adolf-Nadezhdina, a mutual friend who was still held in a camp. Chukovskaya said Ivinskaya insisted on assuming responsibility for the mailings because of Lydia's heart condition; it was necessary to travel to a post office outside of Moscow to mail a package to the camps. No goods ever reached Nadezhdina, and Chukovskaya accused Ivinskaya of the unforgivable theft of gifts intended to help keep an inmate alive. Chukovskaya told Akhmatova and others about the betrayal, but said she never told Pasternak because she didn't want to upset him. "I've never heard of such a thing even among gangsters," said Akhmatova. Nadezhdina, however, strongly objected to Chukovskaya's account when she later read it, and said there was no proof that Ivinskaya stole gifts intended for her and there were other plausible explanations why she might not have received the packages.

Ivinskaya later wrote, "It pains me to think that even Lydia Chukovskaya took one of these slanders at its

109

face value," but she said she followed Pasternak's advice to ignore "filthy insinuations."

"Those who know you will never believe you capable of theft or murder, or whatever it is," she wrote. "If some slander is going the rounds, say nothing . . . And so I simply kept my peace."

The charge nonetheless deeply colored the attitude of some of Pasternak's closest friends toward Ivinskaya. And it led some to believe that Ivinskaya, already seen as demanding and manipulative, was capable of any kind of treachery, including selling out Pasternak himself.

There is some evidence she was not always faithful to him. Varlam Shalamov, a Gulag survivor and one of Pasternak's most ardent admirers, wrote a pair of passionate letters to Ivinskaya in 1956 and seemed to believe they had a future together. Shalamov, who spent sixteen years in the camps and was not allowed to live in Moscow when he was released in 1953, apparently did not know of Ivinskaya's relationship with Pasternak. He later recalled the whole episode as a "painful moral trauma."

"For Mrs. Ivinskaya, Pasternak was just the subject of the most cynical trade, a sale, which Pasternak of course knew," wrote Shalamov in a letter to Nadezhda Mandelstam. "Pasternak was her bet, a bet she used when she could."

Stalin's death led to some searing criticism of the ideological straitjacket suffocating artists and created the expectation of greater imaginative freedom. In the

summer of 1953, the editor of *Novy Mir*, Alexander Tvardovsky, published a provocative poem that dwelled on the sad state of writing:

And everything looks real enough, everything resembles
That which is or which could be
But as a whole it is so indigestible
That you want to howl out in pain.

In the October issue of *Znamya*, Ilya Ehrenburg wrote a piece, "Concerning the Writer's Work," and argued that "a writer is not an apparatus mechanically recording events" but writes "to tell people something he personally feels, because he has 'begun to ache' from his book." There were calls for "sincerity" in literature. Shouting over the fence at Chukovsky that month, Pasternak declared, "A new age is beginning: they want to publish *me*!"

In early 1954, Pasternak's translation of *Hamlet* was performed at the Pushkin Theatre in Leningrad. In April, *Znamya* published ten poems from the set planned for the end of *Doctor Zhivago* — the first publication of original material by Pasternak since the war. The more religious verse from among the poems was excluded, but Pasternak was allowed to write an introductory note describing *Doctor Zhivago*: "It is anticipated that the novel will be completed by the summer. It covers the period from 1903 to 1929, with an epilogue relating to the Great Patriotic War. Its hero, Yuri Andreyevich Zhivago, a doctor, a thinker, a seeker after truth with a creative and artistic cast of mind, dies

111

in 1929. After his death there remain his notebooks and, among other papers written in his youth, poems in finished form, part of which are presented here and which, taken all together, form the last, concluding chapter of the novel."

Pasternak was elated: "The words 'Doctor Zhivago' have made their appearance on a contemporary page — like a hideous blot!" He told his cousin that "I have to and want to finish the novel, and until it is finished I am a fantastically, manically unfree man."

The guardians of ideological rigidity may have been staggered by the changes, but they were not in retreat. As new, unsettling fiction and poetry began to appear, Surkov took to the pages of *Pravda* to warn against such experiments and instruct writers where their duty lay. "The party has always reminded Soviet writers that the strength of literature lies in intimacy with the life of the people, from which it cannot be estranged . . . We have fought against succumbing to literary influences that are not ours, or are no longer ours — against bourgeois nationalism, against great power chauvinism, against the anti-patriotic activity of the cosmopolitans." The following month, another conservative critic singled out Pasternak's poem "The Wedding Party" as representative of this pervasive and false sincerity. Others continued to act as if Pasternak were irrelevant. Boris Polevoi, the head of the foreign branch of the Union of Soviet Writers, said on a visit to New York that he had never heard of any novel by Pasternak. And an accompanying Soviet journalist said Pasternak was

unable to finish the novel because he had become "rich and indolent" from translation work.

Pasternak spent much of the winter of 1954 in Peredelkino working intensively on the novel's last chapters. His study looked out on the garden and across a broad meadow to the small church that the poet occasionally attended. He wrote in a room with a cot, a wardrobe, two desks, including one to stand at, and a narrow, dark-stained bookshelf that included a large Russian-English dictionary and a Russian Bible among a small collection of books. "I personally do not keep heirlooms, archives, collections of any kind, including books and furniture. I do not save letters or draft copies of my work. Nothing piles up in my room; it is easier to clean than a hotel room. My life resembles a student's."

He was a man of routine. He rose early and washed outside at a pump, even on harsh winter mornings, steam rising off his face and chest. When he was younger he regularly bathed in the river, and he still dipped his head in its waters when the ice broke in the spring. Each day, he liked a long, briskly taken walk, and he always took candy for children he might meet around the village.

Pasternak wrote in his upstairs study, and Zinaida was protective of his privacy, refusing to allow visitors to disturb him. She was particularly watchful that winter, having learned that her husband had rekindled relations with Ivinskaya. Akhmatova described Pasternak as half ill, half detained and noted that Zinaida was

rude to him. A visitor described "her lips pursed in an injured Cupid's bow." Pasternak himself was occasionally irritated by distractions from his rush to get *Zhivago* finished. He reluctantly translated the speech of the German poet Bertolt Brecht, who was in Moscow to receive the Stalin Prize, but when the Union of Soviet Writers suggested he translate some of Brecht's poems he was openly irritated: "Surely Brecht realizes that engaging in translations is a disgrace. I am busy with important work, for which the time has not yet come — unlike Brecht's old junk." He refused to go into Moscow for the reception for the visiting German.

Through the summer of 1955, Pasternak continued to edit the manuscript as it neared completion. After reading a newly typed version, he said that several "heavy and complicated passages will have to be simplified and lightened." Even amid the relative relaxation of the "thaw," he was not optimistic about publication. As Pasternak and Ivinskaya walked over the footbridge across Izmalkovo Pond one evening that fall, he said: "You mark my words — they will not publish this novel for anything in the world. I don't believe they will ever publish it. I have come to the conclusion that I should pass it around to be read by all and sundry."

A final revision took place in November, and on December 10, 1955, he said the novel was complete: "You cannot imagine what I have achieved! I have found and given names to all this sorcery that has been the cause of suffering, bafflement, amazement, and dispute for several decades. Everything is named in

simple, transparent, and sad words. I also once again renewed and redefined the dearest and most important things: land and sky, great passion, creative spirit, life and death."

CHAPTER
SIX

"Not to publish a novel like this would
constitute a crime against culture."

The publisher Giangiacomo Feltrinelli was an unlikely
Communist. His entrepreneurial ancestors, stretching
back to the mid-nineteenth century, had over several
generations built a great fortune. These businessmen,
with multinational interests across numerous sectors,
had made Feltrinelli one of those names — like Agnelli,
Motta, and Pirelli — synonymous with the industrial
development of northern Italy. Feltrinelli was born on
June 19, 1926, into a cocooned life of nannies and
tutors that shifted, depending on the season, between
various villas and hotels — Lake Como, Lake Garda,
the Baur au Lac in Zurich, and the Excelsior at the
Venice Lido. The family, much like some of Italy's other
great industrial concerns, coexisted — sometimes
uneasily, sometimes profitably — with Mussolini's
Fascist government, which had come to power in 1922.
Feltrinelli's father, Carlo, died in 1935 of a heart attack
while in the middle of a financial dispute with the
regime over assets held abroad by his mother. He was
fifty-four. The parenting of Giangiacomo and his sister
Antonella now fell to his mother, Giannalisa, insofar as
she devoted time to it. She "would punish and then

116

repent. She would mortify and then shower them with kisses and hugs." Feltrinelli was enrolled by his mother in the Gioventù Italiana del Littorio, the Italian Fascist youth movement. A substantial check from Giannalisa also induced Mussolini to bestow the title Marquess of Gargnano on the boy.

Feltrinelli later described himself as a teenage mass of contradictions, urging on the Fascist armies but also opposing the Germans while listening to Radio London, as some called the BBC World Service during the war. Ignored at home, he befriended the workers and farmhands who took care of his mother's property, and they opened up a previously invisible world of hard labor and injustice. The allied bombing raids and the arrival of the Germans in Italy to prop up Mussolini added to the radicalization of a young man who was searching for a set of ideas to cling to.

Feltrinelli was a man of great enthusiasms, whether for politics or literature. He didn't hold his loyalties and ideas lightly, but when they clashed, as they would over *Doctor Zhivago*, he followed his conscience, not a party line. A friend said his passion was easily aroused and he was devoted to his principles, "but he was just as prepared to abandon a cause, without standing on ceremony, if he felt it was outdated or did not serve his way of thinking." By 1944, after the liberation of Rome, and still only eighteen, Feltrinelli was reading *The Communist Manifesto* and Lenin's *State and Revolution*. That November, he enlisted with the Legnano combat unit which fought with the American Fifth Army, and he saw some action near Bologna.

Feltrinelli joined the Communist Party in March 1945. His mother, a royalist, was appalled. When Italy held a referendum in June 1946 on whether to keep the monarchy or adopt a republican form of government, Giannalisa Feltrinelli handed out leaflets in support of the House of Savoy in the streets of Rome — through the window of her Rolls-Royce. Feltrinelli had already skipped town after intelligence he gathered about pro-royalty meetings in his mother's home ended up in the pages of *L'Unità*, the Communist newspaper. To wit: "On the basis of information received from an excellent source we are able to provide news of an important meeting held in the home of a family of big industrial sharks, the Feltrinellis."

Between the fall of Mussolini (who briefly commandeered the Villa Feltrinelli on Lake Garda, where he was surrounded by a protective guard of crack Nazi troops) and the first postwar election, the Italian Communist Party was transformed from a small underground organization of fewer than 10,000 activists to a mass movement of 1.7 million members. The party benefited, above all, from its vanguard role in the Resistance, where two-thirds of all partisan bands were inspired by communism. After the war, under the leadership of the pragmatic Palmiro Togliatti, the party advocated "progressive democracy" and appeared more anti-Fascist than anti-capitalist. The Communists seemed open to innovation in the arts, literature, and the social sciences. They were allied with or controlled some of the most progressive forces in the country, from the feminist Unione Donne Italiane to the

Movement for the Rebirth of the South to the Union for Popular Sport. The party had a glamorous air. And it attracted a couple of generations of intellectuals and idealists — those who had survived the long years of fascism and young people such as Feltrinelli who were seeking a political movement to champion their desire for social change. The party was the natural home for what the writer Italo Calvino called the "little big world" of anti-Fascists, that passionate, postwar swell of believers who yearned for a new Italy. Feltrinelli was a disciplined and earnest young recruit. "I learned to control, at least in part, my impulsiveness and my impetuosity; I learned method in debate, in the work of persuasion and clarification that I had to carry out among the comrades."

At the age of twenty-one, Feltrinelli came into his inheritance, including substantial holdings in construction, lumber, and banking, and he became a significant financial supporter of the Italian Communist Party. One activist recalled, "We had dreams . . . Giangiacomo could make them come true, and it seemed miraculous to have him on our side." The house at Lake Garda was used as a summer camp for young party members. Feltrinelli drove around in his smoky-blue Buick convertible to put up party posters. At home with his new wife — dubbed the "Muscovite Pasionaria" by her mother-in-law — he hung a portrait of Stalin among the old masters on the wall.

In the late 1940s, Feltrinelli began his formal entry into the world of books. He and Giuseppe Del Bo, a Marxist academic and writer, began to create a library

119

devoted to a history of the working classes and social movements. The Italian police called it a "little university of Marxism," but with Feltrinelli's wealth and his passion for the pursuit of rare books and materials across Europe, it became a treasure house holding tens of thousands of pieces of radical literature — a first edition of *The Communist Manifesto*, original working notes of both Marx and Engels, a first edition of Jean-Jacques Rousseau's *Social Contract*, Victor Hugo's letters to Garibaldi, and a rare copy of Thomas More's *Utopia*. The collection brought Feltrinelli to the attention of the Soviet Union. In 1953, he was invited to Moscow to discuss cooperation between the Biblioteca Giangiacomo Feltrinelli in Milan and the Institute of Marxism-Leninism. Little came of the meeting; it would be his only visit to Moscow.

Feltrinelli also ran his businesses, proving himself an able, sometimes hard-nosed, manager and capitalist. The party drew on his financial acumen as well as his cash. In 1950, Feltrinelli became involved in a publishing house tied to the Communist Party and brought some management systems and financial controls to the floundering entity. Eventually, in 1955, the house was dissolved, and it gave way to a new business, Feltrinelli Editore.

The twenty-nine-year-old was now an independent Milanese publisher, and he looked the part: hair already slightly receding, a wingspan moustache, dark horn-rimmed glasses, and an arched, feline quality to his face. He was nicknamed "the Jaguar." Feltrinelli Editore's first two books came off the presses in June 1955 — *An Autobiography: Jawaharlal Nehru* and *The*

Scourge of the Swastika by Lord Russell of Liverpool. The publisher wanted books that were fresh, progressive, dissonant, and influential. He wanted intellectual excitement, discoveries.

On February 25, 1956, at a secret session of the Twentieth Congress of the Soviet Union, Khrushchev launched an astonishing and devastating attack on Stalin entitled "On the Cult of Personality and Its Consequences." He said the former, hallowed Leader was guilty of the gravest abuse of power, and that during Stalin's rule "mass arrests and deportation of thousands and thousands of people, executions without trial or normal investigations, created insecurity, fear and desperation." Khrushchev spoke of torture, even of former members of the Politburo. He said Lenin wanted to fire Stalin as general secretary of the party. He said Stalin was confused and essentially missing in action when the Nazis invaded. The delegates in the Great Hall of the Kremlin sat in stupefied silence.

The CIA, which obtained a copy of what became known as the "Secret Speech," leaked it to *The New York Times*. For all the shock among many Communists worldwide, there was also a desire for renewal, as if the movement had passed from one age into another. The sense of change was short-lived; it would die with the Soviet invasion of Hungary. But it was in this brief clearing that Feltrinelli received *Doctor Zhivago*. Cooperation with Soviet writers and publishers seemed particularly opportune now that reform was gusting through the Kremlin. Feltrinelli had no sense

yet that his possession of the novel would infuriate the Soviet leadership.

The week after he left Pasternak's dacha in Peredelkino in May 1956, D'Angelo flew to Berlin. He wasn't searched as he left Moscow, probably because he was a fraternal comrade, and he also had no thought that there was anything untoward about carrying the novel out. He landed in Berlin, a city not yet divided by the wall, and went from Schönefeld Airport in the East to a hotel just off West Berlin's showcase shopping avenue, the Kurfürstendamm. D'Angelo called Milan, and Feltrinelli decided to fly to Berlin himself to pick up the manuscript. It was passed the following day from one suitcase to another at a small hotel on Joachimstaler Strasse. *Doctor Zhivago* had found a publisher.

Feltrinelli didn't read Russian, so after he returned from Berlin with the manuscript, he sent it to Pietro Zveteremich, an Italian Slavist, for review. Judgment was swift: "Not to publish a novel like this would constitute a crime against culture."

Pasternak seemed quite pleased with himself after giving the book to D'Angelo, but he also realized that those close to him might think him reckless. When he informed his stepson and daughter-in-law that Sunday in May, Pasternak asked them not to tell his wife. At a dinner with friends that week, Pasternak brought up the subject anyway. "What kind of nonsense is that?" scoffed Zinaida. The table fell silent.

Ivinskaya was in Moscow when Pasternak met with D'Angelo, and returned to Peredelkino only later that evening. Pasternak met her on the road near his dacha, and told her he had had a visit from two charming young people, an Italian Communist and an official in the Soviet embassy in Rome. D'Angelo's companion was no diplomat, and Pasternak was dissembling to cushion the fact that he had handed over his manuscript to strangers, one of them a foreigner. Ivinskaya was furious; she realized that no post-Stalinist glow would shield a writer who defied the system by consorting with Westerners.

Ivinskaya was returning from negotiations with the state publishing house on a one-volume collection of poetry, which was being overseen by a sympathetic young editor, Nikolai Bannikov. "This may put an end to the poetry volume!" she shouted. She was also afraid for her own safety. "I've been in prison once, remember, and already then, in the Lubyanka, they questioned me endlessly about what the novel would say . . . I'm really amazed you could do this."

Pasternak was a little sheepish, but unapologetic. "Really, now, Olya, you're overstating things, it's nothing at all. Just let them read it. If they like it, let them do what they want with it — I said I didn't mind." To assuage his lover, Pasternak said Ivinskaya could try to get it back from the Italian if she was so upset. Or perhaps, he suggested, she could sound out any official reaction to what he had done.

Ivinskaya turned on her heels and went back to Moscow to see Bannikov. The poetry editor was

familiar with the novel. The manuscript had been gathering dust at the state publishing house for several months, and Pasternak had referred to it in the introductory essay for his collections of poems: "Quite recently I have completed my main and most important work, the only one of which I am not ashamed and for which I answer without a qualm — a novel in prose with additions in verse, *Doctor Zhivago*. The poems assembled in this book, which are scattered across all the years of my life, constitute preparatory stages to the novel. Indeed, I view their republication as a preparation for the novel."

The state publisher had been notably silent about Pasternak's manuscript — almost certainly because the senior editors viewed the novel as objectionable. Bannikov was frightened by Ivinskaya's news. After she left, he wrote her a note, which was delivered to her apartment on Potapov Street: "How can anyone love his country so little? One may have one's differences with it, but what he has done is treachery — how can he fail to understand what he is bringing on himself and us as well?"

Feltrinelli moved quickly to secure his rights. In mid-June, he wrote to Pasternak to thank him for the opportunity to publish *Doctor Zhivago*, which he described as a work of enormous literary importance. He then got down to business, discussing royalties and foreign rights. Feltrinelli had a trusted courier hand-deliver the letter and two copies of an enclosed contract. If Pasternak had any real desire to get the

novel back, this was the moment. But he had no second thoughts. A couple of weeks after meeting D'Angelo, Pasternak was visited by the Italian scholar Ettore Lo Gatto and told him he was willing to face "any kind of trouble" as long as the novel was published. After consulting with his sons, Pasternak decided to sign the contract with Feltrinelli. In a letter to the publisher at the end of June, Pasternak told him that, while he wasn't completely uninterested in money, he realized that geography and politics could make it impossible to receive his royalties. The writer made Feltrinelli aware of the risks to Pasternak of first publication in the West but did not bar him from bringing the novel out: "If its publication here, promised by several of our magazines, were to be delayed and your version were to come before it, I would find myself in a tragically difficult situation. But this is not your concern. In the name of God, feel free to go with the translation and the printing of the book, and good luck! Ideas are not born to be hidden or smothered at birth, but to be communicated to others."

The Kremlin leadership quickly learned about Pasternak's contact with Feltrinelli. On August 24, 1956, KGB general Ivan Serov, the head of the secret police and a longtime enforcer of the Kremlin's will, including in Eastern Europe, wrote to the Politburo, the country's small ruling group. The Politburo, led by the general secretary, Nikita Khrushchev, oversaw the Central Committee of the Communist Party of the Soviet Union and its various departments, including culture. In a long memo, Serov informed the

Communist leadership of the manuscript's delivery to Feltrinelli and how Pasternak had requested the rights be assigned to publishers in England and France. After noting that permission to publish *Doctor Zhivago* in the Soviet Union had not been granted, Serov quoted from a note Pasternak had recently mailed with an essay to a French journalist, Daniil Reznikov, in Paris. The parcel was intercepted by the KGB: "I realize perfectly well that [the novel] cannot be published now, and that this is how it is going to be for some time, perhaps forever," Pasternak wrote. Noting the likelihood of foreign publication, Pasternak continued: "Now they will tear me limb from limb: I have this foreboding, and you shall be a distant and sorrowful witness to this event." Pasternak, however, seemed willing to countenance even more danger: He included a biographical essay that he had written for the state literary publishing house, which was planning to bring out a collection of his poems. Pasternak told Reznikov, who had visited him earlier in the year, to do as he wished with the essay.

Serov noted that Pasternak was a Jew and did not have a party card, and said his work was typified by "estrangement from Soviet life."

A week later, the Central Committee's culture department prepared a detailed report on *Doctor Zhivago* for the leadership with a series of tendentious but damning quotations from the novel. The book was described as a hostile attack on the October Revolution and a malicious libel of the Bolshevik revolutionaries by an author who was labeled a "bourgeois individualist."

126

Publication of this novel is impossible, the report concluded. In an accompanying note, the deputy foreign minister of the Soviet Union said officials would use their contacts with the Italian Communist Party to prevent publication abroad. Feltrinelli, after all, was a Communist.

It is unclear exactly how the KGB learned the details of Pasternak's communications with Feltrinelli, including his wish to assign the rights to English and French publishers. That fact must have come directly from an account of Pasternak's meeting with D'Angelo. Both the Italian scout and his companion, Vladimirsky, talked openly at their workplace in Radio Moscow about getting the manuscript and delivering it to Feltrinelli.

Ivinskaya's contacts with various editors about Pasternak's involvement with an Italian publisher and how to salvage the situation also raised an alarm within the system. A senior editor at the state literary publishing house told her that she would show the novel to Vyacheslav Molotov, a senior Politburo member, and seek his advice on how to proceed. The editor of *Znamya*, the magazine that had published some of Pasternak's *Zhivago* poems, said he would inform an official at the Central Committee.

For the next two years, Ivinskaya became the authorities' favored conduit to the writer. It was a difficult and controversial role. The author's well-being, Ivinskaya's fears for her own safety, and the state's interests were tangled up in her sometimes-frantic mediation efforts. "She relieves me from the vexing

negotiations with the authorities, she takes the blows of such conflicts on herself," Pasternak told his sister. She was his chosen emissary, but her contacts with the bureaucrats were watched with suspicion by some of Pasternak's circle. She was in a hopeless position. Ivinskaya was not the informer some would label her many decades later. In a contemporaneous judgment in a top-secret memo, the chairman of the KGB labeled her "very anti-Soviet." She tried to please the officials she dealt with, and they tried to make her their semi-witting instrument but, in the end, her influence on Pasternak was limited. Pasternak was a self-aware and intuitive actor in the unfolding drama, and the key decisions in the matter, from the day he handed the manuscript to D'Angelo, remained his.

Ivinskaya was soon summoned to meet Dmitri Polikarpov, the head of the Central Committee's culture department. The haggard, bleary-eyed Polikarpov said it was imperative that Ivinskaya get the novel back from D'Angelo. Ivinskaya suggested that the Italians might not be willing to return the manuscript and the ideal solution would be to publish *Doctor Zhivago* in the Soviet Union as quickly as possible, preempting any foreign edition.

"No," said Polikarpov, "we must get the manuscript back, because it will be very awkward if we cut out some chapters and they print them."

Polikarpov was known in the literary community as *dyadya* Mitya — "Uncle Mitya" — an unapologetic enforcer of orthodoxy who confronted writers about their errors. Polikarpov once told the deputy editor of

Literaturnaya Gazeta: "Your newspaper I read with a pencil in my hand." The poet Yevgeni Yevtushenko said that "for him the Party came before everything, before people, including himself."

Polikarpov, in front of Ivinskaya, phoned the director of the state literary publishing house, Anatoli Kotov, to tell him to draw up a contract with Pasternak and appoint an editor. "The editor should think about passages to change or cut out, and what can be left unchanged." Pasternak was unimpressed with Ivinskaya's efforts: "I am by no means intent on the novel being published at the moment when it cannot be brought out in its original form." He nonetheless agreed to meet Kotov, who assured him *Doctor Zhivago* was a magnificent work but said that "we will have to shorten a few things, and perhaps add some." Pasternak thought Kotov's proposal was absurd.

The writer Varlam Shalamov wrote to Pasternak to tell him that "without any doubt, this great [publication] battle will be won by you." He told Pasternak that he was "the conscience of our age like Lev Tolstoy was of his" and that "our time will only be justified because you lived in it."

Pasternak continued that summer to hand over copies of the manuscript to various foreign visitors to Peredelkino, including the French scholar Hélène Peltier, who would work on the French translation of *Doctor Zhivago*. The daughter of a French diplomat, she had studied Russian literature at Moscow University in 1947 — a remarkable opportunity just as

the Cold War was intensifying and the regime was intent on preventing any spontaneous contact between foreigners and ordinary Russians. She returned to Moscow in 1956 and got to know Pasternak, who gave her a copy of his manuscript to read. During a visit to Peredelkino that September or another trip to the village at the end of the year, Pasternak entrusted Peltier with a note for Feltrinelli. It was undated and typed on a narrow strip of paper torn from some copybook: "If ever you receive a letter in any language other than French, you absolutely must not do what is requested of you — the only valid letters shall be those written in French." This would prove to be a prescient and critical security measure that would allow Feltrinelli to distinguish between coerced messages and freely written ones from a writer who would soon feel the intense displeasure of the state.

Isaiah Berlin, the Oxford don who first met Pasternak in late 1945, also returned to Russia that summer of 1956, another in a long line of scholars enjoying the liberal, post-Stalin visa regime. Berlin traveled out to Peredelkino with Neigauz, the first husband of Pasternak's wife. Neigauz told the Briton of his concern for Pasternak's safety because the writer was so fixed on getting his novel published. Neigauz said if Berlin got a chance he should urge Pasternak to halt or at least delay foreign publication. Neigauz said that "it was important — more than important — perhaps a matter of life and death." Berlin agreed that "Pasternak probably did need to be physically protected from himself." Berlin was especially cautious

because he feared that his meeting with Akhmatova in 1946 was a major factor in her persecution.

Pasternak took Berlin to his study and pressed a thick envelope into his hands. "My book, it is all there. It is my last word. Please read it." Berlin plunged into the novel as soon as he returned to Moscow, and finished it the next day. "Unlike some of its readers in both the Soviet Union and the West, I thought it was a work of genius. It seemed — and seems — to me to convey an entire range of human experience, and to create a world, even if it contains only one genuine inhabitant, in language of unexampled imaginative power." Berlin saw Pasternak a few days later, and the writer told him he had assigned world rights to Feltrinelli. Pasternak "wished his work to travel over the entire world," and he quoted Pushkin to hope that it would "lay waste with fire the hearts of men."

When she got a chance, Zinaida pulled Berlin aside and, weeping, she begged him to ask Pasternak not to have the novel published abroad without official permission. She told Berlin she did not want her children to suffer. Zinaida believed that their son Leonid was deliberately failed on the exam for entry to the Higher Technical Institute simply because he was Pasternak's son. In May 1950, during Stalin's anti-Semitic campaign, Pasternak's eldest son, Yevgeni, was prevented from finishing his postgraduate studies at the Moscow Military Academy and sent to Ukraine and then near the border with Mongolia for his compulsory military service. Berlin asked Pasternak to consider the consequences of defying the authorities.

He assured Pasternak that his novel would endure and that he would have microfilms of it made and buried in all four corners of the globe so that *Doctor Zhivago* would survive even nuclear war. Pasternak was incensed and, with a dash of sarcasm, thanked Berlin for his concern. He said he had spoken to his sons and "they were prepared to suffer." He told Berlin not to mention the matter again. Surely, Pasternak said, Berlin realized that the dissemination of *Doctor Zhivago* was paramount. Berlin said he was shamed into silence. He later concluded that Pasternak "chose open-eyed" to pursue publication "fully realizing the danger to himself and his family." When he returned to Britain, Berlin brought back a manuscript for Pasternak's sisters in Oxford. And he included the first letter Pasternak had sent his English relatives since 1948. He told them about the novel with his usual preamble of caveats: "You may not even like it, finding its philosophy tedious and alien, some passages boring and long-drawn-out, the first book diffuse, and the transitional passages grey, pallid and ineffectual. And yet — it's an important work, a book of enormous, universal importance, whose destiny cannot be subordinated to my own destiny, or to any question of my well-being." He told them that he had asked Berlin to make up to twelve copies of the manuscript and circulate them among the leading Russians in Britain. And he asked his sisters to ensure that the book found a very good translator — "an Englishman who is a gifted writer with a perfect command of Russian."

Pasternak was visited in mid-September by another Oxford professor, George Katkov, a Moscow-born émigré, philosopher, and historian. An "original," according to a friend, he was a "tall, mustachioed, hugely impressive *ancient regime* Russian *intelligent*." The KGB referred to him contemptuously as a "White émigré." Katkov was a friend of the Pasternak sisters and a colleague of Berlin's. He was much more enthusiastic about publication. Pasternak also gave a manuscript to Katkov and asked him as well to ensure its translation and publication in England. Katkov said that the *Zhivago* cycle of poems would present a special challenge for a translator. He suggested the novelist Vladimir Nabokov to handle the verse. "That won't work; he's too jealous of my position in this country to do it properly," said Pasternak. As early as 1927, Nabokov had expressed his deep irritation with Pasternak's style. "His verse is convex, goitrous and goggle-eyed, as though his muse suffered from Basedow's disease. He is crazy about clumsy imagery, sonorous but literal rhymes, and clattering metre." When he finally read *Doctor Zhivago*, Nabokov was no less derisive, not least because Pasternak's novel would knock *Lolita* off the top of the best-seller list — "*Doctor Zhivago* is a sorry thing, clumsy, trite and melodramatic, with stock situations, voluptuous lawyers, unbelievable girls, romantic robbers and trite coincidences." Nabokov said Pasternak's mistress must have written it.

Katkov promised Pasternak with a kiss that *Doctor Zhivago* would be well-translated into English. He eventually settled on his protégé Max Hayward, a

research fellow at St. Antony's College, Oxford, and a gifted linguist who famously taught himself Hungarian in six weeks. Russians who met Hayward insisted that he must be a native speaker, or at least the son of émigrés. He was neither. Hayward was a Londoner, the son of a mechanic, who sometimes called himself a Cockney. In the interests of speed, Hayward was joined in the translation effort by Manya Harari, the cofounder of the small publishing house the Harvill Press, a division of Collins in London. An émigré, from a wealthy Saint Petersburg family, Harari had moved to England with her family during World War I. The pair alternated chapters and then checked each other's work. Katkov supervised both of them, "going over everything for accuracy and nuance."

Katkov and Berlin would clash bitterly over the novel in 1958. Berlin continued to be concerned about Pasternak's safety and was skeptical of any push for swift publication. "That's all nonsense," Berlin said. "It's an interesting novel, but whether it's published now, or fifteen years from now, doesn't matter." Katkov took a very different view. He advocated for the widest possible dissemination and later argued that, since Pasternak "obviously wished to be a martyr," he "had to be sacrificed to the 'cause.'" The cause was the Cold War struggle against the Soviet Union.

First, however, Feltrinelli had to help *Doctor Zhivago* make its way around the world, and to do so, he had to face down his comrades — Russian and Italian.

CHAPTER
SEVEN

"If this is freedom seen through Western eyes, well,
I must say we have a different view of it."

In mid-September, the editorial board of *Novy Mir* formally rejected *Doctor Zhivago* in a long, detailed review. The critique was written mostly by Konstantin Simonov, the celebrated wartime poet. Four other board members, including Pasternak's next-door neighbor, Konstantin Fedin, offered editorial suggestions and additions. All five men signed the document.

The letter, along with the manuscript, was hand-delivered to Pasternak, who barely acknowledged its contents: "The thing that has disturbed us about your novel is something that neither the editors nor the author can change by cuts or alterations. We are referring to the spirit of the novel, its general tenor, the author's view on life . . . The spirit of your novel is one of non-acceptance of the socialist revolution. The general tenor of your novel is that the October Revolution, the Civil War and the social transformation involved did not give the people anything but suffering, and destroyed the Russian intelligentsia, either physically or morally." The writers continued with a scene-by-scene dissection of the novel's ideological failings, the "viciousness" of its hero's conclusions

135

about the revolution, and Yuri Zhivago's "hypertrophied individualism" — code for Pasternak's fundamental personal flaw.

After a backhanded compliment, they attacked the novel's artistry: "There are quite a few first-rate pages, especially where you describe Russian natural scenery with remarkable truth and poetic power. There are many clearly inferior pages, lifeless and didactically dry. They are especially rife in the second half of the novel." Fedin, in particular, smarted from Zhivago's judgment of his contemporaries, seeing Pasternak's sentiments in Zhivago's words, and all the arrogance of the supremely talented: "Dear friends, oh, how hopelessly ordinary you and the circle you represent, and the brilliance and art of your favorite names and authorities, all are. The only live and bright thing in you is that you lived at the same time as me and knew me."

One of Pasternak's biographers noted that the authors of the letter either missed or did not articulate the novel's "most heretical insinuation: by artistically conflating the Stalinist period with early revolutionary history, Pasternak implied (many years before Solzhenitsyn's *Gulag Archipelago*) that the tyranny of the last twenty-five years was a direct outcome of Bolshevism." For Pasternak, Stalinism and the purges were not a terrible aberration — the accepted Soviet explanation under Khrushchev — but a natural outgrowth of the system created by Lenin. This was an idea that could not be broached even in a rejection letter.

136

Fedin's signature was particularly difficult for Pasternak to accept, as he regarded his neighbor as a friend. Only two weeks earlier, Fedin, pacing the room and waving his arms in enthusiasm, had told Chukovsky that the novel was "brilliant, extremely egocentric, satanically arrogant, elegantly simple yet literary through and through." He may have spoken before he had read the entire novel and was bruised by the implication of Zhivago's words. Or duty may have led him to bury his actual assessment of the work.

Pasternak held no open grudge, and may even have understood the hopelessness of his colleagues' position. He invited Fedin to Sunday lunch a week after getting the letter and told some other guests, "I have also asked Konstantin Aleksandrovich — as whole-heartedly and unreservedly as in previous years — so don't be surprised." He asked Fedin not to mention the rejection and when he arrived the two men embraced. At dinner, Pasternak was in good spirits.

Pasternak didn't bring himself to read the long letter carefully until a week later. He told a neighbor that the critique was "composed very courteously and gently, painstakingly thought out from a viewpoint that has become traditional and seemingly irrefutable." He said, with perhaps a touch of irony, that he was "pained and regretful at having caused my comrades such work."

There was now little reason to believe that even an unexpurgated *Doctor Zhivago* would be published in the Soviet Union; Simonov and the others had pronounced it irredeemably flawed. Still, Pasternak told Katkov that Western publication might yet prompt a

Soviet edition, and said he might countenance some changes to make the novel palatable for the Soviet audience. This was his own private logic. The Soviet authorities did not want the book published — anywhere.

In August, a group of senior Italian Communists, including the party's vice secretary, Pietro Secchia, were guests at the exclusive Barvikha sanatorium just west of Moscow. D'Angelo and his wife visited two old friends there — Ambrogio Donini, a university professor, and Paolo Robotti, an old-school Communist activist.

International Communists in the Soviet Union were also targeted during the purges. Robotti's faith in the cause had survived his arrest and torture by Stalin's secret police when he was living in exile in Moscow before the war; when D'Angelo mentioned that he had handed the manuscript of a Russian novel to Feltrinelli, Robotti was visibly upset. He said the transfer was probably illegal under Soviet law. Secchia and Robotti were subsequently visited by an official from the Central Committee's section on relations with foreign Communist parties. They were told of the Kremlin's concerns about an Italian edition. Secchia and Robotti assured the official they would get the novel back from Feltrinelli. On October 24, the Central Committee was informed through the Soviet embassy in Rome that Robotti had reported, "The issue with Pasternak's manuscript has been settled and it will be returned to you in the nearest future." Robotti was mistaken. The

pressure divided editors at the publishing house. Zveteremich was asked to return the manuscript, and the translation was interrupted for several months, while Feltrinelli, undecided about how to proceed, considered his options. He had not, however, abandoned publication.

The diplomatic note from Rome came just a day after several hundred thousand people flowed onto the streets of Budapest to demand reform, and the Hungarian Revolution began. The popular revolt was eventually crushed by a large Soviet invasion force and some twenty thousand Hungarians lost their lives in often brutal street fighting — as the West, impotent and paralyzed, watched helplessly. The Kremlin and the conservative bureaucracy seized on the events in Budapest to reverse the "thaw" in Moscow. The liberal *Literaturnaya Moskva* (Literary Moscow), which had only recently published Pasternak's "Notes on Translations of Shakespeare's Dramas," was closed; editors were fired across the major literary journals; and young, daring poets such as Andrei Voznesensky and Yevgeni Yevtushenko came under attack. Khrushchev would eventually argue that "bourgeois" tendencies among Hungarian intellectuals had sparked insurrection.

The bloody suppression of the Hungarian revolution was also deeply traumatic for many Italian Communists. Most of the leadership of the party supported the Soviet invasion, but a quarter of a million rank-and-file members abandoned the movement, including significant numbers of artists, academics, and journalists. Even before the worst of the bloodshed in

139

Budapest, Feltrinelli, along with a number of his colleagues at the Feltrinelli library and institute in Milan, signed a letter to the party leadership asserting that in the "fundamental nature of the Hungarian movement" there is "a strong plea for socialist democracy." Feltrinelli watched with dismay the exodus of intellectuals from the party and bristled at the leadership's attempt to argue that "the loss of small fringe groups of intellectuals is not an important phenomenon."

"These comrades," Feltrinelli replied, "have not only brought luster to the party, the working class and the socialist movement but they have enabled us, since the fall of Fascism, to undertake a wealth of politico-cultural projects." Feltrinelli did not immediately turn in his party card, but his willingness to act as a financier began to fade. His desire to proceed with Pasternak's book was only strengthened.

By January 1957, officials in the Central Committee's departments on culture and relations with foreign Communist parties were wringing their hands. Despite the promise of the Italian comrades back in October, there was still no sign of the manuscript. Instead of hoping that Feltrinelli would bow to instructions from his party leadership, it was decided to use Pasternak himself to get the novel back. First, though, such a tactic had to be credible. On January 7, 1957, Pasternak signed a contract with Goslitizdat, the state literary publishing house. "I shall make this into something that will reflect the glory on the Russian people," said his editor, Anatoli Starostin. He was a

genuine admirer of Pasternak, but Starostin was no more than a pawn, and the contract a ruse. The document would simply give greater legal weight to the effort to compel Feltrinelli to return the novel.

The following month, Feltrinelli received a telegram from Pasternak. It was in Italian: "Per request from goslitizdat . . . please hold Italian publication of *Doctor Zhivago* for half year until September 1957 and the coming out of Soviet edition of novel send reply telegram to Goslitizdat — Pasternak." But before he sent the telegram, Pasternak wrote a letter — in French — to his publisher in Milan. He explained that he sent the telegram under pressure and that the state was planning a modified version of *Doctor Zhivago*. He suggested that Feltrinelli agree to a six-month delay of the Italian edition. And then he pleaded with his publisher: "But the sorrow that, naturally, is caused me by the imminent alteration of my text would be far greater if I thought that you intended to base the Italian translation on it, despite my enduring desire that your edition be strictly faithful to the authentic manuscript."

Feltrinelli, at this point, had no reason to doubt a Soviet edition was coming in September. He wrote to Pasternak to say he would agree to the delay and he urged Zveteremich, his translator, to hurry up so an Italian edition could go on sale immediately afterward. Under international publishing law, Feltrinelli needed to publish within thirty days after the appearance of the Soviet edition to establish his rights in the West.

In April, in a letter to one of his Soviet editors, Pasternak asked for an advance against an upcoming

volume of his poetry, his translation of *Faust*, or even *Doctor Zhivago* — although he admitted he was unlikely to get any money for the novel, since everything surrounding it was pure "phantasmagoria."

Feltrinelli met D'Angelo in Milan in May. Feltrinelli told him that Zveteremich was almost finished, and the poet Mario Socrate was polishing the last of the verse at the end of *Doctor Zhivago*. It seemed to D'Angelo that Feltrinelli was both satisfied and relieved. "He assures me that while he is still a man of the left, he will always fight for freedom and as a publisher, he will fight for freedom of thought and culture."

In June, Feltrinelli wrote to Goslitizdat. He agreed not to publish *Doctor Zhivago* until September. He also offered his "dear comrades" his opinion of Pasternak's novel, an assessment that while it invoked Soviet aesthetics no doubt caused some heartburn in Moscow. "His is a perfect portrayal of the nature, soul and history of Russia: characters, objects and events are rendered clearly and concretely in the finest spirit of realism, a realism that ceases to be merely fashion, and becomes art." Feltrinelli noted that the book might give rise to some controversy, but that after the Twentieth Congress, and the exposure of Stalin's crimes, "the revealing of certain facts no longer surprises or perturbs.

"Besides, Western readers will for the first time hear the voice of a great artist, a great poet who has made, in an artistic form, a detailed analysis of the October Revolution, the harbinger of a new epoch in which socialism became the only natural form of social life.

142

For the Western public, the fact that this is a voice of a man alien to all political activity is a guarantee of the sincerity of his discourse, thus making him worthy of trust. Our readers cannot fail to appreciate this magnificent panorama of events from the history of the Russian people which transcends all ideological dogmatism, nor will they overlook its importance, or the positive outlook deriving from it. The conviction will thus grow that the path taken by your people has been for them a progressive one, that the history of capitalism is coming to an end, and that a new era has begun."

Feltrinelli concluded by saying whatever suspicions might exist in Moscow, it was never his intention "to lend this publication a sensational character."

Pasternak thanked Feltrinelli for agreeing to the delay but let him know that September publication in Moscow was a lie: "Here in Russia, the novel will never appear," he wrote in a letter to Feltrinelli at the end of June. "The troubles and misfortunes that will perhaps befall me in the event of foreign publication, that is to say without an analogous publication in the Soviet Union, are matters that must not concern us, either me or you. The important thing is that the work sees the light of day. Do not withhold your help from me."

Pasternak also wrote to Andrei Sinyavsky, another writer who was part of his trusted circle, that although others believed the "thaw" under Khrushchev would lead to more books being published, he "seldom, periodically and only faintly shared that belief." The

publication of *Doctor Zhivago*, he added, was "out of the question."

The atmosphere in Moscow was becoming more hostile for writers and other artists. In May 1957, the party leadership, including Khrushchev, met with the board of the Union of Soviet Writers. Khrushchev spoke for nearly two hours. He described Vladimir Dudintsev's recently published novel, *Not by Bread Alone*, as "false at its base." The novel, which castigated the bureaucracy, had been read by its admirers as an audacious break with the past. The journal *Literaturnaya Moskva* was full of "ideologically fallacious" work, Khrushchev said. And the general secretary said that some writers seemed to have adopted an "indiscriminate rejection of the positive role of J. V. Stalin in the life of our party and country."

In June, the state literary publishing house announced that the publication of the volume of Pasternak's collected poems had been cancelled. That summer, the new Polish journal *Opinie* (Opinions) printed a thirty-five-page excerpt from *Doctor Zhivago*. Pasternak had given the manuscript to a Polish friend and translator shortly after D'Angelo had visited him in Peredelkino. The July/September issue of *Opinie*, which was devoted to Polish-Soviet friendship, introduced the excerpt with a note that said the novel was "a broad intricate story about the fate of the Russian intelligentsia and their ideological transformation which was frequently accompanied by tragic conflicts."

144

A note on the magazine that was prepared for the Central Committee in Moscow said the "choice of stories in the first issue shows that this magazine has a hostile attitude towards us." The Central Committee's culture department said it was "necessary to authorize the Soviet ambassador to draw the attention of Polish comrades to the unfriendly character of the magazine." The Soviet weekly *Literaturnaya Gazeta* was also instructed to attack the Polish magazine, but not in a manner that would "arouse an unhealthy interest abroad in Pasternak's evil plot." The Polish translators were summoned to Moscow and reprimanded. *Opinie* never appeared again. The authorities were also infuriated by the printing of some of Pasternak's more spiritual *Zhivago* poems in the émigré magazine *Grani* (Borders), an organ of the militant National Alliance of Russian Solidarists (NTS), which was published in West Germany. Pasternak had not sanctioned this publication, and his name was not attached to the poems, but it was clear that they were his work.

Officials complained in memos that Pasternak had agreed to revise *Doctor Zhivago* based on the *Novy Mir* critique of the novel, but, one of the bureaucrats wrote, he "has done nothing in terms of editing his novel or making proper changes." For much of the spring and early summer of 1957, Pasternak was hospitalized and in great pain with an inflamed meniscus in his right knee. (Zinaida visited him every day but was upset on one occasion when asked who she was. When she produced her identification, a hospital

employee said there was a blonde in an hour before who had said she was the wife.)

The Central Committee official suggested another effort should be made to obtain the manuscript through the Italian Communists, since a delegation was in town for a World Youth Festival. The Italians were berated. Khrushchev himself complained to Velio Spano, the head of the Italian Communist Party's foreign affairs section, that D'Angelo, supposedly a friend and guest, had created all this turmoil over Pasternak's novel. Khrushchev had apparently been shown "a selection of the most unacceptable parts of the novel."

Pasternak was also sending messages to Italy. In July, he wrote to Pietro Zveteremich, the Italian translator, to tell him that he wanted all the Western publishers to proceed regardless of "the consequences it could have on me.

"I wrote the novel to be published and read, and that remains my only wish."

By August, Pasternak was under close watch. Letters to his sister Lydia in England were intercepted by the KGB and never reached her. That month, Pasternak was summoned to a meeting with the writers' union leadership. Pasternak gave Ivinskaya a note to represent him at the meeting. She was accompanied by Starostin, the editor handling the purported Soviet edition of *Doctor Zhivago*. The meeting was chaired by Surkov, who had risen to become first secretary of the writers' union. Surkov first met privately with Ivinskaya and asked her politely how the novel had ended up abroad.

Ivinskaya said that Pasternak genuinely thought "with the spontaneity of a child" and he believed that in the case of art, borders were irrelevant.

"Yes, yes," said Surkov. "It was quite in character. But it was so untimely. You should have prevented him — he does, after all, have a good angel like you."

When the open session began, Surkov's placid demeanor vanished as he became more and more worked up about Pasternak's "treachery." He accused Pasternak of being driven by greed, and said he was negotiating to get money from abroad. Ivinskaya tried to speak but was rudely told not to interrupt. The novelist and member of the board Valentin Katayev shouted at her: "There really is no point in your being here. Who do you think you're representing? A poet or a traitor? Or doesn't it bother you that he's a traitor to his country?" When Starostin was introduced as the editor of the novel, Katayev continued, "Just fancy that — the editor, if you please. How can something like *this* be edited!"

Starostin was dejected and under no illusion about what the tongue-lashing augured for the novel. "We all left beaten, knowing that the road to publication of *Doctor Zhivago* was closed."

Pasternak later described the event as a " '37 type of meeting, with infuriated yelling about this being an unprecedented occurrence, and demands for retribution." The following day, Ivinskaya arranged for Pasternak to meet Polikarpov from the Central Committee. In advance of the meeting, Pasternak had Ivinskaya give him a letter. It seemed scripted to

infuriate the bureaucrat: "People who are morally scrupulous are never happy with themselves; there are a lot of things they regret, a lot of things of which they repent. The only thing in my life for which I have no cause for repentance is the novel. I wrote what I think and to this day my thoughts remain the same. It may be a mistake not to have concealed it from others. I assure you I would have hidden it away had it been feebly written. But it proved to have more strength to it than I had dreamed possible — strength comes from on high, and thus its further fate was out of my hands."

Polikarpov was so incensed he demanded that Ivinskaya tear up the note in front of him. He insisted on seeing Pasternak. Both Polikarpov and Surkov met with Pasternak in the following days. The conversations were strained but civil, and both men told Pasternak that he had to send a telegram to Feltrinelli demanding the return of the book. Pasternak was warned that failure to act could lead to "very unpleasant consequences." The two men drew up a telegram for Feltrinelli and Pasternak was expected to send it: "I have started rewriting the manuscript of my novel *Doctor Zhivago*, and I am now convinced that the extant version can in no way be considered a finished work. The copy of the manuscript in your possession is a preliminary draft requiring thorough revision. In my view it is not possible to publish the book in its current form. This would go against my rule, which is that only the definitive draft of my work may be published. Please be so kind as to return, to my Moscow address,

the manuscript of my novel *Doctor Zhivago*, which is indispensable for my work."

Pasternak refused to send it. Ivinskaya asked D'Angelo to speak to Pasternak and persuade him otherwise. The Italian was unable to get a word out before an angry Pasternak spoke. "If you're here to advise me to capitulate you should know that your charitable mission shows a lack of respect for me personally. You're treating me like a man who has no dignity. The publication of *Doctor Zhivago* has become the most important thing in my life, and I don't intend to do anything to prevent it. What would Feltrinelli think if he received a telegram that contradicted everything I have written and rewritten to him up to now? Would he take me for a crazy man, or a coward?"

D'Angelo recounted for Pasternak his conversation with Feltrinelli in Milan. Publication was inevitable. Moreover, numerous other Western publishers already had the manuscript and would go ahead on their own even if Feltrinelli were to follow the instructions in an obviously extorted telegram. D'Angelo told Pasternak there was no reason to resist this useless gesture, and it could save Pasternak and his loved ones. The Italian declared that the Soviet state had lost its ridiculous war against *Doctor Zhivago*.

The telegram — in Russian — was sent on August 21, 1957. Immediately, Polikarpov informed the Central Committee and suggested that they arm the Italian Communist Party with a copy so they could use it to add to the pressure on Feltrinelli. Mario Alicata, a literary critic and a senior figure in the party,

was assigned to meet with Feltrinelli at the Milan office of the Communist Party. He angrily waved Pasternak's telegram in Feltrinelli's face, but the publisher would not relent.

Pasternak, meanwhile, was attempting to get messages to Feltrinelli and others lest the telegram be taken seriously. He told the Harvard scholar Miriam Berlin and her husband, who came to visit him in Peredelkino, that he certainly wanted the novel published outside the Soviet Union. Berlin had been asked by Pasternak's sister Josephine to confirm his intentions. Pasternak told Berlin that he had been forced to write the telegram and it should be ignored. "It does not matter what might happen to me. My life is finished. The book is my last word to the civilized world." When the Italian scholar Vittorio Strada came to see him, he whispered to him as he left, "Vittorio, tell Feltrinelli that I want my book to come out at all costs."

Despite all the intrigue and intimidation, Pasternak appeared remarkably unruffled to his visitors. Yevgeni Yevtushenko saw Pasternak that September when he brought yet another Italian professor, Angelo Rippelino, to visit him. "I'm very fond of Italians," said Pasternak. He invited them in for dinner. Yevtushenko remarked: "To look at him, Pasternak might have been forty-seven or forty-eight. His whole appearance had an amazing, sparkling freshness like a newly cut bunch of lilacs with the morning dew still on their leaves. It seemed as if there was a play of light all over him, from the flashing gestures of hands to the surprisingly childlike smile

150

which constantly lit up his mobile face." Pasternak and Yevtushenko drank and talked late into the night long after Rippelino had left. Zinaida admonished the twenty-three-year-old Yevtushenko. "You're killing my husband," she said.

Yevtushenko read *Doctor Zhivago* a short time later and was "disappointed." He said the young writers of the post-Stalin period were attracted by the masculine prose of Hemingway, and the work of writers such as J. D. Salinger and Erich Maria Remarque. *Doctor Zhivago*, in comparison, seemed old-fashioned, even a little boring, the work of an earlier generation. He didn't finish reading it.

The September deadline for a Soviet edition passed, and officials in Moscow were becoming desperate. Soviet trade representatives in Paris and London attempted without success to get the publishers Gallimard and Harvill Press to return the manuscript. The Soviet embassy in London also insisted that, if publication was inevitable, Harvill Press ought to include an introduction stating that Pasternak himself had not wished his book to be published. The Foreign Office, which discouraged Harvill Press from sending a copy of the English translation to Pasternak for his corrections, suggested that instead of a note about Pasternak's purported objections, the publishers simply say, "Banned in the Soviet Union." "That might only be of advantage from the propaganda point of view but would perhaps serve as a slight protection to Pasternak himself," wrote Philip de Zulueta, the Foreign Office

151

representative at No. 10 Downing Street. The remark may have been somewhat facetious, as it's unclear how noting that the book was banned would help Pasternak, although it would certainly boost sales.

Pietro Zveteremich was in Moscow in October and found that "the atmosphere created around the book" was "very ugly." Almost as soon as he arrived in the city, as part of an Italian delegation hosted by the Union of Soviet Writers, Zveteremich was told that publication of *Doctor Zhivago* would be an affront to both Pasternak and the Soviet Union. Zveteremich was handed a typewritten letter purportedly signed by Pasternak; it repeated some of what was in the February telegram and complained that Feltrinelli never replied. In a meeting with officials from the writers' union, Zveteremich said publication of *Doctor Zhivago* could not be stopped. "A brawl, I can truly say, broke out," he recalled. Pasternak felt it unsafe to meet with the translator, but Zveteremich was able to see Ivinskaya, who gave him a note from Pasternak for Feltrinelli, and it reflected the author's true sentiments. In a letter to Feltrinelli, Zveteremich wrote that "P. asks you not to pay any heed to this and cannot wait for the book to come out even though they have threatened to reduce him to starvation." Zveteremich's experience in Moscow led him to leave the Communist Party. "I became convinced that there was no socialism in the USSR, but rather just Asian theocratic despotism," he later wrote. In his short note to Feltrinelli, Pasternak wrote, "Forgive me for the injustices that have befallen you and for those perhaps yet to come caused by my

wretched faith. May our distant future, the faith that helps me live, protect you."

Feltrinelli replied to Pasternak's telegram on October 10. The letter, although addressed to Pasternak, was clearly written for Soviet officialdom and was designed to protect Pasternak by shifting blame away from the author and onto the publisher. Feltrinelli began by saying that he saw none of the shortcomings described in the telegram: that the work was unfinished and needed thorough revision. Feltrinelli reminded his readers that he had agreed to delay publication until September and there was nothing now standing in the way of publication.

And he pretended to lecture his obstreperous author. "In order to avoid any further tension in Western literary circles, created as a result of your wholly regrettable telegram . . . we advise you to make no further attempts to hold up publication of the book, something that, far from preventing it, would lend the entire affair a tone of political scandal that we have never sought nor wish to create."

Surkov traveled to Italy in October as part of a Soviet delegation of poets, but his real mission was to confront Feltrinelli. With a translator in tow, he stormed into the publisher's offices on Via Andegari. His bellowing in Russian could be heard down on the street. Surkov, much like Alicata, waved Pasternak's telegram in the publisher's face. "I know how such letters are written," said Feltrinelli, a photo of Pasternak hanging on the wall over his shoulder. Surkov pressed his case for three hours, but left with nothing. Feltrinelli said he was a

153

"free publisher in a free country," and he told Surkov that by publishing the novel he was paying tribute to a great narrative work of Soviet literature. The work was a testament to the truth, he said, even if the cultural bureaucrats in Moscow didn't get it. After the meeting, Feltrinelli said seeing Surkov was like encountering "a hyena dipped in syrup."

Surkov was not ready to quit, and he introduced the most menacing note to date in the affair. He gave an interview to *L'Unità*, the Communist party newspaper for which Feltrinelli had acted as a stringer eleven years earlier. In the first public comments by a Soviet official on *Doctor Zhivago*, he said he offered the facts, "in all sincerity": Pasternak's novel was rejected by his comrades because it cast doubt on the validity of the October Revolution. Pasternak accepted these criticisms and asked for the manuscript to be returned by his Italian publisher so he could revise it. But despite all this, the novel, according to press reports, will appear in Italy against the will of its author.

"The Cold War is beginning to involve literature," intoned Surkov. "If this is freedom seen through Western eyes, well, I must say we have a different view of it." The reporter noted that he spoke "to make clear how terrible he felt all of this was." Surkov continued: "Thus it is for the second time, for the second time in our literary history, after *Mahogany* by Boris Pilnyak, a book by a Russian will be first published abroad."

The invocation of Pilnyak, Pasternak's executed neighbor, was a direct threat. Surkov was comfortable with the exigencies of state violence. The previous year

154

he told a Yugoslav newspaper, "I have seen my friends, writers, disappear before my eyes but at the time I believed it necessary, demanded by the Revolution." Feltrinelli told Kurt Wolff, Pasternak's American publisher, that Surkov's words should be quoted as widely as possible and *"Time* and *Newsweek* should get on the move."

At the end of October, Pasternak was compelled to send one more message to Feltrinelli. He told him he was "stunned" at Feltrinelli's failure to reply to his telegram, and said that "decency demands that you respect the wishes of an author."

With publication imminent, Pasternak followed up the final October 25 telegram with a private note to Feltrinelli. It was dated November 2:

Dear Sir,

I can find no words with which to express my gratitude. The future will reward us, you and me, for the vile humiliations, we have suffered. Oh, how happy I am that neither you, nor Gallimard, nor Collins have been fooled by those idiotic and brutal appeals accompanied by my signature (!), a signature all but false and counterfeit, insofar as it was extorted from me by a blend of fraud and violence. The unheard-of arrogance to wax indignant over the "violence" employed by you against my "literary freedom," when exactly the same violence was being used against me, covertly. And that this vandalism should be disguised as concern for me, for the sacred rights of the artist!

155

But we shall soon have an Italian Zhivago, French, English and German Zhivagos — and one day perhaps a geographically distant but Russian Zhivago! And this is a great deal, a very great deal, so let's do our best and what will be will be.

The first edition of *Doctor Zhivago* in translation in Italian was printed on November 15, 1957, followed by a second run of three thousand copies five days later. The novel appeared in bookstores on November 23 following its launch the previous evening at the Hotel Continental in Milan. The book was an immediate best seller.

One of the first reviews appeared in the *Corriere della Sera* under the headline "You look for a political libel and find a work of art." "Pasternak does not require any political judgments from us, the first readers of his novel in the West," the review concluded. "Perhaps in the loneliness of his village, the old writer wants to know whether we heard his poetic voice in the story, whether we found proof of his artistic beliefs. And the answer is: yes, we did."

The novel had begun a long journey. But to get back home to Russia, *Zhivago* would have a secret ally.

CHAPTER
EIGHT

"We tore a big hole in the Iron Curtain."

The Russian-language manuscript of *Doctor Zhivago* arrived at CIA headquarters in Washington, D.C., in early January 1958 in the form of two rolls of film. British intelligence provided this copy of the novel. Inside the agency, the novel was the source of some excitement. In a memo to Frank Wisner, who oversaw clandestine operations for the CIA, the head of the agency's Soviet Russia Division described *Doctor Zhivago* as "the most heretical literary work by a Soviet author since Stalin's death."

"Pasternak's humanistic message — that every person is entitled to a private life and deserves respect as a human being, irrespective of the extent of his political loyalty or contribution to the state — poses a fundamental challenge to the Soviet ethic of sacrifice of the individual to the Communist system," wrote John Maury, the Soviet Russia Division chief. "There is no call to revolt against the regime in the novel, but the heresy which Dr. Zhivago preaches — political passivity — is fundamental. Pasternak suggests that the small unimportant people who remain passive to the regime's demands for active participation and emotional involvement in official campaigns are superior to the

political 'activists' favored by the system. Further, he dares hint that society might function better without these fanatics."

Maury was a fluent Russian speaker who had been an assistant naval attache in Moscow when Hitler invaded the Soviet Union. During the war, he served in Murmansk as part of the Lend-Lease program by which the United States delivered over $11 billion worth of supplies to the Soviet Union. Maury, however, had no affection for the former ally. He subscribed to the belief that Soviet action could best be understood through the prism of Russian history. "He considered the Soviet regime a continuation of imperial Russia, and thought the KGB had been founded by Ivan the Terrible," said one of his officers.

The CIA's Soviet Russia Division was stocked with first- and second-generation Russian-Americans whose families, in many cases, had fled the Bolsheviks. The division prided itself on its vodka-soaked parties with a lot of Russian singing. "Our specialty was the charochka, the ceremonial drinking song with its chorus of pey do dna [bottoms up!]," recalled one officer who served in the 1950s.

The American and British intelligence services agreed that Doctor Zhivago should be published in Russian, but the British "asked that it not be done in the U.S." This approach became policy for the CIA, which calculated that a Russian-language edition produced in the United States would be more easily dismissed by the Soviet Union as propaganda in a way that publication in a small European country would

not. Moreover, they feared, overt American involvement could be used by the authorities in Moscow to persecute Pasternak.

In an internal memo shortly after the appearance of the novel in Italy, agency staff also recommended that *Doctor Zhivago* "should be published in a maximum number of foreign editions, for maximum free world distribution and acclaim and consideration for such honor as the Nobel prize." While the CIA hoped Pasternak's novel would draw global attention, including from the Swedish Academy, there was no indication that the agency considered printing a Russian-language edition to help Pasternak win the prize.

The CIA's role in operations involving *Doctor Zhivago* was backed at the highest level of government. The Eisenhower White House, through its Operations Coordinating Board (OCB), which oversaw covert activities, gave the CIA exclusive control over the novel's "exploitation." The rationale behind this decision was "the sensitivity of the operation, and that the hand of the United States government should not be shown in any manner." Instead of having the State Department or the United States Information Agency trumpet the novel publicly, secrecy was employed to prevent "the possibility of personal reprisal against Pasternak or his family." The OCB issued verbal guidelines to the agency and told the CIA to promote the book "as literature, not as cold-war propaganda."

The CIA, as it happened, loved literature — novels, short stories, poems. Joyce, Hemingway, Eliot. Dostoevsky,

Tolstoy, Nabokov. Books were weapons. If a piece of literature was unavailable or banned in the USSR or Eastern Europe, and the work might challenge or contrast with Soviet reality, the agency wanted it in the hands of citizens in the Eastern Bloc. The Cold War was twelve years old in 1958, and whatever illusions might have existed about liberating the "captive peoples" of the East were shattered by the bloodshed in Budapest and the inability of the Western powers, and in particular of the United States, to do much more than peer through the barbed wire. The United States was unable to help the striking East Germans in 1953 or the Poles who also revolted in 1956. Communism would not be rolled back for the simple reason that no one could countenance an intervention that could escalate into war between superpowers armed with atomic weapons.

In the 1950s, the CIA was engaged in relentless global political warfare with the Kremlin. This effort was intended to shore up support for the Atlantic Alliance (NATO) in Western Europe, counter Soviet propaganda, and challenge Soviet influence in the world. The CIA believed the power of ideas — in news, art, music, and literature — could slowly corrode the authority of the Soviet state with its own people and in the satellite states of Eastern Europe. The agency was in a long game. Cord Meyer, the head of the CIA's International Organizations Division, which oversaw much of the agency's covert propaganda operations, wrote that exposure to Western ideas "could incrementally

over time improve the chances for gradual change toward more open societies."

To further its objectives, the CIA, using a host of front organizations and phony foundations, spent untold millions to fund concert tours, art exhibitions, highbrow magazines, academic research, student activism, news organizations — and book publishing. In Western Europe, the CIA channeled money to the non-Communist left, which it regarded as the principal bulwark against its Communist foe. The alliance between Cold War anti-communism and liberal idealism "appeared natural and right" and would not break down until the 1960s. "Our help went mainly to the democratic parties of the left and of the center," said Meyer. "The right wing and the conservative forces had their own financial resources: the real competition with the communists for votes and influence lay on the left of the political spectrum, where the allegiance of the working class and the intelligentsia was to be decided."

In 1950s America, during and long after the poisonous anti-Communist crusade of Senator Joseph McCarthy, it would have been impossible to get Congress to appropriate money for the State Department or any other part of the government to openly fund left-wing organizations and the promotion of the arts in Europe. Even for direct operations against the Communist Bloc, Congress would have struggled to support activities as seemingly effete as book publishing. The CIA budget was black, and perfect for the job. The agency believed with genuine fervor that

161

the Cold War was also cultural. There was a realization that this funding — millions of dollars annually — would support activities that would "manifest diversity and differences of view and be infused by the concept of free inquiry. Thus views expressed by representatives and members of the U.S. supported organizations in many cases were not shared by their sponsors . . . It took a fairly sophisticated point of view to understand that the public exhibition of unorthodox views was a potent weapon against monolithic Communist uniformity of action." Thus the CIA "became one of the world's largest grant-making institutions," rivaling the Ford, Rockefeller, and Carnegie foundations.

President Harry Truman didn't like the idea of a peacetime American intelligence service. Newspapers and some congressmen worried aloud about an American gestapo. And immediately after World War II, a part of the establishment felt queasy about putting down a stake in the underworld of covert operations. But as tensions with the Soviet Union grew, the need for some "centralized snooping," as Truman called it, seemed unavoidable. The CIA was created in 1947, and, as well as authorizing intelligence gathering, Congress vested the spy agency with power to perform "other functions and duties related to intelligence affecting the national security." This vague authority would provide the legal justification for covert action, operations that cannot be traced to the CIA and can be denied by the U.S. government, although at first the CIA's general counsel was uncertain if the agency could undertake "black propaganda" without specific

congressional authorization. In the first years of the Cold War, various government departments, including State and Defense, continued to debate how to institute a permanent and effective capability to run missions, which ranged from propaganda efforts to paramilitary operations such as arming émigré groups and inserting them back inside the Eastern Bloc to commit acts of sabotage.

The intellectual author of U.S. covert action was George Kennan, the influential diplomat and policy planner, who argued that the United States had to mobilize all its resources and cunning to contain the Soviet Union's atavistic expansionism. The United States was also facing a foe that, since the 1920s, had mastered the creation of the front organization — idealistic-sounding, international entities that promoted noncommunist ideas such as peace and democracy but were secretly controlled by the Kremlin and its surrogates. Washington needed a capability to "do things that very much needed to be done, but for which the government couldn't take official responsibility." In May 1948, the State Department's Policy Planning Staff, which Kennan headed, wrote a memo entitled "The Inauguration of Organized Political Warfare." The memo noted that "the Kremlin's conduct of political warfare was the most refined and effective of any in history" and argued that the United States, in response, "cannot afford to leave unmobilized our resources for covert political warfare." It laid down a series of recommendations to support and cultivate resistance

within the Soviet Bloc and support the Soviet Union's émigré and ideological foes in the West.

The following month, the National Security Council created the Office of Special Projects, which was housed at the CIA although at first it was an independent office. The new group was soon renamed the equally anodyne Office of Policy Coordination (OPC). It was led by Frank Wisner, a veteran of the wartime intelligence service, the Office of Strategic Services (OSS). He had served for six months in Bucharest in 1944 and 1945 and watched in despair and fury as Russian troops put 70,000 Romanians of German descent onto boxcars destined for the Soviet Union, where they were to be used as slave labor. "The OSS operative was 'brutally shocked' by the spectacle of raw Soviet power at the same time that Russians were toasting a new era of Allied cooperation." The experience marked Wisner. He was suffused with an evangelical, anti-Communist zeal to take the fight to the enemy.

Wisner divided his planned clandestine activity into five areas — psychological warfare, political warfare, economic warfare, preventive direct action, and miscellaneous. He wanted the ability to do just about anything, from proselytizing against the Soviet Union to using émigré proxies to launch violent attacks and create some kind of anti-Communist resistance. The organization's powers continued to expand under new National Security directives, as did its personnel and resources. There were 302 CIA staffers involved in covert operations in 1949. Three years later, there were

2,812, with another 3,142 overseas contractors. These spies and officers were located at forty-seven locations worldwide; the budget for their operations in the same three-year period grew from $4.7 million to $82 million. In 1952, OPC was merged with the Office of Special Operations to create the Directorate of Plans.

One young recruit, the future CIA director William Colby, said Wisner instilled his organization with "the atmosphere of an order of Knights Templar, to save Western freedom from Communist darkness." Wisner was also "boyishly charming, cool but coiled, a low hurdler from Mississippi." He wanted people with that "added dimension"; war veterans like himself, athletic and smart but not bookish, from the best schools, and especially Yale.

Attracted by the sense of epic struggle and feeling certain about the moral clarity of the moment, writers and poets enlisted with the CIA. James Jesus Angelton, the CIA's counterintelligence chief, was an editor at *The Yale Literary Magazine* and cofounded the literary magazine *Furioso*. He counted Ezra Pound among his closest friends. Cord Meyer Jr., another alumnus of the *Yale Literary*, had published fiction in *The Atlantic Monthly* and continued to hanker for the writing life when he was running the agency's propaganda operations. When one of Meyer's recruits, Robie Macauley, formerly of *The Kenyon Review*, left the agency to become the fiction editor of *Playboy*, Meyer told him, "I might even send you a story under an appropriate pseudonym." John Thompson was another hire from *The Kenyon Review*. John Hunt was

165

recruited around the time his novel *Generations of Men* appeared. Peter Matthiessen, a cofounder and editor of the *Paris Review*, wrote his novel *Partisans* while working for the agency.

"I went down to Washington in the spring of 1951 to enlist in a struggle that was less violent but more complex and ambiguous than the war I had volunteered to join ten years before," said Meyer, a combat veteran who was wounded on Guam and lost one of his eyes.

To funnel its money to the causes it wanted to bankroll, the CIA created a series of private, high-minded organizations. Prominent Americans were recruited to serve on their boards and create the illusion that these entities were stocked with the kind of wealthy benefactors whose involvement would explain away streams of cash. Among the first was the National Committee for a Free Europe, incorporated in 1949 with offices in New York. Members included Dwight D. Eisenhower, soon to be president; film moguls Cecil B. DeMille and Darryl Zanuck; Henry Ford II, the president of Ford Motor Company; Cardinal Francis Spellman, the archbishop of New York; and Allen Dulles, the new organization's executive secretary. Dulles would join the CIA in 1951 and become director in 1953. Most of these volunteers were made aware of or deduced CIA involvement. The Free Europe Committee, as it was renamed, purported to be self-financing through a national fund-raising campaign called the Crusade for Freedom. In fact, only about 12 percent of the FEC budget came from fund-raising,

166

most of that corporate largesse. The bulk of the cash came via a weekly check that the CIA routed through a Wall Street bank.

The Free Europe Committee's principal project was Radio Free Europe, which began broadcasting in Czech, Slovak, and Romanian on July 4, 1950, followed soon after by programming in Polish, Hungarian, and Bulgarian. Radio Free Europe was followed in 1953 by a second station directed at the Soviet Union, Radio Liberation. This broadcaster, later and better known as Radio Liberty, was backed by another nonprofit front, the American Committee for Liberation. The committee, with offices in midtown Manhattan, had a less august board of Americans and was more secretive; at the first board meeting it was simply announced that the money to finance Radio Liberation would come from the "personal friends of the committee members." The agency decided to give Radio Liberation less obviously patrician backing because it was finding that it was sometimes difficult to command the large egos of the Free Europe Committee. Although both broadcasters were designed to further U.S. foreign policy and security interests, they enjoyed a good deal of autonomy if for no other reason than the CIA was unable to manage two large news organizations. After beginning as somewhat shrill mouthpieces, they settled down and became credible news organizations, particularly after 1956 when Radio Free Europe's role in encouraging the Hungarian revolutionaries, and creating the chimera of impending American intervention, was roundly criticized. Occasionally, secret

167

messages were embedded in broadcasts and some officers used the radio stations as cover. But, for the most part, an American management team oversaw émigré editors with little direct interference from Washington, D.C. There was, in fact, no need to exercise stringent editorial control. The CIA saw the kind of message it wished to direct flow naturally from the routine judgments of the anti-Communist staffs. Radio Liberation acted as a surrogate domestic broadcaster largely focused on what was happening inside the Soviet Union, not around the world.

Radio Free Europe and Radio Liberation broadcast from Munich. The CIA, through the American Committee for Liberation, also established a number of related fronts in Munich such as the Institute for the Study of the Soviet Union and the Central Association of Post-War Émigrés, known by its Russian initials TsOPE. The agency's vast presence in Munich was an open secret. One Radio Liberation employee doubted that there was "a single stoker or sweeper at [broadcast headquarters] who did not have some inkling of the true state of affairs." The KGB called Munich *diversionnyi tsentr*, the "center of subversion."

About one-third of the urban adult population in the Soviet Union listened to Western broadcasts. Aleksandr Solzhenitsyn called it "the mighty non-military force which resides in the airwaves and whose kindling power in the midst of communist darkness cannot even be grasped by the Western imagination." In 1958, the Soviet Union was spending more on jamming Western

signals than it spent on its own domestic and international broadcasting combined.

The Free Europe Committee also established its own publishing unit, the Free Europe Press. It couldn't reach over the Iron Curtain via shortwave but it took to the air in its own way. On August 27, 1951, near the Czechoslovakian border in Bavaria, the FEC released balloons that were carried by the prevailing winds across the frontier. Dignitaries from the United States participated in a ceremony marking the first launch of balloons, including the chairman of the Crusade for Freedom, Harold Stassen; the newspaper columnist Drew Pearson; and C. D. Jackson, a former Time-Life executive, who would become one of Eisenhower's key advisers on psychological warfare. The balloons were designed to burst at 30,000 feet, scattering their cargo of thousands of propaganda leaflets on the land below. "A new wind is blowing. New hope is stirring. Friends of freedom in other lands have found a new way to reach you," read one of those first leaflets, prepared by the Free Europe Press. "There is no dungeon deep enough to hide truth, no wall high enough to keep out the message of freedom. Tyranny cannot control the winds, cannot enslave your hearts. Freedom will rise again."

"We tore a big hole in the Iron Curtain," Stassen told *Time* magazine.

Over the next five years, the FEC launched 600,000 balloons, dropping tens of millions of pieces of propaganda across Eastern Europe, including a letter-size magazine. The Czechoslovakian air force tried to shoot down the

balloons. The United States put an end to the program in 1956 after the government of West Germany began to object to "an extremely worrisome violation of airspace sovereignty from the territory of the Federal Republic." The Czechoslovakian government falsely alleged that a balloon brought down an airplane. One balloon did cause a household fire in Austria. (A housewife overturned a cooking burner after she was startled by a balloon landing on her home.) The program was simply too random and crudely visible.

The agency turned to mailing books.

In April 1956, Samuel S. Walker Jr., the director of the Free Europe Press, called a meeting of the young Americans and Eastern Europeans who worked for him at their offices on West Fifty-seventh Street in Manhattan. On the agenda was a potential new project: mailing books across the Iron Curtain. The Eastern Europeans, who had experience sending packages to their relatives, believed it was plausible to mail propaganda. Others, including one of the Free Europe Committee's leading academic advisers, Hugh Seton-Watson of the University of London, feared that Communist censors would intercept books from the West. The final decision rested with Walker, still in his twenties, a former chairman of the *Yale Daily News* who had abandoned a career at *Time* for the intrigue of the Free Europe Press. "Let's do it," he said. The "friends down south," as the CIA was called, backed a plan that called for mailing books to specific individuals in official positions "to reduce the efficiency of the communist administration by weakening loyalty of

the party and state cadres." That didn't work too well. The first mailings, mostly political articles, some translated, some not, were sent from New York and cities across Europe. Many packages never made it to their intended targets, or were turned in to the authorities. Through trial and error, the book program's developers learned that if they had books shipped directly from a publisher they often got through — even provocative titles such as Albert Camus's *The Rebel*. The Free Europe Press began to send lists of books to a wider audience of Eastern Europeans with an offer that if the recipient made a selection the titles would be mailed at no cost. Eventually, the head of the program, George Minden, a former Romanian refugee, told his staff to concentrate on "providing a minimum basis for spiritual understanding of Western values, which we hope to supply through psychology, literature, the theater and the visual arts. This will take the place of political and other directly antagonizing materials." An early planning memo in 1956 said, "There should be no total attacks on communism . . . Our primary aims should be to demonstrate the superior achievements of the West."

The CIA entity purchased books and rights from major U.S. and European publishers, including Doubleday & Company, Harper & Brothers, Harvard University Press, Faber and Faber, Macmillan Publishing Company, Bertelsmann, and Hachette. All business and invoicing was run through the International Advisory Council, another CIA front with offices on East Sixty-fifth Street.

And some delighted responses found their way back to New York. "We are swallowing them passionately — strictly speaking they are being passed from hand to hand," wrote a student from LØódž in Poland who got copies of works by George Orwell, Milovan Djilas, and Czeslaw Milosz. "They are treated as greatest rarities — in other words, the best of bestsellers." A Polish scholar who received *Doctor Zhivago* wrote, "Your priceless publications will serve not only me but a large group of friends as well . . . and will be treated as [a] sensation!"

Shortly after the Free Europe Press began its mailings in 1956, the CIA, through the American Committee for Liberation, approved a book program for the Soviet Union. The agency funded the creation of the Bedford Publishing Company, another group in New York City, and its plan was to translate Western literary works and publish them in Russian. "The Soviet public, who had been subject to tedious Communist propaganda . . . was starved for Western books," wrote Isaac Patch, the first head of Bedford Publishing. "Through our book program we hoped to fill the void and open up the door to the fresh air of liberty and freedom." An initial CIA grant of $10,000 grew into an annual budget of $1 million. Bedford Publishing opened offices in London, Paris, Munich, and Rome, and in those days when money flowed freely, the staff held their annual meetings at places like Venice's San Giorgio Maggiore. Among the works translated were James Joyce's *Portrait of the Artist as a*

Young Man, Vladimir Nabokov's *Pnin*, and George Orwell's *Animal Farm*.

Rather than mailing books, because the controls were stronger in the Soviet Union than in parts of Eastern Europe, Bedford Publishing concentrated on handing out books to Soviet visitors to the West or placing books with Westerners traveling to the Soviet Union so they could distribute them upon arrival. The company also stocked the U.S. embassy in Moscow with titles. Some miniature paperbacks, printed at CIA headquarters, were on the shelves at Stockmann, the famous Helsinki department store where Westerners stocked up on goods before or during stints in Moscow. Members of the Moscow Philharmonic, who were passed books while on tour in the West, hid them in their sheet music for the trip home. Books were also spirited home in food cans and Tampax boxes.

In its first fifteen years, Bedford distributed over one million books to Soviet readers. The program continued until the fall of the Soviet Union, and across the Eastern Bloc as many as 10 million books and magazines were disseminated. One KGB chief grumbled that Western books and other printed material are "the main wellspring of hostile sentiments" among Soviet students.

While the CIA's literary tastes were broad, they were not indiscriminate. The agency's publishing was guided by both the background of its officers and contractors and their understanding of the mission. The novelist Richard Elman complained that "the CIA has stood foursquare behind the Western Christian traditions of

173

hierarchy, elitism, and antimillennial enlightenment of the benighted and has opposed revolutionary movements in literature as well as politics. It has been a staunch advocate of legitimacy, and it has carefully chosen to subsidize or disseminate the writings of literary artists such as V. S. Naipaul and Saul Bellow who were similarly inclined." This may be somewhat overstated given the breadth and numbers of books sent East, but a full analysis of the CIA aesthetics will remain impossible until it reveals all the titles it subsidized, translated, and disseminated — a list, if it exists, that remains classified.

The CIA chief of covert action boasted in 1961 that the agency could: "get books published or distributed abroad without revealing any U.S. influence, by covertly subsidizing foreign publications or booksellers; get books published which should not be 'contaminated' by any overt tie-in with the U.S. government, especially if the position of the author is 'delicate'; [and] get books published for operational reasons, regardless of commercial viability."

Indeed, the CIA commissioned its own works — as many as a thousand publications — because the "advantage of direct contact with the author is that we can acquaint him in great detail with our intentions; that we can provide him with whatever material we want to include and that we can check the manuscript at every stage." One example was a book by a student from the developing world about his experience studying in a communist country. A reviewer for CBS, who didn't know the book's provenance, said, "Our

propaganda services could do worse than to flood [foreign] university towns with this volume." *The New York Times* reported in 1967 that a book purporting to be the journal of Soviet double agent Col. Oleg Penkovsky in the months before he was exposed and executed was an agency creation. *The Penkovsky Papers*, published by Doubleday, was ghostwritten from CIA files, including agency interviews with Penkovsky, by a *Chicago Daily News* reporter and a KGB defector who worked for the CIA. "Spies don't keep diaries," a former CIA official told *The Times*, backing assertions that the "journal" was at best a clever concoction.

"Books differ from all other propaganda media," wrote the CIA chief of covert action, "primarily because one single book can significantly change the reader's attitude and action to an extent unmatched by the impact of any other single medium . . . this is, of course, not true of all books at all times and with all readers — but it is true significantly often enough to make books the most important weapon of strategic (long-range) propaganda."

The remark was eerily reminiscent of Maxim Gorky's statement at the First Congress of Soviet Writers in 1934: "Books are the most important and most powerful weapons in socialist culture."

CHAPTER
NINE

"We'll do it black."

On March 6, 1958, George Katkov, the Oxford professor overseeing the English translation of *Doctor Zhivago*, visited the American consulate in Munich. He was in the city to give a series of lectures to the staff at Radio Liberation. Katkov told an American diplomat that he had information he wanted passed along to officials "on a high level" in Washington. He said one of the French translators of *Doctor Zhivago* had recently met Pasternak in Moscow, and the writer had told her he didn't want the Russian-language edition to be handled by any publishing firm connected to émigrés. Katkov continued that while Pasternak was "eager to see a Russian edition published abroad," he also didn't want it done in the United States or by U.S.-funded groups.

The consul-general sent a dispatch to the State Department about Katkov's visit: Pasternak "fears serious personal difficulties, however, if a Russian edition is first published in the United States or by some organization abroad which is generally known to have American backing, either official, commercial or private."

176

Katkov said there were no "anti-American implications" to Pasternak's request, only "considerations of personal safety." For the same reason, Katkov said, he would advise against a Russian-language publication in France or England. Katkov suggested Sweden as a neutral publishing venue. Alternatively, he noted that the academic branch of Mouton & Co., a distinguished publishing and printing house in the Netherlands, was already negotiating for the rights to a Russian edition; Pasternak had asked one of his French translators to manage a Russian-language edition and they had a meeting with the Dutch firm in December 1957. And Pasternak was enthusiastic about the possibility. "Don't let the opportunity pass, take it with both hands," he wrote the following month to Jacqueline de Proyart. Pasternak knew that Mouton was a house that specialized in Russian texts but was not connected to any émigré groups.

The consul also reported to Washington that after a preliminary check in Munich there was no indication of any plans by Russian émigrés, or similar groups, to bring out a Russian edition of *Doctor Zhivago*.

In Washington, the dispatch was forwarded to the CIA.

Inside the CIA, covert activities such as the radio stations in Munich and the book programs were normally managed by the International Organizations Division headed by Cord Meyer. But the Soviet Russia Division was also involved in getting books into the hands of Russians under a program code-named AEDINOSAUR, whose activities included the purchase

177

of books to be given to tourists visiting the Soviet Union so that they could casually distribute a handful of copies. (The letters AE designated a Soviet Russia Division operation, and *DINOSAUR* was a randomly generated cryptonym.) After internal discussions, it was decided that the Soviet Russia Division would manage *Doctor Zhivago* under AEDINOSAUR.

The CIA had now received two warnings, from British intelligence and indirectly from Katkov, not to publish the novel in the United States or reveal any American involvement. That ruled out using émigré front organizations in Europe, as they were widely regarded as creatures of American foreign policy even if the CIA's specific role was hidden. The agency decided to use a New York publisher to prepare a Russian-language edition in the United States but take the proofs to Europe for printing so no American paper stock, which would be quickly identified as such in Moscow, would be used. If the European printer obtained the rights from Feltrinelli, all the better. If not, the CIA decided, "we'll do it black."

The CIA selected the 1958 Brussels World's Fair as its target for distributing *Doctor Zhivago*. The 1958 Brussels Universal and International Exposition, the first postwar World's Fair, was already shaping up as a Cold War political battleground. The fair opened on April 17 and would run until October 19, 1958; in all, about 18 million visitors came through the turnstiles. Forty-two nations and — for the first time — the Vatican were participating at the five-hundred-acre site just northwest of central Brussels. Both the United

States and the Soviet Union built huge pavilions to showcase their competing ways of life. And what was especially interesting to the CIA: the fair offered one of those rare occasions when large numbers of Soviet citizens traveled to an event in the West. Belgium issued sixteen thousand visas to Soviet visitors.

"This book has great propaganda value," a memo to all branch chiefs of the CIA Soviet Russia Division stated, "not only for its intrinsic message and thought-provoking nature, but also for the circumstances of its publication: we have the opportunity to make Soviet citizens wonder what is wrong with their government, when a fine literary work by the man acknowledged to be the greatest living Russian writer is not even available in his own country in his own language for his own people to read."

To get *Doctor Zhivago* into the hands of Soviet tourists in Brussels, the agency would have to move quickly. And in its haste, the operation almost collapsed in farce. The CIA's publishing partner in New York — a civilian cleared by the agency's Office of Security for participation in a covert operation — nearly proved to be their undoing.

By 1958, Felix Morrow had made a very New York journey from Communist to Trotskyite to willing Cold Warrior for the CIA. The transformation of the fifty-two-year-old was representative of a larger intellectual migration from left to right among the city's radicals. Their disillusionment with the Soviet Union was first crystallized by the show trials of the old Bolsheviks. Stalin's treachery was confirmed by the

Nazi-Soviet nonaggression pact. With the rise of the Cold War, they drifted, almost ineluctably, into the embrace of the new national security state, which found its ablest agitators among the disillusioned left. One loyal Trotskyite said the "loss of faith" among Morrow and others was caused by "Stalinophobia — abhorrence at Stalinism to the point of seeing it as the principal evil force in the world." Within New York's intellectual life "organized anti-Communism had become . . . an industry," and the CIA was its lavish paymaster. One of the agency's largest front organizations, the American Committee for Cultural Freedom, which supported the Paris-based Congress for Cultural Freedom, was stocked with every shade of ex-Communist. Many years earlier, the American Committee's first chairman, Sidney Hook, had been Morrow's philosophy teacher at New York University; they became lifelong acquaintances. Hook, a former revolutionary Marxist, was a "contract consultant" for the CIA and negotiated directly with CIA director Allen Dulles for committee funding.

When Morrow was facing expulsion from the Trotskyite Socialist Workers Party in 1946, he experienced a moment of disbelief at his imminent apostasy. "You can't expel me; I'll live and die in the movement!" he shouted to the party delegates. Ten minutes later, the ousted Morrow found himself "tripping down the stairs of the convention hall with the greatest sense of glee and freedom."

Morrow was a charming, brilliant man, a former opera singer, and a natural storyteller. He had first

worked as reporter for the *Brooklyn Daily Eagle* when he was sixteen and covered the Depression for the *Daily Worker*. His dispatches were translated into Russian and published in Moscow in 1933 as *Life in the United States in This Depression*.

After his break with the Trotskyite movement, Morrow entered publishing. With the help of Elliot Cohen, the editor of *Commentary*, who would later sit on the board of the American Committee for Cultural Freedom, Morrow got a job at Schocken Books, a well-regarded New York publisher. At Schocken, Morrow quickly rose to the position of vice president. In 1956, he branched out on his own, founding University Books, which specialized in the occult. Morrow was drawn to the subject when he was involved in the publication of the best seller *Flying Saucers Have Landed* in 1953.

Morrow formed contacts with those fighting the Cold War and occasionally lunched with CIA officers he had met through a friend who worked as a CIA consultant. A senior official in the agency's security division periodically visited Morrow at his house in Great Neck, Long Island, just outside the city, always arriving with a bottle of whiskey and a box of chocolates.

In early June 1958, Morrow was asked by a CIA officer if he was interested in preparing *Doctor Zhivago* for publication. The agency told Morrow that it planned to distribute the books in Brussels and asked him to also "make arrangements with anti-Stalinist trade unionists in Amsterdam and Brussels to distribute

181

copies of the book at nominal cost to sailors" on ships bound for the Soviet Union. Morrow thought it "an astonishing and attractive task." And he believed he could get the printing done in Amsterdam, where, he said, the police chief, an ex-Trotskyite, was an old friend of his.

Morrow described himself as an "entrepreneur," and he bargained hard with the CIA for the maximum amount of money, including bonuses. The agency found Morrow's prices high but "probably warranted in view of the time factor." On June 23, 1958, Morrow signed a contract with a private lawyer acting for the CIA. Morrow was provided with a manuscript copy of *Doctor Zhivago* and was told that he would soon be provided with a publisher's note or preface to be included after the title page. The agency wanted a "major literary figure" to write a preface, but a staffer at the Soviet Russia Division also prepared a publisher's note as a backup. Initially, the agency was interested in printing 10,000 copies of the novel. Morrow was required to arrange the layout and design work to prepare the manuscript for typesetting; proofread the typeset copy; and produce two sets of photo-offset reproduction proofs. The contract said he would get an additional bonus for every day he came in before the July 31 deadline. The agency also said it would pay him to investigate where the novel could be printed in Europe and that there would be a separate, second contract for any printing in Europe.

There were signs of trouble from the beginning; Morrow either didn't understand or was unwilling to

comply with the agency's demand for secrecy. Even before he signed a contract, he was discussing the operation with outsiders. At a meeting with a CIA officer on June 19, Morrow said he had already used his contacts to explore printing possibilities in the United States. Morrow had close ties to the University of Michigan Press, where his friend Fred Wieck was the director. Morrow was admonished by the CIA that he had no authority to contact any American publishing house.

Morrow also did not tell the agency that he had "credentialed Russian scholars check both the original and the repros" — an indiscretion that might account for rumors among émigrés in New York that a Russian-language edition was imminent. Moreover, the *Doctor Zhivago* reproductions for the CIA were prepared by Rausen Bros., a printing house in New York that was closely tied to the city's Russian community.

Once the European printing was complete, the CIA told Morrow that he could buy the rights to the Russian-language version of *Doctor Zhivago* from the agency — a deal that would have shocked and astonished Feltrinelli, who believed he had exclusive world rights to the novel, including in Russian, because the novel was not published in the Soviet Union. Morrow, however, was balking at the CIA's terms. In a July 7 letter, he said he couldn't secure a willing European publisher and get the printing done in eight weeks. Instead, he said, he could deliver the books with the imprint of an Amsterdam publisher, but he

suggested that he would actually print them in the United States. Morrow also had a warning for the CIA: If the agency didn't back his plan and buy copies of the novel in bulk, he would simply commandeer the reproduction proofs and take them elsewhere. He informed the CIA that when the operation was over he planned to publish his own edition of *Doctor Zhivago* with the University of Michigan Press. "I can publish anywhere else I please," he told the agency.

The CIA's plans were unraveling. Two weeks later, to the consternation of its officers, the Soviet Russia Division was informed that the University of Michigan Press was planning to publish *Doctor Zhivago* in Russian. Not only that, officials in Washington received an inquiry from the academic press's offices in Ann Arbor about how many copies the government might be interested in purchasing. CIA officers were frantic and immediately wanted to know where and how the university press got its copy of the novel. They suspected that Morrow gave a copy of the manuscript to his friend Fred Wieck and the two had decided to publish the novel in some kind of joint venture.

A week later the CIA got even more of a jolt. The university press made a second inquiry about selling copies of the novel to the government and wanted to know about "the CIA's interest in the book and whether or not the agency was subsidizing the publishing of the book in Europe."

"It appears that [Morrow] in his dealings with [Michigan] has gone entirely too far and may well have committed one or more security violations," thundered

the agency's Commercial Staff. The CIA decided it had to stop the University of Michigan Press, and its opening salvo was to have its lawyer in New York contact Ann Arbor and "bring out the fact that the Italian publisher is prepared to sue anyone publishing the book in Russian."

The academic publisher was unimpressed with the CIA's self-serving argument about Feltrinelli's rights. Lawyers for the University of Michigan had made a legal judgment that no one held the rights to the Russian-language edition of the novel for the United States because there was no treaty with the Soviet Union on copyright. The university publisher informed the CIA it was planning to bring out *Doctor Zhivago* in "five or six weeks or sooner" and refused to reveal the source of its manuscript.

At an internal CIA meeting, the Soviet Russia Division representative argued that the University of Michigan Press should not be allowed to publish "in advance of distribution of that edition being published in Europe under Agency sponsorship. Not only is there the question of reducing the effectiveness of the European edition, but there are also the important factors of protecting liaison services with other agencies involved."

On August 25, an officer from the Soviet Russia Division and a second CIA official flew to Michigan to meet with Harlan Hatcher, the president of the University of Michigan. The Soviet Russia Division officer had been given a series of talking points prepared at headquarters in Washington, a series of

temporary buildings on the south side of the reflecting pool on the National Mall.

The CIA officer told Hatcher that the U.S. government had been "instrumental" in arranging the publication of *Doctor Zhivago* in Russian. "It is felt," the CIA officer told Hatcher, "that to have the greatest psychological impact upon Soviet readers the Russian edition of this book should be published in Europe and not in the United States. To accomplish this, the U.S. government has made certain commitments to foreign governments."

The CIA officer also emphasized that "Pasternak specifically requested that the book not be published in the United States for his personal safety and other reasons. We have made every effort to honor the author's petition." The officer said that the CIA believed the University of Michigan Press got the proofs in "an unorthodox manner" and that they were, in fact, "the property of the U.S. government."

Hatcher was sympathetic and saw no reason why the publication of *Doctor Zhivago* couldn't be delayed at least until after it was published in Europe. The two officers met Wieck, the editorial director, the following day. They asked if they could examine the Michigan copy of *Doctor Zhivago* to compare it against the CIA's page proofs they had brought with them. The comparison was made with a magnifying glass and there was no dispute: they were identical. After some negotiation, the University of Michigan Press agreed to hold off on any announcement of its plans to publish

Doctor Zhivago until the agency's edition appeared in Europe.

All that remained to tidy up was the mess with Morrow. The CIA agreed to a confidential settlement, but not before huffing about the publisher's duplicity. "It is our desire that it be made completely clear to [Morrow] that we are aware of his untrustworthy behavior during our relationship, and that we feel we are being most lenient in our final dealings with him."

When the CIA's difficulties with Morrow began, they prompted the agency to contact the Dutch intelligence service, the Binnenlandse Veiligheidsdienst (BVD). The CIA was already following reports of the possible publication of *Doctor Zhivago* in Russian by Mouton Publishers; a deal between the Dutch house and Feltrinelli appeared likely. Kurt Wolff, Pasternak's American publisher, had also heard rumors of a Mouton edition, and in May Feltrinelli confirmed a deal; Mouton offered to print three thousand copies at a cost of $4,160. The CIA wanted to know from their Dutch allies if it would be possible to obtain an early run of the book from Mouton.

The two intelligence agencies were close. CIA subsidies in 1958 paid for about 50 of the 691 staffers at the BVD, and new Dutch employees were trained in Washington. Joop van der Wilden, a BVD officer was dispatched to the U.S. embassy to discuss the issue with Walter Cini, a CIA officer stationed in The Hague. Cini told him it was a rush job and the agency was willing to pay well and in cash for a small print run of *Doctor Zhivago* — but again there should be no trace

of American involvement or of any other intelligence agency.

The Dutch reported back to Washington that Mouton could complete the work, but would need to get started quickly to meet an early September deadline. The Soviet Russia Division decided around the end of July that it wanted to proceed "along this line provided the details [could] be suitably negotiated." On August 1, the reproduction proofs prepared by Morrow were sent to The Hague.

The BVD decided not to deal directly with Mouton but instead turned to Rudy van der Beek, a retired army major who ran the Dutch branch of an anti-Communist group, Paix et Liberté. Van der Beek's organization published a range of anti-Communist propaganda, including a recent attack on the Soviet pavilion in Brussels. A few days after the proofs arrived, Peter de Ridder, a Mouton Publishers executive, along with one of the company's printers, met with van der Beek in the large marble foyer of a grand town house on Prinsessegracht in the center of The Hague — probably number 27, the headquarters of the Dutch Red Cross, whose president served on the Dutch board of Paix et Liberté. The three men spoke for twenty minutes and van der Beek gave de Ridder the proofs of the novel and guaranteed to buy over a thousand copies.

"There was something mysterious about the encounter," said de Ridder, but he decided to take the deal. De Ridder was never clear about what motivated him. Later in 1958, he told a newspaper reporter for

Haagse Post that van der Beek warned him that if he didn't print the book he would go elsewhere, and de Ridder feared that that would ruin the planned Mouton edition being negotiated with Feltrinelli. De Ridder said he tried to reach the Milanese publisher but was unsuccessful because he was on vacation in Scandinavia.

"I felt the book needed to be published," de Ridder said. He also thought he could get away with it. He calculated that a contract with Feltrinelli was about to be signed, and this was simply an early and lucrative sale that would draw no attention.

In the first week of September, the first Russian-language edition of *Doctor Zhivago* rolled off the printing press, bound in Mouton's signature blue-linen cover. The title page acknowledged the copyright of Feltrinelli with the words in Cyrillic, "G. Feltrinelli — Milan 1958." The name *Feltrinelli*, however, was not correctly transcribed in Russian, missing the soft sign after the *l* and before the *t*. The copyright note was de Ridder's last-minute decision, after a small number of early copies were printed without any acknowledgment of the Italian publisher. The use of Pasternak's full name, including the patronymic *Leonidovich* on the title page, also suggested that the book had been prepared by a non-native speaker; Russians would not use the patronymic on a title page. The book also had a short, unsigned preface, probably the one prepared for Morrow by a CIA staffer.

The books, wrapped up in brown paper and dated September 6, were packed into the back of a large American station wagon, and taken to the home of

Walter Cini, the CIA officer in The Hague. Two hundred copies were sent to headquarters in Washington. Most of the remaining books were sent to CIA stations or assets in Western Europe — 200 to Frankfurt; 100 to Berlin; 100 to Munich; 25 to London; and 10 to Paris. The largest package, 365 books, was sent to Brussels.

Visitors to the Soviet pavilion at the 1958 Brussels Universal and International Exposition first had to climb several flights of steps, as if approaching a great museum. Inside, two large statues of a male and a female worker in classic socialist-realist style greeted them. At the rear of the great central hall, which sprawled over nearly 120,000 square feet, stood a fifty-foot-tall bronze statue of Lenin. The revolutionary leader, his heavy coat draped over his shoulders, watched over Sputnik satellites, rows of agricultural machinery, models of Soviet jetliners, oil-drilling platforms, and coal mines, and exhibits on the collective farm and the typical Soviet kitchen.

The didactic message was clear. The Soviet Union was an industrial power to be reckoned with. After the launch the previous year of Sputnik 1, the first satellite in space, the Russians appeared ascendant. "Socialist economic principles will guarantee us victory" in the contest with capitalism, visitors to the Soviet pavilion were told.

Soviet brawn was also accompanied by a more seductive array of cultural offerings, from the Bolshoi Ballet to the Moscow circus, both at the fairgrounds

and in the center of Brussels. The Soviets were going all out to awe and woo.

Hubert Humphrey, the Democratic senator from Minnesota, harrumphed that "from what we know about Soviet plans there will be scarcely a credible Soviet theater group, ballet artist, musician, singer, dancer or acrobat left in the Soviet Union if his services can be used in Brussels."

The United States was slower to recognize that the Brussels Exposition was a Cold War battlefield. Congress only reluctantly appropriated $13.4 million for an American pavilion, compared with the estimated $50 million the Soviet Union planned to spend. And the organizers were dogged by uncertainty about what to include, and whether the United States should also acknowledge the failings of American society, particularly the mob violence surrounding the desegregation of the public schools in Little Rock, Arkansas, the previous year. A small annex exhibition dealing, in part, with race relations was opened in Brussels but quickly closed after objections from southern congressmen.

The United States pavilion was a massive circular building with floor space to fit two football fields, and its creator, the architect Edward Stone, drew inspiration from the Roman Colosseum. With its translucent plastic roof, the structure was intended to be "very light and airy and crystalline." The organizers decided that America should be sold through "indirection," not "heavy, belabored and fatiguing propaganda." And the pavilion became a celebration of American consumerism and entertainment. There were

several fashion shows every day, square dancing, and a Disney-produced film of American vistas on a 360-degree screen that took viewers from the New York City skyline to the Grand Canyon. There were hot dogs and abstract-expressionist art; a jukebox and copies of a 480-page Sunday *New York Times*. Eisenhower insisted on voting machines, and behind the curtains visitors could choose their favorite president, movie star, and musician.

When Anastas Mikoyan, the first deputy chairman of the Soviet Council of Ministers, visited the U.S. pavilion, he chose Abraham Lincoln, Kim Novak, and Louis Armstrong, although he first asked if he could choose Shostakovich for the last category. Another Soviet visitor, the writer Boris Agapov, a member of the board of *Novy Mir* who had signed the letter rejecting *Doctor Zhivago*, was unimpressed with the American pavilion. "These are all lies ... That is why the character, the general thrust of the American exhibition evokes bewilderment and yet another sentiment, which is shame. It is a disgrace that a talented, creative, and hard-working people is represented as a people of sybarites and thoughtless braggarts."

Doctor Zhivago could not be handed out at the American pavilion, but the CIA had an ally nearby. The Vatican pavilion was called "Civitas Dei," the "City of God." The modernist pavilion was crowned by a gleaming white belfry rising to 190 feet and topped by a large cross. Behind the belfry, the main building swooped toward the ground like a ski jump. Inside there was a church, six small chapels, and exhibition

halls with displays on the papacy and the history of the church. The pavilion was nestled close to both the U.S. and Soviet buildings.

Vatican officials and local Roman Catholics began to prepare for Soviet visitors even before the fair opened. Irina Posnova, the founder of a religious publishing house in Belgium, saw an opportunity to proselytize. Born in Kiev in 1914, Posnova was the daughter of an exiled Orthodox theologian; she converted to Roman Catholicism while attending the Catholic University of Louvain. After World War II, Posnova founded Life with God, a Brussels-based organization that smuggled religious books in Russian into the Soviet Union. Posnova worked with the Vatican's organizing committee to set up a small library "somewhat hidden" behind a curtain just off the pavilion's Chapel of Silence — a place to reflect on the suppression of Christian communities around the world. With the help of Russian-speaking priests and lay volunteers, Life with God handed out religious literature, including bibles, prayer books, and some Russian literature. There was a steady stream of Soviet visitors to the Vatican pavilion, drawn, in part, by the presence of Rodin's sculpture *The Thinker*, which had been loaned by the Louvre for the duration of the fair.

Father Jan Joos, a Belgian priest and secretary-general of the Vatican organizing committee for the Brussels Expo, said three thousand Soviet tourists visited the Vatican pavilion over six months. He described them as from "the leading, privileged classes," such as members of the Academy of Sciences,

scholars, writers, engineers, collective-farm directors, and city mayors.

Agapov also visited the Vatican pavilion and provided one of the few accounts of how Soviet visitors were greeted. He said he was first welcomed by a French-speaking priest who showed him Rodin's sculpture. As they talked, he said, the conversation was interrupted by a "sturdy, sloppily dressed woman" who spoke loudly in Russian and introduced him to another priest. This priest — "Father Pierre" — was about thirty-five, with a rosy complexion, a ginger beard, blue eyes, and breath that smelled of cigars and cognac. He spoke like a native Muscovite.

The priest told Agapov that modern man was confused, and only through the guidance of Christian principles could he find salvation. He led Agapov to the hidden library. Father Pierre explained, "We publish special bulletins, in which we state which movies, radio programs and books to watch and read, and which not to." Agapov noted with some satisfaction that he was reminded of the Index Librorum Prohibitorum, the Catholic Church's list of banned authors and books.

"Except for the gospels and prayer books," Agapov observed, "you can obtain all sorts of brochures and booklets in the 'City of God' in which you can find God knows what about our country, communism, Soviet power — despite the fact that this sort of propaganda is in violation of the Exposition's statute."

And, he continued, "Ladies with pointed noses are selling and distributing this with a 'blessed' smile."

In early September, these priests and ladies starting handing out copies of *Doctor Zhivago* in Russian. Finally, the CIA-sponsored edition of the novel was pressed into the hands of Soviet citizens. Soon the book's blue linen covers were found littering the fairgrounds. Some who got the novel were ripping off the cover, dividing the pages, and stuffing them in their pockets to make the book easier to hide.

A Russian weekly published in Germany by émigrés noted, "We Russians should be grateful to the organizers of the Vatican pavilion. Thanks to their efforts, the greatest contemporary work of Russian literature — Boris Pasternak's novel *Doctor Zhivago*, which is banned there — is able to find its way into the country. More than 500 copies were taken into Russia by common Russian people."

Word of the novel's appearance at the fair quickly reached Pasternak. He wrote in September to his friend Pyotr Suvchinsky in Paris, "Is it true that *Doctor Zhivago* appeared in the original? It seems that visitors to the exhibition in Brussels have seen it."

The CIA was quite pleased with itself. "This phase can be considered completed successfully," read a September 9 memo. And officials at the Soviet Russia Division noted that "as additional copies become available" they would be used "in contact and mailing operations and for travelers to take into the USSR." Walter Cini, the CIA officer in The Hague, sent a copy of the English-language edition of *Doctor Zhivago* as a gift to his BVD colleague Joop van der Wilden. He inscribed it and

signed off with a code name: "In appreciation of your courage and relentless efforts to make the monster squeal in anguish. Voltaire."

There was only one problem: Mouton had never signed a contract with Feltrinelli. The Russian edition printed in The Hague was illegal. The Italian publisher was furious when he learned about the distribution of the novel in Brussels. In a letter to Manya Harari, one of the English translators, on September 18 he wrote, "I have just seen that somebody has printed and published somewhere in Holland under my name (!) an edition of DOCTOR ZHIVAGO in Russian. I must say a rather extraordinary way of proceeding." Feltrinelli hired a detective and sent his lawyer to The Hague "to enquire on the matter and have hell broken out." He threatened to sue both Mouton and van der Beek, whose roles were quickly discovered.

For the CIA, the contretemps generated unwelcome publicity. *Der Spiegel* in Germany followed up on reporting in the Dutch press and identified one of the volunteers at the Vatican pavilion as "Count Vladimir Tolstoy" and said he was associated with the "militant American cultural and propaganda organization which goes under the name of Committee for a Free Europe."

Pasternak apparently read the *Spiegel* article and asked a friend if "one of the publishers of DZ in the original, C(ount) Vladimir Tolstoy," was one of Leo Tolstoy's grandsons. The article would also have alerted Pasternak to the intrigue surrounding its publication in Russian.

★ ★ ★

The American press picked up on the conspiracy. In early November, a *New York Times* books columnist wrote that "during the closing days of the Brussels Fair unknown parties stood before the Soviet pavilion giving copies of *Doctor Zhivago* — in Russian — to those interested. Origin of these copies? Classified."

Mouton held a press conference on November 2, and the company director Fred Eekhout mixed truth and lies to try to put an end to the speculation. He said de Ridder had first accepted delivery of the manuscript from some French person he believed was acting on behalf of Feltrinelli. This was nonsense. Mouton did not want to admit that it had dealt with a known Dutch anti-Communist agitator. The company eventually apologized in print, taking out ads in *The New York Times*, *Corriere della Sera*, *The Times*, *Le Figaro*, and the *Frankfurter Allgemeine Zeitung*, among others, to say that "only owing to a deplorable misunderstanding" had Mouton published *Doctor Zhivago* in Russian.

Posnova's organization was also baldly dissembling. At a press conference held at the Foyer Oriental in Brussels on November 10, Father Antoine Ilc said the organization was invited to a conference in Milan in August and was told by some unnamed professor there that Feltrinelli wanted to print *Doctor Zhivago* in Russian as a gesture of gratitude to the author. Fifteen days later, the priest continued, "a gift of copies of *Doctor Zhivago* reached our residence." The books, he said, came with a note: "For Soviet tourists."

The spies in Washington watched the coverage with some dismay, and on November 15, 1958, the CIA was

197

first linked by name to the printing by the *National Review Bulletin*, a newsletter supplement for subscribers to the *National Review*, the conservative magazine founded by William F. Buckley Jr. A writer using the pseudonym Quincy observed with approval that copies of *Doctor Zhivago* were quietly shipped to the Vatican pavilion in Brussels: "That quaint workshop of amateur subversion, the Central Intelligence Agency, may be exorbitantly expensive but from time to time it produces some noteworthy goodies. This summer, for instance, [the] CIA forgot its feud with some of our allies and turned on our enemies — and *mirabile dictu*, succeeded most nobly . . . In Moscow these books were passed from hand to hand as avidly as a copy of *Fanny Hill* in a college dormitory."

Mouton settled with Feltrinelli. The Dutch publishing house agreed to an "indemnity obligation" to print another five thousand copies for Feltrinelli. The Italian publisher imposed special controls on sales and said he would not permit the Dutch firm to fill any orders that might smell like exploitation of the book by intelligence operatives. Feltrinelli told journalists that he wanted only a small run of books in Russian "so that the 12 or 14 reviewers who are experts in Russian can appraise the literary quality of the work, which I feel is of the highest order."

Pasternak eventually saw a smuggled Russian-language edition of the novel — the Mouton edition printed for the CIA. He was sorely disappointed because it was based on an early uncorrected manuscript. "It abounds with errata," he told Feltrinelli. "This is almost

another text, not the one I wrote," he complained to Jacqueline de Proyart, in a letter in March 1959. He asked her to make a "faithful edition."

Feltrinelli was anxious to end the dispute in the Netherlands because another had arisen in the United States. The University of Michigan announced in October — after the appearance of the Dutch edition but before its agreed deadline with the CIA — that it was moving forward with its own edition. The Italian publisher fired off a letter to Ann Arbor saying, "It is our duty to inform you that Pasternak's *Doctor Zhivago* is protected by international copyright." He followed up with two telegrams before Fred Wieck, in a brusque reply, said, "We would be interested to know on what grounds you claim to hold copyright on the Russian text of this novel in the United States of America."

Kurt Wolff of Pantheon, Pasternak's American publisher for the English edition, sent an indignant letter to Hatcher, the president of the university. Noting the "frightful pressure," Pasternak was facing at home, he wrote, "we witness the amazing spectacle where only two institutions try to deny him his basic rights: the Soviet Writers Union which refuses to allow his book to be published in Russia . . . and the University of Michigan Press which is about to publish his work without his or his agent's permission."

Wolff asked the university "to right the wrong done to a man who cannot defend himself."

Wieck replied that the University believed it was extending a service to students and scholars by refusing

to be bound by Feltrinelli's effort to "extend worldwide the censorship of the Soviet Writers' Union.

"You can see, therefore, why we resent your indictment of the University Press," Wieck continued, "and your placing of its procedures in the same category with those of the Soviet Writers Union." Wieck, however, said he was willing to compromise and suggested that Wolff use his influence to secure a license for Michigan from Feltrinelli to avoid having the matter settled in court. Agreement was reached and a University of Michigan edition appeared in January 1959 based on the CIA proof obtained from Morrow.

The CIA concluded that the printing was, in the end, "fully worth trouble in view obvious effect on Soviets," according to a cable sent by Allen Dulles, the agency director. By November 1958, according to a report in *Encounter*, a CIA-sponsored journal, "copies of an unexpurgated Russian edition of *Doctor Zhivago* (published in Holland) have already found their way to the U.S.S.R. Their reported price on the black market is 200–300 rubles."

That was almost a week's wages for a worker and a very steep price for a book in Moscow, but by then the Swedish Academy had awarded the Nobel Prize in Literature to Pasternak, and Muscovites were clamoring to get their hands on *Doctor Zhivago*.

CHAPTER
TEN

"He also looks the genius: raw nerves,
misfortune, fatality."

On October 22, 1958, Max Frankel, Moscow correspondent for *The New York Times*, rushed out to Peredelkino to speak to Pasternak after the newspaper learned that the author of *Doctor Zhivago* seemed all but certain to win the Nobel Prize in Literature. The announcement was expected the following day. The dacha was crowded and Pasternak was surrounded by about a dozen friends. The gathering turned into a celebration with Frankel's news. There was a note of sedition in the air, and the reporter found himself running to the toilet to take furtive notes on some of the incendiary, alcohol-fueled remarks he was hearing. Buoyed by the atmosphere, Pasternak was forthright about the novel's genesis and message: "This book is the product of an incredible time. All around, you could not believe it, young men and women were being sacrificed up to the worship of this ox . . . It was what I saw all around that I was forced to write. I was afraid only that I would not be able to complete it."

Pasternak's anticipation of the honor that Akhmatova believed he wanted "more than anything" — the Nobel Prize — was tinged with some trepidation — a shudder

before the ordeal that was about to unfold. "You will think me immodest," he told Frankel. "But my thoughts are not on whether I deserve this honor. This will mean a new role, a heavy responsibility. All my life it has been this way for me. One moment after something happens to me it seems as though it had always been that way. Oh, of course, I am extremely happy, but you must understand that I will move immediately into this new lonely role as though it had always been that way."

The Nobel Prize in Literature is awarded by the Swedish Academy — a bequest of Alfred Nobel, the Swedish industrialist and inventor of dynamite, who said that the award should go to "the person who shall have produced in the field of literature the most outstanding work of an idealistic nature." The academy was founded in 1786 by King Gustav III as a small institute to promote the Swedish language and its literature — "to work for the purity, vigor and majesty of the Swedish Language, in the Sciences as well as in the Arts of Poetry and Oratory." It also supervises various linguistic working groups on orthography and grammar and projects such as the historical Swedish Academy dictionary of the Swedish language.

After some internal debate about the effect on its fundamentally parochial mission, the academy accepted Nobel's bequest and came to house the most prestigious international prize in literature. The eighteen members of the Swedish Academy appoint the Nobel Committee, a working group of four or five people from its own ranks. The committee solicits

nominees from literary groups and academics around the world, evaluates nominees, and presents a shortlist to the full academy for a final vote. Along with its global prestige, the prize in 1958 carried the princely sum of 214,599.40 Swedish kronor, approximately $41,000.

Pasternak was first nominated in 1946, and he became a serious candidate in 1947 when the Nobel Committee asked the Swedish academic Anton Karlgren to write a detailed report on his work. Karlgren noted that Pasternak was the first Soviet writer to be considered by the academy; the émigré Russian writer Ivan Bunin had won the prize in 1933, but he spurned Moscow's offers to return home and embrace the Communist state. Largely focusing on Pasternak's poetry, Karlgren was not entirely positive and described the writer as often inaccessible to the ordinary reader. But Pasternak, he said, was regarded as the leading Russian poet by the most discerning Western critics. He added that in his prose Pasternak demonstrated the ability to seize upon "the most secret movements of the spirit," and compared him to Proust.

Pasternak was considered every year for the Nobel Prize from 1946 to 1950. In 1954, the year Ernest Hemingway won, Pasternak believed he had been nominated again — although he was not. Pasternak said in a letter to his cousin that he was pleased "to be placed side by side, if only through a misunderstanding, with Hemingway." She replied that "never has dynamite led to such happy consequences as your candidacy for the throne of Apollo."

Pasternak was finally shortlisted in 1957, the year Albert Camus won the Nobel. In a lecture at the University of Uppsala on December 14, 1957, a few days after he accepted the prize, Camus spoke of the "great Pasternak" and opened a year of speculation that Pasternak's moment had now arrived. Although he yearned for the honor, Pasternak understood his candidacy was fraught with political peril. Four days after Camus spoke in Sweden, Pasternak wrote to his sister Lydia in Oxford. "If, as some people think, I'm awarded the Nobel Prize in spite of Soviet protests, then I'll probably be subjected to every kind of pressure here to refuse it. I think I have enough resolution to resist. But they may not allow me to travel to receive it."

By the February 1958 deadline, Pasternak was separately nominated by Renato Poggioli and Harry Levin, professors at Harvard, and Ernest Simmons of Columbia University. Poggioli was the only one of the three who had actually read *Doctor Zhivago*, and he said the novel was "modeled on *War and Peace*, and unquestionably is one of the greatest works written in the Soviet Union where it cannot appear for that reason."

Simmons wrote of Pasternak's "fresh, innovative, difficult style, notable for its extraordinary imagery, elliptical language and associative method. Feeling and thought are wonderfully blended in his verse that reveals a passionately intense but always personal vision of life. His prose likewise is highly poetic, perhaps the most brilliant prose to emerge in Soviet literature, and

in fiction, as in his long short story, "Detstvo Lyuvers" [The Childhood of Luvers], he displays uncanny powers of psychological analysis ... One can characterize Pasternak's literary flavor by describing him as the T. S. Eliot of the Soviet Union."

Levin told the Swedish Academy, "In a world where great poetry is unquestionably increasingly rare, Mr. Pasternak seems to me one of the half-dozen first-rate poets of our own time ... Perhaps the most extraordinary fact about his career is that, under heavy pressures forcing writers to turn their words into ideological propaganda, he has firmly adhered to those esthetic values which his writing so richly exemplifies. He has thus set an example of artistic integrity well deserving of your distinguished recognition."

The publication of *Doctor Zhivago* in Milan gave new weight to Pasternak's standing in Stockholm. Anders Österling, the permanent secretary of the Swedish Academy, read the Italian edition and also compared the novel to *War and Peace.* On January 27, 1958, he wrote a review of *Doctor Zhivago* in the newspaper *Stockholms-Tidningen*, and his glowing assessment was an important if not decisive early endorsement: "A strong patriotic accent comes through but with no trace of empty propaganda. With its abundant documentation, its intense local color and its psychological frankness, this work bears convincing witness to the fact that the creative faculty in literature is in no sense extinct in Russia. It is hard to believe that the Soviet authorities might seriously envisage forbidding its publication in the land of its birth."

Doctor Zhivago had immediately generated headlines in Europe and the United States. The press focused on what they saw as its anti-Communist flavor and the efforts to suppress it by the Kremlin and the Italian Communist Party. *The New York Times*, in a piece on November 21, 1957, reproduced some of the more damning quotes uttered by characters about Marxism, collectivization, and the failure of the revolution to achieve its ideals. A few days later, *Le Monde* said the novel could have been another achievement for the Soviet Union if not for the country's inept censors. And *The Observer* in London wondered, "What are they afraid of?" The articles were translated for the Central Committee, but the Kremlin kept its silence on the publication of the novel, deciding that there was no advantage in any further statements after Surkov's failed mission to Italy. There was also some measure of self-deception. Polikarpov even suggested in one note to his colleagues, including the Politburo member Yekaterina Furtseva, that the novel didn't get a lot of attention in Italy and the efforts of those who wanted to organize an anti-Soviet sensation had failed.

Some of the continent's major writers as well as Russian scholars were weighing in on the book. They expressed some qualms about Pasternak's mastery of the novel as a form, but were still absorbed by its world, and the sensations it stimulated. In a long essay entitled "Pasternak and the Revolution," Italo Calvino wrote that "halfway through the twentieth century the great Russian nineteenth century novel has come back to haunt us, like King Hamlet's ghost." Calvino argued

that Pasternak "is not interested in psychology, character, situations, but in something more general and direct: *life*. Pasternak's prose is simply a continuation of his verse." He wrote that Pasternak's "objections to Soviet communism seem . . . to move in two directions: against the barbarism, the ruthless cruelty unleashed by the civil war" and "against the theoretical and bureaucratic abstractions in which the revolutionary ideals become frozen."

In *The Dublin Review*, Victor Frank, the head of the Russian service at Radio Liberation and the son of the Russian philosopher Semyon Frank, who was expelled from the Soviet Union by Lenin, also concluded that Pasternak is "not really at home in prose." He still found the novel "a truly great and a truly modern piece of art.

"What makes the novel look as odd as an Aztec temple in a row of glum tenement blocks is its supreme indifference to all the official taboos and injunctions of modern Soviet literature. It is written as if the Communist Party line on art did not exist. It is written by a man who has preserved and deepened his freedom — freedom from all external restraints and all internal inhibitions."

Pasternak followed the novel's reception in the West, and the anti-Soviet complexion of some of the coverage. He argued that if the Soviet authorities would just issue the novel "in an openly censored form it would have a calming and soothing effect on the whole business. In the same way, Tolstoy's *Resurrection* and many other of our books published here and abroad

before the revolution came out in two sharply different forms; and no one saw anything to be ashamed of and everyone slept peacefully in their beds, and the floor did not give way under them." The idea of publication was now anathema, and after the novel's appearance in Italy, Surkov, in a speech in Moscow, attacked efforts "to canonize" Pasternak's works.

Pyotr Suvchinsky, a Russian friend of Pasternak's living in Paris, wrote to him to tell him about the Italian translation. "The reviews were enthusiastic; they all agreed that this novel was of world significance. All of a sudden, a hidden Russia and Russian literature came back to life for everyone. I read your 'romanza' in Italian with a dictionary. So many questions came up!"

Noting the Cold War tone in some articles, Suvchinsky added: "It is, of course, annoying, unforgivable and stupid that the American blockheads are making a political case out of it. That makes no sense at all." Pasternak, too, was distressed by any reduction of his novel to something akin to a political pamphlet indicting his home country. "I deplore the fuss now being made about my book," he said in late 1957. "Everybody's writing about it but who in fact has read it? What do they quote from it? Always the same passages — three pages, perhaps, out of a book of 700 pages."

The year 1958 began badly for Pasternak. In late January, he developed a blockage in his bladder. He was running a high temperature and experiencing sometimes violent pain in his leg. His family was unable

to get him the proper treatment; the previous year the writers' union had decreed that Pasternak was "unworthy of a bed in the Kremlin Hospital." His wife gave him mustard baths and a nurse fitted him with a catheter at home. Pasternak's neighbor Kornei Chukovsky visited him on February 3. Pasternak was exhausted, but seemed at first to be in good spirits. His neighbor noted that he was reading Henry James and listening to the radio. All at once, he seized Chukovsky's hand and kissed it. "There was terror in his eyes," recalled Chukovsky.

"I can feel the pain coming back. It makes me think how good it would be to . . . ," said Pasternak.

He didn't utter the word *die*.

"I've done everything I meant to in my life," Pasternak continued. "It would be so good."

Chukovsky was infuriated that "nobodies and lickspittles," as he called them, "scorned by one and all [could] command luxurious treatment at the drop of a hat, while Pasternak [lay] there lacking the most basic care."

Chukovsky traveled into Moscow and he and other friends pleaded with the authorities to have Pasternak hospitalized. A bed was eventually found in the Central Committee Clinic and an ambulance was dispatched to his dacha. Zinaida dressed her husband in his fur hat and coat. Some workers cleared the snow from the front door to the street, and Pasternak was carried on a stretcher to the waiting ambulance. He blew kisses as he passed his worried friends.

Pasternak spent a couple of months in treatment and convalescing. He was unable to work with any consistency and spent much of his time answering the admiring letters that began to arrive in increasing numbers from abroad. There was time to reflect on the achievement of having written *Doctor Zhivago*. "More and more does fate carry me off nobody knows where and even I have only a faint idea where it is," he wrote to a Georgian friend. "It is most probable that only many years after my death will it become clear what were the reasons, the great, the overwhelmingly great reasons that lay at the foundation of the activity of my last years, the air it breathed and drew sustenance from, what it served."

Pasternak came home in April and Lydia Chukovskaya saw him at her father's house. "My first impression was that he looked great: tanned, wide-eyed, youthful, grey, handsome. And possibly because he was so handsome and young, the mark of tragedy that had been on his face over the last years stood out even more. No weariness, no aging, but Tragedy, Fate, Doom." Her father concurred and thought Pasternak "cut a tragic figure: twisted lips, tieless . . . but he also looks the genius: raw nerves, misfortune, fatality."

Excitement about the novel continued to build abroad as translations into other languages neared completion. In February 1958, Kurt Wolff, the head of Pantheon Books, which was planning to publish *Doctor Zhivago* in the United States, wrote to Pasternak to introduce himself. He told Pasternak that he had only been able to read the novel in full in Italian as the

210

English translation was still in progress. "It is the most important novel I have had the pleasure and honor of publishing in a long professional career," wrote Wolff. The German-born publisher reminisced about his time as a student in Marburg, a year before Pasternak attended in 1912. "It would be nice to chat about all this and more — perhaps there will be an opportunity in Stockholm toward the end of 1958." Pasternak replied, "What you write about Stockholm will never take place, since my government will never give permission for me to accept any kind of award."

The French edition of *Doctor Zhivago* was published in June 1958. When Pasternak saw a copy of it, he burst into tears. He wrote to de Proyart to say that "the publication of *Doctor Zhivago* in France, the remarkable personal letters, dizzying and breathtaking, which I have received from there — this is a whole novel in itself, a special kind of experience which creates a feeling of being in love."

Camus wrote to Pasternak that month, and enclosed a copy of his lecture in Uppsala. "I would be nothing without 19th century Russia," he said. "I re-discovered in you the Russia that nourished and fortified me."

Doctor Zhivago was published in Britain and the United States in September. In a long review in *The New York Times Book Review*, Marc Slonim was hugely enthusiastic: "To those who are familiar with Soviet novels of the last twenty-five years, Pasternak's book comes as a surprise. The delight of this literary discovery is mixed with a sense of wonder: that Pasternak, who spent all his life in the Soviet

211

environment, could resist all the external pressures and strictures and could conceive and execute a work of utter independence, of broad feeling and of an unusual imaginative power, amounts almost to a miracle." Publication in Germany followed in early October, and in the *Frankfurter Allgemeine Zeitung*, the critic Friedrich Sieburg said, "this book has come to us like a refugee, or rather, like a pilgrim. There is no fear in it and no laughter, but certainty of the indestructability of human kind as long as it can love."

The notices were largely but not entirely positive. The daily reviewer for *The New York Times*, Orville Prescott, said the novel was merely "a respectable achievement."

If it were written by a Russian émigré, or by an American or English author who had done a lot of conscientious research, *Doctor Zhivago* would be unlikely to cause much stir." Speaking on the BBC, E. M. Forster said he thought the novel was overrated. "It quite lacks the solidity of *War and Peace*. I don't think Pasternak is really very interested in people. The book seems to me to be most interesting for its epic quality."

Although the Kremlin had made no statements following the publication of the novel in Italy, official hostility toward Pasternak endured. When Surkov met the British journalist and politician R. H. S. Crossman in the summer, he defended the banning of the novel. "In your bourgeois society, so-called freedom is conceded not only to Shakespeare and to Graham Greene but to pornography. We see nothing immoral

about forbidding publishers to print horror comics or damaging novels. Pasternak is a peculiar fellow. Some of his most distinguished colleagues tried to persuade him that the end of the novel was wrong, but he wouldn't accept their advice. Officially, he is a member of our union but spiritually he is anti-social, a lone wolf."

When Crossman remarked that many great writers were peculiar, including Nietzsche, Surkov shook his fist and shouted: "Yes, and we would have banned Nietzsche and in that way prevented the rise of Hitlerism."

Crossman noted that he was arguing about a novel he hadn't read.

"But *Doctor Zhivago* is notorious," Surkov angrily replied. "Everyone is talking about it."

"Everyone in Moscow?" replied Crossman with a little glee.

The attention Pasternak had received in the West not only brought fan mail, but letters from domestic critics. One writer from Vilnius, the capital of the Soviet Republic of Lithuania, told him, "When you hear the hired assassins from the Voice of America praise your novel, you ought to burn with shame." Fyodor Panfyorov, the editor of the literary journal *Oktyabr* (October), aggressively suggested to Ivinskaya that Pasternak go to Baku and write about the construction of oil rigs in an effort to redeem himself.

In April, Georgi Markov, a senior member of the writers' union, returned from an official trip to Sweden. He informed his colleagues that the Swedish

intelligentsia and press were constantly discussing Pasternak and *Doctor Zhivago*. Markov passed along the rumor that potential candidates for the Nobel Prize included Pasternak, the Italian novelist Alberto Moravia, the American writer Ezra Pound, and Mikhail Sholokhov, the author of *And Quiet Flows the Don*. Sholokhov was Khrushchev's brother-in-law and a favored author of the Kremlin. His novel was held up as a model of socialist realism and was one of the most-read books in the Soviet Union. Moscow had pressed his nomination in previous years. Citing Swedish writers close to the academy, Markov said there was also some discussion about Pasternak and Sholokhov sharing the prize, and there was precedent for two writers winning the Nobel in the same year. "Wanting justice to be served and Sholokhov to win, our Swedish comrades believe that the struggle to support Sholokhov should be intensified," Markov wrote.

Dmitri Polikarpov, who along with Surkov had led the efforts to suppress the novel's publication in Italy the previous year, urged his comrades to go on the offensive to oppose Pasternak's candidacy. In a memo for the Central Committee, Polikarpov suggested that the newspapers *Pravda*, *Izvestiya*, and *Literaturnaya Gazeta* should immediately run articles about Sholokhov's writing, and his public activities. (Sholokhov was a member of the Supreme Soviet of the USSR, the country's highest legislative body.) Polikarpov said that the newspapers should also emphasize that Sholokhov, who had written nothing of note in years, had just

214

completed the second volume of *Virgin Soil Upturned.* The first volume had come out in 1932.

Polikarpov also wanted the Soviet embassy in Stockholm to reach out to its contacts in the arts in Sweden and explain to them that selecting Pasternak would be "an unfriendly act." A few days later, the novelist and former war correspondent Boris Polevoi wrote to warn the Central Committee that the West might attempt to create an anti-Soviet "sensation" out of the Nobel Prize, and use it to stress the "lack of freedom of speech in the Soviet Union" and to claim there is "political pressure on certain authors." Polevoi recognized Pasternak's literary gifts but regarded him as alien to Soviet letters — "a man of immense talent; but he's a foreign body in our midst."

The Swedish Academy had experienced and rejected Soviet pressure before. In 1955, Dag Hammarskjöld, a member, wrote to a colleague, "I would vote against Sholokhov with a conviction based not only on artistic grounds and not only as an automatic response to attempts to pressure us, but also on the ground that a prize to a Soviet author today, involving as it would the kind of political motivations that would readily be alleged, is to me an idea with very little to recommend it."

Any efforts on Sholokhov's behalf failed again. The academy shortlisted three candidates for consideration: Pasternak; Alberto Moravia; and Karen Blixen (pen name Isak Dinesen), the Danish author who wrote *Out of Africa* in 1937.

215

By mid-September, Yekaterina Furtseva was requesting potential responses in the event that Pasternak won. Remarkably, Polevoi and Surkov said that *Doctor Zhivago* should be quickly published in a small edition of 5,000 to 10,000 copies that would not be sold to the general public but would be distributed to a select audience. They argued that such a printing would "make it impossible for the bourgeois media to make a scandal."

The proposal was rejected because the head of the Central Committee's culture department concluded that the Western press would make a scandal whether the book was published or not. Moreover, he feared, if the novel was published in the Soviet Union, it almost certainly would appear in other Eastern Bloc countries where it was also banned.

Instead, Polikarpov and other members of the Central Committee formulated a series of measures to be followed if the Swedish Academy took the "hostile act" of awarding the prize to Pasternak. Mikhail Suslov, the Kremlin's éminence grise and chief ideologist, signed off on the proposals.

The campaign to vilify the author began to take shape: The 1956 *Novy Mir* rejection letter should be published in *Literaturnaya Gazeta*. *Pravda* should run a "satirical article" denouncing the novel and "unveiling the true intentions of the bourgeois press's hostile campaign around the awarding of the Nobel Prize to Pasternak." A group of prominent Soviet writers should issue a joint statement that the award was an effort to ignite the Cold War. Finally, Pasternak should be told

to refuse the Nobel, "since the award does not serve the interests of our Motherland."

In the summer, Pasternak was visited in Peredelkino by the Swedish critic Erik Mesterton, who was an expert for the academy. The two discussed the Nobel Prize and any risk the award might entail for Pasternak. Mesterton also met Surkov and when he returned to Sweden he told Österling that the prize could be awarded to Pasternak despite the political shadow over the author in Moscow. Pasternak mistakenly believed that the Swedish Academy would not make him the laureate without the approval of the Soviet authorities — and that, he thought, would never be forthcoming. He continued to meet other Swedish visitors and told them that he "would have no hesitation about receiving the prize." Pasternak continued to stress the eternal values in his work and his distance from the polemics of the Cold War. "In this era of world wars, in this atomic age . . . we have learned that we are the guests of existence, travellers between two stations," he told Nils Åke Nilsson, another Swedish academic close to the academy. "We must discover security within ourselves. During our short span of life we must find our own insights into our relationship with the existence in which we participate so briefly. Otherwise, we cannot live!"

Pasternak occasionally seemed hesitant about the growing speculation, telling his sister, "I wish this could happen in a year's time, not before. There will be so many undesirable complications." He sensed that the

political threat to his position was only "temporarily eased" and that official silence masked seething hostility.

These concerns were mostly private. With the foreign visitors who alighted at his door, he was as voluble as ever, and he could appear supremely indifferent to the probability that he was being closely monitored. "He several times referred to the Soviet way of life with a grin and an airy wave in the direction of his windows as *vsyo eto:* 'all that,'" the British scholar Ronald Hingley recalled. When Hingley told Pasternak that he was nervous about a lecture he had to give at Moscow University, Pasternak dismissed his fears: "Never mind that; let them look at a free man." But when Hingley and Pasternak, who were chatting in the writer's upstairs study, saw a black sedan slowly and repeatedly pass the house, Pasternak stiffened.

Russian friends feared for him. Chukovsky warned Pasternak against attending a poetry evening at the Writers House because he feared that some of those in attendance "will turn the reading into a riot — just what Surkov wants." At an evening event of Italian poetry that fall, Surkov was asked why Pasternak was not present. Surkov told the audience that Pasternak had written "an anti-Soviet novel against the spirit of the Russian Revolution and had sent it abroad for publication."

In September, Österling argued before the academy that it should choose Pasternak, and not worry about any political fallout. "I strongly recommend this

candidacy and think that if it gets the majority of the votes, the Academy can make its decision with a clear conscience — regardless of the temporary difficulty that Pasternak's novel, so far, cannot appear in the Soviet Union."

In a last-minute bid to postpone the award for at least a year, Pasternak's German friend the poet Renate Schweitzer wrote to the Swedish Academy on October 19 and enclosed a page from a letter Pasternak had sent her. In it, Pasternak said that "one step out of place — and the people closest to you will be condemned to suffer from all the jealousy, resentment, wounded pride, and disappointment of others, and old scars on the heart will be reopened." Schweitzer implored the committee to delay making an award to Pasternak for a year. Österling circulated the letter within the academy just before the final vote, but he told the members that the purported letter by Pasternak was not signed and, in any case, contradicted what Mesterton and Nilsson told him after they visited Pasternak during the summer.

The academy vote for Pasternak was unanimous. But in a nod to political sensitivities in Moscow, the citation that was agreed to did not mention *Doctor Zhivago*. The final language naming Pasternak said: "For his notable achievement in both contemporary poetry and the field of the great Russian narrative tradition." But *Doctor Zhivago* was singled out in Österling's official remarks: "It is indeed a great achievement to have been able to complete under difficult circumstance a work of

such dignity, high above all political party frontiers and rather apolitical in its entirely human outlook."

At 3:20p.m. on October 23, 1958, Österling entered the sitting room of the Nobel Library in Stockholm and announced to the waiting press: "It's Pasternak."

CHAPTER
ELEVEN

"There would be no mercy, that was clear."

Wearing an overcoat and his old cap, Pasternak was walking in driving rain in the woods near his dacha on the afternoon of October 23 when a group of journalists who had come out from Moscow found him. The newsmen asked for his reaction to Österling's announcement, and his pleasure was obvious. "To receive this prize fills me with great joy, and also gives me great moral support. But my joy today is a lonely joy." He told the reporters there was little more he could say as he had yet to get any official notification of the Swedish Academy's decision. He seemed flushed and agitated. Pasternak told the correspondents that he did his best thinking while walking, and he needed to walk some more.

Pasternak got further confirmation that the prize was his when Zinaida came home from Moscow, where she and Nina Tabidze had been shopping. They had run into a friend of Tabidze's in the city who told them she had heard about the prize on the radio. Zinaida was shocked and upset, fearing a scandal.

That night, at around 11:00, Pasternak's neighbor, Tamara Ivanova, received a phone call from Maria Tikhonova, the wife of the secretary of the writers'

union, who told her that Pasternak had won the prize. Ivanova was thrilled. Tikhonova, aware of the unease in official circles, said it was too early to get excited, but said Ivanova should alert Pasternak, who didn't have a phone. Ivanova roused her husband, Vsevolod, who got up and put on a housecoat and a winter coat over his pajamas, and the two of them padded over to Pasternak's house. Nina Tabidze let them in and a delighted Pasternak emerged from his study. While Tabidze opened some wine, Tamara Ivanova went to Zinaida's bedroom to tell her the news. Pasternak's wife refused to get up. She said she didn't expect anything good would come of the prize.

The first official Soviet reaction was muted and condescending. Nikolai Mikhailov, the Soviet minister of culture, said he was surprised by the award. "I know Pasternak as a true poet and excellent translator, but why should he get the prize now, dozens of years after his best poems were published?" He told a Swedish correspondent in Moscow that it would be up to the writers' union to decide if Pasternak would be allowed to receive the prize.

The Ivanovs got another call the following morning, Friday the twenty-fourth. They were told to tell Konstantin Fedin, Pasternak's other next-door neighbor, that Polikarpov was on his way out from Moscow. The Central Committee had earlier decided that Fedin had some influence with Pasternak and he should relay the Kremlin's decision that he must refuse the Nobel Prize. Polikarpov came directly to Fedin's house, gave him his instructions, and told him he would wait for him to

return with Pasternak's response. From their window, the Ivanovs watched Fedin hurry up the path to Pasternak's door. When Fedin came in, Zinaida was baking. It was her name day, and her mood had improved over the previous night; she was now considering what she might wear in Stockholm at the awards ceremony. But Fedin ignored her and went directly up to Pasternak's study. He told Pasternak it was an official, not a friendly, call. "I'm not going to congratulate you because Polikarpov is at my place and he's demanding that you renounce the prize."

"Under no circumstances," said Pasternak.

They argued loudly for a few more minutes, and a report to the Kremlin stated that Pasternak was very aggressive and "even said, 'They can do whatever they want with me.'" Pasternak finally asked for some time to think things over, and Fedin gave him two hours. Polikarpov, infuriated by the delay, returned to Moscow. Fedin sent a message to Polikarpov later to say that Pasternak never showed up with an answer. "That should be understood as his refusal to make a statement," Polikarpov told his superiors.

After Fedin left, Pasternak walked over to Vsevolod Ivanov's house to talk about Fedin's ultimatum. He appeared hurt and offended by the visit.

"Do what seems right to you; don't listen to anyone," his neighbor told him. "I told you yesterday and I say it again today: You're the best poet of the era. You deserve any prize."

"In that case I will send a telegram of thanks," Pasternak declared.

"Good for you!"

Kornei Chukovsky heard about the award from his secretary, who was "jumping for joy." Chukovsky grabbed his granddaughter Yelena and rushed over to congratulate Pasternak. "He was happy, thrilled with his conquest," Chukovsky recalled. "I threw my arms around him and smothered him with kisses." Chukovsky proposed a toast, a moment that was captured by some of the Western and Russian photographers who had already arrived at the dacha. (Fearful that his embrace of Pasternak could compromise him, Chukovsky, the victim of an earlier slander campaign that traumatized him, later prepared a note for the authorities explaining that he was "unaware that *Doctor Zhivago* contained attacks on the Soviet system.")

Pasternak showed Chukovsky some of the telegrams he had received — all from abroad. Several times, Zinaida said aloud that the Nobel Prize was not political and not for *Doctor Zhivago*, as if she could wish away her sense of danger. She also worried that she would not be allowed to travel to Sweden and whispered quietly to Chukovsky: "Kornei Ivanovich, what do you think? . . . After all, they have to invite the wife too."

When the photographers left, Pasternak went up to his study to compose a telegram for the Swedish Academy. Later in the afternoon, he sent it: "Immensely grateful, touched, proud, astonished, abashed. Pasternak."

When he was finished writing, he walked for a short while with Chukovsky and his granddaughter. He told them he wouldn't be taking Zinaida to Stockholm.

After leaving Pasternak, Chukovsky called on Fedin, who told him, "Pasternak will do us all great harm with all of this. They'll launch a fierce campaign against the intelligentsia now." In fact, Chukovsky was soon served with a notice to attend an emergency meeting of the writers' union the following day. A courier was going house to house in Peredelkino with summonses for the writers in the village — each understood the public indictment that was to come and felt again Stalin's shadow. After Vsevolod Ivanov received his notification, he collapsed and his housekeeper found him lying on the floor. He was diagnosed with a possible stroke and was bedridden for a month.

When the courier arrived at Pasternak's house, the writer's "face grew dark; he clutched at his heart and could barely climb the stairs to his room." He began to experience pain in his arm which felt as if it "had been amputated."

"There would be no mercy, that was clear," Chukovsky wrote in his diary. "They were out to pillory him. They would trample him to death just as they had Zoshchenko, Mandelstam, Zabolotsky, Mirsky and Benedikt Livshits."

Chukovsky proposed that Pasternak go see Yekaterina Furtseva, the only woman in the Politburo, and tell her that the novel had been taken to Italy against his wishes and that he was upset by all the "hullabaloo

surrounding his name." Pasternak asked Tamara Ivanova whether he should write a letter to Furtseva. His neighbor thought it was a good idea. "Well, because, after all, she is a woman."

Dear Yekaterina Alekseyevna,

It always appeared to me that Soviet man can be something other than they want to let me believe, more alive, open to debate, free and daring. I do not want to abandon that idea and I am prepared to pay any price to stay true to it. I thought the joy of receiving the Nobel Prize would not be mine alone, but would be shared with the society which I am part of. I think the honor is granted not only to me, but to the literature to which I belong, Soviet literature, and to which, with my hand on my heart, I have contributed a thing or two.

However great my differences with these times may be, I would not want them to be settled with an axe. Well then, if it seems right to you, I am willing to endure and accept everything. But I would not want that willingness to look like a provocation or impudence. Quite the contrary, it is an obligation of humility. I believe in the presence of higher forces on earth and in life, and heaven forbids me to be proud and presumptuous.

B. Pasternak.

When he read it, Chukovsky was dismayed by the references to God and the heavens, and fled Pasternak's house in despair.

At some point in the afternoon, Pasternak also visited Ivinskaya at the "Little House." He probably brought over the letter to Furtseva, which was never sent and was found much later among Ivinskaya's papers. Like Chukovsky, she would have realized that this was not the act of contrition the authorities were looking for. Pasternak also told her about the telegram he had sent to Stockholm and was in an agitated state, turning over what Fedin had demanded. "What do you think, can I say I repudiate the novel?" He didn't really want an answer. Ivinskaya felt he was having a prolonged dialogue with himself.

The Kremlin regarded the reaction in the West to the award as entirely predictable. The despised Radio Liberation announced that it would immediately begin broadcasting the text of *Doctor Zhivago*; it was ultimately directed not to by the CIA for copyright reasons. In the American and European press, Pasternak was celebrated as a nonconformist facing down an oppressive system. In an official response to Österling, the Soviet Ministry of Foreign Affairs noted his remarks about *Doctor Zhivago* and wrote: "You and those who made this decision focused not on the novel's literary or artistic qualities, and this is clear since it does not have any, but on its political aspects since Pasternak's novel presents Soviet reality in a perverted way, libels the socialist revolution, socialism and the Soviet people." The ministry accused the

academy of wanting to intensify the Cold War and international tension.

The full fury of the authorities was about to be unleashed, but in Pasternak's home the celebration continued as more friends came to toast him and celebrate Zinaida's name day. "No one foresaw the imminent catastrophe," Chukovsky wrote in his diary.

On Saturday morning, Muscovites snapped up copies of *Literaturnaya Gazeta* as word spread in the city about an extraordinary attack on Pasternak. The newspaper printed in full the 1956 rejection letter written by the editors of *Novy Mir*, and it was accompanied by a long editorial brimming with insults under the headline "A Provocative Sortie of International Reaction." For ordinary readers, many of whom were learning about *Doctor Zhivago* and the Nobel Prize for the first time, it was a feast of delicious detail about the novel's sins. Rarely were readers provided such unexpurgated descriptions and quotes from a piece of banned literature. By 6:00 a.m. people were lining up to buy copies of *Literaturnaya Gazeta*. The newspaper had a circulation of 880,000 and it sold out within a few hours.

The editorial read: "The internal emigrant Zhivago, faint-hearted and base in his small-mindedness, is alien to the Soviet people, as is the malicious literary snob Pasternak — he is their opponent, he is the ally of those who hate our country and our system."

Repeatedly, Pasternak was called a "Judas" who had betrayed his homeland for "thirty pieces of silver." The

228

"Swedish litterateurs, and their inspirers from across the Atlantic," turned the novel into a Cold War weapon. After all, the readers of *Literaturnaya Gazeta* were told, Western critics didn't think much of *Doctor Zhivago*. Negative reviews from Germany, the Netherlands, and France were quoted to make the point that "many Western critics expressed themselves quite openly on its modest artistic merits." But when such an "arch-intriguer" as the owner of *The New York Times* extolled the novel for "spitting on the Russian people," *Doctor Zhivago* was guaranteed ovations from the enemies of the Soviet Union. The novel and "the personality of its author became a golden vein for the reactionary press."

"The honor conferred on Pasternak was not great," the editorial concluded. "He was rewarded because he voluntarily agreed to play the part of a bait on the rusty hook of anti-Soviet propaganda. But it is difficult to hold this 'position' for long. A piece of bait is changed as soon as it goes rotten. History shows that such changes take place very quickly. An ignominious end waits for this Judas who has risen again, for *Doctor Zhivago*, and for his creator, who is destined to be scorned by the people."

Around the city, bureaucrats took their cues from the newspaper and a drumbeat of condemnation began to dominate radio and television broadcasts. At the prestigious Gorky Literary Institute, the director told the students that they would have to attend a demonstration against Pasternak and sign a letter

denouncing him that would be published in *Literaturnaya Gazeta*. He said their participation was a "litmus test." But despite the threats, many students balked at condemning Pasternak. As administrators went through the dorms, some hid in the toilets or the kitchen, or didn't answer their doors. Three students in Leningrad painted "Long Live Pasternak!" on the embankment of the river Neva. In Moscow, only 110 of about 300 Literary Institute students signed the letter, a remarkable act of defiance. Also, only a few dozen people from the student body attended the institute's "spontaneous demonstration," as administrators later described it. It was led by Vladimir Firsov, a budding poet, and Nikolai Sergovantsev, a critic. The group walked to the nearby Union of Soviet Writers building, and their handmade posters picked up on the anti-Semitic tone of the *Literaturnaya Gazeta* editorial. One placard depicted a caricature of Pasternak "reaching for a sack of dollars with crooked, grasping fingers." Another said: "Throw the Judas out of the USSR." They handed a letter to Konstantin Voronkov, a playwright and member of the union board, and said they planned to go to Peredelkino to continue the protest in front of Pasternak's house. Voronkov advised against it until an official decision was made to increase pressure on Pasternak.

Inside the union's palatial headquarters about forty-five writers who were also members of the Communist Party held a meeting about Pasternak. The comrades expressed their "wrath and indignation" and there was general agreement that Pasternak should be

230

expelled from the Union of Soviet Writers — the ultimate sanction, as it would deprive him of the ability to earn a living and could also threaten his state-provided housing. A number of writers, including Sergei Mikhalkov, author of the lyrics to the Soviet national anthem, went further and said Pasternak should be expelled from the Soviet Union. There was also criticism of Surkov for allowing the situation to get out of control; at the time he was away at a sanitarium and didn't participate in any of the debates surrounding the Nobel Prize. A number of writers felt that Pasternak should have been expelled when it was learned he had given his manuscript to a foreigner. They deluded themselves into believing that if the *Novy Mir* rejection letter had been printed earlier it would have prevented Pasternak from winning the Nobel Prize, since "the progressive press all over the world would not have let it happen." A formal decision on expelling Pasternak was put on the agenda for a meeting of the union's executive on Monday.

Pasternak, as a matter of habit, didn't read the newspapers but the scale and vehemence of the campaign was inescapable. *Le Monde* correspondent Michel Tatu visited Pasternak with a couple of other journalists after the appearance of the harsh *Literaturnaya Gazeta* editorial. It had been raining for six days and they found Peredelkino desolate and melancholy. Pasternak, however, was in good spirits and they talked in the music room. Pasternak tried to speak French, not very well, but he enjoyed the effort. He told the reporters that the Nobel Prize was

not only a joy but a "moral support." He added that it was a solitary joy.

Pravda, the official organ of the Communist Party, weighed in next with a long personal attack on Pasternak that was written by one of its more notorious journalists, David Zaslavsky. Both Lenin and Trotsky had dismissed Zaslavsky, an anti-Bolshevik before the revolution, as a hack. "Mr. Zaslavsky has acted only as a scandal monger," said Lenin. "We need to distinguish a slanderer and scandal monger from an unmasker, who demands the discovery of precisely identified facts." But under Stalin, the *Pravda* journalist was a favored hatchet man. Zaslavsky and Pasternak also had history. In May 1929, Zaslavsky began his career as a provocateur when he used the pages of *Literaturnaya Gazeta* to accuse Mandelstam of plagiarism. Pasternak, Pilnyak, Fedin, Zoshchenko, and others signed a letter defending Mandelstam and calling him "an outstanding poet, one of the most highly qualified of translators, and a literary master craftsman." The return of the seventy-eight-year-old Zaslavsky from semi-retirement to attack Pasternak gave the *Pravda* article "an especially sinister nuance."

The piece was headlined: "Reactionary Propaganda Uproar Over a Literary Weed."

"It is ridiculous, but *Doctor Zhivago*, this infuriated moral freak, is presented by Pasternak as the 'finest' representative of the old Russian intelligentsia. This slander of the leading intelligentsia is as absurd as it is

devoid of talent," Zaslavsky wrote. "Pasternak's novel is low-grade reactionary hackwork."

The novel, he continued, "was taken up triumphantly by the most inveterate enemies of the Soviet Union — obscurantists of various shades, incendiaries of a new world war, provocateurs. Out of an ostensibly literary event they seek to make a political scandal, with the clear aim of aggravating international relations, adding fuel to the flames of the 'cold war,' sowing hostility towards the Soviet Union, blackening the Soviet public. Choking with delight, the anti-Soviet press has proclaimed the novel the 'best' work of the current year, while the obliging grovelers of the big bourgeoisie have crowned Pasternak with the Nobel Prize . . .

"The inflated self-esteem of an offended and spiteful Philistine has left no trace of dignity and patriotism in Pasternak's soul," Zaslavsky concluded. "By all his activity, Pasternak confirms that in our socialist country, gripped by enthusiasm for the building of the radiant Communist society, he is a weed."

The state's giant propaganda machine was now working at full tilt, according to the Albanian writer Ismail Kadare, who was studying at the time in the Gorky Literary Institute. "The radio, from 5 in the morning until 12 at night, the television, the newspapers, the journals, magazines, even for children, were full of articles and attacks on the renegade writer."

Pasternak's friend Alexander Gladkov was in a barber shop on Arbat Square Sunday afternoon when Zaslavsky's article was read out over the radio. "Everybody listened in silence — a sullen kind of

silence, I would say. Only one chirpy workman started talking about all the money Pasternak would get, but nobody encouraged him to go on. I knew that cheap tittle-tattle of this kind would be much harder for Pasternak to bear than all the official fulminations. I had felt very depressed all day, but this silence in the barber's shop cheered me up."

Pasternak tried to laugh some of it off but "it was in fact all very painful to him." On Sunday, Ivinskaya's daughter, Irina, visited Pasternak with two fellow students from the Literary Institute, the young poets Yuri Pankratov and Ivan Kharabarov. Pasternak wasn't happy to have visitors and made it clear he wanted to be alone. He said he was ready to "drink his cup of suffering to the end" as the three young people accompanied him along part of his walk. "One had the clear impression of his loneliness — a loneliness borne with great courage," recalled Ivinskaya's daughter. Pankratov recited some lines from one of Pasternak's poems:

That is the reason why in early Spring
My friends and I foregather,
Our evenings are farewells
Our revelries are testaments,
So that suffering's secret flow
Should warm the cold of being.

Pasternak was visibly moved, but the visit ended on a note of disappointment. Pankratov and Kharabarov explained that they were under pressure to sign the

letter of denunciation at the Literary Institute and asked Pasternak what they should do. "Really now," said Pasternak, "what does it matter? It's an empty formality — sign it."

"When I looked out the window I saw them skipping with joy as they ran off hand in hand," Pasternak later told Yevtushenko, seeing their relief as a small betrayal. "How strange young people are now, what a strange generation! In our time, such things were not done."

Other former friends hurried to distance themselves. The poet Ilya Selvinsky, who had previously called Pasternak his teacher, and Pasternak's neighbor, the critic Viktor Shklovsky, sent telegrams of congratulations from the Crimea, where they were vacationing. But Selvinsky quickly followed it up with a letter when he read about the official reaction. "I now take it on myself to tell you that to ignore the view of the Party, even if you think it is wrong, is equivalent, in the international situation of the present moment, to deliver a blow at the country in which you live." Selvinsky and Shklovsky then wrote to a local newspaper in Yalta and accused Pasternak of "a low act of treachery."

"Why? The most terrible thing is I don't remember anymore," said Shklovsky many years later. "The times? Sure, but we're the time, I am, millions like me. One day everything will come to light: the records of those meetings, the letters from those years, the interrogation procedures, the denunciations — everything. And all that sewage will also dredge up the stench of fear."

The literary community was now "gripped by the sickening, clammy feeling of dread" and it led to a near-frenzy of condemnation. These inquisitorial feedings were an almost ritualistic part of the Soviet literary system that stretched back to Stalin. Error was followed by collective attack. The fallen writer was expected to respond with contrition and self-criticism before being welcomed back into the fold. Writers scurried to attack Pasternak. They were motivated by the need to survive within a system that could just as easily turn on them. Some despised Pasternak for his success and what they sensed or knew was his disdain for them. And others were true believers who were convinced that Pasternak was a traitor. The scale of the rhetorical assault and the global attention it drew was unprecedented. Moreover, Pasternak failed to follow the time-honored script.

The meeting of the executive of the writers' union was scheduled for noon on Monday. Pasternak went into town early with Vyacheslav "Koma" Ivanov, his neighbor's son. At Ivinskaya's apartment, Ivanov, with the support of Olga and Irina, argued that Pasternak should not go to the meeting, which was likely to be an "execution." Pasternak, who was pale and feeling ill, said he would instead send a letter to the meeting. It was written in pencil in a series of bullet points and Pasternak apologized in the text that it was "not as smooth and persuasive as [he] would like it to be." It was also not apologetic:

"I still believe even after all this noise and all those articles in the press that it was possible to write *Doctor*

Zhivago as a Soviet citizen. It's just that I have a broader understanding of the rights and possibilities of a Soviet writer, and I don't think I disparage the dignity of Soviet writers in any way."

Pasternak described his attempts to have the book published in the Soviet Union, his requests to Feltrinelli to delay publication, and his unhappiness at the selective quotations from the book that had appeared in the Western press.

"I would not call myself a literary parasite," he told his colleagues. "Frankly, I believe that I have done something for literature.

"I thought that my joy and the cheerful feelings I had when the Nobel Prize was awarded to me would be shared by the society I've always believed I am a part of. I thought the honor bestowed on me, a writer who lives in Russia and hence a Soviet writer, is an honor for all of Soviet literature.

"As for the prize itself nothing would ever make me regard this honor as a sham and respond to it with rudeness."

He concluded by telling his colleagues that whatever punishment they might dole out would bring them neither happiness nor glory.

Ivanov rushed by taxi over to the writers' union and a young man "with the cold eyes of a dutiful clerk" took the letter from him. The vestibule of the old union building buzzed with the sound of voices as writers arrived for the meeting in the White Hall. All the seats were taken and writers lined up along the walls. Pasternak's letter was read, and greeted with "anger

and indignation." Polikarpov's summary of the meeting for the Central Committee described the letter as "scandalous in its impudence and cynicism."

Twenty-nine writers spoke and the rhetoric became increasingly pitched. The novelist Galina Nikolayeva compared Pasternak to the World War II traitor Gen. Andrei Vlasov who collaborated with the Nazis. "For me it is not enough to expel him from the Writers' Union. This person should not live on Soviet soil."

Nikolayeva later wrote a letter to Pasternak declaring her love for his early poetry but adding that she would not hesitate to "put a bullet through a traitor's head."

"I am a woman who has known much sorrow and I am not a spiteful person, but for treachery such as this, I would not flinch from it," she wrote. Pasternak replied in a letter that said, "You are younger than I, and you will live to see a time when people take a different view of what has happened."

The novelist Vera Panova's speech was "harsh, very direct, hostile." When Gladkov asked her later why she was so vicious she said she panicked, felt like it was 1937 again, and had to protect her large family.

Nikolai Chukovsky, Kornei's son, also spoke at the meeting. "There is one good thing in this whole, shameful story — Pasternak has finally taken off his mask and openly acknowledged that he is our enemy. So let us deal with him as we always deal with our enemies."

Chukovsky's younger sister, Lydia, was appalled when she heard about his participation. She recalled in her diary that since her brother had tasted success with

his novel *Baltic Skies* he increasingly had found his sister's outspokenness "sharp, ill-considered, or even dangerous for him." Nikolai wanted to protect his career in the Soviet literary bureaucracy; Chukovsky had recently set up the translators' section of the writers' union.

The meeting dragged on for hours and some writers slipped out to smoke and argue. Alexander Tvardovsky, known as a liberal editor at *Novy Mir*, was sitting under the painting entitled *Gorky Reading "The Girl and the Death" in the Presence of Stalin, Molotov and Voroshilov* when he was approached by Vadim Kozhevnikov, the editor-in-chief of the journal *Znamya*.

He teased Tvardovsky.

"Well, Sasha, tell me, didn't you want to publish that novel?"

"That was before my time," Tvardovsky replied. "But the former board did not want it either, and you know it . . . Get out of here!"

"Why should I?"

"Because you lack conscience and honor."

"Why do I lack conscience and honor?"

"Go [to hell]."

A gloomy-faced Polikarpov also prowled the halls. He seemed uncertain if expulsion from the Union of Soviet Writers was the correct punishment. And a number of writers — Tvardovsky, Sergei Smirnov, and Konstantin Vanshenkin — told him they were opposed.

Both Smirnov and Nikolai Rylenkov would regret their dissent and would forcibly condemn Pasternak in the coming days.

The vote to expel Pasternak was "unanimous," according to the official record, and a long, formal resolution stated that "the novel *Doctor Zhivago*, around which a propaganda uproar has been centered, only reveals the author's immeasurable self-conceit coupled with a dearth of ideas; it is the cry of a frightened philistine, offended and terrified by the fact that history did not follow the crooked path that he would have liked to allot it. The idea of the novel is false and paltry, fished out of a rubbish heap . . .

"Bearing in mind Pasternak's political and moral downfall, his betrayal of the Soviet Union, socialism, peace and progress, which was rewarded with the Nobel Prize for the sake of fanning the cold war, the presidium of the board of the Union of Writers . . . strip Boris Pasternak of the title of Soviet writer and expel him from the Union of Writers of the USSR."

Pasternak and Ivinskaya were now being followed by the KGB. The agents made no secret of their presence and harassed the couple — sometimes pretending to hold drunken parties outside Ivinskaya's apartment on Popatov Street. "Good day to you, microphone," said Pasternak when he entered Ivinskaya's room in Peredelkino. She recalled: "We spoke mostly in whispers, frightened of our own shadows, and constantly glancing sideways at the walls — even they seemed hostile to us." Pasternak took solace in small gestures of kindness like the postman who greeted him as always despite the secret policemen parked nearby.

240

On Tuesday morning, Lydia Chukovskaya went to see Pasternak. As she walked from her father's house, she saw four men sitting in a car, watching her. "To my shame, I have to say that fear already touched me." When she approached Pasternak's gate she expected to hear someone shout stop.

"Did they expel me?" asked Pasternak.

Chukovskaya nodded.

Pasternak took her inside and sat with her in the piano room.

"In the bright morning light, I saw his yellow face, with his shining eyes, and his old man's neck."

Pasternak began to talk with his usual fervor, jumping from subject to subject, and interrupting himself with questions.

"What do you think, will they also hurt Lyonya?" he asked, speaking of his son.

Pasternak told Chukovskaya that the Ivanovs had warned him to move into the city because they were afraid the dacha would be stoned by protesters.

He jumped up and stood in front of Chukovskaya. "But that's nonsense, isn't it? Their imagination has run away with them?"

"Right," said Chukovskaya, "pure nonsense. How is that possible?"

Chukovskaya, trying to change the subject, mentioned a recent poem by Pasternak.

"Poems are unimportant," he replied a little peevishly. "I don't understand why people busy themselves with my verses. I always feel awkward when your dad pays attention to this nonsense. The only

thing worthwhile that I have done in my life is the novel. And it's not true that people only value the novel because of politics. That's a lie. They read it because they love it."

In his voice, she heard "something dry, something troubled, something more restless than in his usual impassioned speech."

Outside, in the quiet of the morning, Pasternak glanced around. "Strange," he said, "there is nobody there, yet it feels as though everybody is watching us."

Later that day, Pasternak went over to see Ivinskaya, who had come out from Moscow with her teenage son, Mitya. His mood had darkened and Pasternak spoke in a tremble. "I cannot stand this business anymore," he said to Olga and her son. "I think it's time to leave this life, it's too much."

Pasternak suggested that he and Olga take a fatal dose of Nembutal, a barbiturate.

"It will cost them very dearly," he said. "It will be a slap in the face."

Mitya went outside after listening to this plan to have his mother commit suicide. "Mitya, forgive me, don't think too badly of me, my precious child, for taking your mother with me, but we can't live, and it will be easier for you after our death."

The boy was pale with shock but obedient. "You are right, Boris Leonidovich. Mother must do what you do."

Ivinskaya, who had no desire to kill herself, told Pasternak that his death would suit the authorities.

"It shows we were weak and knew we were wrong, and they will gloat over us into the bargain," she said.

Ivinskaya asked him for time to see what the authorities wanted, and if there was no way out then, she said, "we'll put an end to it." Pasternak agreed. "Very well, go wherever it is today . . . and we'll decide then. I cannot stand up anymore to this hounding."

After Pasternak left, Ivinskaya and her son walked through a nasty sleet to Fedin's house. The roads were soft with slush, and by the time they reached their destination they were soaking wet and trailing mud. Initially, Fedin's daughter wouldn't let them beyond the hallway, but her father eventually appeared on the landing above and told Ivinskaya to come up to his study. She told him that Pasternak was contemplating suicide. "Tell me: what do they want from him? Do they really want him to commit suicide?"

Fedin walked over to the window, and Ivinskaya thought she saw tears in his eyes.

But when he turned around he had adopted his official manner: "Boris Leonidovich has dug such an abyss between himself and us that it cannot be crossed," he said.

"You have told me a terrible thing," he continued. "You realize, don't you, that you must restrain him. He must not inflict a second blow on his country."

Ivinskaya said she was looking for a way out and was "willing to write any letter to whomever, and convince Pasternak to sign it."

Fedin wrote a note to Polikarpov about Ivinskaya's visit. "I think you should be aware of the real or

imaginary, serious or theatrical intention of Pasternak. You should know there is such a threat, or maybe it is an attempt to maneuver."

The following morning, Pasternak and Ivinskaya spoke by phone and argued. Ivinskaya accused him of being selfish. "Of course, they won't harm you," she said, "but I'll come off worse."

That same morning, Pasternak's brother drove him into the Central Telegraph Office near the Kremlin. He sent a second telegram, in French, to Stockholm: "Considering the meaning this award has been given in the society to which I belong, I must reject this undeserved prize which has been presented to me. Please do not receive my voluntary rejection with displeasure — Pasternak."

The Swedish Academy responded that it "has received your refusal with deep regret, sympathy and respect." It was only the third time a Nobel award had been rejected. Three German scientists had refused the prize on Hitler's orders. The German dictator had been infuriated when Carl von Ossietzky, who was in a concentration camp, was awarded the peace prize in 1935, and Hitler decreed that in the future no German could accept a Nobel Prize.

Pasternak sent a second telegram to the Central Committee informing the Kremlin of his decision and asking the authorities to allow Ivinskaya, who had been blackballed by official publishers, to work again.

Pasternak told a Western reporter: "I made the decision quite alone. I did not consult anybody. I have not even told my good friends."

The strain was now beginning to show. Pasternak's son Yevgeni was shocked when he saw his father later that day. Pasternak was "grey and disheveled," he later wrote.

"My father was unrecognizable."

Ivinskaya met Polikarpov and he told her that she had to stay by Pasternak's side and prevent him from getting any "silly ideas into his head." (The Central Committee also dispatched a nurse to Pasternak's dacha to keep watch over him; the nurse was told she was not wanted, but she refused to leave and was eventually set up with a cot in the drawing room.)

"This whole scandal must be settled — which we will be able to do with your help," Polikarpov told Ivinskaya. "You can help him find his way back to the people again. But if anything happens to him, the responsibility will be yours."

The decision to reject the Nobel Prize brought no respite, however. In fact, it was treated as an act of spite by a man who was expected to surrender and make no attempt to control events. "This is an even dirtier provocation," said Smirnov, reversing his support for Pasternak. The refusal of the prize, he said, "carries treachery still further."

CHAPTER
TWELVE

"Pasternak's name spells war."

The evening before Pasternak sent the telegram to Stockholm rejecting the prize, Vladimir Semichastny, the head of Komsomol, the youth wing of the Communist Party, was summoned to a meeting with Khrushchev at the Kremlin. The Soviet leader was waiting in his office with Mikhail Suslov, the party's enforcer of ideological purity.

Khrushchev remarked that Semichastny was making a major speech the following evening and told him he wanted to include a section on Pasternak. Semichastny said that something on the Nobel controversy might not be suited to the speech, which was supposed to celebrate the fortieth anniversary of the Komsomol organization.

"We'll find a place where it fits," said Khrushchev, who called in a stenographer. Khrushchev dictated several pages of notes, and goosed up the speech with a string of insults. He promised Semichastny that he would visibly applaud when he reached the passage about Pasternak. "Everyone will understand it," Khrushchev said. The following evening, on October 29, Semichastny spoke before twelve thousand young

people at the Sports Palace in Moscow. The address was broadcast live on television and on the radio.

"As the Russian proverb goes, every flock has its mangy sheep," said Semichastny as Khrushchev beamed in the background. "We have such a mangy sheep in our socialist society in the person of Pasternak, who appeared with his slanderous work . . . And this man has lived in our country and been better provided for than the average workman who worked, labored and fought. Now this man has gone and spat in the people's face. What can we call this? Sometimes, incidentally, we talk about a pig and say this, that or the other about it quite undeservedly. I must say this is a calumny on the pig. As everybody who has anything to do with this animal knows, one of the peculiarities of the pig is that it never makes a mess where it eats or sleeps. Therefore if we compare Pasternak with a pig, then we must say that a pig will never do what he has done. Pasternak, this man who considers himself amongst the best representatives of society, has fouled the spot where he ate and cast filth on those by whose labor he lives and breathes."

Semichastny was interrupted by repeated bursts of applause. He then issued the threat Pasternak feared most: "Why shouldn't this internal emigrant breathe the capitalist air which he so yearned for and which he spoke of in his book? I am sure our society would welcome that. Let him become a real emigrant and go to his capitalist paradise. I am sure that neither society nor the government would hinder him in any way — on

the contrary, they would consider that his departure from our midst would clear the air."

The following morning, Pasternak read accounts of Semichastny's speech. He discussed the possibility of emigrating with his wife. She said that in order to live in peace he could go. Pasternak was surprised and asked, "With you and Lyonya?" referring to his son.

"Not in my life, but I wish you all the best and hope you'll spend your last years in honor and peace," said Zinaida. "Lyonya and I will have to denounce you, but you'll understand, that is just a formality."

"If you refuse to go abroad with me, I will not go, never," said Pasternak.

Pasternak also spoke to Ivinskaya, and wrote and tore up a note to the government requesting permission for Ivinskaya and her family to emigrate with him. Pasternak felt completely tied to Russia, and, in any case, he again found it impossible to choose between his two families. "I must have the work-a-day life I know here, the birch trees, the familiar troubles — even the familiar harassments."

Ivinskaya feared Pasternak might be given no choice. And she continued to try to wheedle some form of compromise. She went to see Grigori Khesin, who headed the "author's rights" section of the writers' union. He had always treated Ivinskaya well and had long declared his admiration for Pasternak. But his agreeability had vanished and he greeted his guest coldly.

"What are we to do?" asked Ivinskaya. "There is this dreadful speech by Semichastny. What are we to do?"

"Olga Vsevolodovna," replied Khesin, "there is now no further advice for us to give you . . . There are certain things one cannot forgive — for the country's sake. No, I'm afraid I cannot give you any advice."

As Ivinskaya left, slamming the door behind her, she was approached by a young copyright lawyer, Isidor Gringolts, who said he would like to help. Gringolts described himself as an admirer of Pasternak: "For me, Boris Leonidovich is a saint!" Ivinskaya, desperate for any help, didn't question his gushing solicitousness. They agreed to meet two hours later at the apartment of Ivinskaya's mother. When Gringolts arrived he suggested that Pasternak write directly to Khrushchev to avoid being expelled from the country, and he offered to help draft a letter.

Ivinskaya called together her daughter, Irina, and some of Pasternak's close friends, and they debated the merits of a direct appeal to Khrushchev. The campaign seemed increasingly sinister — Pasternak was receiving threatening letters, and there were rumors that the house in Peredelkino would be sacked by a mob. One night a group of local thugs threw stones at the dacha and shouted anti-Semitic abuse. After Semichastny's speech, a demonstration of workers and young Communists outside Pasternak's home threatened to get out of hand, and police reinforcements were called to the scene.

Khesin of the writers' union had also informed Ivinskaya that unless Pasternak showed remorse he would be expelled from the country.

"It seemed clear to me that we had to give in," said Ivinskaya, who rejected her daughter Irina's defiant

insistence that Pasternak should never apologize. Ivinskaya's stance was supported by the chain-smoking Ariadna Efron, the poet Tsvetaeva's daughter. Efron had just returned to Moscow after sixteen years in the camps and exile; she didn't think a letter would achieve much, but thought it couldn't hurt.

The group reworked the text prepared by Gringolts to make it sound more like Pasternak. A draft of the letter was brought to Pasternak in Peredelkino by Irina and Koma Ivanov. He met them at the gate of the dacha. "What do you think, with whom will I be expelled?" he asked. "My thought is: in Russian history, those who lived in exile meant a great deal more to the country: Herzen, Lenin."

The three walked down to the village post office, where Pasternak had a long telephone conversation with Ivinskaya. He agreed to review the letter and made only one change — adding that he was tied to Russia by birth, not to the Soviet Union. He signed a few blank pages in case his friends needed to make further revisions. His willingness to resist was draining away:

Dear Nikita Sergeyevich,

I am addressing you personally, the Central Committee of the Communist Party of the Soviet Union, and the Soviet Government.

From Comrade Semichastny's speech I learn that the government would not put any obstacles in the way of my departure from the USSR.

For me this is impossible. I am tied to Russia by birth, by life and by work.

I cannot conceive of my destiny separate from Russia, or outside it. Whatever my mistakes and failings, I could not imagine that I should find myself at the center of such a political campaign as has been worked up around my name in the West.

Once aware of this, I informed the Swedish Academy of my voluntary renunciation of the Nobel Prize.

Departure beyond the borders of my country would for me be tantamount to death and I therefore request you not to take this extreme measure against me.

With my hand on my heart, I can say that I have done something for Soviet literature, and may still be of service to it.

B. Pasternak

Irina and a friend brought the letter to the Central Committee building on the Old Square that night. They asked a guard smoking in the shadows of the entryway where they could hand in a letter for Khrushchev.

"Who is it from?" asked the guard.

"Pasternak," replied Irina.

The guard took the letter.

At noon the following day, the virulence of the offensive reached something of a climax inside Cinema House, a

classic piece of constructivist architecture near the writers' union. About eight hundred writers from the Moscow branch of the union crowded into the main theater to discuss the single agenda item — "the conduct of B. Pasternak." The meeting was designed to rubber-stamp Pasternak's expulsion from the Union of Soviet Writers and, in the wake of Semichastny's speech, echo his call for Pasternak's expulsion to the West. Attendance was mandatory and the brave simply called in sick. There was already a heaving, moblike atmosphere when Sergei Smirnov opened the meeting. Smirnov spoke at great length and recapped the usual charges against Pasternak: remoteness from the people, the mediocre prose of his shocking novel, and his treachery in colluding with foreigners. "He sent the manuscript to the Italian publisher Feltrinelli, who is a renegade and a deserter from the progressive camp, and you know that there is no worse enemy than the renegade and that the renegade nurses an especially strong hatred for the thing that he has betrayed." At times Smirnov's blustering indignation stretched to the almost comic: "A Nobel Prize went to the fascist-inclined French writer Camus, who is very little known in France and who is morally the kind of person that no decent person would ever sit by."

Murmurs of approval rippled through the crowd and some chorused: "Shame!"

The speech's defining element was not the outrage but the undercurrents of jealousy and long-standing resentment that surfaced in Smirnov's mocking tone and his attempt to imitate Pasternak's way of talking.

252

The myth of Pasternak was fostered by his small group of friends, Smirnov said, and it was one "of an entirely apolitical poet, a child in politics, who understands nothing and is locked away in his castle of 'pure art' where he turns out his talented works . . . From this coterie, this narrow circle around Pasternak we have heard 'oohs' and 'ahs' about his talent and his greatness in literature. Let us not hide the fact that there have been people among Pasternak's friends who have stated at meetings that when Pasternak's name is spoken, people should stand."

The meeting ran for five hours, and Smirnov was merely the first of fourteen speakers. And they included some surprising names. When Yevtushenko saw that the poet Boris Slutsky, who had solicited Pasternak's opinion on his verse earlier that summer, was scheduled to speak, he warned him to be careful, fearing he would defend Pasternak, rile the crowd, and hurt himself.

"Don't worry," Slutsky replied. "I shall know how to make my point."

Slutsky had only recently been admitted to the Union of Soviet Writers, and he felt that his budding career would be ruined if he didn't speak out against Pasternak. He kept his speech short and avoided the violent language of some of the other speakers. "A poet's obligation is to seek the recognition of his own people, not of his enemies," he said. "This year's Nobel Prize winner could almost be called the winner of the Nobel Prize against Communism. It is a disgrace for a man who has grown up in our country to bear such a title."

253

In private, Slutsky was angry with Pasternak. He felt he had damaged the possibilities for the "young literature" emerging after Stalin's death. Over time he was haunted by his participation. "That I spoke against Pasternak is my shame," he said years later.

The chairman of the meeting, Smirnov, also said that the "blot" on himself for his attack could "never be washed away." But in a bitter exchange of letters with Yevtushenko in the 1980s, another speaker, Vladimir Soloukhin, said that Pasternak's supporters, who remained silent, were as culpable as those who spoke against him. Yevtushenko, who attended the meeting, was approached about speaking, but refused.

"Let's agree that all of us, all 14 people, were cowards, time-servers, lickspittles, traitors and bastards who will never 'clear themselves,'" wrote Soloukhin. He asked where Pasternak's friends were, among the hundreds in the room. "Why did they keep silent? Not a single sound, not a single move. Why? Not a single exclamation or remark or word in defense of the poet."

Yevtushenko replied that "for 30 years, this sin of yours, Vladimir Alexeyevich, has lain safely hidden . . .

"But glasnost, like spring waters, has dissolved the shroud of secrecy and your old guilt comes to light like the arm of a murdered child emerges from the snow when it begins to melt," Yevtushenko continued. "I have never considered my refusal as heroism. However, is there no difference between direct participation in a crime and refusal to participate?"

Most of the speakers, in contrast to Slutsky, wielded the knife with striking vehemence. Korneli Zelinsky, the

literary scholar who taught at the Gorky Literary Institute, was once a friend of Pasternak's, but his speech was "particularly vile." At Pasternak's request, he had chaired one of his recitals at the Polytechnic Museum in 1932 and had written about Pasternak's work over the years, generally favorably. He had described Pasternak as a "dacha-dweller of genius" and said some of the poems in the collection *Second Birth* would "always remain in Russian poetry . . . as masterpieces of intimate lyric poetry." After the war, Zelinsky attended one of the first readings of *Doctor Zhivago* at the dacha in Peredelkino.

Zelinsky told the audience that he had gone through the novel the previous year with "a fine-tooth comb." He had been involved in the negotiations that led to a contract in early 1957 to bring out an abridged version of the book in the Soviet Union. And Zelinsky had expressed some mild concerns about the novel's remoteness from contemporary themes in the summer of 1958 in an interview with Radio Warsaw. Perhaps it was his involvement with Pasternak's work that led him to speak with such venom.

"I was left with a feeling of great heaviness after reading" *Doctor Zhivago*, Zelinsky told the audience. "I felt as though I had been literally spat upon. The whole of my life seemed to be defiled in the novel . . . I have no wish to spell out all the evil-smelling nastiness which leaves such a bad taste. It was very strange for me to see Pasternak, the poet and artist, sink to such a level. But what we have subsequently learned has revealed in full the underlying truth, that terrible

traitorous philosophy and that pervasive taint of treachery.

"You ought to know, comrades, that Pasternak's name in the West where I have just been is now synonymous with war. Pasternak is a standard-bearer of the cold war. It is not mere chance that the most reactionary, monarchistic, rabid circles have battened upon his name . . . I repeat that Pasternak's name spells war. It heralds the cold war."

After Zelinsky spoke, he approached Konstantin Paustovsky, one of the grand old men of Russian letters, who turned away in disgust and refused to shake his hand.

Smirnov moved to end the meeting with thirteen more writers waiting in the wings to speak. The crowd was exhausted. After a show of hands, Smirnov announced that the resolution was adopted unanimously. "Not true! Not unanimously! I voted against!" shouted a woman who pushed her way to the front of the crowd as others headed for the exits. The lone dissenter, a Gulag survivor, was Anna Alliluyeva, Stalin's sister-in-law.

The pillorying of Pasternak was front-page news around the world. Correspondents in Moscow reported in detail on the media campaign, the expulsion from the Union of Soviet Writers, the acceptance and rejection of the Nobel Prize, and the threat of exile. Editorialists weighed in on the startling virulence of the assault on a solitary writer. In an editorial headlined "Pasternak and the Pygmies," *The New York Times*

declared, "In the fury, venom and intensity of this reaction there is much that is illuminating. Superficially the Soviet leaders are strong. At their command are hydrogen bombs and intercontinental ballistic missiles, large armies and fleets of mighty bombers and warships. Against them is one elderly man who is completely helpless before the physical power of the Kremlin. Yet such is the moral authority of Pasternak, so vividly does he symbolize the conscience of an outraged Russia striking back at its tormentors, that it is the men in the Kremlin who tremble."

In the *St. Louis Post-Dispatch*, the cartoonist Bill Mauldin created a Pulitzer Prize-winning image of Pasternak as a ragged Gulag prisoner wearing a ball and chain and chopping wood in the snow with another inmate. The caption read: "I won the Nobel Prize for Literature. What was your crime?"

The French newspaper *Dimanche* described the literary crisis as "an intellectual Budapest" for Khrushchev.

The Swedes issued their own rebuke. On October 27, the Lenin Peace Prize was presented in Stockholm to the poet Artur Lundkvist. Three members of the Swedish Academy who had been scheduled to attend, including Österling, boycotted the event. A string quartet that was booked to perform refused to play, and a florist sent wilting flowers in protest.

Bewilderment at the treatment of Pasternak only increased when three Soviet scientists won the Nobel Prize for Physics. The award was celebrated in Moscow as a national achievement; Western correspondents

were invited to meet two of the winners at the Russian Academy of Sciences, where they discussed their research into atomic particles — and their hobbies and home life. The Soviet press was forced into some contortions in logic to explain the contrasting coverage of the different Nobel Prizes, often on the same pages. *Pravda* explained that while the award in science illustrated "the recognition by the Swedish Academy of Sciences of the major merits of Russian and Soviet scientists . . . the award of this prize for literature was prompted entirely for political motives." Bourgeois scientists "were capable of objectivity," the newspaper concluded, but the assessment of literary works is "entirely under the influence of the ideology of the dominant class."

Feltrinelli was in Hamburg when the loud disparagement of his writer began, and he immediately began to use his contacts in publishing to rally writers in defense of Pasternak. Literary societies from Mexico to India issued statements as the drama unfolded. A group of prominent writers, including T. S. Eliot, Stephen Spender, Somerset Maugham, E. M. Forster, Graham Greene, J. B. Priestley, Rebecca West, Bertrand Russell, and Aldous Huxley, sent a telegram to the Union of Soviet Writers to protest. "We are profoundly anxious about the state of one of the world's great poets and writers, Boris Pasternak. We consider his novel, *Doctor Zhivago*, a moving personal testimony and not a political document. We appeal to you in the name of the great Russian literary tradition for which you stand not to dishonor it by victimizing a writer revered

throughout the whole civilized world." PEN, the international association of writers, sent its own message, saying the organization was "very distressed by rumors concerning Pasternak" and demanded protection for the poet by maintaining the conditions for creative freedom. "Writers throughout the world are thinking of him fraternally."

Radio Liberation solicited messages of support for broadcast from Upton Sinclair, Isaac Bashevis Singer, William Carlos Williams, Lewis Mumford, Pearl Buck, and Gore Vidal, among others. Ernest Hemingway said he would give Pasternak a house if he was expelled. "I want to create for him the conditions he needs to carry on with his writing," said Hemingway. "I can understand how divided Boris must be in his own mind right now. I know how deeply, with all his heart, he is attached to Russia. For a genius such as Pasternak, separation from his country would be a tragedy. But if he comes to us we shall not disappoint him. I shall do everything in my modest power to save this genius for the world. I think of Pasternak every day."

The controversy reinvigorated sales of the novel across Europe, and in the United States, where it was published in September, the novel finally hit the top of *The New York Times* bestseller list, dislodging *Lolita*. The book had already sold seventy thousand copies in the United States in its first six weeks. "That is fantastic," his publisher Kurt Wolff wrote. The Nobel controversy boosted sales of an already successful book to rare heights. "You have moved beyond the history of literature into the history of mankind," Wolff concluded

in a letter to Pasternak toward the end of the year. "Your name has become a household word throughout the world."

The U.S. secretary of state John Foster Dulles told reporters that Pasternak's refusal of the Nobel Prize was forced on the writer by the Soviet authorities. "The system of international communism," he said, "insists on conformity not only in deed but in thought. Anything a little out of line, they try to stamp out."

The U.S. embassy in Moscow cautioned the State Department against official involvement, and senior officials in Washington said relatively little; instead they relished what they saw as a propaganda coup for the West that was entirely manufactured in Moscow. At a meeting of Dulles's senior staff, he was told that "the communists' treatment of Pasternak is one of their worst blunders. It is on par in terms of embarrassment and damage to them with the brutality in Hungary." Dulles told his staff to explore the possibility of covertly subsidizing publication of the novel in the Far East and the Middle East; presumably he knew that his brother, the head of the CIA, had already organized a Russian edition as they both served on the Operations Control Board. State Department officials were told to coordinate their publication efforts with the "other agency," government-speak for the CIA.

Dulles told his senior staff that he hadn't had a chance to read the book but "supposed he would have to do so." He asked if the novel was damaging to the Communist cause. Abbott Washburn, deputy director of the United States Information Agency, said, "It was

because it reveals the stifling of an individual under the oppressive communist system and that the very suppression of the book shows that the communist leaders regard it as injurious." Others at the meeting argued that *Doctor Zhivago* was not particularly anti-Communist but "that the treatment received by the author was the real pay dirt for us."

At first, the CIA also concluded that it should not overplay its hand. Director Allen Dulles said agency assets, including Radio Liberation, should give "maximum factual play" to the Nobel Award "without any propagandistic commentary." Dulles also said the agency should use every opportunity to have Soviet citizens read the novel.

For some within the CIA, Pasternak's plight was another reminder of the West's inability to affect events inside the Soviet Union and Eastern Europe. "Reactions of revulsion and shock cannot conceal from Free World consciousness the sense of its own impotence to further the cause of liberalization within the Bloc," stated an agency memo sent to Dulles. "Any further attempt on our part to portray the personal ordeal of Pasternak as a triumph of freedom will only, as in the case of Hungary, heighten the tragic irony which informs it."

Dulles was not persuaded. At a meeting of the National Security Council's Operations Control Board a few days later, there was "considerable discussion of the actions which the U.S. has taken and might take to exploit" the Zhivago affair. Earlier, some on Dulles's staff had recommended that CIA assets should be used

to "sparkplug" anti-Soviet coverage, and encourage the "leftist press and writers" in the West to express their outrage.

The sound of Western consternation was nothing new in Moscow. Much more troubling for the Soviet Union than the statements of "bourgeois writers" and American officials such as John Foster Dulles was the damage to its reputation among friends and allies, and in parts of the world where it expected a sympathetic hearing.

In Lebanon, the affair was front-page news, and the CIA noted approvingly that in a front-page editorial the newspaper *Al-Binaa* concluded that "free thought and dialectical materialism do not go together." In Morocco, the daily *Al-Alam*, which was rarely critical of the Soviet Union, said, whatever the Soviet Union accuses the West of in the future, it "will never be able to deny its suppression of Pasternak." *The Times* of Karachi described the treatment of the writer as "despicable."

The Brazilian writer Jorge Amado said the expulsion of Pasternak from the writers' union demonstrated that it was still controlled by elements from Stalin's time. The Brazilian paper *Última Hora*, which had supported good relations with the Soviet Union, called the affair "cultural terrorism."

The Irish playwright Sean O'Casey wrote to *Literaturnaya Gazeta* to protest the decision of the Union of Soviet Writers. "As a friend of your magnificent land since 1917, I would plead for the withdrawal of this expulsion order," he said. "Every

artist is something of an anarchist, as Bernard Shaw tells us in one of his prefaces, and the artist should be forgiven many things."

The Icelandic novelist Halldór Laxness, a Nobel laureate and the chairman of the Iceland-Soviet Friendship Society, sent a telegram to Khrushchev: "I implore you as level-headed statesman to use your influence mitigating malicious onslaughts of sectarian intolerance upon an old meritorious Russian poet Boris Pasternak. Why light-heartedly arouse the wrath of the world's poets, writers, intellectuals and socialists against the Soviet Union in this matter? Kindly spare friends of the Soviet Union an incomprehensible and most unworthy spectacle."

"Iceland?" said Pasternak when he learned of the telegram, "Iceland, but if China intervened it would help?"

In fact, the case was drawing major attention in Asia, particularly in India, a nonaligned country that nonetheless had strong ties with the Soviet Union. Prime Minister Jawaharlal Nehru had visited the Soviet Union in 1955 and Khrushchev had traveled to India the following year. The treatment of Pasternak infuriated leading writers in India, including some prominent Communists. And concern about his plight culminated at a press conference in New Delhi when Nehru said Indian opinion had been pained by the daily abuse. "A noted writer, even if he expresses an opinion opposed to the dominating opinion, according to us should be respected and it should be given free play," he told reporters.

The Soviet Union's cultural diplomacy was also being damaged. The Norwegian press demanded that the government abrogate a recently signed cultural-exchange program. Swedish officials threatened to postpone indefinitely a youth-exchange program. Twenty-eight Austrian writers said in an open letter that all future cultural and scientific exchanges should be conditional on Pasternak's complete rehabilitation as a citizen and a writer.

The international backlash was unwelcome and the Kremlin wanted a way out of the crisis. After receiving Pasternak's letter, Khrushchev ordered a halt. "Enough. He's admitted his mistakes. Stop it." The terms were left to the bureaucracy.

While the writers were fulminating at Cinema House, Polikarpov began maneuvering to end the affair. Khesin, the man who had cold-shouldered Ivinskaya the day before the meeting, phoned her at her mother's apartment, where she had gone to try to get some sleep. (Ivinskaya's movements were clearly being monitored.) Khesin oozed a fake friendliness. "Olga Vsevolodovna, my dear, you're a good girl. They have received the letter from Boris Leonidovich and everything will be all right, just be patient. What I have to say is that we must see you straight away."

Ivinskaya was irritated by the approach, and told Khesin she didn't want to have anything to do with him. Polikarpov came on the line. "We must see you," he said. "We'll drive over to Sobinov Street now, you put on a coat and come down, and we'll go together to Peredelkino. We must bring Boris Leonidovich to

Moscow, to the Central Committee, as soon as possible."

Ivinskaya told her daughter to go ahead to alert Pasternak. It seemed to Ivinskaya that if Polikarpov was in such a hurry and willing to go to Peredelkino to fetch Pasternak, it could only mean that Khrushchev would meet the writer. A black government Zil pulled up outside Ivinskaya's mother's apartment building, and Polikarpov and Khesin were inside. The sedan traveled in the middle lane reserved on Moscow streets for select government cars and whisked them to Peredelkino ahead of Irina.

Pasternak was now emotional and fragile, subject to severe mood swings and very much caged in his dacha. Telegrams from well-wishers in the West were piling up on his desk, but at home he felt increasingly isolated and people he thought of as friends were shunning him. When the sculptor Zoya Maslenikova visited Pasternak that Friday around lunchtime, he broke down and wept, his head on the table; the prompt for his tears was a telegram that contained a line from one of his *Zhivago* poems: "To see no distance is lonely."

As Ivinskaya rode with the two men toward Peredelkino, Khesin whispered to her that it was he who had sent Gringolts to her. Ivinskaya gasped at how easily she had been manipulated into getting Pasternak to write a letter to Khrushchev. And now Polikarpov, turning around to face her from the front seat, wanted more. "We're now relying entirely on you," he said. When they arrived in the village, there were already a number of official cars near Pasternak's house, with

other officials from the writers' union. Irina, when she arrived, was asked to go to the dacha and get Pasternak; Ivinskaya would not risk meeting Pasternak's wife, but Zinaida tolerated her daughter. Zinaida was frightened by the official hubbub, but Pasternak emerged with a strange cheerfulness. As he got into Polikarpov and Khesin's car, he started to complain that he wasn't wearing a suitable pair of trousers because he, too, concluded that he was to meet Khrushchev. "I'm going to show them," he blustered. "I'll make such a fuss and tell them everything I think — everything." He joked all the way into town, and the mood "was one of almost hysterical gaiety."

At Polikarpov's request, Ivinskaya brought Pasternak to her apartment for a short interlude before they went over to the Central Committee building. When they arrived at the latter, Pasternak went up to the guard and told him he was expected but had no identification except his writers' union card — "the membership card of this union of yours which you've just thrown me out of." And then he continued to be preoccupied with his trousers. "It's all right, it's all right," said the guard, "it doesn't matter, it's quite all right."

There was no meeting with Khrushchev. Pasternak was ushered into a room with Polikarpov, who had freshened up and was acting as if he had been sitting at his desk all day. He rose to his feet and "in a voice befitting a town crier" announced that Pasternak would be allowed "to remain in the Motherland."

But Polikarpov said Pasternak would have to make peace with the Soviet people. "There is nothing we can

do at the moment to calm the anger," said Polikarpov. He noted that the following day's issue of *Literaturnaya Gazeta* would include a sampling of this anger.

This was not the meeting Pasternak expected and he erupted in fury. "Aren't you ashamed, Dmitri Alexeyevich? What do you mean 'anger'? You have your human side, I can see, but why do you come out with these stock phrases? 'The people! The people!' — as though it were something you could just produce from your own trouser pockets. You know perfectly well that you really shouldn't use the word 'people' at all."

Polikarpov sucked in his breath to contain himself; the crisis had to be ended and he needed Pasternak's acquiescence. "Now look here, Boris Leonidovich, the whole business is over so let's make things up, and everything will soon be all right again.

"Goodness me, old fellow, what a mess you've landed us in," he continued, coming round to pat Pasternak on the shoulder.

Pasternak recoiled from the intimacy and the reference to an "old fellow."

"Will you kindly drop that tone? You cannot talk to me like that," he said.

"Really now," Polikarpov continued, "here you go sticking a knife in the country's back, and we have to patch it all up."

Pasternak had had it with the accusations of treachery. "I will ask you to take those words back. I do not wish to speak to you anymore."

He headed for the door.

Polikarpov was aghast. "Stop him, stop him, Olga Vsevolodovna."

Ivinskaya, sensing Polikarpov's weakness, told him, "You must take your words back!"

"I do, I do," mumbled Polikarpov.

Pasternak stayed, and the conversation continued in a more civil tone. Polikarpov suggested he would be in touch soon with a plan and quietly told Ivinskaya as she left that another public letter from Pasternak might be necessary.

Pasternak was pleased with his performance. "They are not people but machines," he said. "See how terrible they are, these walls here, and everyone inside them is like an automaton . . . But all the same I gave them something to worry about — they got what they deserved."

In the car, on the way back to Peredelkino, Pasternak loudly replayed the whole conversation with Polikarpov, ignoring Ivinskaya's warning that the chauffeur was certain to report back on everything that was said.

In a lull, Irina recited some lines from Pasternak's epic poem "Lieutenant Schmidt":

In vain, in years of turmoil,
One seeks a happy ending —
Some are fated to kill — and repent —
While others go to Golgotha . . .
I suppose you never flinch
From wiping out a man.
Ah well, martyrs to your dogma,
You too are victims of the times . . .

I know the stake at which
I'll die will be the boundary mark
Between two different epochs,
And I rejoice at being so elect.

Pasternak fell silent. A very long Friday had come to an end.

CHAPTER
THIRTEEN

"I am lost like a beast in an enclosure."

The wrath of the people appeared under the headline "Rage and Indignation: Soviet People Condemn B. Pasternak's Behavior" in *Literaturnaya Gazeta*. Twenty-two letters were spread out over much of a broadsheet page under subheads such as "Beautiful Is Our Reality," "The Word of a Worker," and "Paid Calumny." The excavator operator F. Vasiltsev wondered who this Pasternak was. "I have never heard of him before and I have never read any of his books," he wrote. "This is not a writer but a White Guardist." R. Kasimov, an oil worker, also asked: "Who is Pasternak?" and then dismissed his work as "aesthetic verse in obscure language incomprehensible to the people."

Lydia Chukovskaya assumed that the letters were the creations of the editors, and she said she could just imagine "a wench from the editorial board" dictating their content. This assessment was unfair; the letters were written by real people, even though some variation on the words "I have not read *Doctor Zhivago* but . . ." appeared in a number of missives and led to much amused mocking among those who sympathized with Pasternak. The newspaper was indeed inundated with letters, about 423 in all between October 25 and

December 1, and a clear majority reflected the genuine response of Soviet readers. They had, unsurprisingly, absorbed the unrelenting message of the previous days that Pasternak was a money-grubbing traitor who had stigmatized the revolution and the Soviet Union. This, many readers felt, was not only grievously insulting, but an attack on their achievement in building Soviet society. "The revolution remained central to these people's consciousness and socioethical order, the sacred foundation of a mental universe," said one historian, "and their reaction to the Pasternak affair was above all a defense against any attempt, real or imaginary, to undermine this intellectual cornerstone of their existence."

American psychologists who were visiting the Soviet Union during the attacks on Pasternak found some sympathy for him and demand for the novel, but such sentiments were far from universal. "There was also substantial evidence that many, perhaps the majority, of students in the literary, historical and philosophical faculties of Moscow and Leningrad higher-educational institutions accepted the official line condemning Pasternak as a traitor to Russia," they reported in a summary of their visit. "Acceptance of the official point of view seems to have been based, in part, upon resentment of what was felt to have been exploitation in the West of the Pasternak matter in the interests of anti-Russian propaganda."

At the height of the Nobel crisis, Pasternak was also getting fifty to seventy letters a day, both from Soviet citizens and from abroad. Most offered support —

albeit anonymously from his fellow countrymen. Even among the letters to *Novy Mir* there were about 10 percent, mostly from young people, who backed Pasternak's right to publish *Doctor Zhivago* or their right to read the novel. There is some evidence that the editors of *Novy Mir* forwarded letters defending Pasternak to the KGB.

There were also letters that wounded Pasternak. He singled out one that was addressed "To Pasternak from Judas: 'I only betrayed Jesus, but you — you betrayed the whole of Russia.'"

For a time, all of Pasternak's mail was blocked. At his meeting with Polikarpov, Pasternak had demanded that letters and parcels be allowed through, and the following morning the postwoman brought two bags full. The German journalist Gerd Ruge estimated that in all Pasternak received between twenty thousand and thirty thousand letters after the award of the Nobel Prize. His delight in this correspondence, even though it soaked up his time, was expressed in the light poem "God's World":

I return with a bundle of letters
To the house where my joy will prevail.

The letters broke his isolation, reconnected him with old friends in the West, and forged new literary bonds with writers such as T. S. Eliot, Thomas Merton, and Albert Camus. "The great and undeserved happiness bestowed on me at the end of my life is to be in touch with many honorable people in the widest and far

world and to engage with them in spontaneous, spiritual and important conversations," he told one correspondent in 1959. He stayed up until two or three in the morning answering these letters, using his dictionaries to help him respond in multiple languages. "I'm troubled by the volume of it and the compulsion to answer it all," he said. There were moments, as he put it in one poem, when he felt he would like to "merge into privacy, like landscape into fog."

He was troubled, too, by the desire of Western admirers to resurrect and publish many of his old poems, work that he felt was often best forgotten. "It is an unspeakable grief and pain for me to be reminded again and again of those scarce grains of life and truth, interspersed with an immensity of dead, schematic nonsense and nonexistent stuff," he told one translator. "I wonder [at] your . . . attempt to rescue the things deservedly doomed to ruin and oblivion." Nor was he happy with some overelaborate interpretations of the novel in the West. He rejected a proposal by Kurt Wolff to publish a collection of critical essays to be called *Monument to Zhivago.* "Didn't the doctor have enough trouble?" Pasternak asked Wolff in a letter. "There can only be one monument: a new book. And I am the only one who can do that."

Along with the appearance of the letters in *Literaturnaya Gazeta,* the Soviet news agency Tass reported on November 1 that should Pasternak wish "to leave the Soviet Union permanently, the Socialist regime and people he has slandered in his anti-Soviet work, *Doctor Zhivago,* will not raise any obstacles. He

can leave the Soviet Union and experience personally 'all the fascinations of the capitalist paradise.'"

Pasternak's wife told a reporter from United Press International the following day that Pasternak was not feeling well and must rest. She said expulsion from the Soviet Union would be the worst thing that could happen to him. "I am going to cook for him as well as I can, and we shall live very quietly here for one year or longer — with no visits or interviews." Like Emma Ernestovna, the housekeeper of Viktor Komarovsky in *Doctor Zhivago*, Zinaida saw herself the "matron of his quiet seclusion," who "managed his household inaudibly, and invisibly, and he repaid her with chivalrous gratitude, natural in such a gentleman."

On November 4, Polikarpov phoned Ivinskaya's apartment while Pasternak was visiting. "We must ask Boris Leonidovich to write an open letter to the people," he informed her. The letter to Khrushchev was insufficient as a public apology. Pasternak immediately began to craft another attempt. It echoed his earlier statements that he always felt the award of the Nobel would be a matter of pride for the Soviet people. When Ivinskaya brought a draft to Polikarpov, he rejected it and said he and Ivinskaya would have to fashion a more acceptable version. "We 'worked' on it like a pair of professional counterfeiters," said Ivinskaya. When she showed the rewritten version of the letter to Pasternak, he "simply waved his hand. He was tired. He just wanted an end to the whole abnormal situation."

The letter, addressed to the editors of *Pravda*, was published on November 6. Pasternak said he

voluntarily rejected the Nobel Prize when he saw "the scope of the political campaign around my novel, and realized that this award was a political step, which had now led to monstrous consequences." He said he regretted that he had not heeded the warning from the editors of *Novy Mir* about *Doctor Zhivago*. And Pasternak said he could not accept erroneous interpretations of the novel, including the assertion that the October Revolution was an illegitimate event. Such claims, he wrote (or rather Polikarpov wrote), have been "carried to absurdity . . .

"In the course of this tempestuous week," the letter continued, "I have not been persecuted, I have not risked either my life or my freedom, I have risked absolutely nothing."

The letter concluded with "I believe that I shall find the strength to restore my good name and the confidence of my comrades."

Exhaustion and concern for Ivinskaya combined to give the authorities the concession they wanted even though most careful readers of the letter knew it was not from Pasternak's hand. The repeated assertion that he was acting voluntarily stretched the credulity of even *Pravda* readers. But the fact that he signed any letter of contrition disappointed some Russians. In Ryazan, a schoolteacher named Aleksandr Solzhenitsyn "writhed with shame for him" — that he would "demean himself by pleading with the government."

Anna Akhmatova dismissed Pasternak's ordeal as inconsequential compared to what she and Zoshchenko had suffered when they were thrown out of the Union

of Soviet Writers in Stalin's time. Pasternak and his family were left untouched in his fine house, she remarked. "The story of Boris is — a battle of butterflies," she told Chukovskaya. Some long-standing tension between Akhmatova and Pasternak had begun to surface. The Leningrad poet smarted from what she felt was Pasternak's lack of homage to her art; she was irritated by his manner, but still loved him and craved his admiration. Akhmatova continued to believe that *Doctor Zhivago* was a bad novel "except for the landscapes," and that Pasternak was too self-satisfied with his martyrdom and his fame. Later in the year, when the two met at a birthday party in Peredelkino, Akhmatova commented, "Boris spoke the whole time only about himself, about the letters he was receiving . . . Then for a long time, in a totally boring way, he played the coquette when they asked him to read. After I read, he asked me, shouting across the table: 'What do you do with your poetry? Pass it around to your friends?' "

Akhmatova recalled visiting the composer Dmitri Shostakovich at his summer home in Komarovo outside Leningrad. "I looked at him and thought: he carries his fame like a hunchback, used to it from birth. But Boris — like a crown which just fell down over his eyes, and he shoves it back in place with his elbow."

The *Pravda* letter was a tactical retreat; Pasternak still had to support two households. The authorities in return for Pasternak's signature agreed to restore his and Ivinskaya's ability to earn a living through

translation work; Polikarpov also said that a second edition of Pasternak's translation of *Faust* would be published. He lied. That winter, Pasternak was unable to earn any money. His translation of *Maria Stuart* by Juliusz Sløowacki, which was about to be published, was suspended; the production of Shakespeare and Schiller plays that he had translated was stopped; and no new translation work was commissioned. In January he wrote to the Soviet copyright agency to ask what had happened to payments he was scheduled to receive and he also wrote to Khrushchev to complain that he couldn't even participate in the "harmless profession" of translation. He even suggested to the copyright agency that it could get his royalties in exchange for fees owed to Western writers who were published in the Soviet Union but not paid, such as Hemingway. The Soviet Union did not pay for the Western books it translated and published until 1967, when it entered into an international copyright agreement.

On paper, Pasternak was a wealthy man. Feltrinelli had been depositing payments from publishers around the world into a Swiss bank account, and both the CIA and the Kremlin speculated that Pasternak was already a millionaire. Accessing some of that money would bring relief, but also more heartache and tragedy. Pasternak realized his wealth was a poisoned chalice and that if he sought permission to transfer it to Moscow, he would face "the perpetual accusation of treacherously living off foreign capital." He did tell his publisher in February to disburse $112,000 in gifts of various sizes to his friends, translators, and family in

the West. But initially he expressed some indifference about his fortune, telling Feltrinelli, "The fact that I am completely lacking in curiosity regarding the various details and how much it all amounts to must not amaze or hurt you."

The pinch of no income eventually began to hurt. "Their desire to drown me is so great I can see nothing but this desire," Pasternak said. And he expressed bewilderment at his predicament. "Have I really done insufficient in this life not to have at seventy the possibility of feeding my family?" He began to borrow money, first from his housekeeper and then friends. In late December he asked Valeria Prishvina, the widow of the writer Mikhail Prishvin, if he could borrow 3,000 rubles, about $300, until the end of 1959. Early in January, he borrowed 5,000 rubles from Kornei Chukovsky, who presumed it was for Ivinskaya. His neighbor found Pasternak older. "His cheeks are sunken but no matter: he's full of life." Chukovsky told him he hadn't slept in three months because of what Pasternak had endured. "Well, I'm sleeping fine," Pasternak responded.

He told Ivinskaya the following month, "We must put our financial affairs, both yours and mine, in order." Pasternak asked Gerd Ruge, the German correspondent, if he could get him some cash that would be paid back from the money held in the West by Feltrinelli. Ruge gathered about $8,000 worth of rubles at the West German embassy from Russians of ethnic German origin who had been granted permission to emigrate but could take no money with them. Ruge

278

took their cash in exchange for the payment of deutsche marks when they reached Germany. The German journalist handed Ivinskaya's daughter a package of cash when the two brushed by each other at the metro station Oktyabrskaya in a prearranged piece of amateur spycraft.

Pasternak seemed to realize the danger Ivinskaya and her family faced when he involved them in these secretive efforts to get money. He alerted his French translator, Jacqueline de Proyart, that if he wrote to her and told her he had scarlet fever, it meant that Ivinskaya had been arrested and she should raise the alarm in the West.

In April, Pasternak asked Polikarpov if he could get permission to receive money held by his Norwegian publishers, and he offered to donate part of the royalties to a fund for writers in need. "You know that as of this moment, I have not received one single penny of what is owed to me in royalties from the foreign editions of my novel," Pasternak said.

The authorities, unmoved, warned him not to accept any money held in Western banks, and forced him to sign a letter renouncing the funds. When Ivinskaya complained that Pasternak and she had nothing to live on, Polikarpov replied ambiguously, "It wouldn't be so bad if they even brought you your money in a sack as long as Pasternak quiets down."

Feltrinelli also sent in seven or eight packages, or "rolls" (Brötchen) as they called them, amounting to about 100,000 rubles with another German journalist, Heinz Schewe, who had become friends with Pasternak

279

and Ivinskaya and worked for *Die Welt*. At the end of 1959, Pasternak asked Feltrinelli to turn over $100,000 to D'Angelo, who had written to the author to tell him he could purchase rubles in the West and safely smuggle the cash into the Soviet Union.

The average annual income of a Soviet citizen at this time was about 12,000 rubles. Under the official exchange rate, which bore no relation to the black market, one dollar in early 1959 would buy ten rubles. This money smuggling was all well-intentioned but reckless. Pasternak and his circle were still being watched, as were all foreigners in touch with him. Pasternak's Western friends, riven by their own interests and jealousies, wanted to please him. The KGB was monitoring the various streams of cash, and biding its time.

In 1959, Pasternak was caught in another imbroglio, partly of his own making — a bitter business dispute between Feltrinelli and Jacqueline de Proyart. A Radcliffe College graduate who had traveled to Moscow in late 1956 to perfect her Russian at Moscow State University, de Proyart happened to read a manuscript copy of *Doctor Zhivago*, and some Russian friends brought her to see Pasternak on the evening of January 1, 1957. Pasternak had invited them to share leftovers from the New Year's feast; earlier he had had dinner with Akhmatova, Voznesensky, the Neigauzes, and Ariadna Efron, among other friends. Pasternak was thrilled at the presence of a young Frenchwoman — de Proyart was just shy of thirty — and the evening stretched out pleasantly. Pasternak talked about Paris,

which he had visited in 1935 for the Congress of Writers in Defense of Culture; about Stalin and the Leader's wife; and about Mandelstam.

The conversation turned to *Doctor Zhivago*. Pasternak asked his guests if they had detected the influence of any Russian writers on his novel. "Leo Tolstoy," said someone, but it was not the answer Pasternak was looking for. He turned to de Proyart, who risked, "Chekhov."

"Magnificent!" cried Pasternak. "You've guessed correctly."

It seemed to de Proyart that Pasternak's willingness to trust her turned on that single answer. They met several more times in January and February. Pasternak showed her his contract with Feltrinelli, and de Proyart expressed reservations about allowing such a young publisher, who didn't speak Russian, to control the novel's destiny. Pasternak gave de Proyart a handwritten literary power of attorney — a decision that could only bewilder and infuriate Feltrinelli.

De Proyart would eventually attempt to assert control over any Russian edition of *Doctor Zhivago*, the publication of some of Pasternak's earlier works, and, armed with a fresh letter from Pasternak, the management of all of his royalties. Feltrinelli felt betrayed. "To find myself bereft of your trust, of the support of your authority, is an unexpected surprise, and an extremely painful one." Pasternak envisioned de Proyart as an aesthetic companion to Feltrinelli's publishing acumen, but the two despised each other

and much of 1959 was spent in painful correspondence, disentangling the mess. "I have confused the issue beyond measure," he told them in a joint letter. "Forgive me, therefore, both of you." The confusion was compounded by the difficulty of getting letters in and out of Peredelkino. To discuss publishing and financial matters both Pasternak and his closest Western friends often used trusted couriers to communicate, and letters often took weeks or months to reach their destination. "Conducting business, making decisions, and coming to agreement by means of a mail service that is so uncertain, slow and ill disposed, over such distances, with such tight deadlines — it is a torment, an unsolvable problem, a wretched misfortune," Pasternak wrote.

The novel was the subject of continued attention and acclaim in the West. The premier American critic Edmund Wilson wrote a long and glowing review in *The New Yorker* in November, although he was unhappy with the quality of the translation into English: "*Doctor Zhivago* will, I believe, come to stand as one of the great events in man's literary and moral history. Nobody could have written it in a totalitarian state and turned it loose on the world who did not have the courage of genius."

When Anastas Mikoyan, the first deputy chairman of the Soviet Council of Ministers, visited the United States in early 1959, he went out for a sightseeing stroll and was famously photographed outside a bookstore window full of copies of *Doctor Zhivago*. He gazed into

the window as if a little perplexed. Later, outside the venue where a private steak dinner was hosted by the Motion Picture Association, Mikoyan was confronted by protesters carrying placards that read: "Suffering from delusions about Communism? Consult Dr. Zhivago."

By March 1959, 850,000 copies of the novel had been sold in the United States. The *Sunday Times* in London declared *Doctor Zhivago* the novel of the year. When an Uruguayan journalist visited Pasternak, he told his Soviet minder, "Pasternak is so fashionable in Uruguay that girls from aristocratic families believe it is a must and good manners to have copies of *Doctor Zhivago* in your hand when you go out to parties." At an anti-Communist rally held by Roman Catholic youth in Vienna, a massive photograph of Pasternak was raised above the speakers' platform. *The New York Times* reported that "a photomontage made [Pasternak] appear to be standing behind barbed wire. From a distance he seemed to be wearing a crown of thorns."

Not everyone regarded Pasternak as a religious hero, and one of the strongest objections to *Doctor Zhivago* came from David Ben-Gurion, the Israeli prime minister, who was appalled by the novel's position on assimilation and said it was "one of the most despicable books about Jews ever written by a man of Jewish origin." He added that it was "a pity that such a book came from the pen of a man who had the courage to defy his own government."

The Nobel awards ceremony took place on December 10, 1958, at Stockholm Concert Hall, which

was packed with two thousand dignitaries, including Gustaf VI, the Swedish king, and the Soviet ambassador. The Soviet science laureates, along with the other winners, sat in a row of plush red chairs; Igor Tamm, wearing a broad grin, bowed so deeply before the king that his medal almost fell off. Toward the end of the ceremony, Österling simply noted of Pasternak that "the laureate has, as is known, announced that he does not wish to accept the prize. This renunciation in no way changes the validity of the distinction. It remains only for the Swedish Academy to state with regret that it was not possible for the acceptance to take place." The audience listened in complete silence.

In the weeks after the *Pravda* letter, Pasternak was circumspect with journalists, and the public hysteria of late October and early November began to fade. "Tempest not yet over do not grieve be firm and quiet. Tired loving believing in the future," Pasternak said in a telegram to his sisters in mid-November. He was worn out. The following day he wrote to a cousin, "It would be best of all to die right now, but probably I shall not lay hands on myself."

His spirit slowly rekindled, however, inflamed by the pettiness of the authorities and disgust at the continuing abuse of old foes like Surkov. At the Congress of Writers in December, Surkov spoke of Pasternak's "putrid internal émigré position" and said he was an "apostate our righteous wrath has driven from the honorable family of Soviet writers." Surkov also was forced to admit that Pasternak's expulsion from the writers' union had "disoriented progressive writers and put in their

hearts some doubt about the Tightness of our decision."

In a draft letter to the Central Committee, which was obtained by the KGB, Pasternak railed against the "supreme power": "I realize that I can't demand anything, that I have no rights, that I can be crushed like a small insect ... I was so stupid to expect generosity after those two letters."

His anger rising, Pasternak told the British journalist Alan Moray Williams in January 1959, "The technocrats want writers to be a sort of power for them. They want us to produce work which can be used for all kinds of social purposes, like so many radioactive isotopes ... The Union of Soviet Writers would like me to go on my knees to them — but they will never make me." He told another journalist that "in every generation there has to be some fool who will speak the truth as he sees it."

In a letter to Feltrinelli, he displayed some of his old heightened vigor, describing his life as "distressing, deadly dangerous, but full of significance and responsibility, dizzyingly enthralling, and worthy of being accepted and lived in glad and grateful obedience to God."

Pasternak was also enervated by strains in his relationship with Ivinskaya. He had talked about making a break with his wife and spending the winter in Tarusa, about ninety miles south of Moscow, with his lover. The writer Konstantin Paustovsky had offered them his home. Ivinskaya more than ever wanted to marry. But Pasternak changed his mind at the last minute. He said he didn't want to hurt people who "wanted only to preserve the appearance of the life they

were used to." He told Ivinskaya that she was his "right hand" and he was entirely with her.

"What more do you need?" he asked.

"I was very angry indeed," recalled Ivinskaya. "I felt intuitively that I needed the protection of Pasternak's name more than anyone else." She stormed back to Moscow.

In the following days, Pasternak wrote several poems, including one called "The Nobel Prize." It began:

I am lost like a beast in an enclosure
Somewhere are people, freedom, and light,
Behind me is the noise of pursuit,
And there is no way out.

Pasternak showed it to Chukovsky, who thought it was a mood piece, written on impulse. Pasternak gave a copy of it to Anthony Brown, a correspondent for the *Daily Mail* who visited him for an interview on January 30. When it was published, "The Nobel Prize" created another global sensation. The *Daily Mail* declared that "Pasternak is an outcast" under the headline "Pasternak Surprise: His Agony Revealed in 'The Nobel Prize.'"

"I am a white cormorant," Pasternak told the journalist. "As you know, Mr. Brown, there are only black cormorants. I am an oddity, an individual in a society which is not meant for the unit but for the masses."

Pasternak said he asked the journalist to give the poem to Jacqueline de Proyart, and never intended it for publication. He complained to other reporters who

visited him on February 10, his birthday. "The poem should not have been published," he told one correspondent. "It makes me look like a young girl who is admiring herself in the mirror. Besides, the translation is bad." Pasternak said the poem was written in a pessimistic mood, which had passed. His wife was furious. "How many times did I tell you that you should not trust reporters?" she asked. "If this is going to continue, I'm leaving you."

Pasternak protested a little too much about Brown's betrayal — perhaps in deference to the hidden microphones. In early 1959 he could no longer legitimately claim to be unaware of the consequences of passing his writing to unknown foreigners. To hand over such a personal and polemical piece of work so soon after the Nobel Prize trouble was perhaps foolish, but it was characteristically defiant. "Only a madman would do such a thing," commented Chukovsky, "and I'm not sure there isn't a glint of madness in his eyes."

CHAPTER
FOURTEEN

"A college weekend with Russians"

In the West, there was no longer any doubt that Pasternak's renunciation of the Nobel Prize, and the letters of apology to Khrushchev and *Pravda*, were coerced. The authorities reacted with predictable fury to the *Daily Mail* article. Polikarpov told Ivinskaya that Pasternak was to cut off all contact with the foreign press. The writer was also "advised" to get out of Moscow during a visit by British prime minister Harold Macmillan so the inevitable retinue of reporters would not make their way to Peredelkino.

In the face of Ivinskaya's outrage, Pasternak took up an invitation to visit Nina Tabidze in Tbilisi with Zinaida. Ivinskaya took off for Leningrad "in a cold fury."

Georgia was a wonderful escape. Tabidze's house looked out over the city with views of the distant Daryal Gorge and Mount Kazbek. Tabidze told Pasternak that he was the third disgraced Russian poet, after Pushkin and Lermontov, to be sheltered by Georgia. She prepared a private room for him. Pasternak spent his days reading Proust, thinking about a possible new work to be set, in part, in Georgia, and walking the cold, cobblestone streets of the Old Town.

In the evening, actors and writers crowded into Tabidze's apartment to eat and drink with Pasternak.

The painter Lado Gudiashvili held a reception in his honor, despite official warnings that Pasternak was not to be celebrated in any way. The poet recited by candlelight, amid the artist's vivid, colorful works, which crowded the walls. Pasternak inscribed Gudiashvili's scrapbook with lines from the poem "After the Storm":

The artist's hand is more powerful still.
It washes all the dust and dirt away
So life, reality, the simple truth
Come freshly colored from his dye works.

Pasternak wrote frequently to Ivinskaya and spoke of the need to move beyond the "scares and scandals." "I really should draw in my horns, calm down and write for the future." He reproached himself for involving Ivinskaya so deeply "in all these terrible affairs."

"I am casting a large shadow on you and putting you in awful danger," he wrote. "It's unmanly and contemptible." He doted on her in his fashion: "Olyusha, my precious girl, I give you a big kiss. I am bound to you by life, by the sun shining through my window, by a feeling of remorse and sadness, by a feeling of guilt (oh, not toward you of course, but toward everyone), by the knowledge of my weakness and the inadequacy of everything I have done so far, by my certainty of the need to bend every effort and move mountains if I am not to let down my friends and prove

289

an imposter . . . I hold you to me terribly, terribly tight and almost faint from tenderness, and almost cry."

He was also a little smitten with Gudiashvili's nineteen-year-old daughter, Chukurtma, a dark-haired ballet student. Pasternak fell to his knees and read her his poetry, and she went out walking with him, taking him to the excavation of a tenth-century site outside Tbilisi; Pasternak considered writing a novel about geologists discovering their links to early Christianity in Georgia. Lado Gudiashvili thought his daughter, prone to depression, bloomed under the poet's attention. In a letter to Chukurtma after he returned to Moscow, Pasternak told her that she had moved him. "I don't want to talk nonsense to you, don't want to offend your seriousness or my life with something ridiculous or inappropriate, but I have to tell you this. If by the time I die you have not forgotten me, and you, somehow, will still be in need of me, remember that I counted you among my very best friends and gave you the right to mourn for me and to think of me as someone very close."

The trip also brought a reminder of the state's cruelty. The elderly Georgian poet Galaktion Tabidze, a cousin of Nina's murdered husband who had survived Stalin's purges, was pressured by the authorities to write a letter to the newspaper condemning Pasternak. His mental health was already fragile, and Tabidze found the latest official harassment unbearable. He jumped to his death from a hospital window.

290

On March 14, shortly after he returned to Russia, Pasternak was hauled into Moscow for a meeting with the chief prosecutor of the Soviet Union, Roman Rudenko, who had also led the Soviet prosecution team at the Nuremberg trials of the leading Nazi war criminals. After the appearance of the poem "Nobel Prize," Rudenko recommended that Pasternak be stripped of his citizenship and deported, but the presidium of the Supreme Soviet of the USSR, which had the power to do so, did not approve the measure.

Rudenko was, however, authorized to interrogate the writer. He accused Pasternak of "double-dealing" when he turned over his poem to Brown. He threatened Pasternak with a charge of treason. Pasternak said it was an act of "fatal carelessness," but said he never intended the poem to be published, according to Rudenko's report of the interrogation, which was countersigned by Pasternak. "I denounce those actions of mine and I am well aware that I may be criminally liable in accordance with the law," Pasternak admitted, according to the report. Rudenko told his colleagues that Pasternak "behaved like a coward."

Pasternak's own report to Ivinskaya was somewhat different. "Do you know I've been talking to a man without a neck?" Pasternak told her that Rudenko had asked him to sign a statement saying he would not meet foreigners, but he had refused.

"Cordon me off and don't let foreigners through, if you want," said Pasternak, "but all I can say in writing is that I've read your piece of paper. I can't make any promises." No further action was taken by Rudenko.

The state appeared unwilling to draw further attention to Pasternak by openly persecuting him. In England, Isaiah Berlin thought that Pasternak seemed "like Tolstoy in 1903 or so, when all the disseminators of his gospel were punished by the government but the old man himself was too eminent & odd to be touched by the police."

When he got home, Pasternak nonetheless put up signs in English, French, and German on his front and side doors in Peredelkino. They stated: "Pasternak does not receive. He is forbidden to receive foreigners." Zinaida also continued to insist that he not admit foreigners. "You have to stop receiving that trash," she told him, "or else they will cross the threshold of this house over my dead body."

The signs were routinely taken as souvenirs, and the message varied: "Journalists and others, please go away. I am busy." When the journalist Patricia Blake visited him on Easter, Pasternak spoke to her on the top step of his porch and did not invite her in. "Please forgive me for my terrible rudeness," he said, explaining that he was in serious trouble and banned from meeting foreigners. Although Blake found him "astonishingly young for a man of sixty-nine, she was shocked by the immense weariness in his face, in his whole bearing." When she left the dacha, plainclothes policemen followed her back to the train station. The Swedish professor Nils Åke Nilsson didn't make it out of the station before the police told him to return to Moscow. The enforced isolation extended to warnings that Pasternak should not attend public events in Moscow.

His friends shrank to a small circle, and the close monitoring continued; the KGB recorded the names of the guests who attended his sixty-ninth-birthday party at the dacha.

The CIA's efforts to exploit *Doctor Zhivago* were re-energized by the Nobel crisis. The agency continued to try to get its dwindling supply of Russian-language copies of *Doctor Zhivago* into the Soviet Union, and it also purchased copies of the English edition for distribution. At first, the agency gave the novel only to non-Americans who were traveling to the Soviet Union, preferably by air rather than train because it calculated that fewer of those passengers would be thoroughly searched. If stopped and checked, visitors carrying the novel were instructed to say they purchased it from a Russian émigré or it was obtained at the Brussels Fair so that the smuggling effort could not be linked to the U.S. government.

As the storm over the Nobel Prize abated, the CIA decided that other parts of the U.S. government, as well as American travelers, could openly participate in the novel's dissemination. The agency calculated that the original rationale for secrecy — to avoid the "possibility of personal reprisal against Pasternak" — was no longer an issue.

"The worldwide discussion of the book and Pasternak's own personal statements have shown that his personal position has not become worse," a CIA memo concluded. "In other words, an all-out overt exploitation of *Dr. Zhivago* would not harm Pasternak

more than he has already harmed himself." Shortly afterward, the Soviet Russia Division said it was forwarding by sea freight a batch of copies of the University of Michigan edition of *Doctor Zhivago* so that American travelers in Europe could also carry it into the Soviet Union: "It would be quite natural for an American who speaks or reads Russian to be carrying and reading the book, which has been number one on the bestseller list for the past three months."

The CIA also provided elaborate guidelines for its agents to encourage tourists to talk about literature and *Doctor Zhivago* with Soviet citizens they might meet.

"We feel that *Dr. Zhivago* is an excellent springboard for conversations with Soviets on the general theme of 'Communism versus Freedom of Expression,'" the head of the Soviet Russia Division, John Maury, wrote in a memo in April 1959. "Travelers should be prepared to discuss with their Soviet contacts not only the basic theme of the book itself — a cry for the freedom and dignity of the individual — but also the plight of the individual in the communist society. The whole Pasternak affair is indeed a tragic but classic example of the system of thought control which the party has always used to maintain its position of power over the intellectual. Like jamming, censorship, and the party's ideological decrees for writers and artists, the banning of this book is another example of the means which the regime must use to control the Soviet mind. It is a reflection of the *Nekulturnost*, the intellectual barbarity, and the cultural sterility which are features of the closed society."

294

The memo went on to say that Americans and other visitors could raise doubts about the tenets of socialist realism: "Perhaps a good opening to such conversations is to ask the Soviet interlocutor about the latest developments in Soviet drama, poetry, art, etc. A sympathetic but curious attitude towards the innovations and trends in the Soviet artistic world will usually set a friendly tone for the conversation. After discussing the latest artistic developments, a Westerner can inquire about what makes the works of Soviet writers such as Sholokhov, Pasternak, Margarita Aliger, Fedin . . . as great as they are. After discussing the works of these writers he can ask what limits the party has placed upon artistic works."

Maury then suggests that the tourist "can point out that a true artist must be free to speak of the ideals as well as the iniquities of any society, to criticize capitalism or communism, in short to say what he believes to be true. A number of American and European writers such as Steinbeck, John Dos Passos, Upton Sinclair, Sinclair Lewis, Sartre, Camus and others have criticized as well as defended various aspects of life in their home countries."

Agency officials congratulated themselves that "in one form or another, including full-length and condensed books and serials in indigenous languages, this book has been spread throughout the world, with assistance from this agency in a number of areas where interest might not normally be great." (Unfortunately, CIA documents provide no further detail on these efforts.) The CIA also considered publishing an

anthology of Pasternak's works, including a pirated, Russian-language edition of his *Essay in Autobiography*. This had recently been published in translation in France, and the agency obtained the Russian-language manuscript from which the French translation was made.

In the end, the CIA just went forward with another edition of *Doctor Zhivago*. As early as August 1958, even before the publication of the first Russian-language edition of *Doctor Zhivago*, the CIA began to consider a miniature, paperback edition to be printed on "bible-stock" or similar lightweight paper. Such an edition had the obvious benefit of being "more easily concealed and infiltrated" than either the Mouton or University of Michigan editions. During the height of the Nobel crisis, officials at the agency also considered an abridged edition of the novel that could be handed out to Soviet sailors or even ballooned into East Germany. In November 1958, the Soviet Russia Division began to firm up plans for its miniature edition. In a memo to the acting deputy director for Plans, the chief of the Soviet Russia Division said he believed that there was "tremendous demand on the part of students and intellectuals to obtain copies of this book." The agency reported that Soviet customs officials were instructed to search tourist baggage "for this particularly hot item." In fact, in late 1958, the Soviet Union reinstituted searches of tourist luggage, which it had abandoned after the death of Stalin. One of the seized Mouton copies of the CIA edition of *Doctor Zhivago* was turned over in 1959 to the closed

special collections section of Moscow's V. I. Lenin State Library, where top party officials and approved researchers could read banned publications. Books designated for the shelves in this area of the library were affixed with one or two purple hexagonal stamps, the marks of the censor. Different censors had different numbers; *Doctor Zhivago* was stamped once with "124" — a designation that should have allowed some people to read it. But the novel was kept under strict KGB embargo and was off-limits even to favored academics, according to a former librarian in the special collections section.

The CIA had its own press in Washington to print miniature books, and over the course of the Cold War printed a small library of literature — books that would fit "inside a man's suit or trouser pocket." Officials reviewed all the difficulties with the Mouton edition published in the Netherlands, and argued against any outside involvement in a new printing. "In view of the security, legal and technical problems involved, it is recommended that a black miniature edition of *Dr. Zhivago* be published at headquarters using the first Feltrinelli text and attributing it to a fictitious publisher."

By July, at least nine thousand copies of a miniature edition of *Doctor Zhivago* had been printed "in a one and two volume series," the latter presumably to make it not so thick, and easier to split up and hide. "The miniature edition was produced at headquarters from the original Russian language text of the Mouton edition," the agency reported in an internal memo. The

CIA attempted to create the illusion that this edition of the novel was published in Paris by ascribing publication to a fictitious entity that was called the Société d'Edition et d'Impression Mondiale. Some of these copies were subsequently distributed by the NTS (National Alliance of Russian Solidarists), the militant Russian émigré group in Germany, another measure to hide the CIA's involvement, although the agency's released records don't mention the organization.

At a press conference in The Hague on November 4, 1958, Yevgeni Garanin, a member of the executive board of the NTS, said his group was planning to print a special bible-stock edition of the novel. Garanin said the NTS had obtained a copy of *Doctor Zhivago* at the Vatican pavilion, but no decisions had been taken on the size of the print run or where the novel would be printed. He said the group planned to distribute copies among sailors and visitors from Russia. A new, unsigned foreword was written by Boris Filippov, a Washington, D.C., resident and prominent Russian émigré who had previously edited *Grani*, the NTS journal; Filippov claimed in correspondence with a colleague that he had "released" this edition of *Zhivago*. Without mentioning the CIA by name, he complained that his introduction was "so maliciously and ignorantly mutilated by the man who gave money for the edition that I removed my name from the edition and the article."

CIA records state that the miniature books were passed out by "agents who [had] contact with Soviet tourists and officials in the West." Two thousand copies

of this edition were set aside for dissemination to Soviet and East European students at the 1959 World Festival of Youth and Students for Peace and Friendship, which would be held in Vienna.

The festival, which was sponsored by Communist youth organizations, took place between July 26 and August 4. The Kremlin spent millions of dollars on these events, and the Vienna festival was supervised personally by Alexander Shelepin, the head of the KGB. Until 1958, when he moved to the Lubyanka, Shelepin was the vice president of the International Union of Students, a prime mover behind the festival. After becoming head of the KGB, Shelepin kept his position at the International Union of Students for another year so he could supervise events in Vienna, which attracted thousands of young people from across the world. The Soviet Union underwrote the attendance of delegates from the developing world. Because it was the first such festival held in the West, it was also the target of efforts covertly orchestrated by the CIA to disrupt the proceedings — or as the agency's young provocateurs preferred to call the jamboree, "a tool for the advancement of world communism." Half of the Northern Hemisphere was Communist and the superpowers increasingly fought for the allegiance of Latin Americans, Africans, and Asians.

The CIA created another front organization, the Independent Service for Information (ISI) in Cambridge, Massachusetts, to recruit American students to disrupt the festival. The ISI was headed by Gloria Steinem, a

recent graduate, who was made aware of the CIA's role when she asked about the organization's funding. When the CIA's involvement was revealed in 1967, Steinem said she found the CIA officers with whom she worked "liberal and farsighted and open to an exchange of ideas. I never felt I was being dictated to at all . . .

"The CIA was the only one with enough guts and foresight to see that youth and student affairs were important," said Steinem, who said no member of the ISI delegation passed information to the agency. "They wanted to do what we wanted to do — present a healthy, diverse view of the United States."

The ISI set up a news bureau to feed information to Western correspondents who were refused entry to the festival and smuggled copies of an unsanctioned newspaper into event venues. Newspapers published in several languages were brought in at night and placed in the toilets. The festival grounds were guarded by a security force that checked credentials and patrolled for interlopers. Hotel porters were paid to slip newspapers under the doors of senior officials attending the festival.

Much of the group's activities took the form of student high jinks. Zbigniew Brzezinski, later President Jimmy Carter's national security adviser, tried to sow discord, by bumping into Russian delegates and then in a thick Polish accent telling them in Russian, "Out of my way, Russian pig!" Brzezinski, Walter Pincus — later a national security correspondent at *The Washington Post* — and one of Brzezinski's students at Harvard hid on a rooftop over Vienna's Rathausplatz just as the festival's closing ceremony was about to begin below.

The three men hung Hungarian and Algerian flags with the centers cut out in a somewhat strained attempt to equate communism with colonialism and express solidarity with the movements against both. They also hung two white bedsheets with the words *Peace* and *Freedom* spelled vertically and in German. The three used a plank to escape onto another rooftop and away from the festival's security personnel, who dimmed the lights over the square and raced toward the roof to tear down the flags and banners. Pincus later described the ISI's shenanigans in Vienna as "a college weekend with Russians." At the time, however, it all seemed very important. "I suppose this was my small world equivalent of going off to join the Spanish Revolution," Steinem told her aunt and uncle in a letter.

There was a significant effort to distribute books in Vienna — about 30,000 in fourteen languages, including *1984*, *Animal Farm*, *The God That Failed*, and *Doctor Zhivago*. The goal was "to expose delegates from the Soviet orbit to revisionist writing" and to "supply the delegates from uncommitted areas with exposes of ideas competing with Communism." The books were handed out from kiosks and sold at discounted prices at bookstores around town. Young activists from the West noted that these locations "were under observation by communist agents." The scrutiny in and around the festival grounds was so intense that teams of young people followed sightseeing delegates so they could hand out books at locations such as museums where the minders were not able to exercise as much control. Alexei Adzhubei, Khrushchev's

son-in-law and the editor of *Izvestiya*, as well as the Soviet ambassador to Austria, "complained bitterly" about ISI's projects in Vienna.

Plans for a Vienna book program were created by Samuel Walker, the former editor of the CIA-funded Free Europe Press, and C. D. Jackson, a Time-Life executive who previously had served as an adviser to the Eisenhower administration on psychological warfare. Walker, with the blessing of the "friends," as he called the CIA, set up a dummy company in New York, the Publications Development Corporation, to target the Vienna youth festival with books. Overall responsibility for getting books into the hands of the delegates was mostly left to Austrian allies of the effort. When one of Jackson's European partners, Klaus Dohrn, a Time-Life executive in Zurich, worried that "special efforts . . . will have to be made to secure the original Russian text of Dr. Zhivago," Jackson replied: "Don't worry about the 'Dr. Zhivago' text. We have the authentic one, and that is the one that will be used."

Apart from a Russian edition, plans also called for *Doctor Zhivago* to be distributed in Polish, German, Czech, Hungarian, and Chinese at the festival.

The novel had been published in Taiwan in Chinese in 1958 and serialized in Chinese by two newspapers in Hong Kong late the same year. Reaction to the novel in the Chinese press was hostile and in the periodical *World Literature*, Zang Kejia, the managing secretary of the Chinese Writers Association, said *Doctor Zhivago* was an ulcer on the Soviet Union. At the Vienna festival, the four-hundred-strong Chinese

delegation was even more cocooned than their Eastern European comrades; delegates were instructed not to communicate with the Westerners they encountered, even the waiters who served their meals. And a report by a group of Polish anti-festival activists found the Chinese, unlike other delegations from Communist countries, to be "absolutely uncommunicative." The Free Europe Committee flew in fifty copies of *Doctor Zhivago* from Hong Kong for distribution.

The New York Times reported that some members of the Soviet delegation "evinced a great curiosity about Mr. Pasternak's novel, which is available here." Occasionally it was not only available but unavoidable. The Soviet delegation of students and performers arrived in a sweltering Vienna from Budapest on forty buses; among the Soviet visitors was the young ballet dancer Rudolf Nureyev. Crowds of Russian émigrés swarmed the Soviet convoy when it entered the city and tossed copies of the CIA miniature edition of *Doctor Zhivago* through the open windows of the buses.

Pasternak's novel was the book most in demand among many of the delegations, and copies of it and other novels were handed out in bags from Vienna department stores to disguise the contents; in the darkness of movie theaters; and at a changing roster of pickup points, the locations of which were circulated by word of mouth. For the trip home, delegates tucked books inside camping equipment, stage sets, film cans, and other hiding places.

None of the secret police accompanying the delegations were fooled. When the Polish students were

set to return home, one of the group's leaders warned there would be a thorough search at the border, and it was best to turn in any illicit books before departure. When he got almost no response, he compromised and said, "Only *Dr. Zhivago* should be given up."

One Soviet visitor recalled returning to his bus and finding the cabin covered with pocket editions of *Doctor Zhivago.* "None of us, of course, had read the book but we feared it," he said. Soviet students were watched by the KGB, who fooled no one when they described themselves as "researchers." The Soviet "researchers" proved more tolerant than might have been expected. "Take it, read it," they said, "but by no means bring it home."

In the summer of 1959, Pasternak began work on a drama to be called *The Blind Beauty.* "I want to re-create a whole historical era, the nineteenth century in Russia with its main event, the liberation of the serfs," he told one visitor. "We have, of course, many works about that time, but there is no modern treatment of it. I want to write something panoramic, like Gogol's *Dead Souls.*" He envisioned the drama as an ambitious trilogy with the first two parts taking place on a country estate in the 1840s and then the 1860s before the action shifts to Saint Petersburg in the 1880s. The trilogy includes a serf who loses her sight, but the blind beauty is Russia, a country "oblivious for so long of its own beauty, of its own destinies."

"I don't know whether I'll ever finish it," Pasternak told a visitor. "But I know that when I complete a line

that sounds exactly right, I am better able to love those who love me and to understand those who don't."

Pasternak began to put aside his massive correspondence to focus on this "happy endeavor," his enthusiasm for the subject rising as he delved into the research and writing. "I have been eagerly zealous at my new work of late," he told his sister in July. He told a correspondent in Paris, "Since the time when I first lukewarmly toyed with the idea of the play, it has turned from an idle whim or trial shot into a cherished ambition, it has become a passion." He began to read scenes out loud to Ivinskaya, who found the language colorful and every word alive. She felt that the play would "be a work just as bound up with his life and artistic nature as the novel was."

Some of the official hostility in Moscow began to ease that summer. At the Third Congress of Soviet Writers in May, Khrushchev suggested that writers should keep their feuds in-house and not trouble — or embarrass — the government. Pasternak was not mentioned and of course did not attend, but Khrushchev was bothered by the Zhivago affair. Smarting from the global reaction to the campaign against Pasternak, he asked his son-in-law, Alexei Adzhubei, to read *Doctor Zhivago* and report back. According to *The New York Times*, Adzhubei said that while the novel "is not a book that would cause a good Young Communist to toss his cap in the air . . . it is not a book that would touch off counter-revolution." Adzhubei concluded that with the removal of a mere three hundred or four hundred words, *Doctor Zhivago*

could have been published. Khrushchev exploded, and had Surkov removed as secretary of the Union of Soviet Writers; one report said he grabbed Surkov by the collar and shook him furiously.

In a speech to the Third Congress, Khrushchev told the delegates, "You may say: 'Criticize us, control us; if a work is incorrect, do not print it.' But you know that it is not easy to decide right away what to print and what not to print. The easiest thing would be to print nothing, then there would be no mistakes . . . But it would be stupidity. Therefore, Comrades, do not burden the government with the solution of such questions, decide them for yourselves in a comradely fashion." Later in the year, the Union of Soviet Writers suggested that Pasternak could apply to be reinstated, but he rejected the approach. "They all showed themselves up at that time," he said, "and now they think that everything can be forgotten."

Pasternak began to venture out in public in Moscow, and his first appearance, to attend a concert of the New York Philharmonic conducted by Leonard Bernstein, drew press notice. The Philharmonic was playing in Moscow, Leningrad, and Kiev — the first major concert tour by an American organization after the signing in 1958 of the United States-Soviet Union Cultural Exchange Agreement. Bernstein was a sensation, bringing audiences to their feet, although some Communist critics were unhappy with what they saw as his attempt to lift the Iron Curtain in music. As well as American compositions, he played works by Igor Stravinsky that had never been played in the Soviet

Union. Before pieces, Bernstein also spoke directly to the audience, and Soviet listeners were completely unused to that kind of engagement with a conductor. Before playing Stravinsky's *Rite of Spring*, he said the composer "created a revolution before your own revolution. Music has never been the same since that performance." *The New York Times* noted that "when the savage rhythms and weird melodies had reached their climax, there was a moment of breathless silence and then a great explosion of wild cheering."

While in Leningrad, Bernstein got Pasternak's address and invited him to the final Moscow concert on September 11. Pasternak responded in a letter with two postscripts in which he accepted the invitation but went back and forth on an invitation to Bernstein and his wife to visit him in Peredelkino on the day before the concert. His changes of mind may have reflected Zinaida's objections before he finally defied her and asked them to come in the final postscript. When Bernstein and his wife arrived they were initially left outside in the pouring rain while Pasternak and his wife had a lengthy argument. The guests, upon being admitted, were told that the family squabble was about what door they should enter; they evidently never suspected that Pasternak's wife despised the thought of foreign visitors.

Bernstein and his wife ate with Pasternak, and the conductor found him "both a saint and a *galant*." Bernstein reported that they talked for hours about art and music and the "artist's view of history" before later correcting himself and noting that the conversation was

"in fact virtually monologues by him on aesthetic matters." When Bernstein complained about his difficulties with the minister of culture, Pasternak replied, "What have ministers got to do with it?"

"The Artist communes with God," he told the American, "and God puts on various performances so that he can have something to write about. This can be a farce, as in your case; or it can be a tragedy — but that is a secondary matter."

Moscow Conservatory's Great Hall was packed with much of the intelligentsia. Pasternak attended with his wife and "every eye in the hall seemed to focus on the two people . . . there was a subdued buzzing in the hall as people motioned to one another and stared.

"The tension, almost unbearable in its intensity, was broken suddenly when Mr. Bernstein appeared on stage, followed by a tremendous cheer. Some of those present, perhaps including Mr. Bernstein, were sure that at least part of the enthusiastic greeting was meant to be shared by Mr. Pasternak."

Pasternak visited Bernstein backstage and the two men shared a bear hug. "You have taken us up to heaven," said Pasternak. "Now we must return to earth."

CHAPTER
FIFTEEN

"An unbearably blue sky"

Pasternak turned seventy on February 10, 1960. When he arrived at Ivinskaya's to celebrate, he was red-faced from the piercing wind; there were frost flowers on the windows and snow fluttered in the air. Pasternak warmed his stomach with cognac and settled in with the assembled company, including the German journalist Heinz Schewe. Ivinskaya served roast chicken with homemade cabbage salad, and the meal was washed down with more cognac and two bottles of Georgian red wine. Pasternak was happy and loquacious. He spoke at length about a number of German writers. There were lots of presents, and notes of congratulations from around the world. Pasternak's sisters sent a telegram. An alarm clock in a leather case came from Prime Minister Nehru. The owner of a gas station in Marburg mailed him earthenware pots.

"How late everything has come for me," he told Ivinskaya. "If only we could live forever like this."

Pasternak had 109 days.

Late the previous year, he had written to a Western correspondent, "A short time ago I began to notice now and then a disturbance at the left side of my breast. This is allied to my heart — I am telling no one about

it as, if I do mention it, I shall have to give up my habitual daily routine. My wife, relatives, friends will stand over me. Doctors, sanatoriums, hospitals crush out life before one is yet dead. The slavery of compassion begins." Earlier that winter, Katya Krasheninnikova, one of his young devotees, visited Pasternak. He told her he had lung cancer, and one or two years to live. He asked her to tell no one but to go to communion with him.

On his birthday, Pasternak still appeared vigorous; he hid the sometimes sharp pain in his chest. But in letters to distant friends, there were hints of an end foreseen, a summing up. "Some benign forces have brought me close to that world where there are no circles, no fidelity to youthful reminiscences, no distaff points of view," he told Chukurtma Gudiashvili, the young Georgian ballerina, "a world which the artist prepares himself all his life to enter, and to which he is born only after death, a world of posthumous existence for those forces and ideas for which you have found expression."

Among his more exotic valedictory thoughts was that Feltrinelli should buy his body from the Soviet Union, bury him in Milan, and have Ivinskaya watch over his tomb. His lover began to notice that his strength was ebbing. He would tire while working on commissioned translations and seemed less buoyant during their walks. She was frightened by a grayness that had begun to creep into his complexion.

At Easter, a German admirer, Renate Schweitzer, came to visit. The two had shared an intimate correspondence since Schweitzer, a poet who worked as

a masseuse, first wrote to him in early 1958. She was entranced by a newspaper photo of Pasternak and then by the Russia of Pasternak's *Zhivago*. Schweitzer was a thunderstruck fan, and Pasternak was somehow transported by this epistolary relationship to the Germany of his student days in Marburg. Schweitzer became so moved by the confessional, tender tone in Pasternak's letters — in one he ruminated on his complicated life with Zinaida and Olga — that she considered trying to become a Soviet citizen and moving to Peredelkino. Pasternak preferred her as a creature of their correspondence and was ambivalent about the visit, particularly because he was feeling so poorly.

At the dacha, where she ate Easter dinner with the Pasternaks and their guests, Schweitzer noted the pallor in Pasternak's face and how little he ate. She also visited Ivinskaya with Pasternak, and emboldened by alcohol and in front of her hostess, she kissed her hero with more ardor than affection. She asked the unamused Ivinskaya if she could "have him for a week."

After walking Schweitzer to the train station, Pasternak complained that his coat was "so heavy." He also felt compelled to ask for Ivinskaya's forgiveness, but she was more troubled by his overwrought state — sobbing, on his knees — than the brazen kisses with Schweitzer. Later that week, he also told Nina Tabidze that he thought he had lung cancer but swore her to secrecy. As the pain in his chest became more pronounced, he wondered to Ivinskaya if he was

"falling ill as a punishment for what I did to you over Renate."

The following week, Pasternak began to keep a journal on his health, scribbling notes in pencil on loose sheets of paper. "I have heart complaints, pain in the back. I think I've overtaxed myself during Easter. Can hardly stay on my legs. Tiring to stand at my writing desk. Had to stop writing the play. The left arm feels dull. Have to lie down." He sent Ivinskaya a note that he would have to stay in bed for a few days. "I give you a big kiss. Everything will be alright."

On the twenty-third, he surprised Ivinskaya when she saw him approaching her on the road, carrying his old suitcase. He was expecting money from Feltrinelli to be brought to him by Schewe or an Italian courier. He looked "pale and haggard, a sick man."

"I know you love me, I have faith in it, and our only strength is in this," he told her. "Do not make any changes in our life, I beg you."

They never spoke again.

On the twenty-fifth, Pasternak was examined by a doctor, who diagnosed angina and recommended complete bed rest. Pasternak was unconvinced. "I find it hard to imagine that such a constant pain, as firmly embedded as a splinter, should be due only to something wrong with my heart, very overtired and in need of attention as it is."

Two days later, Pasternak felt better and the results of a cardiogram were encouraging. "It will all pass," Pasternak wrote in his journal.

At the end of April, Pasternak was struggling to get up the stairs to his study, and a bed was made for him in the music room downstairs. He told Ivinskaya not to make any attempt to come to see him. "The waves of alarm set off by it would impinge on me and at the moment with my heart in this condition, it would kill me," he told her in a note. "Z in her foolishness would not have the wit to spare me. I have already taken soundings on the subject." He told her not to get upset, that they had come through worse things. But he was now in some physical distress. "The effect on my heart of the slightest movement is instantaneous and horribly painful," he told her. "All I can do that is relatively painless is lie flat on my back."

On May 1, Pasternak was visited by Katya Krasheninnikova, the young woman with whom he wanted to have communion at the church. "I'm dying," he told her. Pasternak asked her to go through the sacrament of confession with him; he read the prayers aloud with his eyes closed, his face serene. Pasternak asked Krasheninnikova to open the door so his wife could hear and then loudly complained that Zinaida refused to call a priest or organize a church burial. Krasheninnikova said she passed Pasternak's confession on to her own priest, and he said the prayer of absolution. "That's how they used to do it in the camps," she later told Pasternak's son.

A few days later, Pasternak again thought he felt better. He got out of bed, but after washing his hair he suddenly felt very unwell. He continued to advise Ivinskaya that the condition was temporary and

counseled her to be patient. "If I were really near death, I should insist that you be called over here to see me," he told her in another note. "But thank goodness this turns out to be unnecessary. The fact that everything, by the looks of it, will perhaps go on again as before seems to me so undeserved, fabulous, incredible!!!"

On the night of May 7, Pasternak suffered a heart attack. The USSR Literary Fund Hospital dispatched Dr. Anna Golodets and several nurses to provide care for him around the clock. Golodets found her patient battling a high temperature and severe lung congestion. She thought the low, slanting bed set up downstairs had to be very uncomfortable, but she found Pasternak uncomplaining and determined to hide the extent of his disease from his loved ones. He liked the window open during the day; outside, his garden was in full bloom.

Marina Rassokhina, the youngest nurse at just sixteen, delivered updates to Ivinskaya and sometimes spent the night with her. She relayed to Ivinskaya how Pasternak, without his false teeth, felt unbearably ugly. "Olyusha won't love me anymore," he told the nurse. "I look such a fright now." He was frustrated that he couldn't shave but allowed his son Leonid to do it for him. One of the other nurses, Marfa Kuzminichna, who had served at the front during the war, admired Pasternak's courage as death neared. "I already feel the breath of the other world on me," he told her. He spoke about his "double life" and asked her not to condemn him. He didn't entirely lose his sense of humor. As the nurses prepared for a blood transfusion, he told them they looked like "Tibetan lamas at their altars."

In mid-May, Pasternak was examined by four doctors, who diagnosed a heart attack and stomach cancer. Pasternak was given a series of injections that led to some hallucinations. He thought he spoke to the writer Leonid Leonov about *Faust* and was very upset when he learned that event had not happened. An oxygen tent seemed to ease his breathing and reduce the nightmares.

Zinaida sent a telegram to Oxford, assuring his sisters that he was being treated by Moscow's best doctors. She was draining her savings to pay for some of the care. Western correspondents in the capital tried to obtain antibiotics for him through their embassies.

By now the foreign press was at the gates of the dacha seeking updates in what became a round-the-clock death watch. There were concerned visitors — Akhmatova, the Ivanovs, the Neigauzes, among others — but Pasternak declined to see them. He told them he loved them, was comforted they were nearby, but said the Pasternak they knew was gone. The patient only wanted his wife or his son Leonid, or the nurses, in his sickroom. He didn't even like to see doctors without being freshly shaved with his false teeth in. Silence enveloped the house, and Zinaida, monosyllabic and unsentimental, managed the daily routine, helped by Pasternak's brother, Alexander, and his wife, who had moved out to Peredelkino to assist.

Zinaida several times offered to allow Ivinskaya to see Pasternak and to leave the house while she visited. Over the previous year, she was tormented by gossip about the affair with "that lady," which grew to

humiliating proportions because of Pasternak's fame. Pasternak said he couldn't bear to see Zinaida "in tears" because of all the whispers. Zina, he said, is "for me like my own daughter, like my youngest child. I love her as her dead mother would."

Pasternak was adamant that his lover should not come over. Instead, she came to the gate of the dacha weeping and Pasternak's brother would speak to her. Zinaida thought it was "monstrous" that Pasternak would not see her. She wondered if her husband was disappointed in Ivinskaya, and if the relationship had soured. Pasternak's notes to Ivinskaya suggest not. He simply could not bear the stress and the pitched emotion of an Ivinskaya visit. He did not want her to see him in his reduced state, and he did not wish to foist all the drama of a visit on his family. He was too decorous, and his lives with these two women were, for him, distinctly separate. It wasn't who Pasternak loved, but how he wanted to die that kept Ivinskaya hovering near the dacha gate and Zinaida nursing his dying body.

In late May, a portable X-ray machine was brought to the house and it showed cancer in both lungs that was metastasizing to other major organs. There was no hope of recovery. Pasternak asked to see his sister Lydia. Alexander sent a telegram to England: "SITUATION HOPELESS COME IF YOU CAN." Despite pleas directly to Khrushchev, Lydia spent a week in London waiting for the Soviet authorities to make a decision; by the time they issued a visa it was too late.

316

On the twenty-seventh, Pasternak's pulse dropped, but the doctors worked to revive him. Opening his eyes again, he told them he had felt so good while asleep and now his worries were back. He was still feeling low, and unusually blunt, when he spoke to his son Yevgeni later that day.

"How unnatural everything is. Last night I suddenly felt so good, but it proved to be bad and dangerous. With quick injections they tried to bring me back and they did.

"And now, just five minutes ago, I started calling the doctor myself, but it proved to be nonsense, gas. On the whole, I feel everything is steeped in shit. They said I had to eat to make my stomach work. But that's painful. And it's the same in literature, recognition, which is no recognition at all, but obscurity. It would seem I was already buried once, and for good; enough. No memories. Relationships with people all ruined in different ways. All fragmentary, no unbroken memories. Everything is steeped in shit. And not only we, but everywhere, the whole world. My whole life has been a single-handed fight against the ruling banality, for the human talent, free and playing."

By the evening of the thirtieth, it was clear to the doctors that death was imminent. Zinaida went in to see Pasternak. "I have loved life and you very much," he said, his voice momentarily strong, "but I am leaving without any regrets. Around us there is too much banality, not only around us, but in the whole world, I simply cannot reconcile myself to it."

317

His sons followed at about 11:00p.m. "Borenka, Lydia will soon be here, she's on her way," Yevgeni told his father. "Hold on for a while."

"Lydia, that's good," said Pasternak.

He asked everyone but his sons to leave the room. He told them to stay aloof from that part of his legacy that lay abroad — the novel, and the money, and all the attendant complications. Lydia, he said, would manage it.

Pasternak's breathing became more and more labored. The nurses brought in the oxygen tent. He whispered to Marfa Kuzminichna: "Don't forget to open the window tomorrow."

At 11:20p.m. on May 30, Pasternak died.

Zinaida and the housekeeper washed and dressed the body. The family stayed up through much of the night.

At 6:00a.m., on the road near Pasternak's dacha, Ivinskaya saw Kuzminichna coming off duty, her head bowed. She knew without asking that Pasternak was dead and stumbled, crying and unannounced, into the big house: "And now you can let me in, now you don't have to fear me anymore."

Nobody bothered her. She found her way to the body. "Borya was lying there still warm, and his hands were soft. He lay in a small room, with the morning light on him. There were shadows across the floor, and his face was still alive — not at all inert."

She summoned his voice and could hear him recite "August," one of the *Zhivago* poems.

Farewell, azure of Transfiguration,
Farewell the Second Savior's gold.
Ease with a woman's last caress
The bitterness of my fatal hour.

Farewell, years fallen out of time!
Farewell, woman: to an abyss
Of humiliations you threw down
The challenge! I am your battlefield.

Farewell, the sweep of outspread wings,
The willful stubbornness of flight,
And the image of the world revealed in words,
And the work of creation, and working miracles.

Word spread through the village. Lydia Chukovskaya told her father, whose hands began to tremble. He sobbed without tears.

"The weather has been unbelievably beautiful: hot and stable," Chukovsky wrote in his diary later that day. "The apple and cherry trees are in bloom. I've never seen so many butterflies, birds, bees and flowers. I spend entire days out on the balcony. Every hour there's a miracle, every hour something new, while he, the singer of all these clouds, trees and pathways . . . is now lying in state on a pitiful folding bed, deaf and blind, destitute, and we shall never again hear his impetuous, explosive bass."

The Soviet press did not report Pasternak's death, although it was front-page news around the world. Prime ministers, queens, and ordinary people sent their

condolences. In Milan, Feltrinelli said in a statement, "The death of Pasternak is a blow as hard as losing a best friend. He was the personification of my nonconformist ideals combined with wisdom and profound culture."

In Moscow, there was silence. Finally, on June 1, a small notice appeared on the bottom of the back page of a minor publication *Literatura i Zhizn* (Literature and Life): "The board of the Literary Fund of the USSR announces the death of the writer and member of Litfond, Pasternak, Boris Leonidovich, which took place May 30 in the seventy-first year of his life after a severe and lengthy illness, and expresses its condolences to the family of the deceased."

There was not even the standard expression of regret in this final attempt at insult. A writer as prominent as Pasternak would normally be memorialized with numerous obituaries in all the leading dailies as well as an appreciation signed by many of his fellow writers in *Literaturnaya Gazeta*. Pasternak was still a pariah worthy of only one run-on sentence, and the Central Committee in an internal memo said that the snub "was welcomed by representatives of the artistic intelligentsia." On June 2, the literary newspaper reprinted the perfunctory notice from *Literatura i Zhizn* and gave it the same small play at the bottom of the back page. But on the same page was a large article about the Czech poet Vítězslav Nezval under the headline "A Magician of Poetry." For some readers, the juxtaposition was no coincidence but the sly tribute of some unknown editor.

There were other notices about Pasternak's death, handwritten and taped to the wall near the ticket office in Moscow's Kiev Station, where the suburban trains departed for Peredelkino. "At three o'clock on the afternoon of Thursday June 2, the last leave-taking of Boris Leonidovich Pasternak, the greatest poet of present-day Russia, will take place." Other versions of this message appeared in different locations around the city. When they were torn down by the police, new ones took their place.

The afternoon of the funeral was another in what had been a series of hot days, and one with an "unbearably blue sky." The apple and lilac trees in Pasternak's garden were ablaze with pink and white and purple blossoms, and underfoot there was a carpet of wildflowers peeking out from the freshly cut pine boughs that had been laid to protect the young grass.

When the American journalist Priscilla Johnson caught the train around 1:00p.m., it was clear that many of the passengers, wearing black and carrying sprigs of lilac, were on their way to the funeral. And when the train pulled into Peredelkino, it emptied out, disgorging passengers who seemed to her to be either very young or very old. The authorities described them as "mostly intelligentsia" and young people, students from the Institute of Literature and Moscow State University. They formed a loose procession to the dacha. The police were stationed at all the intersections, and they told those who arrived by car, including the foreign press, that they would have to park and walk the last part of the way.

The authorities hoped to manage the funeral, and how it was seen by the world. On the eve of the burial, the local Communist Party chief had provided a tour of the village for foreign correspondents, including the cemetery, where a freshly dug grave stood in the shade of three tall pine trees and within sight of Pasternak's dacha. It was a cemetery of competing ideas: crosses or red stars marked the different graves. "Pasternak will be buried in the best site in the graveyard," the functionary boasted.

Representatives of the USSR Literary Fund had visited the family after Pasternak's death and said they would pay for the burial and help manage the logistics. The KGB set up temporary headquarters in a local office, and agents were sent out to mingle with the crowd and record who attended. Word had already spread among members of the Moscow branch of the Union of Soviet Writers that they should not attend, and in the days before the funeral some writers had snuck in and out through the backyard to pay their respects without being seen by the ubiquitous informers.

Only a few writers were willing to risk the wrath of the authorities by attending the funeral. When the playwright Alexander Shtein was asked why he didn't go to the funeral, he replied, "I don't take part in anti-government demonstrations."

The curtains were drawn in the house of Pasternak's neighbor Konstantin Fedin, Surkov's successor as secretary of the writers' union. Fedin was ill, but his absence was taken as an affront. Two mourners clashed

by Pasternak's coffin over Fedin's failure to attend. One had claimed that Fedin was so sick he didn't know about Pasternak's death. Another had angrily retorted: "He can see perfectly well from his windows what is going on here."

The novelist Veniamin Kaverin was so incensed he later wrote to Fedin. "Who can forget the senseless and tragic affair of Pasternak's novel — an affair which did so much damage to our country? Your part in this business went so far that you even felt compelled to pretend you had not heard of the death of the poet who was your friend and lived next door to you for 23 years. Perhaps you could see nothing from your window as people came in their thousands to take their leave of him, and as he was carried in his coffin past your house."

The garden quickly filled to overflowing. Western newsmen stood on boxes by the dacha gates; some climbed into the trees to get a better view. The mourners waited silently to enter the house by the side door and file by the body before exiting out the front door. Pasternak was dressed in his father's dark gray suit and a white shirt. "He could have been lying in a field, rather than in his own living room, for the coffin was banked with wild flowers, with cherry and apple blossoms, as well as red tulips and branches of lilac." The flowers became more and more heaped as mourners left their own sprays. A group of women dressed in black — sometimes including Zinaida and Yevgenia, Pasternak's first wife — stood at the head of the coffin.

The journalist Priscilla Johnson was shocked when she saw the body, "for the face had lost all of its squareness and strength." Veniamin Kaverin thought that Pasternak's familiar face was now "sculpted in white immobility," and he detected what he thought was "a tiny smile lingering on the left corner of his mouth." The body had been embalmed on May 31 after the artist Yuri Vasilyev had made a death mask. On June 1, a local priest held a private requiem service in the dacha for the family and some close friends.

When Johnson asked Pasternak's sister-in-law if the burial would be preceded by a service in the nearby fifteenth-century Russian Orthodox Church of the Transfiguration, she looked the American up and down. "You," she said, "are very naïve."

Ivinskaya passed by the body, unable to linger because of the stream of people behind her. "Inside people were still taking leave of my beloved, who lay there quite impassive now, indifferent to them all, while I sat by the door so long forbidden to me." She was approached by Konstantin Paustovsky, the eighty-year-old dean of Soviet letters, and Ivinskaya began to cry as he bent down to speak to her. Paustovsky must have imagined that she was unable to enter the house because of her complicated situation. "I want to go past the coffin with you," he said, taking Ivinskaya by the elbow.

Paustovsky remarked on what "an authentic event the funeral was — an expression of what people really felt." He said one was bound to recall "the funeral of

Pushkin and the Tsar's courtiers — their miserable hypocrisy and false pride."

The secret police moved among the crowd, eavesdropping or taking photographs. They were unmistakable to many of the mourners and the "sole alien element in the crowd which, with all its diversity, was united in its shared feeling."

"How many were there altogether?" Pasternak's old friend Alexander Gladkov wondered. "Two or three thousand, or four? It was hard to say but it was certainly a matter of several thousand." Western correspondents placed the number at a more conservative one thousand and the authorities counted five hundred. Even a crowd of a few hundred was remarkable. Gladkov had worried that the funeral would turn out to be "rather poorly attended and pathetic."

"Who could have expected so many when nobody *had* to come just for form's sake, by way of duty, as is so often the case," Gladkov marveled. "For everybody present, it was a day of enormous importance — and this fact itself turned it into another triumph for Pasternak."

People ran into old friends in the front garden — comrades, in some cases, from the camps. Gladkov met two former inmates he had known and not seen in years. It seemed entirely natural to meet again at this moment, and Gladkov recalled Pasternak's lines from "Soul":

My soul, you are in mourning
For all those close to me
Turned into a burial vault
For all my martyred friends.

Around the back of the dacha, people sat on the grass as some of Russia's finest pianists played on an old upright, the notes wafting through the open windows of the music room. Stanislav Neigauz, Andrei Volkonsky, Maria Yudina, and Svyatoslav Richter took turns, performing slow dirges and some of the melodies Pasternak loved, particularly those by Chopin.

Shortly after 4:00p.m. Richter ended the music with a rendition of Chopin's "Marche Funèbre." The family asked those still inside the house to move into the front garden so they could have a last moment alone with the deceased. Ivinskaya, outside by the front porch, strained to see inside, at one point climbing up on a bench and looking through a window. One observer thought that "in her humiliated position, she looked overwhelmingly beautiful."

After a short period, Zinaida, dressed in black, her hair highlighted with henna, stepped onto the front porch. It was time for the funeral procession.

The mounds of flowers from around the coffin were passed through the windows to the crowd. The organizers from Litfond had driven up a blue minibus to carry the coffin quickly and ahead of the mourners to the grave, where the casket was to be hastily buried. The pallbearers, including Pasternak's two sons, refused to put the body in the vehicle. The open coffin

was hoisted on their shoulders, and the crowd parted as they set off, through the garden, right on Pavlenko, and along "the melancholy dirt road" which "bitterly threw up dust" as the crowd made its way to the cemetery.

The young writers Andrei Sinyavsky and Yuli Daniel, both disciples of Pasternak, followed with the coffin lid. In the Russian tradition, it would not be screwed on until the moment just before interment. The pallbearers, at the head of the throng, walked with such haste that the body appeared to be bobbing on an ocean of humanity. Young men stepped out of the crowd to assist in carrying the coffin when the pallbearers appeared to tire.

Some of those in attendance took a shortcut across the newly plowed field in front of Pasternak's dacha. It led directly down to the cemetery, which stood on a small hillside near the brightly colored cupolas of the local church. The graveyard was already crowded when the procession with the coffin arrived. When the pallbearers reached the edge of the grave, they raised the casket high above the crowd just for a moment before placing it on the ground.

"For the last time, I saw the face, gaunt and magnificent, of Boris Leonidovich Pasternak," recalled Gladkov.

The philosopher Valentin Asmus, a professor at Moscow State University and an old friend of Pasternak's, stepped forward. A young boy leaned in to Priscilla Johnson and told her who he was. "Non-party," he added.

"We have come to bid farewell to one of the greatest of Russian writers and poets, a man endowed with all the talents, including even music. One might accept or reject his opinions but as long as Russian poetry plays a role on this earth, Boris Leonidovich Pasternak will stand among the greatest.

"His disagreement with our present day was not with a regime or a state. He wanted a society of a higher order. He never believed in resisting evil with force, and that was his mistake.

"I never talked with a man who demanded so much, so unsparingly, of himself. There were but few who could equal him in the honesty of his convictions. He was a democrat in the true sense of the word, one who knew how to criticize his friends of the pen. He will forever remain as an example, as one who defended his convictions before his contemporaries, being firmly convinced that he was right. He had the ability to express humanity in the highest terms.

"He lived a long life. But it passed so quickly, he was still so young and he had so much left to write. His name will go down forever as one of the very finest."

The actor Nikolai Golubentsov then recited Pasternak's poem "O Had I Known" from the 1932 collection *Second Birth*.

A slave is sent to the arena
When feeling has produced a line
Then breathing soil and fate take over
And art has done and must resign.

A young man, nervous and stammering, read "Hamlet" from the *Zhivago* cycle of poems. The poem, like the novel, had never been published in the Soviet Union but still "a thousand pairs of lips began to move in silent unison" and a charge seemed to course through the crowd. Someone shouted, "Thank you in the name of the working man. We waited for your book. Unfortunately, for reasons that are well known, it did not appear. But you lifted the name of writer higher than anyone."

The officials from Litfond, sensing the hostile murmur of the crowd, moved to bring the funeral to an end. Someone began to carry the lid toward the coffin. The closest mourners bent over the body to kiss Pasternak farewell. Among the last was Ivinskaya, crying uncontrollably. At certain points during the graveside ceremony, she and Zinaida were just steps away from one another at the head of the coffin. Zinaida was irritated that Ivinskaya and her daughter had pushed their way to the front. As Ivinskaya said her farewell, Zinaida "stood smoking by a fence, not 20 feet from the coffin . . . and throwing baleful glances now and then at the man whose body was about to be lowered into the grave."

Spontaneous shouts continued from the crowd.

"God marks the path of the elect with thorns, and Pasternak was picked out and marked by God!"

"Glory to Pasternak!"

"The poet was killed!" someone cried, and the crowd responded, "Shame! Shame! Shame!"

One of the Litfond officials yelled, "The meeting is over; there will be no more speeches!"

A copy of a prayer for the dead was placed on Pasternak's forehead by his longtime housekeeper, and the lid was hammered shut. There were more cries as the coffin was lowered and the first thuds of dirt hit the wood — "faint, muffled and terrifying."

The sky clouded over. Most of the crowd quickly dispersed but about fifty young people stayed at the grave, reciting Pasternak's poetry. They were still there when the sun began to set — "the voice now of one, now another, rising and falling in an eloquent singsong." The KGB decided not to interfere, but the Central Committee later told the Ministry of Culture and the Union of Soviet Writers to pay attention to the education of students because "some of them (and their number is trifling) have been poisoned with unhealthy, oppositional ideas and are trying to position Pasternak as a great artist and writer who was not understood by his epoch."

Through the long, exhausting day, Lydia Chukovskaya, despite her sorrow, had a "strange feeling of triumph, of victory.

"The victory of what? I don't know. Maybe of his poetry. Of Russian poetry?" she wondered. "Of our unbreakable bond with him?"

CHAPTER
SIXTEEN

"It's too late for me to express regret that
the book wasn't published."

Ivinskaya was arrested in Peredelkino on August 16. It was dusk, and she was drinking tea with her mother and stepfather when several men came through the garden gate. "You were expecting us to come, of course, weren't you?" said one of the KGB officers, pink-faced and smiling with satisfaction. "You didn't imagine, did you, that your criminal activities would go unpunished?"

Over the previous eighteen months, the secret police had been watching various foreigners bring money into the country for Pasternak — and Ivinskaya was charged with illegal currency trading. While her arrest was at first kept secret, the authorities eventually decided to scapegoat her in a crude attempt to somehow reclaim the early Pasternak, not the author of *Doctor Zhivago*, as a great Soviet writer. Pasternak, according to Surkov, had been misled by an "adventuress who got him to write *Doctor Zhivago* and then to send it abroad, so that she could enrich herself."

In the last year of his life, Pasternak was a rich man, but control of his fortune lay frustratingly beyond his reach. He authorized Feltrinelli to give $100,000 from

his royalties to D'Angelo after the Italian had written to Pasternak to tell him he had "reliable" friends who could carry cash into the Soviet Union.

Pasternak was wary at first: "Olyusha, where should we leave all that money?"

"Well, in that suitcase over there!" replied Ivinskaya.

Feltrinelli transferred the money to D'Angelo from an account in the tax haven of Liechtenstein in March 1960. D'Angelo immediately began purchasing rubles in Western Europe and then arranging for Italian friends to smuggle the currency into the Soviet Union and pass it secretly to Pasternak via Ivinskaya or her daughter. D'Angelo described himself as "running" an "operation" with his own security protocols.

The Italian, however, was no match for the KGB.

The secret police watched as Giuseppe Garritano, a Moscow correspondent for the Italian Communist newspaper *L'Unità*, arranged the transfer of a large sum of rubles that D'Angelo had purchased. In March 1960, Garritano's wife, Mirella, called Ivinskaya's city apartment, which was almost certainly bugged and under close surveillance, and asked her to come to the post office and collect some books for Pasternak. Ivinskaya was laid up with a sprained leg and Pasternak was reluctant to meet an unknown foreigner. They agreed to send Ivinskaya's daughter, Irina, who took her younger brother with her. They were handed a shabby black suitcase and when it was opened back in the apartment, Ivinskaya and Pasternak "gasped with astonishment: instead of books, it contained bundles of

332

Soviet banknotes in wrappers, all neatly stacked together, row upon row of them."

Pasternak gave Ivinskaya one bundle and took the suitcase to Peredelkino.

The Italians agreed to take back some documents to Feltrinelli. Garritano and his wife lost the papers while vacationing in the Caucasus, including a signed instruction that gave Ivinskaya control over Pasternak's royalties. When she noticed the papers were gone, Mirella Garritano thought the documents might have fallen out of her bag during a rainstorm. Her husband suspected they were being watched and the documents were stolen when she put her bag down at a party. In August, Ivinskaya separately forwarded to Feltrinelli a power of attorney that Pasternak had signed in December 1956 and gave her "power to carry out all tasks related to the publication of the novel *Doctor Zhivago*." But this did not provide any broad authority to manage his posthumous affairs.

The Garritanos' carelessness made for a very complicating loss. Pasternak left no will, and often unseemly struggles for control over various parts of his legacy began almost immediately after his death and were litigated by friends and family well into the 1990s.

In late 1959, Feltrinelli had sent Pasternak a new contract, which gave the Milan publisher control over the film rights for *Doctor Zhivago*, Pasternak's other writings, and also sidelined de Proyart as the author's second legally sanctioned adviser in the West. Hesitant about offending his French friend, Pasternak procrastinated for several months. Pressed by both Ivinskaya and the

German journalist Heinz Schewe, Feltrinelli's trusted courier to Moscow, Pasternak eventually signed the contract in April 1960.

In the week after the funeral, Ivinskaya wrote to Feltrinelli and after mentioning her "terrible sorrow" told him that they urgently had to talk about practical matters. "In April, when Boris wanted to dedicate himself exclusively to his drama and already felt weak, he wrote me a power of attorney for you," she said, referring to the material she had entrusted to the Garritanos. "It says that he wishes my signature to be as valid as his own whether it concerns financial agreements or any other sort of document." She wrote that D'Angelo's friends would pass it along. She also promised to support Feltrinelli in any conflict with Pasternak's family, including his sisters in England. "The Pasternak family has no claim to the publishing rights," Ivinskaya wrote. "The last power of attorney is the agreement I just informed you about."

Feltrinelli wrote back to Ivinskaya to tell her that he thought D'Angelo's methods "were too dangerous" and she should trust only the German correspondent. In his own effort at spycraft, Feltrinelli enclosed half of a thousand-lira banknote and told Ivinskaya that in the absence of Schewe she should deal with the person who could produce the other half of the bill. Ivinskaya thought the banknote was something out of a "bad thriller," and she would pay a steep price for possessing it.

Ivinskaya said she hadn't had a "quiet moment" since she learned the documents were gone and feared

what would happen if they fell into the wrong hands. "My dear, dear Giangiacomo. Let's hope that the most horrible thing will not happen and that I will keep my liberty, for as long as it takes."

Following the death of the author, Feltrinelli hoped that Ivinskaya could continue to entrust him with Pasternak's affairs. The publisher had no previous contact with Pasternak's wife and children, and his adviser Schewe was predisposed to Ivinskaya, not the widow, Zinaida. "I will always make sure that a substantial part of the profits is left for you and Irina," Feltrinelli promised Ivinskaya. He also told her that his contracts with Pasternak "must never end up in the hands of the authorities or the Pasternak family."

Excluding Pasternak's family was a venal suggestion, and one that would be exploited by the Soviet Union. But it didn't entirely reflect Feltrinelli's position. He accepted Ivinskaya as Pasternak's executor but told her "not to get involved in a battle in Moscow" and to be "generous with money matters," for there could be "dangerous enemies."

Unaware of Feltrinelli's misgivings, D'Angelo continued with his own plans. In July, he gave a second, large installment of cash to another Italian couple, the Benedettis, who drove to Moscow from Berlin in a Volkswagen Beetle. The money was hidden in the paneling of the car. When they arrived in Moscow, the couple carried the cash to Ivinskaya's apartment in a large rucksack. The Benedettis brought in 500,000 rubles, which was worth about $125,000 at the official exchange rate, but

could be acquired for much less, about $50,000, on the gray market in Western Europe.

Ivinskaya tried to refuse the money after her daughter sensed the danger in accepting it. But the Benedettis had come too far not to complete their mission. "You have no right to refuse it," they said. "This is a personal debt." Ivinskaya's caution was shortlived. She bought a motorcycle for her son and, on the day of her arrest, a polished wardrobe, part of a shopping spree certain to draw attention to a woman with no visible income. Some of the hasty spending may have been caused by a currency reform that would have required Soviet citizens to turn in old rubles for new by the end of the year. The Pasternaks were also involved in some head-turning spending. In April, shortly before his death, Pasternak bought a new car, a Volga, for 45,000 rubles, a strikingly big-ticket cash purchase for an author who had ostensibly lost a great deal of income after the Nobel Prize controversy.

The KGB began to pressure Ivinskaya almost immediately after Pasternak's funeral. She was visited by a "thick-set man with black eyes" who produced the red identity card of a KGB agent and demanded the manuscript of Pasternak's work in progress, *The Blind Beauty*. Ivinskaya was told that unless she produced the original copy she would be "taken to a place that will certainly be more traumatic." Ivinskaya handed it over, but soon after arranged for Schewe to get another copy of the play out of the country. Feltrinelli promised not to publish it without Ivinskaya's permission.

The secret police also began to isolate Ivinskaya's family. Irina was engaged to a French student, Georges Nivat. But before the August 20 wedding he fell ill with a mysterious illness. He was hospitalized after he broke out in blisters over much of his body and started running a high temperature. He recovered but his visa was not renewed and he was forced to fly home to France on August 10. All pleas on his behalf, including directly to Khrushchev from the French ambassador to the Soviet Union, were ignored. In retrospect, Irina considered the possibility that Nivat's contagious disease and hospitalization were not accidental, but organized to stop the marriage.

Day-to-day harassment of Ivinskaya and her family was stepped up. "Strange groups of young people" hung around outside the Moscow apartment, and when Olga and her daughter went out they were shadowed by men who made no effort to hide themselves — repeating a tactic from the days of the Nobel Prize controversy.

On August 16, the day of Ivinskaya's arrest, her rental home in Peredelkino and her apartment in Moscow were searched — as were the homes of some of her friends. She had hidden the remaining money as well as some of Pasternak's papers in a suitcase in a neighbor's house, where it was found. Pasternak's house was also searched by two agents, who said they were acting on information from Ivinskaya that Pasternak had received one hundred pairs of boots and fifty coats from abroad, as well as cash. The lead about the clothing was patently false, and it's doubtful there

was any such "tip" from Ivinskaya. The search was probably focused on finding money and documents.

Sandwiched between two agents, Ivinskaya was driven to the Lubyanka — KGB headquarters — where she had been held in 1949.

"I was overcome by a peculiar feeling of indifference," she recalled. "Now that Borya was in his grave, perhaps it was just as well that I had been plucked out of the hopeless dead-end of my existence."

The twenty-two-year-old Irina was arrested on September 5. She was interrogated every day but never for more than two hours. "After all, you are a teeny-weeny criminal," her investigator said.

Feltrinelli learned of Ivinskaya's arrest in early September. "We have read all of your letters at once, as soon as we came home from vacation, and are absolutely appalled," he wrote to Schewe. "The sequence of events — with the culmination in your last letter — is truly awful. This, unfortunately, is due to the carelessness and temporary mistrust in us of our lady friend who, against all cautions and warnings, took advantage of the other party whose goals are very shady." He was apparently referring to D'Angelo's couriers.

"As for D'Angelo, I am really in the dark," he continued. "We are dealing here either with a provocateur or an idiot."

At first the mother and daughter were held in secret; there was no announcement of their arrest. D'Angelo and his wife visited Moscow in September, unaware of what had happened. They checked in at the Hotel

Ukraine, the Stalinist skyscraper near their old apartment by the Moscow River. When he called Ivinskaya, a strange female voice answered and said she wasn't home. The following day when D'Angelo called back, someone that he believed to be Irina told him, "Mom's on vacation in the south and she won't be back until the end of the month."

"Well, maybe we could get together with just you and Mitya," said D'Angelo.

The fake Irina eventually agreed that they could come over, but when they did, only Mitya, Ivinskaya's son, was at home. He said his sister was really sorry but "she had to leave rather suddenly. She had a chance to get a ride with friends who are driving to the south and she wants to go visit our mother."

The boy seemed nervous and uncomfortable. The conversation was being monitored. D'Angelo and his wife withdrew.

At the Lubyanka, Ivinskaya was again subjected to daily interrogations. At one point, she was questioned by Vadim Tikunov, the deputy chairman of the KGB, whose involvement signaled the importance the authorities attached to the case. Ivinskaya described him as consisting of three spheres: "his backside, his belly and his head."

When Ivinskaya was brought before Tikunov, a copy of *Doctor Zhivago* lay on his desk, along with some of Pasternak's letters to her.

"You disguised it very well," he said, "but we know perfectly well that the novel was written not by Pasternak but by you. Look, he says so himself."

Tikunov quoted from one of Pasternak's letters to Ivinskaya: "It was you who did it all, Olyusha! Nobody knows that it was you who did it all — you guided my hand and stood behind me, all of it I owe to you."

"You have probably never loved a woman," said Ivinskaya, "so you don't know what it means, and the sort of things people think and write at such a time."

Ivinskaya was indicted on November 10, 1960.

The trial began and ended on December 7, a day of driving sleet. Ivinskaya and her daughter were brought to Moscow City Court on Kalanchevskaya Street in Black Marias. They were overjoyed to see each other and "could not stop talking."

There were no witnesses, family, or press in the courtroom — only the judge, lawyers, court staff, and investigators. Some of Irina's friends had learned of the trial, probably from the defense attorneys, and they stood at the gates of the courthouse to wave to the women as they were driven in.

The prosecutor told the court that the correspondence between Ivinskaya and Feltrinelli convinced him that the novel was sent abroad by Olga, although Pasternak had also "sold himself to the Western warmongers." The prosecutor said he was uncertain who had actually written the novel — Pasternak or Ivinskaya — but the point was moot as the charges were limited to currency smuggling and trading. The half of Feltrinelli's thousand-lira note was produced in court, and the roster of couriers was detailed along with the amounts of money they smuggled in.

Ivinskaya's lawyers argued that Ivinskaya and her daughter had smuggled nothing and had never exchanged foreign currency for rubles. Moreover, they said, Feltrinelli and his emissaries were following Pasternak's instructions. And the lawyers questioned why couriers who were under surveillance were never arrested.

There was never any doubt about the verdict, but when the length of the sentence was announced, there was utter bewilderment at its severity — eight years forced labor for Ivinskaya, three years for Irina.

In January, the two women were sent by train to a camp in Taishet, Siberia, nearly three thousand miles east of Moscow. The nearest city was Krasnoyarsk. Surrounded by common criminals and nuns who sang about Christ, they were kept in cages inside the train coaches on the journey east. The cold was terrible and Irina was wearing only a light spring coat. The final leg of the trip was a forced walk at night in temperatures of minus twenty-five degrees Celsius. Ivinskaya found it "unbearable for Muscovites like [her and Irina] who were quite unused to such bitter cold."

The regime at the camp, a facility for women convicted of political offenses, proved not to be too harsh. The barracks were warm, there was a *banya* (sauna), and parcels from Moscow arrived without difficulty. Olga and Irina were nicknamed the "Pasternachkis" by the other inmates. But their stay was short-lived. While they were being transported to the camp in Taishet, the Gulag — the system of forced-labor camps that began under Stalin — was

officially abolished. After several weeks, the women were sent back west to Potma — the camp where Ivinskaya had served her time between 1950 and 1953 and part of the penitentiary system.

Word about the arrest and trial seeped out slowly. At first a number of Western writers and academics, including Graham Greene, François Mauriac, Arthur M. Schlesinger Jr., and Bertrand Russell, wrote quiet appeals to the Soviet authorities, which were ignored. Russell, an elderly philosopher who had campaigned hard for unilateral nuclear disarmament, told Khrushchev in a letter that the Soviet persecution of Olga and Irina "was the sort of thing that made my campaign for better relations with Russia extremely difficult."

The news broke publicly January 18. *The New York Times* described the sentence as a "pure act of revenge" against "Boris Pasternak's close Collaborator and intimate friend, who inspired the novel 'Doctor Zhivago' and served as the model for its heroine, Larisa."

Radio Moscow responded on January 21. The English-language broadcast described the smuggling of cash and quoted from Feltrinelli's letter in July in which he asked Ivinskaya not to let his contracts with Pasternak fall into the hands of the authorities or the Pasternak family. The report said that Ivinskaya had confessed, and it ended with an arch commentary that recalled Hamlet's description of his mother: "Frailty, thy name is woman!" A week later the international broadcaster followed up and recapped the prosecution in a long commentary in Italian: "The dream of

fantastic riches impelled her to crime and she began to trade Pasternak's name, wholesale and retail. The more the author's health declined, the greater grew the trade; even death did not stop business."

The report went on to detail what it described as "a whole conspiratorial system, similar to those usually described in thrillers. They had everything: a code language, clandestine meetings, aliases and even identification codes: an Italian currency note cut in half was used as identification token."

The broadcast concluded that "the last page of this sordid history is closed: the Moscow City Court, on behalf of millions of Soviet citizens whose land has been besmirched by these dregs of society, bought with dollars, lire, francs and marks, has pronounced sentence."

In the West, the story was far from over. The prosecution of Ivinskaya was seen as a continuation of the Nobel campaign against Pasternak. "People in the West will be justified in asking what one can expect, on the level of relations between states, from a regime which displays so little courage and generosity toward its own citizens and so little respect for the great culture of which — in many ways — it is the custodian," wrote the retired American diplomat George Kennan in a letter to *The New York Times*. *The Times* of London concluded that the "radio statement is much too vindictive in its wording and too melodramatic to be swallowed whole."

The basis of the Soviet case against Ivinskaya was challenged. Feltrinelli released a statement on January

28: "As Boris Pasternak's publisher I have preferred hitherto to refrain from making any statement, because I maintain that controversy in this matter does not help the persons involved in the case — not even the late author's family. So gross, however, are the inaccuracies reported by the most varied sources that it is my duty to state today a fact of which I am personally aware.

"I myself know that the 100,000 dollars, converted entirely or in part into rubles and transmitted to Moscow, came from funds at the disposal of Boris Pasternak in the West. The amount in question was withdrawn on a written order in the author's own hand, dated 6th December 1959."

Feltrinelli said the order arrived in the West in March 1960.

"In conclusion, it is my opinion that Olga Ivinskaya is not responsible either for the transfer of the sum or for its eventual destination. In the first place, the transfer order was given, I repeat, by Pasternak himself; secondly, it was Pasternak himself who wished that the sum converted into rubles should be sent, without distinction, either to himself or to Mrs. Ivinskaya.

"Nor can one rule out that the wish of the author was, in fact to consider Olga Ivinskaya as his heiress. I trust therefore that the Soviet judicial authorities will take into account the circumstances which I have related, which are all confirmed by irrefutable documents."

D'Angelo also published a series of articles that included the text from Pasternak's letters to him and contained "irrefutable proof to the effect that it was the

344

author himself who requested and received the money." And Nivat told reporters in Paris, "Knowing the ties between Boris Pasternak and Madame Ivinskaya, I know that she would never have undertaken anything without his initiative." Through a friend Nivat asked Queen Elisabeth of Belgium, who in 1958 was the first royal to visit the Soviet Union, to intervene. "Had Boris Pasternak, whom I loved as a father, still lived, this would not have happened," he wrote.

Surkov entered the fight with an interview in the French Communist daily, *L'Humanité*. He expressed surprise that he was getting letters from writers such as Graham Greene. "What, you intervene and demand the liberation of rogues of whom you know nothing? Now this is really a question of an illegal currency deal and is not connected with Pasternak, who was a great poet. His family, it must be said, has nothing to do with this sordid story. All these rumors offend the writer's memory. If people abroad wish to respect his memory then they should not stir up mud around him, just because among his friends there was an adventuress."

Surkov also wrote to David Carver, the general secretary of International PEN, to say that Ivinskaya "advertised her intimacy with Pasternak" and "despite her advanced age (48) did not stop to have many parallel and frequent intimate relations with other men."

The following month, Surkov and Alexei Adzhubei visited Britain. They brought with them what they called documentary evidence proving Ivinskaya's guilt, including photographs of bundles of rubles; a

345

photograph of the now-famous half of Feltrinelli's thousand-lira note; a letter from Feltrinelli to Ivinskaya; and a copy of a handwritten statement Ivinskaya gave to the KGB.

"We have brought documents and letters which will give you absolute evidence that she was mixed up in some very dirty business, which could only harm Mr. Pasternak's name," said Adzhubei at a press conference in London.

The Soviet officials in London had little understanding of how Ivinskaya's alleged confession would be read in the West: "Everything in the accusation is the essential truth," she wrote. "For my part, I dispute none of it. (Perhaps with the exception of details about which I myself may have become confused owing to my nervous condition.) On the other hand, I wish to thank the interrogator for his tact and correctness, not only in connection with me, but also with my archives, which have been carefully sorted, part of them returned to me, part delivered to the [literary archive], and nothing which I wanted to preserve destroyed."

Adzhubei demanded that British newspapers publish the documents "without comment whatsoever" and accused the British press of censorship when editors told him that this was not how journalism in the West was practiced. The British press also pointed out that none of this material had been published in the Soviet Union and noted that the case against Ivinskaya had been subject to an almost total news blackout.

Surkov persisted in his efforts to cast Pasternak as a great poet who was exploited in his old age by

Ivinskaya. And the state began to publish some of Pasternak's work but not, of course, *Doctor Zhivago*. A literary committee "was formed a month after the poet's death to arrange for the publication of his work of which all Russians are very fond," Surkov announced. It was a mixed group of friends and family, including Vsevolod Ivanov, Ehrenburg, Zinaida and Pasternak's sons, as well as some officials. Several months later, Surkov made a selection of Pasternak's poetry for a collection to be published by Goslit, the state publishing house. Some of Pasternak's family and friends objected to the choice of poems and the slimness of the volume, but Zinaida Pasternak was happy to see anything published and get some income. "I don't care how it looks," she said, "as long as they put it out quickly."

Zinaida was left in poor straits in the wake of Pasternak's death. She spent a good deal of money on specialist care in the weeks before his death, and had no way to access the royalties that sat in bank accounts in the West. She suggested that the Soviet government repatriate and take all of the royalties if they would just give her a pension. "I'm a pauper," she complained to Chukovsky.

In August 1961, she asked Surkov if the family could transfer royalties held abroad for Pasternak's poems and other works, but not from *Doctor Zhivago*, which they would reject for "moral reasons." Surkov supported an effort to help her, noting in a memo to his colleagues that "she has practically no means of subsistence" and "has always been and is loyal to the

Soviet power." She "never approved" of Pasternak's novel, he added.

Polikarpov, the Central Committee bureaucrat in charge of cultural matters, rejected any attempt to withdraw money from accounts held abroad, arguing that it could lead to "yet another anti-Soviet campaign in the reactionary press."

"It seems appropriate to stop discussing this issue," he wrote.

In 1966, a number of writers and artists wrote to the Politburo to ask for a pension for Zinaida, who had suffered a series of heart attacks since her husband's death. Polikarpov blocked it, apparently because he "had a longstanding dislike for Zinaida . . . who he viewed as overly blunt and lacking in cultural refinement."

Zinaida never saw a ruble and died on June 28, 1966. She was buried next to her husband. Zinaida and Pasternak's son, Leonid, died ten years later of a heart attack while sitting in his car near Manège Square in central Moscow. He was only thirty-eight.

The money continued to pile up in Western Europe. In 1964, Feltrinelli sold the film rights to *Zhivago* to Metro-Goldwyn-Mayer for $450,000. Feltrinelli insisted that the screenplay not misrepresent or distort "the author's ideas in a way that might lead to their being attributed with a meaning and a political orientation that was not in conformity" with his intentions. In Hollywood, this was dismissed as posturing, and the film's producer, Carlo Ponti, thought that Feltrinelli "didn't give a damn, all he wanted was the money." The

film, starring Omar Sharif as Zhivago and Julie Christie as Lara, was directed by David Lean, and key scenes were shot in Spain and Finland. The movie was a major hit, and introduced vast numbers of people who had never read the novel to the story of *Doctor Zhivago*. The movie was banned in the Soviet Union. The Soviet Foreign Ministry protested to the United States embassy when American diplomats held private showings of *Doctor Zhivago* in their apartments. The ministry labeled the screenings "frankly provocative" and said the movie, like the book, "falsified Soviet history and the life of the Soviet people."

The film, like most adaptations, was not entirely faithful to the novel, and was criticized for its naive rendering of history and its melodrama. But like the novel, the film had a huge impact on popular culture. Omar Sharif as Zhivago and Julie Christie as Lara are still remembered in those roles, the cinematography was breathtaking, and the music of "Lara's Theme" by Maurice Jarre remains instantly familiar. Adjusted for inflation, *Doctor Zhivago* is one of the highest-grossing movies of all time.

One Russian reader of *Doctor Zhivago* who changed his mind about the novel was Khrushchev. The Soviet leader was ousted in October 1964 by his colleagues, including Vladimir Semichastny, the former youth leader who compared Pasternak to a pig and had since risen to become chairman of the KGB. In retirement, Khrushchev's son gave him a typewritten, samizdat copy, and he took a long time to read it. "We shouldn't

have banned it," he said. "I should have read it myself. There's nothing anti-Soviet in it."

In his memoirs, Khrushchev reflected, "In connection with *Doctor Zhivago*, some might say it's too late for me to express regret that the book wasn't published. Yes, maybe it is too late. But better late than never."

In October 1965, Mikhail Sholokhov, the candidate long favored by the Kremlin, won the Nobel Prize in Literature. The Swedish Academy said the award was "for the artistic power and integrity with which, in his epic of the Don, he had given expression to a historic phase in the life of the Russian people."

Sholokhov proved to be an ungracious winner. "I am the first Russian writer, the first Soviet writer to win the Nobel Prize," he told a press conference in Moscow. "It is natural that I should feel proud. It did come rather late, however."

Pasternak, he said, "was just an internal émigré" and "I am not going to change my opinion of Pasternak just because he's dead."

Sholokhov did change his opinion of the academy, which he had said was "not objective in its judgment of an individual author's worth" when Pasternak won the prize. But in 1965, he "gratefully" accepted the honor.

In Moscow, too, the academy was no longer depicted as a stooge of the West. "The fact that this bright talent has received the world's recognition is estimated by Soviet writers as a victory of Soviet literature," said Leonid Leonov, a Union of Soviet Writers official. "This is the rehabilitation of the Nobel Prize itself as an objective and noble recognition of literary talent."

The Swedish Academy's rehabilitation did not last very long. In 1970, Aleksandr Solzhenitsyn, who had chronicled life in the Gulag, was awarded the Nobel Prize. Then, the Union of Soviet Writers said that "it is deplorable that the Nobel committee allowed itself to be drawn into an unseemly game that was not started in the interests of the development of the spiritual values and traditions of literature but was prompted by speculative political consideration."

Ivinskaya was released from prison in late 1964; Irina had been released two years earlier, also after serving half her sentence. While at the camp in Potma, Ivinskaya had written to Khrushchev to plead for clemency, particularly for her daughter, whom she described as "dying slowly right in front of my eyes." In June 1961, *The New York Times* reported that Ivinskaya and her daughter were seriously ill and hospitalized. Irina was reported to have a stomach ulcer.

"I am not saying that I am not guilty because I believe Pasternak was guilty," wrote Ivinskaya at the start of the letter, dated March 10, 1961. Nor did she blame Pasternak, although she was frank in her descriptions of his involvement in the effort to bring in his royalties. "One cannot just present [Pasternak] as an innocent lamb," she said, stating the plainest of facts. "This does not deceive anyone and neither does my 'criminal case.'"

In the long, rambling letter that sprawled over sixteen handwritten pages, Ivinskaya argued that the case against her was flawed, if not ludicrous. And she expressed disbelief that her daughter, "this girl," was

imprisoned — "and for what? Just for holding the suitcase . . . ?"

Ivinskaya said she only learned at KGB headquarters that the receipt of money from abroad — even though such transactions weren't particularly appealing — had damaged the state. She noted, as had her defense lawyers and Pasternak's defenders in the West, that the author had received royalties from abroad for some time and the money helped support Pasternak and his family. Ivinskaya mentioned the Pasternak family's purchase of a new car. "It was impossible not to know the money came from abroad," she wrote.

"I shared Pasternak's life for 14 years and in most cases I shared not his royalties but all his misfortunes and the vicissitudes of his fate and very often in contrast to my beliefs," she continued. "But I loved him and I did my best as my friends joked to shield him with my 'broad back.' And he believed that I was his closest and dearest person, the person whom he needed most."

She noted — as she would later in her memoir — that she intervened with D'Angelo to delay publication of *Doctor Zhivago* and that the Central Committee had asked her to stop Pasternak from meeting foreigners. In that, she had an even sterner ally in Zinaida Pasternak.

Ivinskaya concluded that Pasternak would "turn in his coffin if he found out the terrible end of my life was caused by him.

"Please return me and my daughter to life. I promise I will live the rest of my life so that it will be good for my country."

The letter was accompanied by a report from the camp commander on the "characteristics of the detainee." Ivinskaya was described as conscientious, modest, and polite, and it was noted that she "correctly understands" the politics of the Communist Party and the Soviet government. But the commander added that "she feels her conviction was wrong, that she was convicted for a crime she did not commit."

Tendentious excerpts from Ivinskaya's letter to Khrushchev were published in a Moscow newspaper in 1997 when Ivinskaya's heirs were in a dispute with the State Archives of Literature and Art over some of Pasternak's papers. The article, employing selective quotes, attempted to smear Ivinskaya as a KGB informer. The complete letter was not published. Unfortunately, the effort to damage Ivinskaya's reputation largely succeeded, as the article's allegation was uncritically reproduced in the Western press. A reading of the full letter, which is available in the State Archive of the Russian Federation in Moscow, simply doesn't support the label of informer. The KGB, in its own secret assessment, described Ivinskaya as anti-Soviet. The letter is the plea of a desperate woman who tried to ingratiate herself to the Soviet leader — as did countless other inmates who sought mercy from the Kremlin.

After her release, Ivinskaya resumed her career as a literary translator and started writing about her life. Her memoirs were taken out of the Soviet Union in 1976 by Yevtushenko and published under the title *A Captive of Time: My Years with Pasternak*. She died in

1995 at the age of eighty-three. Her daughter, Irina Yemelyanova, lives in Paris and has published two memoirs of her own.

Sergio D'Angelo lives in Viterbo, Italy, and continues to write about the Zhivago affair and charm guests as easily as he did Pasternak. He unsuccessfully sued Feltrinelli for half of Pasternak's royalties in the 1960s. He believed he had a claim to the money because of a note Pasternak had written, asking that D'Angelo be rewarded. D'Angelo had hoped to use the royalties to establish a literary prize in Pasternak's name that would be "awarded to writers who have championed the cause of freedom." The court battle was protracted and D'Angelo finally abandoned his appeal of a lower-court ruling. The English translation of his memoir is available online.

In 1966, the Pasternak family, with the support of the Soviet authorities, began to negotiate a settlement with Feltrinelli over the royalties and the transfer of Pasternak's money to the Soviet Union. "It seems to me that the time has come for frankness and loyalty, all the more fitting by way of a tribute to the memory of the late Poet," Feltrinelli wrote to Alexander Volchkov, the president of the College of International Jurists in Moscow, and the Pasternak family's representative. "The time is therefore ripe, in my opinion, for all of us to take a more open and straightforward step forward, including those who at the time showed no mercy to the noble figure of the late Poet."

A deal took several years to reach — so long that the Soviets, on their visits to Milan, "learned to wind

spaghetti around their forks," in the words of Feltrinelli's son. Schewe reported that Ivinskaya was "bellicose and uncompromising as ever" and reluctant to share the estate, although she had no legal standing to challenge any agreement. She received the equivalent of $24,000 in rubles in acknowledgment of her role as Pasternak's "faithful companion" when a final settlement was reached in 1970.

By that year, Feltrinelli's political passions were beginning to consume him. After he broke with the Italian Communist Party, he felt like he "no longer believed in anything. No type of commitment either ideological or political." But two visits to Cuba in 1964 and 1965, and long discussions with Fidel Castro, whose memoirs he hoped to publish, had a rejuvenating effect on Feltrinelli. Here was a political experiment he could admire. The Cold War adversaries seemed hopelessly corrupt to him as the 1960s progressed — the Americans were killing in Vietnam and Soviet tanks were smothering the Prague Spring. In Italy, Feltrinelli feared a Fascist coup. The publisher gradually and then completely immersed himself in a radical, anti-imperialist struggle, and his views hardened to the point that he advocated "the use of systematic and progressive counter-violence" to ensure the success of the Italian working class. For the Italian secret services, he was fast becoming an enemy of the state. When bombs exploded in Milan at the Banca Nazionale dell'Agricultura, killing sixteen and injuring eighty-four, Feltrinelli's name was floated as a suspect by the police. He could have fought the accusation, but

instead went underground — seeking "untraceability," as he called it. "It is the only condition that allows me to serve the cause of socialism," he said in a letter to his staff. He moved from place to place between Italy, Switzerland, France, and Austria. He assumed new identities. He was unsuited to a life on the run and seemed increasingly haggard and disoriented. "He's lost," his wife, Inge Schönthal Feltrinelli, wrote in her diary. When she met him in Innsbruck in April 1970, she failed to recognize him. "He looked like a tramp." A year later, when the Bolivian consul in Hamburg — a regime thug — was assassinated, the gun was traced to Feltrinelli. He was not involved in the conspiracy but probably met the assassin through his Latin American contacts and gave her the gun — a .38 Colt Cobra — on the Côte d'Azur. There was now no way back. He was a revolutionary outlaw. He wrote a long letter to the Red Brigades, a violent Marxist-Leninist paramilitary group, suggesting that they work together on "a political, strategic and tactical platform." Later in 1971, he wrote a new manifesto, *Class Struggle or Class War?* — a call for the revolutionary movement to confront, wear down, and disarm the political and military power of its adversary.

On March 15, 1972, the body of a man was found under a high-voltage electricity pylon in a suburb of Milan. It was Feltrinelli. He was killed when the bomb he and some co-conspirators planned to use to cause a power cut went off prematurely. "Did the explosion happen because of a sharp movement up on the crossbar (the fabric of the pocket pressing against

the timer, the pin making contact) or did someone set the time with minutes instead of hours?" Feltrinelli's son Carlo asked in his memoir of his father. "The answer might close the story, but it would not resolve what really matters."

In 1988 and 1989, as he rode the subway in Moscow, the journalist David Remnick was arrested by an incredible sight: "ordinary people reading Pasternak in their sky-blue copies of *Novy Mir*." The intelligentsia had long since read *Doctor Zhivago* and the other banned works of seven decades of censorship. Now it was the turn of ordinary people to experience the excitement of what for so long had been forbidden.

Official attitudes toward Pasternak began to soften in the early 1980s — before the reformist Mikhail Gorbachev became the Soviet leader and his policy of glasnost allowed the publication of banned works. Pasternak's former protégés, including the poets Voznesensky and Yevtushenko, began to agitate for the publication of *Doctor Zhivago*. Voznesensky described publication as a litmus test of the times, an act necessary to lance the past. "It will be a triumph over the witch hunt against anti-Sovietism," he said.

"You destroy the black magic myth," he continued. "The lie against Pasternak will be dead. It will be a revolution."

The magazine *Ogonyok* (Little Flame) published some short excerpts from *Doctor Zhivago* in December 1987. From January to April 1988, *Novy Mir*, the journal that first rejected *Doctor Zhivago*, serialized the novel and Soviet readers could finally and openly

read Pasternak's work in full. A first legal Russian edition appeared the following year and the copyright line read: "Giangiacomo Feltrinelli Editore Milano."

At the V. I. Lenin State Library, which was later renamed the Russian State Library, a copy of the CIA edition of *Doctor Zhivago* that had been hidden away since 1959 was transferred out of the Spetskhran (Special Collections) and made available to the public, albeit on a controlled basis because the edition is considered very precious. In libraries across Russia, thousands of titles and "a wealth of noncommunist philosophy, political science, history, and economics and the treasure trove of Russian émigré memoirs and literature" emerged from the hidden stacks.

Olga Carlisle, who had interviewed Pasternak shortly before his death, was in Moscow at the time *Doctor Zhivago* began to appear. On a spring evening on Gorky Street, she and a friend saw a line of two or three hundred people. Carlisle's companion, a Muscovite, joined the queue out of habit before knowing what was for sale, an old Soviet instinct in case some rare consumer good or food had made it to the threadbare shelves of the city's stores. The line ended at a bookstore and the crowd, they soon learned, was expecting a shipment of copies of *Doctor Zhivago* the following morning.

Also in 1989, the Swedish Academy invited Yevgeny Pasternak, who along with his wife, Yelena, had become the tireless compiler and editor of Boris Pasternak's complete works, to come to Stockholm. In a brief ceremony in the academy's great hall on December 9,

Sture Allén, the permanent secretary, read the telegrams Pasternak had sent accepting and then rejecting the Nobel Prize in October 1958. Yevgeny was overcome with emotion when he stepped forward and on behalf of his father accepted the gold medal for the 1958 Nobel Prize in Literature.

Afterword

"A successful stunt, don't you think?" said the Dutch intelligence officer C. C. (Kees) van den Heuvel, who worked with the CIA on the first printing of *Doctor Zhivago*.

There was something of the caper about the Zhivago operation and, more generally, the books program. Émigrés, priests, athletes, students, businessmen, tourists, soldiers, musicians, and diplomats — they all carried books across the Iron Curtain and into the Soviet Union. Books were sent to Russian prisoners of war in Afghanistan, foisted on Russian truck drivers in Iran, and offered to Russian sailors in the Canary Islands, as well being pressed into the hands of visitors to the Vatican pavilion in Brussels and the World Youth Festival in Vienna.

The Zhivago operation left such an impression on CIA officer Walter Cini and his Dutch colleague Joop van der Wilden that they were still talking about it in the 1990s, and discussing the possibility of opening a museum dedicated to Pasternak. The CIA had genuinely lofty ambitions for the vast library of books it spirited east. In one of its only claims for its covert

intellectual campaign ever made public, the agency said the books program was "demonstrably effective" and "can inferentially be said to influence attitudes and reinforce predispositions toward intellectual and cultural freedom, and dissatisfaction with its absence."

Even after many of the agency's activities in the cultural Cold War were disclosed in the press in the late 1960s, forcing the agency to halt some of its political warfare operations, the secret distribution of books remained largely unexposed and continued until late 1991. From the birth of the books program in the 1950s until the fall of the USSR, the CIA distributed 10 million books and periodicals in Eastern Europe and the Soviet Union. Either CIA funds went to small publishers who smuggled books or the agency ran its own one-off operations, as in the case of *Doctor Zhivago*. In the program's final years, when Gorbachev was in power, at least 165,000 books were sent to the Soviet Union annually. Not just fiction was smuggled in pockets and suitcases, but "dictionaries and books on language, art and architecture, religion and philosophy, economics, management, and farming, history and memoirs, and catalogues."

Some of this extraordinary story has come out, piecemeal, in revelations by former employees of CIA-sponsored organizations and in the work of scholars such as Alfred A. Reisch, who have put together a history of the programs in Eastern Europe from records in universities and private hands. "Millions of people," he concluded, "were affected one way or another by the book project without ever hearing about its existence."

For these individuals, the books program meant a well-thumbed piece of literature or history received in secret from a trusted friend and, in turn, passed on to another.

Much of the official record of this effort, including all the files of the Bedford Publishing Company, which targeted the Soviet Union, remains classified. There are reasons to fear that some of the agency's — and the public's — rich inheritance no longer exists. A former CIA officer told the authors that the agency for a long time had kept a collection of its miniature bible-stock publications, but many of the books were destroyed to make room for other material.

The battle over the publication of *Doctor Zhivago* was one of the first efforts by the CIA to leverage books as instruments of political warfare. Those words can seem distasteful and cynical, and critics of the CIA's role in the cultural Cold War view the agency's secrecy as inherently immoral and corrupting. But the CIA and its contractors were certain of the nobility of their efforts, and that in the face of an authoritarian power with its own propaganda machine, a resort to secrecy was unavoidable. All these years later, in an age of terror, drones, and targeted killing, the CIA's faith — and the Soviet Union's faith — in the power of literature to transform society seem almost quaint.

The global standing of the Soviet Union was bruised by its treatment of Pasternak. "We caused much harm to the Soviet Union," wrote Khrushchev, who said he was "truly sorry for the way [he] behaved toward Pasternak." Khrushchev was a virtual prisoner in his own home when he dictated his memoirs, and in an

irony that would surely have brought a small smile to Pasternak's face, he allowed the tapes to be spirited out of the Soviet Union and published in the West.

It was a path that many others, following Pasternak's example, would take. He became a model for a line of courageous Soviet writers who followed his example of publishing abroad. Aleksandr Solzhenitsyn may be the most prominent example. Their number also included Sinyavsky and Daniel, the two young men who carried the lid of Pasternak's coffin, and another Russian Nobel Prize winner, the poet Joseph Brodsky.

In the wake of Pasternak's death, a new community emerged that strived for the same "intellectual and artistic emancipation as the dead poet had," wrote the historian Vladislav Zubok. "And they viewed themselves as the descendants of the great cultural and moral tradition that Pasternak, his protagonist Yuri Zhivago, and his milieu embodied. Thus, they were Zhivago's children, in a spiritual sense."

Brodsky said that, beginning with *Doctor Zhivago*, Pasternak caused a wave of conversions to Russian Orthodoxy, especially among the Jewish intelligentsia. "If you belong to Russian culture and you think in its categories, you know perfectly well that this culture is nursed by Orthodoxy," he said. "That's why you turn to the Orthodox Church. Let alone that it is a form of opposition."

Pasternak's grave became a pilgrimage site, a place to pay homage "to all hunted and tormented poets," as one poet described his visits to Peredelkino in the 1970s. The young people who stayed late reciting

Pasternak's poetry on the day of his burial kept coming back, and year after year, new faces and generations continued to recite the lines from his poem "Hamlet":

Yet the order of the acts is planned
And the end of the way inescapable.
I am alone; all drowns in the Pharisees' hypocrisy.
To live your life is not as simple as to cross a field.

Acknowledgments

We have been helped by many very generous people who made this book possible. Thank you.

Paul Koedijk introduced us and started our conversation about *Doctor Zhivago*, exchanges that led to our decision to write this book together. Raphael Sagalyn, our literary agent, shepherded us into the world of publishing. Kris Puopolo, our editor, believed in this story from the first moment.

We thank Sonny Mehta, the editor in chief of Knopf Doubleday, and Dan Frank, the editorial director of Pantheon Books, for taking us into the same house that published *Doctor Zhivago* in the United States in 1958; Daniel Meyer of Doubleday; and Ellie Steel and Matthew Broughton at Harvill Seeker in London.

Ken Kalfus, Patrick Farrelly, Kate O'Callaghan, and Paul Koedijk gave us early and important feedback.

We want to single out Natasha Abbakumova of *The Washington Post*'s Moscow bureau, whose assistance was extraordinary.

A number of people were critical to our understanding of this story. Carlo Feltrinelli and Inge Schönthal-Feltrinelli at *Doctor Zhivago*'s first home in Milan;

Sergio D'Angelo in Viterbo; the late Yevgeni Pasternak; Natalya Pasternak, Yelena Chukovskaya, and Dmitri Chukovsky in Moscow; Irina Kozovoi (Yemelyanova) and Jacqueline de Proyart in Paris (1998); Roman Bernaut and Alexis Bernaut in Reclos, France; Gerd Ruge in Munich; and Megan Morrow in San Francisco.

We are grateful for the support of Joe Lambert, Mary Wilson, Bruce Barkan, Debbie Lebo, Marie Harf, and Preston Golson at the CIA, and we thank all the officers who served in the CIA's Historical Collections Division. After being greeted with a polite no when we first asked about the agency's *Zhivago* papers, Bruce van Vorst, former CIA officer and journalist, helped through various intermediaries to bring our project to the attention of the right people at the agency. Former CIA officers Burton Gerber and Benjamin Fischer provided insights along the way. We were also helped by Dirk Engelen, in-house historian at the Dutch intelligence services, the ATVD, formerly the BVD. The assistance of the late BVD officer C. C. (Kees) van den Heuvel was invaluable as was that of former MI6 officer Rachel van der Wilden, the widow of BVD officer Joop van der Wilden. Other former CIA officers who assisted us did not wish to be identified.

We have been aided by librarians and researchers across the United States and Europe. Our thanks to: Ron Basich, who conducted research at the Hoover Institution Archives; Janet Crayne and Kate Hutchens at the University of Michigan Library; Valoise Armstrong at the Dwight D. Eisenhower Presidential Museum and Library; David A. Langbart and Miriam

Kleiman at the National Archives in College Park, Maryland; Tanya Chebotarev at Columbia University's Bakhmeteff Archive; Koos Couvée Jr., who conducted research at the National Archives in London; Jan Paul Hinrichs, Joke Bakker, Bryan Beemer at Leiden University Library; Willeke Tijssen at the International Institute of Social History in Amsterdam; Professor Gustaaf Janssens at the Archive of the Royal Palace in Brussels; Patricia Quaghebeur of the KADOC (Documentation and Research Centre for Religion, Culture and Society) in Leuven, Belgium; Johanna Couvée for research in the academic libraries in Brussels; Delfina Boero, Paola Pellegatta, Vladimir Kolupaev at the Fondazione Russia Christiana, Villa Ambiveri in Seriate, Italy; Lars Rydquist at the Nobel Library; Magnus Ljunggren in Stockholm; Elisabet Lind for her warm hospitality in Stockholm; Linda Örtenblad, Odd Zschiedrich, and Ulrika Kjellin for their support at the Swedish Academy; the staff of the State Archive of the Russian Federation (GARF); Yelena Makareki at the Russian State Library in Moscow; Anne Qureshi at the Frankfurter Buchmesse; and Rainer Laabs at Axel Springer AG Unternehmensarchiv in Berlin.

We would like to say thank you to Svetlana Prudnikova, Volodya Alexandrov, Maria Lipman, and Anna Masterova in Moscow; Shannon Smiley in Berlin; Leigh Turner in London; Theo Maarten van Lint at Oxford University; Pieter Claerhout in Ghent; Maghiel van Crevel and Jinhua Wu at Leiden University, and Mark Gamsa at Tel Aviv University.

In the United States, we would like to acknowledge the help of Denise Donegan, Max Frankel, Edward Lozansky, Gene Sosin, Gloria Donen Sosin, Manon van der Water, Jim Critchlow, Alan Wald, Anton Troianovski, Jack Masey, Ulf and Ingrid Roeller, Ansgar Graw, and the Isaac Patch family.

In the Netherlands, the late Peter de Ridder was welcoming and helpful. We are grateful to his family and, in particular, his son, Rob de Ridder. We want to thank the late Cornelius van Schooneveld; Dorothy van Schooneveld; Barbara and Edward van der Beek; and the Starink family. Thanks to Roelf van Til for bringing Couvée's articles about the Zhivago story to a broad Dutch audience on public television in January 1999, and to Bart Jan Spruyt for the introduction to Kees van den Heuvel. Also our thanks to: Brigitte Soethout; Michel Kerres and Edith Loozen; Igor Cornelissen; Rob Hartmans; Elisabeth Spanjer; Kitty van Densen; Han Vermeulen; and Dick Coutinho.

Peter Finn writes: It has been a privilege to work for the Graham family for eighteen years: I would like to thank Don Graham and Katherine Weymouth for the wonderful professional home they created. Editors at *The Washington Post* allowed me to take a leave of absence to work on this book. Thanks to Marty Baron, Kevin Merida, Cameron Barr, Anne Kornblut, and Jason Ukman. I've worked with many great editors and reporters over the years, including my colleagues in the National Security group, but I am especially grateful to Joby Warrick, David Hoffman, Scott Higham,

Jean Mack, Walter Pincus, Robert Kaiser, Anup Kaphle, and Julie Tate for their help and encouragement on this book.

I spent my leave at the Woodrow Wilson International Center for Scholars, a wonderful institution that allows the time to think and write. I'm grateful to Peter Reid for getting me in the door, and to the center's leaders and staff, including Jane Harman, Michael Van Dusen, Robert Litwak, Blair Ruble, Christian Osterman, William Pomeranz, Alison Lyalikov, Janet Spikes, Michelle Kamalich, and Dagne Gizaw. Also thanks to my fellow visiting scholars at the Wilson International Center: Jack Hamilton, Steve Lee Myers, Mark Mazetti, Michael Adler, and Ilan Greenberg. I'm very grateful for A. Ross Johnson's continuing interest in this project. I was fortunate to be able to work with two wonderful Wilson International Center interns, Chandler Grigg and Emily Olsen, who conducted research at the National Archives and the Library of Congress.

I would like to acknowledge the support of Walter and Stephanie Dorman; John and Sheila Haverkampf; Barry Baskind and Eileen FitzGerald; Joseph FitzGerald Jr.; and the late Joseph and Deirdre FitzGerald.

In Ireland, I want to thank my brothers Greg and Bill, and their families. It's a great regret that my parents, Bill and Pat, didn't live to read this book. Also, a tip of the hat to old friends: Jeremy and Mary Crean, and Ronan and Grainne Farrell.

Thanks to Rachel, Liam, David, and Ria Finn, who watched this book take shape with pride and patience. Nora FitzGerald is a partner in everything. (Love you!)

369

* * *

Petra Couvée writes: In Moscow I was fortunate to enjoy the encouragement of Thymen Kouwenaar, cultural counselor at the Embassy of the Kingdom of the Netherlands, and the intelligent support of Menno Kraan. The Netherlands Institute in Saint Petersburg provided all sorts of general and technical support. I would like to thank Mila Chevalier, Anna Vyborova, Aai Prins, and Gerard van der Wardt at the Netherlands Institute, Saint Petersburg; my Russian colleagues, especially Vladimir Belousov, at the Lomonosov State University in Moscow, and Irina Mikhailova at the State University of Saint Petersburg; and all my Russian students. Thanks to the Dutch Language Union (Nederlandse Taalunie), Ingrid Degraeve, and my colleagues and students at the 2013 summer course in Zeist for granting me a leave to finalize the book.

I am continuously grateful to my family and my friends Manon van der Water, Harco Alkema, Kees de Kock, Arie van der Ent, Maarten Mous, Nony Verschoor; Maghiel van Crevel, for being illuminating; and Henk Maier for literature and lifelong loving loyalty. My parents, Koos Couvée Sr. and Paula van Rossen, for being together and each for their own part an inspiration.

A Note on Sources

We have been interested in the Zhivago story for a number of years. Petra Couvée, who now teaches at Saint Petersburg State University, first wrote in 1999 about the role of Dutch intelligence, the BVD, in the secret publication of *Doctor Zhivago*. One of the BVD's former senior officers, Kees van den Heuvel, after consulting with his former agency colleagues, told Couvée that the BVD helped arrange a printing of the novel in The Hague at the request of the CIA. This admission was the first semi-official acknowledgment of CIA involvement. Couvée's findings were published in the Amsterdam literary magazine *De Parelduiker* (The Pearl Diver). Peter Finn wrote about the theory that the CIA sought to win the Nobel Prize for Pasternak in *The Washington Post* in 2007 when he was the newspaper's Moscow bureau chief. That story led us to start communicating about the Zhivago affair after we were introduced by the Dutch Cold War historian and journalist Paul Koedijk.

Eventually we began to consider writing a new history of *Doctor Zhivago* in the Cold War. We believed this book could not be written unless we were able to

clarify exactly what the CIA did or did not do. The CIA had never acknowledged its role in the secret publication of *Doctor Zhivago*. In 2007, Peter Finn told Yevgeni Pasternak, Boris Pasternak's son, that he would attempt to obtain any CIA records about the operation. Yevgeni Pasternak was skeptical. He did not live to see the release of any material and, in any case, regarded the whole CIA connection as a distressing and "cheap sensation," as he told Finn. His father would no doubt have agreed. Pasternak was unhappy about the exploitation of his novel for Cold War propaganda purposes. He never knew about the CIA's involvement in the secret printing of the novel in Russian; he had reason to believe that it was the work of Russian émigrés, though he knew well that they operated in a murky world that sometimes involved Western intelligence services.

Finn asked the CIA to release any documents that it had on the printing of *Doctor Zhivago*. The first request was made to the agency's public affairs office in 2009. We finally obtained the documents in August 2012. The CIA released approximately 135 previously classified internal documents about its involvement in the printing of two Russian-language editions of the book, the hardback edition distributed in Brussels and a paperback edition printed at CIA headquarters the following year. The CIA's own historians found and reviewed the agency's documentation and shepherded the internal declassification process. We were able to review these documents before their public release. The

CIA placed no conditions on our use of these documents and did not review any section of this book.

The documents reveal a series of blunders that nearly derailed the first printing of the book and led the CIA to make the second printing of the paperback edition an entirely black operation. The CIA plans to publish these documents itself and post them on its website. There are undoubtedly still classified documents in the possession of the CIA that bear on the subject, but a U.S. official said the vast majority of the documents that were found in an internal search of agency records have now been released and those withheld will not affect public understanding of the agency's operations regarding *Doctor Zhivago*. A number of documents that were referenced in the released material but were not found are presumed to have been lost, the official said. The CIA did redact most names and those of some allies and institutions in its documents, but through other sources it was possible to identify key actors in the drama. Still secret is the name of the original source who provided the manuscript to the British. The endnotes for chapters 8 and 9 provide details on the reasoning behind all deductions we have made. We hope this release will prompt the CIA to declassify more material on the Cultural Cold War it waged against the Soviet Union, including on the vast books program it underwrote for several decades.

A wealth of new material has appeared since the fall of the Soviet Union, including the Kremlin's own files and a rich array of memoirs and letters. The authors

have drawn on Soviet documents in the State Archive of the Russian Federation (GARF), and the files of the Central Committee of the Communist Party of the Soviet Union, which were published in Moscow in 2001 as "*A za mnoyu shum pogoni . . .*" *Boris Pasternak i Vlast' Dokumenty: 1956–1972*. (Behind Me the Noise of Pursuit: Boris Pasternak and Power. Documents 1956-1972) (referred to in the notes as *Pasternak i Vlast'*). The Soviet documents in *Pasternak i Vlast'* are not available in English, but they have been published in French as *Le Dossier de l'affaire Pasternak, Archives du Comité central et du Politburo*.

Almost all of Pasternak's writing, including prose, poems, autobiographical sketches, correspondence, and biographical essays by family and friends, some of it never published in English, can be found in an eleven-volume collection edited by Yevgeni and Yelena Pasternak, his son and daughter-in-law: *Polnoe Sobranie Sochinenii, s prilozheniyami, v odinnadtsati tomakh* (Complete Collected Works with Appendices, in 11 Volumes). Volume 11, "Boris Pasternak remembered by his contemporaries," is a collection of memoirs and excerpts from memoirs; for this reason we cite the authors of these memoirs when referencing *Polnoe Sobranie Sochinenii* in the bibliography. In the notes and bibliography,we have directed readers to an English translation of material cited, when available, and to English-language books or articles.

The correspondence of Boris Pasternak and Giangiacomo Feltrinelli has been published by Yelena and Yevgeni Pasternak in *Kontinent,* 2001, nos. 107

and 108, and can be read in English in *Feltrinelli: A Story of Riches, Revolution and Violent Death*, Carlo Feltrinelli's memoir of his father, and in Paolo Mancosu, *Inside the Zhivago Storm: The Editorial Adventures of Pasternak's Masterpiece*.

We have also been able to interview a number of participants and contemporaneous witnesses in the drama, and some of their relatives or descendants, including Yevgeni Pasternak, Carlo Feltrinelli, Sergio D'Angelo, Andrei Voznesensky, Irina Yemelyanova, Yelena Chukovskaya, Dmitri Chukovsky, Gerd Ruge, Max Frankel, Walter Pincus, Roman Bernaut, Peter de Ridder, Rachel van der Wilden, Kees van den Heuvel, Cornelis H. van Schooneveld, and Jacqueline de Proyart. Some of these interviews took place before we planned on writing this book when we were working on shorter articles about various aspects of the Zhivago Affair.

We have also drawn on the great number of memoirs of the era, many of which appeared after the fall of the Soviet Union. Carlo Feltrinelli allowed us to hold and peruse the *Doctor Zhivago* manuscript carried out by D'Angelo — a visceral and electrifying moment for us. Megan Morrow, the daughter of the New York publisher Felix Morrow, gave us the relevant portions of her father's still-sealed oral history, which describes his work for the CIA on *Doctor Zhivago*; his oral testimony is held at Columbia University. Peter de Ridder, one of Mouton's publishers, gave his consent to the General Intelligence and Security Service (AIVD), the successor to the BVD, to turn over any files they

held on him to us. We received the files in September 2009; the documents simply record his travel to the Soviet Union and Eastern Europe as a representative of Mouton.

We have consulted archives and personal papers in Russia, the United States, Italy, the United Kingdom, the Netherlands, Germany, Belgium, and Sweden. They are listed in detail in the bibliography. All newspapers, magazines, and journals consulted are cited in the endnotes.